A Jacques Barzun Reader

Books by Jacques Barzun

Samplings and Chronicles (ed.; 1927)

The French Race (1932/1966)

Race: A Study in Superstition (1937/1965)

Of Human Freedom (1939/1964)

Darwin, Marx, Wagner: Critique of a Heritage (1941/1958)

Romanticism and the Modern Ego (1943)

Introduction to Naval History (with G. Crothers,
E. Golob, and P. Beik) (1943/1946)

Teacher in America (1945; 2d ed., 1954/1971/1981)

Berlioz and the Romantic Century (1950; 3d ed., 1969)

Pleasures of Music (1951/1960)

The Selected Letters of Lord Byron (ed.; 1953/1957)

God's Country and Mine (1954/1959)

Music in American Life (1956/1962)

The Energies of Art (1956/1962)

Berlioz and His Century (1956)

The Modern Researcher (with Henry F. Graff) (1957; 5th ed., 1992)

The Selected Writings of John Jay Chapman (ed.; 1957/1959)

The House of Intellect (1959/1961/1975)

Classic, Romantic and Modern (1961/1975)

The Delights of Detection (1961)

Science: The Glorious Entertainment (1964)

Follett's Modern American Usage (ed.; 1966/1974)

The American University: How It Runs, Where It Is Going (1968/1970)

A Catalogue of Crime (with Wendell Hertig Taylor) (1971; rev. ed., 1989)

On Writing, Editing, and Publishing (1971/1986)

Burke and Hare: The Resurrection Men (ed.; 1974)

Clio and the Doctors (1974)

The Use and Abuse of Art (1974)

Simple & Direct: A Rhetoric for Writers (1975/1985/2001)

Critical Questions (1982)

A Stroll with William James (1983)

A Word or Two Before You Go: Brief Essays on Language (1986)

The Culture We Deserve (1989)

An Essay on French Verse for Readers of English Poetry (1991)

Begin Here: The Forgotten Conditions of Teaching and Learning (1991)

From Dawn to Decadence: 500 Years of Western Cultural Life (2000)

Sidelights on Opera at Glimmerglass (2001)

Translations

La Parisienne, by Henry Becque (1949)

The Epidemic, by Octave Mirbeau (1952)

Rameau's Nephew, by Denis Diderot (1952)

Dictionary of Accepted Ideas, by Gustave Flaubert (1954/1968)

Fantasio, by Alfred de Musset (1955)

New Letters of Berlioz: 1830–1868 (1954/1974)

A Door Should Be Either Open or Shut, by Alfred de Musset (1956)

Evenings with the Orchestra, by Hector Berlioz (1956/1973)

A Rule Is a Rule, by Georges Courteline (1960)

Figaro's Marriage, by Pierre-Augustin Caron de Beaumarchais (1961)

A
Jacques Barzun
Reader

Selections from His Works

EDITED WITH AN INTRODUCTION
BY MICHAEL MURRAY

PERENNIAL CLASSICS

HarperCollins books may be purchased for educational, business, or sales promotional use. For information please write: Special Markets Department, HarperCollins Publishers Inc., 10 East 53rd Street, New York, NY 10022.

First Perennial Classics edition published 2003. Perennial Classics are published by Perennial, an imprint of HarperCollins Publishers.

Designed by Barbara DuPree Knowles, BDK Books, Inc.

Library of Congress Cataloging-in-Publication Data

Barzun, Jacques.
[Essays. Selections]
A Jacques Barzun reader: selections from his works/ edited with an introduction by Michael Murray.—1st Perennial Classics ed.
p. cm.
ISBN 0-06-093542-1
1. Civilization, Modern—Historiography. 2. Civilization, Modern—Philosophy. 3. Civilization, Western—Philosophy. 4. Social history—Philosophy. 5. Barzun, Jacques, 1907—Political and social views. 6. Culture. 7. Humanities. 8. Intellectual life—History. 9. Learning and scholarship—History. I. Murray, Michael, 1941–. II. Title.

CB358 .B29 2003
909.8—dc21
2003040512

10 ❖/RRD 10 9 8 7 6 5 4

In
Parentum
Nostrorum
Memoriam

*The finest achievement of human society
and its rarest pleasure is Conversation.*

1959

Contents

Contents

Introduction

by Michael Murray

In the spring of 1927, to celebrate its 125th year, the Philolexian literary society of Columbia College published a volume of student reminiscence titled *Samplings and Chronicles*. The editor of the book was Jacques Barzun— a Columbia College senior, nineteen years old—who was soon to be president of the society and had recently won its Essay Prize. He was also editor-in-chief of *Varsity*, drama critic for *Spectator*, and a contributor to *Morningside* and the *Columbian*. For him, too, that spring deserved celebrating: it saw him inducted into Phi Beta Kappa and granted a university fellowship, in addition to being appointed valedictorian and graduating at the head of his class.

His introduction to *Samplings and Chronicles*—his first publication in hard cover—begins with this remark: "Commentaries are notoriously double-edged. At the same time as they may be excellent criticism of the thing commented upon, they serve equally as faithful indices to the character and intellect of the commentator. More often this latter function is unconsciously—even self-treacherously—performed. But examples are not lacking in which self-revelation is at least partly the object of the critique. Self may then be extended to mean a philosophic attitude, a definite group, a nation, or an entire age; but in any case, to the discerning observer, the character

of the agent is transfixed by the expression of opinion, no matter how objective."

Jacques Barzun's own character is transfixed, as you will see, by the writings presented here. And though they offer various delights, including the delight of prose well wrought and of ideas inherently provocative, a chief pleasure is the discovery, as Pascal has it, of a man rather than an author.

That discovery is of course not exhaustive; it consists in the main of glimpses—but these can be multifaceted. Thus we detect both laughter and sobriety in Barzun the reviewer writing about a biography of Ruskin, one of his admirations: "This book is mad and I mean to shoot it!" Other admirations are as stoutly championed, among them Shaw, Berlioz, Swift, Hazlitt, Butler, Sayers, and both Jameses, and not personalities and ideas alone but their avatars in manners and institutions. For a motive discernible throughout is the wish to set the record straight by showing how things differ from their thought-clichés, to say "Look! It is not as you think." Also evident throughout is that many-sided view, comprehensive without being exclusive, which led Barzun at nineteen to stretch "self" to include philosophies and nations.

His career at Columbia spans half a century. A month after receiving his A.B., he was teaching a course in Contemporary Civilization. A year later he received his M.A. and, in 1932, his Ph.D. Appointed lecturer in history in 1928, he was then made instructor (1931), assistant professor (1938), associate professor (1943), full professor (1945), Seth Low Professor of History (1960), and University Professor (1967). In 1955 he became Dean of the Graduate Faculties, in 1958 Dean of Faculties and Provost. He retired from the university in 1975.

He in addition has served as president of the American Academy of Arts and Letters, member of the Council on Foreign Relations, Extraordinary Fellow of Churchill College, Cambridge, director of the Council on Basic Education, literary adviser to Charles Scribner's Sons, history consultant to

Life magazine, literary critic for *Harper's* magazine, member of the editorial board of *The American Scholar,* and, with W. H. Auden and Lionel Trilling, founder and director of two book clubs. At Columbia a chair in history is endowed in his honor. A Jacques Barzun Prize in Cultural History has been created by the American Philosophical Society. A recent cabinet secretary has called him "the conscience of American education."

Eminence in the republic of letters came with his scores of articles for such magazines as *The Nation, Encounter, Saturday Review, The New Republic, The Atlantic Monthly, Partisan Review,* and *The American Scholar,* not to mention *Life* and the *Saturday Evening Post,* and with such books as *Darwin, Marx, Wagner: Critique of a Heritage* and *From Dawn to Decadence: 500 Years of Western Cultural Life,* each of which attained the bestseller lists, as did *Teacher in America,* which for fifty-five years has remained continually in print.

The cultural critic, as Barzun once remarked, needs an audience that knows what to make of his utterances, and his own audience grew vast and diverse. This resulted in part from his triune conviction that history should remain a branch of literature and address the non-specialist reader, that its subject matter rightly includes the cultural, and that its effects can be transcendent: "The use of history is for the person. History is formative. Its spectacle of continuity in chaos, of attainment in the heart of disorder, of purpose in the world is what nothing else provides: science denies it, art only invents it. Reading history remakes the mind by feeding primitive pleasure in story, exercising thought and feeling, satisfying curiosity, and promoting the serenity of contemplation. It is a spiritual transformation."

With distinction naturally came controversy—over his writings in the 1930s criticizing established views of Romanticism, over his writings in the late 1990s describing societal decline. Crisis, confusion, decadence may well characterize our present culture, but not every thinker shares Barzun's belief

that that culture is coming to an end. Nor in the intervening decades were his judgments on progressive education, the New Criticism and Deconstruction, psycho-history and quanto-history, sociology, or linguistics universally approved.

But his dissenters can admire him for relishing the battle that engenders no animosity—the battle of ideas in which frankness and courtesy are in balance. He likes nothing better than hammering out differences vigorously but with good will. He writes, for example, to a colleague at Harvard: "I generally agree with your ideas, but I think it would take your very persuasive powers to make me feel that actual creation in the arts must in every case go with critical and historical appreciation. I hope we can sometime go to the mat on this perennially exciting topic." Barzun is of course neither impervious nor a paragon; rather, he believes that the healthy imagination holds at least two, often twenty, ideas at a time, each modifying or opposing the others, and that the pragmatic test will eventually show which ideas to embrace. Besides, "the born intellectual has the flexibility and toughness of steel."

But controversy and distinction lay in the future when, at twenty-four, he received his doctorate. By then, early thoughts of a career in diplomacy or the law had been supplanted; the lure of history, strong since childhood and reinforced by a revered professor, had become compelling. Barzun had felt it the more strongly when he recognized, in about 1929, that history could be conceived of as cultural. So conceived it embraced everything—everything literary or musical, for example, that might help to depict the substance, the feel, the import of the past. Cultural history was in fact a genre that he would help to create.

It differs markedly from political or social history and more subtly from intellectual history, which deals with the successive systems of ideas as found in the philosophers and their critics. Cultural history deals with ideas, but with ideas as they flourish in the marketplace—some derived from the

systems and no longer pure, others from the minds of reformers, politicians, artists, indeed anybody. And though it can accommodate illustrative slices of political history or sociology, cultural history, unlike these, has neither method nor limitation. Its limits are fixed by the breadth of the practitioner's knowledge, eloquence, and tact.

Barzun's writings embody this broad view, beginning in 1932 with his first book, *The French "Race": Theories of Its Origins and Their Social and Political Implications.* The quotation marks, removed by his publisher, signalize Barzun's repudiation of race-thinking, a position he elaborated in 1937 in *Race: A Study in Modern Superstition,* and which underlay a warning he issued in 1939 in *Of Human Freedom:* "Racialism sits enthroned today as a world power because it feeds on our most inward and familiar feelings. It expresses first of all our vigilant concern with culture, for does not racialism sit as a judge on the products of minds? It claims for itself absolute validity; for we want a sure test to apply with a view to taking action. It thwarts none of our other prejudices, for it wears the mantle of science, which is the garment of our most authentic magicians. But it has a final and conclusive appeal: its simplicity. If good and bad qualities are transmitted by race, we no longer need to think about personal conduct. We must merely purge the nation on the principle that a race brother can do no wrong and an alien can do no right.

"Unfortunately there is no agreement about what constitutes a race or what its distinctive signs are; which puts us at the mercy of any group that finds it convenient to separate the sheep from the scapegoats on arbitrary lines of their own. Long before things get to that stage, however, the habit of race-thinking has gangrened our minds, played havoc with our culture, and made us emotionally ready for the familiar acts of discriminatory cruelty."

Not that racialism is the only idea with which his first books have to do, for the race superstition is undergirded by determinism and misplaced abstraction, and the fight against

these—against machine-thinking—would engage Barzun for a lifetime. Thus in 1941, in *Darwin, Marx, Wagner: Critique of a Heritage,* he appraised some common assumptions about society, human nature, and progress, of which racialism was but one of several marks. And when in 1943, in *Romanticism and the Modern Ego,* he identified among the tendencies of the modern period self-consciousness and self-depreciation, his aim was to show the need for a new look at established attitudes at large—and incidentally to show that Fascism, then an acutely pertinent question, did not grow inevitably from Romanticism. Indeed, Romanticism preoccupied him, then and later on. He deemed it a *Zeitgeist,* not a movement, and he saw it both as a temper that affected one's whole being and as a way of tackling the post-Revolutionary problems of life and art. Since he held also that all political theory begins with a psychology, and since he had no use, as he put it, for an historian who was not usable, it was a duty as well as a congenial task to correct misapprehension.

He found it particularly congenial to rehabilitate admired figures—to show how the reputations of Berlioz, William James, Hazlitt, Chapman, Shaw, Bagehot, Swift, Agate, Wilde were one-sided or insufficient. "It is the fate of geniuses," he writes, "to engender a conventional view, a plausible simulacrum of the true figure, which the attentive biographer must first destroy before he can attempt a faithful portrait. This preliminary labor entails the explanation of many things, the reorientation of the common mind upon the evidence, and the straightening out of faulty logic. But under the strain of taking all this in, the common mind tends to be suspicious and it soon snaps back into its old groove of belief. That is why conventional opinion persists in spite of scholarship and critical biography." That is why Diderot, Nietzsche, Butler, and Lincoln, not to mention Shakespeare and Rousseau, lead double lives to this day. And that is why at least three of Barzun's works will remain enduringly useful: *Berlioz and the Romantic Century* (two volumes, 1950), *The Energies of Art: Studies*

of Authors Classic and Modern (1956), and *A Stroll with William James* (1983).

The historian too leads a double life, in another sense: "He must see the strivings of past epochs with generous fellow feeling, and he must feel as well the needs—which include the lacks—of his own time. Out of the contrasts come, one hopes, the critical judgments that lead to truth." Barzun posited this principle in 1961 in *Classic, Romantic and Modern,* but it directs his work before and since.

In *The House of Intellect* (1959) he holds that a tradition of Intellect exists when the tendency of certain arrangements makes for order, logic, clarity—those arrangements including the state of the language, the means and objects of communication, the supplies of money for thought and learning, the codes of feeling and conduct, and the system of schooling—and he holds that this tendency has been reversed. In *Begin Here: The Forgotten Conditions of Teaching and Learning* (1991), as in *Teacher in America* (1945) and *The American University* (1968), he defends beleaguered institutions by reminding us of first principles, among them that the removal of ignorance is the chief purpose of schooling. In *Science: The Glorious Entertainment* (1964), he contends that the techniques of scientific thinking, which are to analyze, to objectify, and to abstract, have so risen to pre-eminence in our culture as to dominate our "taking" of experience—that we apply the *esprit de géométrie* in situations requiring the *esprit de finesse* and that the misapplication leads to corruptive conclusions and attitudes. In *The Use and Abuse of Art* (1974) and *The Culture We Deserve* (1989) he embellishes this theme by showing that the power of art resides in particulars—the antithesis of abstracting—and that the press, the academy, the "abolitionist" artists and critics fritter that power away if they succeed in persuading us that art can consist of anything. And in *From Dawn to Decadence: 500 Years of Western Cultural Life* (2000) he sees as tokens of decay the decline of manners and of conversation; the neglect by institutions of their origi-

nal purpose or their inability to continue to fulfill it; the turning of debate into a classifying of motives rather than a meeting of arguments; and the all-encompassing shift from the democratic to the demotic.

If he were asked what practical difference can be made by "the critical judgments that lead to truth," Barzun might stare, as he did in a lecture at Princeton, that "nothing kills or promotes quicker than the word-of-mouth. The gross example is of course the best-seller, but the same mechanism is at work elsewhere. Its most frequent effect is that of artistic rehabilitations. In my time I have seen Mozart and Henry James lifted from the status of empty, frivolous virtuosos to that of great and deep geniuses; El Greco rescued from a negligible place as a baroque artist; Berlioz raised from grudging toleration to the highest eminence; Italian opera recognized as permissible to attend; and the Cubists credited with sole seminal power in our century. All these conclusions began by being ideas in solitary minds, lone dissenters from the crowd. It follows that what you think—what you decide and keep firmly in mind—is of the utmost importance. Before you know it, your conviction comes out in attitudes and words, which in turn start echoes and arguments distant from your own corner, and after that anything may ensue."

And when he is asked whether a decadent era unavoidably ends in cataclysm, he replies that though society may be threatened by economic or ecological calamity, or by famine or thermonuclear war, history shows that sharp corners can be turned. Not that he is optimistic. "I've always been—I think any student of history almost inevitably is—a cheerful pessimist. That is, the evil of the day doesn't eat into you and make you go around with a hangdog look and thoughts of the rope or a dose of poison. Still, nowadays the powers of synthesis, organization, reasoned order are outweighed by the number of people to handle, of difficulties to cope with, by the very size of everything that we know how to do. That's what makes

it likely that we'll come to a jam. But reading history, one finds that there have been periods, say toward the end of the Middle Ages, the late fifteenth century, when everything looked very much as it looks now. And even though we may say that their difficulties were lesser, their mechanical powers were less too. The interesting question is whether our greater powers and our greater knowledge—and by that I don't mean our deeper knowledge, I mean our more extensive awareness of what's going on everywhere at once—are going to be helpful or harmful. The possible harm of knowing too much is that it excludes possibilities that might work. You say: 'Oh, we can't do *that!* Look at the statistics!' "

The reader who in these pages thinks seriously with Barzun about serious matters will perhaps relish the contrast between the historian and the humorist, the critic and the lover of crime fiction. On this, no more need be said: the extracts on the criminous—like the studied absurdity of Barzun's clerihews—can be left to show by themselves what cheerful pessimism can comprise. It remains to say that the selections are arranged independently of date or length, that editorial changes are not specified, and that the selections from books and long articles are abridged, my purpose being to represent, so far as a single volume could do it, the scope and variety of Barzun's interests and their expression in print over a span of seventy-five years. The reader who wishes to peruse the full originals will find direction in the Bibliography.

I

On a
Pragmatic View
of Life

Toward a Fateful Serenity

The will is free, but who can account for his own acts and opinions without invoking influences and accidents? Would I have devoted my life to reading and teaching history, would I feel so keenly the passing of an era—five hundred years of high creation going down in confusion; would I, instead of repining, cultivate and recommend a spirited pessimism if I had not had, at a particular time and place, a vivid sight of an earlier world, soon followed by its collapse in wretchedness and folly?

Growing up before the First World War in an artistic milieu in Paris and also a conventional one in Grenoble, furnished the mind of the child I remember with two main perceptions. One was that making works of art by exerting genius was the usual occupation of adults; the other was that such a life was hedged about by traditions, manners, and prosperity.

Needless to say, neither of these notions was explicit—or abstract as in the retelling. But faith in their reality encouraged a precocious interest in all subjects, persons, ideas, and words half-understood. The joy of being was the joy of being *there:* the zest for life was tied to the spectacle of good things being done with confident energy.

The outbreak of war in August 1914 and the nightmare that ensued put an end to all innocent joys and assumptions. The word *Never* took on dreadful force. News of death in every message or greeting, knowledge that cousins, uncles, friends, teachers, and figures known by repute would not be

seen again; encounters at home and in the street or schoolyard with the maimed, shell-shocked, or gassed, caused a permanent muting of the spirit. This emotional darkness in daylight was punctuated by the hysterical outbursts of suddenly grief-stricken women and the belief of some in "communications from the dead" that sounded grimly absurd even to a child.

Throughout, poisoning all other sentiments, was the continual outpouring of public hatred. By the age of ten—as I was later told—my words and attitudes betrayed suicidal thoughts; it appeared that I was "ashamed" to be still alive. Steps were taken: before the end of the school term in 1918 I was bundled off to the seashore, away from "events," including the bombardment of Paris by Big Bertha and the scurrying to cellars during air raids.

With beach life and surrender to a great lassitude, calm slowly returned, helped out by reading adventure stories. But it was not Gulliver and Robinson Crusoe alone who restored the will to live: it was also Hamlet. I had taken him off the shelf in Paris, not in secret but unnoticed, and I brought him away with me. The opening scene promised a good ghost story.

As I read on, I discovered that the rotten state of Denmark was the state that had overtaken my world: hatred, suspicion (spies were seen everywhere), murderous fury, unending *qui vive*. It contradicted all the assurances of the catechism. But what could be reinvigorating about Hamlet? Well, to begin with, his skill in warding off menaces from all sides; he was the equal of Crusoe in survival. And especially comforting was his ability to overcome his doubts in the terrible murkiness of his situation. His death at the end was a fluke, not a failure; Fortinbras said what a good king he would have made "had he been put on."

Thus were the trials of my young life made coherent in a view of Hamlet I have never found reason to alter. My bewilderment and pain were transmuted by a story into a kind of armor. Later reverses of fortune could bruise but not wound.

* * *

In any age, life confronts all but the most obtuse with a set of impossible demands: it is an action to be performed without rehearsal or respite; it is a confused spectacle to be sorted out and charted; it is a mystery, not indeed to be solved, but to be restated according to some vision, however imperfect. These demands bear down with redoubled force in times of decay and deconstruction, because guiding customs and conventions are in disarray. At first, this loosening of rules looks like liberation, but it is illusory. A permissive society acts liberal or malignant erratically; seeing which, generous youth turns cynic or rebel on principle.

Either option is almost certain to end in waste and regrets; and anyhow, disillusion should be a one-time misadventure, not a lifelong grievance. But to avoid resentment requires a clear alternative, some purpose to turn the aggressive reaction away from the self or from the image of the world as Grand Conspirator. The purpose I gradually fashioned took the form of a resolve to *fight the mechanical.*

Such a struggle has nothing to do with the popular cursing of machinery. Machines are admirable and tyrannize only with the user's consent, absent-mindedness, or laziness. Yielding to the mechanical is still more culpable when it comes from ignoring the fact that Nature, which we are taught to see as a machine, contains the unmechanical mind of man—which it is a disgrace and a danger to let lapse into automatism.

Where, then, is this enemy? Not where the machine gives relief from drudgery but where human judgment abdicates. Any ossified institution—almost every bureaucracy, public or private—manifests the mechanical. So does race-thinking—a verdict passed mechanically at a color-coded signal. Ideology is likewise an idea-machine, designed to spare the buyer all further thought. Again, "methods" substituted for reading books and judging art are a perversion of what belongs to science and engineering: "models," formulas, theories. Specialism too turns machine-like if it never transcends its single task. The smoothest machine-made product of the age is the

organization man, for even the best organizing principle tends to corrupt, and the mechanical principle corrupts absolutely.

Language itself, the most flexible expression of mind, has succumbed and promotes the mechanical. Its corruption can be seen in the continual use of misplaced abstraction. The jargon-bred speaker now feels more at home with the technical label than the primitive word: *rain* sounds childish compared to *precipitation*. (No need to explain why I have spent so much of my life fighting for the sanctity of plain words.)

The source of my antipathy to the mechanical was not itself an abstract idea. It arose from an attachment to the matter and manner of history. This is not a popular addiction. Far from a welcome heritage, history today is only the intruder at the door and the past is—passé. By a fortunate accident, my mind was given a different turn early in life. I had a great-grandmother, born in 1830, who talked to me of the world in her young days in such a way that her memories became part of my imaginative life. Enchanting vistas of the nineteenth century, and tragic ones also, shone for me with the light of present fact. I trace to this privilege my choicest pleasures and clearest convictions, my conception of existence, and not solely my life's work.

History is concrete and complex; everything in it is individual and entangled. Reading it, mulling it over does not weaken concern with the present, but it brings detachment from the immediate and thus cures "the jumps"—seeing every untoward event as menacing, every success or defeat as permanent, every opponent as a monster of error.

A sense of "how things go" in history—how they come *and* go—also protects against the worst among machines: the bandwagon. To keep from climbing on is harder than ever since that other machine, the media, has been installed. So many projects, attitudes, and "concepts," as they are quaintly called, are launched with all the trappings of true ideas that holding aloof looks like egotism or the sulks; but it is not sulking to stare as the lemmings rush by; it is self-defense.

Happily, the historical outlook serves other than defensive ends. Its best reward, as I think, is the positive good of reviving the lost faculty of admiration. The past is full of men and women (and children too) whose lives and deeds are worthy of honor, wonder, and gratitude, which I take to be the components of admiration. That talents and virtues graced the least favorable ages is a tonic fact, and it keeps alive the belief in a similar (even if hidden) provision of merit in our own bad times. Admiration also makes one want to amend careless Posterity and draw fresh attention to the forgotten or misknown. I for one have felt that this effort helped justify my existence when I was writing about such figures as John Jay Chapman, Samuel Butler, Walter Bagehot, or Berlioz.

Besides, when looked at in detail, lives of this kind confirm or reinstate a just estimate of life itself. The modern dogma that art is the only redeeming feature of the much-pitied "human condition" rejects nine-tenths of life, and with it those not dedicated to the highest pursuits. Faulkner in that mood said that one of Keats's odes "was worth any number of old women." Such literary conceit is also bad logic. Life is good because it is the source and container of everything we value. It is old women, not Grecian urns, that have in their time borne Keatses and Faulkners.

Accepting life whole and keeping one's love of art from idolatry means remembering that nonliving things must be loved soberly. The living have first claim, and fellow feeling for them should stir not only at the sight of sorrow and pain, but at the call of the imagination. Yet pity (or compassion as it has been renamed) is a dangerous emotion; it easily turns condescending and self-righteous. Therefore act quickly to remove pity's cause and thereby minister also to your own spiritual health. For the same reason, indignation—the cheapest of the emotions—is righteous for about five minutes. After that, work to undo the wrong or make sure that some genuine obstacle prevents. It is the mark of the sentimentalist that he applauds himself when he only stands and weeps.

But what form should action take when it is in one's power? Free societies make it easy to start or join a cause—that is one way. Another is to deal more or less alone with the trouble nearby. That has been my choice, temperamentally and from knowing through history what happens to causes. The public reformer may well be effective, but agitation is necessarily for an abstract general good, and the new principle is seldom accepted until time and talk have weakened and distorted it. Public reform, though indispensable, never catches up.

The other kind of battle against abuses is not so visible but it is more assured. The helper knows the local conditions and characters, and whatever influence he needs comes not from leading a group, but from competence in his regular work. It is here he must be on guard, for careers limit freedom—one must not rock the community boat, one owes and needs favors, one represents a profession, which in one of its aspects is a collection of people captive to a set of ideas. So the great difficulty is to achieve independence without rebellion. Preserving urbanity is not sought for its own sake, but because rebellion uses up energy and deflects intention; it brings publicity and followers who compel one to keep on rebelling.

Remains the question of choosing which neighbors' troubles to attend to. Every inhabited spot is the scene of some wrong, and it does not turn into Utopia after redress. I found the selective principle in William James: "Every claim creates an obligation." The imperative looms large, but it does not preclude knowing the limits of one's abilities or seeing that some claims are frivolous or immoral. The obligation is to listen and devise or suggest means of relief; and as this requires a craftsman's sense of order as well as a moral impulse, it often happens that aesthetic feeling becomes the dominant motive in "setting things right."

James's maxim also helps to subdue laziness and prejudice, including indifference: "Why should I help a stranger? Or someone I dislike?" James retorts "Why not?" and there is really no answer. The commonest prejudice is self-absorption:

"I am busy and my time is my own, after all."—Yes, perhaps after all *others'*. It is unlikely that "all" form a multitude, unless one is a world figure, and in that case the claims cease to be local. Yet read the letters of Bernard Shaw to see how far the neighbor's sense of duty can stretch, and even accompany the successful promotion of causes.

For the rest of us, responding to particular demands settles doubt about utility· the help is *wanted*. And it rules out meddling, which notoriously reduces the sum of human happiness. Sometimes, too, local example incites others to act in imitation.

It may be thought that James's principle presupposes a religious belief. It need not, and some beliefs might prove a hindrance. To set things right, one must think mankind naturally good, as did St. Thomas Aquinas, and not hopelessly bad, as did Calvin. Nor should one be so preoccupied with one's own salvation that all other concerns disappear, as in *The Pilgrim's Progress*. The faith that inspires social duty is the honor of being a man, of being a man of honor.

"Honor" here means knowing how little one brings and how much one has received, and feeling impelled to discharge the debt. Since repaying ancestors is not possible, neighbors and descendants become our natural creditors. To be sure, for those who live without history there are no ancestors to repay. And it is doubtless less agreeable to think of debts than to think of rights, which serve our needs incessantly and so make us by instinct rights advocates. But anyone who claims the fundamental right of equality—the right to every other right—is culpable if he does not know and feel that Equality implies Reciprocity. To enjoy rights without making a return is the game of the usurper and despoiler.

In a high civilization the things that satisfy our innumerable desires look as if they were supplied automatically, mechanically, so that nothing is owed to particular persons; goods belong by congenital right to anybody who takes the trouble to be born. This is the infant's normal greed prolonged

into adult life and headed for retribution. When sufficiently general, the habit of grabbing, cheating, and evading reciprocity is the best way to degrade a civilization, and perhaps bring about its collapse.

The belief that the time before 1914—*la belle époque*—was one of settled order and insouciant calm is contrary to fact. It was a time of international crises, domestic unrest, and what is now called terrorism. From 1880 on, public figures were assassinated right and left until the killing of Francis Ferdinand and his wife precipitated the "Great War." Yet there is a palpable difference between then and now. Shocking events were read about rather than seen and heard and thus were less shattering. The five continents were wider apart than at present, and with populations smaller and less mobile, human contacts were more often at one's discretion. Work, too, despite long hours, had not yet changed its nature from strain to stress; and other anxieties, including crime, had not become permanent obsessions. There was more time and space in the world.

This quality of life was partly recovered during the period between wars but was utterly lost again. My present sense of surroundings is thus akin to that of my childhood in wartime. Crime on the streets, hijacking in the air, hostage-taking and bombing in once well-policed countries—this state of siege, coupled with the daily warnings of danger from food and drink, medication and machinery, clothing, toys, and sex, viruses and killer diseases seconded by polluted air and water, has reconstituted the situation of permanent *qui vive*. Even when no thought of nuclear war is present to the mind, the atmosphere forbids delectation, let alone complacency.

In these conditions, can the recourse to history that I practice really sustain the spirit? Granting that it can cushion the blows that affect the imagination with disaster, can it help when the statistically overwhelming ills fall on oneself or those close by? My answer is yes: I see no better steadying force than to take history personally; I mean, not solely as an

aid to serenity, but as a power with the right to be "the intruder at the door." The calamities we see and hear of, unprovoked, undeserved, are Proteus himself, multiform and menacing all impartially, forever. Hence, from fellow feeling once again, we come to see that fate, which commands our awe, also deserves something like our affection, for fate is as much within us as without: it has made what we are and what we love. The love of fate is part of that understanding by which we remain superior to the mechanical. In this relation, the free will I spoke of consists in the way we "take" what comes.

If it is asked whether this ancient *amor fati* can be attained without enlisting the aid of history, the answer again is yes. I offer no unique nostrum. Let every temperament choose its image of the cosmic round. The scientist may like to look at his favorite star exploding in space. The Greeks used the make-believe of tragedy to inoculate their ailing spirits, and a modern soul may temper its steel by doses of contrived horror, as the king did his body against poison by swallowing it—in moderation.

True, the result is not always what was hoped for. A measure of deliberate calmness will not satisfy the impulsive and exuberant. Nor can the historian's studious love of fate be termed a smiling love. But neither is it the severe tenseness of the Stoic. What then is it? At the outset, I used the phrase "spirited pessimism" because I could find no better one to denote the peculiar blend of opposite emotions. But pessimism is an ambiguous word. Of a true pessimist's mood it was once said that "at his most sanguine, it's apprehension." Far from that, "spirited" in my sense verges on cheerful, and "pessimism" means: not startled—much less downcast—by the badness of things. So in place of "apprehensive," read "watchful without jitters"; and instead of "sanguine," "in good heart without great expectations." *1990*

II

*On the Two Ways
of Knowing:
History and Science*

The Search for Truths

As an historian, I am naturally, professionally, interested in truths—thousands of them—and this interest brings with it several kinds of puzzle. The first is the disentangling of the muddled reports of the past. Another is how to describe faithfully what bygone ages took to be absolute truths, now disbelieved or forgotten. A third is what test of truth to apply in each case. The last and most baffling is to frame a clear idea of what truth actually is.

In any definition of truth, reality is mentioned or implied. What is said to be true must relate to something experienced and must state that experience accurately. Moreover, the whole vast store of recorded truths is supposed to hang together, and every new one must jibe with the rest of them as well. These demands make up a tough assignment, and when one looks at any sizable portion of these claims to truth, one keeps finding a good many more to challenge than to adopt. An obvious sign of this is the amount of nonstop arguing and fighting in the world. Human beings, individually and in groups, are sure that they possess the truth about things here and hereafter, and when they see it doubted or attacked by their neighbors, they find such dissent intolerable and feel that it must be put down.

There is, of course, an obvious exception to this chaos of thought and action. If one measures by the yardstick, then this piece of string is 28½ inches long. One can measure carelessly and make an error, but as soon as it is pointed out, one agrees

with the correct answer. Other measures—the meter, the calendar, the clock, the number series, or any other system that rests on common agreement and fixed standards—yield statements that are not denied by anyone in his senses who is familiar with the terms.

These conventions are endlessly useful, both in science and in practical life. But there is a host of equally immediate and important concerns for which no system and no terms have been agreed upon. It is about these interests that the battle of ideas and the bloodshed take place. This in turn tempts one to think that these contested truths are the most important of all. They have to do with religion, art, morals, education, government, and the very definition of man and his nature and his role in the universe.

A cultural historian's work brings him face to face with those passionately held ideas. At a certain time and place, millions of human beings felt sure that a divine revelation proved the existence of God, who dictated all men's beliefs and actions. The uniformity of that faith stamped it as unshakable truth. After more than a thousand years, some of the descendants of those millions began to question the revelation and all it meant. Since then, there have been many different "truths" about it, each clung to with the same fervor and confidence as before. A like diversity runs through the rest of the culture—in morals, government, and the arts.

The only sure thing is that mankind is eager for truth, lives by it, will not let it go, and turns desperate in the teeth of contradiction. That may be a noble spectacle, but it is tragic too—and depressing. If, as required, all truths must hang together consistently, it would seem that in religion, art, and the rest, truth has never reigned. Human beings begin to look like incurably misguided seekers for something that never was.

At this point, a small but remarkable group of people put on a superior grin and say: "You forget the method that clears up all doubts and delivers truth on a platter. We scientists are

busy taking care of your troubles. Look at what we have done: We have gotten rid of all the follies and superstitions dreamed up about the real world in the first five thousand years of man's existence. Give us a little more time and we will mop up all the other nonsense still in your heads and give you cast-iron truth."

This sounds delightful, but even in those disciplines where exactness and agreement appear at their highest, there is a startling mobility of views. Every day the truths of geology, cosmology, astrophysics, biology, and their sister sciences are upset. The earth is older than was thought; the dinosaurs are younger; the stars in huge galaxies have so much space they can't collide, yet they collide just the same; Mars, after being dry as dust, has liquid water; the human bones in Central Africa do not mean what they were said to mean; a new fossil shows the origin of birds to be different from the origin posited yesterday; as for the speed of light, it can be exceeded. If only the latest is true, then all earlier ideas were hardly better than superstitions.

The condition is still worse in the semi-sciences of psychology and medicine, and confusion grows as we get to the social sciences, ethics, and theology. There are "schools" in each—the telltale sign of uncertainty. The boasts of an earlier day about finding laws governing society and predicting its future have been muted for some time. In history and philosophy, some wise heads have admitted that these laws are not exact transcripts but simply documented visions, respectively, of the past and of Being as a whole. None excludes other accounts of the same particular subject.

A number of scientists have taken time to ponder these puzzles of their own making and have offered two suggestions. One is that science is not description but metaphor. It seems a poor term. A metaphor needs four parts: in "the ship plows the ocean," the ship is likened to a plow and the ocean to a field. The facts and the language of science add up to two parts, not four. Perhaps the meaning is that science is not literal but

poetic, its phrasings inspired by observation and calculation. That must be why we now come across the word "charm" and others like it in theoretical physics, a tacit recognition of its suggestive, poetical character.

If so, it also means that reality is beyond our grasp, and truth along with it. Such is, in fact, the other suggested answer to the riddle, which is that there is no need for the idea of reality. From this negative it follows that we should stop being so solemnly intent on truth. Above all, we should stop fighting over tentative notions we believe in. Imagine instead that we are at a picnic, making up disposable fictions about what we see and feel. We then play with the jigsaw, but pieces are missing and others don't fit.

Where does that leave me as an historian who struggles to discover what happened in the past and to make of events and persons some intelligible patterns? First, I am not ready to throw reality into the trash can. I feel it ever present and call it by the more vivid term *experience*. It includes all my thoughts and feelings, the tabletop and the electrons, light as waves and as particles, the current truths and the past superstitions. The common task, I conclude, is to place each of these within its sphere and on its level; they are incompatible only under a single-track system. One must, moreover, be ready to deal with new paradoxes and contradictions, because experience is neither fixed nor finished; it grows as we make it by our restless search for truth. Truth is a goal and a guide that cannot be dispensed with. The all-doubting skeptics only pretend to do without it.

But we must recognize that our work to attain truth succeeds only piecemeal. Where our hope of truth breaks down is at the stage of making great inferences from well-tested lesser truths. Still, we cannot help inferring. Our love of order impels us to make theories, systems, sets of principles. We need them both for comfort and for action. A society, however pluralist, needs some beliefs in common and will not trust them unless they are labeled truths. It is there that our efforts

betray us. Sooner or later, experience jabs us with an event, a feeling, or a perception that shatters the truth-value of the great inferred idea. It is like actually going to the moon or prospecting the planets with a sensor and finding that the entirely logical and satisfying inference is dead wrong. As the historian knows, the breakup of old truths is painful, often bloody, but it does not condemn the search for truth and its recurrent bafflement, which are part of man's fate. It should only strengthen tolerance and make us lessen our pretensions. Just as in the past man was defined as the rational animal and later comers said, "No—only capable of reason," so man should not be called seeker and finder of truth but fallible maker and reviser of truths.

2000

History as Counter-Method and Anti-Abstraction

In common as well as academic speech, the phrases "historical method," the "historian's methods," are current and supposedly well understood. This usage makes plausible the program of mingling or fusing other methods with the historical, though how their elements mesh is not explained. One excellent reason for the omission is that history has no method or methods. This truth is evident if one takes science or industry or accounting or medicine or law or psychiatry for comparison. Each of these has a procedure, a systematic mode of progressing from question to answer, difficulty to remedy, purpose to result. Each has indeed a number of methods, adapted to the variety of purposes and means. There are apparently two ways to manufacture household ammonia, and several to determine atomic weights, file an answer to a charge, audit a business, treat cancer, and recondition a neurotic. All are

methods in that they follow a largely predetermined course: they repeat, and it is the repetition, the "normalization" that ensures or gives a high probability of success.

Now, the historian only seems to perform in a like manner. The handbooks say: consult your sources, test and authenticate them, assemble the ascertained facts, write your report, and give clear references. After publication another volume is classified as history on some library shelf. But all this is hardly more than a general description of the work of intelligence, such as is performed by every student and professional, with or without a method. Method for the historian is only a metaphor to say that he is rational and resourceful, imaginative and conscientious. Nothing prescribes the actual steps of his work: What defines "his" sources? What tells him where they are and in what sequence he should approach them? What does it mean to "test" them—has he a reagent in a bottle, a casebook, a table of coefficients? (To be sure, an historian may go to a chemist and ask him to analyze a piece of paper to ascertain its composition and thus infer its age and the genuineness of the document. But that is only to make use of another worker's facts, to rely on *his* method, not the historian's, else there would be no need to consult.) Think of the "scientific" historian Freeman acknowledging that Niebuhr could ascertain the truth by "laborious examination and sober reflection." Think of Woodrow Wilson ascribing Mommsen's greatness to "his divination rather than his learning," which was none the less enormous. To be sure, the historian will be *methodical* in taking notes (though not always) and in reasoning out discrepancies of date or fact; but that is no more than a good bookkeeper does when his accounts do not jibe. On that level it is even possible for the historian to be a poor "bookkeeper" and by other qualities survive his shortcomings.

Let us then abandon the metaphor and leave "method" to those who can show that they possess one in the strict, procedural sense of the term. It will often be found that the "method" is only a vocabulary. When mixing terms is as far as

the attempt has gone, the inference is strong that history resists any genuine application of method.

The reason lies in the difference between two orientations of the human mind: the intuitive and the scientific. Pascal, who possessed the genius for both, gave of them a definitive account in his *Pensées*. Whoever wants to understand the difference between, say, Carlyle's *French Revolution* and Crane Brinton's *Jacobins*—why one is a history and the other not— should turn to Pascal's first chapter and assimilate the series of distinctions set forth there between the *esprit de finesse* and the *esprit de géométrie*. Neither *esprit* is higher or deeper or better than the other. They are only radically divergent modes of conceiving and working with reality.

A compressed paraphrase could run as follows: in science (the geometrical mind), the elements and definitions are clear, abstract, and unchangeable, but stand outside the ordinary ways of thought and speech. Because of this clarity and fixity, it is easy to use these concepts correctly, once their strange artificiality has been firmly grasped; it is then but the application of a method. In the opposite realm of intuitive thought (*finesse*), the elements come out of the common stock and are known by common names, which elude definition. Hence it is hard to reason justly with them because they are so numerous, mixed, and confusing: there is no method.

From the dissimilarity it follows that genius in science consists in adding to the stock of such defined entities and showing their place and meaning within the whole system of science and number; whereas genius in the realm of intuition consists in discerning pattern and significance in the uncontrollable confusion of life and embodying the discovery in intelligible form.

Obviously the two modes of thought do not mix well: there are no natural transitions from the one to the other, the *movement* of the mind in each goes counter to the other. Once understood, the opposition resolves many puzzles and conflicts

in contemporary culture, which is torn and racked by the imperialistic demands of each "mind" simultaneously.

The distinction once made, it is important not to turn it into a biological postulate. There are not two *species* of mind, only two orientations, comparable to the further differentiations which, within the intuitive group, lead an individual toward music, or the graphic arts, or poetry. The human mind is one: otherwise every sort of thinker or artist would be excluded from the understanding of other sorts. History, again, is not a unique mode of thought. Historians think and work like critics and scholars and lawyers and statesmen, when these are not bound by external system.

What, then, are the criteria by which history may be known? There are four: Narrative, Chronology, Concreteness, and Memorability. History is first of all a story; "interpretation" is optional, and some histories can do without it; for example, Barante's *History of the Dukes of Burgundy*. The "story" is, of course, intended as truth and it gives particulars of change within time and place, the stretch of either being narrow or wide according to choice.

Next, concreteness prevails over any other interest. The event, the what-happened, is the main fare. In that axiom is to be found the difference between history and biography, for biography may be a study of character, ideas, or spiritual states, in which a few private events are pegs for the analysis. This test obviously marks off history from studies of situations, also actual, but not dealt with as events in continuous time; for example, institutional problems, cultural types, or the "anatomy" of comparable conditions, such as revolutions, decadence, slavery, or the status of women. Yet concrete does not necessarily mean physical. There are "events" in the history of culture and they can be described and fitted into a narrative, provided what happened in art or ideas is not abstracted into a series of "problems" and "influences" and divorced from the mundane facts surrounding the cultural.

Finally, history is the story of what is memorable, in the two meanings of "worth remembering" and "capable of being remembered." This doubly defining clause is very broad; there are no clear limits to what one person or another will deem worth remembering. Yet it is evident that no one wants "all the facts," even if it were possible to collect their traces. The two senses of memorable therefore point, one to selectivity, the other to intelligible pattern.

The definition of history by these four criteria suggests further traits for judging the immense variety of histories. Though the great ones accord with the description, many other works of merit will appear as only in part historical. In books legitimately entitled "A History of . . ." will be found many kinds of data that "belong" to other disciplines—geography, ordnance, numismatics, medicine, and so on *ad infinitum*. The stream of truly historical statements gives motion to the rest. What is more, the historian may pause to comment, explain, argue, speculate, moralize, and compare. Such interruptions of the narrative are often found in the great histories, but the digressions, whether to acclimate the unfamiliar or inject opinion, are not allowed to become ends in themselves. The data of one kind are not gathered from end to end and tabulated for scrutiny and generalization. The upshot of any chapter or part is not a simple formulated truth, but the communication of many truths, in an artful mixture of order and disorder addressed not to the geometric but to the intuitive mind.

To sum up: History, like a vast river, propels logs, vegetation, rafts, and debris; it is full of live and dead things, some destined for resurrection; it mingles many waters and holds in solution invisible substances stolen from distant soils. Anything may become part of it; that is why it can be an image of the continuity of mankind. And it is also why some of its freight turns up again in the social sciences: they were constructed out of the contents of history in the same way as houses in medieval Rome were made out of stones taken from

the Coliseum. But the special sciences based on sorted facts cannot be mistaken for rivers flowing in time and full of persons and events. They are systems fashioned with concepts, numbers, and abstract relations. For history, the reward of eluding method is to escape abstraction.

Absent method and abstraction, how is it possible for history to hold a serious modern mind, educated to value only what is true and precise? That history has its own precision is the right answer, though as in all products of the intuitive mind no one can offer proofs. Truth and precision in history are perceived by those who know. In this particular, history owns affinity with art, poetry, philosophy, and religion, to which few would deny the possibility of precision and truth though they are untestable by rule.

It may be objected that untestable precision is a contradiction in terms, but that is an error. The precision of science itself ultimately lies in an observer's reading of his instruments; a picture on the wall could be said to hang straight even if yardsticks did not exist: it would be *seen* to hang straight. Instruments only extend the senses and record *degrees* of precision. As to the more or less, Aristotle pointed out long ago that it was a mistake to require of any subject greater precision than it could or need supply—we usually stop at four decimals for π and at two for $. History has no need of mathematical precision because it deals with activity and not process. Activities are what we do and can imagine others having done; processes are what goes on unwilled or unknown. We ask minute detail and close measures in our accounts of process, because without these exact pointers we are not sure *that* we know or *what* we know: the workings of matter are forever closed to our intuition. Whereas the return of the Ten Thousand or the destruction of Carthage needs only to be described to set up within us immediately precise ideas and visions and emotions, the whirling of molecules in a gas occasions no direct insight or sympathy. We understand it

only by analogies painfully sought through elaborate devices and expressed in unevocative symbols.

Of history we ask accuracy of another sort. It is of no moment what percentage of the Ten Thousand wore out their boots on the march home. The figure 10,000 has no *numerical* significance. If the army was composed of 9,900 men or 10,200, nothing in Xenophon's history would be changed. only the rough order of magnitude matters. But other details are all-important—the route, the time spent, the dissensions and who and what caused them, the prospects changing from despair to hope, the great cry "The sea! the sea!" when the retreating force climbed the heights of Mount Theches in Armenia. But it is a defect and a loss for history that we no longer know exactly which peak was called Theches.

Because of such uncertainties, history leads some of its workers into inquiries only appropriate to science. At all times, and especially now because of science, curious minds are charmed by the sport of inference and deduction, which may give knowledge to fill the gaps of evidence and insight. As the tradition of text criticism shows, a long chain of plausible arguments seems to make up for its fragility by its virtuoso skill. It has the appeal of the detective's demonstration in the final chapter. But solid history can only regard such gymnastics as a curiosity. The historian suspects the chain of might-be's in which every weak link is a threat to truth. He wants not a chain but a network of cross-confirming testimony; for he is not deciphering a code, he is visualizing a scene and a story. *1974*

The Imagination of the Real

The perennial difficulty is to choose from the surrounding mass of "conditions" those that illuminate the subject, and once these are found, to avoid the fatal error of slipping into a new determinism. The activity of unearthing facts that spur the re-creative imagination tempts to taking these "conditions" as sufficient and compelling, when they are only limiting or suggestive; for the habit of thought based on linear causation and scientific correlation dies hard, and the common vocabulary of a technological age promotes the deceit. The whole question of "influence" is bedeviled by that error, and so is the practice of finding themes and significances by juxtaposing texts and events or texts and texts. Even in the so-called pure criticism that posits "autonomous" literary works, the interpretation of prose or poetic fiction suffers from the same rigidity and leads to those repetitious "problems" that impel the critics to discover, not so much "the figure in the carpet" as the anatomy of the work and the pathology of its maker.

This urge the cultural critic resists. When coincidences between idea and circumstance strike him hard, he uses his skill to distinguish the quality of belief his findings deserve. He will believe to the full that John Locke in his essays on government was combating Sir Robert Filmer, because Locke takes issue with him by name and Filmer's presence visibly helps Locke to develop his ideas. But a different quality of belief possesses the critic when he assents to the usual statement about Locke's having "written to justify the Revolution of 1688." The critic remembers Locke's intellectual formation—long years of self-exile in Holland and France, where libertarian ideas similar to his own were flourishing

before 1688; and there is Locke himself, speaking not *to* or *out of* circumstance, not as a party hack, but as an original fount of ideas.

The discipline of shading one's beliefs enables a student to regard as significant a miscellany of disparate conditions, not just a single series, and thus to escape the fate of the interpreter who is definable by an adjective: the cultural critic is not more psychological than class-conscious, not more structural than thematic. For him the mixture of elements classifiable under these and other heads varies with each case, and his internal assessment of their force is exact in the degree to which it is finally incommunicable. He can point and explain, but what is at work to give him understanding is, after all, *his* imagination; and in the nature of things he can only give an incomplete report of its contents.

The duty of the cultural critic, then, is to discover and sort out for himself the signs of the distant reality and, in assembling them, to be sensitive without being impressionable. This habit of judgment is not simple skepticism; on the contrary, it opposes its vision of the object not only to the conventional description, but also to its revisionist counterpart, each too often tolerant of large errors while stressing the details of its own *parti pris*. *1977*

Cultural History: A Synthesis

To say that now we all more or less take cultural history for granted does not, of course, mean that we all understand it in the same way. Its wide acceptance is less a common intellectual conclusion than a sign of the self-consciousness which characterizes our times: we love to talk about our culture as we do about our psyches.

But for the reader of cultural history or criticism—and all the more for the writer—many fundamental questions remain, questions that must be clearly put even if no hope exists of final answers. To begin with, what is "culture"? It is not for the historian what it is for the anthropologist. For him culture is an all-inclusive term covering everything from pots and pans to religion. But the historian writing about his own culture obviously need not describe for his readers what they know from daily use. Yet the historian cannot, either, take culture in its purely honorific sense of "things of the mind." The highbrow's culture is too likely to be a very thin slice of life—all butter and no bread—and as such incapable of standing by itself. It requires what we call background and might better be called underpinning. Given the task of appreciating all that is historically wrapped up in a Cavalier lyric, one must know what a Cavalier was, how he looked, whence he drew his ideas of honor and to what wars he was going when he bade farewell to Lucasta. Immediately, the historian is face to face with King Charles's head, the ritual of knighthood, Puritanism, and the origin of the fashion for men to wear long hair in curls. All this and more is necessary for an *historical* understanding of the unique cultural product from which we quote "I could not love thee, dear, so much. . . ." Conversely, the poem preserves an historical moment and can help us reconstruct the cultural, that is to say at once the factual and emotional, past.

The cultural historian, in other words, must steer a middle course between total description (which is possible only to the anthropologist working on a limited tribal culture) and circumscribed narrative (which is the task of the specialist in the institutionalized products of culture: poetry or metaphysics or old silver). No one can say, not even the cultural historian himself, what class of facts he may be called on to bring into his narrative in order to make it intelligible. For example, writing of the 1840s in England or the 1860s in the United States, he would surely have to say a good deal about

railroads, for they were diversely new and influential in the culture. In a history of the 1940s or 1960s he might neglect railroads altogether. The intelligibility of the whole, the relevance of the part are his sole criteria. This means that the cultural historian selects his material not by fixed rule but by the *esprit de finesse* that Pascal speaks of, the gift, namely, of seeing a quantity of fine points in a given relation without ever being able to demonstrate it. The historian in general can only show, not prove; persuade, not convince; and the cultural historian more than any other occupies that characteristic position.

In his private, shifting definition of culture the historian must moreover have regard to his audience. A cultural history of Japan for Western readers must include much that is useless to the Japanese; and even a cultural history of England written for the English will need supplementing for Americans. This is as much as to say that cultural facts do not unmistakably exist as such—a corollary from our elastic understanding of culture. Unlike a political, diplomatic, or economic fact, a cultural fact is generally not singled out for us by gross visible consequences. The publication of *The Origin of Species* in 1859 may resemble a political fact in the uproar it provoked, but we know that evolutionary theory and the belief in it do not date from 1859. This imposes on the cultural historian the delicate task of telling us how and where Evolution existed as a cultural fact for a century before 1859.

Contrast again the clear-cut overturn of a dynasty or the defeat of a government at the polls with the gradual destruction of a moral order such as Victorianism. When does it take place? It begins in the mind, in many minds, but how do we date and measure its progress? Is it from Samuel Butler's conception of *The Way of All Flesh,* finished in 1885, but not published till 1903? Or earlier, from the time when Dr. Clifford Allbutt began to give private lectures on sexual hygiene and Swinburne shocked all decent people with the sensuality of *Poems and Ballads?* In short, how does the moral atmos-

phere change so that FitzGerald's *Omar Khayyám,* a complete failure in the 1860s, is everybody's bedside book in 1900, by which time almost all the respectable beards and stovepipe hats have disappeared, decadence is fashionable, and woman is emancipated? And to add some material factors, how do the bicycle, the typewriter, and the automobile fit into this great cultural revolution? Has the vogue of outdoor sports anything to do with it? And what of the Boy Scout Movement and the prevalence of appendicitis?

All the questions that might be asked raise the one great problem of assessing connectedness and strength of influence— again a task for the *esprit de finesse* and often a grievance to the student. The beginner is impatient and wants "the facts"; he contrasts unfavorably what he calls "straight history" with the apparently crooked ways of cultural history; and in a certain sense he is right. The ways of cultural history are devious and uncertain to the degree that there can never be a handbook which will list all the valuable facts, and no shortcut to arrive at an understanding of relationships. Political and diplomatic history may be intricate in detail but they are emotionally simple—just like war, which they replace and resemble. But cultural life is both intricate and emotionally complex. One must be steeped in the trivia of a period, one must be a virtual intimate of its principal figures, to pass judgment on who knew what, who influenced whom, how far an idea was strange or commonplace, or so fundamental and obvious as to pass unnoticed.

This kind of expertise does not of course exclude the use of statistics when these are available—the numbers of people who attended the Handel Festivals in the eighteenth century, who welcomed Jenny Lind to the United States in 1850, or who visited the Crystal Palace the following year. But most often counting merely confirms; or else—as in the record of a book's sales—the figures themselves need confirmation. When, for example, we refer quantitatively to the great dissemination of Toynbee's *Study of History* in full and abridged forms, we

must look elsewhere to make sure of what we are asserting: is it the acceptance of the author's thesis, and if so is it assent to the whole or to some part? Is it a generalized understanding of his tendency, or do the figures indicate a mere *interest* in the subject, coupled with a vague wish to believe some of the writer's conclusions—conclusions often derived from second-hand reports and preceding the purchase of the book? In a word, what is being counted? Whatever account future historians give of the vogue of Toynbee, the fact of mere interest is what a present historian would assert about the comparable diffusion of, say, Herbert Spencer's works. The verdict would then be that his influence was extensive rather than deep, symptomatic rather than creative. Yet large sales do not always signify the same thing. In the success of Byron's *Childe Harold*, for example, real novelty fell in with a public appetite created by the circumstances of English isolation; and the new work, instead of ending with itself, inspired hundreds of artists for the better part of a century.

That these discriminations are not idle should be apparent. They have to be made in assigning magnitudes within the constellations of those who made the past, and they are the very substance of biography. In making such distinctions it is clear that nothing can supersede insight and judgment, neither the sending of questionnaires to the living nor the measuring of radioactivity from the tombs of the dead. And because this is true the skeptic at this point enters a caveat against cultural history. He deems it the most unreliable of historical genres, the farthest removed from the official, literal documents and figures that other kinds of history are directly based on. "You admit," says the skeptic, "that you cannot measure and demonstrate the influence of ideas, the effect of art forms, the impact of social change, yet you expect us to believe that 'the culture' of France or Germany or the American Colonies two centuries ago was as you describe it. Why, the chances are a thousand to one against there being any connection between your so-called evidence—a pitiful heap of

books and letters and music and furniture—and the vast reality you pretend to reconstruct. What culture leaves to the historian is but vestiges of the doings of a very few. The more articulate your sources, the less likely that they are representative. You fill in and sketch out with your imagination and in the light of your present-day concerns. How can you honestly set forth the cultural history of so recent a time and so near a place as eighteenth-century Europe and America?"

This looks like a formidable indictment, but there is a sufficient answer. In the first place, culture has continuity; it lives on as other kinds of fact do not. We have to learn what happened in the election of 1888 but we do not have to learn what is meant by progress, patriotism, natural science, or grand opera. The cultural historian therefore deals in large part with the modifications, the combinations, the rearrangements of ideas, feelings, and sensations familiar to all who lead a conscious existence. This is what enables him to have insight, much in the manner of the anthropologist, who begins to feel the force of minute events once he has gained familiarity with the culture he has been living in. The cultural historian lives imaginatively in his own culture and also in that he has made his own by study; if at home in both, he is as trustworthy about the one as about the other, no more, no less.

As to the objection that cultural history is restricted to the doings of the highly conscious part of the population, it must be answered that the same objection applies to political and diplomatic history. And if the rejoinder is that the latter activities, led by the few, nevertheless affect the entire people, then the same must be said of cultural affairs. The new ideas of a handful of men in one generation become the fashionable thoughts of the upper class in the next, and the common beliefs of the common man in the third. Everybody now repeats as platitudes what were fresh thoughts in the minds of Jefferson and Franklin; and men of affairs who outside their business seldom give admittance to an idea without a struggle

are now convinced that things first said by Adam Smith are self-evident propositions.

Nor is this descent-with-modification limited to opinions. The folk tune is often the art song of an earlier composer, and designs that originate in sophisticated minds and places wind up on wallpaper and chintzes by the yard. In short, regardless of cultural starting points, social groups and classes and nations exist in history through their conscious activities, through the distinctive forms, the characteristic combining of features, by which they strike the observer, contemporary or subsequent. "Exist in history" could be translated "are memorable," for in the definitive words of *1066 and All That*, "history is what you can remember." Just as in biography we take for granted the subject's daily routine of hair-combing and tooth-brushing, so in history we take for granted the great dull uniformities of vegetative behavior.

Hence it is beside the point to argue that millions of our fellow men live and die without bothering their heads about the work of Einstein or Freud or Bernard Shaw. Either the indifferent masses will ultimately feel the impact—the bomb will explode over their heads—or their existence is demonstrably related to mankind's articulate thought through their acting as background, subject matter, or chief obstacle. For the makers of culture do not make it in a vacuum, and whether they are hindered by the conservative third-hand culture of the mass, or draw the inspiration of their work from meditating on the vast stream of unconscious life, they are part of it, shaped by it. The example of a work such as Hegel's *Philosophy of History* shows how unimportant can be the gap between rarefied thought and its raw material—in this instance the philosopher's difficult vision encompassing the dumb travail of Europe's millions during the Napoleonic wars. It is the same miracle which in Goya's drawings of the same period turns the casual disasters of war—pillage, rape, hanging, shooting—into spiritual treasure. *1956*

Alfred North Whitehead

The most notable event since my last writing is the death of Alfred North Whitehead in his eighty-sixth year. Perhaps because he had worked in this country for a quarter century, or because he was a more versatile and practical mind—and therefore less like the common notion of an abstruse thinker—Whitehead never received the attention that Einstein did—and this despite the fact that his appearance was fully as picturesque and his character equally saintly.

One obtains a measure of the man from the *Essays in Science and Philosophy,* which begin with half a dozen autobiographical fragments and then give samples of Whitehead's main lines of work: metaphysics, mathematics, logic, education, and the history of science. Now that our intellectual leaders are addressing themselves to the problem of treating science as one of the humanities, Whitehead's lifelong contributions to the matter and method of this subject should receive more general attention: it is years since he wrote a masterpiece entitled *Introduction to Mathematics,* but the little work could still teach and delight any reader, from the layman who thinks he hates mathematics to the professional who thinks he knows all he needs to know.

In speaking of his own education, Whitehead paints a quietly impressive picture of the social and intellectual circumstances that formed his mind. They comprise such elements as a clerical background, a classical education, a discussion club, and a wife whose upbringing in the old cosmopolitan and aesthetic tradition of women's education makes our modern brand look like emergent barbarism. Although after reading Whitehead's reminiscences one is no more able

than before to explain his genius, one can certainly account for his range of powers and sureness of touch. Even when his prose is full of snarls and knots, which is usually the result of trying to tame original ideas, one always has the sense of his direct contact with experience, of his concreteness.

This last quality is what is so conspicuously lacking in what is offered us today as thought. We like to believe that it is the Whiteheads of this world who are "abstract thinkers" and need to be brought down to earth. The fact is, only a great mind has the secret of being in touch with things; the abstract ones are the run-of-the-mill philosophers and historians, and the breed becomes more abstract as we reach the pseudos in each kind. It is your plain fellow whose head is a gas balloon, and who can only be brought down to earth by being exploded.

<div align="right">

1948

</div>

William James: The Mind as Artist

The part that conventional knowledge plays in the history of culture has never been properly assessed. Conventional knowledge is usually based on some evident truth, above which is reared a superstructure of misunderstanding and fallacy. Conventional knowledge about William James starts with the truth that he expounded the doctrine known as Pragmatism. Next, by verbal and historical association, James is linked with John Dewey, also a Pragmatist. General opinion then assumes that James's view of the human mind is identical with Dewey's. Now, Dewey's being the better known, thanks to his extensive writings on education, the linkage leads directly to the conclusion that James's Pragmatic psychology finds the pattern of thought in the mental operations of science: the mind of man is a scientist *in posse*.

In *How We Think*, Dewey gives the outline of this act of mind, which he calls the reflective. It consists of five steps: (1) the occurrence of a difficulty; (2) the definition of it; (3) the occurrence of suggestions to explain or resolve it; (4) the rational elaboration of each suggestion—its bearing and implications; and (5) the corroboration of one of them by experiment or other kinds of testing. Dewey concludes that "thinking comes between observations at the beginning and at the end of a problem."

This "model" is perfectly good as far as it goes, but the first thing to say about it is that it does not begin at the beginning. It takes for granted a mind already full of objects, ideas, abstractions, generalities, concepts, and rules. If we concede that this is how we think, there appears to be a play on words hidden in the thought-cliché that unites James and Dewey and their Pragmatisms.

For what Dewey describes is either deliberate cogitation or well-established habits for meeting difficulty; he is concerned with reasoning, formal and informal. James begins much earlier, biographically speaking. He begins with consciousness and examines how it behaves in its rawest possible state, before it has acquired enough experience to define problems and canvass clear-cut suggestions.

What does James find? The complex answer is in *The Principles of Psychology* under the title "The Stream of Thought," a title which in the *Briefer Course* published the following year became the influential phrase "the stream of consciousness." In the first place, according to James, consciousness is not an entity, but a function. The usual notions of a receptacle for ideas, a mirror of external objects, a sensitive plate recording impressions, a subject-spectator watching the "real world" must be given up if we are to understand what goes on not *in* but *as* consciousness. Consciousness is clearly involuntary: not *I think* but *it thinks*, whether I want it to or not. Languages record an awareness of the fact in expressions

like *methinks, il m'en souvient, es dünkt mich,* and again in "it occurs to me," "the idea crossed my mind," and so on. *I think* is not parallel to *I walk.* That we have the sensation of owning this self-propelling stream is also true, but making it do our bidding is difficult—and rare. And that is why it is important for education to follow Dewey's analysis and make out of the five steps a conscious method of organized and sequential thought.

But it is equally important (and for much more than education) to understand the working of the mind in its native, original course. It can be shown, for instance, that a great deal of criticism in the arts is vitiated by ignorance of the way the mind perceives and preperceives objects. Thus all theories of "pure" art assume impossibilities in both the making and the witnessing of art. And even in science and mathematics, as more than one great discoverer has testified, the deliberate march of mind in five steps is not so much actual as ideal: it helps to verify rather than to create—the reason being that the mind is natively not a scientist but an artist.

James does not use that figurative way of telling how consciousness works, but the metaphor is not far-fetched, nor is it meant here to bestow an honorific quality, let alone take sides in the foolish, profitless rivalry between art and science. The term is used only as a catchword that may help to remove the conventional error caused by Dewey's pedagogic intention.

The mind according to James is a stream composed of waves flowing endlessly without gaps. Each wave (or pulse) presents a crest or focus of intensity surrounded by a fringe. The focus is clear, the fringe dimmer, and what is in the fringe surges forward to become the next clear focus as the previous one fades out. We record this phenomenon in many of our ways of speech. We refer to what is "uppermost" in our minds; we know and speak of what "interests" us and can name what "holds our attention": all these words imply the focus. Compared with it, the fringe, aura, or margin is vague and thus not

readily namable. It takes the power of a poet to evoke the fringe by offering a series of images to focus on. In life, we have intimations or presentiments of what may come next to mind, but these escape the net of words because the stream has a way of pressing forward as if driven by a purpose, looking toward an end not yet known—quite as in a story full of suspense. The "interest" at the focus wants each following pulse to be equally interesting or attention wanders off to something more promising.

This rough summary of James's description of the stream shows to begin with that there is a form to thought as it is given to us natively. Thought is not the scattered bits of a kaleidoscope that Dewey dismissed as of no use to him. On the contrary, there is no disconnection at any point, and the sense of making toward a goal on the crest of interest, with troughs of lesser intensity, but true connection, is a fundamental form. We find it embodied in every kind of human discourse, from the sentence to the symphony.

To be sure, the products of art or communication are trimmed and compressed by other operations of the mind. Even the so-called stream-of-consciousness novel is a simplified artifact and not a transcript of the luxuriant shoots of ideas and feelings in the author's consciousness. The fact remains that the works of the artistic intelligence are not made by imposing on absolute chaos an order from outside, but rather by effecting a distillation of the stream and ultimately respecting its inherent form.

What remains to be said is that in the mode of inquiry Dewey propounds, "purpose" bears the workaday meaning of setting out for results. In the portion of James's work I have discussed, purpose is an intrinsic quality: the stream moves forward from crest to crest and toward an end without effort and without a defined goal. The mind's interests, says James, are practical and aesthetic, and these root tendencies must also, I think, be distinguished from deliberate worldly practicality and aesthetic aims. It then becomes clear that James's

Pragmatism differs from Dewey's in being, as it were, innate—not exclusively a logic and a method, but simply the way consciousness pursues and makes the most of its interests.

1985

Thomas Beddoes, M.D.

In a remarkable piece of scholarly detection, *In Search of Swift*, Denis Johnston refers to an opinion expressed in 1807 by "a certain Dr. Beddoes." As an historian of letters Mr. Johnston might have suspected that he was speaking of the father of Thomas Lovell Beddoes, the poet. Had he done so, he might have found that the subject of his dismissive phrase was also the great-grandfather of Gerard Manley Hopkins, another poet; and perhaps our critic might have gone on to catch a glimpse of a remarkable figure in the history of science and medicine.

But it must be admitted that the elder Beddoes is not easy to get at. His works are in few libraries. *The Dictionary of National Biography* is cool about him, and the *Dictionary of Scientific Biography*, though more sympathetic, adopts the dying Beddoes's own view that he had wasted his talents by scattering. Even that delightful compendium of bedside reading, the *Familiar Medical Quotations*, overlooks Beddoes senior in favor of his son, also a physician, but mainly a poet, and so represented in that compendium. What a pity to forget the man who made such observations as: "How comes it that when [people] find their whole life to be made up of such comfortless portions, they should take the trouble of eating and drinking to prolong it?" Or this one about a King's messenger: "He had posted through the world without having seen, or desiring to see, any one object distinctly." Or again, in soberer

vein: "The use of Definitions is to enable different persons to collate their ideas upon the same subject."

That last maxim comes from a lecture on the Sexual System of Vegetables. Passing to the corresponding system in use among human beings, Beddoes wonders at "the multitudes of unemployed bachelors and autumnal maidens in Warwickshire." Again, with the eye of the medico-psychologist, he recommends *interesting* exercise: "Task exercises hold the same proportion to health as the castigations of penitents to piety and virtue." And he gives another key to his life and mind when he remarks that "those who decry experiments in medicine do not perhaps perceive that they cut off all hope from those at present incurable." At the same time he knows that "it is a poor project to lay oneself out for the praise of ingenuity by proposing plans which are in no danger of being tried."

But it is not as a philosophic aphorist that Beddoes best deserves to be remembered. It is as a man of science and a medical pioneer who worked at the critical time when chemistry was building its truths on unshakable experimental and mathematical foundations. Beddoes was among the very first to see that with its roots in chemistry medicine could become a more precise art.

What then accounts for his prolonged neglect by the recorders of human achievement? Well, chronology to begin with. Thomas Beddoes was born in 1760 and died in 1808. He therefore belongs to a typically lost generation. The high tide of the Enlightenment is over; the high achievements of the Romantic period are not yet visible; and while the new works are being elaborated, the tramp of armies and the sudden overturns of states distract public attention. What is worse, the effects of the French Revolution and the Napoleonic wars prod the gifted in too many directions. A period of transition, say the pundits. True, but readers of history should know by now that it is in those periods of seeming incoherence and excessive fer-

ment that innumerable new starts are made which later comers bring to fulfillment—and reap the credit for.

So it was with Beddoes. Born of a modest Welsh family long settled in Shropshire, Thomas was a precocious child, insatiable for books and disinclined to games. He was encouraged in his tastes by a wise grandfather, whose death when Thomas was nine disclosed the boy's predispositions. Seeing the acute interest shown by the child at the grandfather's bedside, the surgeon in attendance used him as helper, then asked him to his surgery for long talks.

Thomas went to local schools and was later tutored for the university. He entered Pembroke (Oxford) and became an "elegant Latinist" and, what was more unusual, a rapid learner of modern tongues. Graduation was followed by the study of anatomy in London under the celebrated Sheldon, then independent study of physiology and of all the new science that was coming from abroad. This, combined with the gift of tongues, led to the first published works. Beddoes was barely twenty-four when he translated the dissertations of Spallanzani from the Italian and annotated Cullen's translation of Bergman's *Physical and Chemical Essays*—actually a thorough bringing up to date of Bergman, showing wide reading and experimental knowledge of chemistry. Within the next two years Beddoes translated from the German both Bergman's *Essay on Elective Affinities* and Scheele's *Chemical Essays*.

Meanwhile, Beddoes had spent two years at the University of Edinburgh Medical School, where he was active in student affairs and produced papers on geology, botany, and chemistry. He returned to Oxford in 1786 to take his M.D. degree, then concluded his training with two more terms at Edinburgh. Thus by the middle of his twenty-sixth year Beddoes had had a varied experience as medical student and as writer, lecturer, and translator in scientific subjects. He was a rising figure in a world seething with new ideas. And thanks

to the loose structure of education in those days, he had also been practicing medicine in his native country, and with such success that he was idolized, especially by the poor.

That last relationship completes what might be called the definition of Beddoes's genius. His lifework was to combine scientific theory and experimentation with social preoccupations and their embodiment in medical practice and propaganda. This concern about society was in truth to be so greatly stimulated by the revolutionary times at hand that it led Beddoes to political acts—not many, but enough to make him enemies and give him the reputation of a dangerous eccentric.

This fusion of elements in a medical career reminds us of Beddoes's American contemporary Benjamin Rush. The resemblance of tone in their efforts to create an awareness of public health is striking. It is, of course, an effect of the *Zeitgeist*. On this point I may be permitted to mention a remote ancestor and exact namesake of mine, who took his medical degree at Montpellier and offered as one of his theses an *Essai sur la Constitution des Paysans* (1811) which may be read in the British Museum. Some of its observations and recommendations have a Beddoes-like ring, though patently uninfluenced by the Englishman who had died three years before.

But by the date of that premature ending, one may legitimately ask, what had Beddoes's tireless activity accomplished? Clearly, the writers of encyclopedia articles want palpable, namable lumps of performance which they call "great discoveries" before they will accord "a place" to a man of science. Hats are taken off to Lister because he used carbolic acid to make wounds aseptic. The fact that this treatment was soon abandoned and a less drastic form of cleanliness adopted does not affect his standing in the eyes of the ordinary historian. But perhaps a subtler standard of merit should apply to more complex cases—such as Beddoes—which are also more ramified and lasting in their consequences.

Perhaps the only account of his work that is finally convincing is the detailed biography by John Edmonds Stock:

Memoirs of the Life of Thomas Beddoes, M.D., with an Analytical Account of His Writings (London, 1811)—over four hundred quarto pages, one monumental chapter without a single break! On reflection, this unsparing consecutiveness is appropriate to Beddoes's endeavors, which are also monumental and persistent. They may be grouped under three heads: the campaign for public health and preventive medicine; the intellectual passion for experimental science, pursued both for knowledge and as an aid to medicine; and the faith that applying the mind to society is bound to relieve misery, poverty, and injustice.

After his degree Beddoes traveled abroad, met scientists, including Lavoisier in Paris, and projected a tour of Germany which the outbreak of revolution prevented. At home he formed a friendship with Erasmus Darwin that led to Beddoes's having a hand in his older friend's greatest work, the *Zoonomia,* in which a profound theory of evolution is argued and supported. Grandson Charles, when his attention was drawn to it, exclaimed: "Whole chapters are laughably like mine!" From surviving fragments of the criticism Beddoes furnished to the great Dr. Darwin, it is clear that the young scientist read the manuscript with philosophic care.

At the same time Beddoes was holding, without salary, the Readership of Chemistry at Oxford and his lectures were drawing an extraordinary number of students, "the largest class in Oxford," wrote Beddoes facetiously to a friend, "since the rediscovery of Justinian's code." It amounted, according to a modern scholar, to a revival of science at the university. But politics and personality brought the revival to an abrupt close. First Beddoes attacked the Librarian for not discharging his duties and for neglecting to buy modern scientific books. However justified, the tone and the public manner of the onslaught alienated some members of the university. Then he published essays and handbills about such topics as the undesirability of an Indian Empire and the British exaggeration of the excesses committed by the French revolutionists. The

clamorous outcry in Oxford and London forced Beddoes to resign. It was a double pity, since a few months later he himself was disillusioned by the massacres of September 1792.

Indirectly, his leaving Oxford proved productive. Uncertain at first, he projected a few works, wrote a best-selling novel of moral-medical purport called *The History of Isaac Jenkins,* based on close observation of rural life and dialect, and finally decided to settle somewhere in the west of England to pursue medico-scientific researches. Like a born project director he found the money, the men, and the site. This was Clifton, near Bristol, where in 1798 Beddoes opened the first medical research laboratory. Among the donors were the Wedgwoods and the Edgeworths; among the friends and well-wishers were the engineers Boulton and Watt, George Stephenson, and that trio of radical poets, Wordsworth, Coleridge, and Southey. Bristol was then the second city in England, prosperous through world trade, and noted for its elegant society and its lively intellect, which was more adventurous than conservative. Had it not returned to Parliament the great liberal thinker Edmund Burke? And now it harbored the liberal satirist Sydney Smith and those three poets aforementioned, whose physician Beddoes was.

The purpose of his "Pneumatic Institution" was to study and practice the inhalation treatment of respiratory diseases. The impetus to this effort came of course from the new chemistry of Lavoisier and Priestley and the recognition of the "factitious airs" (as Beddoes called them in his voluminous reports): oxygen, hydrogen, nitrogen, nitrous oxide, and hydrocarbonate (illuminating gas). For his experiments Beddoes, aided by James Watt, designed what amounts to the first oxygen tent. Beddoes also engaged an unknown young man whose earliest writings had attracted his interest, Humphry Davy. Their joint work was thorough and precise, and, in addition, dangerous. Davy nearly put a factitious end to his career by the experimental inhaling of hydrocarbonate. But he

lived to publicize the discovery that nitrous oxide had anes-
thetic properties. Fully aware of the implications, the report
suggested its use "during surgical operations in which no
great effusion of blood takes place" (June 25, 1800; the actual
discovery goes back to April 17, 1799). The medical profes-
sion was at fault in not picking up the hint. The other conclu-
sions were less sure. It seemed as if oxygen was "useful for
scrofula, white swellings, ulcers, and asthma . . . advantageous
in paralysis, harmful in apoplexy, and valuable in simple
exhaustion."

Beddoes's patronage of Davy is a gauge of the older man's
sureness of judgment. The young man left Beddoes and
Clifton after a couple of years and reached the heights of fame
in London. But it was not his departure that diverted the work
of the Pneumatic Institution. Rather, it was the great typhus
epidemic of 1800, which turned the research laboratory into a
populous clinic. With his strong social conscience, Beddoes
could not refuse to treat patients in dire need.

Clinical experience and reforming zeal persuaded Beddoes
that public health was a new and necessary service, not a vague
and idle dream. He seconded Dr. Clark's suggestion of a
National Board of Health and went to work upon his own
large constituency, "the middle and lower classes," preaching
cleanliness, good diet, even temperature, and rational dress.
He gave series of lectures in Bristol on preventive medicine,
on the rudiments of science, and on the rules of hygiene. "Filth
and confinement," he was sure, were the real killers. Another
course, guaranteed not to alarm "the delicacy of the most
timid," was to teach ladies some physiology. For Beddoes was
also a feminist. He deemed women equal to men in intelli-
gence and helpless victims of "a studied neglect." Yet never
sentimental in his convictions, he could also say that women
in high society often stultified medicine by taking advantage
of fashionable doctors' sycophancy. And for the undress of
evening balls in drafty rooms and the tight-lacing of ordinary
wear he had nothing but scorn.

In all aspects of public health Beddoes stressed the enormous value of preventive action. To this end he studied neighboring schools—all private as yet—and wrote model plans of what they should be for boys and for girls. He was appalled at the dietary of girls' schools ("forty fed for two days on one leg of mutton"); he wanted instruction in sex ("such a book should be frank"); and he was moved to the depths by the ravages of the reigning linked diseases, Consumption and Scrofula.

It was Beddoes's contention that the two were related and needed a frontal attack by scientific medicine. He made endless observations, which his fine theoretical mind classified according to age, occupation, income, mode of life, and climate. His conclusion was the modern one, that correct diet, reduction of toil, and even temperature were contributory to cure. Some of his measures appeared eccentric but had a point, as when he had a rural patient transferred to his barn, where the animals' heat ensured a continuous mild temperature, as the hovel did not. He observed that under certain conditions the ill was contagious and told mothers not to nurse their healthy babes. He noted the remission of tubercular symptoms during pregnancy and their recurrence when the poor woman patient went back to her cooking and washing. Meanwhile he admonished the well-to-do about the misuse of their advantages, about their addictions and indolence, their tight clothes, and silly ideas: "The medical description of ten rich and ten poor persons would do more for health and happiness than all the moral treatises ever written."

In his *Hygeia,* a collection in three volumes of eleven essays first issued as separate parts, Beddoes spread abroad a multitude of ideas, great or small, that have become part of the common stock of belief about health. His fundamental assumption is also that of our modern social conscience; for example, the parents should be the first "inspectors of health." Not even the educational value of "rational toys" escaped Beddoes's fertile imagination, and he spent time and effort (in vain) to have them accepted.

Nor did he overlook the prevalence of mental disorder. He gave vivid descriptions of "low spirits, bad nights, nightmares and anxiety" and drew conclusions remarkably up to date. He thought hypochondria in males equivalent to hysteria in females and he used hysteria in the modern sense. He was convinced of the coordination between the mental and corporeal systems—diseases are psychosomatic—and his diagnosis of the madness of "the celebrated Dr. Swift" was that it came from "brooding on his neglected superiority and friendless solitude." Beddoes saw even further and asserted that mania and melancholy are one disease, not two; the symptoms alternate, and like many other mental ills they are related to "preoccupation with passions without gratification."

No summary of Beddoes's thought about man's life and man's ills can do justice to the subtlety and amplitude of his perceptions. The summarizing to which one is limited lacks the sharp and abundant clinical detail found in his writings. His views were not just happy guesses—for instance, after the remark that "madness has no essential character" but is relative and wanting in an exact criterion, Beddoes's observations lead him to a theory of the imagination that includes in its ambit religious fears, delirium, paranoia, and poetic power. But in this rational system are also taken into account the observed effects of concussion, of debauchery, and of the "uniform occupation of artizans." He regrets, moreover, "our present ignorance" about sleep.

Dr. Beddoes, in short, was a great observer and synthesizer at a time when close attention and numerical results were only beginning to be reported. He had the intuition of all that a science-based medicine should be. He called for the publication of classified cases by all hospitals, instead of mere numbers of admissions and discharges. He urged meetings—colloquia—on "striking deviations from ordinary phenomena." He noticed that the elderly needed special treatment and called for "conservatories of old age," foretelling geriatrics. He stressed the need for "general scientists" in medicine, in place

of "unphilosophical" practitioners. He pointed out the innumerable connections between the organic and inorganic forms of being. He was shouting in the desert, but not wholly in vain. As always happens, even those who laughed or turned away in contempt were in the end affected, and the next generation began to cultivate the seeds that Beddoes so profusely scattered.

Beddoes suffered a severe illness two years before his death, which on postmortem examination was attributed to "compensatory emphysema" of the right lung and "contractive atalectasis" of the left, complicated by "chronic purulent pericarditis." The first two complaints would now be treated by modalities he himself initiated. In place of them he twice endured the torture of the "boiling blister" therapy.

Beddoes was foolish to die so young. Another quarter century would have vindicated his views and settled his fame. His son, another type of genius, made the same mistake, dying in Germany, an unknown poet, at just his father's age. The elder Beddoes, who had been an excellent tutor to boys in his youth, failed with his own son. Both were shy, embarrassed men, who took a great deal of knowing. The older Thomas was "uncommonly short and fat, with little elegance of manner and nothing characteristic externally of genius and science." But all those who pierced the outer shell became friends and worshippers. Humphry Davy loved him "the more he knew him." Coleridge "wept convulsively" on hearing of his death and said: "More hope was taken out of my life by this than by any former event. For Beddoes was good and beneficent to all men."

In times of troubles, maintaining an equipoise between seemingly disparate aims is hard even for the strongest minds; and for that reason no later comer can say to the creative genius: "You should have done otherwise." Beddoes declared in the motto of his book on Factitious Airs: "I desire to be

instrumental in diffusing a taste in the most useful species of knowledge and in converting nations into HUMANE SOCIETIES." Prefixed to a treatise on a new type of medical treatment, the words sound irrelevant. But it was the same man who in a book of homely advice addressed to the general public said: "The light and load of former ages are upon every mind that thinks. . . . All of the human species, not idiots, must theorize."

1972

Science and Scientism

The handiwork of science in the modern world is a topic of everyday reference, and among those who lead opinion the reference is generally adverse. During the past thirty years the articulate have unceasingly cried out against the tyranny of scientific thought, the oppression of machinery, the hegemony of things, the dehumanization brought about by the sway of number and quantity. On these themes the nations most renowned for science and industry have applauded the wounded poets, the philosophers of myth, the devotees of agrarianism, the novelists of the life of instinct, and the painters and dramatists who scorn civilization—to say nothing of the day-to-day critics of mass culture.

At the same time the leaders and the popularizers of science and technology have not been silent, and in serving their more limited aims they too have managed to establish about science some widespread convictions. Together, these two choruses have supplied journalism and conversation with a number of thought-clichés. The reading and listening public "knows," among other things:

that in our culture there are two cultures, composed of the

men of science and the men of non-science—an alarming split when we consider how fast knowledge is growing among the men of science;

that there has been a scientific revolution, or perhaps two—or more—for the surer saddening of man: first Newton removed God from the center of the universe, then Darwin removed Man, and finally Freud removed Mind;

that thanks to scientific analysis nothing is any longer what it seems, everything being the effect of some hidden, blind, irresistible force beyond control—except by science;

that whereas the physical sciences have made great progress and given us control over nature, the moral and social sciences have lagged behind and failed to give us control over human nature, which explains war and juvenile delinquency;

that science being the only reliable enterprise of reason, it will gradually resolve men's doubts and difficulties and thus remain sole master of thought and queen of the curriculum;

that science is incurably difficult for the layman, who ought not to compete with the few who are "mathematical" and destined for it; scientific revolutions occur so frequently that any recollection of one's scientific studies is almost sure to be wrong; and yet the new knowledge permits a return to the belief in God and immortality;

that unless science is taught to everybody, thoroughly and soon, Russia will conquer and bury us; the East, in fact, is bound to win, because it is training nothing but technicians;

that no matter what anybody does, science and technology are reshaping human life in the same way for East and West;

that technology, the offspring of science, is the cause of the century's troubles—isolation, alienation, anomie, the low estimate of art, and the breakup of the family;

that in a rapidly changing world full of technical problems, scientists should have a voice in government; although it is also true that the patient work of science unfits a man for making decisions and tolerating the hit-and-miss processes of democracy;

that the machine civilization produced by science is lift-
ing the masses everywhere from the bondage of disease and
superstition and into the higher preoccupations of the good
life, such as leisure-time reading and community work;

that the machine civilization produced by science destroys
all human values—they flourish far better in primitive soci-
eties. The machine breeds only urban materialists who now
stand on the brink of mutual destruction by man's highest
achievement, the Bomb; or, alternatively,

that the technologically developed countries stand at the
threshold (not brink) of the atomic age, when the marvels of
science will be widely diffused and appreciated—atomic
power plentiful and clean, life made in a test tube and pro-
longed indefinitely on a diet of plankton, art for all, the scien-
tific control of man's evil impulses, and the adventure of
exploring, perhaps colonizing, Space.

These propositions are used to define our present (excit-
ing) (miserable) condition. What are they worth? Or rather,
which of them—if any—should survive comparison with its
neighbor or with recorded fact? It is not true, for example,
that technology is the offspring of science, and that art today
is held in low esteem. Even apart from truth, it is regrettable
that informed opinion should accept such incoherent tempta-
tions to belief: science for everybody and for the few, science
dominant among us and in danger of neglect, science man's
highest achievement and spiritual blight, science the benefac-
tor and the common enemy.

Below this confusion lie many unresolved questions. It is
not clear to anyone, least of all the practitioners, how science
and technology in their headlong course do or should influence
ethics and law, education and government, art and social philos-
ophy, religion and the life of the affections. Yet science is an all-
pervasive energy, for it is at once a mode of thought, a source of
strong emotion, and a faith as fanatical as any in history.

From this remark some may hastily infer that I am
"against science." And indeed this charge was occasionally

made by readers of *The House of Intellect,* despite the fact that it contained a parallel discussion of art, which led other readers to say that I was "attacking art." Such notions of attacking and being against are perhaps native to the age; they are foreign to me. I do not understand what is meant by being against, *or for,* wholes—art, science, education, medicine, the state. I can as readily imagine being against sunsets and for the tides. Criticism as I understand it differs entirely from attack or complaint. Its difference from complaint is especially important here, for I am persuaded that complaints against the machinations of culture today have become as poisonous as the things complained of. This is not surprising. Resentment and indignation are feelings dangerous to the possessor and to be sparingly used. They give comfort too cheaply; they rot judgment, and by encouraging passivity they come to require that evil continue for the sake of the grievance to be enjoyed.

Criticism, on the contrary, aims at action. True, not all objects can be acted on at once, and many will not be reshaped according to desire; but thought is plastic and within our control, and thought is a form of action. To come to see, in the light of criticism, a situation as different from what it seemed to be, is to have accomplished an important act. The contemporary world, cluttered with leagues and lobbies and overawed by the zero-weighted look of large numbers, has forgotten that to redirect fundamental opinion—including one's own—is also to *do* something. It can give solace or mastery, or at the very least replace a plaintive passivity with a stoic impassivity.

That is why, in the present work, which is primarily descriptive, and which, like its predecessors, often uses for illustration not what is merely typical, but what is especially worthy of regard, I sometimes employ the rhetoric of argument—the form that most naturally incites the internal action called thought. To the reader it should not greatly matter whether or not he agrees with the conclusions I reach. The point of offering them is to reduce confusion and provide a spur to reasoning. For the aim of a critic, beyond that of saying what

he thinks, is to make two thoughts grow where only one grew before.

Such an aim implies a reader willing to follow discourse even though the subjects brought together are very diverse, and to lend his mind to attitudes that may seem dubious coming from one who lays no claim to being an expert. But in matters of public interest the public must judge and not ask its guides for certificates and guaranties, for there are no guaranties. It is an error to suppose that when a physicist talks about science he is bound to be more reliable than a layman who has taken the trouble to inform himself and to think. For if scientific specialization means anything, it means that the physicist has final authority only on such questions of physics as fall within his specialty. Whitehead, whose eminence was first as a mathematician, devoted his life to grappling with questions of philosophy, history, literature, and education. These are public questions, and he served the public interest by bringing to bear upon them his vast intelligence and experience of life. So can anyone serve in the degree of his ability, provided he uses his intellect as a guide in the great regions outside his narrow profession.

To use the word "culture" in the meaning it bears for the educated reader today is to enter at once into the scientific state of mind. For culture in that sense is not learning or cultivation or even the local society one lives in: it is an object for the inquisitive mind of man to study and report on, an object considered as if it existed by itself.

You may accordingly like to think of culture—I often do—as an enormous pumpkin, hard to penetrate, full of uncharted hollows and recesses for cultural critics to get lost in, and stuffed with seeds of uncertain contents and destiny. Or again, it is an interminable marine monster, like the one at Loch Ness, dimly seen and badly photographed, about which endless debate goes on. Though many have observed its twistings and some have been shaken by its commotions, no one

has cast his eye down the whole length of it and given a complete description. One reason may be that we are all cramped and darkling inside it, like Jonah; but we are none the less determined that it is an object out there, acting on us, apart from us, and of which, despite its size and obscurity, we can find the secret. Culture is thus like the universe as science conceives it.

This object-like view of culture is a recent acquisition. It dates from about seventy-five years ago, when social questions were reclassified and renamed on the pattern of the natural sciences. Anthropology was one of the subjects redefined in this intellectual renovation at the turn of the century. Concerned with the varieties of mankind and therefore studying the primitive, anthropology took as its scientific unit the whole society—all the mental and material workings of a people. This it called "a culture." From looking with detachment at every word and gesture of a self-contained group, and from the envious pleasure that Western man took in the reports of growing up in Samoa or elsewhere, came, by imitation, the habit of looking at ourselves anthropologically, as "a culture."

The first consequence of the new attitude for literature and common thought was an increase of self-consciousness, which proved at once liberating and crippling. Thoughtful men lost confidence in their own customs, but in compensation cultural criticism became the playground of fancy, which freely disported itself, at home in the unprovable. Soon, like other popularized technicalities, the anthropological method became a trick of the sophisticated mind and finally a mode of everyday speech. It is now a journalistic commonplace to write: "In a scientific culture such as ours. . . ." The anthropologist's view of culture as a natural object becomes for the public a scientific fact, and that object is an agent: "Culture brings about" this or that; "our culture produces . . . determines . . . demands. . . ."

The vagueness of such formulas is convenient in a democracy when one must distinguish social groups. Few are sure of

being understood if they speak of classes, and "sect" sounds old-fashioned and inappropriate. The talk is of cultures and subcultures, thanks to which it is possible to express curiosity, animus, or alarm. That is how, in the current preoccupation with science and technology and the future of the West, one of the best-informed observers, C. P. Snow, ventured to propose—and has all but established—the diagnosis of "the two cultures."

He meant by this that a main feature of our society is the split of its intellectuals into two parties having little to say to each other. The difference in language and cast of mind between those trained in the sciences and those trained in the humanities seems to Sir Charles so radical as to justify his calling each group a culture: the scientists cannot read Dickens and the humanists do not understand the meaning of "mass" and "acceleration." Each type of man lives in a separate world, thinks with an exclusive set of terms and symbols, aims at goals shared only by those in his group, and thrives in complacent ignorance of the ways and aims of the other group—as would the inhabitant of a distinct culture.

The crack will obviously not repair itself. If one talks first to a representative scientist and then to an art critic or literary man, their remarks suggest that they are rapidly moving in opposite directions. But this is probably an illusion, as I shall try to show; and in any case it does not mean that two cultures confront each other across the widening chasm. To begin with, neither of the two groups is homogeneous: persons and interests intermingle. What is more, when added together the two "cultures" leave out ninety-nine-hundredths of the population. Does this remnant form a third culture, neither scientific nor humanistic?

Besides, within each of these two clans precision would require that we distinguish subgroups, as isolated as the parent pair. Consider the meaning of "avant-garde" and "academic" in the arts: these terms mean that in any given art parties exist which refuse to acknowledge kinship. They are

thrown back on mutual scorn as the only bond they can find. And within the subgroups radical divisions continue. The same is true within science. Radio astronomers and observational astronomers, algebraic topologists and ordinary analysts, decline to speak the same language even when they can. Their supposed common devotion to science, their presumed inability to read Dickens, do not make them fellow members of one culture, clearly distinguishable from that of the Action painters and the Old Dickensians, who likewise address one another rarely.

The truth is that all these men, together with those for whom the issue does not even begin to exist, belong to one culture, the scientific culture of the Western world in the twentieth century. If there were not in fact one culture, where would be the danger of occupational castes? If modern culture were not one, why did the discussion of the split bring forth so many plans for teaching science universally and the humanities more effectively? The answer is: Tradition. We have been reared, we live, and we believe in one culture, a culture which is common and traversable despite its compartments. That culture is now properly called scientific, because its defining characteristics come from science; or rather, it has grown scientific along with what we artificially set apart as Science.

To determine in what sense, other than casual, this is true requires an understanding of science not usually found among either humanists or scientists. Science is an awe-inspiring force, known to do remarkable things. Everyone, therefore, is presumed to know also how and with what effect science works. But few in fact pay attention to the nature and consequences of an activity so deeply approved. When this state of affairs obtains in a society about its dominant intellectual pursuit, the gap between popular reverence and common lack of knowledge is filled by conventional beliefs that range from clichés to superstitions. Gradually the relation between men and their own acts is hidden by the conventions, and one has to wait for the future historian to say what went on. There is

thus something premature about my attempt to describe the chief workings of the scientific culture in which we live, for I am bound to be blinded by certain conventions too. But it is less important at this time to be right than to try to see effects and connections that are difficult to trace or that we have stopped noticing.

It is not clear, to begin with, what we mean when we speak of science. Is science a method of inquiry, the result of the method, the application of the results, or—which is very different—the understanding of the cosmos vouchsafed by the method and its results?

And a second large question that needs settling is: Who shall answer those previous ones? It is not at once apparent who is qualified to be the interpreter of a society in which science is so near and yet so far. Are the scientists alone to judge their role, and if so, which scientists among the innumerable kinds? Or should we go to the sociologists, who have assumed the privilege of the very young to poke into every corner? Perhaps we should consult those ex-scientists who have gained worldly experience and a public position? Or the government servants and university administrators who have studied the scientist in captivity? Or, as a last resort, the cultural critics, who are almost as numerous as the totality of articulate citizens?

Supposing that we knew where to turn and were given the right definitions, we should still face the riddles posed by the current cant about science. For example, what does a respected atomic physicist and leader of engineering education mean when he asserts that "from now on science and technology will shape the world"? The phrase is not particularly his; it must occur a hundred times a day in the speeches of political and business leaders. The assumption seems to be that science and technology work by themselves, but we are not told what "world" they will change. It is not likely that an enthusiast for science is thinking of the odd shape the human world will present after an atomic war, though more and more people

tend to associate science with destruction. Others have utopian visions of ease and plenty resulting from applied science. In either case, the argument takes for granted an inevitable future, the result not of human wills and actions, but of the acquired momentum of science and technology. This seems to invite scrutiny, but by whom?

Again, public opinion has passively accepted the belief in a "scientific revolution," which is said to have recently taken place or to be still going on. Given the modern abuse of the word "revolution," which often means no more than a change of names and slogans, it is hard to define the supposed revolution. Is it a physical or a mental change? Who is gaining power and who is losing it? Does the belief assume the identity of science and technology and simply point to rapid mechanical progress? Is the revolution the shift to the study of energy in place of matter, or does the term refer to a social movement, by which science will monopolize all talent and re-express all knowledge in mathematical form? To test the reality of these beliefs would be a laborious study in common opinion. But these unresolved ambiguities are symptoms of our state, and I cite them to show the encyclopedic carelessness with which this century speaks of its proudest achievement.

Let us then try to state what modern science is. Since the living soul of science is not easily accessible, and since free discussion runs the risk of being misinterpreted as hostility, I begin my answer with a eulogy: I affirm without irony or reservation that modern science is one of the most stupendous and unexpected triumphs of the human mind, just as modern machinery is a collection of breathtaking artifacts often too complacently received by a heedless public.

But praise is not definition, and true definition shows things in their purity, in a perfection which is bound to be dimmed in the world of practice. Still, a definition is needed: I understand by modern science the body of rules, instruments, theorems, observations, and conceptions with the aid of which

man manipulates physical nature in order to grasp its workings. Taken together, these ideas, symbols, and apparatus form the subject and method of the so-called pure sciences. The adjective "scientific" is thus capable of a strict meaning: it is properly applied to any of the enumerated elements. When applied to a brand of tooth powder or a method of piano playing, the word loses its force; it suggests only: "based on some conclusion of one of the sciences"; or more often merely: "tinged with one of the externals of scientific work." And sometimes the word degenerates into a vague honorific, synonymous with the advertiser's "reliable" or "guaranteed."

When one speaks of modern culture as scientific, neither the strict nor the loose meanings are intended. What is meant is that the elements of natural science exert on common life a prevailing influence, impart to all activity and thought a characteristic coloring. A scientific culture is a type of contemporary society through which the ideas and products of science have filtered—unevenly, incompletely, with results good and bad, but so marked that they affect the whole unmistakably. The test is simple: not only does such a society support and respect many varieties of scientific worker, but these are so placed that their work gives off emanations, practical and spiritual, which affect every part of the culture.

Here it may be objected that the emanations are not part of science; they are unintended by-products for which science itself must not be blamed. Errors, disasters, pseudo-sciences, superstitions, have no connection with the noble essence of science; they are the doings of an ignorant and imitative society. To this the reply is that blame has no place in the intended description; but that if description is to be exact, the so-called side-effects cannot be excluded from the account. The culture is scientific because science pervades it. Science is not an isolated hobby, but an overarching ideal; and like every other ideal it cannot realize itself in a vacuum. Supposing the method and principles of science were set down in a book and never tried out, its greatness and beauty would be, not

increased, but diminished. The purpose must be acted out, and thereby distorted, before it can claim our full devotion. In this regard science resembles all great and good things: the only kind of science we know or shall know is one that has to work in the midst of a credulous mankind, poorly taught, ruled by mixed moralities, and bent upon many other things than the search for truth. The public which receives and distorts science is no different from the public which receives and distorts art, and it is foolish to expect a better fate for either in the future.

The scientific community itself, consisting of specialists who are also men and citizens, shows the same imperfections. Human diversity and indeed mere numbers affect every intellectual pursuit, and it would be difficult to ascertain at a given moment from "the scientists" as a group what the latest deliverance of "Science" was on any given point. We should find only the usual confusion, uncertainty, and debate. Max Planck tells us in his *Autobiography* that he does not believe that science progresses by the self-correcting action of minds. Rather, he thinks, the new ideas are promoted by the young as being new and especially theirs, and the old men with the wrong ideas eventually die off. This is undoubtedly the truth, and from its pathos I draw a further argument in praise of science. For it has found the means, despite human frailty, to make its findings largely cumulative and coherent, and thanks to its control of terms, reasonably stable and clear.

No one, then, should feel upset because a scientific culture is a hodgepodge which owes its character as much to the derivatives of science as to the rigorous core. A scientific culture is one in which the structure of the atom is studied and comes to be more or less vaguely known; it is also a culture in which a winning racehorse is named Correlation and in which the matching pieces of a woman's suit are sold as "coordinates"; it is a culture in which the photograph of the diffraction of electrons by zinc oxide resembles a prevailing mode of painting, and in which a polished roller bearing or a magnified diagram

of the male hormone, when colored, can be used as a decoration in the home.

Even without these tokens, no impartial observer of scientific culture can deny its remarkable unity and range. A parallel that may help to describe it is medieval culture in the West. Though often called a religious culture, it is more exact to call it theological, in the same fashion as ours is scientific. Just as but few men were then theologians, so few among us are scientists. Just as the language of theology ended by permeating common thought, so with us the language of science. The ultimate appeal was then to the certitudes or sanctions of theology, as with us to the certitudes or sanctions of science. The highest concern of the culture was to support, to perfect, and to disseminate theological truth and practice, as with us to support, perfect, and disseminate scientific truth and practice.

This is not to say, as some have done, that we "worship" science—the phrase is a careless metaphor; nor does the medieval parallel imply an exact correspondence between two intellectual enterprises, even though medieval abstraction and analysis are closer to science than science or scholastic thought is to the pragmatism of the artist and the historian. It is worth noting that "layman" now means "not a scientist" as before "not a cleric," which suggests the same faith in the one kind of knowledge worth having. The similarity between science and theology obtains again in the crude, fitful, uncontrollable relation between a dominant intellectual system and a large heterogeneous society, which does not so much assimilate the thought as take from it a tone and a direction. So regarded, our present Western world shows, I repeat, not two cultures but one. The very conception of "a culture" means that it is one and indivisible. If it shows a mixture of interests and tendencies, that fact merely defines a large and well-developed type of culture. Our civilization has reached the stage where groups coexist without sharing the same concerns, or without recognizing the same symbols even when they share the same con-

cerns. Those who understand hydrogen bonding do not understand insurer's bonding, and the public understands neither. But the widespread alarm over the increasing diversity in the languages and aims of intellect is further evidence that people today still want to be at one through cultivating the sciences, because science, like theology before it, is the reigning queen.

With these definitions and parallels in mind, our present situation seems, if not simple, simpler: our culture is one by reason of its common roots, its long history of exchange and assimilation, and also—and chiefly—by the universal trust it has acquired in science and scientific method. The scientific stance is everywhere, even among the overt enemies of science; it is the strongest unifying force, because in the world of thought it is the only one. True, art has latterly won a naïve adoration, but as I shall show, art too is under the sway of science, which it resembles in being a pure and self-justifying activity. That is why today these two alone, art and science, are revered, however differently, and act proud, sensitive, and resentful of challenge. While business and the state are scorned as frauds and religion is dismissed as a private matter; while the reality of love is sneered at and life itself is often repudiated, science and art are held above reproach as disciplines a man can worthily give his life to and be fulfilled by.

But art is the lesser power. Men have turned to science because it seems to give truth an exact and inalterable embodiment, and in a sense this is no illusion. But in another sense, science alters much more than art and the humanities, which according to cliché have not "progressed." The humanities, moreover, lack a stance of their own. Hence their tendency to ape science, which confirms once again the inescapable oneness.

The spectator may take pleasure in this uniformity, but it leaves strange questions. How explain the paradox of a society which is bound by so ardent a faith to one undertaking, yet by and large withholds its mind from it, saying it lacks the time and the talent to do anything but remain ignorant? And how

is it also that the sacrosanct enterprise, without being formally criticized or disparaged, has alienated the minds of those most alive to the motions of man's spirit? Here certainly we differ from the medieval world, in which clergy and clerisy were one body, however divided on points of doctrine.

The questions are of two kinds. One is historical; it asks us to account for the common vagueness about the fundamentals of science, which one would suppose to be its oldest and simplest parts: what it does, how it works, which part of it is truth and which assumption, and how far its rights extend. The second sort of question is philosophical. It wants to know about the moral and material effects of science; how the grateful wonder about antibiotics merges into the fear of the greatest antibiotic of all, the Bomb. And before the Dance of Death, there is to be explained what many ascribe to the workings of science—the relentless self-destruction of the modern ego, the misery, accidia, wanhope; in short, the conviction that mankind is at the helm of a black ship bound for hell. To have brought us to this point, to have turned our culture scientific and made it conquer the world, only to leave us in despair while still largely ignorant of our accomplishment, there must have been at work some powerful motive inspired by an idea. How did Western man, reared theological for a thousand years, become "scientific"?

The best answer is that he early developed into a maker and lover of machines and has lately come to believe them products of science. The layman says "science and technology" as if they were identical twins. They have in fact distinct origins and histories, and they are still different in nature and purpose, but their union—in part a very recent development, in part a false association of ideas—has engendered the common faith in science.

Even when this link is seen, the transformation of the common mind and the common habits in less than three hundred years is a puzzle for the historian. The story is still so imperfectly known, and so absurdly represented as the clear

triumph of truth over error, that one must try to re-create actual notions and sentiments with the aid of contrasts and parallels.

A man of Galileo's time, even if educated, saw no connection between the peasant's wheelbarrow and the physicist's speculations on his *Two New Sciences.* But a man of today thinks he sees the truth of science demonstrated in every gadget he uses. He thinks he grasps the goal and justification of science when he sees the increased production of food, shelter, and clothing which has come from the harnessing of modern power to modern tools.

The reasoning is obvious: the appliance works, its principle is understood, and it is made in thousands of copies with decreasing human effort. From the Power and the Device springs the great argument that has redirected the Western mind. We are scientists by proxy on the strength of the work done by Newcomen and Stephenson and Watt. But science was not the initiator, it was the beneficiary, of mechanical invention.

To be sure, as far back as the thirteenth century some purely scientific ideas challenged the theologians' monopoly of explanation. But ideas alone do not change an entire culture, they require the aid of strong and simple motives. The handful of disinterested men who follow truth wherever it leads cannot act directly on the masses, and masses are moved by what is at once tangible and hopeful. We consequently ask what bound medieval man to theology as we are bound to science. Clearly, it was the desire for a permanent happiness, for a reward offsetting the pains and privations of this world. Under theology the Power and the Device to supply this want were, as with us, lodged in a class of men—the clergy—whose language differed from the vernacular and whose modes of thought were remote from the ways of common sense. But since the general longing was for a better life, the clergy's strongest competitors were not the men of science telling a different story of the

heavens; the true rivals were the inventors who said nothing but increased man's power to wrest a living from nature.

If we like to fix history in our minds with symbolic events and dates, we may choose the original appearance of Dr. Faustus and the date 1587 as a hypothetical turning point in Western culture. For in that year was published the first account of Faust's compact with the devil, an established Power and Device which an enterprising magician like Faust would naturally come to terms with. The bargain that he made then should not be confused with later versions of the tale. The favors Faust was asking for in the sixteenth century were not knowledge and a beautiful woman to love. They were: abundance of food and clothing. Faust also asked for pocket money and, by way of entertainment, he expressed a wish "to fly among the stars."

In the next two hundred years the abundance of food and clothing was sought and found by technologists, and we are getting closer to fulfilling the last request. The means to all this came from artisans and other clever men who built devices and developed power without the aid of scientific method or principle. The steam engine, the spindle frame and power loom, the locomotive, the cotton gin, the metal industries, the camera and plate, anesthesia, the telegraph and telephone, the phonograph and the electric light—these and other familiar wonders were the handiwork of men whose grasp of scientific ideas was slight, or at best empirical.

By a coincidence not wholly clear, while these inventions were being made or perfected, a succession of great mathematicians and scientists were erecting a new system of ideas and symbols, and propounding it as the scientific order which is now above cavil in the intellectual sphere. But whereas the achievements of the inventors soon became vivid realities on the public scene, the discoveries of the scientists remained by comparison hidden and hard to grasp. The original difference between technology and science thus persisted for generations.

It began to fade when men of science became interested in measuring and explaining ordinary machines and in suggesting applications of their own newly discovered principles. Thereafter the identity of the two movements was assumed, though not without inconsistency. It is only in our time that the big industries have established research divisions, where science is practiced for the benefit of technology; only recently and timidly that governments have come to recognize the practical value of fundamental research.

At this point our original question about the reign of science takes on a new form: how did mass society approach science close enough to acquire unquestioning respect for this mode of thought, which is not only difficult but also in constant flux? How did the skeptical, argumentative, irreverent fellow freed by the revolutions of 1789 and after convert his strong attachment to machinery into a blind faith in signs and conceptions he cannot grasp? At some point there must have been for the common man something like a discovery of the existence of science.

That event, if one can call it so, was late in coming. The steady progress of the scientific elite goes back three hundred years, but it was after 1859 that the achievements of the Age of Reason in astronomy, physics, chemistry, and biology were given sudden and violent publicity by the controversy over Darwin's *Origin of Species*. Evolution was not new and Darwin did not discover it, but the polemic about his book had the effect of bringing everybody up to date about all of science. For whatever else it proved, the debate made plain two things: One was that the men of science formed a powerful party whom Western civilization would now have to reckon with. The other was that pure science was engaged in sketching, bit by bit, the plan of a machine—a gigantic machine identical with the universe. According to the vision thus unfolded, every existing thing was matter, and every piece of matter was a working part of the cosmic technology. The rules of its functioning were being rapidly discovered and would

soon be within the grasp of all who cared to give the requisite attention.

Modern science can date its cultural supremacy from the conclusion of that period of intense argument and popularization. Like a radical party, the articulate scientists appealed to the uncommitted mob of the young and the spiritually discontented, over the heads of the Establishment. For forty years adulation of science in the abstract and controversy about what it concretely implied raged throughout Europe and America. New inventions, new sciences and pseudo-sciences proliferated. Domestic and foreign policy, social and economic issues, were fought on would-be scientific grounds. Old religions recast their dogmas to "meet" those of science, and Christ himself was called a scientist. Finally it was clear that the birth pangs of the scientific culture were over. By 1900 science had conquered its share of the curriculum, won a regular place in the press and the pulpit, invaded literature and the common tongue, and begun to alarm peoples and governments with the incalculable powers it might unleash.

For the educated, the authority of science rested on the strictness of its method; for the mass, it rested on its powers of explanation. It explained by the analogy of the machine—the simplicity of the great push-pull principle, which was everywhere applicable, permitting everyone to verify laws and formulas for himself, by sight and common sense. The great propagandists, the Huxleys and Tyndalls and Spencers and John Fiskes, often said that science was but organized and extended common sense; and they may well have believed what they said in the heat of missionary zeal. For until the rise of quantum mechanics and relativity physics, science still dealt chiefly with the large and visible portions of the universe. Leading scientists were willing to affirm that for any formulation of science a mechanical model could be built. It was the high moment of popular science in the best sense, when the scientist, as yet only in part a specialist, could lead his lay pupils from the entrancing phenomena on earth to the

spectacular workings of the heavens, through an ascending series of machine-like structures conforming to a handful of superbly simple general laws.

It was a high moment in civilization also, for science made the power of mind tangible as nothing else in history had done. For the first time even boorish ignorance was cowed into respect as it dimly grasped that here was no fraud or magic, no subtlety of art rebuking grosser sense, no luxury product for the rich and wellborn, but on the contrary an exercise of mind democratically open to all. The common virtues of patience, neatness, accuracy, and modest ambition were all that anyone needed in order to participate and even to contribute.

If science had stood still on the apparently firm base of Newton's four laws, had only refined its measurements of conservation and atomic weights, had succeeded in subsuming electricity under mechanics and proving the existence of the ether, always increasing its power to predict until it filled out the grand system foreseen by the Galileos, Descartes, Newtons, Goethes, and Darwins, the peoples of Europe and America might shortly have mastered, if not the scientific habit of mind, at least the scientific vision; and the historian of ideas might have spoken with literal truth of a "scientific revolution."

But just when it had captured power and authority, nineteenth-century science had to face insurrection within, a radicalism sprung from the anti-mechanical facts of electricity. As these difficulties were tackled one by one and revealed the strange workings of both the subatomic and stellar worlds, the great vision broke up, the fragments became less and less graspable, specialties multiplied, the proofs by observation and common sense gave way to mathematical demonstration—in short, science lost communicability through words, and with it lost the eager and informed interest of the educated, though keeping their respect. For a time the same turn of the wheel brought hope to the moralists and religious philosophers who had been repelled by the spectacle of a universe as

mindless as a machine. Twentieth-century science, they were assured by some scientists, leaves room for the creative act and for religious and moral freedom.

But this relief was local and temporary. The unsophisticated public of the nineteenth century had been converted with a finality that later ideas could not upset. To the extent that one can speak today of a common view of science, it is that of nineteenth-century mechanism tricked out with newer words. It is the boy's view, matching his taste for popular mechanics; it dominates ordinary speech, and it serves most attempts to reach the layman. No newspaper reader finds it strange when man is called a chemical machine, and many scientists themselves readily equate the operations of their own minds with the work of a digital computer.

There has thus been no scientific revolution at large; that is, no completed revolution of the intellect caused by science. There has been rather a social revolution, which has enthroned science in the name of increased production, increased communication, increased population, and increased specialization. The burst of zeal for a comprehensive knowledge of the cosmos through science, which shook Western society for a brief time in the second half of the nineteenth century, was a putsch that failed.

1964

Myths for Materialists

The Anglo-Americans of the twentieth century complained that they had no myths. Their poets, critics, and scholars kept bewailing this supposed lack and some even tried to supply it by artificial drafts upon the Irish, Greek, or Oriental mythologies. Modern investigation, however, points to the familiar truth that the people of that restless culture

were calling for something they already had. Myth so pervaded their lives that they could not see it for what it was.

The proof of this statement rests chiefly on the finds recently made in a great hollow formed below the Manhattan schist, probably during the Big (or subatomic) Depression of 1999. Under the usual pile of rubbish in this vast and naturally airtight enclosure, excavation has revealed a group of small buildings, with some adjoining structures shortly to be described; and within the best preserved of these buildings, a large room virtually undamaged. This room may have been the library of a club, or alternatively—the indications are ambiguous—a dentist's waiting room. In either event, the discovery remains the most significant since that of the lost continent itself. For although the books add little to our knowledge, the large mass of magazines dating from the middle years of the century constitute an illuminating and priceless collection.

In putting this high value upon it, I have in mind not the reading matter, which presumably satisfied the contemporary readers, but the much greater bulk of pictorial representations, often accompanied by brief text, which resemble earlier fragments identified by the symbol ADVT. Scholars have disputed at length over the meaning of this device. I can now, I believe, settle the principal doubts and confidently advance a theory. Those pictures, that text, enshrine the mythology of the twentieth century. After comparing some seven thousand pieces, I am in a position to sketch in broad strokes the religious thoughts and the moral feelings evoked by that body of myths.

I draw my assurance from the curious structures adjoining the buildings recently found. Collapsed though these structures now are, it is clear that they were once meant to stand upright as panels of great size, occupying open spaces set apart to afford the widest visibility. This suggests a religious consecration of both site and structure. On the face of these panels (often marked Outdoor Advt.) were the same colored images

as in the periodicals, but of heroic proportions and usually accompanied by some pithy aphorism. The number of such dedicated placards in a relatively small area like the one examined justifies my belief that we have in these words and pictures literally the revealed religion of the twentieth century.

It is normal in any culture for the commonest beliefs to be tacit and for the meaning of symbols to be so obvious as never to give rise to any glossary. From the outset, then, we face the double enigma of those four letters ADVT. What was their ordinary meaning and what their ultimate significance? The three main hypotheses regarding the first question are that the mark stands for (1) Advertising, (2) Advantage, and (3) Adventitious. Not the least startling conclusion I have come to is that the symbol denotes all three ideas. There is no discrepancy among them, even though historically the first meaning was the most usual. In twentieth-century usage, "advertise" was a verb derived from the character of the Bitch-Goddess of Appearance, whose sacred name is now lost. The four letters stood for something like "Behold Me"—whence the plausible but false etymology of "advert eyes."

Without at first suspecting it, we touch here the central dogma in the Anglo-Americans' religious system. What they called their "modern" civilization was built on the preponderance of one physical sense over all the others, the sense of sight. Their science was not, as with us, the whole of knowledge, but only such knowledge as could be brought within range of the eye, directly or through instruments. They believed only in what they could measure, that is, what they could lay along a ruler, or between two hairlines, or could otherwise visually place. No competent student of their age can deny that they displayed extraordinary ingenuity in achieving this universal reduction of Being to the grasp of a single faculty.

But this monomania entailed an ascetic drying up of the inner life in every member of the culture. It was a prodigal expense of spirit for which ordinary life had to supply emo-

tional compensation. Hence the need for, and the slow creation of, the vast mythology known as Advertising. An "ad"—as it came to be called in demotic speech—was, simply, the power of things made into pictures. Through the eye was given what actual life denied: beauty, strength, leisure, love, and personal distinction.

"Objects," as one contemporary philosopher confessed, "change their usual faces with the myth-maker's emotions." How much did he know of the origin and results of this transformation in the familiar things about him? We cannot tell, but in his day mind control through icons was well-nigh omnipotent. For example, by collating scattered references in the ancient literature with the newly found "ads," it is clear that just at the moment when the myth-makers began to invoke the supernatural power of citrus to sustain and embellish existence, technological improvements were depriving the fruit of its natural color, taste, and chance of ripening. At the very time when the sense of life as a whole was being atomized into a series of "processes," the mythology was verbally making up for the deficiency by a poetical iteration having life as its theme. "Vital" became a magic word, as for example in an *ad* referring to the various kinds of popcorn eaten at breakfast: "Be sure you get the *vital* outer covering of wheat."

About the same period also, the mysterious substances called Vitamins—precious if measured by cost, and complex if judged by their name—became the object of an official cult created jointly by the mythologers and the medicine men. To carry out the myth, Vitamins were chosen by symbolic letters and were weighed in thousands of "life-giving units." A last example will show how unremitting was this grasping after a runaway sense of well-being. Ten, twenty, thirty times a day, the Anglo-Americans were reminded of their need for vigor, for youth, for a "lift" by drug or weed—the worship of Pep. Initiated by one of the national heroes, Ponce de León, this quest was originally for a fountain in the South (*soda-fountain*). Many claimed to have found it and "advertised" to that

effect. Bottled drinks and packaged foods bore the magic syllable. "To be full of Pep" was equivalent to our "enthusiastic" or possessed by the god—the rare state then known in full as *pepsicola*.

We now turn from the concept to the embodiment, the pictures. What strikes the observer at once is the overwhelming emphasis on womanhood presumably as the inexhaustible fount of human life—and on the situation of sexual approach as the characteristic moment in that life. If one did not know the ways of myth-makers, their habit of juxtaposing incompatibles for the sake of a higher truth, one would suppose that the Anglo-Americans were unable to do anything without a member of the opposite sex in a state of provocative or compliant amorousness. In their iconography, seductiveness and sheeps' eyes invariably accompany eating, working, and driving, securing food, clothing, and shelter, listening to music or averting constipation.

The motive is clear enough: the artificial search for life through objects can only be kept at high pitch by associating the objects themselves with the strongest of desires. Advertising maxims were explicit: "Look sweeter in a sweater," "Use the soap with sex appeal," etc.

This mythopoeic principle did not, however, rely solely on the mating instinct. It employed two others, closely related—vanity and devotion to the Mother. This last, which goes back very far in the Western tradition, was in its latest form singularly debased. Though it is clear that the best literary and pictorial talent of America went into this highly revered and highly paid art of mythography, all the efforts of these creative artists did not succeed in making the Mothers interesting. The type remained domestic and sentimental. One has only to think of the earlier school of Madonna makers, or of the medieval poet von Goethe-Faust, to see the difference.

The decline may well have been due to some obscure physical cause: the American myth-mother is always depicted

as frail, gray-haired, with glasses and a senile rictus. Yet by a strange contradiction, the American maiden or young matron is almost always represented as nature makes her during the months of lactation. This is an improbability—or a religious mystery—that I do not pretend to have fathomed.

Contrary to the feeling of all mankind about ancestors, the second appeal, directed at personal vanity, occupies a much larger place than mother worship. Yet the anomaly disappears when we understand the democratic paradox of competition within equality: everyone has a mother; not everyone has a Packard (a highly upholstered locomotive). Moreover, mass production tended to make any class of objects (as of persons) virtually identical; some kind of mythical individuality had to be imparted to them in hopes of its transfer to the mass man. More and more, the social self came to depend on the constant tonic of acquiring these specially wrapped goods.

I cannot agree with a famous critic of that epoch, Veblen, who spoke of "conspicuous consumption" and attendant waste as the mainspring of "modern" behavior. He described, it seems to me, an earlier age, that of kings and nobles, who translated power into munificence. The common man, on the contrary, receives his satisfaction from objects, directly; and for the reason I gave earlier: that the goddess ADVT consecrates matter by guaranteeing (1) secret worth and (2) miraculous origin. This is in keeping with all we know about myth. The medicine man infuses the magic into the familiar thing; whence the American advertising formulas, "A Wonderful Buy" and "It's Different," i.e., supernatural. A fuller text of the best period informs us, over a beguiling triptych, "Not just a fur coat, but an important aid to gracious living. It will give your morale a lift, *as well as impress your friends.*" (Italics added.) No distinction between direct and indirect help to self-esteem could be clearer, and as it happens, the distinction was noted even at the time by the author of the satiric poem, "Civilizoo." As he tersely put it: "Women think fur beauty,/

Scholars, books knowledge." Here was expressed the simple faith in the fetish.

It would be tedious to enumerate the myriad forms of the faith: they equal the number of consumable articles. Some, however, lent themselves to the arousing of fear preparatory to flattery. To be soothed by possession of the fetish, the citizen must be first alarmed by a dramatization of evil—halitosis, falling hair, teeth, garters, B.O. (undecipherable), as well as by the ever-present threat of Wrong Choice.

In this connection I may instance the farthest reach of magic power found in our documents. As with us, the Anglo-American word for "spirits" had a double meaning, for alcohol makes man cheerful and enterprising. But the ancients' impressionable souls seem to have drawn virtue not alone from the contents of the bottle; they were affected by the label upon it, which conferred tone or talents on the buyer. Thus a celebrated whisky was normally advertised as being "For Men of Decision." One would have thought that the thing needed was a whisky for men of *Indecision*, but doubtless the poet was using the rhetorical figure known as hypallage—taking the result for the action. In a like manner, medicines, food, and personal attire were, wherever possible, held up as proved fetishes.

That "shopping" was an essential part of mental health is naturally assumed by the *advertisers*. But the practical proof of the assumption was never more striking than in the serious incidents of the so-called Reconversion Period of the mid-1940s. Drained of goods by war, the people nearly perished. They starved, not in their bodies but in their imaginations: six years virtually without the consolation of ads were to them as the suspension of the sacraments would be to us. The shops, though bare, were haunted by women as by insects seeking prey, while the entire population grew distempered. Women fought over nylon hose (i.e., leg coverings) and men committed suicide for lack of telegrams. Diaries tell us that those who

by luck secured even a single object—an icebox or a shirt—showed the restorative effect immediately. It was at the worst of these bad times that a laconic sage summed up the sense of deprivation in the famous phrase, "Money, no Object."

Such is, in rough outline, the mythology of the Anglo-Americans as far as archeological research can reconstruct it. I reserve the right to give a fuller account at some later time and to make it more vivid, though I trust not more persuasive, by the addition of plates in color. For the role of ADVT was to suffuse visible matter with invisible virtues, adding to bread the nutrition it had lost and to stone or steel the warmth it had never had. *1946*

III

On What Critics Argue About

Criticism: An Art or a Craft?

Many excellent critics have said that they were artists in the same sense and on the same footing as those whose work they criticize. But this claim has been made only within the last hundred years. It is worth noting that the identification of the two roles has come toward the end of an age that was the first to make Art and Artist terms of highest praise, objects of worship.

The locus classicus of this new contention is Oscar Wilde's essay of 1891, *The Critic as Artist*. About the same time, across the English Channel, Charles Maurras and Remy de Gourmont were making the same assertion, and across the ocean James Huneker reported the gratifying sentiment. At least two of the four had the double qualification for passing so novel a judgment. Wilde was accomplished in many genres and he gave English literature two masterpieces, one a poem, the other a play. Remy de Gourmont was a poet and novelist of high if not supreme merit. Presumably, they were able to judge the motions of mind and spirit that lead to criticism and to creation and spent a little thought before declaring them interchangeable.

Their main argument was this: Art—modern art especially—is so complex and subtle that it inevitably seems obscure even to the educated reader. Before the public can understand, let alone enjoy, such delicate, sophisticated art, a technician with a practiced sensibility—that is to say, another artist—must explain the work, demonstrate its meaning and

value by taking it apart. Only after a guided tour of its intricacies can its form and intention become clear.

What is the force of this argument? Let us grant that the modern arts are often obscure and that a trained observer can help unwind the tangle of impressions produced. The ability to analyze, which means to break down, in no way implies the ability to put together. Analyst and maker or creator are not synonymous terms. Take an analogy: under the hood of a modern motorcar sits a machine increasingly complex as new and subtle functions are added year by year. When it goes wrong, it takes an unusual mechanic to set it right. Even at official repair shops the trouble may baffle the ordinary crew. But often there is one man there who never fails—the boss calls him a genius. He has intuition, imagination, and a sure eye; only one visit is needed for diagnosis and cure. But has one ever heard of such a man inventing a new suspension or valve, or reorganizing the whole system? The very affinity with actual arrangements seems to preclude innovation.

This analogy is not an argument; it is only an illustration of the statement that insight is not foresight, analytic power not creative. If the critic were an artist, one of these gifts must imply the other. But most great artists are poor critics; they see only into their own work, or the next thing to it. True, nothing prevents a man or woman from having both gifts. Oscar Wilde had them, as I said, and other notable instances will readily occur: Dryden, Diderot, Goethe, Delacroix, Berlioz, Poe, Yeats, Shaw—the list is impressive, but it appears very small when matched against the list of other great artists, on the one hand, and on the other, the host of good, useful, responsible technicians whom we call critics.

What, then, is a critic? Long before being dubbed an artist in the 1890s, he was but a specialized man of letters. He became prominent in the world side by side with the artist, who also used to be considered a mere craftsman. The history of their rise to high standing in modern society is instructive about the point at issue. In antiquity, the critic's sole duty was

to make clear the literary text of a poet or prose writer. In ancient Alexandria the scholars of the Mouseion or Library worked over the Greek classics, and tradition has singled out a matched pair: Aristarchus the amiable and Zoilus the cross-patch, who always found fault. That is ancient criticism from A to Z.

You may ask, what about Plato and Aristotle, and later Horace, Cicero, and Quintilian? They were critics indeed, in the sense that they published theories for particular genres and compared individual artists and their works. Aristotle as a scientist was interested in the form and purpose of tragedy and Plato in the nature and role of poets. The Romans wanted to ascertain the basic rules of oratory; Horace went further and set down those of effective poetry. But in none of these few exceptional statements is a work of art subjected to criticism in our sense, nor was criticism a regular, professional activity.

For centuries after the Romans, we find only artisans and craftsmen, who did not find it necessary to write out their recipes or their opinion of one another's productions. In their locality, what they made or wrote, what they sang or built doubtless occasioned comment based on likes and dislikes, but again it was not systematic or recorded.

Only at the Renaissance did criticism as a large, conscious undertaking begin to take shape. It started as in antiquity from the need to establish texts. The recovery, and later the publication, of the ancient classics called forth editors who worked on manuscript sources to produce versions free from the errors and alterations of copyists. These works when purified created so much enthusiasm among the educated that they inspired theorists to explain their perfection. Aristotle and Horace were relied on for first principles in the judgment of poetry and drama, but their rather spare utterances were soon elaborated with the aid of current religious, philosophical, and linguistic ideas. When the theory of genres was developed far enough to show the perfection or imperfection of a particular work, judicial criticism came into being, the criti-

cism that measures performance by accepted rules to reach a verdict of good or bad. Thus a new, composite type of criticism was added to the first, purely editorial criticism of texts.

From, say, the sixteenth century to the beginning of the nineteenth, criticism remained within these limits, the great critics arguing about the validity of the rules in force, their proper application, and the merits of current poems and plays. The label of Neo-Classicism appropriately designates this long tradition, when a critic was expected to judge, and to judge according to system. Even the famous quarrel that broke out between the Ancients and the Moderns in the seventeenth century was only on the question whether the modern writers were as good as the ancients, not whether they had different aims and different canons of excellence. All this implied that there was only one kind of critic beyond the editor of texts.

With the nineteenth century and the breakdown of Neo-Classicism, the seven devils of confusion cut loose and suddenly we confront the modern situation. Blame Shakespeare! What I mean is this: By 1750, when Shakespeare began to be rehabilitated as an artist and used as a champion against Voltaire the playwright, the very idea of a work of art began to change, and with it the role of the critic.

What the promoters of Shakespeare—the New Critics of that time: Lessing, Morgann, Edmund Burke—dared to say is that art does not consist in imitating a model, an ideal of perfect beauty; it consists in expressing deep emotions and sublime thoughts. Genius, as in Shakespeare, is often wild; that is why he had been condemned. But now he must be listened to and learned from. In a word, individuality, and with it irregularity, was merit. Form in art is free and may be new in each work. The public is shocked, but the good critic is there to guide and comfort the bewildered.

The growth of this new criticism took about half a century. By the time of Coleridge and Carlyle, who established the dogma that Shakespeare was the greatest poet of all time, the supreme genius, it was also established that any great

artist had to wait for recognition until criticism had explained him and validated his work. The artist was for the first time called a creator, which implies the original, the unheard-of and baffling—until it is got used to. All these words: genius, creator, originality were of recent usage by 1800. In terms rather more familiar to us, "autonomous" art and the "cult of the new" had triumphed over the assumptions of judicial criticism and the elaborations of Horace and Aristotle.

Now this new, early-nineteenth-century critic, though he had to perform a new task, imaginative and without rules, did not as yet think of himself as a creator on a par with Shakespeare and Wordsworth. The greatest of them in England, William Hazlitt, always made it clear that his task was subordinate to that of the creator and distinct from it. The very difference in medium made this plain—lucid prose and simple statement as against often intricate verse and astonishing ideas. Besides, the mood of the time was worshipful. High art was fast becoming the substitute religion that it now is, and all the great English critics of the Romantic period—Coleridge, Hazlitt, Lamb, De Quincey, Walter Scott—would have thought it disgraceful to equate their critical writings with art.

This last step, as I said, came at the end of the century, when art itself had made another turn of the screw in the direction of intricacy and obscurity. To solve its mysteries seemed a superhuman feat; and by then specialism had set in. Critics came in different guises. There was the theorist-critic, who dealt with forms and genre; the historical critic, who traced influence and the connections of art with social life; the psychological critic, who speculated about instinct and emotion; the impressionist critic, who recorded for the reader (as Anatole France put it) "the adventures of his soul among masterpieces"; and there was of course the ubiquitous reviewer, who might be any one of these types or a little bit of each in a casual mixture of his own.

All of them might also act as judicial critics, in the sense

that they discussed merits and faults and expressed preferences among old and new. But these judgments were not according to a common standard, for no standard was agreed upon. Both the production of art and its reception existed in the state of anarchy we are familiar with and call pluralism. Artists clustered in schools, at least long enough to issue a manifesto denouncing their predecessors, and then disavowed the label that critics, usually hostile, pinned on their works. The shift in the support of art from individual patrons to the state and the public at large meant that a school was well advised to have a critic as a bodyguard; or even better, a regular reviewer in a newspaper or leading periodical. Where large material interests were at stake, as in the theater and the publishing of novels, the possession of a staunch, well-paid critic was as indispensable as the finding of a shrewd and fearless advocate was to each successive avant-garde.

It was in this environment that the critic-as-artist was born. Pure and incorruptible, he naturally associated himself with the avant-garde, maintaining that all the other artists and critics were old fogeys or journalistic hacks. They knew nothing about art and misled the public by their daily reports. Despised even more were the stooges of officialdom, often dull academic minds, who substituted scholarship for aesthetic perception, of which they were incapable. Such was the doctrine of the critic-as-artist.

With these convictions this superior critic tended to be an impressionist. His soul was sensitive, his taste delicate, but also farseeing and deep-seeing; he wrote like a poet if not like an angel. He was saturated in art, all the arts. In reviewing a play or a poem, he invoked Leonardo and Wagner as needed, for by then the several arts had developed their critical literatures and the aesthete critic kept up with their catchwords. In short, he lived art like Tosca: *Vissi d'arte*. Indeed, he often lived with artists, whose habits and prejudices against the world he shared without affectation.

That world, dominated by industry and democracy,

looked like the natural enemy not only of art and artists, but of whoever had cultivation and disliked business—that is to say, the whole intellectual class. Its members identified themselves with artists, so that when the critic declared himself an artist it was as much from instinct as from reasoning; it did not express his egotism but his class consciousness.

And it must be admitted that writers such as Walter Pater, Oscar Wilde, Remy de Gourmont, Anatole France made the identification plausible by their literary performance in more than one genre. The other types of critic, historical, psychological, or judicial, could not have got away with it. For one thing, all these were moralists, whereas a main tenet of the aesthete-critic was that art and morality have nothing to do with each other. Morality is of the world; Art is of an ideal realm beyond. As legionnaires of art these critics were dedicated to it alone and forever—exactly like artists. Their critical writings, therefore, must be art too.

It was not an unworthy claim—in their time. But its prolongation in ours has become an absurdity. Criticism, however lofty, profound, subtle, and divinatory, remains exposition and analysis; it is referential and argumentative; it is not original, creative, independent of a text or a theory. Of course, one can stretch the meaning of the word "art" to include all fine work whatever. We would then have cookery and diplomacy, horsemanship and knitting as realms populated by artists. But that is not what the usurping critics had in mind. Again, it can be granted that the great critics were artists in prose. Dryden, Hazlitt, Wilde, Shaw were superb essayists, masters of a literary genre. But they were artist-creators only when they were writing plays, poems, or novels. These three things used to be called properly *fiction*—things made up; criticism is derived. It cannot be made up without ceasing to be criticism.

Does the distinction matter? If so, why? First, because it is always important to think straight, which means keeping words as strict as possible. Second, because criticism has no justification, no claim on public attention except as the hand-

maiden of art. We need it; at times we need it badly; but its loss would not mean the end of art. Civilizations have lived for centuries without it. Since its rise it has been uncertain in form and quality, and tolerated solely for its usefulness, for its services ranging from workaday reporting to luminous essay-writing. Great critics have been rare, perhaps because transcendent gifts of perception and composition have gone mostly into the making of art itself, into genuine fictions.

The history of criticism since 1900 seems to me a further proof of what I say. When aestheticism declined, it left the academic, historical critic in possession of the field for over a decade. In the 1920s he was attacked and routed by the New Critics, who introduced Method into the game. The method was compounded of "close reading"—the French schoolboy's *explication de texte*—and the demand for logical structure. The Metaphysical poets were in vogue and all images, symbols, and themes must "work out."

It was a return to the Neo-Classical system. Method once tasted, there followed an orgy of procedural rigor based on ideologies. The world witnessed Marxist criticism, Thomist criticism, Freudian, Jungian, structuralist, post-structuralist, phenomenologist, semantic, stylistic, and latterly Deconstructionist, each with a patron saint and a formula.

In these pseudo-scientific operations the critic has surely compromised his claim to the title of artist. To sustain his new, solemn attitudes, he has chosen to write unintelligibly, abominably. He no longer elucidates, since that word means "to shed light." He does not need to, for he has got rid of the work of art, saying: in literature there is properly no text, only some variable, fugitive hints to unpredictable, capricious readers. Every man is his own artist.

The individualism and pluralism that I blamed symbolically on Shakespeare has run its full course and ended in the suicide of criticism and attempted murder of art. A representative critic of today has written: "I consider that there is no difference in kind or in degree between the language of criti-

cism and the language of poetry." If this remark does not merely say that all words come out of one dictionary, it must mean that criticism has grown deaf to the characteristic voice of poetry. If the critic finds in his own work the compression and suggestiveness of the poet, then he is blind to both sense and style. Of what use a deaf and blind critic may be, no theory ancient or modern has yet indicated. *1990*

The Scholar-Critic

People outside the academic profession as they know it today are always surprised to hear the distinction made between the scholar and the critic. Not only do they associate the names of leading critics with colleges and universities, but they take it for granted that scholarly method is nothing if not critical, and that all critics must deal with fact in a scholarly manner or lose their character for reliability.

Yet it was not much more than thirty years ago that inside the university the name of critic was a bar to advancement. None but scholars were wanted, and the scholar was defined negatively as one who, if he wrote or should write, would not be accepted by any of the journals known as critical.

This definition contradicted an older one, according to which the scholar acknowledged no limits to his interests, but wrote and lectured on whatever subjects attracted his fancy, from history to morals and from language to mathematics. It has been said of such universal professors that they occupied not chairs but settees. The historical fact is that down to the middle of the nineteenth century the intellectual life tended toward unity; it was a specialty in itself and as a whole. Classical scholars wrote poetry, poets carried on scientific experiments, statesmen translated Homer, lawyers wrote metaphysical

inquiries, and men of science were deep in theological controversy.

With the shift in the meaning of the word "science" due to the successfully enlarged study of nature, the unity of knowledge was broken up into ever more categories, and specialization became truly a categorical imperative. As a result, and by imitation, the treatment of literature and the arts underwent a series of transformations. First, the study of the ancient classics ceased to be encyclopedic and became exclusively philological. Next, the modern literatures and the fine arts changed status: from being sources of diversion they became objects of study. English literature, for example, entered the British and American curriculum in the 1880s, but only after much resistance from those who thought it no subject at all. Finally, thanks to the spread of literacy through public schooling, and the cheapening of books through technological progress, the general public grew accustomed to the attitude and methods of scholarship, at least in their surface manifestations. Just as the scholar was used to seeing an error creep into a text, so the layman saw the footnote creep into journalism. The habit of citing sources, of "giving the background," of reporting accurately ("and I quote . . .") grew commonplace, until today scholarship, would-be scholarship, and pseudo-scholarship coexist indiscriminately in the worlds of education, literature, art, government, industry, journalism, and advertising.

The currents that propelled this cultural change were obviously strong enough to sweep the critic back into the university, and with him came the poet, painter, and musician. They landed on the campus in two capacities—as refugees from economic competition: the free lance could no longer earn a living; and as welcome missionaries: the academic mind had lost some of its "scientific" austerity and become touched with aesthetics.

Before we can appreciate why this came about we must

recall the way in which the humanities had managed in the late nineteenth century to turn themselves "scientific." They did this by adopting the historical attitude and applying the literal part of the historical method—the part that stops short of intuition and imagination. Success was immediate, and as soon as the system was applied, the same desiccation that had overcome the classics began to overtake the study of modern literature and the fine arts. Academic promotion and prestige were to be had for the writing of little papers in which a point was made about a text, or an unnoted similarity teased out into an "influence." It was "shown" that Shelley and Keats had both used the image of boat, rock, and wave in poems a few years apart. In other words, the scholar could be distinguished from the critic by his unwillingness, and soon by his inability, to interest anybody but his alter ego at another university. Whatever was not factual and "shown," whatever was imaginative and readable, was unscholarly. The critic, on the contrary, was a man with ideas, an excrescence comparable to the prehensile tail which man as fully evolved scholar had lost.

The intellectual asceticism of the scholar was, of course, not wholly stupid and futile. It led to genuine discoveries which enlarged knowledge, and it resisted in the name of evidence, soberness, and truth the frequent intellectual libertinism of the critic. For during the same decades, the Impressionist and Symbolist movements had triumphed in literature and inspired a criticism in their own image: the impressionist critic recorded his sensations under the spell of a masterpiece and re-created its mood or meaning. But there was no way to make him accountable; he might invent experiences in order to entertain and he often drew attention away from the work to fix it on his fascinating self. After the First World War, a reaction set in against both the literal scholar and the introspective critic. It condemned both history and impressionism as irrelevant and useless, and asserted that the work itself was the thing—not its genesis and not its effect. Within the tan-

gible confines of the poem or painting there was need for the application of intelligence and imagination equaling, perhaps, that required for the original creation.

The New Critics advocated the old method borrowed by the French lycée from the medieval scholastics—*explication de texte,* or the unfolding of true or hidden sense from words, sometimes renamed "close reading." In literature this criticism tended to be verbal and philosophical; in the fine arts, it supplemented the discovery of similarities by the interpretation of symbols; in music, it tried to isolate the ingredients of a style by discerning hidden forms beneath the obvious devices. Stylistics and exegesis were in fact the common aims of the New Criticism in literature and the arts, even though it is usually assumed that the movement was exclusively literary.

In repudiating the historical method and what might be called the sociological interest, the New Criticism was also expressing a distaste for the world and paying homage to art as the true reality. "Explication" suggested that material forms are not to be taken at face value, that art is seldom what it seems. But owing to the continuance of specialization, few noticed that in taking this new path criticism was but following the general evolution of thought; it was still in the wake of the physical science and the "sociology" which it rejected. For the "hidden-meaning" postulate was a derivative of the new physics and the new psychology which could also be seen at work in anthropology, semantics, philosophy, mythology, and folklore. Indeed, many experts in these disciplines, themselves caught by the new hunger for fine art, fell upon its products like starved augurs, dismembering each specimen to show by their several "methods" what it *really* meant.

The attitude in these demonstrations was far more clinical than before, and the language as barbarous as ever it had been under the historical dispensation. The very word "method" showed that the intent was to reach verifiable truth by systematic procedures, though this base technology was concealed from practitioners and followers by the novelty of the discourse.

Because each writer spoke from a well-defined point of view and brought forward evidence from outside the common range of vision, he was deemed a critic and not merely a scholar. He passed judgment, wrote in literary quarterlies rather than scholarly periodicals, and showed (or claimed) sensitiveness to aesthetic experience. Not for him the mere cataloguing of boats, rocks, and waves: he developed their symbolism, their ambiguity, their architectonic relations to the whole and to the infinitude of parts discernible in the work once the right method was applied. No effort was spared or concealed, until it was hard to say which was the work of imagination—the poem or the gloss upon it.

The energy of the New Criticism and the far vistas it seemed to open recommended it to the young, and soon it rivaled within the academy the older historical scholarship. Departments of literature first took on one critic, with mixed doubt and pride; after which "our critic" was matched by others, their specialties of method being equally acceptable, provided that when laid end to end they covered the historical periods and traditional genres.

In the enthusiasm for the new its points of likeness to the old were scarcely seen. Because meaning was the goal, the same preoccupation with textual and verbal minutiae impugned in the former historical scholarship was now felt to be justified. It was not seen that a new literalism was developing as destructive of art as the old, and more congenial only because it was more anarchic. Everyone could preach and contemn, no one could argue or refute, for symbols were ambiguous and elusive and each vaunted method was at bottom arbitrary, indeed "impressionistic." Anyone brought up on *explication de texte* knows how much is "found" by visceral fiat.

Again, the interpretation which lighted up the refreshing new "facts" was secretly loaded with history; for it is evident that to explain anything by reference to the special or ancient meaning of words, by the play of allusion and symbol, by the echoes of tradition and myth, by the recorded ideas and expe-

rience of the artist, is to rely on historical sources, whether the search for them is original or secondhand. The dictionary is an historical compendium, as is also Freudian doctrine based on case histories, or Frazer's *Golden Bough,* compiled from the written survivals of prehistory.

The pretense, moreover, of remaining "inside the work" is an illusion, while the boasting about it is as doubtful a sign of artistic sensibility as it is a clear one of low reasoning power. Either a work stands by itself, intelligible and potent, and then it needs no explaining; or else it requires explicating, and then something has to be brought to it from outside, were it only the beholder's experience of life and residue of education.

Finally, practice has shown that it is not in the methods themselves but in the few who have invoked them with talent and tact that the merits of the New Criticism reside. Theme analysis and image hunting and myth decipherment, when carried on by persons of ordinary parts, have yielded the same results as the discredited historical method—dullness and triviality. The net gain, apart from the decrial of piddling irrelevance in historical "studies" and the astringent use of close reading after a surfeit of loose impressionism, has been the reinstatement of the critic as a member of the academic company. But this still leaves the burden on each lover of literature to find out for himself who are the critics that deserve the name otherwise than formally. *1958*

James Agate and His Nine Egos

Who is James Agate?" asked the eminent critic Sir Edmund Gosse some twenty years ago. Given the circumstances, the question was inexcusable—it was just one of Gosse's ways of being eminent—for at that time both men

were on the staff of the London *Sunday Times*, Gosse as chief book reviewer, Agate as chief drama critic.

But American readers today may be pardoned for asking the same question, since the fame of drama critics, especially the recently dead, does not carry across the ocean. Students of the theater everywhere are no doubt familiar with Agate's biography of Rachel the actress, and with the collections he made of his own and other critics' writings. He himself was well known to his American colleagues, but with the exception of a few articles here and there—in newspapers and anthologies—he may be said to have remained unpublished and unread.

In time his best writing is bound to emerge, for he was a superior craftsman and dealt with subjects of perennial interest, but there would be small reason to discuss him now if during the last fifteen years of his life he had not produced an extraordinary piece of work, unique in form, though not in kind, which is a storehouse of varied pleasures: his autobiographical diary, in nine volumes, called *Ego*.

Do not throw up your hands in feigned horror: nine volumes! Life is short, I know, and one's own life demonstrably shorter than Agate's seems to be. But in the lively chronicle you will not hear the drone of a single voice; you will not exclusively retrace the fortunes of one man nor live by proxy within a limited circle of contemporary Englishmen. Far from it. You will not even keep to one set of subjects, all intellectual, but will range freely through space and time and human activity. Food and the footlights and the screen take their turn with golf and motorcars and music. Literature and choice gossip alternate with bilingual puns and portraits of celebrities—live, dead, dying.

Dip in anywhere: "Sacheverell Sitwell has written a book about Mozart in which he said silly things about Wagner. Ernest Newman ripped the bowels out of Sacheverell, who wrote of Wagner's 'vulgar, tweed-clad tunes.' Osbert tried to defend his brother, and I had not the courage of my true conviction, which is that both brothers are artists who enjoy pre-

tending to be asses. Osbert talked all the time and I never got a word in edgeways. I don't dislike him, though I understand why some people may. There is something self-satisfied and having-to-do-with-the Bourbons about him which is annoying, though there is also something of the crowned-head consciousness which is disarming."

Or if you prefer dialogue: "Am afraid I was rude to H. G. Wells last night. It was at the Cafe Royal and Wells, sitting at a nearby table, shouted in his loudest whisper that he had just come from *The Devil's Disciple,* and how much better it was than any film. J. A.: 'I don't agree. *Northwest Passage* isn't a work of art. But it brings your heart into your mouth and keeps it there.' H. G.: 'Ah, well, I don't know what a work of art is.' J. A.: 'Oh, yes, you do. But never mind that. Why praise one kind of good thing at the expense of another kind of good thing?' H. G.: 'I stand corrected.' "

And again there is correspondence, almost never one-sided and often pleasantly extravagant, as the letters of warm friends should be: "Dear Cardus:—*Re* your *Ten Composers*. Have corrected your spelling. Also your Italian, German, French, and occasionally your English. Have put your French accents right. Have emended your quotations. . . . Titivated your titles. In places made the clumsy felicitous. Verified your keys. Rationalized your punctuation. . . . Have elected for 'Newman' *tout court,* as I can't make out whether it's the Cardinal or the critic of the *Sunday Times* who 'often quotes Coleridge with affection and point.' In short, I have put this entrancing book right in all matters of fact and left only its errors of taste and judgment."

No collection of samples will exhaust the variety of genres and moods which Agate makes use of. One can only say that nine volumes of this ideal bedside reading are none too many. Nor does the series as a whole leave an impression of feckless meandering. A design has been traced; inspired by the *Journals* of Arnold Bennett, those of Agate easily surpass them in richness and sense of form. Together they span fifty years of

English civilization, but *Ego* is the more animated portrait of an era; it is in fact a kind of vast *roman à clef* of which the key is not hidden.

In the midst of his populous circle sits James Agate, a watchful host, or rather an unceremonious master of ceremonies, who takes care not to bore his reader-guest by too long a course of any one subject. A seasoned journalist, who worked for at least three grades of subscribers, he is adept at making every topic he touches attract every type of duffer. To me, for example, cricket and golf spell only my invincible ignorance, yet I can read with at least a primitive pleasure what Agate says of his favorite sports. He also loved to breed and show hackney horses, and he makes us share his devotion to the stables as if we were all Houyhnhnms together.

When it comes to literature and the arts, Agate invariably displays the passion of the true critic with its attendant zest for intellectual debate: he always knows what the other side is saying. He knows, moreover, how to temper insistence by a masterly use of quotation. We hear him repeatedly on *Macbeth*, about which he is truly admirable, but Hazlitt follows as prop or amendment. Agate propounds the greatness of Bernhardt and Irving, but the opposition speaks through Shaw or Max Beerbohm. At other times he peppers his pot with the adverse judgments of others upon his own opinions and character, and then defends himself with toughness and vehemence. It is a fine spectacle in these tedious days of superficial fraternity. We cheer his hits as much as we envy his poise, and the result, contrary to the French maxim, is that the Ego is not hateful but lovable.

In time we come to know the diarist as nearly as possible *au naturel,* for his rule, Never to Embellish, he observed even to his detriment. Outwardly a self-made man like Shaw, he was as fully aware as Shaw of what had gone into the making. James Evershed Agate was born in Lancashire in 1877, an unwilling heir to the calico trade. His father was a mill owner and James, the eldest of six children, stuck to the business for

a good many years. But it was honestly that he came by his other aspirations: Manchester in the eighties was a center not solely of cotton spinning but also of art, especially music, and Agate's father took him to the Hallé Orchestra from the age of seven. Agate's mother, who had been reared in Heidelberg and Paris and had learned music on a piano once owned by Chopin, taught her son the instrument and made him a master of French.

This childhood acquirement explains Agate's feeling of freedom in quoting from Balzac and other French writers in the original: the diarist is not showing off. The reader who cannot follow him will skip—and may swear—but must not feel snubbed.

All the Agate children developed artistic interests, and we are lucky to have five of them on show in the pages of James's book. The one sister, May, became an actress and wrote from firsthand knowledge an excellent book on Sarah Bernhardt. The brothers Gustave, Edward, and Harry have each his special branch and tone of voice, Edward predominating as savant, satirist, and composer—a proudly impecunious foil to the worldly James.

Though he was over forty when his career took shape, James was the only one to achieve real power—by which I mean not merely the power of recognized authority, but that of habitual command over his medium. Both kinds he undoubtedly owes to a trait that some may be inclined to call vulgarity. If this is correct, it is a vulgarity devoutly to be wished. In an age when many intellectuals think they owe it to themselves to be delicate, tentative, and easily bruised, Agate is content to be downright, full of knowledge, and underidable. His apparent complacency is simple strength. He likes Shakespeare with the same fervor and the same acute organs with which he likes wine and horses; he is at home in life and lets you know that the best of life is meant for him. Nor does his love of literature serve him as protection against a low opinion of himself, for he did not have to climb into the

possession of cultivated tastes; he has no philistine memories to palliate with "sensitivity."

As late as 1920 he was keeping a shop in London, but his early acquaintance with genuine artists gave him the familiarity that breeds contempt of make-believe. Indeed, Agate carries this impatience to the point of being unjust to Bloomsbury and its intellectual mulch. He is temperamentally an anti-modernist. But for the same reason he is also free from the guilty modern wish to foist "high" tastes upon others. Although he was the first English critic to take the movies seriously (in an article of 1921 on Charlie Chaplin), he rejects the common excuse for distorting great novels and plays on the screen: "Is it to popularize Shakespeare? But with me he is already popular." Agate steadily fights the highbrow attempts to ram culture down the throats of people; he knows it can only bastardize culture and the people too. Yet in this he is just the reverse of snobbish: he respects the ordinary man's desire for better pubs and cheaper boxing and vaudeville, and he recognizes their priority over a National Shakespeare Theater. Not so the welfare state, which tends to be tyrannical; wherefore during the Second World War Agate had to campaign so that the troops on leave might be given gay musicals instead of *Oedipus Rex* played by the Old Vic.

But make no mistake: as the stir of this humane endeavor dies down you hear Agate inveighing against a great many things generally deemed democratic and popular, such as slovenly manners and the sham education that produces commonness. Of a young woman bred on modern literacy, movies, and crooners he says with certitude: "Explore her mind to its inmost crannies and you will find nothing there but curiosity about the latest hair dye."

Agate knows how much effort and steadiness are needed to develop even a marked bent toward intellectual occupations. Despite his early advantages he found he must subject himself to the stiffest discipline in order to make and keep his place as a critic. By dint of hard work after business hours he

forged a technique and style that he could rely on, besides learning the history of the theater, of actors and acting, and of British and French dramatic criticism. It is from experience that he draws his definition of a professional: "A man who can do his job when he doesn't feel like it."

Agate served seven years' apprenticeship on the *Manchester Guardian,* then after army duty in France until 1918 tackled London without influence and persuaded the *Saturday Review* to let him write its drama column. Two years later he had a call to the *Sunday Times,* and afterwards subdued *The Tattler* into accepting him as film critic and *The Daily Express* as book reviewer. For virtuosity's sake he took on the job of broadcasting theatrical comments for the BBC, and he wound up as literary consultant for the British M-G-M.

As if this were not enough, we soon see Agate becoming a popular lecturer, in especial demand as an after-dinner speaker. He next assumes the role of universal godfather to the ambitious young in acting, writing, and making music; and he finally blossoms out as autobiographer and diarist. The writing of a few novels and the preparation of some two dozen anthologies helped fill in the leisure not taken up by golf and horses. One wonders when he found time to attend the theater.

Like Balzac and Trollope, Agate was justly proud of his powers of work. He measures and reports his annual output like an industrial nation. But he does not write in order to break records and he does not scamp. To him writing must exhaust meaning while invigorating the reader, a task which is doubly difficult when one wants to introduce uncommon facts or ideas into the rigidly guarded mind of the newspaper addict.

This never came easy. Agate might exclaim, "What fun words are!" but every play notice cost him blood. He goes at it four or five times, leaves the copy with his editor; then in the middle of dinner thinks of a better beginning or ending, rushes back to retrieve the proof—only to find that the editor (who boasts of being able, if required, to cut the Lord's Prayer)

wants three hundred words taken out. *Ego* reproduces several dozen of these short articles. They are without exception terse, free from stumbles in sense, and original in a way that one comes to think of as Agatian. The writer's style is of that excellent kind which sounds like a man speaking. We are sure that its simplicity is genuine when we compare the play reviews and the letters. Here, for example, is Agate answering a friend who had asked about Olivier's *King Lear:* "I thought Olivier began extraordinarily well, with just the right amount of testiness. A magnificent head, and everything royal about him. The whole subsequent performance brilliantly imagined and achieved. Mind working all the time and making one see things one had not previously noticed. For example, in the 'loop'd and window'd raggedness' speech, at the line 'O I have ta'en too little care of this!' one sensed an unclouding of the mind and a return to the responsibilities of kingship. Yes, any amount of subtlety and intellectual appeal. But was I moved? Not so much as I ought to have been. Was it because of the echoes of the same actor's Justice Shallow? And shouldn't Olivier, knowing he was going to tackle the big thing, have let the lesser one alone?

"The actor chipped off every bit of the character—but took me out of my critical self not more than three times—in the 'Terrors of the earth' speech, in the second half of the mad scene, and from the entrance with the body of Cordelia to the end. . . . Do you want it in a nutshell? Wolfit's Lear is a ruined piece of nature; Olivier's is a picture of ruins most cunningly presented."

Supply a couple of verbs in the opening sentences and this might be part of Agate's first-night report in the *Sunday Times*. His critical prose is perhaps not capable of conveying the highest originality or fineness of perception. It lacks the poetic contraction of Hazlitt, the sinewy embrace of Shaw; but like Hazlitt and Shaw it has tactical vigor and consecutiveness— none of your newspaperish maunderings which leave the

reader in doubt whether any two paragraphs are really by the same man or alternately by Philip drunk and Philip sober. Agate's criticism has all the businesslike qualities which are so rare in businessmen, and of which Walter Bagehot deplored the absence in writers generally: "So few people that can write know anything . . . an author has always lived in a room, has read books . . . but he is out of the way of employing his own eyes and ears." Agate at his best was all eyes and ears, and he never forgot that he was paid not simply to express but to *make up* his mind.

Besides the discovery of a formidable character, the reward of reading the three thousand pages of *Ego* is the acquisition of a new set of friends, inexpensive to maintain and not likely to be troublesome. They are mostly actors, playwrights, painters, musicians, and journalists, but there is also a sprinkling of semi-lunatics and peers of the realm. And unlike the tight-lipped visions in Arnold Bennett's *Journal,* Agate's friends talk.

There is Mrs. Patrick Campbell, for instance, listening to a bore in full spate about the marvelous social organization of the ants—their police force and their army. Mrs. Campbell leans forward and with grave voice and mien interrupts: "No navy, I suppose?" Another time, Agate compliments the charming, elderly Lady Tree on her beautiful hair, and she gaily acknowledges: "How perfectly sweet of you to call it mine!" Or again, he is in a restaurant with an aging beauty, and as she reads the menu at arm's length, a catty friend suggests that she should really reconcile herself to wearing glasses. The retort flashes back: "There's nothing wrong with my eyes; it's just that my arm isn't long enough!"

The conversation is often by letter, pursued for many months on topics certain to outlast the writers. Thus Agate argues with J. B. Priestley about immortality, with Charles Morgan about the mystical experience, with John Gielgud about *King Lear,* and with all his friends about his diary. All of them want something put in or left out. It is a lesson in crit-

icism and in human vanity to see what incurable whittlers intelligent people are. Still, this helps us to measure Agate's mind through its inclusiveness. His brother Edward says of him, in a sweeping untruth: "His income and his intestines fill his whole life," but that very quotation makes it clear that somewhere between income and intestines brother James finds a place for enshrining Edward's rare quality of mind.

Similarly we find full delineations—often self-portraits—of the inimitable Scotsman Alan Dent, text editor of the *Henry V* and *Hamlet* films and dramatic critic of the *News-Chronicle*; of Leo Pavia, a cantankerous musician and wit; of George Lyttelton, an Eton scholar; of Montague Shearman, traveler, jurist, and sportsman. And more than once we meet—among many others—Noël Coward and Cedric Hard-wicke, Margot Asquith, Rebecca West, Mark Hambourg, Sybil Thorndike, Alfred Douglas, Constant Lambert, Charles Laughton, Christopher Fry, Vivien Leigh, Laurence Olivier, George Moore, Maurice Baring, and Bernard Shaw.

Before we tire of the moderns we are transported back-ward into the company of Lamb and Dickens, Balzac and Shakespeare. Through Agate's early acquaintance with the far-flung Garcia family, we draw on a whole century of bygone music and theater; our diarist's delving into obscure corners of literature supplies the rest: he makes Kean, whom he never saw, as actual as Irving, whom he did see. He has a passion for saving from oblivion all that is curious or great, and he does this with a scholarly skill free from antiquarianism. A taster of prose, he is full of the poets and even exhibits himself in light verse.

More, he rescues the casual human document on its way from the mailbag to the wastebasket, and for good measure gives us an occasional fiction—sometimes a series of plots in the manner of Villiers de l'Isle Adam. At other times, he prints his friend Pavia's letters from a group of imaginary German artists in London—a little masterpiece of parody.

As these figures on different planes of existence enter,

return, marry, become successful or die, and as Agate moves from one milieu to another, one is forcibly reminded of Johnson and his circle. Agate Boswellized quite consciously. That is why *Ego* is so full of verbatim conversations, of luncheons, trips, and evenings at the Club. But although he takes both roles, Agate is more a Johnson than a Boswell. He and the great Doctor are linked by their unfaltering common sense, and distinguished from their entourage by the speed and force with which they utter it. That common sense is uncommon is a platitude without ceasing to be a paradox. Agate's talk and behavior help us to solve the paradox by suggesting that common sense is chiefly integrity plus energy; it is the ability and the will to sort out the relevant from the muck of the plausible which convention automatically piles up around all things. Sticking to the point like Agate will make you fadproof like him. But it may prove dull business for others unless you also cut and thrust like him: "It was a dire day for the pictures when Hitchcock or somebody discovered that a woman screaming emits the same sound as a train entering a tunnel. Fusion became the rage, what began as woman ended as tunnel, and why she was screaming or who was in the train ceased to matter. It is this kind of thing which makes our high-brow critics hail *King's Row* as a masterpiece."

Again, in the more difficult situation of justifying himself and his work, see him clear his friends' minds of cant; they had vainly expected in 1940 that in the face of the "emergency" he would discontinue *Ego:* " 'It means that you regard your Diary as more important than the war?' I said: 'Well, isn't it? The war is vital, not important. . . . Because I am suddenly stricken with cancer, must cancer become my whole world? . . . Cancer has become vital to me, but not important; except in so far as I am a coward, it does not fill my mind.' " He concludes: "In a hundred years, when my great toe began to ache and when it stopped aching will be of more interest to anybody coming fresh to this Diary than the peace terms. It will be news; they will be merely history."

Needless to say, *Ego* tells us nothing of Agate's toes. We are given just enough about his health and spirits to feel a living body behind the sentences and to recognize other grounds of likeness to Johnson. Agate, burdened with asthma, loathed death, was subject to sudden causeless fears, and shared the neurotic compulsion to touch or count objects in a certain order. But apart from this, what sanity and good humor! His favorite phrase is "Let's face it!" The words introduce no truisms but either a listing of his own shortcomings or else propositions one would not expect from so British a bloke. For instance, he reads anthropology and learns that man's brain has remained unchanged in 250,000 years: "Nonsense! I do not believe that pre-historic man was the colossal idiot that his successor has demonstrably become." *1951*

The Grand Pretense

The title of Mr. Richard Southern's highly original work—*The Seven Ages of the Theatre*—is misleading if taken apart from his introductory motto: "Theatre is an Act—His Acts being seven ages." Without this clue, the worn quotation from *As You Like It* suggests only a history of the theater divided into seven parts and probably too long. But what in fact Mr. Southern has done is to discern in the scholarship of theatrical history seven phases, each of which takes the central fact of acting in a different manner and exhibits it upon a different physical structure—all this being related to diverse beliefs and purposes and yielding different effects and pleasures.

Mr. Southern deals with a great variety of historical evidences, drawn from all over the world, and organized to show the sequence from tribal rites to the latest theater-in-the-

round. That he can make his thesis clear and his account historical in three hundred pages is a tribute to his powers of exposition, aided by photographs and line drawings from his own pen.

His success is also due to the clarity of his conception, which at first may meet resistance from the literary mind reared on traditional ideas of drama and playwriting. The tendency is to think of the substance or atmosphere of what we have seen in the playhouse to which we are accustomed. There seems to be no link between the Cornish antics of the Padstow Horse and *The Cherry Orchard;* the voluble Ibsen seems so far away from the Kathakali action, which is silent except for the inarticulate sounds appropriate to demons, that one is tempted to think artificial any scheme of evolution that brings them into relation.

But Mr. Southern knows what he is about and his unusual and quite engaging way of addressing the reader, taking his elbow, reasoning with him, and conducting him, now deliberately, now hurriedly, over unfamiliar terrain, soon makes a willing captive, full of curiosity about what is coming next. It is easy to believe that Mr. Southern is a successful director: he gives a sense of acting out his ideas before you, while also telling you where to stand and how to behave yourself.

His thesis about Theater (without *the*, like "painting" or any other art) is that it is the exhibiting of a player. A human being dresses up and acts. Everything follows from that very singular characteristic of mankind, which is perhaps as differentiating as the power of speech and the making of tools. It is in truth man's making a tool of himself, for purposes both sought and only half foreseen. Ritual, symbol, myth; propaganda, entertainment, contemplation; laughter, catharsis, sociability follow from the original "aping" which is man's alone. And not merely the actor but his audience also is transformed by this denial of self and this assumption of a false front, which Shaw so justly said was the most dangerous of spiritual adventures.

Mr. Southern does not speculate in this vein beyond the needs of his narrative purpose. He does not forget that he is writing a history, although it is one which shall make the reader radically change his notion of what the history of theater is. After he has established and illustrated his conception of the act by the costumed player, he describes the ways in which the theater as a place has changed with the centuries in East and West.

In the sixteenth century in the West comes the interesting bifurcation between the acting stage—Shakespeare's, let us say—and the scenic, invented for Ben Jonson's masques and the early Italian operas. Already in Elizabethan times the question of how to make a stage was of great importance, for in secularizing itself and becoming a profession, playacting falls under economic necessity, having entered into a kind of contract with an unknown and vagrant public. Thereafter carpentry becomes of immense significance, that is, the convenience, the look, the size, the lighting, the novelty, the illusion, the gadgetry, the participation all become elements our poor old aboriginal mummer has to reckon with.

We can thus understand why in our century so much thought and energy has been devoted to trying out and arguing about new shapes and devices for projecting the act. In a complicated civilization habits wear out fast, remote influences quickly bear down to change familiar sights, and opposite conceptions of man compete with each other to take possession of art, including the stage. Hence the battle over the picture-frame stage outlined by the proscenium arch, the vogue of arena staging—the theater-in-the-round, and, for all we can tell about radioactive fallout, the foreseeable theater-in-the-ground. Mr. Southern is convinced that "the act," which Goethe said was in the beginning, will also be there at the end.

Having from a state of skepticism acquired enthusiasm for Mr. Southern's views, I should like to give a few examples of his style and treatment, including—to be fair—some faults.

Though always perfectly clear, our author is not always exact. There are gaps in his discourse which could perhaps be filled, but which cause one to trip. He writes, for example, of the player's nervous response: "One of its manifestations is 'stage fright,' which is not fright but a high 'nervous key' in the presence of something capable at any moment of an unpredictable attack on you." At that rate I have no fears of a springing tiger, but my high nervous key can probably be heard in the next county. There *was* a distinction to be made between a theater audience and a lynching mob, though Mr. Southern failed to make it, being more at home in description and narrative than in consecutive theorizing.

He is none the less a true scholar and, what is rare, one who is pleasantly aware of the species' unamiable traits. He says of James Burbage's playhouse: "we can guess much concerning the auditorium, but about the details of the stage which was built in that playhouse, we remain as ignorant, and consequently as irascible, as about any theatrical item in the world."

At his best, on every page, one finds passages such as this, on the difficulty of mixing actor and audience for "participation": "But the second [reason] is far more subtle and important. It is because an actor in his part has still an element of the horrifying if you go too near. This is not alone because of any item of exaggerated make-up (though that plays a weird part), but because the man himself is strange compared with ordinary men. His mind is working on other than normal lines. He is dedicated to other objects than those to which we dedicate ourselves. He is withdrawn from normal impressions. He is concentrating on another situation than reality; he is concentrating on a fiction. He is not unlike a mad person; he is abnormal; he is a mask; the man himself can no longer be seen. And that (unless he is to some extent removed from us, elevated into another plane, insulated in some sense from us) can be a very uncomfortable thing." *1962*

On Sentimentality

What is sentimentality? If one asks somebody who ought to know, one is told: an excess of emotion; or again, misplaced emotion. Both answers miss the point. Who can judge when emotion is too much? People vary not only in the power to feel and to express feeling, but also in their imagination, so that a stolid nature will deem it excessive as soon as love or grief is expressed vividly and strongly. Shakespeare is full of "exaggerated" emotion, but never sentimental. The same remark applies to the other answer. When is feeling misplaced? at the sufferings of the tragic hero? at the death of a pet? at the destruction of a masterpiece? One may argue that any emotion out of the common should be restrained in public, but that is another question, one of social manners that has nothing to do with a feeling's fitness to its occasion. The diagnostic test must be found somewhere else.

Sentimentality is feeling that shuts out action, real or potential. It is self-centered and a species of make-believe. William James gives the example of the woman who sheds tears at the heroine's plight on the stage while her coachman is freezing outside the theater. So far is the sentimentalist from being one whose emotions exceed the legal limit that he may be charged with deficient energy in what he feels; it does not propel him. That is why he finds pleasure in grief and when he is in love never proposes. Sterne accurately entitled his story *A Sentimental Journey*: the tears he shed over the death of the donkey and his preoccupation with the girl at the inn caused him no upset nerves, no faster pulse or quickened breath. He reveled in irresponsible grief and love. This condi-

tion explains why the sentimentalist and the cynic are two sides of one nature. In such matters the arts are transparent and the connoisseur can easily tell imitation feeling from the real thing. *2000*

Samuel Butler

England produced one man of genius whose opposition to Darwinism began shortly after the appearance of the *Origin of Species* and continued unabated on all planes of thought—biological, social, metaphysical, and religious—until his death in 1902. This was Samuel Butler, the grandson of Darwin's old headmaster at Shrewsbury. When the *Origin of Species* appeared, Butler was on his way to New Zealand to earn a competence raising sheep. He read the book there in the solitude of his ranch and at once became a convert to the idea of evolution. The hypothesis even spurred him to write for a local journal a skit called *Darwin Among the Machines,* the leading idea of which—that of machinery evolving by itself and ultimately conquering man—has since acquired the taste of an unpleasant truth. This idea of course also contained the germ of the satire *Erewhon,* published when Butler returned to England.

More reflection and several rereadings of the *Origin of Species* gradually made Butler very much dissatisfied with the Darwinian theory of Natural Selection as it stood. Perhaps his own fancy about the machines gave him the clue to the weakness of Darwinism—what he ultimately came to call the *Deadlock in Darwinism.* The deadlock was simply that machines, having no purposes of their own, could not evolve; but since animals and plants were treated by Darwin just as if they were machines, Darwinian evolution was impossible. The

operation of Natural Selection might conceivably aid us to understand which forms survived, but it could never tell us how these forms had come to be. Natural Selection was an undoubted *fact* but could never be a theory or a cause. As Butler put it, "To me it seems that the 'Origin of Variations,' whatever it is, is the only true 'Origin of Species.' "

In examining Darwin's text, Butler had found that small random variations were taken for granted or occasionally ascribed to a somewhat metaphysical entity called Variation, in order to provide Natural Selection with something to work on. But Butler also found Darwin relying in several places upon use and disuse, and he traced the origin of this hypothesis to Lamarck, whose name and work Darwin openly discredited. This led Butler to Buffon, Goethe, and Erasmus Darwin, and he thus became the first careful historian of the evolutionary movement. After comparing Darwin's theory in all its vacillating forms with the theories of the earlier trio, Butler came to the conclusion that the grandfather, and not the grandson, had met most nearly the difficulties involved in any evolutionary hypothesis. The grandson had of course marshaled many more facts indicative of evolution than the grandfather; he had, as Butler proclaimed, taught people about evolution; but he had not made out a convincing case for the mode of species change. He had at most emphasized in Natural Selection a fact previously noted by zoologists that "those who can survive do survive." The secret of the Origin of Species still lay hidden in the Origin of Variation.

Had Butler contented himself with offering these criticisms, he might conceivably have gained a hearing for them. But his mind once aroused, he was not given to stopping short. Assuming that in the presence of established facts his thinking might be of use, Butler offered in *Life and Habit* a suggestion to replace—or rather supplement—Darwin's Natural Selection. Starting from the fact that the organism is a living thing and not a machine, Butler asserted that its characteristic feature is that it has an "interest": it wants to do cer-

tain things and not to do others. The physical action of living beings is, in other words, the expression of a mental action—meaning by mind not Intellect, but consciousness, however low and limited. This was going dead against the Automaton Theory, not yet discredited. It followed that for Butler, effort, endeavor, purpose have something to do with biological evolution, and from this it was only a shorthand expression to say that living forms evolve because they want to: desires lead to efforts; successful efforts result in new powers; and new powers create new desires. As Butler saw it, the process was of course limited by the environment and the narrow powers of the creature, but it corresponded to what could be readily observed in the phenomena of growth, habit, and learning. Above all it got rid of the inexplicable mechanism by which the evolution and the life of living things was made to result from chance push-and-pulls from outside.

Besides reinstating purposes into a world that had become a vast roulette table, it also made society something else than a Coliseum where human beasts strive with one another in moral darkness. Mind, feelings, ethics, art—all these things were once more real and not the dreams of automata accompanying the physico-chemical changes called digestion, respiration, reproduction, and death. It was still possible and instructive to look at these functions in their physico-chemical aspects, but to do so did not exhaust the meanings inherent in them. Lastly, Butler's theory made the problem of religion one that could not be shirked or relegated to a superstitious past. Men live by some sort of faith, life indeed is a form of faith, and the repeating of scientific formulas is not its only ritual. Though Butler often used scriptural language, he reinterpreted its truths according to his lights; there was nothing orthodox about his religion. It was nevertheless a consistent set of beliefs, far from the atheism which a misguided modern critic has ascribed to him, though seemingly unintelligible to both the churchmen and the scientists of his own day.

What puzzled them was that Butler seemed to be striking

out on a new line instead of choosing, like everybody else, between theology and materialistic science. For one thing, he disclaimed at the outset any scientific warrant for his theory or even any originality. The hint of it, he said, lay in Lamarck, and it had been fully exploited by Erasmus Darwin. What Butler was doing was to give it another hearing at a time when a completely mechanical view of life was sweeping the field of old theologies. Butler thought them both inadequate, mechanical evolution even more so than supernatural creation, for creation was at least a fact of daily experience whereas mechanism was an abstraction born of scientific needs.

Unfortunately Butler's initial modesty was misplaced. Far from receiving thanks, he was assailed by both sides in truly professional manner as "lacking authority." Here was a man who had never worked in a laboratory or served aboard a *Beagle,* who had made fun of churches and churchgoers in *Erewhon,* and who had the effrontery to criticize, speculate, and dogmatize. It was an infringement of monopoly. It seemed to the gentle Darwin "clever and unscrupulous." It was of no use for Butler to reply that he took the very facts which the scientists supplied him with, that no one had detected him in a factual error, that his theory had never even been criticized. Official science had no time to listen—only time to invoke the Principle of Authority and write insulting reviews.

Oddly enough, a man like Spencer, who was no more a practicing scientist than Butler and at the same time a far more deductive, *a priori,* unscientific mind, was gravely attended to by the official Darwinians. And when after twenty-five years of exclusive enthusiasm for Natural Selection he made it share the throne with his earlier love, Lamarckism, no one thought it particularly "impudent" or "unscientific."

Again, G. H. Lewes, who held and promulgated a theory of life identical with Butler's, was respected and quoted, though only on matters of detail, by the professionals. The reason for this discrimination seems to have been that Spencer

and Lewes both revered Darwin and set up no other idols—particularly earlier evolutionists—in his stead. Butler was too direct in his questionings of a famous man twenty-five years his senior, and it is doubtful whether even with the aid of scientific degrees and a less readable style he would have made any impression on either orthodoxy. As it was, all parties grew more obstinate, Butler more and more peppery and irreverent, and his Darwinian opponents more and more "pleasant-like and frothing at the mouth."

The result was lifelong neglect for Butler and the postponement until the twentieth century of the pleasure and honor of rediscovery. Bateson's recognition of Butler's importance in 1909, Shaw's successful campaign to give him his due place in English thought, and the numerous biographies of him which have appeared to date, do not begin to exhaust the points of interest in his mind and personality. The many anticipations of William James and Freud, for instance, that can be found in *Life and Habit* will delight and surprise the attentive reader. And it is increasingly apparent that, without knowing it, Butler was in line with the most fruitful speculations of his age. Unconscious Memory, for example, was a suggestion very much akin to the renascent interest in genetics. Butler perceived that if he made creature-purpose the moving factor in evolution, he had to explain how these purposes accumulated. He concluded that instinct, which was inherited, was a sort of memory buried in the germ plasm; and, anticipating Weismann, he argued that life was in fact continuous and not chopped up into the fragments we call individuals.

Shortly before publishing these views, Butler found that a German professor named Hering had given expression to similar ideas at a scientific congress not long before. Butler thereupon fathered his own theory on the shoulders of the accredited degree-holder, not suspecting that Asa Gray and Joseph Leconte in the United States had also attributed instincts to inherited memory. But once again Butler had no response. He persisted, however, republishing his historical

account of evolution and finally summarizing all his arguments under the crystal-clear title of "Luck or Cunning?"

Butler's criticism of Darwin is summed up in his objection that Darwin had banished mind from the universe. This does not mean, of course, that Butler's suggestions have been proved true. But neither does it mean that Butler's objections were grounded on a mere preference for the banished "Mind" as against the ever-present "Matter." Many materialists still think a sense of personal deprivation of this sort is the sole ground of any such objection. The fact is that the objection is directed at the inevitable tendency of analysis to disregard whatever elements it provisionally sets aside. Mind was but the traditional name for those experiences that were not mere movements of particles. It was the name for those things which Huxley and Tyndall declared themselves unable to measure, account for, or lead up to by means of material analysis. Let them set mind aside as much as they wished for certain purposes of investigation, still mind must not be forgotten like an inconvenient umbrella in the cloakroom. It must reappear somewhere in the final inventory. If it came to a choice, for Butler, of making mind all matter or matter all mind, he preferred the latter as more consonant with the facts.

Lewes agreed with him, perhaps without knowing it, occupied as he was in striking out new paths in biology, equidistant from the metaphysical and the mechanical. "Materialism," says Lewes, "in attempting to deduce the mental from the physical puts into the conclusion what the very terms have excluded from the premises." His hypothesis, which would have satisfied equally Samuel Butler in 1887 and Professor J. S. Haldane forty years later, is that "the physical process is only the objective aspect of a mental process." Nor was Lewes a new convert to this conclusion. As early as 1853, in *The Physical Basis of Mind,* he had defined God as Life and echoed the Roman poet's "Life is everywhere and nowhere Death."

Both in Butler and in Lewes this conviction came from a true familiarity with more than one realm of thought. Just as

Butler rediscovered Hegel's law of contradiction without reading Hegel, and carried forward Schopenhauer's notion of the will without reading Schopenhauer, so Lewes, who as a philosopher had read both, could anticipate the doctrine of Emergent Evolution and stand out in amiable dispute against his century. As a competent and well-connected scientist, Lewes could draw confirmation for his theories from many quarters. Paget on the tissues, German cell physiology and neurology, French work on medicine—all seemed to converge on the point that, though Supernaturalism was a metaphysical mistake and a stumbling block for science, materialism was untenable too, and for the same reasons. Life was not just atoms in a bag.

Unfortunately, Lewes died prematurely in 1878, and his work never won the place which it deserved; but its merit can be tested, like Butler's, by the fact that the younger generation was falling in with its tendency. It was in 1875–1876 that the young William James, saturated with German science, began to wean himself away from Spencerism and psychophysics, that Lange brought out the second edition of his polemical *History of Materialism,* and that biologists in many parts of the globe began to make those attacks on Natural Selection which led to Darwin's "tacit" recognition of their weight.

1941

On Romanticism

The flood of emotions stirred, the hopes and ideas raised between 1789 and 1815—ideas that were fought for, suppressed, misdirected, or misunderstood during the quarter century—were to be reviewed, adapted to the times, shaped into some kind of order. The outburst against abstract reason

and the search for order make up one continuous effort, which has acquired the historical name of Romanticism. What began as a cluster of movements became the spirit of an age. As a result, the name has seemed to some critics unusable because it was attached to disparate sets of facts and tendencies. There is first the galaxy of artists—poets, painters, musicians, and theorists of art and society—an outpouring of genius hard to match in any period for variety and numbers. Then there is the many-sided religious revival that made eighteenth-century Deism and atheism look like dry, shallow ways to confront the mystery of the world. Next, Romanticism included political and economic ideas either new or developed forms of earlier views. Finally, there are Romanticist philosophies, morals, and attitudes, scientific innovations, and the rediscovery of certain past periods, thanks to the characteristic discipline of History.

Such are the reasons why Romanticism was not a movement in the ordinary sense of a program adopted by a group, but a state of consciousness exhibiting the divisions found in every age. Hence all attempts to define Romanticism are bound to fail. The critics ask: "What about this element?"— or: "What of the thought of So-and-So?" A respected American historian of ideas found eighteen different romanticisms, which has suggested dropping the name altogether. That is impossible; the term is there, embedded in history and in a billion books and minds, where it will continue to lead an active life. Like "Puritan" it must be retained and—to repeat— shown to be a *Zeitgeist* and not an ideology. The spirit was inclusive: the liberal Victor Hugo, his reactionary compatriot Joseph de Maistre, the radical Hazlitt, his enemies Coleridge and Southey—all are, were, and must be called Romanticists—and not in different degrees but equally. One unifying thought was the altered conception of Man—necessarily altered by the extraordinary experience of a doctrinaire revolution, the spectacle of the self-made master of Europe, and a series of wars waged by nations instead of dynasties.

The span of years when Romanticism was the spirit of the age is roughly the last decade of the eighteenth century and the first half of the nineteenth. Those sixty years witnessed the work and struggles of three generations, but this work is not chronologically parallel in every country. Germany and England were first in line: the artists and writers born in the 1770s brought out their innovations in the 1790s and early 1800s (Wordsworth, Coleridge, Constable). At that time France, Italy, Spain, and East Central Europe seemed culturally stagnant under the Revolution and Napoleon. The second generation, born around 1800, showed its powers beginning in the 1820s (Pushkin, Lamartine, Delacroix, Emerson), and was the last contingent fully to share the prevailing temper. The next was a broken wave. The talented born around 1810 partake of the original source (Wagner, Liszt, Gautier, Melville), but in their mid-career the world changed and they reoriented themselves and their beliefs.

The present age is not simply "the heir of the Enlightenment" as many complain or boast; it is also the heir of the age that corrected the Enlightenment's errors and, while adding errors of its own, deepened and amplified all the categories of art and thought. *2000*

Dorothy Sayers

Dorothy Sayers manifested early a gift and a passion for words. Born in Oxford, she was the only child of a clergyman and musician and of a woman of modest education but energetic, highly intelligent, and proud of an ancestress who was a cousin of Hazlitt's. Unfortunately for mother and daughter, four years after the child's birth the family moved to a vicarage in Cambridgeshire, remote but handsomely endowed. There

the wife grew increasingly bored with her husband, and the child was reared with hardly any young friends or other society. Dorothy amused herself by voracious reading, writing stories and poems, imagining what the outer world was like, and pondering the details of the Christian faith, which she read as a story. At the same time, she was a tomboy, full of life like her mother and practical in everyday matters. These traits shaped her subsequent career: innocence, energy, a down-to-earth attitude that did not limit imagination, and a peculiarly intimate feeling for what has been called the Christian epic.

She went to Somerville College at Oxford, where she became a fine scholar (read her next-to-last tale, *Gaudy Night*), and was one of the first batch of women to receive a full Oxford degree instead of a certificate—or rather, two degrees in one ceremony: Bachelor and Master of Arts. So far, her life had been smooth and pleasant; now she must earn a living. She served as secretary to a man who ran a service associated with a school in France. They had a sort of love affair—in words—that was the first of her misfortunes in that domain. After two more episodes, which left her with an illegitimate son who turned out handsome and intelligent, she found late in life a congenial husband, though his latter days darkened hers by his becoming ill, alcoholic, and of uncharacteristic bad temper.

So much for the unedifying yet anguishing odyssey that Sayers had to endure while developing her literary gifts. A job as copywriter in the largest London advertising agency proved useful (read *Murder Must Advertise*) and enjoyable too: there was good writing even in ads. In all that she wrote she aimed at the simple and direct.

Like Henry James, who gave a full-blown theory of the novel, Sayers laid down that of the detective tale, using her scholarship by turns seriously and with humor. Interviewed on the subject, she manifested her forthright ways of speech: "imbeciles and magazine editors" would ask her to discuss crime fiction "from the woman's point of view. To such

demands one can only say 'Go away and don't be silly.' You might as well ask what is the female angle on the equilateral triangle."

On aesthetics at large she wrote an extraordinary little book, *The Mind of the Maker*. Its thesis is that the ordinary experience of making anything—creating art or applying workmanship to any object—corresponds to the meanings symbolized by the Trinity. First comes the creative Idea, which foresees the whole work as finished; this is the Father. Next comes the creative Energy, which engages in a vigorous struggle with matter and overcomes one obstacle after another; this is the Son. Third is the creative Power of the work, its influence on the world through its effect on the soul of the user-beholder; this is the Holy Spirit. All three are indispensable to completeness as they unite in the work. The demonstration had a double purpose, critical and religious. While analyzing human creation it showed that God's work as revealed in Christian theology followed the same pattern and man is indeed made in God's image.

Before writing this highly original book, Sayers had lectured and written plays on religious themes for festivals held in Canterbury cathedral and other churches. For these she did research in medieval history, literature, and language and her activity brought her national attention as an intellectual evangelist. When the BBC commissioned her to present in dramatic form six programs depicting the life and death of Jesus, she wrote a script that combined simplicity in word and idea with emotion free of sentimentality. And like naturally religious persons in the Catholic tradition, she enjoyed being humorous about the objects of her faith. In *Pantheon Papers*, for instance: "St. Supercilia's unworthy father brutally commanded her to accept the hand of a man who, though virtuous, sensible, and of good estate, knew only six languages and was weak in mathematics. At this the outraged saint raised her eyebrows so high that they lifted her off her feet and out

through a top-storey window, whence she was seen floating away in a northerly direction."

Sayers continued without letup what she considered her mission to show the role and validity of belief, using reason and example in the manner that makes *The Mind of the Maker* a work of permanent interest, comparable to C. S. Lewis's works. But Sayers was not an absolutist. Belief in God she thought indispensable to answering unavoidable cosmic questions and as a fixed point by which to settle earthly ones, but to demand or enforce a particular conception of the Deity would ensure only division and oppression. She was explicitly a pragmatic relativist. More than once, in various contexts, she writes: "The first thing a principle does is to kill somebody."

The research she had done in the history and literature of the Middle Ages had persuaded her that she could translate Dante. Competent in Greek, Latin, and French, she now learned Italian and rendered Dante in the terza rima verse scheme of the original. Her youthful scribblings had trained her to think metrically and she chose the simplest, briefest language to give due place to Dante's wit, sarcasm, and humor—little or none of which had appeared in previous efforts; all were solemn in deference to the theme.

She died suddenly at the age of sixty-four before quite finishing. But a friend supplied the lack and the translation appeared in the Penguin Classics, to mixed reviews, some enthusiastic. Much praise came from C. S. Lewis. Her version has two merits: it makes for an easily readable and dramatically effective work, like Samuel Butler's prose translation of the *Iliad* and the *Odyssey;* and her interpretation of Dante is tenable if one remembers that he wrote a pamphleteering poem in which, as a wandering exile, he damned his political and personal enemies, extolled friends, and put forth dogmas by no means all orthodox.

What will remain of her work as a whole is a matter for conjecture. The attitudes and prose style of crime fiction have

changed, though several of her tales keep being reprinted. *The Mind of the Maker* has the survival value of an original idea perfectly developed and expressed. In the rest of her religious writings Sayers was ahead of time. The present preoccupation with the Bible, Jesus, and Creation should lead back to her views. If the colloquial Dante finds no lasting favor, the scholarly introduction and notes must remain important for students.

Sayers's conclusion that principle kills had been borne in upon her by the onset and the conduct of the Great War. National honor, naval supremacy, colonies for show rather than benefit, regions that must be conquered to "redeem people of our race," and "No peace, no surrender" had been goals pursued so stubbornly that Europe had turned itself into a vast burnt offering without seeing that the two sides were cooperating to that end on identical principles. *2000*

John Jay Chapman

Though few Americans know it, Coatesville, Pennsylvania, is an historic name in the annals of both the country's social evolution and its literary biography. Two events, a year apart, give Coatesville this singular distinction. The first occurred in August 1911. On Saturday night the twelfth, a Negro named Zacharia (or Ezekiel) Walker was brought under police guard to the Coatesville Hospital after a series of incidents which remain shrouded in doubt. The clear facts that emerge are that he had shot and killed a special officer of the Worth Steel Company and was himself wounded in the head. Almost at once a mob stormed the hospital, dragged Walker outside the town, bound him to his cot, and put both on a pile of rubbish to which they set fire. When the ropes burned

away, Walker made a dash for freedom and tried to escape over a fence. But he was recaptured and thrown back into the flames.

Two days later, the mob still in control, attempts made to identify the lynchers and sift testimony proved useless. According to some reports, Walker had been holding up a man when he was surprised by the company officer he killed. According to others, Walker confessed to having drunk too much and in his elation fired three shots near the steel plant, which led to a challenge and a fatal scuffle. After his confession, Walker is said to have begged, "Don't give me a crooked death because I am not white."

These are the facts and allegations on which John Jay Chapman, then almost fifty, brooded during the ensuing year. As he wrote later: "I was greatly moved at the time the lynching occurred, and as the anniversary came round my inner idea forced me to do something. I felt as if the whole country would be different if any one man did something in penance, and so I went to Coatesville."

As a young man Chapman had had several years' experience in New York politics on the side of reform. But his mood when he decided to do penance for the country at Coatesville was not that of agitation. Leaving his understandably apprehensive wife at Islesboro, Maine, Chapman went to New York and discussed his intention with a friend, Miss Edith Martin, who read with approval the address he had prepared and offered to accompany him. This, as Chapman wrote to his wife, "puts my mind at ease as if I had a big bulldog to guard me, not from lynchers but from—I don't know what." The next day Chapman set out to reconnoiter alone; he reports: "Very hard to get a hall—the prejudice against the subject. I have hope to get the City Mission (sort of Salvationists) but naturally can't get it Sunday, therefore try for Saturday."

He made other plans and on Friday, August 16th, the citizens of Coatesville could read in their afternoon *Record* the notice of Chapman's meeting:

In Memoriam

A PRAYER MEETING WILL BE HELD
ON SATURDAY MORNING AT 11 O'CLOCK,
AT THE NAGEL BUILDING

SILENT AND ARAL [*SIC*] PRAYER:
READING OF THE SCRIPTURES:
BRIEF ADDRESS BY JOHN JAY CHAPMAN

IN MEMORY OF THE TRAGEDY OF AUGUST 13, 1911
O LORD RECEIVE MY PRAYER.

The details of Chapman's efforts to publish this announcement are given in a letter of the same day to Mrs. Chapman: "By good luck the local newspaper is a daily which appears in the afternoon, so—having hired my room by 9.40 this morning (and most grateful to get a room—which I succeeded in by slightly changing my policy. It occurred to me that it was *not necessary*—nor morally right—to *burden* the conscience of the real estate men with my plans and purposes. By not knowing them *they* remained innocent). Curious experience in the backward working of principles in moral force: I was a little afraid last night that perhaps I wasn't quite sincere—and really was after an agitation and not a prayer meeting—so I resolved it must be real, and drew the notice so. Well, at the newspaper office there was some doubt and trouble and the head man was called in. (Everybody says he's a tremendous shouter for peace and not an honest man.) But as I stood waiting for him to decide I thought to myself—'If the *Record* refuses to print that notice—the Philadelphia papers will give Coatesville such a hammering as they have never received'— (the hammering by the press of the country is what has injured them and pained them) and I was just going to suggest this when he saw his way to print the ad. He somehow saw it. He must be an able man. The room will hold 20 people but is very conveniently situated. If there should be a crowd, we can

always move to a larger place. What I mean about principles is that by really abandoning politics I had bungled into the astutest thing I could have done.

"No one who has not been up against it can imagine the tyranny of a small town in America. I believe a good old fashioned Medicean, or Papal, or Austrian tyranny is child's play compared to it. There's a dumb, dead, unlistening decision to do what it *has been decided* must be done—what business demands—e.g. to not raise the lynching issue in Coatesville today—by Jove, it's amazing! It doesn't irritate me—as the old political tyranny and hatred of opinion. Merely because the battle is won. It's a joke, this idea of Coatesville—whereas there was a good deal of seriousness in the successful way they used to put down independent ideas in New York. The great men of Coatesville are not so heavy. . . .

"I haven't suffered from either fatigue or change of climate. I got into a nasty old hotel yesterday—didn't like the morale of it either—filthy room and no air—piazza in front, and a bar room as big and desolate as a dream. My, what that long dreadful stretch of stinking bar implies—one hundred men could drink there—fifty anyway, and what ruffians! Now, I've come across the street to an airy, clean, large, comfortable room and have nothing on my mind and nothing to fret about. I have sent for Miss Martin, though I *almost* didn't—because it's so long a journey—and then I thought after all that was her mission. Yours Jack."

By Saturday the 17th Chapman was convinced that the inhabitants "*rather like* the idea of a prayer meeting. I get this in the air. 'Who's back of this?' said the editor of the *Record* fiercely. 'No one,' said I; 'at least, I am.' This satisfied him as he didn't know what kind of a feller I was, but I looked meek."

If the Coatesvillians liked the idea, they visibly did not like the reality, for besides Miss Martin from New York only two people came—"one an anti-slavery old Negress, who lives in Boston and was staying in Coatesville; the other a man who was, I think, an 'outpost' finding out what was up. We held

the meeting just as if there was a crowd, and I delivered my address. There was a church meeting going on opposite us, and people coming and going and gazing, and our glass front windows revealed us like Daniel when he was commanded to open the windows and pray."

How Chapman prayed and what passages he read from Scripture, we do not know, but his address remains, under the sufficiently evocative title "Coatesville." Like all of Chapman's work, it is an image of him and it contains things which tell us why he was at once a superior critic of his America and quite incomprehensible to it. He had not spoken two minutes at Coatesville before he pierced through to the core of the mystery, the secret motive which brought the "hundreds of well-dressed American citizens" to look on at torture "without provocation, . . . standing by merely in cold dislike." The explanation is the passage of the address that begins: "As I read the newspaper accounts of the scene enacted here in Coatesville a year ago, I seemed to get a glimpse into the unconscious soul of this country," and which ends: "No theories about the race problem, no statistics, legislation, or mere educational endeavor, can quite meet the lack which that day revealed in the American people. For what we saw was death."

These few lines, from a man who had never heard of Freud and whose vocation since youth had been neither practical politics nor academic psychology but literature, are enough to show how inadequate is the tag of "belated Abolitionist" which Chapman's friend Owen Wister tried to fasten on him. There was nothing belated about Chapman, and his fanaticism is not abolitionist but creative. I say creative despite the degraded usage which permits writers of conventional short stories in a college course and compilers of copy in a public relations firm to call their work "creative." Chapman wrought no fictions like these; he created because he worked to bring into existence in the culture of his time something which no one before had conceived—a new American type which, while

remaining native and natural, would differ in thought and feeling from the American, common or distinguished, of the post–Civil War period.

What Chapman saw in the American soul at Coatesville was death, and what he struggled to substitute for it was life—life through the free activity of mind. His tragedy was that he himself was heavily burdened with death, with aboli tionism, and that his entourage, far from fanning the spark of life in him, or bringing it fuel, isolated it and in the end all but extinguished it. Whether bent on life, as at Coatesville, or on death, as in the early episode leading to the self-mutilation of his left hand, he was known as "mad Jack Chapman," and his soberest, wisest thoughts reached little farther than the circle of friends who found him "fascinating."

No one using that word then or now seems to be aware that it implies the immobility and imminent end of a weak creature in the grip of a strong and strange one. But the fact remains that he who fascinates is bound to destroy, not create. And this suggests the way in which the lack of a suitable environment eliminates genius—by surrounding him, not with calculated antagonism and directed force, but with weakness and passivity. It was this kind of environment, conformist by commercial tradition, that Chapman found smothering American culture and thwarting the country's possible destiny.

Chapman is obviously a forerunner, with Mencken and the writers of *The Smart Set,* of the critical activity which gave its character to the twenties. But though Chapman lived until 1933 he did not take part in the great postwar change or clearly grasp its significance. To him "the war" and "the postwar mood" always meant the events and attitudes of his formative years, the brassy, resonant, hollow years from 1861 to 1914. The second aftermath of blood held nothing for him. The First World War had wounded him in his attachment to European civilization, had deprived him of a much-loved son, and had left the death side of him uppermost. In the twenties his balked energies burst forth spasmodically in utterances of

the most deplorable sort against racial and religious groups, contradictory explosions of anger which he soon forgot, but which revealed in him the accumulation of guilt, the frenzy of impotence seeking a scapegoat for its failure to achieve cultural regeneration.

It is the unmerited lot of those who, like Chapman, are born in the wrong time and the wrong class and with the wrong income—whether too large or too small—that they catch only occasional glimpses of their actual role. At times Chapman knew perfectly well what he would mean to succeeding generations: "I am saying things which will some day be thought of, rather than trying to get the attention of any one." Translate "getting the attention of any one" into political or literary success and you begin to see why it was necessary, beneficent, that Chapman should fail. No man of reputation in politics or letters could have gone to Coatesville, even if such a man had been as ready as Chapman was to risk his life. The increased public importance of the act would most likely have turned penance into riot, and would certainly have robbed the day and the deed of their inward and symbolic meaning.

But Chapman also knew that in order to have the things he was saying thought of in a later day, he would have to appear in his fragmentary and not wholly satisfactory form: "I confess that I had rather stand out for posterity in a hideous silhouette, as having been wrong on every question of my time, than be erased into a cypher by my biographer. But biographers do not feel in this way toward their heroes. Each one feels that he has undertaken to do his best by his patron. Therefore they stand the man under a north light in a photographer's attic, suggest the attitude, and then take the picture—whereas, in real life, the man was standing on the balcony of a burning building which the next moment collapsed, and in it he was crushed beyond the semblance of humanity."

One is struck by the recurrence of the image of burning in

Chapman's life and works: it was by burning his hand deliberately that he tried to atone for thrashing a man with whom he later found he had no legitimate quarrel; and it is as by a kind of capricious flame that his genius gave life to the most miscellaneous of miscellaneous writings—two books on political reform, essays on Greek genius, on Emerson, Whitman, Balzac, Shakespeare; sketches of his contemporaries; translations and moral and religious speculations; a life of William Lloyd Garrison; and numerous attempts at original plays—for adults and for children—on such native themes as Benedict Arnold and John Brown. Much of Chapman's best work was published in periodicals and later gathered into volumes now very scarce; but much else remains, unknown even to scholarship, in the Houghton Library at Harvard.

Yet as one looks today at this neglected but indispensable witness of an age in part destroyed, the first thing one notices is that though the burning building blotted him from view, his features were not crushed out of human semblance. Indeed, in his fiery incompleteness and buffeted integrity he looks like some of his predecessors from Poe to Melville and the elder Henry James, or like his contemporaries Adams and Mencken; he looks, in short, like the American as Critic.

But Chapman would be simply another specimen, of different stature and scope, if he did not possess two characteristics uniquely his—his humor and his style. To this day, and perhaps for all time, the fact that his work gives no earnest of solemnity will stand in the way of his acceptance by some readers: it is so hard, apparently, to believe words that one can readily make out, and so unnecessary to be grateful for thoughts that are given us fully, quickly, and agreeably. Some remnant of savage fear tells us that profundity has no business with the easy and the agreeable, so that in our atavistic moments we do not trust the man who writes as if improvising and who flouts professionalism. Listen to Chapman trying to de-contaminate literature, a premature advocate of the great

books who appeals to the comic spirit rather than to philosophy: "Literature is for our immediate happiness and for the awakening of more literature; and the life of it lies in the very seed and kernel of the grain. Footnotes and critical information attack the creative instinct. The spirit is daunted, the tongue tied by them. Many a lad has known less about Shakespeare after a college course on Shakespeare than he did when the only phrase he knew was 'Aroint thee, witch'—and he didn't know where that came from. Now he can write the etymology of the words on an examination paper; but the witch herself has vanished. Information is the enemy to poetry. If the old Greeks had known as much about Achilles as we do, the Iliad would never have been written. . . .

"A scholar reads the books of other scholars, lest he shall say something that shows ignorance. Conscience and professional ambition keep him at it. He dare not miss a trick; just as the social climber dare not miss a party. Jaded and surfeited, both scholar and climber accept the servitude. They must know all these dull people, because these dull people are in the game that they are playing. Thus, one result of scholars and scholarship is to interpose a phalanx of inferior minds between the young intelligence and the great wits of the past. Must the novice read those forty pages of Willamo-witz-Mollendorff which cover each dialogue of Plato like the grease on a Strasbourg pâté? . . . Accurate scholarship, when it prevails, is the epilogue to literature."

What then was Chapman's intent throughout the variety of subjects and causes that he espoused? If he was a Critic, why is he not as much a parasite on genius as those he attacked? What did he criticize that puts him in a special category? Quite simply, it was the mind of America. Chapman, whose means enabled him to follow his unprofitable bent, made cultural criticism his sole vocation and he suffered the penalty. For it is obvious that the Republic has no use for critics of his sort. Partisan objectors, yes, since they satisfy party feelings.

But a Socrates, no. Not only does such a man annoy, without furnishing a reasonable ulterior motive, but he is usually hard to interpret. What, for example, is Chapman's book on Garrison? How do we classify it? Longer than an essay, it is not a biography, for it pays no heed to proportion or chronology; and though based on much reading and reflection, it does not exhibit that sashaying among monographs which we readily take as a guaranty of soundness.

American historians now treasure Chapman's *Garrison*, which is hard to come by, but its author made not the slightest attempt to have his readers either like it or approve it. Pretense of any kind was foreign to him, and he felt no shame in writing to his wife, about his projected *John Brown*, "You know I've never known the literature of the subjects I wrote on. I never knew the Emerson literature—except Emerson himself." But Chapman went to Harpers Ferry, staying at the Hillton House, and noting that "the coffee is made of peanuts, but the eggs are very good." The remark is a clue to Chapman's criticism, as it is to that of all great critics, from Dryden and Hazlitt to Nietzsche and Shaw: their work is autobiography enlarged; their opinions are not gathered but felt; their truth is not a work of ratiocination but a secretion from experience. Chapman belongs to that company by his dedication and depth, and despite the fact that he was an American working on the native mind.

1957

Remembering Lionel Trilling

Death holds few gifts that the witnesses of her work will thank her for—except at times a merciful swift stroke. But rather more often, when the departed has been chargeable with deeds of note, death earns our grudging thanks for releas-

ing the pent-up praise of many hitherto silent contemporaries. They are shocked into utterance, and their words have the ring of truth. So it has been for Lionel Trilling. Ever since his death last November, we have been learning who he was. With scarcely a moment's hush, the chorus of recognition broke out. Obituaries in superlatives, long articles at the head of reviews, reissues of books, adoption by book clubs, suggestions of collected works, offers of posthumous honors, proposals for biographies, agitation over the fate of his papers—all express a sorrow in which may be discerned a tremor of self-reproach. The *Times* of London summed up the subject of this late *empressement* and the judgment about its cause: "A LITERARY CRITIC OF MAJOR STATURE."

This change in the weather of opinion, experienced meteorologists agree, comes about only because the beneficiary is no longer part of it. For thirty-five years, Lionel Trilling thought and wrote and received due notice as his books appeared. They were admired; they were caviled at; they were liked; they were ignored; they were classified: thoughtful essays from a mind once involved in radical politics and now working for "culture" with the ideas of Freud. The times then and *The Times* now cannot both be right.

It is no doubt unprofitable to look for reasons behind the fact of an unwarrantably subdued reputation, but it may be said in passing that if Trilling had written more novels than one, or if he had spoken as a free lance instead of from an academic platform, the response might have been different—not wiser, perhaps, but louder and nearer the mark. These conditions are at any rate worth noting, because they bear on American intellectual habits during the last half-century and suggest appropriate questions about Trilling's intellectual position, about his life and his career.

In its outward form, Trilling's career typifies the lot of the American writer after the First World War. By the 1920s only the highly successful playwright or novelist could live by literature. Journalism was at once inhospitable and devitalizing;

and it was a long time since consulships and other government sinecures such as had helped Hawthorne or William Dean Howells could be thought of. Arts and letters began to take refuge in the most unexpected sanctuary, the University. Nobody then deemed it a hardship, but rather an advance in our cultural arrangements. The literary youth who in college had had dreams of writing went on to graduate work and found himself in the academic groove without any arduous choice.

Thus it was that in 1925 Lionel Trilling, having just been graduated from Columbia College, began studies for a higher degree, started teaching, first in Wisconsin, then at Hunter, a girls' college in New York City, and finally returned to Columbia as an instructor in 1932. There, in the undergraduate division which he always preferred, and in a seminar for Ph.D. candidates which he and I organized and taught together, Lionel spent all his adult life. Only towards the end did he make three excursions for lectureships at Harvard and Oxford. One could paraphrase Stendhal's epitaph and say: "He lived, he taught, he wrote."

But the academic life, to which he was in a double sense reduced, explains little about the character or significance of his work. Trilling was the very negation of an academic critic. His volleys of thought were not discharged from behind any walls, nor did his complexity subserving clear principles arise from method, scholarly or new-contrived. The clue to the form his genius took lies elsewhere, in his origins and historical situation.

Lionel Trilling was born in New York City on July 4, 1905, in what used to be termed "modest circumstances." The old phrase, which denoted solvent respectability, connoted the lack of expensive experiences, such as travel and a wide acquaintance. But it did often imply a family setting in which the life of the mind holds the highest place. This was true of Lionel. Both parents were great readers—Dickens was read aloud to him before he knew his alphabet—and they could

claim, on each side, close family links with members of the intellectual professions. The education they wished for their son and a musical daughter they regarded as much more than the accepted means of economic advancement. It was a ladder, no doubt, but also a rooftop from which to contemplate the world. A second piece of good fortune for the children was that in those prehistoric days the free city schools had not yet become nurseries of illiteracy and vandalism; they still supplied excellent instruction and thorough preparation for college.

This is not to say that Lionel distinguished himself as a student. When I first knew him in Columbia College, he seemed content to do well, with little exertion, in what he liked and to stumble through the rest. He nearly failed of the degree from invincible ignorance in maths, but a farseeing mathematician-dean rescued him by legerdemain at the last minute. To the superficial glance of another youth, fresh from Europe, the young Trilling appeared to be indulging himself in a borrowed bohemianism. He read much and wrote a few delicate sketches of Symbolist cast for campus publication. He affected a languid, sauntering elegance (of manner, not of dress). And while I was dimly aware of a brooding strength, I failed to make out any particular direction it might take. Nor did I suspect the great shyness which was being masked by a manner and which persisted for a lifetime after the manner was gone.

The first half-dozen years of Lionel's teaching were arduous, at times desperate. The city college for girls, where he landed after his Midwestern beginnings, paid by the piece— one student, one unit fee (slightly larger for the more advanced). During the Depression, Lionel had become the sole support of his family, and in 1929 he married. I had lost track of him, for in college we were only casual acquaintances. On his return to Columbia, which I had never left, we quickly became friends; and in 1934 we were assigned to teach a joint colloquium for upperclassmen. Its contents were "the great

books" from the Renaissance to the end of the nineteenth century; and it was in those weekly Wednesday evenings with senior students, as well as in the private sessions of preparing, that Lionel and I began the association that was to last until his death.

The first years of our teaching together was the time when not merely literature at large, but criticism as a genre was making its way, cuckoo-like, into the nest of scholarship. It was still risky for the young to write and publish "outside"—say, a book review in a weekly journal of opinion—or (as I learned to my cost) to be seen at a concert. Promotion to tenure, that is, final acceptance by the academy, depended on the writing of a doctoral dissertation, and nothing more plainly shows how unprepared the university was for harboring critics than that it allowed Lionel, without a word of warning, to spend seven mortal years in writing a masterpiece of intellectual biography and criticism—his *Matthew Arnold* of 1939. Inappropriate and little regarded as a dissertation ("based on published sources only"), it is still in print and still what one of our less articulate Columbia students called it: "insurmountable."

From the scope of that book and the evident sympathy between author and subject, it has been hastily inferred by some that Trilling's lifework was but a continuation, an adaptation of the gospel of culture. This view is mistaken. Arnold's purpose is mainly a moral purpose. Trilling's is political and intellectual—and moral in a different sense. Where Arnold touches politics, he shows a fear of massed philistines and democrats, and he prays in aid from poetry and the benevolent state. He thinks, moreover, that the historical ingredient in works of the mind is negligible or misleading. On all these points Trilling is his habitual opposite. To be sure, both men use literature to frame a theory of life, but the stance of the *politique et moraliste* is no monopoly of Arnold's. It is a common role since the early nineteenth century, and it implies no common outlook.

The deep difference between Trilling and Arnold derived from their dissimilar upbringing and situations. In the 1930s a young American who would be a critic faced, in life and art, the choice between a reactionist aestheticism upholding the autonomy of the work of art and the Marxist interpretation (and employment) of art as a weapon in the class struggle. Like many others, Lionel was drawn to Marxism by his idealism and generous humanity; but not for long. He soon found unacceptable the apparatus imposed on thought by Marxian teachings and even more repellent the deeds of the practitioners. He began to develop his own Third Position, a position on the Left as a critic of the Left. Out of it came all the premises and conclusions in politics, art, morals, and psychology that made him from the outset unclassifiable.

Since the successive statements of Trilling's thought were grounded in teaching and thinking about literature in the broadest sense, I cannot avoid saying something here about the readings and conversations that Lionel and I engaged in, first as part of our teaching duties, and later as the basis and habit and reward of our fraternal companionship. Our relation was entirely free from the restraints of egotism or envy, and free also from emotional ups and downs. I do not remember in forty-three years of weekly conferrings a single moment of irritation at anything said or done, despite my being much the more impatient character of the two. Throughout, we were always more interested in each other's mind and feelings than in the details of our separate day-to-day existence, though we did not scruple to bring these in if they were entangled with our plans and purposes. We talked of what we knew intuitively to be of common concern, an ever-enlarging field of search and reflection; and we read and discussed nearly all of each other's writings in first draft.

No false conclusions should be drawn from this intellectual communion. We agreed on innumerable points and often could not remember which idea was whose—we would say

that it came "from the bank"—but we also differed, in opinion as in temperament; and we achieved without effort a total independence, an entire individuality, in our acts as in our writings. The evidence is best seen in the decisive matter of style.

Now, common literary tastes and intentions are not a sufficient foundation for lasting friendship, but a common view of life is; and it was that common view which enabled us to diverge in style and purpose while yet imparting to our students a unified mode of thought we came to call "cultural criticism."

No such thing was recognized or in favor anywhere when we began—more by intuition than design—in the autumn of 1934. Cultural criticism was historical criticism, because it regarded circumstance as one means of understanding literature. But such an understanding is incomplete, since it leaves out intention and received meaning, which require judging the work or idea taken by itself. The need, we believed, was for a just union of history and formal judgment, our view of art being that in it Purpose and Necessity forever play hide-and-seek.

Cultural criticism was inevitably damned for overlooking the autonomy of the work of art and its inherent indifference to meaning; for ignoring the dialectic of history and the flimsiness of the cultural "superstructure"; for neglecting the "rigorous" critical methods recently opened to those who could count metaphors, analyze themes, and trace myths. For us, a critic or student was ultimately on his own, his sole resources being strenuous reading and a demanding imagination. To this exercise, unassuming but difficult and fallible, all our preparation and all our Wednesday evenings were devoted.

What was the common view of life which underlay this wayward venture? Here, though still speaking for both of us, I return to the proposition that Trilling developed and illustrated throughout that galaxy of essays he published during

the last thirty-five years. It is this. Intuition and perception alike show not merely that life overflows ideologies and coercive systems—so much is obvious: there would be no systems and ideologies if life were not impossibly hard to regiment. The contention is rather that the only things worth cherishing in life are necessarily destroyed by ideology and coercion from their first onset. In other words, variety and complexity are but different names for possibility; and without possibility—freedom for the unplanned and indefinite—life becomes a savorless round of predictable acts. There is then no point to literature or thought; there is in fact no literature and no thought, but a mere ideological echo of a diminished life.

For a critic, the best way to sustain the possibilist mind was clearly through the examples of literature, the lessons conveyed not by or out of an abstract of meanings, but out of the love and pleasure of literature itself; out of the fears and passions literature holds and radiates, out of the illusion of timelessness it inspires—feelings and illusions which can only be felt spontaneously; awakened, perhaps, but unlearned, and which constitute the chief freedom of the mind.

This is the "word" that Trilling felt he must utter and illumine, as indeed he did with ever-widening powers of reference and interconnection. To the very last, as in his Harvard Lectures entitled *Sincerity and Authenticity* (1972) and his Jefferson Essay *Mind in the Modern World* (1974), his affirmations were opposed not solely to overt schemes of social and political repression charged with philanthropic intent, they opposed equally all other fixities professing to be sufficient or complete, whether derived from natural science, depth psychology, or peremptory moralizing.

That this outlook is not a disguised anarchism, a longing for an unconditioned life, is shown in its first full exposition in the volume of essays that has given a new phrase to the language, *The Liberal Imagination* of 1950. That imagination was once expansive and generous, but time and circumstance had reduced it to a mere animus propelling certain judgments

triggered by certain words and images. Political liberalism in the 1880s had responded to unavoidable pressures by becoming a program of social management, and this explained the twentieth-century liberals' sentimental attachment to the Soviet Russian society. At the same time, Western liberals retained a visceral sort of individualism and continued to demand intellectual freedom. Between these incompatibles, the liberal position amounted to a pseudo-ideology made up of pieties about the poor, the child, the criminal in our midst. It was a residual Christianity, largely negative, and which could thus be very fierce in attack and defense: attack against institutions and traditions at home, and defense of those regimes abroad that seemingly organized and enforced the good of the common man in the name of equality. For the sake of a "rational" human life, liberal culture felt it imperative to simplify.

To these reflex acts and ready-made ideas, Trilling gave in effect the rejoinder that so often marked his teaching and his conversation: "It's complicated. . . . It's much more complicated. . . . It's very complicated." The positive counterpart was also, in effect: "Continue to think and feel, and to will only what you have first fully imagined." To that imagining, literature, especially the novel, is the great inciter. The great novels are also the books that in his time Trilling could count on his readers knowing or being willing to take up. Hence his many essays on the novelists, concluding with the posthumous "Why We Read Jane Austen."

Yet there can be no doubt that Trilling's teaching of the great books that are not novels played an important part in the formation of his thought. He differed from his peers (as we flatteringly call them) in two important respects: first, he had to reread at least once a year the works that most intellectuals sooner or later reduce to handy clichés, their own or the conventional ones. At this late hour of the West, intellectual debate is often carried on between writers of equal powers but unequal armament—on the one hand, the writer who has made

it his business to study a thinker or school, and against him the "well-educated" who knows what is to be said on the subject. Trilling had the advantage of repeated immersion in the facts. This explains why, unlike almost all his contemporaries, he never uttered the usual things about Rousseau (back to nature, the noble savage, a maker of paradoxes, the father of progressive education): he knew the works and rated them high.

His second advantage was that he was virtually alone among critics in not having been reared on the French critical tradition. He read the language with difficulty and escaped the force of those writers that gave Irving Babbitt, T. S. Eliot, and their followers formulas from the 1890s to adapt to the 1920s: the great troop of analysts from Remy de Gourmont and Léon Hennique to André Gide and Ernest Seillière. Of course, Trilling read Eliot and Babbitt, but they did not "take" in the proper way, the ground not being prepared by a firsthand knowledge of the French poets and men of letters.

A different tradition more than filled this gap—the English liberal tradition that includes Mill and Arnold but is not restricted to them, whatever modern opinion may say. There is Burke and Hazlitt, Bagehot and James Fitzjames Stephen, Ruskin and Morris, Yeats and even Walter Pater in his radical early days. Since the turning of liberalism on its head that I have referred to, it is increasingly difficult to make oneself clear by referring to thinkers as liberal or conservative, especially when the new criteria of social democracy, which are irrelevant historically, are added to the diagnostic list. What *is* clear is that the men I have just cited exhibited in their time a self-critical liberalism of the kind that Trilling thought indispensable. When he deplored the lack of an intelligent conservative tradition in American literature, he meant the absence of discussion about premises and consequences such as is found in England in the liberals themselves—Mill as well as Bagehot, Stephen, and the rest. In the United States, even before the contentious 1930s, the party lines were so drawn that only headlong advocacy or a bland assumption of moral

unanimity was to be found. The truth was that, as always in the nature of important ideas, "it's much more complicated, it's very complicated."

So imaginative a vision of our twentieth-century predicaments and automatisms deserved to be shown in a piece of imaginative literature, and Trilling seized the earliest chance to make the attempt. The result was his novel, *The Middle of the Journey*, first published in 1947 and reissued last year, when more than one critic was pleased to call it a masterpiece. Some months after its first appearance, it attracted attention because its central figure drew upon the life and character of Whittaker Chambers. After the trial of Alger Hiss, inferences were made about other persons in the story; but as their creator said in the Introduction to the reissue, the attributions are groundless.

Nor is it because of the link with a namable hero (or villain) that the work marks a moment in our century's intellectual history, like *Fathers and Sons* or *L'Education Sentimentale*; it is because it depicts the aberration of reason and deadening of sensibility that I have been trying to suggest in discursive terms. It would take more than an essay of quasi-personal reminiscence to suggest further how *The Middle of the Journey*, whose title from Dante's opening line reminds us of the descent into Hell, was related in the author's mind to the vast subject of art in its modern role of angry prophet and exclusive savior. Liberal unimaginativeness about society and eager advanced views in art go hand in hand, and the principle of perpetual displacement by a new avant-garde encourages the taste for restless change. A corrective judgment can only resist fashion by being comparative, that is to say, historical, but this is incompatible with taking pleasure in obsolescence. The product of all these sentimentalities is the culture-philistine, whom Nietzsche pinned on a labeled card a century ago. Multiplied since by access to (a half-) education and by the mass diffusion of art and thought, this new type of culture consumer finds a literature written for him, serving his

predilections by contrived shock, routine political dissent, and sadistic assaults on the Old Philistine, long since dead, but theatrically still necessary.

It is at this point that, in Trilling's work (and, I may add, in mine), the maxim that literature is a criticism of life is given its continuation and counterpart: life is and ought to be a criticism of literature. Where one dips down for a sample of "life" is another question. But since the French '90s, with their separation of art from life and morality, the critical game has permitted itself a convenient double standard. High art is autonomous—nothing to do with anything outside itself; but in order to get rid of bad literature (cheap or merely unfashionable) just say it's a travesty of human life as we know it. Ridden by such ideas and seeking new ways out of the straits, writers and artists have finally arrived at anti-art, with its fine democratic overtones of Any Number Can Play, while critics have pushed back "life" to a surmised pre-infantile stage, or moved it ahead into an elective madness—all for the sake of an untroubled existence: no more effort of will, no conflict or other hard conditions. On this topic Trilling wrote one of his last essays, a brief manual for endurance under modern cultural exposure: "Art, Will, and Necessity."

One wishes in vain that he had embodied his perception of types and attitudes in other novels and that he had lived to finish the Memoir he had just begun about the middle of *his* journey—the 1930s and '40s. The absence of other novels is not to be explained by native bent or turn of mind. Trilling's desire to write fiction was strong. He wrote some short stories, including the superb and much anthologized "Of This Time, Of That Place," where the reader will find in the depiction of two diversely blinkered minds, who meet tangentially in the clear consciousness of a third, a prophetic refutation of the recent theories about the superiority of madness to which I have alluded. The main reason why Trilling did not write more novels is that teaching leaves too little energy and

unbroken time for self-absorption, let alone for writing on the large scale. Lionel was cursed with a pedagogic conscience in a time when lofty neglect was readily permitted to men of his standing. He did not take advantage of the license but did his duty to his students in class and conference, discharging it as if each of them too were a mind alive. This perpetual squaring of one's own mind with the demands of another's is exhausting, and the necessity of wide and repeated reading for our seminars was only part compensation.

The habit of teaching, moreover, makes the critical didactic essay seem the more accessible form of expression in the intervals of lecturing, counseling, and meeting in committee. Hence Trilling's books, composed of essays and lectures worked and reworked until they formed: *The Liberal Imagination* (1950); *The Opposing Self* (1955); *A Gathering of Fugitives* (1956); *Beyond Culture* (1965); *Sincerity and Authenticity* (1972); and, in addition, the little-known series of introductions in the three volumes of readings called *The Experience of Literature* (1967), in which the reader can learn, free from polemical reference and close to the summits of world literature, what is meant by a literary critic of major stature. Among other, still scattered essays, a number deal with the thought of Freud, to which Trilling returned in many connections, too complex to discuss here. It is enough to repeat that Trilling could no more accept the reduction of literature to psychic determinants than to economic. For the "interpreters" who made clinical cases out of great novels and poems, Trilling had only good-natured scorn. Anybody possessed of even a simple liking for literature could see that "it was more complicated."

Having instanced the constraints of the academic life as a reason why *The Middle of the Journey* had no counterparts, I want to add two relevant details. Trilling received from his, or other, publishers no urging to write another novel. Indeed, the publisher of the first one, speaking to an English colleague who showed interest, shrugged it off as an unimportant excur-

sion. In fact, Lionel Trilling's production in general was never encouraged, stimulated, by "the trade," including editors, but only by a handful of intimates.

Again, his devotion to his students requires the modifier that there were times when he was heartily sick of their presence and their needs and wanted to hide and think like a hermit in a cell. Luckily, it was in the spring that this fit would come on him, whereas my lackluster eye tended to turn upon the group in autumn. On first acquaintance, Lionel was warmly receptive to the assorted temperaments we had chosen for the year and was immediately popular, while I seemed to them a beast, though possibly a just one. But when his friendly curiosity cooled off, I would become the refuge of the bruised. He and I would accuse each other of being a saint for enduring one or another irritating youth, but it is clear that with us saintliness was merely a seasonal weakness and not really a rooted fault of character.

Without trying, Trilling naturally made disciples, and of the best kind—not expounders of a system or repeaters of catchwords, but scholars, critics, teachers who were awakened from dogma by Lionel's "word" or who caught on the wing an idea, perhaps casually thrown off, and nurtured that germ into a free-standing plant. It would be difficult to exaggerate the spread of Trilling's ideas in these ways, for his teaching was, by the nature of his thought, a reshaping of the mind, not an indoctrination. And in assessing influence one must also consider the relative effect of publishing in print and in class. The printed idea reaches an uncertain number of readers and for but a few moments. Most of them are adults and impregnable, whereas students are still plastic and they drink in during thirty to forty hours each term not only the words but also the presence of the thinker. The many hundreds who listened to Lionel Trilling over a span of forty years may have believed that they were studying this or that "course"; actually they were permitting their minds to take an imprint which, given interest and admiration, is permanent.

In that same period, the young showed as always a preference for systems and methods by which the labor of learning about the world may be reduced and the degree of certitude increased. Trilling no doubt disappointed some by having no method or system to offer. In that disappointment there is always a trace of regret at not belonging to a specially equipped group—a task force for the elimination of literary problems. With his sense that intelligence is where you find it, and irreplaceable when found, Lionel was always hostile to the claims of these self-licensed groups. He attached no preferential labels to the diverse activities of the mind. He was not a "humanist" against science or social science, or a "critic" against "scholarship." Nor did he look down on the general public as an undifferentiated mass of barbarians: all his remonstrances were directed in the first place at professionals who could fight back and whose views were public and prevailing.

It is therefore not surprising that in 1950 Lionel Trilling greeted with interest a proposal made by a former student for starting a book club on the usual pattern, but purposing to disseminate "good books." If the scheme succeeded, it would benefit readers and authors alike, by breaking through the barriers that stand between a "trade" book and its potential buyers. To make the plan work it was necessary not only to choose several books each month, but also to introduce them to the club subscribers by means of a critical article, a review not a blurb. And this double duty being more than one man could carry, it must be shared with like-minded critics. Lionel approached Wystan Auden and me, and we performed in remarkable harmony for thirteen years, each of us writing in the form of these introductions the equivalent of a couple of volumes. It was from these small essays of his that Lionel made *A Gathering of Fugitives*.

The perceptive reader will have noticed well before this point that there must have been in Lionel Trilling's work an opposition of some kind between the desire to show the complexity

that thought must attain in order to do reality justice and the need for lucid simplifying which teaching undergraduates or reviewing books for general readers entails. The tension was there, and it was at times painful. It was the price paid for living in our odd demotic culture and working in an institution dedicated to art and intellect yet bound by the written or spoken word. Popular standards apply throughout; only scientists have the right to be complex—or at least they have got hold of the only excuse.

How any of us resolves this antinomy between telling what we perceive and telling all to all obviously affects the quantity of our production and the manner of producing it. Trilling's collected essays will bulk larger than they seem to do now, because of the number of pieces—often lectures—that he never brought together. But it remains a fact that he was shackled by the contradictory requirements I am discussing: he wrote easily and fast, and he composed very slowly. Except once or twice, a finished essay would represent from five to fifteen times the number of pages it finally filled. The *Matthew Arnold* of which I read the successive chapters in countless drafts, must have consumed a dozen reams of paper.

The outcome of this struggle was Lionel's characteristic style. It is not to everyone's taste, especially if one approaches prose with pre-established patterns of how it should sound and break up its cargo of thought. But whoever is willing to let the long roll and retreat and fresh surge of Trilling's thought carry him from outset to destination will find that it is clear, firm, undeviating despite its wave-like movements, and unambiguous in its delivery of the particular complication it proposes to establish. It may seem strange that differing as we did in our aims and dispositions we could do each other any service by reading each other's first legible drafts. Let somebody else find the logic of it; each of us possessed the intuition of what the other wanted to do, and we challenged diction and thought to that end, not to redirect them to another.

This generality covers the day-to-day exchanges, so to

speak. On special occasions, important exceptions occurred, on both sides. I might strongly object to what I considered an excess of elaboration, a surfeit of modifiers intended to take care of imaginable demurrers or confusions. "It's complicated *enough!*" The debate—warm from opposite convictions but never straying from the temperate zone—would often end far from its subject. By dint of illustration and argument, we would find ourselves conversing animatedly about something else, the sentence or paragraph forgotten. The ultimate decision about it would be a compromise, or the wretched thing was removed, or it was *stet* from stem to stern. One or two of Lionel's essays still bother me by what I think is too many coils of wire for the current. But those belong to the middle period—the '50s. The works of the last fifteen years strike me as the perfect matching of meaning and form.

Those divergent aims of ours are perhaps clear enough. Lionel was bent on developing the large consequences of the often hidden relations and implications for life that he found in literature. I was trying to compress great batches of fact and opinion into descriptions and conclusions that the reader of history could grasp and remember and make part of his stock of prudence or wisdom. I struggled with a different kind of complexity, appreciating it as much as Lionel did his, but trying to reduce it fairly rather than project or amplify it. My bugbear was the historian who publishes his sack of notes. The excess on my side that Lionel reproved was, therefore, a characteristic unwillingness to "go into it." Some decisive formulation of mine would make him curious, raise his antennae for the complex, and he would say, "Open it up—that sentence deserves a paragraph"; or "Only a paragraph! You need a page!" Seen apart from the practical purpose in hand, these mutual summonses must at times have resembled high comedy: I wish I had been there to see it.

To speak of the comic and the practical in our friendship makes it appropriate to close these random opinions and recol-

lections with a word more on Trilling's temperament. In one most respectful obituary, his person was described as showing to the world "a sad, solemn sweetness." This is wrong on all counts. He was not solemn or sad but, whenever chance offered, bursting with the impulse to joke, ironize, make puns, and be gaily irresponsible. He naturally did not indulge his high spirits on the platform, and his features when thoughtful or intent may have given the impression of rooted melancholy. Perhaps even with friends he may, while fishing, have looked grave: it is a solemn business, of which the platonic idea escapes me, and to which he attached great importance. But with all allowances made, his enormous *power* precludes the notion of a mild melancholic gazing at life with only an inward response.

As for sweetness, the word is again inappropriate. Lionel had great generosity as well as civility and tact, and he often gave others an impression of invariable gentleness. That was unintentionally misleading. He reserved his tender feelings for a small group, though he treated with delicacy, on principle, all who approached him and were willing to return his courtesies, social and intellectual.

This admirable conduct and character, a well-wisher who was not also a friend might be tempted to regret. Had Trilling been less shy and honorable, more moody, tempestuous, and self-willed, a likeness of him closer to the expected image of the thinker-pathfinder would have impressed itself on the public mind and made more dramatic, more emphatic the bearing of his "word." At the end of his life he knew his worth but not his "place." None of his belated panegyrists had distinctly let him know it. Nothing we can do now will repair the oversight, which has worked to our disadvantage much more than to his occasional disappointment. *1976*

IV

On Language and Style

Rhetoric—What It Is;
Why Needed

Y ou want to be a writer, or let us rather say: you want to write. Or again, you do not want to write but are required to. In any of these cases you face Difficulty. The trouble is not "to learn to write," because you already know how to form letters and words and you have written prose for years. But you probably need to write better, or would like to—with less pain each time and with fewer faults and errors. Writing always presents problems, dilemmas, some of which beset all writers, even great ones; but there is no need to be baffled by *all* the difficulties every time you write. The effort to which you are being invited is to learn the usual pitfalls and how they are avoided, while also learning the devices—tricks of the trade— by which writing can be both improved and made easier than it seems to most people. With alertness and practice, writing can in fact become enjoyable, like physical exercise or playing the guitar.

By the same effort, you may also learn to be clear and to afford pleasure to those who read what you write. Bear in mind that the person you address, friend or stranger, is like you in his capacity for being bored by dull writing and irritated by what refuses to make sense. Consider the following exchange of words between persons whom we will call Q. and A.

Q. There was one other you remember
A. There was like I said
Q. And the one you knew I mean the one
A. The one yes that's the one I knew otherwise
Q. But not his name just another
A. Yes like I said

Why is the meaning of these few plain words so hard to follow? The dialogue, as you may have guessed, took place in court. You must imagine it as very brisk—a series of mutual interruptions, which the stenotypist took down as so many spoken words and nothing else. Before they could be printed for the report of the trial, punctuation had to be supplied, in order to reproduce the connection or disconnection of ideas. For the intended meaning is not apparent and how to punctuate not obvious. In the first question, for instance, did the attorney say:

"There *was* one other—you remember?" or:
"There was *one* other, you remember?" or:
"There was one other [that] you *remember?*"

In speech the pauses, stresses, rising inflections, and other uses of the voice and facial expression help to make the meaning clear. There is also context, which is that part of the entire situation which explains another part, by ruling out such doubts as are expressed in the three possibilities just cited.

But even with correct underlining and punctuation, which partly make up for the indications of voice and face in speech, the chances of misunderstanding remain great, because the art of writing differs at many points from the practice of speaking words. Even in court it takes a great many questions to work the meaning free and clear of entanglements. If you observe your conversation with friends, you will note the same difficulty. Few people organize their thoughts and words in fully intelligible remarks. It seems easier to use a sort of oral shorthand and rely on the listener to jump to the

right conclusion. He often fails. You correct him or he asks you questions to settle his uncertainty.

With a written text there is no opportunity to ask questions. All the reader has is words and punctuation marks. It follows that these must be set down right—right for the purpose and right for the reader. *Rhetoric is the craft of setting down words and marks right;* or again: Rhetoric shows you how to put words together so that the reader not simply may but must grasp your meaning.

Rhetoric in its essence is not concerned with your reason for writing. It is not for "formal writing" or "important writing" or "official writing." Leaving a note on the door for the milkman, or sending news to the family, or translating one's confused feelings of loneliness and longing into a love letter—all these alike make demands on rhetoric. The word "rhetoric" comes from a Greek root meaning "word" or "I say," and for centuries the term was used for the art of haranguing masses of men in the open air on political or legal subjects. Now the meaning has shifted with changes in civilization and it refers chiefly to the art of making oneself understood in the modern situation of continually having to put words on paper for the perusal of readers known or unknown.

Almost any professional writer will tell you that nobody can teach another person to write. That is true. But all writers admit that they were helped by criticism; somebody showed them the effect of what they had written—the unintended bad effect. In doing so the critic pointed out where the trouble lay and perhaps what its cause was. Since troubles of this kind are not unique to each performer, it is possible to discuss types of fault and suggest how to correct or avoid them. That is all that a handbook of rhetoric does.

The truth remains that the would-be writer, using a book or a critic, must teach himself. He must learn to spot his own errors and work out his own ways of removing them: "This is the bad phrase (sentence, connective, transition); what do I

A Jacques Barzun Reader

put in its place, or how do I get around it?" Every writer asks himself this sort of question a hundred or more times in each extended piece of writing.

The first job, then, is to look at what one has spontaneously written and go over it critically. This is not easy. The mind tends to run along the groove of one's *intention* and overlooks the actual *expression*. That is why writers usually put their work aside for some days and go back to revise when the *ideas* have faded from the memory and they can scrutinize the *wording* with a stranger's eye. But this delay has one drawback. If the first draft is not reread on the very day of writing, one or more phrases may later prove incomprehensible, their meaning irrecoverable. Hence the first brushing up while one's intent is fresh in the mind.

We are thus led to ask what the writer looks for and how he trains himself to look for it. The answer is: he makes himself habitually aware of words, positively self-conscious about them, careful to follow what they say and not jump to what they might mean. Suppose he finds a headline in the paper which reads: "City Bottleneck Soon to Be Broken." If he has the slightest humor in him, a concrete image will flash before his mind's eye and he will laugh. *Bottleneck* as a metaphor means *traffic jam, congestion, slow exit*. But as soon as the idea of breaking is joined to this figurative expression, the bottleneck becomes literal again and one hears the tinkle of falling glass. This danger from metaphor everybody has heard about, but it is not the worst. There are hundreds of other pitfalls to be avoided, confusions to be dispelled, common errors to be rooted out of one's verbal habits, before one's prose can be called good. And I mean by good reasonably clear and straightforward.

In saying that a person who wants to write adequately must put his mind on words to the point of self-consciousness, I was not exaggerating. Words for him must become objects in themselves, as well as automatic signalers of meaning. (Notice

152

"signalers," which I have just used: have you ever seen it? Is there such a word? Why not "signals"? Explain to yourself the difference between the shorter and the longer form—and why not just "signs"? If questions like these leave you undecided, reach for the dictionary.)

What a fuss over a word! Yes, but let me say it again: The price of learning to use words is the development of an acute self-consciousness. Nor is it enough to pay attention to words only when you face the task of writing—that is like playing the violin only on the night of the concert. You must attend to words when you read, when you speak, when others speak. Words must become ever present in your waking life, an incessant concern, like color and design if the graphic arts matter to you, or pitch and rhythm if it is music, or speed and form if it is athletics. Words, in short, must be *there,* not unseen and unheard, as they probably are and have been up to now. It is proper for the ordinary reader to absorb the meaning of a story or description as if the words were a transparent sheet of glass. But he can do so only because the writer has taken pains to choose and adjust them with care. They were not glass to him, but mere lumps of potential meaning. He had to weigh and assemble and fuse them before his purposed meaning could shine through.

If you will set about mastering this rebellious material, the reward—I can guarantee it—is that you will soon find words interesting. Making them do their proper work will become a hobby. You will catch yourself reading the ads in buses to improve them and injecting sense into the directions on the bottle, because you will recognize the types of mistake the writer fell into.

But ads and printed instructions and your friends' stammerings are not enough. Reading abundantly, in good books, is indispensable. It is only in good writing that you will find how words are best used, what shades of meaning they can be made to carry, and by what devices (or the lack of them) the reader is kept going smoothly or bogged down in confusion.

You may think the sense of motion and pleasure depends on the subject matter. That is not so. It depends on tone, rhythm, sentence structure, selection, and organization. The *composition* of all the elements of writing is what occasions the reader's pleasure while ensuring his comprehension.

The writer, consciously or not, writes for someone. He begins by being his own audience, in the sense of having to act toward himself like a demanding reader. His perpetual question is: Do these words, does this paragraph, does the entire piece, suit my present purpose? The purpose at large is always the same: it is to be understood aright. Reader and writer have both wasted their time if mental darkness is the only result of their separate efforts. And—this is the very ethics of writing—the reader's part of the effort must never become a strain. You have no doubt attended speeches or lectures that consisted of a paper read aloud. These are often dull and hard to follow, not because of poor delivery or poor material, but because of a defect in the rhetoric used. The person on the platform is not making a speech, but reading an essay; that is, he has neglected the special needs of listeners. The syntax, rhythm, diction, and other elements of the prose do not suit the occasion.

The adapting of words to needs, this goal of *suitability*, about which the writer continually challenges himself, naturally breaks up into a great many particular questions—is this the suitable term or form? the suitable order of ideas? the suitable length? and so on. At every point there is a choice to be made ("Do I use 'signs,' 'signals,' or 'signalers'?") and behind the decision there must be a reason. For to acquire self-consciousness also means finding reasons for what you do with each word and being able to state them. Granted that after a while most of the choices are made by reflex action on seeing what the trouble is, that desirable speed and sureness come only with practice. And practice gets under way only when one has learned to *see a choice wherever there is one*.

Your inner response to what I have been saying may be:

"That's all very well, but it's hard enough to make a start on a piece of work and push through to the end without getting into a nervous state over each miserable word." I should not blame you if the prospect I have raised of endless "choices" made you groan. But hold on! You already make choices as you write; only, you are not aware of them, and so probably make them blindly. How do I know? I know because I am a writer myself and because I have watched students writing exams. You do not run on like a streaming fount of words any more than they or I do. You pause and chew your pencil or x-out phrases on the typewriter. You hesitate because you feel your thoughts leading you this way or that, and you must choose—or else halt altogether. When you get stuck it is no doubt because you are facing so many possibilities that they cancel each other out. Your mind, you feel, is a blank.

I am not proposing to add to this paralyzing excess, but to suggest ways of sorting it out, of testing the words and forms that crowd your attention—or that refuse to come because of that crowding. Without damage to your intuition of what is good or suitable, you will find yourself developing principles of choice, devices for substitution, heightened powers of awareness about the work in hand. In law, medicine, diplomacy, business administration, scientific research, and other professions where writing is frequent, the subject matter itself often provides the writer with such decisions and devices ready-made. These are the technical terms that come easily to mind and must be used correctly or not at all. The undertaking proposed to you in this book is to acquire the same control over common words that the professional has over the technical—and this for whatever purpose you may wish to use words in future.

1975

The Retort Circumstantial

Mr. Donald Lloyd's article is the culmination of a lively correspondence between him and me, in the course of which I feel sure that I repeatedly cut the ground from under his feet. Since from the outset he hadn't a leg to stand on, my efforts were bound to be useless, but we were both having such a good time that neither of us noticed his plight. At my suggestion he has consented to display his miraculous position in public, and I must therefore return to the charge. The public will judge.

It seems clear in the first place that by preaching the attitude of the mere recorder, the *registrar* of linguistic fact, Mr. Lloyd disqualifies himself for remonstrating with me or anybody else. I, as a writer, am his source, his document, his *raison d'être*, and he can no more logically quarrel with me than he can with a piece of papyrus. Nevertheless, I am willing to concede his human (and very modern) right to inveigh against my moralism in the tones of an outraged moralist.

What then does his objection come to? That in seeking to criticize certain tendencies in current literary English, I am usurping an authority I do not possess and interfering with the natural evolution of the language. This is the prime fallacy in his case, which rests on a chain of reasoning somewhat as follows: English has greatly changed through the ages; many of these changes were resisted by purists; but the evolution was irresistible and the result something we now consider correct and natural. Hence Mr. Barzun's attitude is *contra naturam*; he is an old fogey, a snob, and an ignoramus who thinks he can set his face against the future only because he is blind to the past.

The truth is, of course, that one does not obtain "nature" by merely stopping human action, wise or unwise. Nor can we know what is inevitable until we have tried good and hard to stop it. The whole analogy with nature is false because language is an artificial product of social life, all of whose manifestations, even when regular, bear only a remote likeness to the course of nature. Being a social product, language is everybody's football, and that is precisely what gives me, as well as Mr. Lloyd, the right to kick it this way or that by argument.

And here it is important to remember that resistance to change is by no means futile. The history of the language is not what the gallant libertarians make out—a struggle between the dauntless Genius of English and a few misguided conservatives. It is a free-for-all. At this point it is usual for the advocates of the "Hands Off" policy to trot out the word "mob," which Swift attacked with several other curtailed forms, and pretend that it was ridiculous of the Dean to boggle at it, "in the light of what came after." Well, what came after is that we deodorized "mob," and abandoned altogether the other vulgarities he was deprecating: we no longer use "rep," "pozz," "phiz," "hipps," or "plenipo." The future, in short, belonged as much to Dean Swift as to his opponents—and rather more if we count the hits and misses.

So much for the pseudo-naturalism of the linguistic registrars. Their vow not to judge among words and usages is a fine thing as long as it expresses a becoming sense of incapacity, but it must not turn into a union rule enforceable on those who have taken precisely opposite vows—namely, to exploit, preserve, and possibly enrich the language. This is the duty of the writer, it calls for judgment, and it brings us to that blessed word "disinterested," which seems to have acted on Mr. Lloyd like a whiff of mustard to the nose.

My simple and meritorious deed as regards "disinterested" was to draw attention to its widespread misuse as a duplicate of *uninterested*. Examples abound, and the fight against the plague may already be lost without the confusion being any-

thing like over. Every piece of printed matter exhibits it, and nearly every conversation. Just the other day I heard this sentence, spoken to identify a stranger: "He is an impresario, but when it comes to art, he's completely disinterested." Did the speaker mean, X has no interest in art? Or: he is so much interested in it that money is no object? According to current usage this is impossible to determine without questioning the speaker. Not even his presumed degree of education will settle the matter, for the wrong use has affected all ranks.

At the phrase "wrong use," Mr. Lloyd twitched his nonexistent leg, and with his hands made the motions of a man taking to earth in a dictionary. A few American, and especially collegiate, dictionaries do give the meaning "uninterested" as a second choice—which is a sufficient reason for me to view with a lackluster eye Mr. Lloyd's naïve faith in lexicographers. The one work that seems relevant to the argument is the *O.E.D.,* which gives us the history of the word. It tells us that the meaning *un*interested is obsolete and it lists five separate earlier forms, going back to the French of Montaigne, all connected with the idea of "removing the self-interest of a person in a thing." As an English adjective, examples are given from 1659 to Dr. Livingstone in 1865, with the meaning: "not influenced by interest, impartial, unbiased, unprejudiced." My original remark was to the effect that nowadays the "disinterested judge" is probably taken to mean one who sleeps on the bench. My final remark is: As a writer concerned with the precision and flexibility of the language I use, I cannot regard the return to an obsolete and ambiguous form as useful or in any other way justified.

I now carry the war into the enemy's camp. If instead of complacently taking notes on the growing confusion, and protecting under pretext of "science" the vagaries of modern usage, Mr. Lloyd and his compeers would reflect upon their data, they might be able to safeguard the complex instrument of our speech by telling us when and why these deplorable losses occur, and how they might be repaired—loss of clarity

and exactness at large, absolute loss of meaning in a word such as "disinterested" and in another such as "connive." Everyone has seen this last used as a synonym for "conspire" and "contrive"; I have heard it in the intransitive sense of "manage" about some trivial business: "How did you connive?" These instances are not isolated, and I shall accept statistical refutation only from someone who can show that he reads each year more written matter than I, and hears a greater variety of local uses from a larger body of students.

Meantime, the generality which I hazarded, and which Mr. Lloyd assails as undemocratic and tainted with critical feeling, is that with the rapid extension of educational opportunities, many persons of otherwise simple hearts are snatching at words half understood in order to bedeck their thoughts. Only the other day I read in a "literary" review about a distinguished American critic who was so full of insight that he could be called a *voyeur*. The writer meant *voyant* if anything, but he could certainly be sued for slander before an educated court.

Foreign words are always treacherous, but what of the newspaper editorial which states that Mr. So-and-So's election is "highly fortuitous" (to mean "fortunate"), or the college dean who tells parents that his institution gives the students "a fulsome education"? Then there are those who believe that "to a degree" means "to a certain extent," instead of just the opposite. Have not the oil and drug companies been forced to change their labels to "flammable" because many users of their products took "*in*flammable" to mean non-combustible? At that stage, the issue ceases to be comic or inconsequential. With the tremendous output of verbiage by air and print to which we are all subjected, the corruption of meaning is rapid and extensive. We are at the mercy of anyone who thinks the sense of a word is discoverable by inspection, and whose misuse consequently liberates an echoing error in the minds of his peers.

To put it differently, the danger to English today is not

from bad grammar, dialect, vulgar forms, or native crudity, but from misused ornaments three syllables long. The enemy is not illiteracy but incomplete literacy—and since this implies pretension it justifies reproof. There is no defense against the depredations of the brash except vigilance and no quarter given. I am certain that in this regard Mr. Lloyd, who writes with so much felicity and force, does exactly this in his capacity as a college teacher of English. Why then does he not square his precepts with his practice? I cannot answer for him, but to help his amputated philosophy to its feet, I want by way of conclusion to quote from a writer who, being anonymous and attached to both journalism and business, can hardly be suspected of flaunting pedantry and preciosity. The extract is from *Fortune:* "Language is not something we can disembody; it is an ethical as well as a mechanical entity, inextricably bound up in ourselves, our positions, and our relations with those about us."

1951

The Necessity of a Common Tongue

As one looks at the state of our public and private life, one is struck by a paradox. On the one hand, whatever social and individual freedom we enjoy is a product of pluralism in theory and practice. On the other hand, every move made for the extension of freedom to the minorities results in demands for a self-centered, exclusive separateness which is the opposite of pluralism. A strong desire prevails *not* to engage in "conversation." Groups emphasize their roots; the public schools are beset by difficulties of "communication," in whatever language; and bilingual programs try to offset this return to quasi-tribal existence. These programs cover not just the few large groups one readily thinks of as speaking English unwillingly

or with difficulty—the Black or the Hispanic; the number of languages offered comes to eighty-five and includes many aboriginal tongues as well as dialects. But there is doubt whether the teaching leads to schoolwork in American English; the tendency seems rather to reinforce the existing barriers, to recreate distinct nationalities: not cultural pluralism but cultural solipsism.

This attitude naturally goes beyond the mere use of a vocabulary and grammar. Language molds our thoughts; it gives color and shape to our desires; it limits or extends our sympathies; it gives continuity to our individual self along one line or another. These effects occur whether we are conscious of them or not. It is fair to say that they are not deliberately sought, but the resistance to changing native ways of speech *is* deliberate; it is an effort at self-assertion to preserve something valuable. It also assumes that all languages and dialects are of equal value. That is the tragic mistake, the self-inflicted wound that may be fatal—and tragic and fatal not merely to the nation that suffers this resistance, but to the resisting individual and his legitimate hopes.

The false assumption about language comes from pride, of course, but also from ignorance, both understandable enough. Still, that state of mind and feeling raises the question: Is a standard language necessary? The question deserves to be settled, not arbitrarily by the native speakers of a dialect or of Standard, but reasonably by all those who can be brought to judge the facts of the case. What are these facts? They fall into two sets, whose meanings are not hard to grasp. The first set of facts has to do with the character of a widespread standard language; or, What makes it different from some other kind of language? The second set of facts has to do with the origin of a standard language; or, How did it come to possess that character?

We start with a fact that we all feel instinctively—the difference in the forms of speech that we use on different occasions. Casual talk with an old friend differs from the language used

during an interview to obtain a job. These kinds shade into each other, overlap in vocabulary and grammar at many points, but at the extremes the words and the forms—vocabulary and grammar—are noticeably unlike. There are even differences in the speech that one finds natural in different moods: remembering a birthday party or a funeral brings different ranges of words to the mind. All this is to say that language is a flexible instrument which responds to the thoughts and feelings of the user; it adapts itself to the occasion and the purpose in view.

But the fitness of a word or grammatical form is not determined solely by the user; it is also arrived at by a kind of social decision. The habits of surrounding speakers compel us almost automatically to use what is appropriate. Yet here again differences may occur. At the funeral, for example, some oversensitive souls will be careful to say "passed on"; the more forthright will say "died"; and only the hostile or heartless would say "kicked the bucket."

It is these variations in response to individual and social choice that cause all the difficulties and arguments implied in the terms *Standard English, substandard, colloquial, slang, dialect,* and *jargon.* If a language were a uniform means of expression; or if its varieties could be clear-cut; or if, again, those varieties were not linked with certain other things that people take as signs of low or high education, of economic status, social habits, and even moral and religious attitudes, the question of language would not arouse such feelings or bring up the great matters of democracy, equal rights, elitism, and snobbery.

That being so, if one truly wants to think about human speech without prejudice or rancor, one must try to suspend judgment until one understands how language does its job. Take, to begin with, the type of language which goes by the name of *cant* or *thieves' argot.* It is a vocabulary based on the standard speech, but so altered that only the thieving fraternity can make out a meaning. By extension, the term *argot* can

be applied to special words used by any group, even though they do not intend to conceal their meaning. Shoptalk among people of one trade or profession is such an *argot*, largely unintelligible to an outsider; a landlubber finds it hard to follow the conversation of sailors about sailing. But that is a result of his ignorance; it is not the intention of the users. The more usual name of this kind of professional or trade speech is *jargon*.

What may we conclude about these types of speech, which are related to the mother tongue, but which differ from it and from each other while using many of its resources? Just one thing—that they are limited; they do not cover the whole range of experience; and they are exclusive: by confining the users to certain kinds of expression they prevent the non-users from understanding what is being said.

These two results, of exclusion and of limitation, lead to what is really a very obvious idea—the idea that a larger, all-purpose language for everybody is clearly desirable. The need is for a set of words and grammatical forms that every native or adoptive user can be expected to understand and to find adequate: in other words, a standardized language. With such a language one need not belong to a special group, whether of thieves or sailors, mechanics or lawyers, in order to attempt to speak it. It belongs to all trades, professions, all groups, ranks, and even to all peoples if they will only learn it. Its utility is plain: it brings together through a common medium of verbal exchange the largest possible number of people, in one nation or more than one. Such a language is a common currency whose value is known at sight.

It might be supposed that sensible people would recognize the fundamentally democratic character of a standard language—a language designed to be the same for all users regardless of special interests. But because the standard tongue has sometimes been described as the language of the best writers and speakers, because it is the language of the educated and the

successful, of the so-called opinion leaders, it is believed to be their property alone, so that in recent years it has been attacked as a device of snobbery and oppression. It is charged with putting at a disadvantage those who do not know it or do not handle it well. And in reaction, the feeling has developed that local, limited forms of speech are better than Standard—better for the group of users as being more natural and also as being their inherited possession, which should not be taken away or altered from outside.

To put this argument in linguistic terms, *dialects* have been ascribed a value superior to that of the standard idiom. This doctrine tries not only to reverse the previous ranking, dialect now claiming superiority; it is also trying to reverse an evolution of the last thousand years of Western civilization. Dialects start as languages limited geographically as well as in range of expression. The name "dialect" implies that grammar, vocabulary, pronunciation, and idiom look and sound distinct from Standard without being so different as to form a separate tongue. It is this betwixt-and-between character that tempts the admirers of dialect to deny the merits of the standard language and attack it as a cruel imposition.

At first sight, the dialect looks as if it could serve all the needs of its users just as well as Standard—and more easily. But it does not. To begin with, it may be unintelligible in the next township. Consider an example from outside the area of debate. England, small as it is, still shows here and there pockets of surviving dialectal speech in the midst of Standard. The contemporary English novelist V. S. Pritchett recalls in his autobiography how, when he was a child, his parents moved from London to Yorkshire, where the other children spoke a dialect hard for him to understand, while his accent and vocabulary made him a virtual foreigner. Yorkshire is about as far from London as Chicago from Peoria; this gives a measure of one of the limitations of dialect.

But there is worse. Dialect falls short in breadth of vocabulary and flexibility of construction and it usually lacks a liter-

ature that records past experience; in short, dialect denies access to the full range of ideas and feelings that a civilization has discovered and given names to. Its rigidity is an emotional and intellectual straitjacket, for a dialect does not produce much—if any—formal writing, and so it does not steadily enlarge its means of expression like the standard tongue.

A standard language keeps up with new discoveries and with new ideas and feelings by means of new words and idioms, which are in turn organized and preserved by the written record. Without the written word, seconded by the art of printing, a widespread language would slide about and, by uncontrolled change, scatter its resources in so many directions that it would fail of its single purpose, which is: ready communication among the largest possible number of fellow speakers. And this large number—let us not forget—includes the users of past generations and those to come. One has only to look at another special language—slang—to see how insufficient it is and how rapidly it perishes. Slang excludes the majority of native users except for the short time when a phrase is in vogue. To repeat, jargon, dialect, slang are exclusive by nature. The standard tongue is the democratic form of the language par excellence.

The issue, therefore, between the standard tongue and any dialect, however attractive in itself, cannot remain one of patronizing regard for dialect on the part of the educated or of "rights" and preferences on the part of minorities. Short of the total population, numbers are irrelevant; for in various circumstances of life every one of us may find himself or herself in a linguistic minority, sometimes a minority of one. It happened to me when as a youth I found myself in England speaking only French. It happened again a little later when, having learned English English, I came to the United States and heard around me many words and pronunciations I was unfamiliar with. Fortunately, from my early days in London all the way to this very moment, I have been able to stay in touch with other people—thanks to the broad unity of the standard

tongue: it is hospitable enough to include London English, American English of the Northeast, the American English of Texas or Ohio, as well as my own mixed kind of speech: none of them excludes a traveling minority of one such as myself, which a dialect would inevitably do.

To keep up a standard language, then, is simply a practical endeavor. It is especially practical for the members of cultural minorities. For among their rights is surely that of full self-development, which presupposes self-knowledge and self-expression. Development and expression alike depend on the command of a sophisticated and flexible instrument of thought—and there is no other but the prevailing standard language.

Consider just a few of the daily-life situations in which command of the common tongue is important, the importance ranging from the convenient to the indispensable: travel (avoiding misdirection or being taken advantage of, overcoming the sense of being lost and forlorn); reading (news, warnings, pleasant or profitable opportunities); employment (applying effectively, qualifying for interesting work); love and friendship—the point hardly needs elaboration.

Nor should it have to be said that if a highly gifted child is born in a family and region where a dialect or "local standard" is the first language, the recognition of his or her gifts and their use for the public good through a brilliant individual career depend on that child's early mastery of the wider standard tongue, oral and written. No one is going to reach the bench of the Supreme Court speaking only Cajun or Sicilian. A truly pluralistic society must take care of its human resources regardless of where they come into being; as the United Negro College Fund says in its appeals: "A mind is a terrible thing to waste."

When one stops to think about these plain, virtually platitudinous truths, it seems incredible that anybody professing a liberal outlook and applying it to the language question

should argue for the perpetuation of dialects and speak of Standard as optional. If acted out, such a "philosophy" would mean holding a citizen imprisoned within the confines of his origins. Free and endowed with the common rights in other respects, this person is told by the sentimentalists that he or she need not open the gate to the common speech. One can only be amazed to discover that professional groups of *teachers of English* have gone on record as favoring school programs that reinforce attachment to native forms of speech and that represent Black English as sufficient to open careers to talent.

The liberal outlook, as a businessman of Hispanic origins has pointed out, dictates the opposite policy. Speaking of the growing practice of translating notices into Spanish, he says: "Fair play? I think not. Unfairness would be to deny these people the opportunity to learn English." And he goes on to speak of opportunity as a general right which includes the opportunity to learn Standard.

These arguments from ordinary life are self-evident, but they are not the only potent ones, they are only the most obvious, as another writer has shown when reporting a fact that would not readily come to mind: Lack of a common language is a barrier to psychiatric help, and it turns out that some Hispanic patients cannot make themselves understood even to a physician who speaks the standard form of their own Spanish dialect. This in turn reminds one that for the same reason schoolchildren in certain bilingual classes resist the Spanish or other foreign medium of instruction, because it differs from their own dialect of that same language. Nor with that dialect is it possible to teach them, for it lacks the terms of arithmetic—or whatever—that are required for elementary instruction. As well, in these conditions, make the jump to English—and Standard English at that, with due allowance for transitional stages and, needless to say, avoiding any offense to the feelings of the learners.

Certainly the position of Standard as the most widely used, most popular of all modes of speech in the nation need

imply no disrespect toward dialects or other tongues, any more than formal writing disparages colloquial conversation. As we saw at the beginning, in matters of language, appropriateness to circumstance is the only guide, and the standard tongue is the appropriate device for individual and national life in modern civilization. *1980*

The Word "Man"

I adhere to the long use of "man" as a word that means human being—people—men and women alike, whenever there is no need to distinguish them. The reasons in favor of prolonging that usage are four: etymology, convenience, the unsuspected incompleteness of "man and woman," and literary tradition.

To begin with the last, it is unwise to give up a long-established practice, familiar to all, without reviewing the purpose it has served. In Genesis we read: "And God created Man, male and female." Plainly, in 1611 and long before, "man" meant human being. For centuries zoologists have spoken of the species Man: "Man inhabits all the climatic zones." Logicians have said "Man is mortal," and philosophers have boasted of "Man's unconquerable mind." The poet Webster writes: "And man does flourish but his time." In all these uses "man" cannot possibly mean male only. The coupling of "woman" to those statements would add nothing and sound absurd. The word "man" has, like many others, two related meanings, which context makes clear.

Nor is the inclusive sense of human being an arbitrary convention. The Sanskrit root *man, manu,* denotes nothing but the human being and does so par excellence, since it is cognate with the word for "I think." In the compounds that

have been regarded as invidious—"spokesman," "chairman," and the like—"man" retains that original sense of human being, as is proved by the word "woman," which is etymologically the "wife-human being." The *wo* (shortened from *waef*) ought to make "woman" doubly unacceptable to zealots, but the word as it stands seems irreplaceable. In like manner, the proper name Carman is made up of *car*, which meant male, and *man*, which has its usual *human being* application. *Car*, originally *carl* or *kerl*, was the lowest order of freeman, often a rustic.

In English, words denoting human beings of various ages and occupations have changed sex over time or lost it altogether. Thus at first "girl" referred to small children of either sex, likewise "maid," which meant simply "grown-up," and the ending *-ster*, as in "spinster" and "webster," designated women. It is no longer so in "gangster" and "roadster." Implications have shifted too. In Latin, *homo* was the human being and *vir* the male, so that "virtue" meant courage in battle; in English it long stood for chastity in women. The message of this mixed-up past is that it is best to let alone what one understands quite well and not insist on a one-sided interpretation of a word in common use.

Some may brush aside this lesson from usage old and new with a "Never mind. Nobody knows or thinks about the past and 'man' remains objectionable." At this point the reformer must face practical needs. To repeat at frequent intervals "man and woman" and follow it with the compulsory "his and her" is clumsy. It destroys sentence rhythm and smoothness, besides creating emphasis where it is not wanted. Where "man" is most often used, it is the quick neutral word that good prose requires. It is unfortunate that English no longer has a special term for the job like French *on*. But *on* is only the slimmed-down form of *hom(me)*—man again.

For the same neutral use German has *man*, true to the Sanskrit and meaning people. English had the identical word for the purpose until about 1100. German has also *Mensch*

with the sense of human being. So at bottom both French and German carry on the same double meaning of "man" as English, just more visibly; it is the only convenient generic term when it is not perversely interpreted. There is after all an obligation to write decent prose and it rules out recurrent oddity or overinsistence on detail, such as is necessary (for example) in legal writing. Besides, the reformers of usage utter contradictory orders. They want "woman" featured when men are mentioned but they also call for a ban on feminine designations such as "actress."

The truth is that any sex-conscious practice defeats itself by sidetracking the thought from the matter in hand to a social issue—an important one, without question. And on that issue, it is hardly plausible to think that tinkering with words will do anything to enhance respect for women among people who do not feel any, or increase women's authority and earnings in places where prejudice is entrenched.

Finally, the thought occurs that if fairness to all divisions of humanity requires their separate mention when referred to in the mass, then the listing must not read simply "men and women," it must include *teenagers*. They have played a large role in the world and they are not clearly distinguished in the phrase "men and women." Reflection further shows that mention should be given to yet another group: children. The child prodigy in music is a small category. But one must not forget the far larger group of eight-, ten-, and twelve-year-olds: boys (and sometimes girls in disguise) who in the armies and navies of the West have served in fife-and-drum corps or as cabin boys. Columbus's ships had a large contingent; all the great explorers of the New World relied on teams of these hard-worked crew members. Manet's painting of the small fife player and one by Eva Gonzales remind us of the continued use of these waifs past the mid-nineteenth century. Perhaps the last child to be so memorialized is to be seen in Eastman Johnson's "Wounded Drummer Boy," portrayed at the height of the American Civil War.

The teenagers' cultural contribution is more varied and better recorded, and the thought it brings to mind is the marked difference between earlier times and our own in the feeling about age. When the nineteenth-century novelist George Sand at twenty-eight declared herself too old to marry (by custom she had been an old maid since twenty-five) or when Richard II, fourteen years old, alone in a large field, faced Wat Tyler's massed rebels and pacified them with a speech, attitudes were taken for granted that are hard for us to imagine. Nearly to the beginning of the twentieth century, society accorded teenagers roles of social responsibility. Rossini first conducted an orchestra at fourteen and led the Bologna Philharmonic at eighteen. Weber was even younger in a comparable position.

In war and government, posts of command were won early. Alexander Hamilton, also at fourteen, set the rules for captains who traded with the firm that employed him on St. Croix Island, and he was nineteen when Washington made him aide-de-camp. Pitt the Younger was prime minister at twenty-three. Lagrange was professor of mathematics at the Turin School of Artillery at nineteen. And in Castiglione's manual of Renaissance manners, *The Courtier,* one of the engaging figures is Francesco della Rovere, nephew of the pope, Lord General at seventeen, and soon to be "General of Rome." In the book he has just lost a battle but not the respect of his friends. His rank, his charm, and his mind ensure his being listened to as if he were a mature philosopher. Teenagers could lead armies in battle, for an older warrior's young page might be made a knight at twelve and there was no ladder of ranks between the first signs of talent and the top—witness several of Napoleon's marshals. Cultural expectations were based on early mortality and spurred the young to live up to them. *2000*

On Biography

On one occasion, Goethe is reported to have said that classicism was health and romanticism disease; and this has been repeated as a final judgment by someone who was in a good position to know. It would be interesting to go into what Goethe and Schiller meant by their own "classicism," which Goethe was contrasting at that moment with romanticism. But it is enough to say that he was then finishing his second *Faust*, which he was not ashamed to call "Classic-romantic," and in which he eulogizes the spirit of modern poetry under the shape of Byron. Moreover, if we apply Goethe's own excellent test—the test of seeing whether a man's outlook paralyzes his will to create—we find a full refutation of the disease theory in the mere mass of Romantic work. Chateaubriand's declaration: "I was overwhelmed with a superabundance of life," characterizes the group as a whole, and explains its labors.

An equal test of power, but bearing on quality rather than quantity, is the situation in which Hazlitt found himself when courting a very ordinary coquette. Driven to despair by her contradictory antics, the essayist felt he had to relieve his anxieties by writing down the facts and observations which compose that remarkable document, the *Liber Amoris*. Here we think we catch sight of Romantic life in its most typical aspect—the aspect of unhappy love. "As usual," you say to yourself, "the infatuated Romantic works the poison out of his system by dilating upon his woes, as if they were of the slightest interest to anybody else." Before you even read a line you conclude that this confession, this so-called book of love, must be mere slush, not to say time wasted on egocentric display. If

your mind is made up and you do not read the book, you miss of course the singular merit of the work as a psychoanalytic report on a common situation; you assume falsely that almost anyone can make the pangs of disprized love interesting; worst of all, you assume that while undergoing them Hazlitt did nothing but brood upon himself. The truth is that at that very time he was also producing the critical essays which form the second volume of his *Table Talk,* work of a quality as high as any he ever did. With respect to Hazlitt's ego, then, Goethe's test of "egotism paralyzes" gives a complete negative.

This instance could be duplicated many times over from the biographies of the Romanticists. It may be De Quincey at grips with opium and poverty, Balzac with his creditors, Byron and Shelley with their families and friends, Victor Hugo or Mazzini with the police—production goes on, as if the issue of a war depended upon it.

Some critics who have perceived this priority given to work over concerns that would paralyze most men have argued that the work must be "insincere" or "empty" or "a refuge." These are opinions that must be examined in their particular applications, a task beyond the scope of this book. But note in passing that they contradict that other critical gravamen, of a Romantic disease ending in artistic paralysis.

One cause of our confusion is our utter lack of technical skill in assessing lives and works. We are not sufficiently aware that a biography or autobiography can only hit the high spots of a man's life, his spectacular encounters with mankind or the universe. Going from peak to peak, it does not explore the valleys where the quiet work is done, even on a day of storm and stress. We, and not the Romantics, do the exaggerating. We take the entirely true statement that on a given occasion the artist was overwhelmed by a piece of news and remained distraught for six hours, and fail to compute that that leaves him eighteen in which to be himself again. We imagine, we like to imagine, we prefer to imagine the Romantic artist flying feverishly from one turmoil to another, and

doing his greatest work in fits of absence of mind. We construct a storybook Romanticism out of incomplete observations and then attack this fiction as if its faults belonged to the reality behind it.

We should remember that in any biography the ratio between years and pages is always misleading, and in both directions: too much and too little. When you consider that many of the best-known Romantics died before the age of forty, that most of them met with every kind of rebuff, and that even the temperamentally indolent or the physically disabled have left enviable memorials of their talents, you will be compelled to admit that these men, who are dubbed idlers, wastrels, and lovelorn egotists, had a remarkable knack for getting things done.

Meantime we need not be surprised that the Romantic life was robust and productive, because, as we know, the Romanticists were encouraged, stimulated, and justified by historical circumstances. The French Revolution and Napoleon had, in Stendhal's phrase, made a clean slate. But this stimulation was purely spiritual. No one was waiting with open arms to receive their gifts. One has but to read the lifelong complaints of Goethe—a relatively fortunate man as well as a stoical mind—to see that the energetic life had to be lived in a dampening milieu. For the habits of individual men change at unequal rates, and when it seemed to the young Goethe or Schiller "impossible" to go on turning out literature in the manner of their predecessors, it seemed to the good burghers not only possible but desirable that it should be done.

If we kept in mind the disordered lives of classical specimens such as Cardinal de Retz, Richard Savage, John Wilkes, or Voltaire; if we lingered over the love affairs of Racine, and cared as much about Descartes's mistress and illegitimate daughter as we do about Wordsworth's; if we had more vividly before us the falsifications of Pope; if we recalled Johnson's rowdiness or his bursts of weeping at the reading of his

own poetry, we should perhaps form a more balanced conception of what human beings are like under comparable circumstances, and we should cease to find monstrous or titillating the lives that the Romantic artists led. *1961*

Venus at Large: Sexuality and the Limits of Literature

The student of literature is instinctively loath to set theoretical limits to the art he studies, and so, surely, does the writer feel about the art he practices—unless he is a mere follower of convention. But in recognizing this axiomatic freedom, it is one thing to say that sexuality, like any other human power, deserves limitless literary expression; it is quite another to say that literature should find room for ever more detailed descriptions of the sex act. And it tends to be the second proposition that modern readers and writers maintain as the test of freedom and as the gateway to further discoveries in literature.

The confusion of these two views is in itself a subject for inquiry; for no one, probably, would raise the question of limits if *sexuality* were the element that literature had to accommodate. But the element is in fact *sex*. Common speech makes the distinction quite unconsciously, and it tells us that what is under review, what is beginning to raise critical doubts, is the representation in words of actual or imaginable copulation.

In consequence, "limits" can take on two meanings: Have we had enough verbal sex by now, so that it is time to desist? Or if this quantitative limit seems trivial or unenforceable, has literature gone as far as it can, or should, in its study or exploration of sex? As to the first, there is some evidence that the

public is getting weary of what has become for every novelist who wants to be read the *scène à faire*. Readers are beginning to feel unduly bed-ridden, and fatigue is in itself a criticism. To answer the other question, whether the literary art has found natural limits in the subject of sexual activity, one must begin by asking why coitus entered literature in the first place.

Clearly, people knew more than the rough outlines of the physics of sexual reproduction before our novels began to descant upon it. In Western civilization since the Greeks the greater part of literature is erotic in motive and contents. From Helen of Troy to Isolde and the Princesse de Clèves to Tess of the d'Urbervilles, the presence of desire is not overlooked, nor are its physical expression and consequences blinked: couples embrace, run away to live together, idolize the visible body, and produce offspring. These are not the acts of innocents, and we should no longer labor under the delusion, born of the anti-Victorian crusade, that in the twentieth century a few bold spirits discovered the genitalia.

Still, it will be said, it was those bold spirits who put them within the covers of freely circulating books; and it is the wish to do so and the wish to have this done that we must explain before we can measure the limits—if any—within which this exhibition is aesthetically fit and spiritually good. What are we actually given in those pages of modern books at which the library copies open all by themselves? There is, by and large, a standardized sexual act for literary use: a brief conversation leads to a couch or bed; an undressing follows, of the woman by the man or of the woman by herself; passing attention is then given to some physical detail of her body, not necessarily beautiful or attractive (this shows the force of desire), after which the act takes place almost directly and, judging by the prose, at a military speed. The report of sensations and responses is from the woman's point of view, though occasionally the act is seen or interpreted from the man's. In most cases the enterprise is successful, despite the lack of preliminaries such as the works of theory deem imperative; in most cases no

thought is given to consequences—a careless ease which flouts the entry in the Kinsey Report *"pregnancy, fear of"*; in most cases, there is no repetition of the act, or indeed any sort of artistic conclusion, unless orgasm itself and a sketchy resumption of clothes are to be taken as such.

As literary realism all this is most unsatisfactory. We are brought to infer that any suggestion of realism is accidental. What is intended is symbolism. The modern sex act in print, which causes the police and the puritan so much pain, is only a fable, a device to correct this or that deficiency of our upbringing and culture. At first, depicting sexual intercourse was a reminder to the public of what preoccupies human society. Not only the Edwardians, who made the revolution, but the late Victorian novelists themselves, felt that the absence from literature of direct signs showing mankind sexually driven was an absurd and arbitrary exclusion. The barrier finally broke and the sexual obsession is with us, obsessively reproduced. Why it should stay there is not so clear.

Whenever a marked change occurs in the conventions of literature, one may question whether the place accorded the new topic is a late recognition of its intrinsic importance or an exaggeration due to external causes. After all, the battle against Victorian primness was won a good many years ago. Why go on battering the open door? The answer lies in the fact of such external causes: they changed literature and are still at work. Not the pressure of industrialized urban life alone, but its combination with self-consciousness felt as a disease impelled writers from the outset of the nineteenth century to make of sexuality a symbol and an argument. In Blake sexuality denotes freedom, energy, and joy. In Goethe it typifies the dark forces of nature. In Balzac it is for the first time a compulsive manifestation of ego, will, ambition, and fatalism (*Peau de Chagrin, Cousine Bette*). Stendhal studies (but also enjoys) the fantasies and illusions of the sexual force; and Baudelaire, crying out against vulgarity, moralism, and the

déjà vu, turns to abnormal sexuality as a means of protest and underground resistance for the self in its war with society. Behind them all stands Rousseau, whose confessional principle breaks with that of the Church and confronts mankind not with the slogan "Back to Nature," as the textbooks foolishly say, but with the riddle "What *is* Nature?" After him the naturalism of science is matched by the naturalism of literature, which tries through fiction to discover the roots of man.

At first, then, sexuality and, later, sex are literary devices to restore respect for instinct, to tap a source of power which can at once abate the disease of extreme self-consciousness and counteract the stupefying effect of the world of machines. For sex is in a curious way the most and the least personal of man's activities. Used in the novel, it could rebuild the whole man and show his oneness with all men. Again, if literature was to criticize life and lead the revolt against convention, it needed a new element that was indeed elemental and yet was instantly felt as intimate and defining. That element was the sexual, and since in art what is novel in conception requires a striking embodiment, sexuality was bound to move steadily toward its ultimate form in the sex scene.

In English fiction, the great growling presence was kept in the background much longer than on the Continent. True, a general awareness was shown in the staggering number of "proper" novels that hinged on seduction, but the temptation itself is always hurried over, and one has to wait till Bradley Headstone in *Our Mutual Friend* to meet the obsessive force face to face. Meanwhile *Jane Eyre* and *Wuthering Heights* are alive with physical passion, and even though Thackeray hems and haws about Becky Sharp, he is dying to tell all. Hardy alone (if we except the poets Coventry Patmore and Meredith in *Modern Love*) comes out with the facts in *Tess* and demonstrates in *Jude* that sexuality is so strong that it can, by repulsion, make a woman jump out of the window.

But even by the mid-nineties the English mind was not ready to accept calmly the revelation of what it knew very

well. George Moore's *Esther Waters* caused a scandal. Zola's publisher was jailed, and the virulence of the press, the law, and public opinion in the trials of Oscar Wilde proved that the repressive effort, though now desperate, was still potent. Nor should we forget that in Germany at the same time (Sudermann) and in France even earlier (*Madame Bovary*), the guardians of society had tried suppression by law. Ibsen's struggles in Scandinavia, too well known to recount, owed much of their violence to the correct suspicion that the playwright was vindicating sexuality in *Ghosts,* and if not free love, at least freedom for the instinct of love, in *Hedda Gabler* and elsewhere.

These entanglements of literature with public opinion and the law are not extraneous to the discussion of literary limits, for they make clear a fundamental point: the advent of sexuality in fiction marks primarily a social emancipation, not a literary or emotional one. To be sure, the freedom claimed by the artist to write as he pleases looks like purely literary business. Actually, freedom for the artist is but another way of attacking bourgeois standards; Bohemia *versus* the conventions, art for life's sake. Hence the moral overturn at the dawn of the twentieth century belongs to political history more than to the history of art. Indeed, political revolution is almost always linked with sexual revolt. The Victorians knew this so well that one of their motives in repressing certain thoughts and words was to keep down the masses and avert revolution. The masses went on being ribald and loose, but the upper crust held for a hundred years. When between 1900 and 1914 the great tide of change that had been gathering strength for forty years swept over every part of European culture, literature was only the vehicle for anarchism and socialism, bohemianism and feminism. What literature celebrated directly and through the symbols of sexuality was the rise of the masses, the women, and the artists.

These last two had a special significance as the chosen vessels of the instinctual life, which in a world of machines and

make-believe emerges as the truest means of salvation. This belief was something apart from the love of primitivism evinced by old civilizations, and it drew unexpected support from science. Sixty years of industry had thrown up, among other victims, an inordinate number of misfits—neurotics, hysterics, paranoiacs, schizophrenics. Clearly, the machine and the moral code were pressing down too hard on the instincts. Charcot amid his eccentrics at La Salpêtrière offered the diagnosis for hysteria that it was *toujours la chose génitale*. Freud shortly came out with his epoch-making hypothesis of Libidinous Man, and Krafft-Ebing studied and published the pathology of the sexual instinct. Clinical theory thus met and joined the intimations of literature reinforced by philosophy— Schopenhauer, Hartmann, Nietzsche, and Samuel Butler. It was at this point that the literary use of sexuality shifted from simply promoting social liberation to attempting individual, that is, emotional, liberation.

The forerunner here was Butler in *The Way of All Flesh*, in which the discovery of sex aids the transformation of seemingly irrelevant feelings and finally disposes of the tyrannical family. There is nothing like this in Zola, who, though he is the poet of the id, does not even in *Germinal* present sexuality as healthful, but rather as Desire the Destroyer. It was a full generation after Butler, and evidently under his inspiration, that Maugham showed where the social and sexual liberations led. *Of Human Bondage* is in a sense the counterpart of the revolt. The hero enslaved by lust resists it fiercely, but it is no longer from moral scruples, it is from the strongest intellectual and aesthetic emotions. By 1915, then, the id takes the fictional guise in which the whole century now knows it: an autonomous force. No doubt it had already acted as such in Balzac, in Flaubert's last novel (see the peacock scene in *Pécuchet*), in all the works of Zola, in Mirbeau, in Schnitzler, and even in E. M. Forster. But the simpler, more insistent demonstration in Maugham, at the threshold of the latest period, makes the lesson unmistakable.

One must say "at the threshold" because by that date the literary sex act had not yet been performed in public. The line of asterisks used by Elinor Glyn and her tribe to mark the passage from one room to another and from banter to felicity had only just been patented. It took more than sultry novels, it took the First World War, to make the transition from sexuality to sex. That is, men and women the world over had first to be torn loose from their homes and habits, their ambitions and their fears, their notions and their clothes before they could enter into a new set of feelings—feelings at variance with the old religious dogmas and contrary to the assumption that the surrounding world is solidly based and its code enduring.

In that palpably existential situation of the 1920s, literature, particularly the novel, was led to devise its new sexual symbolism on principles both new and old. The doctrine of lifelikeness, which was not new, said: Copulation is frequent and ubiquitous, why conceal it? Add a due measure of it to the other ingredients of the slice of life. Next, the movement of ideas caught up with the novelist and informed him that Freud had brought forth twenty years before a new man who must be "studied" in literary form. His compulsions, difficulties, and powers in the arena of sexual encounters must be caught in the act, from the stream of consciousness virtually to that of the gonads. In between, all the appropriate gestures must be recorded.

The new opportunities seemed endless, for the sexual imagination of the author as man or woman was necessarily involved, and that imagination is luxuriant in spite of all rebuffs. Finally came the employment of the sexual act (or its subdivisions) as metaphor, myth, allegory, and sermon. These do not exclude realism, as we see in Molly Bloom's soliloquy, and they permit the adaptation of physical facts, at best circumscribed, to the purposes of poetry. Vivid sexual imagery has dominated modern verse from the satiric passages in *Prufrock* and *The Waste Land* to the efforts in student magazines, where protests against life and society take the form of

anatomical similes. And the thighs and breasts and other generalized intimacies that enliven dour juvenile metaphysics afford vicarious sexual satisfaction as well.

That there is need of this satisfaction is shown not only by the sheer amount of explicit sex in modern literature high and low, but also by the emphatic, brutal quality of most of it. The words used, the things done, suggest a tremendous impatience—not a surge of passion but a frantic thrust for relief. Such sexual anxiety is kept up, undoubtedly, by the effect upon the senses of advertising, a sub-literary genre which is no longer so crude that it cannot work a spell even on sophisticated minds. Mr. Erich Kuby has aptly shown in *Rosemarie* how logical it is that the mysterious but manifest damaging of sexuality by industrial life should be made up for through a "sexualization of the masses by optical stimulation." But advertising is designed to create or inflame desire, not satisfy it. Hence the relief proffered in poetry and prose, which seem to say: "Down with all the teasing and tantalizing! Here is what you do and how it feels. . . ." Some of these portrayals, when they are not violent or self-centered, are meant to be exemplary, not to say pedagogic. Whether it is Mr. Mickey Spillane taking time away from murder to make his hero tenderly examine his wife's rotundities (thus answering Faulkner's demand that American husbands should caress their cars less and their wives more), or whether it is Mrs. Doris Lessing keeping a Golden Notebook on the interesting variations of every internal and external feature of love-making, the novel pursues its educational task and, by its willing elaboration of the factual, furthers the fleeting joys we find in the echoes of sex in poetry.

This being so, one might suppose that literature was resuming one of its ancient roles, that of mirroring a pan-sexual world. In such a world the wonderful generalities of the fourth book of Lucretius would be made particular and pleasing. But this is not so. At the London trial of *Lady Chatterley* for obscenity, it was remarkable how many of the literary wit-

nesses interpreted the book as an allegory of a desiccated world. To these critics, industrial England still remained more real than the gamekeeper's woods. Again, insofar as one can judge the effect of sexualized literature on its readers, themselves depicted in other works, the sexual tension is great in individuals but weak between partners, which is the very contradiction of sex. Out of this contradiction come the innumerable studies and reports (by which I mean novels) that deal with sexual maladjustment. The phrase denotes sex without sexuality and its cause is not obscure. Ancient literature was cheerful about sex, except perhaps when its awesome universal purpose came into view. The rest of the time sex was a comedy freely though not obsessively witnessed. In *Lysistrata* Aristophanes gives no sense that he is daring in his use of sexual images and events to develop his theme and cause laughter. The processions of women in the *Thesmophoriazusae* carry leather phalluses ten feet long and tied in knots. In the novelists and satirists down to Petronius, the joke is on, and with, the lovers, whose mutual acts are envied and derided all at once. It is delight mixed with difficulty but no strain.

With us the mood is opposite. We are not awed. We are solemn or complaining and cannot be anything else. And "us" here means the literary world as far back as 1800—the apogee of Western civilization and of its discontents. From Aristophanes to the *Contes Drôlatiques* is one tradition; from *La Cousine Bette* to *An American Dream* is another. The dividing line clearly shows that it is not Christianity as such that has desexualized man's view of the world. Even when demonic, as in the medieval story of *Mary of Nijmegen*, sexuality is acknowledged and the sin is first enjoyed. The last word has not been said about the causes of Christian puritanism, nor is this the place to say it. But one may point out that the same *Golden Bough* which helped revive in modern men of letters the appreciation of myth and the value of primitive feelings, also reports on the pre-Christian cults of Diana, Astarte, and Cybele, whose male votaries unmanned them-

selves by mutilation. There is evidence, besides, that the Christians' hostility to women and sex after a period of possibly carnal love feasts—the normal revolutionary phase—was due to a political and social anti-feminism, compounded with a revulsion from the sexual aggressiveness that women in high civilizations develop along with their other rights.

In any art, a time comes when amplification and variation are still possible but nothing new results. Are we at that stage and, if we are, does this position permit us to summarize and judge? Why not? At worst the attempt can be dismissed as premature.

The limits of one sort of sexualized literature have certainly been reached in Norman Mailer's *American Dream*, I mean the literature of realism. The hero's motiveless performances with women in that book seem designed, as several critics have said, chiefly to flatter the author's ego. Life and the id are not in it; and one has only to compare an earlier work, *Time of Her Time*, to see the difference between credible sex scenes, however tendentious, and a sheer phantasmagoria of sex. In this latter wild genre, reminiscent of Rabelais though without his gaiety, there is also nothing more to do. Henry Miller has established by massive production a monopoly it would be foolhardy to compete with. In him one gets the full range, from the disagreeables of perfunctory fornication in the early works to the vicarious rewards of the easily pleased in the later ones. The reader who wishes can "identify" and almost believe that he is Frank Harris.

Do possibilities perhaps remain in the literary use of sex for preachments against absurd society, bourgeois convention, and the cankering dullness of modern life? This path too is blocked off by massive works. Joyce began piling them up, and nearly half a century of incessant fictional denunciation down to *The Ginger Man* has put the point beyond the reach of forgetfulness. The instinctual life is held in honor, and so is the bohemian artist, the tramp, the Panurge. The organized

world is despised; the criminal Genet achieves literary saint-hood; and there is no devil's advocate, no vocal opposition that even dreams of defending the civilized life.

There is then but one other subject for literature to treat through sex that might be considered unexhausted, and that is sexuality. Have the modern generations learned from the sex in their novels all there is to know about sexuality? Well, they seem to be quite familiar with its aberrations, inversions, and concomitants. Colloquial talk makes free with masochism and with sadism, even when only plain cruelty is meant. The sin of repression, the charms of incest, the sexual interpretation of dreams, and the belief that the foundation of character is laid by giving and taking orgasms are the main points of doctrine. If all this amounts to a fair knowledge of sexuality, then we are well taught, and literature has done its utmost.

But one cannot help noticing that the understanding of sexuality sought by modern man is also fed by expository literature, and perhaps better fed, even when that literature does not profess to be scientific. To read Colin Wilson's *Origins of the Sexual Impulse* gives more information and supplies fuller nuances than to read his *Sex Diary of Gerard Sorme*, entertaining as that fiction is. Again, the survey by Jeannette Foster of *Sex Variant Women in Literature* shows how repetitious and inconclusive is all this novelizing of psychosexual fact. One is thus brought to acknowledge the great limitation of sex in portraying sexuality. Sex—that is to say the particulars of the act—is an inescapably trite and insignificant event for literature. The failure of *Candy* as a parody suggests that there is in serious sex nothing to exaggerate.

Sexuality is on the contrary the very atmosphere in which all literature breathes and lives. But sexuality can be made palpable in thousands of ways, ancient, modern, and still to be discovered. There is surely more to the sexual instinct and its derivatives than the rapid mechanical transaction we have been given as its sum and summit. There are tendernesses and hesitancies, sensations and fantasies that are not of the readily

namable sort, and the language for them does not as yet exist. It is the business of art to create it. Literature need not go back to the reticence of the past in order to find both direct and allusive ways of re-creating sexuality. But it must first understand that the single kiss in *The Golden Bowl* suffices *with the rest* to establish the intense sexuality of that novel, whereas many a modern work that might qualify as a *coitus uninterruptus* is frigid.

Since sexuality is of our very being, sex cannot be called illegitimate, immoral, or uninteresting. But it is terribly limited; and its appeal being unfailing, it is—or it ends by being—a cheap device. When, moreover, sex is present to make up for deprivations in the culture of a whole age, it becomes a burden to literature. As Shaw said in praising the purity of Poe, "Literature is not a keyhole for people with starved affections to peep through at the banquets of the body." One is permitted to think that the glut of sex in our prose and verse fictions will remain as the special mark of our work, the brand of the times on our genius; and one may perhaps imagine further that sooner or later a Cervantes will come, who in a comic saga of sex will bury our standardized bedroom adventures like so many tales of chivalry. *1966*

Onoma–Onomato–Onomatwaddle

To readers who like poetry so much that they also read essays about poets, nothing is so familiar as a passage in which the writer, having quoted a few lines that he admires, goes on to explain by onomatopoeia why they are admirable. "Notice," he will say, "the alternation of *l* and *r*, repeated in the second line, and rhythmically punctuated there by the strong *d* and *k*

sounds, which convey the conflict between indolence and duty which is the theme of the stanza."

I do not believe a word of it. Onomatopoeia is a fiction. The magic, color, music of the words said to be onomatopoetic in poetry is due primarily to their meaning.

Let us test this negative contention by taking the least advantageous example. In his *Essay on Criticism*, Pope lays down a principle. He says: " 'Tis not enough no harshness gives offence/The sound must seem an Echo to the sense." He goes on to illustrate the proposition:

> *Soft is the strain when Zephyr gently blows*
> *And the smooth stream in smoother numbers flows;*
> *But when loud surges lash the sounding shore,*
> *The hoarse rough verse should like the torrent roar.*

I maintain that "soft is the strain" sounds gentle because of what it says. "Tough is the strain," with virtually the same sounds, conveys the opposite of ease and gentleness. Indeed, the word "strain" by itself makes my point: supply the right context and it will "echo" groaning effort as readily as airy music. As for Pope's last two, contrasting lines, the arrangement of *l*'s, *r*'s, and *s*'s is exactly that which elsewhere would be pointed out as making mellifluous music. "Roar" is not inherently a loud word; it is much less so than "bore." Only at the halting "*hoarse* rough verse" does diction add anything to the sense—and it is rhythm that does it, not melody.

The question is whether some words are not onomatopoetic by nature and origin—"splash," "crash," "croak," "murmur," "moan," "hiss," and so on. Tennyson is famous for their adroit employment; every believer in onomatopoeia quotes: "The moan of doves in immemorial elms/And murmuring of innumerable bees." The recurrent *m*'s and *n*'s are supposed to copy the reality. But forget the words and fill your mind's ear with the moaning and the buzzing, for—come to think of it— do bees buzz or murmur? A little of both? They hum, too, so

that we have three different renderings for what in nature is one. Nor does the sound in nature include the *r* of "murmur," the *h* of "hum," or the *b* of "buzz." The verbal imitation is certainly partial and impure.

Nor is this all. Go to another language. In French, bees *bourdonnent,* with the intrusive *b* and *r* and a bunch of *n*'s— not an *m* in sight or in the ear. Turn to Tennyson's moaning of doves. What do the doves do in France? *Elles roucoulent,* a more liquid operation that seems to capture a clear *k* sound. Tennyson leaves out both liquidity and the catch in the throat. Returning to his "murmuring," we may well ask whether the word as commonly used does not also fit the noise of an angry crowd; and again, the half-swallowed utterance of a person too shy to speak out.

I do not see what to conclude but that so-called onomatopoeia is the product of a convention by which a single element, more or less aptly chosen from a complex natural sound, stands for that complex and is then extended, with less and less accuracy, to other vaguely similar situations. And in the end, it is the meaning attached to the word through variable uses which gives the impression that the word suggests in turn each of these quite different sounds. Usage, meaning, does the work.

This roundabout effectiveness explains the diversity among languages as to what copies reality: English "splash" = French *gicler* or *éclabousser;* "croak" = *coasser;* and so on. Even the directly imitative attempts differ: English "cock-a-doodle-doo" corresponds to *cocorico*—the sound *k* is the only common feature, as posited in the theory I offer. German, closer to English, does hardly better: frogs that croak in English *quaken* or *quäken* in German, and rooks that "caw" for us *krächzen* across the North Sea. These examples, moreover, are efforts at imitation nearest to parroting nature. The last of them makes one think of "crash," which it is all too easy to believe echoes the sound of breakage. But we use it for the fall

of a glass on the floor and of a plane from the skies, as well as for the collision of two cars—three different sounds.

There is really no telling what will strike the would-be imitator as suggestive. A Chinese poet says that the wind goes *liao-liao*—surely not a wind from the West. With us it "soughs" (suffs) or whistles. But other things, not at all wind-like, also whistle. Thus Racine describes the appearance of the Furies during Orestes' hallucination: *"Pour qui sont ces serpents qui sifflent sur vos têtes?"* This much-praised line states quite rightly that the serpents whistle. But onomatopoeia is supposedly achieved by means of the five s's. Now, did the snakes hiss or whistle? According to convention either will do; but it *is* a convention, and one that holds good only when the meaning gives it support.

With their stronger and more numerous consonants, the Germanic languages would seem to have a better opportunity to produce genuine onomatopoeias, because the sounds of nature have an edge which the vowels that predominate in French cannot approximate. That is as may be. But until further notice I shall believe that English can show only one true onomatopoeia, and that one not intended: it is the word *adenoidal*.

1990

V

On Some Classics

Swift, or Man's Capacity for Reason

Dean Swift passes not unnaturally for a misanthrope, and the tragic end of that somber genius has stamped itself on the popular imagination." With this excellent start in conventional criticism, it is not hard to catch the idea and complete the thumbnail sketch in the same vein: "A late product of his genius was *Gulliver's Travels* (published 1726), a masterpiece of satire but morbid and sensational, reflecting the author's egomania and disappointed ambition. His was unquestionably a great mind, though marred by oddities such as the love of puns and the addiction to baby talk. An enemy of science, he ended his life as a madman." The reference to disappointed ambition should perhaps be explained by saying that Swift really wanted to end his life as a bishop.

This epitome once set down, I am not at all sure that Swift's end has stamped itself on the popular imagination, seeing how shallow an impression his masterpiece has made there. It is a commonplace that *Gulliver* is most popular in the nursery, where it flourishes—or used to flourish—in expurgated form. As for the attitude toward Swift's life and work in run-of-the-mill criticism (I do not speak of a handful of great studies), it is one of grudging admiration mingled with fear. For readers at large the approved capsule of comment and biography is meant as prophylaxis, lest we become misanthropes too and—who knows?—start talking baby talk.

No one is obliged, of course, to like Swift's work and personality. I have the greatest sympathy with anyone who

openly and violently detests both. For Swift is aggressive, complicated, unpredictable. His character takes much knowing and his humor is a special taste. But he does not deserve to be merely misliked or explained away by such words as misanthrope. It is unworthy, just as the expurgation of *Gulliver* is of all expurgations the worst cheat. Today, when we are so full of complicated aggressions ourselves, we ought on the contrary to have an enlarged edition of *Gulliver,* bulging with supplements, from *A Modest Proposal* to some of the lesser products of Swift's savage fury (say *The Character of the Earl of Wharton* or various papers on the behavior of servants), and we should keep the book at hand as a manual of malediction.

Gulliver as it stands will do, provided we appreciate its variety of matter and purposes. It is not enough to rely on our childhood memories, or on the all-too-slight meanings attached to the four words from it that have passed into common speech, one word from each voyage: Lilliputian, Brobdingnagian, Struldbrug, and Yahoo. Nor is the hierarchy of motives behind *Gulliver* adequately felt when we simply say satire. Swift's ripest and most comprehensive, the work is a testament. Satire it is as well, for that was Swift's *métier.* He had been mocking men since his thirtieth year, when he was still a protégé of Sir William Temple and had come to his defense in the quarrel of the Ancients and Moderns by producing *The Battle of the Books.* In the *Travels* he meant to impart what thirty years more of strife in literature and politics had brought him of scornful knowledge of the world. His first impulse to creation, in short, was personal—which does not mean private—and he said so: it was "to vex the world rather than divert it, to make folly bleed," that is, to strike back in an age that was used to battle and did not require falsetto courtesies from the strong.

Next come the literary motives—the pleasure of virtuosity with words, the pleasure of humorous invention, of narrative skill, of parody in drawing portraits and landscapes. For we must not forget that *Gulliver* is a novel. During the reign

of the nineteenth-century Realists this fact may have been obscured, but after Joyce and Kafka we can no longer insist that a novel be a literal transcript from life. The travel form is lifelike enough without sustained characterization; it requires only a rich and exact fantasy encased in a realistic shell of seagoing adventure. In *Gulliver* the joins are well hidden, thematic unity is preserved, and the reader's curiosity is kept alive without faltering: no more can be asked of any novelist.

But deeper than the craftsman's urge lay that of the recorder, the historian, indeed the newspaperman. Swift wanted to cram into one work the actual yet representative detail of the worst he had encountered in his dealings with men. He wrote Part III after Part IV and kept it open as a catchall, not only to break the monotony of parallel voyages by a marked difference of plot, but also that he might add episodes based on the most recent events in current politics, some of them so vivid that they were instantly suppressed by the publisher and not restored for years. That an old hand at politics, a famous pamphleteer once a member of England's kitchen cabinet, should be so brash and tactless—this is what lends color to the charge of egotism. Swift has the mettle of the troublesome witness, like Rousseau, Nietzsche, John Jay Chapman, or Bernard Shaw. Where the Neo-Classic age, with its violence and coarseness of hide, felt the contemporary offense, we feel the generic assault and infer misanthropy. It is not that we lack a sense of humor or think ourselves blameless; we like those who make fun of us—but it must be in fun. Chaucer, Thackeray, Sterne are mild-mannered fellows who will drink with us afterward. What we cannot stand is the confident glare of the moralist who thinks his eye designed by Providence to see straight where a whole age squints. We cry "Conceit!" while he says "Look!"

Yet when Swift, without raising his voice, reduces us to silence, he is taking no pleasure in his superiority. He is wounded by his own aggression, his scorn disturbs him to the depths; indeed, the motive underlying all the rest is to pose a

philosophical question: Is man nothing but a spoiled beast? a creature lost to instinct and unredeemed by reason? an ape with ghastly pretensions? Reared as a rationalist in an age of reason, and as a Christian on the most conscious edge of Christendom, Swift was beset by the two great contradictions that the contemporary expounders of Christianity and rationalism glossed over.

The first contradiction is: that society, which is meant to protect man from bodily and mental harm by fostering equity and justice, multiplies evils. It kills and maims, tempts to injustice, and strengthens iniquity. Swift's demonstration of this paradox begins in the Voyage to Lilliput with the parody of political passion, and reaches its high point near the end of the second book, where the King of Brobdingnag interrupts Gulliver: "You have clearly proved . . . that laws are best explained, interpreted, and applied by those whose interest and abilities lie in perverting, confounding, and eluding them." The King "not unnaturally" turns misanthrope, saying that men are "the most pernicious race of little odious vermin that nature ever suffered to crawl upon the surface of the earth."

When this very tenable proposition is discussed nowadays, it generally divides the company into groups whose responses and remedies are predictable. The orthodox believers cheer at the reaffirmation of original sin and assure the rest that the City of the World is doomed. Prepare, while there is yet time, for the Hereafter. The political conservatives shake their heads and aver that a traditional order which looks human nature in the face and moves slowly works pretty well: the world is not so bad as it is painted, Swift's digestion was probably at fault. Meanwhile to the left, liberals and radicals hardly contain themselves at the recital of these "hoary platitudes." They want to act, first eliminating the opposition and gaining a free hand for the practical reform or thoroughgoing upheaval to come. In these terms could be written the 250 years of history since Swift raised his voice in the great debate on the nature and prospects of Western man.

But it should be observed—and Swift will help us to see this—that none of these positions entirely squares with the advocates' practice, that none is reasonable taken by itself, and that where each has found application in society, the quality of the belief accorded to the doctrine has been more important than its abstract fitness. In other words, the use of reason in dealing with the "little odious vermin" is limited by the vermin's protean complexity and inconsequence. For example, the otherworldly who are marooned on this earth obviously make the same demands on society as they do on Heaven, or they would not know that society was bad. To be consistent, our preachers of original sin should say that this world was excellent in its kind, and reject all improvements. Again, the conservative plays favorites: he faces more cheerfully the evils he causes than those he apprehends, and though he praises tradition for its working institutions, he shows little gratitude toward the innovators who created them in the teeth of an earlier conservatism. Finally, the arch-reasoners of reform or revolution blind themselves to the character of society—its bodily inertia, slow intelligence, and weak imagination—and turn tyrannical when like a dumb ox it resists their often imbecile and always divided counsels.

The contradiction between the aims of society and its achievements is thus to be referred to the character of even the best, most reasoning, if not most reasonable, of the creatures that make it up—odious vermin if seen *en masse*, as Swift knew when he said that he "heartily loved John, Peter, Thomas, and the rest, but not that animal called man."

This should give us pause when we are tempted to damn too especially an age, a group, or its leaders. And so rational a hesitation brings us to the second great contradiction, which may be only the more fundamental form of the first. It is that the use of reason leads to its refutation. In a thousand ways, to be utterly reasonable would be quite unreasonable—in our affections, in conviviality, in art, in love, in medicine, in religion. Pascal's *"La coeur a ses raisons"* puts in a nutshell the

discovery that the groundwork of our existence is irrational. Swift's thought also encompassed the mystery without explaining it: "Although reason were intended by Providence to govern our passions, yet it seems that in two points of the greatest moment to the being and continuance of the world, God hath intended our passions to prevail over reason. The first is, the propagation of our species, since no wise man ever married from the dictates of reason. The other is, the love of life, which from the dictates of reason every man would despise, and wish it at an end, or that it never had a beginning."

The reader's unreasonable love of life is probably too strong to let him accept this judgment, and he is quite sure that he would not give up this world's chaos and misery for the sober Utopia of Houyhnhnmland. But Swift makes him swallow the truth with the aid of a paradox: soon after Gulliver is rescued by the Portuguese ship and we hear him talk, we cannot help exclaiming: How logical that the truly rational view of life which Gulliver has learned from the Houyhnhnms and now expounds to his rescuers should convince the ship's captain that Gulliver has lost his reason! If Houyhnhnm ways necessarily appear to us unlifelike, inhuman, impossible, is that not further proof that reasonableness and life are antitheses?—the Houyhnhnms are so free from the familiar concomitants of civilized existence: "spleen, dullness, ignorance, caprice, sensuality, and pride." But how did Swift, a civilized man, learn to desire anything else? By reason.

When in our weariness we look back to the great ages shining in history by their art, science, and the merged glory of worthy lives and deeds, we long for their clear outlines and envy their unchallengeable merit. They seem both the product and the evidence of order, of reason; particularly so if Reason was one of their slogans and historians have turned the word into a descriptive tag. Actually, no generation of men has set out to be unreasonable. And if the Age of Reason, the age of classi-

cism, the age of order, hierarchy, and monarchy, looks to us like a haven for our distraught selves, it is only another mirage induced by distance and desire.

There is something restful about what cannot be changed, and obviously Queen Anne is immovable. Versailles, Racine, Milton, Dryden, Molière, Pope, Louis XIV, Newton, Locke are—as we like to say—"fixed values," whereas our own are in doubt and in flux. But this fixity is something which *we* enjoy, not they. They were in the same flux and perhaps at a greater disadvantage toward it than we to ours. Setting Swift aside for the moment as a witness some would disqualify, we may take a turn among other great classical spirits and see how reason served them. As is logical in the scheme that makes reasonableness (or the appearance of it) a standard that all must obey, the strongest classic note is satire. It heralds in clear tones the deviation from the norm. Nothing can be more lucid and rational-seeming than the work of Boileau, or more inspired. The inspiration is largely hate. He cannot stand women, Paris, bad writers, idle priests, the poets of the Renaissance, or the colloquialisms of Molière. His *Lutrin* is a delightful masterpiece which deploys epic powers to describe the removal of a lectern and the quarrel that ensued. Boileau was right to reprove, satirize, and make glorious verses, but can his feelings and his occupation be called reasonable? We know well enough that they were not when he indited sickening eulogies to Louis XIV which compared him to Alexander.

Boileau's counterpart is Pope, whose vision of harmony and order lives in unforgettable couplets, but his battle with the age ended in a deed of sustained hatred, violence, and injustice—*The Dunciad*. There even illness and poverty are imputed as crimes and many of the imputations are false. Pope has in fact been praised as "the English poet who best knew how to lie in the service of the truth." The truth was, one supposes, that if X was actually not a cheat and a pimp afflicted with a loathesome disease, Z was, or some other man, men being what they are. La Bruyère, one of our best observers of

the classic order, shows that it lacked none of these despicable characters, nothing of what plagues us: "I meet on this earth a greedy man, insatiable, ruthless, who means to look after himself, at no matter whose expense. Let no one cross his path, he is going to make his fortune and be swollen with goods. . . . But there is [also] on earth a wretchedness to break the heart. Some are altogether without food, they fear the winter, and are afraid of being alive. Elsewhere, people eat early fruit, force the soil, and anticipate the seasons to feed their delicate palates.

"What a sad condition is man's, enough to disgust him with life. He must sweat, work late, bend the knee, be dependent, all in order to have a little comfort, or else owe it to the death of a relative.

"The Court does not make people happy; it only prevents their being so elsewhere. . . . Men want to be enslaved in some way: [at Court] their profession is to be seen and seen again, and they never go to bed without having performed this service which is so essential to the body politic. They are in any case well informed about all indifferent matters and know all the news that everyone cannot help knowing. All they lack is talent to make a little headway. [Others] come in and nod slightly, swing their shoulders and purr like a woman. They ask you something without looking at you, speak loud, and show everybody they are a cut above those present. They stop, and people crowd around them; they have the floor. They owe their fortune to themselves alone and they maintain it with the same skill that created it. They no longer approach their peers, no longer salute them; they speak when others are abashed; they eat with delicacy and deep reflexion; and where others of great title or great merit in the army of the state are excluded, these have the ear of princes."

It was this classic Hollywood, undoubtedly, which revolted the mind of Molière's Misanthrope, a reasonable man in the manner of Swift, though less aggressive. He retires to the country, taking with him our esteem, even our admira-

tion, but leaving his less engaging friend as the symbol of the *socially* reasonable man, that is to say the moderate, unilluded, kindly, semi-conforming gentleman. Social reason comes down to two uninspiring virtues: self-control and tact.

Whether it is fair to conclude from historic attempts to make reason prevail that by forcing an alien ideal on man they produce what they try to avoid is something not easily settled. The alternative is to recognize man's irrationality and allow it scope—or at least deal with it as a given element rather than an enormity. This has been the dominant opinion ever since Romanticism decried the rigidity and hypocrisy entailed by making reason a god. But many today consider that to recognize the irrational is to encourage it. Accordingly they preach a return to the classical model in art, politics, and morals. In the light of this conflict, Swift's position becomes doubly interesting. He does not merely vex his age, he condemns it without appeal. But he also disposes of the traditional belief that the agents of this world's evils, men, were intended to be rational beings. The fundamental drives to reproduction and self-preservation disprove it.

It was Shaw who suggested during the First World War that Swift's pessimism, like Shakespeare's, was probably due to his having spent long years of his youth in a time of war. Certainly Gulliver never tires of describing warfare and the miracles of gunpowder to his hosts. In Swift's hands this is no stock argument to prove unreason; it is rather an obsession he would like to purge. Massacre, plunder, rape, bombardment from the air turning men into cave dwellers, the likelihood that science is for man's self-destruction—these terrors haunt Swift's imagination as they do ours. If, still trusting God, he sees the passions prevailing over reason in order to ensure the begetting and preserving of life, what does Providence intend by the contrary urge to destroy? And we go on to ask—great though his self-knowledge is, does Swift see that he is aping what he hates? To make folly bleed is still to make war, and so is the spirit's self-flagellation. He did not give his emotion the

name of death wish, but he did understand its nature, for in his epitaph he projects himself "where savage indignation can no longer lacerate his heart."

The mind that tortured itself to make these soundings cannot be reduced to the simple image of the misanthropic man. Indeed there is a sense in which he is the most representative European of his age, and not merely the uncorruptible witness to its corruption. Fifteen years before the *Travels*, Swift had, with a book entitled *The Conduct of the Allies*, stopped a world war. For in those days the British government had the omnipotence that comes of supplies, and Swift was in that occasion their conscience and their strategist. As one can see from the *Travels*, he kept thinking of Europe. When the narrator is Gulliver-Swift he always speaks of Europe as one civilization; only when he is Gulliver-Gull does he indulge in the vanity of being an Englishman. Dreaming of Europe to the end, Swift thought that he might save it by importing a few Houyhnhnms as tutors to the West's Yahoos.

We know today that his plan failed. But we may take comfort in the evidence he gives us of the Western world's constancy: much has changed, but none of our woes is fundamentally new. Go back to the *Travels*, in reverse order, from the Yahoos who will fight over food sufficient for ten times their number, to the scientists who neglect life for the elixir of death; from the coarse giants (living not far from California) who insist on isolationism and are gentle because they are strong, to the conceited Lilliputians whose infantile greed and malice make Gulliver noble by contrast—take these and any other symbols of jungle life and ask yourself whether fiction here is not simple fact. At what moment during the past two hundred years would it have been false to say that "the account of our affairs during the last century was only an heap of conspiracies, rebellions, murders, massacres, revolutions, banishments, the very worst effects that avarice, faction, hypocrisy, perfidiousness, cruelty, rage, madness, hatred, envy, lust, malice, or ambition could produce"? *1956*

Why Diderot?

Whenever I am looking for enjoyment from literature and the arts, and also when, in the modern manner, I "study" them for clues to intellectual or social history, I find myself most drawn to the geniuses whose fame is unsettled. Of the ancients I prefer Euripides and Lucian; in recent times, William James, Walter Bagehot, and Samuel Butler; before them, Berlioz and Diderot. Their works and characters pull me back again and again to speculate and admire.

This preference may be temperamental in part, just as their incomplete or grudging recognition is in part accidental. But my choice is also rational, like the state of their reputations, and both are possibly instructive. Of course, if the situation is to tell us something new, we must be sure that we have got hold of a truly great mind, and not merely an approximation of one. Nor should we confuse what I call unsettled fame with obscurity. The group of geniuses I have in mind are figures known, at least by name, to all who discuss ideas and their history. Nor has praise been withheld from my chosen men. Their distinction lies in the perennial disquiet they inspire. Their praise is mixed with doubts. Most significant, perhaps, the reasons for valuing their work are many and conflicting. In a word, the men and their achievements resist classification.

The effect of this lack of pliability upon the ordinary critic is extraordinary. Thus in the excellent *Oxford Companion to French Literature* one reads that Diderot "had not the patience and method to produce any single great work." This comes after the statement that the direction of the *Encyclopédie* was "the most notable of his contributions to the advancement of

knowledge, and a vast burden of which, with great courage and perseverance, he bore the main share." Apparently perseverance is not patience and the *Encyclopédie* is not a work of method. What is more, this estimate of Diderot's character tells us that he was "affable, generous, a faithful friend . . . bubbling over with ideas, enthusiasm and coarse gaiety; at the same time violent and unbalanced."

I attach great importance to such summaries in reputable handbooks, for they reflect in their bland confusion the general uncertainty I speak of; and they naturally spread it further, to the newcomers for whom such books are intended. In these same pages Diderot's great works—and particularly that masterpiece, *Rameau's Nephew*—are listed as "minor philosophical works," while the doctrine to which they contribute in this minor way is said to be philosophical determinism. Diderot was "an experimental materialist" who anticipated "in some respects later evolutionary ideas." He was in addition an "ardent moralist" and "the founder of art criticism in France," though "his underlying principles are full of fallacies." I am reminded by these wondrous judgments of the "authoritative" literature on Berlioz thirty years ago, when I began wading through its naïve incoherence and factual inaccuracy.

For this state of affairs, which recurs and will recur in the history of civilization, I discern two causes: profound originality and transcendent imperfection. I say transcendent to suggest a superior quality, that of work produced at a time when perfection along established ways is no longer of any value. For example, after the tales of Voltaire—after *Candide* especially—and after Rousseau's *Confessions,* no possibility is left of insinuating philosophy, morality, and psychology agreeably through narratives couched in a diction limpid and calm. Nothing less than the scabrous irregularities of Diderot in *D'Alembert's Dream* and the vulgar language and detail in *Rameau's Nephew* satisfy the need to re-establish contact with common life.

Men such as Diderot, then, are *uncompleting* men

because they are finders and initiators, not concluders and finishers. That is why they puzzle the tidy minds of the academy, whose valuable role is to affix labels and put away in glass cases. Diderot, they rightly say, cannot be "associated with a stabilized genre" (this failure sounds ominous) "much less with a single recognized masterpiece." Here one might demur. If *Rameau's Nephew* is not a masterpiece, then the term had best be abandoned. "Recognized" is again a matter of opinion. If Goethe and Freud recognized in Diderot a master of reality, he can wait for the professors of literature. Meantime we grant them that Diderot is not of those who, to the sound of public acclaim, drive the last nail into the edifice their predecessors have built. Rather, they destroy and build anew, groping and stumbling at times, seeming paradoxically full of old ideas as well as of new, and unable to point to unmistakable followers because posterity altogether, in all its diversity and warfare, follows in their steps.

Their very career, in a worldly sense, is untoward. Here is Diderot, a great figure in his own day, courted by the crowned heads of states and of intellect, a hero in the struggle for liberty of thought, a voluminous, indefatigable writer not one of whose productions is without originality or importance, yet whose ultimate greatness depends on three or four works, written relatively late in life, nearly lost, and published half a century after his death. In life, his friends might dub him *"le philosophe"* and Voltaire liken him to Plato, but the high performance justifying these epithets was hidden from those who spoke them.

Under "Diderot" in Flaubert's *Dictionary of Accepted Ideas* we read: "Always followed by d'Alembert"; and under "Encyclopédie," which the joining of the names evokes, we find: "Quaint and old-fashioned; but even so, thunder against." To get at Diderot, to read him, understand him, and love him, one must push to one side the gigantic and successful enterprise to which he devoted thirty years of his life. Not that the

twenty-eight folio volumes of the encyclopedia, packed with knowledge and doctrine, wit and good prose, are a negligible achievement. They testify to Diderot's enormous intelligence, just as the story of the vicissitudes endured by the solitary editor defines his heroic character. But on the scale of the eighteenth century the work was but a mass medium for spreading culture. Diderot himself described it in terms we recognize as good advertising copy: "a complete library"—"lavishly illustrated"—"no one who wants to be up to date can afford, etc. . . ." But strange as it may seem after the consequences, good and evil, that have been ascribed to the *Encyclopédie,* Diderot's superhuman labors to produce it were but his tribute to the spirit of the day. One proof of this is that the work was a great commercial success. Many of the "best people" were encyclopedists. To write the text Diderot found a hundred contributors. To write his late masterpieces or to read them aright he found only himself, and we are still "discovering" him 175 years after his death.

There is even a subtle contradiction between the bearing of the *Encyclopédie* and Diderot's innermost convictions. The idea of knowledge codified and portable, of enlightenment by system, went against Diderot's earliest and deepest perceptions. If ever the editor wondered why he was striving so hard to put that loaded alphabet in order, he may have told himself that he was doing it only to clear the public mind for receiving his own fluid speculations. He did not, of course, reason in this way, so far as I know; I only make up this internal dialogue to render the contrast I see between the plain business of the *Encyclopédie* and the evocative meaning of the final great works. Yet my fancy is not wholly without warrant. In his *Letter on the Blind,* just before Diderot enters the long tunnel of editorial work, he gives as it were a last look at reality and exclaims: "I cannot conceive why people do not grow bored reading so much and learning nothing."

For his own part, Diderot had been reading a great deal since early youth, when he was a very fair student of the arts

and sciences, particularly mathematics. He had made his bohemian way in Paris by tutoring in that science, by translating from English and Italian, which he had mastered alone, and by other hackwork. But none of this was meant to foster a respectable career as man of letters. Diderot was a hot, passionate, rebellious youth. He quarreled with his well-loved father over marrying, and was even sent to prison on that account. And for his earliest *Pensées* (1746) Diderot used Shaftesbury's name to cover his own, so that he might express his faith in "enthusiasm," in rash deviation from eighteenth-century taste.

What is more, this fledgling philosopher spoke in a new voice. His prose was rapid, trenchant, sinewy. One might suppose that these adjectives apply as much to Voltaire, but the two styles are worlds apart: Diderot's tone becomes less and less "polite" as he becomes more and more himself. He relies increasingly on colloquialism—and hence on dialogue—to achieve what he seeks, what we should today call "realism." He is dissatisfied with anything less than the exactitude of intimacy and concreteness, and he says so: "In general any language is poor in words adequate to the uses of writers with a lively imagination. They are as badly off as intelligent foreigners— the situations they invent, the delicate nuances of character they perceive, the naturalness [*naïveté*] of the depictions they want to give, make them continually depart from ordinary modes of speech and make them use turns of phrase that are always admirable provided they are neither precious nor obscure. . . . The license taken with the common tongue is overlooked, the truth of the rendering alone strikes us."

This is the creed of a literary Romantic, dated 1749, the year of Goethe's birth. Nor is it with Diderot an isolated intention, a vagary. His view of man, his artistic tastes, his morality, his science, his metaphysics, and his ultimate philosophy are in tune with this new *impatience*. Diderot wants to cut through the resilient web of conventional words and tested generalities so as to reach and grip the reality that flashes and

beckons to him from between the joints of the Neo-Classic. And the first particle of that new truth shows him that Descartes's founding universal reason on the thinking self is an illusion. Men are diverse, each is unique, individualism and pluralism follow: "Since I am someone who acts thus and so, anyone who could act otherwise could not be me."

In the relativism of that sentence and in others about "matter capable of thought," critics have found Diderot's materialism and determinism. The propriety of using these terms can be plausibly argued, but then their definition has to be made so singular that they cease to have the common meaning in order to denote a position peculiar to Diderot. It would seem simpler to begin by saying what Diderot meant. Whatever he was, he cannot be classed with those who take comfort in the explanation that matter-in-motion alone exists, giving rise to human consciousness as an "epiphenomenon" that chemistry will one day explain. Diderot believes the opposite: "Man is the sole starting point and end to which everything must finally be related. It would be absurd to put a cold, insensitive, speechless being in place of man, for if you banish man . . . from the face of the earth, this sublime and moving spectacle of nature will be but a sad and lifeless scene—the universe will be hushed, silence and darkness will regain sway . . . why should we not indeed make man the center of all that is?"

Deciding to do so does not, it is true, account for the mystery of life, but that is a mystery which it is permissible to fail to solve. When Diderot supposes "thinking matter," he is but trying to get rid of the dualism of soul and body, like Goethe, Coleridge, the elder Darwin, and other vitalists half a century later. It was Diderot's "lively imagination" that enabled him to seize by direct intuition the primacy of life and the likelihood of organic evolution. These notions present difficulties, like all philosophic beliefs, and it is not my concern to prove them right or wrong partly or as a whole. They show the direction of Diderot's thought and his intellectual temper and

it is these I am concerned with. They announce a tendency which takes its rise in the late eighteenth century and dominates the early nineteenth; it lacks an historically ratified name; but supposing the thing and the name each properly understood, it could be called Pragmatism.

Certainly William James, had he studied Diderot, would not have disowned him as a forerunner. They have in common the sense, rare in philosophers and undeveloped in the ordinary man, of the native and irremediable variety, the radical confusion of things. Hegel had this sense only to clamp down a waffle iron over the plastic mass. Other philosophers assure themselves that the disorder is but Appearance. Very few are sufficiently radical empiricists to adopt stubborn rules in the philosophical task of making order out of chaos, saying to themselves: "Remember! Concreteness, direct contact with the given first and last!"

It is very likely that this rule is no more reliable than any other. The algebraist, for example, does pretty well when he leaves concreteness behind and leaps across the void of abstraction—as Diderot the mathematician was fully aware. But I am describing a philosophical complexion, and one must admit that the empirical pluralist, whose obsession is to find out first what the experience feels like, tastes and smells and thinks like, and only afterwards connects it, in patches, to create local order—such a philosopher avoids many errors and makes many discoveries. His temper is in fact the generator of novelty. Since I have paired Diderot and William James, it is apposite to give an example of Diderot's concreteness in psychological method, which is also a specimen of his originality in self-knowledge. The passage is from his *Letter on the Deaf and Dumb for the Use of Those Who Can Hear and Speak:* "Sensation does not follow the successive unfolding of speech. If it could dictate to twenty mouths, each mouth uttering its word, all the preceding ideas would be expressed together. That is indeed what sensation would wonderfully perform on an ocular keyboard."

On this "ocular keyboard," I presume, the world played with Diderot's unconscious a duet to which he listened in order to transcribe it. His views on art and on morality reflect his determination not to tamper with his own naïve, uncorrected impression. If he interprets it, he must do so without distorting the given; if he explains, he amplifies merely, and does not explain away. It is characteristic that in the great dialogue called *D'Alembert's Dream* the true philosopher is man *dreaming*. Only in that state can he at once perceive and convey the nature of life. Waking, he suffers from too many constraints; the presence and the expectations of an interlocutor or a woman would spoil the deliverance. When Diderot wants to push further the exploration of the self and examine the coercion of wild impulse by society, he makes use of Rameau's nephew to render plausible the inner dialogue of a double self, id and ego, each embodying a Reason the other cannot assimilate or defeat. It is the nephew, a Panurge-like character speaking in the accents of a modern novelist—Joyce or Céline—who points out to the philosophic "I" that the aim of being a good man by fulfilling one's duty to society is self-contradictory.

The repression that society exerts on appetite, that is, on the creature's urge to survive, master its environment, and enhance its share of life, is fitful but inescapable. The upshot of the struggle is what fills the prisons and the pages of history— pain, violence, and disgrace, the warping of character and the tragic downfall of ambitious talents. But that same erratic force is also the cause of the world's false standards. Diderot is not resigned to the hypocrisy which the good must put up with, and sometimes imitate, in order to live. As he says in *Rameau's Nephew,* in the whole kingdom everybody must dance his little cowardly dance of social flattery. Only one man walks—the King—and even he goes through contortions if he is ruled by a mistress.

Such is the price of civilization, which makes Diderot

long for the primitive simplicity of Tahiti, or—what comes to the same thing—makes him understand the calculating self-ishness of the disabused, typified by the wastrel Rameau. Yet Diderot is not a cynic and he cannot return to a primitive exis-tence. He knows as well as Rousseau that there is no "going back to nature." Diderot's origins and upbringing spoke con-sistently with his judgment and his tastes. The son of a cutler, he knew the value of technology in the making of civilization. Again like Rousseau, he had made his way upward from a social class well below that of the comfortable bourgeoisie, and he saw society as much more chaotic than "polite." Once at the top he kept his impressions and some of the manners of his beginnings: in all Europe only Diderot conversing with Catherine the Great could have seized her knee to make her listen to an argument. This naturalness was of a piece with his complaint to his family about the portrait that was painted of his father: "What you have done, you and the painter, is alto-gether worthless. I asked you for my everyday father and you have sent me nothing but the Sunday one."

To a love of external reality akin to the desire for an "everyday father," a love which is in large measure accessible to all once the spell of convention and abstraction is broken, Diderot added the less common love of emotional truthful-ness. Long cultivated, this power is what enabled him to throw out in his dialogues so many remarkable hints of later systems, such as the famous argument by which he tries to convince Rameau of the necessity of moral education: "If your little savage were left to himself and to his native blindness, he would in time join the infant's reasoning to the grown man's passions—he would strangle his father and sleep with his mother." Less well known is that Diderot was the first regular reviewer of art exhibitions. He discussed the Paris Salon, where painters exhibited bi-yearly, twelve consecutive times, from 1759 to 1781, penning his critiques in such a way that the thickest mind and slowest eye would be aroused to think

and perhaps to see. No parallel to this monumental work—one thousand closely packed pages—could be cited until Bernard Shaw, in the 1880s, did the same thing.

We have a glimpse of Diderot's method—if method it was—in the frequent asides that interrupt his dialogues. For example, after a wonderful pantomime by Rameau in behalf of expressiveness in music, Diderot asks himself: "Did I admire? Yes, I did admire. Was I moved to pity? I was moved. But a streak of derision was interwoven with these feelings and denatured them." It is reasonable to suppose that the dialogue form became his chosen medium because of its adaptability to this sort of interruption and introspection. The novel in the eighteenth century was too rigid and monotone to permit the nuance-seeking which became Diderot's chief concern as thinker and writer. The dialogue form is not dramatic but dialectical; it is not narrative but anecdotal. Its advantages are precisely those which the artist-philosopher requires, permitting him to render the dramatic and narrative quality to be found in ideas, without having to delay the movement or distort the shape of the regular play or novel form.

This latitude does not mean that the writer of dialogues can let his pen run on as statement and rejoinder occur to him, nor again that his work is but the parceling out of arguments and objections among lay figures. One has only to compare with Diderot's the dialogues of Hume "Concerning Natural Religion" to see the difference between a philosopher *tout court* and one who is also an artist. Diderot's figures are vivid creatures, even when asleep, as is d'Alembert in the famous *Dream*. In *Rameau's Nephew*, as Goethe pointed out, the aimlessness is a superficial appearance. The work has the tightest weave imaginable and is cut to a perfect model. In fact, since Plato and Lucian, literature affords but few examples of mastery in this difficult though oft-attempted genre.

His originality could, of course, be illustrated much more fully than I have done. His remarkable views on sexuality, on pragmatic religion, on the emancipation of women, and on

innumerable issues of aesthetics and social philosophy would make a long list. And it would justify the claim that he belongs among the half-dozen geniuses that stand out among the great galaxy of eighteenth-century minds. *1962*

William Hazlitt

Hazlitt is not so much forgotten as half-known: his mode of thought is out of favor and his range is too broad to let him be classified. Unlike his friend Charles Lamb, he does not invite that coziness which generates a "Friends of" Society, with a quasi-scholarly newsletter.

Hazlitt was first a painter and a metaphysician, then a drama critic, a political commentator, an autobiographer, and a master of the familiar essay. In all genres he excels; in every line he wrote he was Criticism personified. He ranks moreover among the distinctive English stylists. As Stevenson said with the perspective of half a century: "We are all clever fellows, but we cannot write like Hazlitt." One reason that he is not linked as a critic with Coleridge, De Quincey, and Landor is that he was their political enemy, hated and abused in their periodicals. *The Quarterly* said that he wrote Cockney English, or again called him "pimply-faced," though he had a clear, smooth complexion. His crime was that he had not abjured the French Revolution like the Coleridge coterie, nor had he joined the nation in making a bogeyman of Napoleon. Like Scott, he wrote a four-volume life of the emperor, but taking the other side.

It is easier to describe what Hazlitt does in his critical essays than to convey the impression they make. Perhaps one's strongest feeling is that the ideas are not conclusions "recollected in tranquillity" but worked out in front of you. Those long, enveloping sentences feel hot from the forge. In his

Characters of Shakespeare's Plays, in his *Lectures on the English Poets,* in his essay "On Genius and Common Sense," indeed, in whatever his mind lights on, Hazlitt finds the deep source of the matter and traces its implications and ramifications; he sees how the event, the impulse, or the vision took shape; he relates what is there to other parts of the same work, to the work of others, to the author's life, to life in general, to his own life. It is not analysis, it is judgment encompassing its object, leaving it whole and illuminated.

As remarked earlier, criticism of this order is out of favor today because it follows no system, lacks a jargon, and affords pleasure when read. How can it be "rigorous"? It is "impressionistic." These and other strictures must be understood as part of the competition between art and science. To be up-to-date and acceptable nowadays, any mental activity must use principles couched in special abstract terms and forming a system. What is poured into the mold other than impressions drawn from the work is not stated. But one has only to read Hazlitt without preconceptions as to what he ought to do to see that he is both rigorous and exhaustive. His practice is to describe and define and to describe again, adding a line, a touch, developing the complete image. You see a draftsman, a painter at work. He persists and insists that you shall see the way he perceives—not that he is trying to persuade you of an idea, only to make you as good a reader as he is. And that means one who not merely knows more than the careless or unguided but enjoys more.

In his familiar essays Hazlitt gives pleasure and wisdom like Montaigne. He speaks of himself as a witness in the same way and he quotes almost as much. But he does so in English and he sticks rather more closely to his announced subjects: "On People With One Idea"; "On the Indian Jugglers"; "On Living to Oneself"; "Why Distant Objects Please"; "On the Feeling of Immortality in Youth"; "Whether Actors Ought To Sit in the Boxes." His subjects divide between the unexpected and those born of common experience.

The reader who is captivated will want to go on in two directions: to *The Liber Amoris* and to *The Spirit of the Times.* This last consists of bio-critical essays on the leading political figures of the day. The characterizations are verbally sharp, but never caricatures. For example, describing Lord Eldon, the Lord Chancellor, Hazlitt says: "He has a fine oiliness in his disposition which smoothes the waves of passion as they rise." The most remarkable portrait is the one of Burke. Here is the man whose ideas had given strength to counter-revolutionary thought in England, who was the embodiment of Conservatism, a party that but for him would have ruled in mere dumb resistance, with nothing to say for itself—here, in short, was Hazlitt's quintessential enemy. Yet so balanced is the judgment at work that the essay turns out the finest of eulogies. Hazlitt makes clear the wrongness (as he thinks) of Burke's ideas of freedom, of government, of religion, and of the English Parliament. But Burke's genius as a thinker and writer and the worth of his character are represented in glowing lights and delicate shades. It is a perfect exhibition of critical genius.

The Liber Amoris, "the book of love," relates the curious behavior of a young woman Hazlitt fell in love with and his baffled response to it. The telling, again, is immediate, yet detached; it stands halfway between a case study and a novel, like the *Adolphe* of Benjamin Constant, in which the narrator dissects his love-subjection to Germaine de Staël. One more work, the *Conversations with Northcote,* shows Hazlitt matching opinions with a painter, as he was qualified to do by his early practice of the art and lifelong passion for it.

Hazlitt as philosopher is not without originality. As for being philosophical in the ordinary sense, Hazlitt qualifies for the label: after years of quasi persecution and disappointments, on his deathbed and no doubt thinking of his intimacy with art and literature, his last words were: "Well, I've had a happy life."

2000

How the Romantics
Invented Shakespeare

People who take an interest in literature and the arts usually develop a neighboring interest in the lives and personalities of their favorite artists and authors. They read biographies and critical essays, and these lead naturally into the history of styles and movements. Such readers learn about the rise and fall of classicism, romanticism, naturalism, and other isms. They enjoy discovering, for example, how Virginia Woolf used her practiced bow and arrow against the realistic novel and helped to shoot it dead. But these connoisseurs of criticism seldom go on to look into the history of reputations. It is of course more difficult to get at, being rarely written up in full. Yet if they did, they would learn things no less surprising and valuable.

The history of Shakespeare's reputation is a good illustration of this generality. That history is interesting and valuable on two main counts—one, because it concerns Shakespeare; and two, because it tells us a great deal about the Romantic movement. Along the way, this backward look at Shakespeare's position in successive periods and places shows how literary fame is made, obscured, and sometimes restored.

To understand what the Romantic poets, artists, and critics did for Shakespeare, one must review the earlier estimates about his merit. We may take it for granted that in his lifetime he was a popular author, admired by some of his fellow poets and resented for his success by others. This is normal. But one should recall the remark made by his friend and rival dramatist Ben Jonson, that he wished Shakespeare had "blot-

ted" a thousand lines from his plays. This casual comment is central to the story of what follows.

After his death, in 1623, Shakespeare's works were performed less and less frequently, and the favorable mentions of his name also grew fewer. The reason for this is clear and was made explicit at the time: by the mid-seventeenth century, the work of most Elizabethans was considered crude, barbaric, ignorant—with the single exception of Ben Jonson's output, which had been constructed on the so-called classical models and showed classical learning. In a word, Neo-Classicism had set in. A writer of the period sums up the point of view: "Nor was much of Comedy known before the learned Ben Jonson, for no Man can allow any of Shakespeare's, except *The Merry Wives of Windsor.*"

When Samuel Pepys went to one of the rare performances of Shakespeare, he had no good word for it. Of *Romeo and Juliet* he says: "a play of itself the worst that I ever heard." Of *Midsummer Night's Dream:* "the most insipid, ridiculous play I ever saw in my life." As for *Twelfth Night,* it was "well acted though it be but a silly play."

True, during this same second half of the seventeenth century the great poets Milton and Dryden professed admiration for Shakespeare's *poetry.* Milton speaks of Shakespeare's "native woodnotes wild"—that is to say, not classically trained; and Dryden expresses similar reservations in the midst of his praise. As a dramatist, Shakespeare was thought uncouth. In short, he was a good poet here and there but no artist. A critic writing in about 1730 has this to say of *Othello:* "There is in this play some burlesk, some humour, and some ramble of comical Wit, some shew and some Mimickry to divert the spectators; but the tragical part is plainly none other than a Bloody Farce without salt or savor."

So general was this type of opinion that Nahum Tate and a dozen or more Neo-Classical authors of high or low degree took on the task of improving, of rescuing some of Shake-

speare's plays from their clumsiness and imperfection. One James Howard, believing as he did that "there was no popular love for Shakespeare, . . . arranged *Romeo and Juliet* for the stage with a double denouement—one serious, the other hilarious. If your heart were too sensitive to bear the deaths of the loving pair, you had only to go on the succeeding afternoon to see them wedded and set upon the way of a well-assured domestic felicity."

But again, a true poet of the time, Alexander Pope, was shrewd enough to value the poetry and he produced an edition of Shakespeare that pointed out the "beauties" in it; that is, the passages that stood out from the remainder, felt to be bombast, vulgarity, and unintelligible nonsense. In other words, the Shakespeare of—let us say—1750 is considered a gifted poet who in his own day catered to an audience as lacking as himself in judgment and education.

But in the next generation, the first faint signs appear of a weariness with Neo-Classical standards. A young man—the future Bishop Percy—becomes interested in folk poetry and collects border ballads, which are the poetry of the uneducated. Next, a poet named Macpherson writes a large composition and palms it off as the work of an ancient Irish bard named Ossian. The point is that poetry from barbarian sources can be great. Accepting these novelties implies a change of taste that softens the objections to Shakespeare. When Dr. Johnson in his turn edits Shakespeare in 1765, he does not stint his praise—though he continues to think that "you cannot find six lines without a fault" and that, as plays, only Shakespeare's comedies come up to standard. To him, *Macbeth* seemed a work that was the worse for being acted.

But the slow shift toward a new cultural outlook gathers strength. A new view of wild nature, of human emotion, of genius, of the Middle Ages, of places outside Europe gradually enlarges the horizons of cultivated people. This loosening of the limits of the beautiful and the rules of art is often called pre-Romanticism. And right then comes the first call for a

radical reversal of Shakespeare's position. A man named Maurice Morgann, not otherwise distinguished, published in 1777 an *Essay on the Dramatic Character of Falstaff*, in which he sets down his conviction that "Whatever may be the neglect of some, or the censure of others, there are those who firmly believe that this wild, this uncultivated Barbarian has not yet obtained half of his fame." And he follows this with a prophecy: "When the name of Voltaire and even the memory of the language in which he has written shall be no more, the Appalachian Mountains, the banks of the Ohio . . . shall resound with the name of this Barbarian."

But it takes more than one critic, no matter how determined and argumentative, to revolutionize opinion and make a great artist or poet out of a figure which for 150 years has been thought demonstrably incomplete and imperfect. After Morgann it took half a century more to achieve this uprooting of old ideas and effecting a reversal of common judgment. Not until the Romantic poets had themselves begun to be accepted were they able to impose their view of Shakespeare—a Shakespeare whom they may be said to have "invented."

The high point of Romanticism—the period 1800–1840—was a time of unparalleled creativity, a time marked by the appearance all over Europe of a galaxy of geniuses, a time of cultural revolution if ever there was one. The change in Shakespeare's status was part of that revolution; his new repute was part of that creativeness. Listen to Coleridge, the creator with Wordsworth of English Romantic poetry—listen to his lecturing various London audiences between 1802 and 1818 and turning upside down the stereotype about Shakespeare: "Let me now proceed to destroy . . . the popular notion that he was a great dramatist by mere instinct . . . a delightful monster—wild, indeed, and without taste or judgment. . . . I have said and I say it again, that great as was the genius of Shakespeare his judgment was at least equal to it."

This bold claim seemed to many a pure paradox, but it

soon converted many critical minds; it was in fact a judgment independently arrived at by other writers in England and on the Continent. How did this come about? For one thing, the ground had been laid—as we saw—by a scattering of new interests in the late eighteenth century. And Coleridge himself tells us in another connection how cultural shifts occur. He speaks of "elements that are wanted" at a particular time. These elements are ideas, attitudes, visions, moods, forms, hopes which poets and other writers supply or fail to supply in their works. Wanted elements are sought for in the past or in another country. If they are not found, they are created.

But the yearning for new artistic forms and subjects was not the only force tending to redirect contemporary culture. There was also a political feeling at work. It can be best observed in Germany, where as early as 1768 the great critic and playwright Lessing, who wrote reviews of the current drama in Hamburg, steadily attacked the plays of Voltaire and promoted those of Shakespeare. As a reader of English literature, Lessing knew the plays and began to use them as a battering ram against the long-established authority of the French drama. A pair of German writers translated the complete works and among these avant-garde spirits he became *Unser* Shakespeare.

Earlier, when Frederick the Great had wanted to urge his people to speak and write in German, he had to write his pamphlet in French to get the attention of the educated classes. The French language, French plays and poems and criticism, French manners, and French ideas had been for a century or more the only fashionable ones in Europe, as far as Russia. And at long last, this intellectual slavery was being resented. To overthrow it, another language, another literature was needed. The Germans, led by Lessing, started the revolt in the name of English literature, with Shakespeare as their champion.

In England, something like the same conditions had existed since the return of Charles II and his court from their exile in France. French models in manners, dress, and literature were followed, less slavishly than in Germany, but still

without any resistance from national, patriotic feeling. But when Morgann made his plea for Shakespeare, it was against Voltaire and against the French language. The two together must be put down and forgotten.

A significant fact in the English Romantics' advocacy of Shakespeare, fifty years after Morgann and Lessing, is that for the first time English writers paid serious attention to German literature and philosophy. Coleridge visited Germany; Carlyle translated Goethe, Schiller, and Richter and gave an account of modern German thought. Much of this new curiosity about a people which had formerly been held culturally negligible was due to a best-seller of the year 1807 called *On Germany*. It was by a Swiss woman traveler, Mme. de Staël. She had interviewed the notables of the emerging country, and her book was a résumé of the anti-French, anti-classicist point of view. She was not yet a full-fledged Romanticist; that name itself was still a subject of misunderstanding and confusion. But her description of an outlook at odds with the French orthodoxy was so vivid that Napoleon took it as politically harmful, banned the book, and exiled the author.

Politics helps to explain why the Romantic movement proper became established at different times in different countries of Europe, even though the urge toward the wanted elements arose about the same time everywhere. France was the last to give up Neo-Classicism, because it had largely created it and more especially because the Revolution and Napoleon were at war with the nations where Romanticism was bred and developed.

But by the time of Coleridge's pronouncement about Shakespeare, the Continent as a whole had come to know and admire a particular work by a contemporary German— Goethe's *Faust;* and although *Faust* is not a Shakespearean play, it is in form and philosophy the antithesis of any of Voltaire's. *Faust* created enthusiasm by its freedom from rules and its use of the elements that were wanted—variety, contrasts, realism, passion, superstition. Its implied message was

congenial too: it was the story of a search; it was man in motion and valuing experience above book knowledge. It showed that the universe was far bigger than the social world, and the social world itself bigger than the court at Versailles or the literary coterie of any town. These propositions might be called the working principles of Romanticism. And their relation to Shakespeare is visible in the small fact that when a series of Shakespeare's plays was given in Paris in 1827 it was a raging success, whereas five years earlier a similar attempt had been a failure.

I have been using Coleridge's phrase about elements newly desired to suggest how and why Romanticism came into being. As to the contents of the phrase, the elements themselves, it must be added that most often they are partly discovered in the past—in a writer or a school of writers—and partly created by the eager minds of the discoverers. It is a group affair in which each participant contributes something to the new view of the past. That is what happened, for instance, in the Renaissance, when all the lively minds found in the remains of ancient Greece and Rome the "elements that were wanted" in the thirteenth century and later. And it happened again in the nineteenth century with Shakespeare at the heart of that particular Renaissance. He was soon flanked by the other Elizabethan dramatists and poets, and by Chaucer and Langland.

The Romantic discovery and invention of Shakespeare, the all-wise poet and dramatist, founded in one generation the cult, the hero-worship, of the bard of Avon. This is not a figure of speech. In 1840, Thomas Carlyle, writing about the hero as poet, defined Shakespeare's place in contemporary opinion: "the best judgment, not of this country only, but of Europe at large, is slowly pointing to the conclusion that Shakespeare is chief of all poets hitherto."

This transformation of the crude, classically ignorant, and fault-ridden writer, who could not turn out six good lines in a

row and who should have blotted a thousand, into "the chief of poets, a veritable hero and demigod" is one of the most extraordinary spectacles in the history of reputations. But the story is not over at this point, and it continues to be extraordinary.

Carlyle was right in saying that his conclusion held good for the centers of culture throughout Europe. The evidence for it can be found in the writings of critics, the translations of Shakespeare's plays, their influence on young poets and playwrights, and—most convincing—in the flood of paintings and engravings, of songs, symphonies, ballets, and operas based on Shakespeare's themes and characters. To take just two instances from the nation formerly most Neo-Classical, the French painter Delacroix, on discovering Shakespeare, produced at once a series of lithographs based on *Hamlet;* and the French composer Berlioz produced throughout his life score after score on Shakespearean motifs, from *The Tempest* to *Romeo and Juliet,* and death music for Ophelia and Hamlet.

What strikes one in this great surge of enthusiasm for Shakespeare is that it occurred mainly in the breasts of poets, critics, dramatists, painters, and musicians—and I should add: actors and actresses. It was already evident in the eighteenth century that the zest for Shakespeare was strong in those who saw in him a vehicle, beginning with David Garrick, who nevertheless felt free to change the ending of *Romeo and Juliet.*

In the Romantic period, a still wider public attended the revivals of the great plays, and after a time the name Shakespeare became in the popular mind a synonym for great drama. But it was clear from the box office returns that the public went primarily to see a great actor in a big part—John Kemble or Mrs. Siddons *in* Shakespeare, rather than Shakespeare played *by* Kemble or Siddons.

With readers, as against spectators, Shakespeare's popularity in the Romantic period was further extended by Thomas Bowdler's special edition *The Family Shakespeare.* It took out all the obscene passages and low jokes; it even replaced the

word "body" by a suitable substitute such as "figure," depending on the context.

That this was needed at the very time when Shakespeare came to be considered perfect may seem yet another paradox, but an anecdote will make the point. Mrs. Trollope, the mother of the future novelist, came to this country in 1827 to make her fortune by opening a general store in Cincinnati. She failed, but recouped her losses by publishing a lively book called *Domestic Manners of the Americans*. In it she satirizes the people of Cincinnati, including a gentleman with whom she had an argument about English literature, which he did not appreciate. "And Shakespeare, sir?" asked Mrs. Trollope. "Shakespeare, madam, is obscene, and thank God, we are sufficiently advanced to have found it out!"

Of course, the gentleman was right, and Mrs. Trollope exemplified the indiscriminate fervor for the new poetic star. The dialogue in Cincinnati makes it clear that in the nineteenth century Shakespeare could not be swallowed whole, except by writers and artists of large views. But what were these missing elements newly found in Shakespeare's works? Variety of scene, violent contrasts, striking events, psychological insight, and character development. Compared with the Neo-Classical tragedy, which had dominated playwriting for 150 years, Shakespearean drama was chaos. That is why Voltaire had called Shakespeare "a savage," a man who wrote "like a drunken brute." There was no order, symmetry, or conventional restraint in those would-be tragedies and comedies. Only the English mob could stand them. Why, even the two dramatic genres were mixed together: there were jokes in *Hamlet* and *Macbeth,* and as mentioned earlier, one English critic found *Othello* mostly "burlesk." In short, the stateliness and decorum of tragedy was shattered, while the systematic working out of one great human passion in conflict with another was neglected in favor of a tangle of motley figures, strange events, and disparate purposes. In Shakespeare, restless

movement and vulgar emotions distracted the mind from the contemplation of pure feeling and strict form.

It was these very faults, these horrors that were now wanted by people who called themselves artists, who *were* artists and critics too. What had happened to pervert their taste? Why did Stendhal write two pamphlets contrasting Racine and Shakespeare to the former's disadvantage? For one thing, boredom with the old tragedy had set in. Every great genre or form wears out, and a new generation comes along that says, like Othello, "no more of that." But boredom is negative; it tells us we want something new but not what the novelty shall be. By the time Coleridge lectured in London, all Europe had suffered twenty-five years of almost incessant war and revolution. The eighteenth century seemed terribly far away. Danger, death, destruction had become familiar and seemed permanent. Nothing stayed put for more than a few weeks or months. The minds educated in this school of violence were attuned to a different kind of art from that which had reigned in the days of absolute monarchy and hierarchy. Shakespeare's "chaos" thus looked like human experience itself.

The notion of experience as a literary element is complex and cannot be made clear because of its very scope: experience covers anything and everything, including error, illusion, and (as shown in *Faust*) superstition. But one thing about it *is* clear and that is its progression, its movement. Experience is what takes you from one state of mind or body to another, not predictable by logic. Consider the feature of Shakespearean drama that is called character development. It is achieved by choosing a set of situations such that the persons in the drama are changed by successive events. We come to know them through and through, because they are not "types" who repeat their response, but individuals whose inner workings are complex, even mysterious, yet plausible and surprising.

The reason they develop is that the play covers a long

series of events, it is a *history* of those people in an extended spectacle. Such a play defies the classical rules of tragedy, which called for unity of time, place, and action. It depicted the working out of a problem: Will the hero obey the call of love or of duty? Will the heroine give up her love or her religion? The conflict does reveal character through behavior in a clear-cut situation, but the change is from doubt to decision on that one point. In Shakespeare—for instance in Hamlet—the changes are from doubt to murder to rejection of love to pangs of conscience about killing, to disgust with one's mother to swift action at sea to meditation on death to fencing with friends and to death by treachery; all this, followed by posthumous praise from a soldier who has taken no part in the action.

Now, these two linked elements—psychological exploration and narrative history—were Romanticist concerns par excellence. From small beginnings, the taste for history grew apace in the early 1800s. Walter Scott's novels fed this new interest, which became universal and lasted until the early years of the twentieth century. As for psychology, the Romantics made a speciality of it, precisely because they felt that the Neo-Classic abstraction Man-with-a-capital-M did not exist. So when we speak of the Romantics' "morbid introspection" or of their "love of the exotic," what we are actually referring to is their desire to know what different individuals and different cultures can tell us about the diversity of mankind. Similarly, one should stop talking about the Romantics' "revolt against reason" and say "revolt against abstraction." The reason of the eighteenth century had its merits; it accomplished great things, but it was incomplete and concealed realities under general propositions; it needed the concreteness of experience, history, and psychology.

In the course of time, the admiration for Shakespeare became conventional rather than the expression of individual judgment. By then, it had created an industry. Innumerable books explained large meanings and difficult passages; there

were "keys" to Shakespeare: editions of the complete works with illustrations, single plays with notes for school use; scholarship upon the early folios and quartos of the plays; attempts at biographies based on the meager evidence; speculation about the woman mentioned in the Sonnets and "Mr. W. H." who shares the honor with her; comparisons with the other Elizabethan playwrights; finally, rival theories about the true authorship of the plays and the solving of the "ciphers" supposedly hidden in the text. The latest subject of analysis is the personality of Shakespeare's typesetters. They have been identified by their errors and whims in composing the quartos and folios. And the computer has been used to count words and phrases, so as to determine how much of *Henry VIII* Shakespeare wrote and whether *Two Noble Kinsmen* is by him or someone else. Add to all this the applications of critical "methods"—myth, symbol, theme analysis, psychoanalysis, deconstruction—and it is clear that the fuss and fret *around* Shakespeare is of far greater economic and cultural importance than the works themselves.

The plays are indeed produced, often and in many places; actors still want the big well-known parts. But the productions rarely last long or make money. The several Stratfords all need subsidies, and when the English Shakespeare Theater decided to cobble together a two-day show out of Dickens's *Nicholas Nickleby*, it was because they had gone broke playing Shakespeare. When he is put on, his work is cut, rearranged, and these days almost invariably altered in some essentials to make it "attractive." For example, in *The Winter's Tale*, Mamilius is shown frolicking around the stage on a bicycle, which reappears later as "a symbol" by being walked slowly across the stage. In *Measure for Measure*, Isabella's great scene with her brother is played virtually as slapstick, because she is proud of her chastity—today a ludicrous idea. In *Richard III*, the King is shown not only as deformed but as creeping on all fours in imitation of various insects—spider, cockroach, and so on. In another production, *A Midsummer*

Night's Dream is set in an American high school—the main characters are dropouts. As for *The Comedy of Errors,* it is turned into a circus that shows Shakespeare on stage balancing an electric guitar on his chin while other members of the Karamazov troupe of jugglers and acrobats clown it up.

After such things, one can take Professor A. L. Rowse's rewriting of the plays in modern English as the completion of the effort by which Shakespeare's drama and poetry are cured of their many defects. Left as he is, he is too dull for a sophisticated audience.

Thus the "greatest of poets hitherto" stands between two worlds: unlimited praise and fame and study on the one hand, and on the other the works on the stage. The true position of Shakespeare that the Romantics discovered and worshipped is hard to characterize. The regression is striking—at least for the public Shakespeare. To find who really appreciates his plays as written, one must fall back on the small group who read and enjoy him in private—poets, artists, playwrights, or critics, and unassuming lovers of literature. It is a special coterie, as it was in the days of Coleridge, Goethe, Hazlitt, Lamb, Delacroix, and Berlioz. For although the Romantics managed to get their cult of Shakespeare accepted very widely *in principle,* it was an active faith only for a time. We have Hazlitt's testimony on this point. Writing in 1829, he says: "With us Shakespeare forms a sect, and if the truth were to be spoken, not a very numerous one."

Over the years, the best readers have reservations. T. S. Eliot declares *Hamlet* "an artistic failure." A. C. Bradley tells us that "something of the confusion which bewilders the reader's mind in *King Lear* recurs in *Antony and Cleopatra,* the most faultily constructed of all the tragedies." Also about *King Lear,* Wolcott Gibbs, long the drama critic for *The New Yorker,* says that the motives of everybody in that play "arouse in me no emotion more exalted than hilarity." André Gide, who was fluent in English, thinks *The Tempest* strange and unsatisfying, *Richard II* badly constructed, *Henry V* mediocre,

and *King Lear* execrable. John Crowe Ransom, the American poet, found Shakespeare's poetry poorly composed: the "Tomorrow and tomorrow" speech in *Macbeth* is "possibly effective dramatically," but as poetry it "did not work out."

Current drama reviewers are even more severe: one says that *The Tempest* is rarely played because of its inherent difficulty; another thinks that the transformation of *The Taming of the Shrew* into a good play is a modern miracle; a third, after seeing *All's Well That Ends Well,* complains of the "slow exposition, crabby poetry, and infelicities of structure and characterization." As for *Love's Labour's Lost*, the preciosity is hard to bear and the plot "certainly demands patience." George Moore objected to *Macbeth:* "I cannot endure a play with thirty-two curtains." It was left to Logan Pearsall Smith to draw up a catalogue of faults in the essay "On Not Reading Shakespeare." To Smith, Shakespeare is "the most inaccurate of all the poets, the most completely devoid of all artistic conscience."

As is well known, the greatest onslaught on Shakespeare's reputation was mounted by Tolstoy, himself a playwright and a reader of literature in five languages. It is true that he made his repeated attacks in the name of a theory of art which condemns subtlety and complexity. But part of Shakespeare's merit has traditionally been that he is a popular author who, given a chance, appeals instantly to everybody as he did in his own day. How far this is from the truth, we have seen in the extravagant efforts to jazz him up and make him likable. One can agree with Tolstoy that Shakespeare is difficult, not simple, without sharing Tolstoy's desire and purpose to cure the world of its "insane delusion, its collective hallucination" about Shakespeare.

How do we sum up? Where does the Romantics' Shakespeare stand? The answer depends on temperament, education, and geographical situation. The French and the Italians have relapsed into rather classical attitudes toward Shakespeare, now that the Romanticist fervor is past. The English-

speaking and the German publics do not support their conventional attitude with cash at the box office, though actors and stage directors keep soliciting their patronage. The travesties of the plays that producers found necessary would be unthinkable for Ibsen, Bernard Shaw, Chekhov, Pirandello, or for the rare performances of such classics as Molière and Congreve.

Meanwhile, the Shakespeare academic industry goes on full tilt and gives no sign of weakening. The final surprise is, the Romantics did not gloss over the objections to Shakespeare's playwriting and poetry. Lamb developed the thesis that the tragedies should be read and not seen on the stage, because Shakespeare addresses not the senses but the imagination. Hazlitt agreed in part and went on to say that "if Shakespeare had been only half what he was, he would perhaps have appeared greater." Carlyle himself adds to his encomium: "All his works seem, comparatively speaking, cursory, imperfect, written under cramping conditions."

So the Romantics did not labor under an illusion; but they accepted the faults first for the "elements" they wanted at the time, and later because they saw that in works of art faults change their aspect. What seems a weakness in one cultural setting becomes a strength in another: what is "irrelevant" according to the classical rule becomes "a realistic touch" later on; and what is unreal now may eventually be called surrealism—for instance, the stage direction in *The Winter's Tale:* "Exit, pursued by a bear."

These perceptions and nuances within the Romantics' view of Shakespeare explain for us the last category of judges of his work: those whose conception of the work of art is—Shakespearean. Such was Victor Hugo, who said he "admired like a brute." Berlioz and Flaubert likewise found Shakespeare "not a man, but a continent." As Flaubert puts it: "There were great men in him, whole crowds, whole countries. In such men, there is no point in attending to style, they are powerful in spite of all their faults, and because of them."

At this point, take your choice: the Romantics' estimate or its contradictory—Flaubert or Tolstoy. What is not allowable for a serious literary mind is to ignore the pros and the cons and remain in the conventional rut, saying out loud: "Shakespeare—oh, wonderful, sublime!" and thinking: "what a bore!" *1987*

Bernard Shaw

It makes no difference whether one agrees with his opinions, whether one prefers *Heartbreak House* to *St. Joan,* whether one understands the reasons and the facets of the public character he assumed—artist, critic, aesthete, historian, gadfly, ombudsman, rebel, social theorist, political commentator, religious writer—Bernard Shaw remains the only model we have of what the citizen of a democracy should be: an informed participant in all the things we deem important to society and the individual.

Seeing him in that light, one thinks of a comparison that, so far as I know, has never been made. Shaw is to the turn of the nineteenth century what Swift was to the turn of the seventeenth. The same abundance of feeling-thought, the same imagination, the same unbounded public spirit, the same capacity to teach unforgettably, the same mastery of prose—a story-telling prose, no matter what the subject. To be sure, the Swift I am thinking of is not widely known—*Gulliver* is valued through hearsay and *A Modest Proposal* is regularly misrepresented. The pamphlets and poems are terra incognita. Fortunately for Shaw, the stage is a perennial reviver, and though only the best readers will in future go back to the essays and reviews, *Man and Superman* and the two others just cited will bring back to Shaw's living shrine generations

whose minds will have been shaped by what he thought and said in other forms of art.

When Shaw was alive it was almost impossible to get to hear the central scene of *Man and Superman*. Revivals of the play regularly omitted it, out of deference to the immemorial right of commuters to catch the last train, and also out of a vague but firm belief that however brilliant, the interlude was not real drama. This ritual use of the word "brilliant" absolved everybody from any sense of guilt. No sooner was Shaw dead than several of his works once more gave life to our stage, and among the revivals was the amazingly successful and original presentation of *Don Juan in Hell*—the interlude done by itself, without scenery, costume, or "business." It held hundreds of the most varied audiences spellbound by the simple magic of voice and meaning. If this was not drama, what was it?

Well, it could be argued that it was music. Shaw's play as a whole had its origin in a long-pondered plan to take up the Don Juan theme where Mozart had left it, and Shaw's dream of Hell, introduced by musical quotations from *Don Giovanni,* presents four main characters from the opera: Don Juan and Dona Ana, the statue of her father the Commander, and the Devil who has been the underground agent of the tragicomedy. What Shaw does is to compose with words and ideas a quartet in one great movement, or perhaps a fugue for four voices. It would be going beyond the facts to say that the piece was consciously written in musical form, but it is undoubtedly oratorical (which is why it holds an audience so easily) and musical forms are patterned on the basic oratorical scheme of introduction, exposition, development, and recapitulation. The result is that in listening to Shaw's verbal sonata you do not, as in reading, mind the returns and repeats, you welcome them. The *shape* of the vocal rendering gives pleasure—the pleasure of an almost bodily satisfaction—quite apart from the satisfactions of wit, eloquence, and living philosophy.

This last element could, of course, be considered the main

cause of success. Today the whole literate world is troubled by the questions that Shaw raised years ago. Events have taught us that the fate of each man and the future of the race are permanently in jeopardy. What can we do about it? *Don Juan in Hell* addresses itself to the question by making a woman, her father, and her lover wrangle and justify themselves once the adventure of life is done. The Devil acts the part of Greek chorus or public opinion, but in Shaw's version he is no conventional stage figure; he spouts all the advanced liberal ideas. It is Dona Ana who is conventional—sincerely so, just as her father is conventional with hypocrisy. As for Don Juan, we are told that he is a sound thinker. We therefore watch four kinds of awareness at cross purposes, from the woman to the philosopher. Her business is childbearing, that is, embodying the Life Force. His is thought-bearing, or giving the Life Force direction and meaning.

In these terms Shaw restates for us the oldest problem of philosophy and religion: What is the purpose of life? But this is not the only theme of *Don Juan in Hell*. There is a second, contrasting and clashing with the first: What is the nature of happiness? Eager as he is for the Superman to come, Shaw does not forget that we are individuals living now and making personal claims on the universe. He shows us Dona Ana, who has banked on future gains by one sort of self-restraint, appalled at finding herself in Hell. But she can escape from it. For Shaw believes that Life is not preliminary to anything except possibly a more abundant life for our descendants. Heaven and Hell are here on earth, a permanently open choice. The blest are those who prefer effort to illusion and truth to enjoyment, who would live or die for an idea rather than live for their senses and in the fear of death. The damned take the path of least resistance, avoid thought, and surround themselves with nice things.

Knowing that Shaw first published *Man and Superman* at his own expense in 1903, one is tempted to call the Juanesque creed central to his thought in every meaning of the word—

there it stands in the middle of the play that he wrote at forty-seven, when he had exactly forty-seven more years to live, and it forecasts in phrase after phrase the leading ideas of *Back to Methuselah, Heartbreak House,* and *On the Rocks.* A work of ripe middle age, yes. Yet the fact is that the whole conception is already present in a short story called "Don Giovanni Explains," written in 1887 when Shaw was thirty-two. That tale is told in the first person by a young and pretty woman, who, before the end of it, acts like the heroine of *Man and Superman* and makes a declaration of love to the Don; but it is his description of Hell that is most striking: "I found society there composed chiefly of vulgar, hysterical, brutish, weak, good-for-nothing people, all well-intentioned, who kept up the reputation of the place by making themselves and each other as unhappy as they were capable of being." The Prince of Darkness, he adds, is not a gentleman and Hell is a disgusting Liberty Hall. Don Giovanni chooses Heaven. By a significant coincidence, 1887 was the year when Shaw reviewed Samuel Butler and took sides with him in the controversy against those Darwinists who believed evolution to be blind and purposeless.

Out of a scientific dispute, then, and an emancipated view of woman, Shaw fashioned the greatest moral document of our century to date. It is not a question of agreeing with everything he says, but of being moved by his vision. And for this to happen he had to fuse scientific philosophy and ethical passion into a work of art—which brings us back to the question whether *Don Juan in Hell* is real drama. We know it is paying theater. But it is real drama because it shows a conflict about a real issue. Don Juan's damning catalogue of frauds is a challenge to every conscious being. As the advertising says, this means *you:* are you moral or only conventional? artistic or only lascivious? prosperous or only rich? courageous or only quarrelsome? intelligent or only opinionated? social or only gregarious? virtuous or only cowardly?

Yet it would be a mistake to find the truth exclusively in

the Don's speeches. What the Devil says, what Ana feels, and what bothers the Commander—all contain portions of wisdom. If not wholly right, all the characters are *in* the right—which is the essence of lifelikeness and hence of dramatic presentation. The difference between Shaw and a run-of-the-mill dramatist is that Shaw portrays at least one character who thinks—no great improbability—and this in turn upsets the other characters by making it hard for them to express their feelings through ready-made phrases. The audience is naturally upset too, and like the publisher who turned down *Man and Superman* half a century ago, it may find "nothing but an intention to wound, irritate, and upset." Still, in that far-off time it was Shaw who was in the right about himself: "I have honor and humanity on my side, wit in my head, skill in my hand, and higher life for my aim." *1984/1952*

Goethe's *Faust*

Goethe's *Faust* was *the* book of the Romantic period. In an age which produced many great novelties—the heroic verse tales of Byron, the vivid historical novels of Scott, the ironic psychological studies of Stendhal, the vast realistic panorama of Balzac—Goethe's drama kept its position of pre-eminence, and for one sufficient reason: it stood forth as the complete presentment of modern man's doubts and aspirations.

The twentieth century, for equally good reasons, finds the work less satisfying, on which account it forgets to read it and speaks of it at third or fourth hand. But ignorance and partial neglect do not lessen its importance, any more than they dim the pleasure and enlightenment to be drawn from it. Indeed, one *has* to read the poem if one is to grasp the meaning and feel the force of not a few utterances of yesterday and today.

What, for instance, does Spengler mean in *The Decline of the West* when he calls our epoch Faustian? What is Carlyle (echoed by Matthew Arnold) saying when he counsels, "Close thy Byron; open thy Goethe"? Why does Santayana, writing shortly before his death to criticize the American spirit, complain that "we are still in the laboratory of Dr. Faust"? And why does Thomas Mann, in his novels and essays, so persistently return to the subject of Goethe's life and, without awakening a like reminiscence in the reader, remind himself of the great poet?

Again, even though one may care nothing about Gounod's opera on the theme of Faust, nor about Liszt's symphonic poem, Wagner's overture, or Berlioz's music drama, it is clear from these and much else in our musical repertoire that the Faust legend as Goethe bequeathed it to the nineteenth century is an integral part of our culture. Painters too have been inspired by it, no less than musicians, historians, and poets. We think with it and talk to one another in its terms: Mephisto, Gretchen, Auerbach's tavern, the witches on the Brocken are but a few of the symbols that were given life and currency by Goethe's unexampled, mysterious, and powerful creation. It stands there at the threshold of our formative days, a challenge to our understanding. When we know the work we may hope to know ourselves better—besides knowing better our oppressive fathers of the previous century.

Perhaps the quickest way to penetrate the meaning of *Faust* is to reflect on the ambiguity of the word "modern." In one of its senses the term is used to describe the mind and deeds of Western man since about 1500. In another, equally common usage, it applies to any idea or person characteristic of the latest age, the years since the French Revolution of 1789.

In the first sense, the things we associate with modern man include the Renaissance, Protestantism, the humanists' passion for the art of Greece and Rome, the forward strides of physical science, the political forms of mercantilism and

monarchy. We personify all these: Copernicus, Bacon, Shakespeare, Galileo, Luther, Newton, Louis XIV.

With the word "modern" in the second sense, we are apt to associate first the great anonymous movements and ideas which, being still potent, cause us anguish and evoke our doubt or distrust: the Enlightenment, Liberty–Equality–Fraternity, the Industrial Revolution, Utilitarianism, the nation-state, philosophic naturalism and scientism, which is to say the belief in man's evolving powers and the decline of religious faith.

In short, viewed from one standpoint, the man of the twentieth century deems himself the lucky heir of half a millennium of expanding thought which has changed the face of the globe as well as his conception of himself; and from another point of view, which sees in the foreground total war and perpetual revolution, modern man feels himself orphaned, uprooted, outcast, disinherited—and he finds the cause of his misery in the very same expanding thoughts that have changed the face of the globe and his conception of himself.

Whatever opinion one may hold concerning the rights, the wrongs, and the remedies of this situation, it remains true that the two moments of great change within the half millennium were the Protestant Reformation in the sixteenth century and the combined political, industrial, and psychological revolution in the late eighteenth and early nineteenth. To this second moment we give the name of Romanticism, and we record our sense of its nearness and significance by speaking of the earlier time as "the old regime." The old regime is already far enough away for us to idealize it. We forget its violence and oppression because we long for its real or apparent stability—the stability which it lost between 1750 and 1850 when we were catapulted into the *modern* modern world, for whose disturbances we blame the revolutionary Romantic spirit.

Now, the relevance of these general truths to *Faust* is that its author composed it during the passage of Western civilization from its relatively static condition to its present one of

acceleration. Goethe was born in 1749 and lived until 1832. During sixty years of this span, in round numbers from 1770 to 1830, he worked at, or dreamed on, or shied away from the subject *Faust*. Unlike any other great work, this one, which is peculiarly permeated by the feeling of time, grew with its own times. More than that, it grew out of the legend of another time, which happened to be that of the earlier epoch of change, the time of Renaissance and Reformation. In all ways, therefore, the likelihood was great that such a work, developing in the mind of a thinking poet, would be what the nineteenth century in fact took it to be—an epitome of the modern age.

Yet at first blush it is difficult to see how the story of a middle-aged intellectual and dabbler in the occult who makes a compact with the Devil, consorts with witches, and brings an innocent girl to ruin, can reflect or embody the grave issues of a civilization's passage from kingship to democracy, authority to individualism, handicraft to industry, Christian dogma to agnostic science. The very plot of the play seems hopelessly old-fashioned, and when the book itself is read, it is found to contain no direct reference to any of these issues. Rather, it presents a haphazard succession of scenes, mostly in doggerel, interlarded with broad jokes, ribald songs, and occasionally a passage of lyrical nature poetry or philosophizing about God and the universe. Even as drama the work fails to meet expectations. The action is fitful, the dialogue argumentative rather than passionate, and the most spectacular moments—such as the witches' revel—are clearly unrealizable on the stage.

To these handicaps must be added the ambiguity inseparable from any mention of *Faust*: Does the speaker mean Part I, which everybody knows at least by hearsay, or does he mean both parts, the second of which only scholars and critics are supposed to have studied? Part II has the reputation of being obscure and important, but it is clear enough that a sequel is not absolutely required by the self-contained first play—except in so far as the very end of the second shows how Faust

is "saved." We knew from the outset that he was going to be, but the mode of his salvation affects our interpretation of everything that happens in Part I. What the candid reader faces, then, is the paradox of a great dramatic work which is rarely played and seldom read entire, which is obscure or ambiguous in all but its traditional plot, and which nevertheless is felt to illuminate matters it does not visibly treat of.

A sufficient rejoinder to this criticism might be that many other masterpieces are likewise incompletely read and require imagination to appreciate their form and penetrate their mystery. *Hamlet* (which we seldom see entire) is a veritable graveyard for solutions to the riddle it presents, and Dante's *Divine Comedy* (of which the last part is also the preserve of scholars) calls for even more reading-in than *Faust*, despite its still simpler plot. The historical fact remains that the Romanticist generations between 1830 and 1870 were not deterred by paradox or difficulty. They read *Faust* like an open book, saying, "This is a faithful image of ourselves." In other words, through its old plot and medieval machinery *Faust* depicts man and his destiny in a manner exactly matching the idea that Western humanity had of itself a century ago.

The core of that idea is restated by Goethe in a passage relating, it so happens, to Shakespeare: "The highest achievement possible to a man is the full consciousness of his own feelings and thoughts, for this gives him the means of knowing intimately the heart of others." Every word of this maxim could be the subject of an extended commentary. It would be filled with such terms and phrases as Individualism, Experience, and the Eternal Feminine; "two souls within one breast," "the garment of the Deity," and "the night-side of Nature"; the infinite thirst for knowledge, the superiority of striving over achieving, and the primacy of the Act over the Word. Most of these come from the text of *Faust* and have established themselves in the language as names for new principles or realities that Goethe found or expressed in his effort to reach "the full consciousness of his own feelings and thoughts."

Together with their context these formulas compose the image of man which Romanticism recognized as its own.

But we must not think of *Faust* as having been designed from the beginning to fulfill this external and abstract purpose. The abstraction reflects only a judgment passed on the work after it was done. Goethe was the poet of Experience in more ways than one, and as he himself said, he never wrote a line except about events and feelings he had himself undergone, these including of course his imaginings of the unknown.

The first notion of *Faust* came to him from quite a simple feeling, with which young men everywhere are likely to sympathize: he was bored with his studies. Not yet twenty years old, he was by his father's wish studying law at the University of Leipzig and, finding his textbooks dreary, he was attracted by magic and the occult. A year later, having transferred to the University of Strasbourg, he found the idea of a poem on Dr. Faust taking more definite shape. But like all young men of talent and passion, he still suffered from moods; by turns exuberant and depressed, he felt hemmed in and his cloistered energies bred boredom, melancholy, and thoughts of suicide—precisely as in *Faust*.

We know that Goethe was taking note of these storms and stresses of his inner life because five years later, in 1775, he gave them artistic form in the little novel which made his reputation: *The Sorrows of Young Werther*. Werther commits suicide, not solely because of frustrated love, but also because he is balked in his ambitions: the world, he feels, denies him everything, and his will destroys his life. When Faust is on the verge of suicide, his plight is somewhat different: it is not that the world denies him his wish, but that it has nothing to give him. Instead of destroying himself he sets out on a voyage for the rediscovery of reality behind the visible world. He lives by making a career out of his dissatisfaction. He has the Devil's help, to be sure, but it is his own distress that propels him. As the Italian scholar Borgese has finely observed, "It is his

inability to sit that destines him to soar." And this is the reason why Faust is not merely a character in a play, or even a type commonly found, but a collective or universal hero.

His likeness to the men of the Romantic period consists in the fact that they too, coming after the French Revolution and Napoleon, found themselves in a world that had nothing to give them. It was seemingly well ordered; life followed conventions and aimed at stability according to bourgeois standards. But the young, the articulate, the idealists were bored by an aim that called for prudence rather than energy. They were revolted by a conventional order that encouraged conformity rather than discovery. Those that did not commit suicide like Werther pledged themselves to rediscover nothing less than the entire universe, the inner world of man and the outer world of nature: they became Faustian by the decree of time and temperament.

The Faust of Goethe's schoolboy feelings did not, of course, achieve this representative stature at one bound. To understand his final complexity, which is his modernity, one must see how he developed under Goethe's hand from the rather crude Renaissance figure preserved by tradition.

There lived in Germany in the early 1500s an actual Johann Faust, a charlatan leading a vagrant life but in touch with learned men as well as with leaders of the Reformation. Because he performed feats of magic, or boasted of doing so, he was said to have sold his soul to the Devil. He came, in fact, to a mysterious and violent end about the year 1540. The fascinated horror with which stories of his exploits were repeated, mixed with the eternal popular distrust of intellect and science, kept his memory alive until, in 1587, a printed account of his life was published.

Ever since the story of Eve and the serpent, mortals have made compacts with the Devil to obtain knowledge and power, and the retelling of the event has always aroused strong emotions of envy and fear. In the first sixteenth-century Faust tale, however, we are shocked to discover what that age of faith

most desired—and doubtless needed: it was food. The passion that dominates the sixteenth-century Faust is not for power, knowledge, or the sensual delights of love; he longs chiefly to eat his fill. He also wants clothing and pocket money, and by way of entertainment he would like to "fly among the stars." We need not dwell on the up-to-dateness of this pastime, but we should remember to the end of our reading of Goethe the original Faust's first wish. Later in his adventures the primitive Faust is eager to marry, but his helpful demon Mephisto shows him that he needn't trouble about a legal union. Finally, Mephisto has him read a book on human destiny and the origin of the world, which reawakens Faust's learning and makes him foresee his awful end.

This edifying tale was shortly translated into English and captured the imagination of the young poet Marlowe, who made of it his tragedy *Dr. Faustus*. In it the hero is ennobled by desiring chiefly power and experience. He is punished in the orthodox manner, but the spectator feels that the poet sides with Faustus in his rebellion against dogma, custom, and the trammels of mortal flesh.

At this point one might have thought that Faust was in a fair way to become an important symbol. A great poet had lifted the figure of the trickster and magician to a plane where his deeds amounted to a criticism of life. The time seemed ripe; for the sixteenth century was an early Romanticism in its passion for discovery and introspection: its buccaneers explored the New World, and its art and philosophy repudiated the "old regime," which then meant the feudal order and the medieval faith. Man seemed once more a creature of infinite possibilities, the maker of his own fate on earth, which was the true theater of his actions. Marlowe gives us a hint of this new humanism and secularism when he has Mephisto reply to Faustus's question on earth: "Why, this is hell, nor am I out of it." Yet only ten years later the philosopher Giordano Bruno, whom Goethe was later to read, was burned at the stake for bidding "heroic enthusiasts" grasp the idea of an

impersonal God everywhere alive in the visible world. The Reformation had indeed given the loose to speculation, but orthodoxy was strong, and the English Faust, still a heretic, did not enlarge into a model of the New Man.

Far from taking on richer meaning, the legendary figure soon fell below his original state. Strolling players brought him back to Germany, where he became the butt of slapstick. After a while he survived only as a stock character in puppet shows. It was in this guise that Goethe as a child first heard of him. But the times were obviously conspiring to resurrect him, for in 1759, when Goethe was ten years old, the German poet and critic Lessing sketched a serious Faust play and wrote the opening scene. Lessing was then beginning his crusade against the artificial French tragedies which the cultural imperialism of France had long enforced upon German taste. It was logical that he should choose a native subject, popular rather than courtly, yet capable of elevated meaning, while at the same time he preached the free naturalistic technique of Shakespeare.

Matters stood thus when Goethe's mind turned to the old story and its hero in 1769 or '70. The further transformations of the character followed the several stages through which Goethe's vast work moved toward completion. These changes are intimately connected with his life, and it would take a book to retrace them. Only a few decisive steps and dates can be noted here. One date is 1790, when in response to his friends' demand, Goethe published large portions of the poem they knew in manuscript. Clearly labeled "A fragment," this series of scenes is the core of what we know as Part I. In 1808 the completed first play appeared, and in 1832—posthumously, though it had been finished the year before—Part II.

As for the decisive steps in Goethe's conception of Faust, they are at least four, and all have to do with Time.

The first is implied in the conversation between God and Devil in Heaven, imitated from a similar dialogue in the Book of Job. Before the play begins, Goethe makes it clear that

Faust will not be damned. This alters not only the plot of the legend but also the meaning of tragedy, by shifting its place from the hereafter to the here and now. It isn't because Faust, after much travail, may endure eternal torment that he is a tragic figure; it is because he is on earth and a thinking being. The drama *begins* in torment, which continues unbroken until Faust has traversed the small world of private life, depicted in Part I, and the big world of the Emperor's Court, or public life, depicted in Part II. And the torment comes from the awareness that man is at once wretched and great. He is wretched because he is a limited, mortal creature; he is great because his mind embraces the whole universe and knows its own wretchedness.

No ordinary satisfaction can quench Faust's desires; forever he sees and wants something beyond. The ultimate bliss would be to feel at one with nature, through knowledge not merely intellectual but emotional also, virtually instinctive; whereas all learning serves but to make Faust more self-conscious and isolated, till he scarcely feels that he lives. Clearly, this defines the situation of modern civilized man, whose increasing knowledge makes him more and more self-critical, anxious, beset by doubts, and hence more and more an alien in the natural world that is his only home.

For this reason—and this is the second great change in the conception of Faust—the terms of the bargain with Mephisto are entirely new. It is no longer the old deal by which a soul is exchanged for bodily pleasures. Faust undertakes to serve the Devil only if one of the attractions that the Devil spreads before him makes Faust say to the passing moment: "Oh, stay! Thou art so fair!" In other words, magic for Faust, science for modern man, enlarges his sphere of action. Each is committed to trying everything. Mephisto (and science) keep on producing opportunities addressed to the senses, for man does not shed his body merely by becoming interested in the quest for ultimate truth. But the result of trial and error is for both a round of desire, disillusion, disgust, and despair.

Across this headlong flight from misery comes, in Goethe's play, the figure of Gretchen. The story of her love for Faust, her undoing, her misdeeds, her death and that of her brother, are in themselves touching and true. As is shown by Gounod's opera and the public's notion of the whole subject, these scenes constitute the heart of the Faust matter. But the love story is also symbolic. It affirms, among other things, the reality of time. What has happened to the unfortunate Gretchen cannot be erased, undone. There is no realm where her sorrows are "made good," nor are her acts wiped out by her punishment. To be sure, the supernatural machinery of the play is used by the poet to assure us that her faults are those of an innocent, "bedeviled" person, not those of a hardened and scheming criminal: she is "saved." But the wonderful realism of her depiction is there to remind us that she, her brother, and their mother—all killed, like her newborn child, as a result of her love—are persons to be thought of as ends in themselves and not as instruments of God playing parts in a moral tale.

It is this irreducible fact that causes Faust's first unselfish pang. The existence of other people is brought home to him with a sudden violence which punctures his lofty mood and makes his high speculations shrink to triviality. To a feeling being, what can the flights of art, philosophy, and religion weigh against the present, actual pain of another human being? Critics who find a discrepancy of scale between the opening of *Faust I* and its close, because philosophic doubt is "important" and a betrayed girl is "unimportant," are criticizing in the air, thinking abstractly, and missing Goethe's point about the primacy of the concrete. The premise which he makes universal by affirming that "In the beginning was the Act" (not "the Word," as in the gospel) finds a humble but proper illustration in the trivial but truly horrifying details of Gretchen in prison—the locked door, the wanderings of her poor simple mind, the resistless march of time. On earth she is doomed, and her blood is upon Faust's head.

His instant horror when he is reminded by the news of her plight that society does exist and that it is not merely a backdrop for his introspective journey depends upon the third significant change that Goethe introduced into the traditional story. Usually Faust was represented as an old necromancer, thus accounting for his mastery of diabolical secrets. And at first the young Goethe changed him to a young man full of his own melancholy and passion. But as the poet matured, his hero matured with him, and we now find Faust in his study to be a man of middle age—the dangerous age when professional experience and success breed the conviction that the world is stale and all one's past efforts vain. To lead him astray, Mephisto makes Faust young again, and he loves like an ardent youth. Yet he remembers his worldly wisdom, as we can see in the prompt disgust he feels in Auerbach's tavern, and still more meaningfully in the final scenes of his dismay at what he has done.

Unlike most heroes, he has in fact two lives, and by their juxtaposition he learns what is missing from each. In the first, before the play, too much conventional occupation and withdrawal into bookish lore have withered his heart. He feels cut off from both the grand and the dark forces of nature and finds life worthless. In the second, appetite and a desperate courage bring him closer to the heart of nature and carry him through the heights and depths of feeling, but he forgets until too late that he is not alone in the universe. If he were a youth on his first pilgrimage, like the heroes of many a "novel of education," he could find excuses, either in himself or in the eyes of others. But his being a man with an intellectual and moral past doubles his guilt, and he suffers a new form of anguish far worse than doubt and emptiness of soul, for it involves more than himself. His powerlessness is now no longer a defect but a punishment.

The one thing he has gained, or regained, is an erotic outlook upon the world, and it is this, presumably, which propels him through the adventures of Part II. By "erotic" here we

mean a disposition to love, accept, feel *with*—in contrast to the attitude that rejects, denies, scorns, and hates. Eroticism in this generalized sense is perhaps the one element which Romantic with a large *R* and romantic with a small one have in common. The historical Romanticists sometimes seem silly to us because they were disposed to admire, love, and worship. But this willingness to love also denotes courage, venturesomeness, the facing of risks. It is obviously possible never to be fooled and never to appear foolish—always play safe. It takes a self-confidence which we of the twentieth century have evidently lost to face not only disappointment and ridicule but also suffering and irreparable loss.

In his second play, Goethe seems to trace the erotic principle to its source in the weird scene of Faust's visit to "The Mothers," but the less mysterious aspects of love he enshrines in the closing maxim that "the Eternal Feminine draws us onward," and also in the fulfillment of Faust's destiny and his death.

The Eternal Feminine means a good deal more than the proverb which says that love makes the world go round, or even than the definition "God is love." The Eternal Feminine is nothing less than the symbol of life, the irrational ground and irresistible force which is prior to all else, reason included. And Goethe's phrase does but sum up what is shown throughout the entire poem, that nature is alive—an organism, not a machine; that all things are linked with one another by a genetic bond (that is, productive and reproductive), as against the formal or generic bond that we perceive when we merely classify and fail to see life unfolding in Time. Goethe, we must remember, was an early evolutionist whose *Metamorphosis of Plants* revolutionized botany, and whose philosophy and poetry alike repudiated the materialistic mechanism current in the eighteenth century.

His awareness of life-in-time brings us to the fourth and last great twist he gave to the Faust story, the momentous resolution found at the very end of Part II and indispensable for a

true reading of Part I. Having traversed the "big world" and its follies, Faust finds himself, at an advanced age, employed in reclaiming land from the sea, that it may be cultivated. He feels death upon him, and though he wants to complete the work to which he is committed heart and soul, he cannot. The vision of it must suffice and it suggests to him that if realized he could say to the passing minute, "Oh, stay! Thou art so fair!" He dies. "Time is lord," as Mephisto says, thinking he has at last won Faust. But the Heavenly Host intervene, and the Devil is cheated of his prey.

The moral is clear, and possibly surprising, for Faust has described a complete circle: he started as a physician ministering to the well-being of his fellow men; he ends as a civil engineer accomplishing another part of the same task. More than that, we seem for one dizzy moment to have spiraled back to the original Faust, who used his magic to bring him food. The parallel is not exact, but it does remind us that mankind's first necessity is to eat and survive. Whoever contributes to that result obviously loves humanity, loves life. What Goethe would have us believe is that happiness, even for a lofty spirit, consists in devotion to an enterprise of this kind. That this conclusion was no special or transitory one is shown by the fact that in the last part of his "novel of education," *Wilhelm Meister,* Goethe has his hero embark as a surgeon to a group of emigrants to America.

The later Goethe was clearly imbued with the "American spirit" in so far as this implies working at material tasks for the general welfare. Our century's objections to *Faust* on a doctrinal basis are therefore a little hard to countenance, for they bear down equally on the boundless desires and reckless self-seeking of the beginning Faust and on the selfless disciplined manager of public works whom we find at the end. If, as W. H. Auden has ably argued, our age wants poems that symbolize the building of cities rather than the exploring of deserts, one would suppose that Faust was the ideal hero—the

hero as city-planner. But Faust doubtless felt bliss in his collective task because he had first gone through his wilderness alone. We today resent both phases because we have lost his erotic attitude. An unpurged, sneaking, low-grade romanticism in ourselves makes the early Faust appear to us heroic but foolish, while the later Faust seems shrunken and crass.

The question is not, of course, whether we should take Faust as a model, like the men of previous generations, but whether he is a model deserving imaginative credence. The historian of today may be forced to conclude that the poem and our reality are still too close together. Our ears are too full of the dying echoes of Romanticism to heed the original voice. To Carlyle's advice about closing Byron (revolt, exploration) and opening Goethe (the gospel of work), we feel like shouting: "Close them both!" We are not even in a mood to wonder why a scornful, lacerated spirit like Swift should set down as indisputable truth the importance of making two blades of grass grow where only one grew before. We make them grow, mechanically, without loving mankind, because we have largely ceased to love ourselves, and such remnants of the power of Eros as we possess grope to find their object in the deities of orthodox religion.

A cycle is thereby closed, for it was those deities' displacement or redefinition which marked the course of Faust's career, from his magic tricks in Luther's day, through Marlowe's and Lessing's and Goethe's reincarnations of his will to truth.

In comparing our own doubts about man's destiny with those Goethe pictured and resolved for his century, we must remember that a poem persuades by its art, not its arguments. And here too, with respect to art, some find it an effort to experience anew in our day the electrifying force which *Faust* (the first part alone sufficing) exerted on its contemporaries. Not that anyone who reads German could even now remain insensible to Goethe's poetical power. *Faust* contains many

perfect utterances, high moments of lyric and satiric art. It is the work as a constructed whole that has to be justified to an age not merely critical but expert at carping.

For the demands that any period makes upon art vary in relation to the possibilities and satisfactions that life itself holds out. If today we are extremely hard to please it is because our mastery over nature is almost complete yet does not bring us the expected sensations. We are virtually omnipotent in the realm of Faust the engineer, but this only underscores the imperfection we feel within. We complain of frustration, anxiety, and guilt. Accordingly we require art to show with scorn, or with a promise of harmony hereafter, the paradox of power and impotence peculiar to ourselves. We ask for tough mindlessness or moral symmetry, for Hemingway or Dante.

As for the art of *Faust,* no judgment will be entirely just if it neglects the principle that Goethe originally drew from his mode of apprehending life, which is to reconcile the order that means freedom with the passion that denotes life. *1955*

When the Orient Was New: Byron, Kinglake, and Flaubert

I must begin by explaining what is meant by "the Orient" in relation to the three writers named in my title. It means Albania, Greece, Egypt, and Asia Minor—what used to be called the Near East or the Levant before being again renamed the Middle East. The period of the Orient was the first half of the nineteenth century. It may seem odd to say that the place was new. What about Marco Polo, who went through this region in the thirteenth century and beyond it to China? What about the Crusades even earlier, from the eleventh century onward? And Venice, which traded there till modern

times? Surely, long before Byron set foot on Greek soil, there had been many Western travelers and many ambassadors to this extensive Turkish domain, who had published their discoveries and anecdotes in their home countries. If their books were too dull to read—as most of them were—lively writers had used them to create very readable fictions supposedly showing the picturesque facts of life in the Mohammedan world. Montesquieu had written *The Persian Letters* in the early eighteenth century; later, tales and pseudo travels by Voltaire, Dr. Johnson, Beckford, and Oliver Goldsmith had also popularized Oriental manners.

All this is true, but these tales were not firsthand reports, and besides, there is a sense in which a region is new when there has been no recent cause of excitement about it, either literary or political. Remember when Russia became a vivid presence in the West after Sputnik was launched in 1957. People read the spate of books that immediately followed, and college students in droves elected courses in the Russian language, which had formerly attracted eleven students the first semester and five the second.

Now turn to the situation during the first decade of the 1800s—in the spring of 1809, to be precise—when Byron set out on his great journey. For fifteen years Western Europe had lived in turmoil and anxiety. The recent French Revolution had provoked war three years later, after which, with only short breaks, Napoleon had kept the world embattled. England, as the head and paymaster of resistance, constantly feared invasion. Toward the end of 1803 a French *Armée d'Angleterre* was being mustered in Normandy, with a clutch of balloons to assist the invasion. The mental state of the English people can be readily imagined: they were in a fortress besieged.

No landing was made, but three years later war was still going on and the mood was still the same. Eighteen twelve was the year, as everybody knows, when Byron "awoke to find himself famous." He had brought out his narrative poem

Childe Harold's Pilgrimage, planned and completed in the Orient. There has never been a good explanation of this sudden fame. Byron had published twice before with no great success. Some biographers say that it was his imitation of medieval romance that was new and appealing. But Byron keeps up the medieval tone and quaint spelling for only a few pages; the rest depicts the ancient classic lands, so the explanation fails. I believe instead that the reason of *Childe Harold's* success is that his wanderings opened up the mental prison door to the beleaguered English. It gave them a sight of clear blue sky over a new landscape—first, Portugal and Spain seen *not* as the theater of war it actually was, and even more enchanting, the Balkans, Greece, and its islands along the Turkish coast, which is to say, the Orient. The poem itself declares: "Enough of Battle's minions, let them play/Their game of lives." "Portugal," says Byron, "unlocks Elysian gates" and "New shores descried make every bosom gay."

This is not to say that these were the reasons that drove the poet himself eastward. His motives were mixed. He said he had no friends or occupations to keep him in England; the social life there seemed to him dull. He was only twenty; his mother was still alive, but she was a difficult woman with whom he quarreled, and their pecuniary situation was in disarray. Just then, one of Byron's three closest friends, John Cam Hobhouse, was eager to travel. The prospect of a change of scene at low cost and promising adventure must have looked extremely tempting.

At first he was going as far as Persia and British India, and if the sale of a piece of property to retrieve his fortune fell through, he was going to take service in the Austrian or the Turkish army—"if I like their manners." In the event, although the tour lasted over two years, its compass shrank to the Iberian Peninsula, Italy, Albania, Greece, the islands, and Constantinople. Needless to say, he did not become a Turkish soldier.

But he did like "their manners." He was warmly received

by officialdom wherever he went and he did have adventures. He met the warlord Ali Pasha and both his son and grandson. The son addressed him as "You good-looking boy," and tried to dictate the rest of his itinerary. The grandson, aged ten, took a strong liking to Byron and wondered that so great a lord had so few retainers. It was this little boy grown to manhood whom the poet was fighting against when, at the end of his life, Byron joined the struggle for Greek independence.

His first journey east was not all visits of ceremony. He nearly had a duel with an officer in Malta about an ugly rumor of seduction. That was on setting out. At the other end of the trip, on the mountainous coast of Greece, he and his servants—all fortunately armed—encountered some pirates who were holding a group of Greeks for ransom. Byron's party moved forward to free them; the pirates ran away and Byron, with his usual common sense, was glad, not vainglorious.

In Lisbon, Constantinople, and elsewhere, he performed feats of swimming, his great athletic accomplishment. He swam across the Tagus and re-enacted the story of Hero and Leander by swimming the Hellespont, acknowledging it was a hard pull—an hour and ten minutes against strong crosscurrents. He took greater pride in this prowess than in anything else—his verse, his good looks, or his title. Athleticism had to make up for the disgrace of having a deformed foot that made him lame. In Byron's day people still ridiculed deformity; the crowd would jeer and shout insults in the street, and the supposedly well-bred would whisper and giggle and point as the poet entered a drawing room. This recurring experience made Byron touchy, understandably, and from time to time he would seek revenge for his hurt pride. In Constantinople, he demanded precedence over the untitled ambassador Stratford-Canning, and when denied it he left the reception rather than take second place.

His clumsy gait did not keep him from riding well, and he had great stamina. He and Hobhouse averaged seventy miles a day as they covered the five hundred miles from Lisbon

to Gibraltar. In the East, they withstood the usual hardships—poor lodgings, short rations, vermin, robbery on the road and within the party. They also caught the local fever. But Byron was ill only twice for a couple of days, and he plausibly attributed the worst of it to his doctor's harsh treatment.

Part of the trip's vicissitudes came from their wayward servants, guides, and interpreters, who had to be frequently changed. Such was the Orient; for protection and to sustain one's social rank, one needed a retinue. Byron had taken with him William Fletcher, his valet; Joe Murray, a servant he had inherited from his father; young Robert Rushton, to act as a page; and a German whose name and *raison d'être* have remained obscure. Rushton and Murray were sent home from Gibraltar because homesick. Fletcher stayed on but grumbled continually about the food and the non-Englishness of the Turkish world. Other retainers—and horses, alike of dubious character—were hired as needed. To be somewhat independent of guides and interpreters, Byron took lessons in Italian and Romaic (modern Greek). He became fluent in Italian and moderately competent in Romaic, which enabled him to cross and recross the Greek mainland in search of scenery, ruins, and the places whose names he knew from his excellent classical education.

What can we say he gained from his protracted expedition? Byron left home hardly more than a teenager and returned a disabused man of twenty-three. Though he said he had left England without regret, he was then a cheerful, amiable youth, full of *joie de vivre*. The Mediterranean world contributed two things: one was a greatly enhanced passion for Nature, whether stormy or serene. He came to regard the very thought of Nature as a refuge from society and his own melancholy. In a canto of *Childe Harold,* he says: "I live not in myself, but I become / Portion of that around me; and to me / High mountains are a feeling, but the hum / Of human cities, torture." That may be called theme one, not only of the trip and the poem, but of much that he wrote before the grand res-

olution of bitterness into satiric laughter in his final master-
piece, *Don Juan.*

Theme two is related in mood, but Oriental in trappings:
it is the character of the Byronic hero, as critics came to call it.
This hero's behavior is patterned after the masculine feelings
and manners of the Turkish world—warlike, proud, uncom-
municative, domineering toward inferiors as well as toward
women when they are not the object of passionate love. This
figure of course has a Western prototype—the medieval
knight. Hence *Childe Harold,* though created in the Orient,
bears that title and acts the knight, however briefly. Byron fin-
ished his first draft—126 stanzas—at Smyrna in March 1810.
He mentioned this to no one. But he did write home that he
had expressed his revived classical emotions by composing an
imitation of Horace's *Art of Poetry.* He also wrote love lyrics.
Altogether in two years of hard travel, he composed some four
thousand lines of verse.

One might think that his letters to England would con-
tain some impressions in prose. Hardly any. He describes
some of his adventures, but deals chiefly with his day-to-day
arrangements and future plans. He seems purposely to avoid
commenting on what he is seeing and feeling. About Constan-
tinople, for example, he only says that Gibbon's description is
accurate—as far as he can tell. He does add that St. Sophia is
less imposing than some other mosques he has seen and that it
is much smaller than St. Paul's in London. On geography and
ancient ruins he is equally terse and he tells his friends to read
the *Travels* of Sir William Gell.

From this reticence one should not conclude that the Ori-
ent furnished him random sights only and left his mind and
sensibility untouched. On the contrary. He now knew "the
world," and having drawn comparisons with England, he finds
the latter in some ways superior to the Orient; but as to Eng-
land's serious defects he is now "enlightened." What is more
important, he had absorbed the culture of a region that was
closer than Western Europe to the brutal, feudal origins of the

nation-state. This was a lesson in government and morality. In addition, Byron retained for use the color of the land and skies, the costumes and conventions, the religious rites, the violence and the superstitions of the people.

That all this was accurately stored up is shown in the six metrical tales Byron wrote in the four years after his return; the last came out in the year of Waterloo, 1815. Nobody now reads *The Giaour, The Corsair, Lara, The Bride of Abydos, The Siege of Corinth,* and *Parisina,* but it was these melodramatic stories that gave Byron his European fame. They depict heroic deeds, a passion for individual freedom, and brooding melancholy. The desperate situations arise from fierce love or outrage and end in death or revenge, all this set against sunlit plains, rocky coasts, or dark mountains and punctuated by stirring names and shouts in the alien tongue.

Though rapidly written and revised, the tales contain some true poetry in various meters, but their chief literary merit is unfailing forward movement that was Byron's peculiar narrative gift: the rhythm of a line may halt, but the underlying rhythm of the whole is masterly. Nor is the mood all fierceness and sentiment; the satiric note is occasionally heard. The best judges of the time thought these tales great achievements, and their translatability into other languages spread their influence. Whatever we may now think of their defects of technique and psychology, civilized Europeans everywhere were happy to think that in the Orient wild chieftains and beautiful slaves, brigands and traitors with a ruthless will, loved and hated unto death and performed daring actions as part of their daily routine. The odd thing is that to a certain extent this was true. In the Orient that Byron had seen, violent and willful behavior occurred suddenly and irrationally—much as in the Western nations today.

Here then was a literature of escape, a genre which, if it is to transport the reader into another reality, must carry a ballast of facts.

The Byronic hero proved a fertile type. After 1815, he

turns up everywhere—in Pushkin's *Eugen Onegin,* in the novels of Balzac, in *Jane Eyre* and *Wuthering Heights,* in the French Romantic poets, in Italian opera—somebody has made a long list of these lively offspring in world literature. Indeed, down to the mid-twentieth century, many a hero of popular fiction was still quasi Byronic, though no longer Oriental. He appears, for example, as the handsome cavalier in Georgette Heyer's Regency novels; or again in tales of the American West. His last incarnation is a she: in the files of the *Saturday Evening Post* you will find, usually in a country setting, a heroine who is sexually irresistible, haughty, monosyllabic, and sometimes violent. Mounted on a horse, she may well, partway in the tale, slash her handsome suitor across the face with her riding crop for daring to propose a second time.

The Byronic hero was killed at last by our sense that the democratic citizen is a tame bird, his freedom of action almost nil. As for love, it has been replaced by casual sex, which makes jealousy trivial. Besides, our mania for psychologizing has eliminated the clear-cut character. Nobody is violent nobly, few have a cause. Our anger is "road rage" for petty reasons. One falls not into despair but depression.

A final question about Byron's use of the Orient: Did his contact with a less effete civilization make *him* into a Byronic hero? The answer is No. He himself said that he "would not be such a character as Childe Harold for anything in the world." He certainly did none of the things depicted in the Turkish tales. He was at bottom a practical man with the gift of uncommon common sense, as his vast correspondence shows on every page. Though he had bouts of melancholy, he was not vain about it, nor about his fame or his successes as a lover. Replying to a critic, he wrote: "I don't care a lump of sugar for my poetry, but my geography and my history are right."

It is true that in his dramas he gave his heroes at least one of his traits: he was often troubled by strange feelings about his fate. His severe Calvinistic upbringing made him sure that he was doomed to suffer and cause evil. And yet he no longer

believed in a literal Hell. As to love, his fatherless childhood with a frequently raging mother left him with a poor conception of the tender feelings. In his affairs he was doubtless seeking "the real thing," while his looks often incited women to make the advances; in his circle and his times, it was no part of their role to be demure.

At any rate, in the Orient his escapades were few and brief. During the journey east he had a flirtation in Malta with a married woman who had a picturesque history of capture and escape—a real life Turkish tale; and in Athens he was in love with three sisters simultaneously, the daughters of his landlady, all under fifteen years old. Which of the three was the inspiration of the poem "Maid of Athens" is not known, nor whether "maid" was still the right word after he left. But that love poem contains nothing of the Byronic, only his delight at the country he loved and the girl it had produced.

The lonely heart does appear when, about to come home, he writes to a friend: "I have really no friends in the world; though all my old school companions are gone forth into that world and walk about there wearing monstrous disguises, in the garb of guardsmen, lawyers, parsons, fine gentlemen, and such other masquerade dresses. . . . And here I am, a poor traveler and heathenish philosopher, who hath perambulated the greater part of the Levant, and seen a great quantity of improvable land and sea, and, after all, am no better than when I set out—Lord help me!"

But before long he contemplates a life in politics—he was after all a peer of the realm—and reformist politics at that: "I shall perhaps essay a speech or two in the House. If I could by my own efforts inculcate the truth that a man is not intended for a despot or a machine, but as an individual of a community and fit for the society of kings—so long as he does not trespass on the laws or rebel against just governments." Here is surely a double allusion—to Oriental and to English rulers—in this somewhat muddled statement of liberalism. When Byron did make his maiden speech, it was in behalf of the Luddite rioters

who were destroying the textile machinery that was robbing them of their livelihood. His plea for moderation in punishment was well received. He made no second speech. He was not the man to stay put in London and plot party tactics. As he said with a curious turn of phrase: "A man must travel and turmoil or there is no existence." So he reserved his political fire till the Greek expedition of his last years.

At the end too, after abundant practice in poetic satire, he produced his masterpiece, the long, rollicking narrative *Don Juan*. It is about a Byronic *anti*-hero, young Juan, who also goes to the Orient but not as a Childe Harold or other figure of gloom and power. He is a stripling and it is women who teach him about life. He sees the world at war, both East and West, he hides in the seraglio like Achilles, he learns to laugh everything down without losing his buoyant spirits. He is Byron teenager and wanderer, mature poet and sardonic observer in one ultimate incarnation.

The second of our three travelers, Alexander William Kinglake, is the only one of the trio who wrote and published a consecutive account of his tour. It is an extraordinary work, unfortunately little known. He titled it *Eothen*, a Greek word which means "From the Dawn," that is, from the East.

Kinglake was born in 1809, the year Byron left England. It was twenty-six years later that young William, halfway through his law course, followed the poet's example. From someone six years older we should expect a record more mature than Byron's, and it is indeed a fully formed mind that speaks to us in a well-shaped book—though since it was published nine years after the journey, we cannot tell whether its wisdom belongs to the time of travel or to later days.

Eothen is remarkable in any case. For one thing, it is surprisingly short for its rich contents—about the length of a modern crime-fiction novel, readable in one evening. For another, the prose, excepting one or two purple passages, quite justified, is colloquial; one would date it around 1900, or if

told it was earlier one could attribute it only to Samuel Butler, also the author of a great travel book, *Alps and Sanctuaries*. Kinglake is aware of his singularity. The work is supposedly written for and to a friend, and this, says Kinglake, "prevented me from robing my thoughts in that grave and decorous style which I should have maintained if I had professed to lecture the public." You detect at once the irony of the phrasing; it pervades the whole narrative. Kinglake takes neither himself nor the results of his trip solemnly. Yet the book is serious in its observation of Oriental manners, places, and persons; the phases of the very diverse adventures are treated each in its appropriate tone. In a word, the little book is a gem.

Kinglake begins his story like Homer: *in medias res*. He is at Semlin (Zemun) in what used to be northeastern Yugoslavia, staring across the Danube at the Turkish domain. He can enter it only after quarantine has cleared him, for the plague is all around. He assembles his party: servants, interpreter, and the Tatar official who hires out as a courier and answers with his head for the safety of foreign travelers. Then come the picturesque details—about the natives, the government, the women, the poor, the horses and saddles, the elaborate conventions, the many kinds of discomfort; and also the incredible sunshine pouring down on wretches and tyrants, the ruins in starlight, the silence, and the innumerable historical associations for the well-read man. It would take a book to list the striking incidents. There is not a dull page. He editorializes freely—on housing, for example: "With all its charms a mud floor (like a mercenary marriage) does certainly promote early rising."

Kinglake's itinerary was longer and better planned than Byron's or Flaubert's. He went straight to Constantinople, then to the Troad (the region surrounding ancient Troy), Smyrna, Cyprus, and the Dead Sea. He then crossed the Jordan and the Desert to Egypt, Cairo, and Suez, and back north to Syria—Gaza, Nablus, Damascus, and the pass into Lebanon, from which he sailed home. Of our three visitors, Kinglake

was clearly the best entitled to tell the nineteenth-century Westerners what the Orient was like.

Just as Byron found Ali Pasha the dictator governing the lands he went through, so Kinglake found another warrior-tyrant in power, the fierce Mehemet Ali, who won fame by inviting to dinner the ruling corps of Egypt, the Mamelukes, and killing them before canapés were served. But as the travelers found, the sultan's edicts about foreigners—or natives—were fitfully enforced. The motley mix of populations and of religions under different commandments, the slow, uncertain communications, the Eastern officials' love of inaction, and the blessed institution of bribery made every case *sui generis*. This encouraged the spirit of adventure. For example, at the very end of the trip, Kinglake and a Russian general he met on board ship did not want to spend the three weeks of quarantine required of all travelers coming from Syria. The penalty for evasion was death. But at Kinglake's instigation, the pair landed and browbeat the local pasha into letting them proceed. They did not even have an interpreter: they simply made thunderous speeches at the poor bureaucrat till he caved in.

It is important to recall who the Turkish officials were. Far from being highborn or wealthy, much less ambitious, they were poor devils coerced into their jobs. At the height of the Ottoman Empire, the whole bureaucracy up to and including the Grand Vizier or prime minister consisted of slaves. They were picked out young, chiefly in the Balkans, for their promising qualities; then taught to read and write and trained in the duties intended for them. The system worked well for nearly four hundred years; it was ideal for the aristocracy of birth and especially for the sultan, who had little to do but plan his conquests, territorial and sexual, and cut heads off at pleasure.

In Kinglake's day, slavery had virtually disappeared, but the officials were of the same modest birth and not inclined to lord it over well-to-do foreigners. This does not mean that having one's way was easy; Kinglake disliked having to bully

people for ordinary services. His retainer with the most ego and deepest voice was usually detailed to overcome resistance to requests by invoking the great dignity and power of his master.

Apart from this Oriental *savoir faire* and the occasional comic or threatening incident, the daily routine was simple. Kinglake sums it up: "To taste the cold breath of the earliest morn, and to lead or follow your bright cavalcade till sunset through forests or mountain passes, through valleys or desolate plains, all this becomes your MODE OF LIFE, and you ride, eat, and drink, and curse the mosquitoes as systematically as your friends in England eat, drink, and sleep."

But the effect was greater than the cause. "If a man," adds Kinglake, "be not born with a bit in his mouth, there comes to him a time for loathing the wearisome ways of society, . . . for not liking tamed people, for not sitting in pews . . . , for impugning the foregone opinions of men . . . in short, for questioning, scoffing, and railing, for speaking lightly of the opera and of our most cherished institutions." Evidently the Orient inspired Kinglake with something of the Byronic, uttered in the very tone of *Don Juan*.

Once back in England, Kinglake finished his law course, served in Parliament for twelve years, and then devoted the rest of his life to writing a history of the Crimean War in eight volumes. It is said to be one of the great military histories.

While still feeling the freedom that comes of being abroad, Kinglake experienced a moment of vision that was neither conventional nor Byronic. Arrived in Nazareth, he felt a strange exaltation at the thought of the Virgin Mary and the birth of Christ. It is the occasion of the purple passage I mentioned and it must be read to be appreciated. The mystic moment was quickly over and the traveler resumed the tone in which he relates his encounter with the Lady Hester Stanhope. Here we get high comedy interspersed with interesting biography.

She was the granddaughter of William Pitt the Elder and niece of the Younger, whose hostess she had been during his prime ministership. When the European coalition he had formed against Napoleon broke up in 1809, he sickened and died and she left England forever. She went east and became a ruling member of a Bedouin tribe, sharing not only their life on horseback and afoot, but also their warfare. She was a born leader of men; her haughty mien, deep voice, and reckless courage proved her a princess without question. The Bedouin also valued her superior farsightedness, meaning her eyes: their lives depended on seeing any hostile tribesmen at the horizon.

By the time Kinglake visited the old warrior she had retired to Djoun, near Beirut, and held court there with a large retinue that believed in her divinity. She received or snubbed every passing visitor from the West. Kinglake was admitted because his family and hers had been neighbors in England. She asked kindly after his mother and, hardly paying attention to the answer, carried on a monologue of some six hours the first day and three the next, while they smoked narghiles. She did answer some questions, but her concern was to lay down the law to the young man on everything from diet—she lived exclusively on milk—to the truth of magic, astrology, and her own prophecies.

Those conversations must have been entrancing, especially the bits of reality that cropped up now and then. One such was Byron's visit a decade and a half earlier. Lady Hester disliked him: he was affected, spoke in an over-refined manner and with a foppish lisp. But she quickly went back to important things: We were on the verge of "a stupendous convulsion which would destroy the value of all recognized property upon earth. Only those who should live in the East at the time could hope for greatness in the new life." She urged Kinglake to sell his property in England while there was time and get an estate in Asia. It is only fair to add that she also told him he would

go to Egypt and return to Syria—nonsense, he thought, since he planned to go straight home from Egypt. But as things turned out, he did what she had said.

Kinglake's comment on the lady and her entourage shows his powers of introspection. "A man coming fresh from Europe is at first proof against the nonsense with which he is assailed; but often it happens that after a little while the social atmosphere of Asia will begin to infect him . . . and he will yield himself at last to the faith of those around him."

The infection to which he might have yielded after his strenuous and risky crossing of the desert to Egypt was not superstition; it was the plague raging in Cairo. For three weeks he braved warnings, despite the visibly mounting death toll, so that he might see the Pyramids and the local life. His account rivals Defoe's of the plague year in London—corpses piled up in carts at first, then on the ground, people fearing to touch hands or garments. It was defying fate to stay and not easy to get out; quarantine was strict in neighboring regions, except when Kinglake and his friends flouted it. He calmly remarks that "fear of the plague is its forerunner," and he was British, fearless, and immune.

Like Byron, Kinglake was reproached for the scantiness of his retinue. Orientals assumed that anybody coming from afar must be a potentate and should be surrounded by a court. Byron was rather impatient with his servants, English and foreign. Kinglake liked them—"brave, cheery-hearted fellows," whose service "brought upon them . . . toils and hardships that are so much more amusing to gentlemen than to servants, and who yet never uttered or hinted a syllable of complaint." At the same time, when at one point in the desert some of the men pretended that they had no more bread and must share their master's rations, Kinglake, suspecting the claim, was firm. "We stopped and the tent was pitched; the Arabs came to me and prayed loudly for bread; I refused. 'Then we will die!' 'God's will be done,' said I."

One might imagine that Kinglake would end his book

with a prediction of growing European influence that might please his readers back home. Kinglake is too good an artist to close on such a false note. When we last see him, he has just refused the Syrian pasha's compromise suggestion of just one day of quarantine, and is on horseback heading for the pass across the Taurus mountains.

The last of our Orient-bound explorers, Flaubert, was also the oldest. He was nearly twenty-eight when in the autumn of 1849, he too looked for a change of air. He had just undergone a shattering event. After writing an enormously long poetic fiction about the temptations of St. Anthony in the desert, he had read those hundreds of pages to two of his closest friends and they had said: "Throw it into the fire." He trusted them and did as he was told. Now he must remove himself from the scene of his discomfiture. With a journalist friend in Paris, who was also a photographer, Maxime Ducamp, he planned his getaway. His spirits rose, he reveled in the thought of escape: he was going to discover the source of the Nile.

His practical companion, who had already gone once to North Africa and the East and had published a book on these travels, obtained from the French government a double mission. He, Max, was going to search for archeological and architectural data; Flaubert was going to inquire into new opportunities for commerce. It is pleasant to think of the man who all his life excoriated business and the bourgeoisie going about in the Near East like a traveling salesman looking for markets. He disregarded his instructions, of course, and very honestly refused compensation. Meantime, the pair had official letters of introduction that did smooth the way. One of their courtesy visits has a piquant historical connection: they called on Ambassador Aupick, the man who became Baudelaire's stepfather and whom the poet, on hearing that revolution had broken out, rushed out to kill in February 1848.

Flaubert's motives went beyond the impulse to escape and

forget. He still had his Oriental subject, St. Anthony, at the back of his mind and wanted to see for himself the scenery he had worked up from books. He also looked forward to sexual indulgence, about which he was obsessed. A good many of his travel notes are devoted to close descriptions of his encounters, which anyone interested can read about, unexpurgated, in the collection of notes and letters edited by Francis Steegmuller and entitled *Flaubert in Egypt*.

Like Byron and Kinglake, Flaubert went to Greece, Egypt, and Constantinople, and like them he was entranced by the kaleidoscope of colors and customs. He is struck over and over by the simultaneity of incongruous actions in one spot—people eating in Cairo's best restaurant, which has a barber and a dentist attached, and where a man jumps up to pray fervently while yet another relieves himself in a corner. And there is the eternal violence—poor devils bastinadoed for some trivial offense, a slave girl who has run away is cuffed and hauled back to her master, the sheikh evading taxes is tied to a tree till some friend ransoms him. Elsewhere, a far greater sheikh rides over two hundred men who have lain voluntarily on the ground. No less violent is the religious devotion of the whirling dervishes who shout and gyrate till they drop senseless.

As might be expected, Flaubert describes with a sure eye and hand. Whether it is color in landscape, costume, or complexion, or tones of voice, ornate compliments, or animal behavior, the notes are as exact as a bureaucrat would have wished, had these notes been on foreign trade. It is a novelist's sketchbook. Like Byron, Flaubert had a good memory and he filled out many of his jottings with further details after he got home.

On the spot, he was still haunted by his ordeal. He would write a novel; he would not publish for a long time; he would never write again—what was the use? Everything had been done, every style and manner exploited. But the stored-up impressions were not wasted. They served in the novel about

ancient Carthage called *Salammbô* and again in the second *Temptation of St. Anthony*. It has been pointed out that even in *Madame Bovary* he stuck in a bit of his own fantasy when he made her dream of a blissful existence under palm trees on a far-off shore; and I find another echo in *L'Education Sentimentale,* when Frédéric leaves home after a disappointment in love and the author says: "He came to know the melancholy of shipboard, the cold awakings under a tent, the dizzying effect of landscapes and of ruins, the bitterness of interrupted friendships." In short, Flaubert never stopped drawing on the substance of this formative voyage of his late youth.

Something must be said about his companion. They made an odd pair—Flaubert was husky, vigorous, adorned with a large mustache and lengthening beard, compensated for by a shaved skull. Ducamp was skinny and clean shaven and retained his full head of hair. Both seemed to have worn a great many layers of clothing, though Max had to carry heavy photographic equipment, in addition to materials for taking rubbings and squeezes of bas-reliefs, all of which he did conscientiously. He worked like a dog, making their travel arrangements, drawing plans to scale of temples as well as publishable sketches of ruins. A traveler to far places was expected to do no less, and he had a book in mind—several books.

When he brought out the first of them, called *Egypt, Nubia, the Nile, Palestine, and Syria,* the 125 photographic illustrations earned the experts' high praise. They are still mentioned and reproduced in histories of photography for their merit as examples of the wet-plate process. Most of us today are familiar with wet plates only in the kitchen, so a reminder is called for: in photography, it was a process that requires rapid work indoors with plenty of water—no pastime for the desert or on the move. Ducamp had enough trouble with his albumen-paper negatives. He said feelingly that all the cursing and swearing he did over them guaranteed him a place in Hell. Flaubert seems never to have lent a hand. Yet

they quarreled but once; or rather, Max got angry when, there being no water left to drink, Flaubert started shouting "Lemon sherbet! Lemon sherbet!" over and over. Max would not speak to him for a couple of days.

Childishness and laziness had replaced Flaubert's first excitement. It was not the sublime he now looked for but the comic, and to his delight he found the grotesque. For these he need not bestir himself. Max hardly complained of his passivity: "He would have liked to travel stretched out on a sofa and let the panorama roll by." This may have been Flaubert's quick adaptation to Oriental manners, or his brooding over his aborted prose poem. He ate a great deal and noticed he was getting fat. Still, he kept on taking notes, and in so doing preserved a name that inspired that of Bovary: it was Bouvaret. I suspect it also led to Bouvard in the last, unfinished novel, *Bouvard et Pécuchet*.

Then too he wrote letters, particularly to his mother, whom he adored, like many Frenchmen, who are not on that account candidates for the role of Oedipus. It is a cultural trait. It is to her that he confides his vacillating hopes. He is certain of one thing: he will not take a job when he returns. The idea makes him angry, and for once, sharp-tongued and argumentative. To his bosom friend Bouilhet—one of the two executioners of Flaubert's condemned opus—he tells everything, much of it about women. But it is not all sexual prowess; women's bright eyes behind white veils he finds unexciting; they look like reclining ghosts, whatever that may mean. Other sights—girls twelve years old carrying their babies on their backs, eunuchs, black or white, holy men doing rather unholy things in public—all this leaves him no doubt that he is "in another world. It gives you a dreamy sadness, poignant."

Flaubert was not a political mind like Byron; his views on society were piecemeal, but often shrewd. He saw that it was only Turkish oppression that kept all the mingled peoples, sects, and nations at peace in the Middle East. He predicted

that Arab women would soon be emancipated, thanks to the example of European residents and the influence of the ballet, which was popular. Not that he was a westernizer. England would soon seize Egypt and Russia Constantinople. As for the future of society, he saw it as "certain that it would be regimented like a boarding school. Teachers will rule, everybody will be in uniform, and mankind will no longer make mistakes as it works on its insipid assignments."

What was splendid and not subject to change was the Nile—"a crazy, magnificent river, more like an ocean than anything else"—and of course along the Nile all the great temples and sculptures. The combined notes of the traveling pair about their slow journey up the river and down again make delightful reading. Nature, culture, accidents, and individuals form the closest thing to a consecutive story. Flaubert is enchanted. At a chapel along the shore, the birds (he is told) go of their own accord to deposit for the saint the food that people give them. This speaks sympathy with the myth and irony: "Everybody is so backward here. You seldom hear the latest parlor songs from Paris. And where are the railway lines? What is the state of elementary education?"

In the midst of his impression-gathering and self-indulgence, Flaubert remains moody. His prose fiction had been judged no good; therefore poetry, fantasy, the vision of palm trees by the seashore—the very idea of happiness or even charm was now useless for literature. What could replace it? Something somber and unattractive, harsh and even disgusting. This shift of vision is commonly known as Realism overcoming Romanticism, which in turn is taken to mean foolish illusion replaced by a sense of reality. That is false. Palm trees and seashores are real things and the longing for them, also real, is legitimate.

The true meaning is something else and Flaubert's two "realistic" novels, incubated on this trip, show what his literary turnabout actually was. An incident in Egypt and a sentence later contain their essence. After a second night spent

with his favorite dancing girl, Flaubert relates that when she had fallen asleep next to him, he took pleasure in squashing bedbugs on the wall. The moral is: the sordid accompanies the blissful—and Flaubert perversely enjoys it. He says so in that later sentence, which refers to the same incident: "I want a touch of bitterness in everything—always a jeer in the midst of our triumphs, desolation even in the midst of enthusiasm."

The formula was excellent for striking a new note in literature. But the living Flaubert still felt like a young lover when, after leaving his dancing girl, he wishes she could remember him as he remembers her, a distinct individual, special and wonderful. Such feelings can be ridiculed and repressed and kept out of novels, but not killed. He did not ridicule his friend the novelist Gautier, his senior by ten years, when Gautier wrote: "I wish I were with you. I feel nostalgia for Egypt and Asia Minor"—places he had never seen. Nor did Flaubert despise Byron the Romantic; indeed he records that he thought of him during the whole of his own sail through the Dardanelles.

This ambivalence points to an important historical truth. Flaubert did not redirect the literary mind of Europe all by himself. His generation found itself caught between two forces: they were brought up on the great liberal promise of 1789 and saw it defeated by the forces of trade and industry. The organized efforts to establish representative governments ended in disaster when the revolutions of 1848 were suppressed by force of arms. So hopes and ideals had best be abandoned, indeed shown up as "unrealistic." Evils were not remediable.

Realism, then, was a kind of self-torture, of despair ahead of time, in order to avoid ultimate disappointment. Like King Mithridates, you eat poison in small doses to escape lethal poisoning in future. The earlier, Romantic generation was not blind to evil, sordidness, or pain. They knew all about it from the quarter century of war that ended in 1815. But from that reality they distilled the things worth living for. In literature,

evil was something to be conquered, not featured. Byron knew about dirt and crime and death, but his very despair was vigorous, not dejected, much less resigned as in Flaubert's "What's the use?"

It is significant that while in Egypt, Flaubert heard of the death of Balzac and he wondered, "Why has it affected me so deeply?" Admiring his genius, he identified himself with him as a novelist-to-be. And in the years to come, after writing two novels of ignoble defeat and despair steeped in the new despondent mood, Flaubert turned back —to what? to the Orient. In *Salammbô's* Carthage, he lavished "Romantic" color, passion, and violence—absurd, said the critics in Paris: it couldn't happen here. The same elements appear in the second *Temptation of St. Anthony,* with its visions of lust and demons, products of fasting and faith in the Egyptian desert. The mortal blow to his pride that had sent Flaubert to the Orient was avenged at last by a masterpiece that made no concession to Realism with a capital *R.*

Looking back on these separate "discoveries" of the Orient, one may be surprised that its features should have exerted such influence on Western literature. The two great artists, Byron and Flaubert, used their experience of the Orient by distributing it (so to speak) among different worlds that changed the mind of Europe. The lawyer-politician Kinglake fashioned out of his travels a complete work of art which is a classic. The poet and novelist each created a new type of character and a new tone for fiction. Kinglake invented a new kind of prose for the descriptive-narrative genre. No such creativeness, born of appreciation, is to be found in the other Westerners who turned up in the Orient between 1800 and 1850—which is reason enough to single out these three from the rest.

1993

The Permanence of Oscar Wilde

Certain figures cast a spell on posterity and live in the memory by virtue of qualities beyond or apart from those that usually support fame. It is not because of their achievements that Héloïse and Mary Queen of Scots, Byron and Lincoln, require so many volumes to tell and retell their lives. Their attraction is inherent, magnetic; but this does not mean that their persons were greater or finer than their deeds. It means only that by a chain of circumstances they incarnate for us a way of living life which we cannot let alone, which we cannot emulate, reprove, or take for granted. We go back to them as to life itself, mesmerized, because we know that there is no final explanation of the genius, the passion, the error, or the tragedy here embodied.

Oscar Wilde seems such a figure. Biographies, reminiscences, and glosses on the legend continue to appear, and each time popular success is at one with critical opinion: the new publication is found "exciting" and "important"—for many reasons, some incommunicable. Such was the response to Wilde's collected letters, which contained as one of eleven hundred documents the famous *De Profundis*, for the first time complete and unaltered.

Because he belongs to this class of perpetual stars, Wilde is difficult to know. The more he is discussed, the less his mind and the significance of his work are understood. Not even his masterpiece, *The Importance of Being Earnest*, which continues popular, is seen or produced with much intelligence of its meaning: actors and audiences take it as an opportunity for indulging and burlesquing snobbery. Again, people seem to like talking about Wilde as of a pitiable victim of the law,

but they also laugh at his homosexuality and his sunflower buttonhole. They confuse him with Gilbert and Sullivan's Bunthorne in *Patience*, who is not Wilde but Rossetti. At best they recall some commonplaces about aestheticism and the Nineties. They forget the interpreter of life and art who made clear and unforgettable most of the moral and artistic assumptions on which we still live.

I do not of course mean to substitute the image of a gray philosopher for that of the wise youth and darling of the gods, self-destroyed by extravagance and love's excess. Let Wilde by all means live on as the modern Alcibiades. But in everything we are given that prolongs his outward fame are elements of something greater than the details of what he himself called "a life so charmingly, so wonderfully improbable as mine." These elements are not just historically important; they deserve to figure in the less childish and morbid part of our attachment to the man; and they should encourage us to be more curious about his intellect and what he did with it to shape our own.

Born shortly after the middle of the nineteenth century, Wilde reached his majority when the task of decanting the age was the obvious duty of the perceptive: it was the business of the eighties and nineties to get rid of the repressive morals that had grown up with industry, and to reassert against technology and science the lessons of impulse and animated being that Romanticism had urged a century earlier against the dead schemes of pure reason. The opportunities for propaganda and wit, for iconoclasm and brilliance, were therefore great, and they called forth a numerous band: while the poses of Wilde the undergraduate were beginning to astonish Oxford, Bernard Shaw was writing his five unpublishable novels to expound a new morality. Elsewhere in Europe, Nietzsche was upsetting his colleagues in scholarship by a morally subversive book on tragedy; and with a similar purpose Bergson and William James were destroying the materialistic philosophy of Spencer and the orthodox evolutionists. The extraordinary thing was not that these upstarts, unknown to one another,

were engaged on one piece of work; rather, it was that the work defined itself as the turning upside down of every accepted idea. The result was serious, yet seemed a series of jokes; it looked easy, but required courage and a special kind of mind, attuned to the secret desire for change.

Somewhat older men, Samuel Butler and W. S. Gilbert, had preceded these neo-Romantics in their paradoxes, but the influence of the two pioneers was, in the one case slight, in the other diffuse. *The Pirates of Penzance* does ridicule duty, but music and farcical consequences soften the gibe. It is something else when Shaw makes his hero say: "Two things I hate—my duty and my mother"; although that too was without effect until published, much later. Again, Samuel Butler and his witty correspondent Miss Savage could entertain each other by what they called "quoting from memory," for example: " 'Tis better to have loved and lost than never to have lost at all." But such sallies reached no other hearers until *The Way of All Flesh* appeared, when the anti-Victorian crusade was nearly over. All these beginnings matter to us now as signs that the unique role Wilde was to play belonged to the script prepared by the *Zeitgeist:* his part was without question the most conspicuous and the most beautifully acted.

What the script was about we all knew when we were very young, forty years ago: it was about art and religion, sex and morality, the emancipation of women from bondage to men, and of men from the bondage to women called the family. It was also about socialism, the variability of truth, and the importance of art criticism in a period when, as Wilde says, "atmosphere, with its subtlety of nuances, of suggestion, of strange perspectives . . . counts for so much." Once we understand that Wilde's career as a writer and wit had a conscious purpose, that he led—though not alone—the great movement by which our century overthrew its predecessor, then he ceases to seem merely the elegant saunterer of the caricatures, a butterfly among Fabians, who gained accidental renown by being broken on the wheel.

The truth is that Wilde was an extraordinarily tough mind, a quick and far-darting intellect at home in all the realities. Like Byron, he is eminent for common sense, and like him too he only assumed his poses to make a point. Wilde uses his own person as a *persona,* a mask intended to show the philistines that their pieties are frivolous, and that his refusal to be serious in their way is notice served that a new culture is preparing.

In acting out this demonstration, Wilde uttered many things that strike us now as trite or silly or simply not true. I shall have more to say about the relation of his epigrams to his convictions when I speak of his criticism. That remarkable body of work best shows the coherence and solidity of Wilde's thought, but one must approach it free of the image of the trifler, which the critic so sedulously projected to gain attention and to destroy preconceptions. And all one has to do to forget this façade is to read *De Profundis.*

Everyone knows the circumstances of its composition: the time was January to March 1897; the writer was in Reading Jail, after nearly two years of imprisonment as a convicted sodomite. The person addressed in the letter—a memoir of sixty thousand words—was Lord Alfred Douglas, a handsome youth of twenty-seven and a budding poet whom Wilde had known and loved and supported for about five years. It was Douglas's father, the eccentric Marquess of Queensberry, who had goaded Wilde into an action for slander, which recoiled and ruined its instigator.

This letter written *de profundis* has been published twice before and its true character recognized: it is an apologia. But the omissions and tamperings have given rise to interpretations that the full text disallows; or rather, the document when whole no longer suggests the self-pitying recrimination which one could formerly read into it and which encouraged the sentimentalists among Wilde's followers to make his misery his greatest merit. What *De Profundis* actually gives us is

a tragedy in the classical sense, written by the hero about himself: he was great among the powerful, loved and admired and relied upon, and by his own act sprung from a flaw of character he brought ruin and degradation upon his house.

The manner of the telling is perfectly adapted to the theme, difficult as that must be when the aim is to make drama out of autobiography. Two devices create and sustain the impression of an unfolding spectacle—the use of the present tense to recount past events and the repetition of phrases and ideas, which like a chorus punctuate and moralize the tale. To what extent the letter was improvised is difficult to say; much of it must have phrased itself obsessively in the long prison vigils. In its written form, the mingling of soliloquy and remonstrance, of indictment and pained or happy recollection, produces a wonderful kind of suspense. One may read it over and each time feel as if one did not know the outcome; for the succession of ideas, of trivial facts and of measured indignation, remains unpredictable, which is to say dramatically and psychologically true. Only in the first and last sentences does one find any ready-made, artificial lines, and that too is like a play.

But the spectacular energy of the work is not its most amazing quality. Its "plot" (including the relief of the "religious" digression) is extraordinary also in making entirely credible a total villain, and one directly drawn from life. Lord Alfred Douglas lives in these pages as the epitome of the Worthless Beloved. The scenes involving money and illness, the kaleidoscope of moods and places and persons, of telegrams, visits, and quarrels, exhibit a heartlessness Balzac would have wished to behold and that only he could have made us believe. What is more, Douglas as Wilde shows him is not merely believed but understood. He forfeits our sympathy, but we can see why, caught between the father he hated and the friend he exploited, he must act with blind aggression toward the one and with black ingratitude toward the other.

For without breast-beating Wilde exposes his own weak-

ness in full: to the worthless beloved he played the enslaved lover. It is always a painful role to watch; and that Wilde emerges with our respect is due to the detachment which accompanies his complaints. Though the Marquess of Queensberry has made him a bankrupt and a convict, Wilde can pity him without effort for being hounded by such a son as Douglas; and though Wilde sees Douglas in all his callousness, vanity, lack of imagination, and vile conduct, he keeps a place for him in his heart's memory, refusing out of superior veracity to abjure or disfigure the affection he once felt.

If one goes on to say that the whole sordid story is lifted to a plane of tragic nobility by virtue of style, one must not be taken to imply that Wilde is not really addressing the begetter of his ruin, but is posing once more, this time for posterity. Out of context, certain declarations Wilde makes about himself and his Art with a capital *A* lend color to that supposition. But we must remember what he and his contemporaries meant by Art so capitalized, and I shall suggest what this was in a moment. Meanwhile the rest of Wilde's apology and imprecations have the weight and ring of true metal. Given the situation in which he writes, no better test of his sincerity can be imagined than his references to his wife, and they are all admirable, as she herself was. Again, if the writer had had his eye on something other than his subject, his asides on life and thought would not have the simplicity and fitness which they possess. Wilde is not showing off when he writes: "I blame myself for allowing an unintellectual friendship . . . to entirely dominate my life. . . . An artist, the quality of whose work depends on the intensification of personality, requires the companionship of ideas."

And again: "Ultimately, the bond of all companionship, whether in marriage or in friendship, is conversation."—"To be entirely free, and at the same time entirely dominated by law, is the eternal paradox of human life that we realize at every moment."—"The supreme vice is shallowness. Whatever is realized is right."—"Its joy [the joy of love], like the

joy of the intellect, is to feel itself alive."—"The great things of life are what they seem to be, and for that reason, strange as it may seem to you, are often difficult to interpret. But the little things of life are symbols. We receive our bitter lessons most easily through them."—"Suffering is one long moment."—"For I have come, not from obscurity into the momentary notoriety of crime, but from a sort of eternity of fame to a sort of eternity of infamy. . . . And if life be, as it surely is, a problem to me, I am no less a problem to life."—"Nothing is more rare in any man, says Emerson, than an act of his own. It is quite true. Most people are other people."—"In sublimity of soul there is no contagion."—"By the displacement of an atom a world may be shaken."

Even when lifted from the description of jostling emotions and memories which leads up to these summarizing thoughts, their phrasing shows a mind that has mastered its experience and reached the plane where life, literature, and morality are continuous. There *is* recrimination in *De Profundis;* it *is* a flood of long-pent-up bitterness against a worthless lover guilty of that shallowness which is the supreme vice. Yet the epistle neither disgusts by its pitiable detail nor shames our humanity by its exposure of the ego stripped. There are, indeed, moments close to the sublime, for the true subject is a heart passionate, defiant, bewildered, and conscious.

De Profundis could not, of course, be sent to its intended recipient. Prison rules forbade, though it was written on paper stamped with the Royal Arms. The original was handed to Wilde on his release, and was first published, cut by nearly one-third and supplied with its present title, five years after Wilde's death. Taken together with *The Ballad of Reading Gaol,* the work established what might be called the second legend of Oscar Wilde, the one according to which a witty but superficial cynic was turned by suffering into a thoughtful martyr. Led by small groups of worshippers who had never known him, the European public took to Wilde as to an artis-

tic Magdalen. It thrilled to the blighted life, and was charmed by the newly admissible combination of homosexuality and literature.

This image is as misleading and deplorable as the earlier one of the *flâneur*. No one wants to remake history or limit past character, but the student and admirer of Wilde could wish that his "eternity of infamy" had arisen from some other passion and not brought the homosexual interest into the foreground of his fame. For that interest, wherever met, is invariably out of proportion to the excitement it inspires. It would be too much to say that Wilde's homosexuality has only biographical importance, but in truth it has only very little more. His ideas, his genius, his wit, his role, are in themselves unaffected by his erotic preferences. Because homosexuality is officially a crime, because it suffers and practices social exclusion, because it can claim an old connection with philosophy and literature, too much has been written about its critical and artistic value. Justifications based on the nobility of a love represented as the blossoming of intellectual companionship are simply not true to fact. On his own showing, Wilde's passion for Douglas is a prime disproof, repeated many times in what we read of Proust's and Gide's and other modern artists' attachments to chauffeurs and delivery boys. A man's sensual economy is his own affair, and it is time that the misfortune of Wilde's passion and its sad sequels should be left to occupy only the serious biographer—or the prurient newcomer to literature.

Let us therefore try to anticipate a later day and be weary right now of our pride at having discovered the prevalence of sex. It is after all a discovery almost a century old and it is thoroughly embalmed in modern fiction and biography. Leaving it there we can perhaps forget it in criticism and turn our attention to another Wilde than the ex-convict of literature, the charity case of the final years, the unpleasantly fleshy wit who was more hunted for his past than haunted by it.

The thinner, earlier, and greater Wilde was first and fore-

most a critic—one of *the* critics thanks to whose exertions Western art is unique in being an object not only of enjoyment but also of self-aware contemplation. We Occidentals do not merely live with the works of our artistic tradition, we live by them and by it. And this is made possible by the critics, the great critics, who periodically change our stance and vision. In this realm, Wilde in his heyday was both a formulator and an actor. He says rightly: "I stood in symbolic relations to the art and culture of my age." He embodied, that is, a moment of Western thought and feeling, and this is his enduring claim on our gratitude.

He defines that symbolic relation in an epigram—"I made art a philosophy and philosophy an art"—but this tells us little if we do not know at first hand the substance of his critical effort. We must read his dialogues, his essays, and his book reviews; we must see or read his plays for their critical intentions, and likewise interpret his narrative fiction as enactments of the Wildean "philosophy." In the epigram I just quoted, the repeated word "philosophy" has two senses: in the first it should be translated "guide to conduct": "I made art a guide to conduct"; in the second it stands for "criticism": "I made criticism an art."

Wilde's epigrams are tiresome when presented, as they often are, in long lists gathered from his writings by friends and publishers who see nothing in them but levity or cynicism, and who invite us to buy and laugh at the rather mechanical inversion of commonplaces. But when they are put back into their proper places, one sees that Wilde almost never distorts the expected without a point. When he says that "Charity creates a multitude of sins," he is speaking out against perpetuating poverty as an institution—like Shaw or any other "serious reformer." Yet we should not stop there, but read the great essay "The Soul of Man Under Socialism" from which the sentence comes.

Similarly we must go to the dialogues and critiques whenever we meet the maxims which by themselves appear to

affirm nothing more than the pleasures of irresponsible egotism. For what brings us to these capping remarks is the argument that the individual's relation to himself defines the character of society. A right relation can bring more joy to the world than any amount of sympathy and good intentions. With Nietzsche and Shaw, Wilde denounces the worship of pain and the morality of sacrifice, because he knows they often hide aggression, condescension, and complacency. In short, Wilde prepares the ground for the modern view, attributed too exclusively to psychoanalysis, that goodness is not a simple substance: "Anybody can sympathize with the sufferings of a friend, but it requires a very fine nature—it requires in fact the nature of a true Individualist—to sympathize with a friend's success."

It was Wilde's aestheticism, his creed of art for art's sake, which made vivid the principles of this moral revolution. In a hundred connections Wilde showed that a due regard for the aesthetic aspects of behavior leads to superior conduct. Conversely, Wilde had an easy time showing that all the morals conveyed by "noble" works of art are dead letters. It is a universal truth, stated by him before Gide, that "the worst work is always done with the best intentions."

On this view, the genuine artist becomes a model for all, because he is the only candid and practical man in society: he works solely and invariably for the intended effect and does not—indeed, cannot—palm off intentions for results. This philosophy was not new: Wilde's master Gautier had, among other Romantics, expounded it half a century before. But industrialism and the rising tide of democracy had driven the arts into conformity or meaningless rebellion. No theory of art as the guide to conduct, of art for *life*'s sake, was possible until the century grew disenchanted with its prosperity and its repressive morals. Besides, the late triumph of science over religion left vacant the place of moral preceptor, which art in the person of Oscar Wilde filled with alacrity and conviction.

The premise once accepted, innumerable consequences

follow: art is self-conscious, deliberate, finely formed, as against nature, which is formless, careless, and habitual. Art is so potent that, as we know from the most famous of Wilde's paradoxes, "Life imitates Art." Again, work and earnestness belong to the realm of utility and convention. Therefore the new man patterning himself on the artist will assert himself by being idle and languid—a Wildean hero whose duty it is to discourage the dutiful, that they may become more amiable and sightly. Intelligence, serenity, and taste, the beautiful, the rare, and exquisite, must be rescued from the tyranny of their enemies, the needful and the important.

But the notion is more easily stated than shown in action. Wilde's *Importance of Being Earnest* is a masterpiece because it provides this spectacle by reducing to farce the concerns of people who act on the old bustling principles while they talk the new philosophy. "Do you smoke?" asks the hero's prospective mother-in-law, like the Victorian dragon that she is. "Yes," confesses the young man. "I am glad to hear it," says she. "A man should always have an occupation of some kind." It is foolish to say that Wilde's characters are heartless: he is not writing a study of character but a comic allegory, and the miracle is that the absurd battle of clichés and conventions he contrives is at every point a serious criticism of life.

Wilde's other plays are less interesting to us today, because they harp on two propositions—that intelligent men should be disabused and that "lost" women can be attractive and morally fastidious. These repeated parables aided the emancipation of women and the decontamination of bourgeois men. "The Soul of Man Under Socialism" goes further by drawing from the advocacy of socialism the conclusion that it can only be justified if it fosters Individualism.

This grave paradox might almost establish by itself the character of prophetic authority which I think we must come to see in Wilde. But this virtue becomes unmistakable when we reach the critical writings I have mentioned, particularly *Intentions* and the collected pieces known as *A Critic in Pall-*

Mall. The range of subjects is remarkable, like the fullness of Wilde's learning. One understands why during the time of trouble Buchanan wrote courageously and feelingly about him as "a scholar." This unexpected testimonial must stand with the grave admiration accorded Wilde in Yeats's *Autobiography*. The scholar in Wilde was not a pedant, but frequently, and with naturalness, his love of the classics, acquired during his brilliant academic career, supplies him with illustration or parallel. He moreover possesses the historical sense and understands his own intellectual lineage—not a frigid Neo-Classic, but a new Romanticist, to whom Wordsworth and Shakespeare are living presences, witness the intimate and practical knowledge of the plays which shines through "The Truth of Masks."

In his dealings with modern authors, the kindness that Wilde's friends felt in his conversation, no matter how witty, shines forth again. He is a critic without animus, because he follows without self-constraint his own definition of the art: "The true critic is he who bears within himself the dreams and ideas and feelings of myriad generations, and to whom no form of thought is alien, no emotional impulse obscure." Yet he is not so foolish as to believe in the unconditioned mind: "The legacies of heredity may make us alter our views of moral responsibility, but cannot but intensify our sense of the value of Criticism."

The man who could write with minuteness about costume, with sympathy about women writers, with fine judgment about the neglected Stendhal ("the great, I am often tempted to think, the greatest of French novelists"), with uncompromising directness about Balzac ("a steady course of him reduces our living friends to shadows"), with generosity about Whitman ("In his very rejection of art he is an artist"), with friendly repulsion about Ben Jonson ("There are times when one is tempted to liken him to a beast that has fed off books"), and with prophetic insight about the coming time ("In art as in politics there is a great future for monsters")—

such a man need not fear the judgment of his powers that posterity will hand down. If only we will revisit the true dwelling place of his spirit, he must in time emerge as one of those men, greater and stronger than ourselves, whose work answers to his own summary of mind: "Anybody can be reasonable, but to be sane is not common." 1964

Bagehot as Historian

Adam Smith as a Person"; "Why Mr. Disraeli Has Succeeded"—only a genius would propose to himself such enigmas and attempt to resolve them for the public. Walter Bagehot, the proposer of these and other riddles of modern history, has been conceded genius often and willingly enough, yet he remains a shadowy figure in that part of the public mind where reputations are considered settled. The difficulty about Bagehot seems to be not his merits but his role. What is he? "Polymath" is not an acceptable answer; rather, it prolongs the doubt. Economist? Journalist? Political Scientist? Historian? Metaphysician? Liberal? Conservative? Which or how many of these must we apply to Bagehot to "place" him? Nor is this all: if a man has been dead a hundred years and is well-known without being known well, a certain impatience arises at the mere mention of his name. It would be better for him to exchange his ambiguous position for one of complete obscurity. It is easier to pull Kierkegaard out of nowhere and establish his complex presence than to revise our judgments of those who have only half entered the Pantheon, whose nose and cheekbone only are showing, like Shakespeare's in Ingres's painting of the Apotheosis of Homer.

Bagehot is of course in part responsible for the uncertainty of his posthumous fame. He made two capital mistakes—one,

the mistake of bearing a name puzzling to pronounce ("Bad-jit"); the other, the mistake of dying at fifty-one, before the variety and superiority of his mind could force themselves on public opinion by the necessary repetition of tenets and attitudes. A strong but simple mind can make its mark in twenty years; a subtle and humorous mind, endowed always with binocular vision, needs a much longer span as well as a series of emphatic interpreters. Double views are not quickly popular, they were not at all so in Bagehot's time, an age which was trying hard to be single-minded, and which accordingly preferred sermons and prophecies to the historian's temper in essay form.

To a candid reader the most casual dip into Bagehot's pages reveals something quite different. Bagehot is indeed a political historian whose subject is Gladstone or the Reform Act of 1832, but his subject is also, and always, political man. Or to put the same fact in other words, what interests Bagehot is the mainspring of political action, the elusive principles of man's behavior in the social state. Bagehot's concern was with the fate of free political institutions. The bent of his mind and the span of his life conspired to supply his subject matter and its perplexing questions. He had vividly before him, actually or through memoirs of the recent past, the procession of England's great ministers since Bolingbroke. His recital of their merits, their characters, and their vicissitudes puts together a story of the most stable and yet most flexible government of the great age which comes to a close with Bagehot's own career. Toward the end of that period, and coinciding with his mature years, Bagehot had as contrast the spectacle of two other governments, equally rational but not so stable: the Caesarian democracy of Napoleon III, which foundered in 1870, and the American federal republic, which was rent by civil war and had not been reconstructed when Bagehot died in 1877.

Bagehot was thus the witness and the judge of the first attempts to reconcile liberty and stability, self-government by the mass of industrialized mankind and the pursuit of increas-

ingly complex policies. These difficulties, not to say contradictions, are still with us. They exercised Bagehot's imagination, because like a dramatist he felt within himself that the opposing ideals, parties, and human impulses were equally right. And this explains his singular character, which some have mistaken for that of the cynic. Born with the gifts and moods of an *esprit d'élite,* he championed the virtue of stupidity and defended "the right to be a Philistine." Conversely, when the philistine mind sinks into its congenial litter of facts and figures (which Bagehot is well able to handle), Bagehot rouses that mind by a call for principle and theory: "as the argument is often more difficult than the illustration, it is apt not to be used; and political economy is in danger of dissolving into statistics, which is much as if anecdotes of animals were substituted for the science of biology."

In a word, Bagehot is the Socratic ironist in politics; though he is not a mere critic of others' conceptions but develops one of his own. Like his peers—Carlyle, Mill, Arnold, and Ruskin—Bagehot knew that the task of his age was at once to embody and to prevent revolution; that is, to promote yet restrain change, so as to direct it. The stolid, cautious, unimaginative members of society will huddle together and do what they can to prevent revolution by merely sitting still; the restless spirits, lit by generous hope or merely fanatical from rancor, will not wait for inching reforms but will want to establish the perfect state by an overnight coup. Neither party, neither temperament, will ever have the genius to act at any time in deliberate opposition to its own habit. The only hope lies in the politics of equilibrium, the art by which one or more leading men can move the poised mass a little way toward goals that they dimly see.

Hence Bagehot's writing about statesmen and politicians: their importance is calculable; their circumstances instructive. The theorist, knowing that the idea of perpetual revolution is fundamental to modern societies, uses contemporary examples to illuminate past conflicts and vice versa. When, for instance,

Bagehot wants to draw the character of Harley while telling the life of Bolingbroke, the historian puts the appropriate modern words in Harley's mouth: " 'I do not wish in this House,' he would say in our age, 'to be a party to any extreme course. Mr. Gladstone brings forward a great many things which I cannot understand; I assure you he does. There is more in that bill about tobacco than he thinks; I am confident there is. Money is a serious thing, a *very* serious thing. And I am sorry to say Mr. Disraeli commits the party very much; he avows sentiments which are injudicious; I cannot go along with him. . . . Great orators are very well; but as I said, how is the revenue?' "

This perennial cowardice of conservatism was magnified by the great fear that followed the French Revolution of 1789 and the wars of Napoleon; this fear became the major premise, as it were, of the nineteenth century: "A whole generation in England, and indeed in Europe, was so frightened by the Reign of Terror that they thought it could only be prevented by another Reign of Terror. . . . In England we had a state of opinion which did the work of one without one; nine-tenths of the English people were above all things determined to put down 'French principles'; and unhappily 'French principles' included what we should now consider obvious improvements and rational reforms. They would not allow the most cruel penal code which any nation ever had to be mitigated—they did not wish justice to be questioned; they would not let the mass of the people be educated, or at least only so that it came to nothing; they would not alter anything which came down from their ancestors, for in their terror they did not know but there might be some charmed value even in the most insignificant thing: and after what they had seen happen in France, they feared that if they changed a single iota all else would collapse."

This description prepares us to understand the first reform of Parliament in 1832. But we are wrong if we expect that Bagehot will then produce the liberal historian's familiar

effect of Light After Darkness. On the contrary, he is a severe critic of 1832 and of Lord Althorp, the mere politician who against his will saw the Act through: "He was a man so picturesquely out of place in a great scene that if a great describer gets hold of him he may be long remembered." The grave defect of 1832 for Bagehot is that in making reforms it began the destruction of political diversity and put in its place the principle that the change most to be desired is an increase in the power of numbers. Here the same analyst who has shown us the virtue of a Harley in adhering to common sense against the visions of "brilliant and vehement men" demonstrates the limitations of common sense when men such as Althorp "guide legislative changes in complex institutions. Being without culture, they do not know how these institutions grew; being without insight, they only see one half of their effect; being without foresight, they do not know what will happen if they are enlarged; being without originality, they cannot devise anything new to supply if necessary the place of what is old. . . . Such men are admirably suited to early and simple times—English history is full of them, and England has been made mainly by them; but they fail in later times, when the work of the past is accumulated, and no question is any longer simple."

Knowing history to be irreversible, Bagehot is worried— as we are—by the conditions that first produce the mass man, then give him power, and finally face him with complex predicaments. Bagehot knows as well as we do that "the greater power of the working-classes" made for less cruelty and blindness in government, for the diffusion of "a sweeter and better spirit throughout society." But the price seems to him high when he foresees that before long there will be "only one sort of vote and only one size of constituency . . . then the reign of monotony will be complete." The prediction had certainly come true seventy years later, when the representation of the Universities was abolished, when the Liberal party was but a remnant between two political groups competing less

for the nation's support than for the possession of the same welfare program, and when the voters hardly cared which they chose. A. P. Herbert, reviewing his career as a University member, had by then confirmed Bagehot's judgment and shown in repeated instances of inaction and injustice the practical effects of this loss of variety.

By his assorted examples from English history, Bagehot illustrates what we now all perceive about modern life: it sows uniformity and reaps monotony. He may therefore be of greater use to us when in the other half of his doctrine he reminds us that "the common mass of plain sense is the great administrative agency of the world"; that "the constitutional statesman" is not a man of original ideas but "a man of common opinions and uncommon abilities." Bagehot is so sure of the importance of this truth that he repeats it in varied forms—"the powers of a first-rate man and the creed of a second-rate man." And again: "So long as constitutional statesmanship consists in recording the views of a confused nation, so long as success in it is confined to minds plastic, changeful, administrative, we must hope for no better man."

This is a hard lesson for the finer spirits of our century, who were reared upon the belief in theory as the hope of the world, who studied Marx and now wish for "a philosophy of democracy" or who toil at a statistical science of man. It should seem as if our advanced times and those intricate problems facing complex institutions ought to be dealt with by intellect linked with expertise. Yet it is not so. To begin with, the people do not want it so. They rarely choose or do not long support the men of intellect.

And even apart from the people, in whom ultimate power is vested, the leaders of society, men of influence and wealth and education, do not want intellect and theory to lead them. They trust and prefer the "common opinions allied to uncommon abilities." Dash and brilliance tire them out in the end or make them suspicious from the start. Bagehot (in one of his brilliant defenses of dullness) gives us the explanation when he

criticizes Robert Lowe: "The faculty of disheartening adversaries by diffusing on occasion an oppressive atmosphere of business-like dullness is invaluable to a parliamentary statesman. But these arts Mr. Lowe does not possess. He cannot help being brilliant; the quality of his mind is to put everything in the most lively, most exciting, and most startling form. He cannot talk that monotonous humdrum which men scarcely listen to, which lulls them to sleep, but which seems to them 'the sort of thing you would expect,' which they suppose is 'all right.' And Mr. Lowe's mode of using general principles not only is not that which a parliamentary tactician would recommend, but is the very reverse of what he would advise: Mr. Lowe always ascends to the widest generalities . . . ; the middle principles, in which most minds feel most reality and on which they find it most easy to rest, have no charms for him; he likes to go back to the bone, to the abstract, to the attenuated. And if he left these remote principles in their remote unintelligibility, he would not suffer so much: but he makes the dry bones live; he wraps them in illustrations which Macaulay might envy. And he is all the more effective because he uses our vernacular tongue. [His] phrases . . . will be long remembered and will longer impair his influence with grave, quiet, and influential persons. Mr. Lowe startles those who do not like to be startled, and does not compose those who wish to be composed."

There are exceptions to the generality implied by this description, and Bagehot is quick to note them. They belong to the class he calls "dictators," as distinguished from "administrators." Dictators, as he uses the term, legitimately occur in representative government: they are needed in moments of crisis, usually in times of war. William Pitt was such a dictator, and unlike the administrator of ordinary times was a man of ideas—"a fresh stock of youthful thought such as no similar statesman has ever possessed." But it was not the possession of ideas or the coloring they imparted to his proposals that made Pitt the great man he was in Bagehot's eyes. No: "The charac-

teristic merit of Pitt is that in the midst of obvious cares, in the face of most keen, most able, and most stimulated opposition, he applied his whole power to the accomplishment of great but practicable schemes."

That such men as Pitt emerge and succeed—men of ideas and abilities both—naturally leads the political thinker to ask himself why dictators should not be the regular thing. To help him examine the question Bagehot had, as I have said, the example of Napoleon's nephew over the Channel, an example that Europe was to repeat, with variations, a good many times in the twentieth century. Bagehot dealt with Louis-Napoleon's Caesarism in a dozen or more essays, and from the early days of both their careers. Young Bagehot, aged twenty-six, was in Paris in 1852 when the Paris republicans were trying to oppose the coup d'état. One might suppose that as correspondent for a liberal newspaper, and himself of liberal convictions, Bagehot in his articles would attack the usurper and express the familiar liberal indignation. Not so. He wrote home an account of events and causes showing that a dictatorship was at once inevitable and useful. But he also helped the republicans build their barricades. In a word, apart from all reasoned preferences, law and the orderly conduct of business must come first, by force if all other appeals fail.

In after days, without changing beliefs, Bagehot was unsparing in his criticism of the Emperor. He could see that Napoleon III led not only France but a party spread throughout all nations; the new "intelligent despotism" was creating a genre, and the Emperor was "the crowned democrat of Europe." Yet Bagehot was convinced that such a government could serve only "crude and immediate" purposes. It could not endure, and Bagehot predicted its fall a full year before the war that led to the humiliation of Sedan.

It was the democratic, or rather the populist, strength of the new despotism that Bagehot apprehended. Apropos of Napoleon III's last plebiscite Bagehot gives a definition to bear in mind when we read him on this topic of the new polit-

ical force: "Democracy seems to us to consist as often as not in the free use of the people's name *against* the vast majority of the people." He has no love for what he calls "democratic autocracies," by which he means one-party systems based on periodic voting suitably rigged. A free government, for Bagehot, "lives by discussion, a free press has its life in argument and dissertation." Any other rule "is sure to be an *uneasy* government. It prohibits daily and efficient discussion, and the instructed classes, who love discussion, who delight in argument, who love the noble play of mind upon mind, become its irreconcilable enemies." The conclusion is that "free government involves privilege, because it requires that more power should be given to the instructed than to the uninstructed."

Bagehot wrote these words before free public education had been legislated—let alone taken effect upon the industrial masses; and he naturally shared the disquiet of his most thoughtful and liberal contemporaries, from Tocqueville to Matthew Arnold, at the prospect of political power passing wholly into the hands of the illiterate multitude. Before 1885 no example of successful rule by the many existed, unless it was the unedifying one of the Roman plebs. All agreed that government by consent was desirable and that consent implied the participation of all, as voters and potential legislators. But what would the practicing of that theory bring about when the uninstructed masses were suddenly loosed? This question, like the others that Bagehot met with clarity and concreteness, confronts us still in the new nations of the world. Moral and material civilization are not always in parallel, and even moderately free institutions require the moral more than the material.

Bagehot was certain that the English polity in the nineteenth century was based, not upon the aristocracy of birth, but "on property and, through property, upon education and intelligence." Well, education and property have since his day tamed the monster of "democracy" as the word was then used. The industrial masses have not turned into a Roman plebs in

those countries where a parliamentary tradition existed or was begun. And despite all that can be said against their choice of leaders when judged by Plato's standard of philosopher-kings, the nations of the Western world have been "deferential" in Bagehot's sense: the people have deferred to education and ability and have shown a remarkable detective instinct for integrity or the lack of it. Thus under all the changes of a hundred years our political history is continuous with that which Bagehot studied and from which he extracted so many profound lessons. *1968*

Lincoln the Literary Artist

A great man of the past is hard to know, because his legend, which is a sort of friendly caricature, hides him like a disguise. This is the situation that Lincoln occupies. For most people, Lincoln remains the rail splitter, the shrewd country lawyer, the cracker-barrel philosopher and humorist, the statesman who saved the Union, and the compassionate leader who saved many a soldier from death by court-martial, only to meet his own end as a martyr.

The Lincoln I know and revere is an historical figure who should stand—I will not say instead of, but by the side of all the others. No one need forget the golden legends, yet anyone may find it rewarding to move them aside a little so as to get a glimpse of the unsuspected Lincoln I have so vividly in mind.

I refer to Lincoln the artist, the maker of a style that is unique in English prose and doubly astonishing in the history of American literature, for nothing led up to it. The Lincoln who speaks to me through the written word is a figure no longer to be described wholly or mainly by the old adjectives, shrewd, humorous, or saintly, but rather as one combining the

traits that biography reports in certain artists among the greatest—passionate, gloomy, seeming-cold, and conscious of superiority.

These elements in Lincoln's makeup have been noticed before, but they take on a new meaning in the light of the new motive I detect in his prose. For his style, the plain, undecorated language in which he addresses posterity, is no mere knack with words. It is the manifestation of a mode of thought, of an outlook which colors every act of the writer's and tells us how he rated life. Only let his choice of words, the rhythm and shape of his utterances, linger in the ear, and you begin to feel as he did—hence to discern unplumbed depths in the quiet intent of a conscious artist.

But before taking this path of discovery, it is necessary to dispose of a few too familiar ideas. The first is that we already know all there is to know about Lincoln's prose. Does not every schoolchild learn that the Gettysburg Address is beautiful, hearing this said so often that he ends by believing it? The belief is general, of course, but come by in this way, it is not worth much. One proof of its little meaning is that most Americans also believe that for fifty years Lincoln's connection with the literary art was to tell racy stories. Then, suddenly, on a train journey to Gettysburg he wrote a masterpiece. This is not the way great artists go to work—so obviously not, that to speak of Lincoln as an *artist* will probably strike some readers as a paradox or a joke. Even so, the puzzle remains: How did this strange man from Illinois produce, not a few happy phrases, but an unmistakable style?

Pick up any early volume of Lincoln's works and start reading as if you were approaching a new author. Pretend you know none of the anecdotes, nothing of the way the story embedded in these pages comes out. Your aim is to see a life unfold and to descry the character of the man from his own words, written, most of them, not to be published, but to be felt.

Here is Lincoln at twenty-three telling the people of his

district by means of a handbill that they should send him to the state legislature: "Upon the subjects of which I have treated, I have spoken as I thought. I may be wrong in regard to any or all of them; but holding it a sound maxim that it is better to be only sometimes right than at all times wrong, so soon as I discover my opinions to be erroneous, I shall be ready to renounce them." And he closes his appeal for votes on an unpolitical note suggestive of melancholy thoughts: "But if the good people in their wisdom shall see fit to keep me in the background, I have been too familiar with disappointments to be very much chagrined."

One does not need to be a literary man to see that Lincoln was a born writer, nor a psychologist to guess that here is a youth of uncommon mold—strangely self-assertive, yet detached, and also laboring under a sense of misfortune.

For his handbill Lincoln may have had to seek help with his spelling, which was always uncertain, but the rhythm of those sentences was never taught by a grammar book. Lincoln, as he himself said, went to school "by littles," which did not in the aggregate amount to a year. Everybody remembers the story of his reading the Bible in the light of the fire and scribbling with charcoal on the back of the shovel. But millions have read the Bible and not become even passable writers. The neglected truth is that not one but several persons who remembered his childhood remarked on the boy's singular determination to express his thoughts in the best way.

His stepmother gave an account of the boy which prefigures the literary artist much more than the rail splitter: "He didn't like physical labor. He read all the books he could lay his hands on. . . . When he came across a passage that struck him, he would write it down on boards if he had no paper and keep it there till he did get paper, then he would rewrite it, look at it, repeat it." Later, Lincoln's law partner, William H. Herndon, recorded the persistence of this obsessive habit with words: "He used to bore me terribly by his methods. . . . Mr. Lincoln would doubly explain things to me that needed no

explanation. . . . Mr. Lincoln was a very patient man generally, but . . . just go at Lincoln with abstractions, glittering generalities, indefiniteness, mistiness of idea or expression. Here he flew up and became vexed, and sometimes foolishly so."

In youth, Lincoln had tried to be a poet, but found he lacked the gift. What he could do was think with complete clarity in words and imagine the workings of others' minds at the same time. One does not read far in his works before discovering that as a writer he toiled above all to find the true order for his thoughts—order first, and then a lightning-like brevity. Here is how he writes in 1846, a young politician far from the limelight, and of whom no one expected a lapidary style: "If I falsify in this you can convict me. The witnesses live, and can tell." There is a fire in this, and a control of it that shows the master.

That control of words implied a corresponding control of the emotions. Herndon described several times in his lectures and papers the eccentric temperament of his lifelong partner. This portrait the kindly sentimental people have not been willing to accept. But Herndon's sense of greatness was finer than that of the admirers from afar, who worship rather storybook heroes than the mysterious, difficult, unsatisfactory sort of great man—the only sort that history provides.

What did Herndon say? He said that Lincoln was a man of sudden and violent moods, often plunged in deathly melancholy for hours, then suddenly lively and ready to joke; that Lincoln was self-centered and cold, not given to revealing his plans or opinions, and ruthless in using others' help and influence; that Lincoln was idle for long stretches of time, during which he read newspapers or simply brooded; that Lincoln had a disconcerting power to see into questions, events, and persons, never deceived by their incidental features or conventional garb, but extracting the central matter as one cores an apple; that Lincoln was a man of strong passions and mystical longings, which he repressed because his mind showed him their futility, and that this made him cold-blooded and a fatalist.

In addition, as we know from other sources, Lincoln was subject to vague fears and dark superstitions. Strange episodes, though few, marked his relations with women, including his wife-to-be, Mary Todd. He was subject, as some of his verses show, to obsessional gloom about separation, insanity, and death. We should bear in mind that Lincoln was orphaned, reared by a stepmother, and early cast adrift to make his own way. His strangely detached attitude toward himself, his premonitions and depressions, his morbid regard for truth and abnormal suppression of aggressive impulses, suggest that he hugged a secret wound which ultimately made out of an apparent common man the unique figure of an artist-saint.

Lincoln moreover believed that his mother was the illegitimate daughter of a Virginia planter, and like others who have known or fancied themselves of irregular descent, he had a powerful, unreasoned faith in his own destiny—a destiny he felt would combine greatness and disaster.

Whatever psychiatry might say to this, criticism recognizes the traits of a type of artist one might call "the dark outcast." Michelangelo and Byron come to mind as examples. In such men the sense of isolation from others is in the emotions alone. The mind remains a clear and fine instrument of common sense—Michelangelo built buildings, and Byron brilliantly organized the Greeks in their revolt against Turkey. In Lincoln there is no incompatibility between the lawyer-statesman, whom we all know, and the artist, whose physiognomy I have been trying to sketch.

Lincoln's detachment was what produced his mastery over men. Had he not, as president, towered in mind and will over his cabinet, they would have crushed or used him without remorse. Chase, Seward, Stanton, the Blairs, McClellan had among them enough egotism and ability to wreck several administrations. Each thought Lincoln would be an easy victim. It was not until he was removed from their midst that any of them conceived of him as an apparition greater than

themselves. During his life their dominant feeling was exasperation with him for making them feel baffled. They could not bring him down to their reach. John Hay, who saw the long struggle, confirms Herndon's judgments: "It is absurd to call him a modest man. No great man was ever modest. It was his intellectual arrogance and unconscious assumption of superiority that men like Chase and Sumner could never forgive."

This is a different Lincoln from the clumsy country lawyer who makes no great pretensions, but has a trick or two up his sleeve and wins the day for righteousness because his heart is pure. Lincoln's purity was that of a supremely conscious genius, not of an innocent. And if we ask what kind of genius enables a man to master a new and sophisticated scene as Lincoln did, without the aid of what are called personal advantages, with little experience in affairs of state and no established following, the answer is: military genius or its close kin, artistic genius.

The artist contrives means and marshals forces that the beholder takes for granted and that the bungler never discovers for himself. The artist is always scheming to conquer his material and his audience. When we speak of his craft, we mean quite literally that he is crafty.

Lincoln acquired his power over words in the only two ways known to man—by reading and by writing. His reading was small in range and much of a kind: the Bible, Bunyan, Byron, Burns, Defoe, Shakespeare, and a then-current edition of Aesop's Fables. These are books from which a genius would extract the lesson of terseness and strength. The Bible and Shakespeare's poetry would be less influential than Shakespeare's prose, whose rapid twists and turns Lincoln often rivals, though without imagery. The four other British writers are all devotees of the telling phrase, rather than the suggestive. As for Aesop, the similarity of his stories with the anecdotes Lincoln liked to tell—always in the same words—is obvious. But another parallel occurs, that between the short-

ness of a fable and the mania Lincoln had for condensing any matter into the fewest words:

"John Fitzgerald, eighteen years of age, able-bodied, but without pecuniary means, came directly from Ireland to Springfield, Illinois, and there stopped, and sought employment, with no present intention of returning to Ireland or going elsewhere. After remaining in the city some three weeks, part of the time employed, and part not, he fell sick, and became a public charge. It has been submitted to me, whether the City of Springfield, or the County of Sangamon is, by law, to bear the charge."

As Lincoln himself wrote on another occasion, "This is not a long letter, but it contains the whole story." And the paragraph would prove, if it were necessary, that style is independent of attractive subject matter. The pleasure it gives is that of lucidity and motion, the motion of Lincoln's mind.

In his own day, Lincoln's prose was found flat, dull, lacking in taste. It differed radically in form and tone from the accepted models—Webster's or Channing's for speeches, Bryant's or Greeley's for journalism. Once or twice, Lincoln did imitate their genteel circumlocutions or resonant abstractions. But these were exercises he never repeated. His style, well in hand by his thirtieth year and richly developed by his fiftieth, has the eloquence which comes of the contrast between transparency of medium and density of thought. Consider this episode from a lyceum lecture written when Lincoln was twenty-nine:

"Turn, then, to that horror-striking scene at St. Louis. A single victim was only sacrificed there. His story is very short; and is, perhaps, the most highly tragic of anything of its length that has ever been witnessed in real life. A mulatto man by the name of McIntosh was seized in the street, dragged to the suburbs of the city, chained to a tree, and actually burned to death; and all within a single hour from the time he had been a freeman, attending to his own business, and at peace with the world."

Notice the contrasting rhythm of the two sentences: "A single victim was only sacrificed there. His story is very short." The sentences are very short, too, but let anyone try imitating their continuous flow or subdued emotion on the characteristic Lincolnian theme of the swift passage from the business of life to death.

Lincoln's prose works fall into three categories: speeches, letters, and proclamations. The speeches range from legal briefs and arguments to political debates. The proclamations begin with his first offer of his services as a public servant and end with his presidential statements of policy or calls to Thanksgiving between 1861 and 1865. The letters naturally cover his life span and a great diversity of subjects. They are, I surmise, the crucible in which Lincoln cast his style. By the time he was in the White House, he could frame, impromptu, hundreds of messages such as this telegram to General McClellan: "I have just read your despatch about sore-tongued and fatigued horses. Will you pardon me for asking what the horses of your army have done since the battle of Antietam that fatigues anything?"

Something of Lincoln's tone obviously comes from the practice of legal thought. It would be surprising if the effort of mind that Lincoln put into his profession had not come out again in his prose. After all, he made his name and rose to the presidency over a question of constitutional law. Legal thought encourages precision through the imagining and the denial of alternatives. The language of the law foresees doubt, ambiguity, confusion, stupid or fraudulent error, and one by one it excludes them.

As a lawyer Lincoln knew that the courtroom vocabulary would achieve this purpose if handled with a little care. But it would remain jargon, obscure to the common understanding. As an artist, therefore, he undertook to frame his ideas invariably in one idiom, that of daily life. He had to use, of course, the technical names of the actions and documents he dealt with. But all the rest was in the vernacular. His first achieve-

ment, then, was to translate the minute accuracy of the advocate and the judge into the words of common men.

To say this is to suggest a measure of Lincoln's struggle as an artist. He started with very little confidence in his stock of knowledge, and having to face audiences far more demanding than ours, he toiled to improve his vocabulary, grammar, and logic. In the first year of his term in Congress he labored through six books of Euclid in hopes of developing the coherence of thought he felt he needed in order to demonstrate his views. Demonstration was to him the one proper goal of argument; he never seems to have considered it within his power to convince by disturbing the judgment through the emotions. In the few passages where he resorts to platform tricks, he uses only irony or satire, never the rain-barrel booming of the Fourth-of-July orator.

One superior gift he possessed from the start and developed to a supreme degree, the gift of rhythm. Take this fragment, not from a finished speech, but from a jotting for a lecture on the law:

"There is a vague popular belief that lawyers are necessarily dishonest. I say vague, because when we consider to what extent confidence and honors are reposed in and conferred upon lawyers by the people, it appears improbable that their impression of dishonesty is very distinct and vivid. Yet the impression is common, almost universal. Let no young man choosing the law for a calling for a moment yield to the popular belief—resolve to be honest at all events; and if in your own judgment you cannot be an honest lawyer, resolve to be honest without being a lawyer."

Observe the ease with which the theme is announced: "There is a vague popular belief that lawyers are necessarily dishonest." It is short without crackling like an epigram, the word "necessarily" retarding the rhythm just enough. The thought is picked up with hardly a pause: "I say vague, because, when we consider . . ." and so on through the unfolding of reasons, which winds up in a kind of calm: "it appears

improbable that their impression of dishonesty is very distinct and vivid." Now a change of pace to refresh interest: "Yet the impression is common, almost universal." And a second change, almost immediately, to usher in the second long sentence, which carries the conclusion: "Let no young man choosing the law. . . ."

The paragraph moves without a false step, neither hurried nor drowsy; and by its movement, like one who leads another in the dance, it catches up our thought and swings it into willing compliance. The ear notes at the same time that none of the sounds grate or clash: the piece is sayable like a speech in a great play; the music is manly, the alliterations are few and natural. Indeed, the paragraph seems to have come into being spontaneously as the readiest incarnation of Lincoln's thoughts.

From hints here and there, one gathers that Lincoln wrote slowly—meaning, by writing, the physical act of forming letters on paper. This would augment the desirability of being brief. Lincoln wrote before the typewriter and the dictating machine, and wanting to put all his meaning into one or two lucid sentences, he thought before he wrote. The great compression came after he had, lawyerlike, excluded alternatives and hit upon right order and emphasis.

Obviously this style would make use of skips and connections unsuited to speechmaking. The member of the cabinet who received a terse memorandum had it before him to make out at leisure. But an audience requires a looser texture, just as it requires a more measured delivery. This difference between the written and the spoken word lends color to the cliché that if Lincoln had a style, he developed it in his presidential years. Actually, Lincoln, like an artist, adapted his means to the occasion. There was no pathos in him before pathos was due. When he supposed his audience intellectually alert—as was the famous gathering at Cooper Union in 1860—he gave them his concentrated prose. We may take as a sample a part of the passage where he addresses the South:

"Again, you say we have made the slavery question more prominent than it formerly was. We deny it. We admit that it is more prominent, but we deny that we made it so. It was not we, but you, who discarded the old policy of the fathers. We resisted, and still resist, your innovation; and thence comes the greater prominence of the question. Would you have that question reduced to its former proportions? Go back to that old policy. What has been, will be again, under the same conditions. If you would have the peace of the old times, readopt the precepts and policy of the old times."

This is wonderfully clear and precise and demonstrative, but two hours of equally succinct argument would tax any but the most athletic audience. Lincoln gambled on the New Yorkers' agility of mind, and won. But we should not be surprised that in the debates with Stephen A. Douglas, a year and a half before, we find the manner different. Those wrangles lasted three hours, and the necessity for each speaker to interweave prepared statements of policy with improvised rebuttals of charges and "points" gives these productions a coarser grain. Yet on Lincoln's side, the same artist mind is plainly at work:

"Senator Douglas is of worldwide renown. All the anxious politicians of his party, or who have been of his party for years past, have been looking upon him as certainly, at no distant day, to be the President of the United States. They have seen in his round, jolly, fruitful face, post offices, land offices, marshalships, and cabinet appointments, chargéships and foreign missions, bursting and sprouting out in wonderful exuberance ready to be laid hold of by their greedy hands."

The man who could lay the ground for a splendid yet catchy metaphor about political plums by describing Douglas's face as round, jolly, and *fruitful* is not a man to be thought merely lucky in the handling of words.

Lincoln's extraordinary power was to make his spirit felt, a power I attribute to his peculiar relation to himself. He regarded his face and physique with amusement and dismay, his mind and destiny with wonder. Seeming clumsy and diffi-

dent, he also showed a calm superiority which he expressed as if one-half of a double man were talking about the other.

In conduct, this detachment was the source of his saint-like forbearance; in his art, it yielded the rare quality of elegance. Nowhere is this link between style and emotional distance clearer than in the farewell Lincoln spoke to his friends in Springfield before leaving for Washington. A single magical word, easy to pass over carelessly, holds the clue:

"My friends: No one, not in my situation, can appreciate my feeling of sadness at this parting. To this place, and the kindness of these people, I owe everything. . . ." If we stop to think, we ask: "This place"?—yes. But why "*these* people"? Why not "you people," whom he was addressing from the train platform, or "this place and the kindness of *its* people"? It is not, certainly, the mere parallel of *this* and *these* that commanded the choice. "These" is a stroke of genius, which betrays Lincoln's isolation from the action itself—Lincoln talking to himself about the place and the people whom he was leaving, foreboding the possibility of his never returning, and closing the fifteen lines with one of the greatest cadences in English speech: "To His care commending you, as I hope in your prayers you will commend me, I bid you an affectionate farewell."

1959

The Reign of William and Henry

At our first glimpse of William James, he was crossing Harvard Yard in conversation with his students and the year was 1890. The choice of that year was not only to show him on the verge of publishing *The Principles of Psychology;* it was also to hint that we must think of him as a man of the

Nineties. His share in the reform struggles of that time is but a small part of his close relation to it. I am here using "the Nineties" in a special sense shortly to be explained.

In scanning the age, we should picture James as one who, like every outstanding talent, starts out in life from his own corner, working along his own line, and at the midpoint of his journey finds himself rather suddenly in a large and tumultuous company of his peers—the makers of culture for his era and the next. The newcomer to the group is cited, read, written to, agreed and argued with, visited, possibly honored, and he reciprocates those acts. This assimilation explains how these makers come in retrospect to wear a distinctive look, a family likeness. For James the process began during his European trip of 1882–83; it was completed after the publication of the *Principles* in 1890. It is thus no digression to review the exploits of "the Nineties."

That decade evokes its adjectives like many others—as if every ten years, punctually, civilization changed course and put on a new costume. This belief is a little too simple and what the nicknames leave in the memory is largely false. There was no doubt a "mauve decade," a "gay nineties," and a despairing mood properly called *fin de siècle*. "Aesthetes" could be found who shut out the sun with black curtains to brood by candlelight on the refining of their perceptions through art and poetry, while others saw visible change as final decadence. But the landscape should be surveyed from higher ground. Indeed, "the Nineties" ought to mean, in the way of shorthand, the full turn of the century, the period stretching from the Paris Exhibition of 1889 with its Eiffel Tower and Galerie des Machines to the outbreak of war in 1914. So taken, with a ragged edge of years at each end, the epoch reveals a deep transformation: Victorian thought, art, and morals were disposed of and replaced by what must be called Modernism. This label, it is true, has had a footloose existence, applied here and there to several movements of dif-

ferent dates; but it rightly belongs to those twenty-five years in which nearly every idea of the twentieth century was hatched.

The mechanical inventions of the time are still the most familiar props of our daily life: the automobile, the airplane, the movies, the X ray, the wireless. It was then that electricity began to mean "power" and helped to clean up, as well as light up, the factory and the home, while removing from the city (through the streetcar) the unsanitary horse and his threat to public health.

It was the time of other innovations that we tend to think much more recent and peculiarly ours: the popularity of appendicitis, emblem of the new abdominal (and even heart) surgery; organ transplants (in animals); experiments with mescaline and advocacy of the "drug experience"; "research and development" for and by industry; the data-processing machine (Hollerith punch card, still in use); radium treatment for breast cancer; the chlorinated water supply; color photography; and man-made fibers for textiles.

On the domestic scene, the novelties included: the vacuum cleaner; the electric elevator, refrigerator, motorcar, oven, toaster, iron, dishwasher, sewing machine, and central heating plant; stainless-steel utensils; the aluminum saucepan; the flashlight; rubber heels; the zip fastener; toothpaste in a tube; breakfast cereals, margarine, the ice-cream cone, Coca-Cola, chop suey, chewing gum, and book matches; the first printed crossword puzzle and the first fully automated device, the player piano. As for inventions planned in that era and only actualized later, they were numerous, among them the brilliant foreshadowing of the microcard that G. K. Chesterton gave in his first Father Brown story, "The Blue Cross" (1911).

New products and machines were not the cause but the concomitant of an extraordinary ferment in all departments of life. Many social and political ideas, devices and forces that we still reckon with were born or broke out then: sexual emancipation, the battle for women's rights; the concentration camp;

the assassination of heads of state and the planting of bombs in public places to advertise a cause; student riots; the hunger strike; black humor in print and sadism and bloodshed on stage; organized and motorized crime (*la bande à Bonnot*), as well as a host of lesser innovations such as the use of protest buttons (Anti-Imperialist), of acronyms, and of questionnaire surveys; hiring "stars" to advertise soap; the pinup girl (in the form of pocket cards and posters); the Homburg hat for real and gray eminences, Edward VII style; the creation of the Boy Scouts; the invention of musical comedy, the use of gloves in championship boxing, and the inauguration of the striptease. That fecund period gave the thematic catalogue, as it were, of our achievements and our desires.

These facts are known in some fashion today, but hardly felt, which means that the significance of James's time for ours is not understood. We think we have got beyond "the turn," when except for technology we are scarcely up to it. Only in the last few years, for example, has awareness dawned that the "Cubist Decade" in art—1905–14—contains in essence and realizations nearly all that has come since. Because of this laggard state of mind, largely due to the blurring and dislocating effect of the First World War, we still hunt for solutions already found, we stumble over mental hurdles already removed, we rediscover naïvely and painfully. Our contribution, when we consciously build on those early foundations, is to refine and multiply. Our achievement—and it is no small one—has been to standardize and democratize; the car is a prime example, paralleled in hundreds of other machines, opinions, and attitudes. But intellectually, morally, and socially, much from the Nineties that might have been used or surpassed has been lost.

Hence this glance at the work of the twenty-five years I call formative will indicate several further reasons for the present use—the urgent need—of types of thought to which James's own is the best introduction.

* * *

To begin with, James was a true assessor of the intellectual and emotional revolution of his time. The mood he sensed in 1904 applies not solely to the work of professional thinkers but to culture and society at large: "It is difficult not to notice a curious unrest in the philosophic atmosphere of the time, a loosening of old landmarks, a softening of oppositions, a mutual borrowing from one another on the part of systems anciently closed, and an interest in new suggestions, however vague, as if the one thing sure were the inadequacy of the extant school-solutions. The dissatisfaction with these seems due for the most part to a feeling that they are too abstract and academic. Life is confused and superabundant, and what the younger generation appears to crave is more of the temperament of life in its philosophy, even though it were at some cost of logical rigor and of formal purity. I seem to read the signs of a great unsettlement, as if the upheaval of more real conceptions and more fruitful methods were imminent, as if a truer landscape might result, less clipped, straight-edged, and artificial."

The main heads under which the "unsettlement" may be considered for review are: the natural (or material) *versus* the ideal; science as one mode of thought *versus* the world of feeling that it excludes; the permanence of truth *versus* the evolution of all things (the permanence, rather, of perspectivism in truth); the claims of science *versus* those of religion and (just as momentous) the claims of art *versus* those of religion.

To use historical labels for these conflicts, the new consciousness of the Nineties had to deal with Positivism and Darwinism, with Industrialism and Democracy, with Realism in art and Populism in politics, education, and taste. When movements that we know under their limited, topical names—for example, Symbolism and Naturalism—are taken as parts of the larger wave of rebellion and reform, the coherence of the myriad seemingly chaotic efforts becomes clear and their cultural bearing obvious. The only thing that is hard to understand is why this surge of novelty has not hitherto been

treated as one whole and its creators and promulgators as one group, regardless of doctrine and sphere of action. The answer is probably, again, the excessive attention to private concepts—individual ideas—and the neglect of results.

It was no epigram but a sober thought that Wilde offered to the readers of the *Saturday Review* in 1894, when he wrote that Art was the only serious thing in the world. Nietzsche, as yet hardly known, had said the same thing earlier, seeing in art the sole enhancer of life and a protection against having nothing to gaze at but the void created by science; and Tolstoy undertook his crusade to rehumanize mankind with the aid of a simplified and deeply moral art. The triumph of art as a cult meant another change that we also take for granted: it is no longer the work, the craft, that defines the species "artist," but the love of art. So the critic, too, is called an artist, and the connoisseur, and the bourgeois who has seen the light and who "collects" or "subscribes" or "follows." Every educated person must take or pretend an interest in art. Listen to our witness Henry James: "Art indeed has in our day taken on so many honours and emoluments that the recognition of its importance is more than a custom, has become on occasion almost a fury."

What of his own contribution to this state of affairs? At a time when Zola and his fellow-Naturalists offered their "experimental" results in the simple way of mid-nineteenth-century science, Henry James was already a step ahead in his conception of truth. He was, as he told William, a practicing pragmatist—and had been one before William's book supplied the reasons for his intuition. In that same preface, Henry goes on after the words "a unique instrument": "ensuring to the person making use of it an impression distinct from any other. He and his neighbors are watching the same show, but one seeing more where the other sees less, one seeing black where the other sees white." Throughout the eighteen prefaces forming *The Art of the Novel* the word "consciousness" must

recur one hundred times. As for "the same show," it is the world assumed to be "out there"; but for Henry as for William in his *Psychology*, the endless varieties of experience are all we have to go by till we compare—compare reports with our fellows, contrast novels by different authors, compare the less with the more and the white with the black in the search for an ever-new "realism."

These matters of doctrine and practice show in what sense Henry James "represents" or is emblematic of the great quarter century. His work is "realistic" but he is not a Realist; it is full of symbols, but he is not a Symbolist. By the end of his career he was stretching syntax (without distortion) to achieve his unearthly effects, but his novels also form a summa of observations and of moral lessons that point always to ideal behavior—the fine flower of feeling expressed in action. These features taken together make of James's art a synthesis of Naturalism and Symbolism, marked by strong influences direct from the Romantics and colored by the unique perceptions and passions that show Henry and William brothers indeed. Neither took from the other; they shared and intermittently compared notes, doubtless aware of a common inheritance from Henry Sr.

But the literary labels I have used being notoriously inadequate, they need the supplement of the artist's own sayings; Henry James wrote theory to make the meanings of his art unmistakable. The strain of *philosophic* naturalism in him comes out—William-like—in what he calls "the terrible law of the artist . . . the law of the acceptance of *all* experience, of *all* suggestion and sensation and illumination." This radical pluralism keeps him from the Symbolists' desire for attenuation through distilling selected experiences in small drops. But James's mode of notation and expression certainly meets theirs more than halfway; it is the opposite of the *literary* Naturalists' rough, direct handling. Rather, it is to "reduce one's reader, 'artistically' inclined, to such a state of hallucination by the images one has evoked as doesn't permit him to rest till

he has . . . set up some semblance of them in his own other medium, by his own other 'art.' "

The net effect of a fiction, in James, is that of a parable. The images of the observed world carry an idea, his real subject. He is not afraid to start from vague intimations of his most general subject, which is life: "I want," he notes in 1893, "to do something fine, a strong, large human episode . . . that brings into play character and sincerity and passion. . . . I feel again the multitudinous presence . . . the surge of *life*." And although by his method of induced "hallucination" he tends to show passionate conflicts from the inner side of the drama, he also keeps his eye on the usual outer objects—love, money, death, clumsy fears, vulgar ambition, emotional blackmail, and the rest. His observations of the current world move from outer to inner and back again as he sees in 1895 the approaching century: "The deluge of people, the insane movement for movement, the ruin of thought, of life, the negation of work, of literature, the swelling roaring crowds." He is so full of this spectacle that it inspires an occasional doubt as to technique: "I'm too afraid to be *banal*."

But he is altogether a man of the Nineties: his art is his castle. Art presents him with "fearful difficulties," but also with "consolation and encouragements." Without it, "the world would be indeed a howling desert." As soon as he crosses the threshold of art, "I believe, I see, I *do*." Yet—it must be said again—this "1890" brand on the shoulder means, not art for art's sake, but art for life's sake. James loves his characters—especially his women—not alone for their delicacy and fastidiousness, but for their "acuteness and intensity, reflection and passion." The culminating statement of James's loyalty to life is given by Lambert Strether in a great scene of *The Ambassadors* and that statement is addressed not to artists only but to all men and women.

The two Jameses obviously did not lead or outtop the galaxy of geniuses who reshaped the Western mind from 1890 to

1914. But William and Henry were part of the vanguard and may serve as representatives——Henry of the tone and temper of art and its new moral tendencies, William of the new premises of science and the new conceptions of truth, mind, and social life.

And in moral outlook William and Henry were at one. The pragmatism that Henry avowed to William taught that ethics, honor, virtue were the matching of promises or pretensions with conformable conduct. Moral excellence consisted in being fastidious about the means employed to satisfy desires. This criterion is the one William saw as governing the search for truth——truth by results: not *any* results, not careless neglect of other truths; and similarly in the moral life, not neglect of rival claims, for every claim creates an obligation.

When conventional opinion serves up its contrast between William, "typically American," and Henry, so innately civilized that he could enjoy life only abroad, it is well to remember a letter culminating in a famous phrase that William wrote to H. G. Wells in 1906: "Exactly that callousness to abstract justice is the sinister feature and, to me as well as to you, the incomprehensible feature, of our U.S. civilization. When the ordinary American hears of cases of injustice he begins to pooh-pooh and minimize and tone down the thing, and breed excuses from his general fund of optimism and respect for expediency. 'It's understandable from the point of view of the parties interested'——but understandable in onlooking citizens only as a symptom of the moral flabbiness born of the exclusive worship of the bitch-goddess SUCCESS. That—— with the squalid cash interpretation put on the word success——is our national disease."

The imaginary divergence in temper and delicacy between the brothers leads me to discuss a further discord that some have found within their mutual affection and admiration. Henry evidently adored William from childhood, as his words to the end of his life testify. But William has been represented by some devotees of Henry as having repaid this

warmth with a nagging hoity-toity condescension. This elder-brother stance is attributed to William's lack of aesthetic sensibilities, to his energetic, coarse-grained practicality, which resented the other's fineness and thus prolonged "sibling rivalry" into maturity.

In this account of the philistine badgering the artist the pièce de résistance is a letter that William wrote to Henry about *The Golden Bowl* and *The Wings of the Dove*. It begins, let it be noted in passing, with a remark about *The American Scene,* which William says seems to him "in its peculiar way *supremely great."* He goes on: "you know how opposed your whole 'third manner' of execution is to the literary ideals which animate my crude and Orson-like breast, mine being to say a thing in one sentence as straight and explicit as it can be made, and then to drop it forever; yours being to avoid naming it straight, but by dint of breathing and sighing all round and round it, to arouse in the reader who may have had a similar perception already (Heaven help him if he hasn't) the illusion of a solid object, made (like the 'ghost' at the Polytechnic) wholly out of impalpable materials, air, and the prismatic interferences of light, ingeniously focused by mirrors upon empty space. But you *do* it, that's the queerness! and the complication of innuendo and associative reference on the enormous scale to which you give way to it does so *build out* the matter for the reader that the result is to solidify, by the mere bulk of the process, the like perception from which *he* has to start. As air, by dint of its volume, will weigh like a corporeal body; so his own poor little initial perception, swathed in this gigantic envelopment of suggestive atmosphere grows like a germ into something vastly bigger and more substantial."

Now, that is superb criticism—the rare kind which, while objecting to the manner or method or substance of a work of art, nonetheless describes these exactly, vividly, and appreciates the effect without relishing it. William admired without enjoying and said so fairly—not a word here of sarcasm or denigration or

belittlement, which indeed no student of William's character would think possible about *any* subject of discourse, much less the work of the "Dearest Henry," "Beloved H.," whom he salutes at the head of every letter.

True, from the very intensity of that affection, and no doubt from habit as the elder and leader since boyhood, William goes on to warn, not hectoring, only pleading with the solicitude of love: "But it's the rummest method for one to employ systematically as you do nowadays; and you employ it at your peril. In this crowded and hurried reading age, pages that require such close attention remain unread and neglected. You can't skip a word if you are to get the effect, and 19 out of 20 worthy readers grow intolerant. The method seems perverse: 'Say it *out*, for God's sake,' they cry, 'and have done with it.' And so I say now, give us *one* thing in your older, directer manner, just to show that, in spite of your paradoxical success in this unheard-of method, you *can* still write according to accepted canons."

The "paradoxical success" William refers to is that which he himself so fully perceives, not any success Henry had with readers and critics. Henry in his final period lost them, bewildering them as he did *not* bewilder William. Except for a little band of faithful, it took some forty years for the third manner to justify itself and become fodder for academic dissertations. And to this day there are (and will continue to be) objectors, armed with tenable arguments against it. Those put by William imply no obtuseness or philistinism: "For gleams and innuendos and felicitous verbal insinuations, you are unapproachable, but the *core* of literature is solid. Give it to us *once* again!"

In so urging, William was inspired by unmixed devotion. He wanted for Henry the widest renown, the fulfillment of his manifest destiny as the greatest living American novelist. Henry was unmoved, quite properly. He had retorted in strong words to earlier hints of the same sort. The brothers knew how to take each other better than their biographers do:

"your last was your delightful reply to my remarks about your 'third manner,' wherein you said you would consider your bald head dishonored if you ever came to pleasing *me* by what you wrote, so shocking was my taste. Well! write only *for* me, and leave the question of pleasing open!" And William reiterates his clear perception of Henry's achievement: "I have to admit that in *The Golden Bowl* and *The Wings of the Dove* you have succeeded *in getting there* after a fashion, in spite of the perversity of the method and its *longness*." And after the critiques comes a due disclaimer of their authority: "For God's sake don't *answer* these remarks, which (as Uncle Howard used to say of Father's writings) are but the peristaltic belchings of my own crabbed organism."

These brotherly exchanges are exemplary. It is remarkable, to begin with, when members of a family read the books it produces—it is almost unheard of—and still more remarkable that literary artists with different aims should so far sympathize with each other's productions. William saw his own task as discerning, transfixing, and reproducing in concrete language the multiplicities of experience, in order to have it seen as the fundamental reality that we take in endless ways for as many purposes. Henry, out to slay the *very same* conventions of life and thought, wanted to go beneath them into the ramifications of feeling, fantasy, and will that are concealed from ordinary sight. So his exhibiting could not be done through direct exposition like William's, but only through the presentation of the stuff itself: he must not tell, but show—and hence their divergent methods.

That both writers acquired from their father and the home circle a comparable gift of language, a genius for imagery and similitudes, and the power to disentangle and describe the motions of the human mind, is what inspired the anonymous epigram that Henry wrote novels like a psychologist and William wrote psychology like a novelist. But the range of their tastes was not the same, as we just saw, and the "contemporary productions" that William admired and Henry dis-

missed showed William as the more inclusive appreciator. He found merit and pleasure in the works of Shaw, Wells, and Chesterton when these were still dubious newcomers. He read Tolstoy soon after French translations appeared and thought *War and Peace* the greatest novel ever written. He relished Hardy and William Dean Howells, and he fell—like the rest of the Western world—under the spell of the young Kipling ("Much of his present coarseness and jerkiness is youth only, divine youth") though his admiration for some of the later works grew less.

Despite his own disclaimer that he was deaf to poetry, William's prose is studded with quotations and allusions to the English poets from Crashaw to Francis Thompson, as well as to Homer, Dante, the Greek Anthology, and the great French and German writers. He felt the power and the vision in Zola's "truly magnificent" *Germinal,* and in *Madame Bovary* "the persistent *euphony,* a rich river that never foamed or ran thin." As for Renan, then a demigod to the French, James quite early detected in him, behind the music of the prose, foppish vagueness, insincerity, and pretension. He was moved by the "art and spirituality" of Baudelaire at a time when Henry found little in *Les Fleurs du Mal* but "weeds plucked from the swamps of evil." William knew his Whitman thoroughly, taught his students to enjoy him, and quoted him repeatedly and at length, though rejecting his voracious Oneness engulfing all things. He perceived, moreover, the difference between that poetic transcendentalism and Emerson's. He enjoyed reading Shakespeare through in chronological order—not just reading about him—and the upshot was equal surprise at the playwright's power and the amount of ranting and bombast, due no doubt to his "intolerable fluency." Independently of Shaw and Tolstoy, William was also puzzled by Shakespeare's lack of moral, cosmic, or other convictions; for he was close reader enough to see that in a work of fiction without a perceptible tendency, the characters' utterances cancel each other out and produce a species of nihilism. These

judgments, like his objection to the monotony of Palgrave's *Golden Treasury* ("too much of an aviary") were not the conventional ones acquired in college: William had never gone to college; his humanistic education was foreign and we may be sure that his opinions owed nothing to low, middle, or high fashion: they were his own, formed without aid from literary cliques.

To William, then, art was an extension and clarification of the fluid, fugitive deliverances of experience. It was a special, deliberate mode of "taking." It was creation also in the sense in which the mind creates all objects, but with inner and outer relationships offered in a form that gives the impression of complete novelty and a heightened reality. It satisfies a need not satisfied by work, play, thought, or worship. From such a sensibility one might expect a corresponding subtlety of perception and behavior in personal relations. The link is not logically necessary but empirically likely. And indeed we find James acute in thought and feeling about others, alive to their pain or distress in an almost pathological degree—William's sister, Alice, is here the best witness—and we have seen him large-spirited in judgment. There would be no need to say more if the gratuitous partisanship I have mentioned as blinding some of Henry's admirers did not couple with the imputation of insensitivity to Henry's art the charge that his brother treated him in a bullying way that concealed an unconscious jealousy.

The allegation raises large questions about the craft of biography and the application of therapeutic psychologies to documentary evidence. These questions I have discussed elsewhere. William and Henry's exchanges—and they were full and frequent for men moving mostly in different circles and different countries—are in the conversational tone of perfect equality. On the point of William's "bullying" and apropos of literary disagreements, here is one of his messages to Henry:

"Last Sunday I dined with Howells and was much delighted to hear him say that you were both a friend and

admirer of Rudyard Kipling. I am ashamed to say that I have been ashamed to write of my adoration of that infant phenomenon, not knowing, with your exquisitely refined taste, how you might be affected by him and fearing to *jar*."

Not one letter to Henry, incidentally, makes use of the raillery and comradely banter that William occasionally indulged in with friends whom he knew to be ready to reply in kind. Times change, mores also, and the verbal vehemence that obtained at the James Senior's table is doubtless a thing of the past. It was never common in America. Indeed, one may wonder how Henry Sr. fared after writing to an editor about "the slipslop ladled out in your journal," this being said not in anger but in friendly rallying.

To be gentlemanly without being genteel, free and blunt in expression in the manner of European intellectuals, was and is a style at the opposite extreme from the foam-rubber, public-relations language that we nowadays adapt to all occasions. Try to imagine an academic of the 1980s writing to a colleague as William did to John Jay Chapman after reading an article in manuscript: "Wonderful! wonderful! Shallow, incoherent, obnoxious to its own criticism of Chesterton and Shaw, off its balance, accidental, whimsical, false; but with central fires of truth 'blazing fuliginous mid murkiest confusion,' telling the reader nothing of the Comic except that it's smaller than the Tragic, but readable and splendid. Pray patch some kind of finale to it and send it to the *Atlantic*—Yours ever fondly, W. J. (Membre de l'Institut)."

To understand William properly one must grasp at once why the last phrase was tacked on: he disliked titles and honors and pushed away as many as he could, but membership in the French Academy of Moral Sciences had descended upon him and it could not be shuffled off without churlishness. So, once Chapman has been raked appreciatively over the coals, it occurs to James that his closing instructions sound schoolteacherish and he puts down his "qualification" to make fun of himself, knowing that Chapman will be amused.

A period when it was possible to enjoy receiving such a missive and replying in kind was one which bred strong personalities, while manners permitted strength and individuality to be admired. What met with contempt was vulgar feelings—suspicion, envy, self-pity: they were not to be given room in heart or mind; indeed, they were to be chased out if they crept in, and conduct must be in keeping I use "conduct," and not our social science term "behavior," to stress the primacy of responsibility and control. Whether that "inner direction" (in modern technicalese) was better for man and society than the open-heart self-surgery we consider more honest and unassuming is not a question to thrash out here. The fact of the difference is the point, and its bearing on biographical judgment.

The present-day tendency is for biography to tell us not about character—that is, conduct—but about its conditions. The mode is scientism and concept-work; the famous man or woman is a congeries of troubles who collapses into a case. That is how the relations of William and Henry have been traced back by some to a lifelong conflict due to their parents' partiality: William, the bright youth, occupied center stage while Henry sat in a corner reading. Hence arrogant superiority in the older, mixed with an envious hostility to the younger's finer clay. Elsewhere, by the same method, both brothers have been shown as culpably victimizing sister Alice: they blandly suppressed her literary talents, which in turn aggravated her illness and ended her life prematurely. The parents were guilty of injustice, it seems, and as for William and Henry, they wanted no competition in their domain—charming motives all around.

This depiction is made up of anachronisms. American and British society in the later nineteenth century was certainly not hostile to women writers. Hundreds of them achieved success with very slender gifts, just like the men, and Alice James could have done as much had she willed so. Unfortunately she was an Elizabeth Barrett without a Prince Browning. To

require now that her family should have given "encourage-ment" is to ask that the habits of today should have obtained a century ago. Not until education and the cult of art became fully democratized, after the First World War, did it become usual to "encourage" everybody on little or no provocation. Earlier, man, woman, or child had to signalize his or her ambition by an overt performance, before someone—usually a practitioner—gave encouragement. No one yet knows whether our less selective way has brought gain or loss.

What is certain is that the real objection to turning biog-raphy into diagnosis is not that it bemeans those subjected to it. Rather, the issue is: What does the public want to hear about? Some readers think the discussion of art and ideas more interesting than the retrospective gossip that is often substi-tuted for it and they find character blurred, not highlighted, by clinical analysis, since such analysis rests on seeing different *persons* as similar *patients*. *1983*

VI

On Music and Design

Why Opera?

Grand opera is a visual art for a large audience. Obviously, subtle gestures and facial expressions will not carry to such an assembly eager for spectacle. But opera is not merely spectacular, it is verbal and musical too; and while the ears are occupied it is difficult to follow light or rapid movements on the stage. Hence a perfect logic dictates the combination of strong, simple feelings with large, unmistakable manifestations. The amateur of chamber music or *théâtre intime* calls them respectively crude feelings and blatant manifestations; he is applying the criteria of one genre to the features of another, which is to be thoroughly *un*critical. In opera, the sympathetic and educated ear detects and enjoys the subtleties, the refinements, with which the composer has decorated and deepened the gross goings-on of his puppets.

Describing them in those words is appropriate because the true province of grand opera is Vanity and Violence. No one should find this truth unpalatable or think opera unworthy in consequence. In art, nothing is to be scorned for what it portrays, though the same spectacle in the moral life might incur blame.

The wise man therefore accepts the conventions of opera (even while he laughs at them) instead of getting indignant like Tolstoy in his famous critique. In opera it is both funny and quite right that declarations of love, like tender reproaches and useless pleas, should be addressed to the back of the other person twenty feet away. Both parties need plenty of air and room for the limbs. If at some point they *must* embrace, they

do so side by side, like Siamese twins, once again in the interests of free play for the diaphragm. Similar management is needed for the struggle over that leaden goblet containing the poison unknown to science. Firmly grasped by the two contestants, it must be tugged at semi-rhythmically regardless of the dynamics of liquids: those of the music are far more important.

To generalize, in opera—as in all public displays—convention rules and petty realism does not matter. Ritual makes clear the intention, which is why a good opera calls for gorgeous costume, costume magnified beyond credibility and the power to sit down, as in the real life of the eighteenth century. It is true that *Wozzeck* and *Louise* almost manage with department-store clothes, but I predict that future directors of those operas will jealously preserve and gradually exaggerate the period look, for just the reason I advance. Opera wants gold braid and bright reds, sequins and long trains and tiaras: they are half the action, the other half being the scenery. To clinch the point, one need only appeal to experience: the acme of fulfillment for the Idea of Opera is the horse. The horse is the ostentatious and military animal, the visible animal easily identified, the animal that connotes grandeur and expense, the only animal that dresses well. Man on top of horse is the implacable conqueror, the symbol of vain and violent human nature. As a meal on the stage is to a comedy of manners, so is a horse to an opera. *1967*

Is Music Unspeakable?

F ew readers today would recognize the name of Donald Ogden Stewart, though in his time he wrote some entertaining things. One was *Perfect Behavior*—what to do on various occasions. The section "On Taking a Lady to a Concert" begins

this way: "As soon as you are seated, express the wish that the orchestra will play *Beethoven's Fifth*. If your companion asks, Fifth what? you are safe for the rest of the evening."

This brief scene contains the essence of the present discussion. After a concert there is a natural urge to talk. Music is a strong stimulus that calls for outward release. But there is also the wish to be safe, the fear of saying the wrong thing. This awkward relation of words to music is what I hope may be made clearer by considering some neglected facts.

To begin with, why this fear? Nobody is afraid to talk about the play just seen or the novel just read. But music is believed to be something apart. It is forbiddingly technical, and in spite of its direct appeal it seems to have no namable links to daily life, such as are obvious in the novel and the play. This lack is confirmed by warnings from the musical authorities: anything you say about music, other than technical, will be silly or irrelevant. And we have all heard the anecdote of the composer who played his latest piece to his guests, after which one of them asked what its meaning was. The composer sat down at the piano again and played the piece through once more.

The composer's answer was entirely right. But it holds good not just for music. The meaning is inside any work of art and it cannot be decanted into a proposition. Nor does that fact settle the question I have raised. Despite all the warnings and anecdotes, there is an enormous amount of verbalizing about music. Concerts supply program notes, music on disks comes with comments on the covers or in booklets, and newspapers print daily reviews. Are all these words silly or irrelevant?

In program notes, to be sure, there may be bits and pieces of technical description—"the cadence is pleasantly postponed by a run of syncopated chords reminiscent of the second subject." Or: "the piece is scored for the usual strings, two flutes, two trumpets, four bassoons (French practice)," and so on. Quite useless to the laity, superfluous for the professional—

and contrary to the intent of art. For the composer's aim is not to show how clever or correct or daring he has been, but to convey an immediate and complete impression of what he has conceived.

How then can his work be talked about, not assigned a meaning, but described and characterized? Human experience can be widely discussed only in common words. Fortunately, program notes contain few technicalities and daily reviews even fewer. There we are told about the quality of the performance and perhaps about the composer's relation to his time or his peers. The rest—usually the larger part—points out significant details in the music and tries to describe them in ordinary language. Let us look at some examples:

> Even though familiar, Haydn's vivid modulation to C major on the words "Let there be light!" is still a thrilling visual effect.

> Beethoven touches on the range of expressivity available to him, from pessimism to utopian hopefulness, from a kind of coarse bombastic physicality to the most sublime spiritual subtleties.

> Hugo Wolf's art is a means of framing, embodying, presenting, and enacting the life of words.

This last seems a restatement of the problem; the Haydn rashly invokes our eyesight; and the Beethoven psychologizes freely. All offer ideas that some other listener might dispute. What to make of all this? I believe the Haydn example can suggest how to sort out the tangle, but first, let us be skeptical. When I hear the "let there be light" passage, I for one do not *see* anything. Some people do see, like Scriabin, who had what is called synesthesia, the perception of color when a note is sounded. But that is a rare anomaly. All the same, I agree with the reviewer that Haydn has done with sounds what the words denote; the music is more than appropriate; it is perfect.

Before giving the reason, let us be critical again. Why

doesn't that particular change of key in other pieces generate the feeling of the Creator's flooding the cosmos with light? If there were a fixed relation between sound and idea, it would severely limit composition. C major would be permanently tied to Con Edison. Yet we find it equally apt elsewhere; for instance as the key of the Overture to *Meistersinger*.

In the eighteenth century, and in ancient Greece, musicians believed that the several keys and modes did arouse each a definite emotion. Handel and his contemporaries called the system "the affections" and used it in their operas as a matter of course. But they had sense enough not to make it into a fixed code.

What then is the way out of these contradictions—words are used about music but shouldn't be; sounds suggest ideas, but there's no telling which. The facts, I think, are these: Sounds, rhythms, and tone color strike us in definite ways depending on the manner in which they are combined, led up to, contrasted, and varied in speed or volume. These impressions are perfectly definite and distinct, but they have no names. They are not emotions in the ordinary sense of joy, anger, hope, grief, and the rest. What is stirred up by music lies below the emotions, or at least at the core of more than one at a time. For example, anger and hatred seem to have the same inner character; likewise grief and despair, love and joy. The American composer Roger Sessions calls these innermost stirrings "motions or gestures of the spirit." They could also be called visceral pulses. The Haydn effect is not visual, it is visceral.

In saying "visceral" I am not denying Sessions's attribution to spirit, only pointing at the natural root of the spiritual. Is it not true that groups of feeling appear to us as linked at least to tempo and dynamics? Sadness, longing, regret are not loud and should be slow; joy, eagerness, triumph are loud and fast. What threatens seems to growl low in the bass, but fear is up in the treble. Strange connections—and strange words too, for there are no high and low sounds in music. The notes of the

piccolo and of the tuba emerge and travel at the same height above the ground. Incidentally, the ancient Greeks spoke of high and low notes too, but because of the way they tuned and held their stringed instruments, they called low what is our high and vice versa.

Again, we think of tenderness, hesitancy, and sleep as soft, which is another curious metaphor since music is neither hard nor soft. But there is no avoiding such words, as musicians demonstrate with their technical terms: *allegro* means joyful; *adagio* at ease; *andante* walking; *tremolo, agitato* trembling, disturbed. These and dozens of others, some invented ad hoc for one passage, direct how it should be not only played but felt. Whatever the cause, the tie between inarticulate sounds and bodily states is a fact of experience.

That the response is visceral is vividly shown when we look at players and conductors in action. The orchestra player is cramped by his instrument, his neighbor, and his music stand, yet he sways as much as he can and thrusts his head forward at emphatic moments; but the conductor is free to let fly all the gestures that the music imparts to his viscera. How individual his antics are, and how appropriate! They help keep the listeners in their seats, for they too are moved to beat time and wave their arms. The conductor is their surrogate, popular in proportion to his elasticity. But have you noticed that singers do not gyrate? They are content with changes of facial expression. Why are they immune to the visceral impulses? They are not immune; they carry them out through their lungs, throat, and diaphragm—a workout as strenuous and as expressive of the music as the conductor's. This connection between musical impression and physico-spiritual response is the source from which the art of music draws its expressive power and its artistic importance. If music merely tickled the ear, it would still be agreeable, but it would remain a trifling pastime. We know it is much more, and it is plain that the composer can indeed use sounds to set off a particular stirring within us.

But the stirring is nameless, so that if it does not accompany the words of a text and yet we want to refer to it, we have to make up some analogy. As a result, different speakers, different reviewers invent different analogies for precisely the same musical impression. The words of Haydn's oratorio are one analogy for the burst of C major. But other events would go with the music just as well—say, the escape of a prisoner unjustly condemned; or Dante's first sight of Beatrice; or a wanderer in the desert reaching an oasis; or even Archimedes leaping out of his bath and shouting "Eureka!" because he has found the solution to his problem. Viscerally, these correspond.

The list of possible situations, of possible notions analogous to a given musical stimulus is limited only by one's imagination, which in practice is guided by one's tastes or one's knowledge: Beethoven's life and letters will suggest the interpretation I quoted of pessimism, bombast, and idealism in the Ninth Symphony. But it must not be forgotten that such connections, though valid, are never cast-iron. Aaron Copland wrote a choral piece called *In the Beginning* which also has the words "Let there be light!" What sounds did they inspire? The reviewer tells us: "Copland piles on layers of skittish counterpoint. The music is almost crazed with wonder." Here adjectives do the work of analogy: skittish, piled in layers, and so on.

Of course, it is easy to challenge the adjectives and to make fun of the analogies. Somebody in the nineteenth century said that the opening chords of Beethoven's *Fifth You-Know-What* represent Fate Knocking at the Door. All right, but the knocking repeats and repeats; if it were real life, one would call the police. And it's a feeble Fate that can't get in at the first knock. Ridicule is a useful reminder that analogies are never literal, only suggestive, and that they must not be carried beyond the spot where they serve as signposts.

If the thought occurs that turning particular musical impressions into words in this free and easy way is an offense

against the art of sound, which some people want to protect from everything "extra-musical," from all that is "literary," think again. Musicians have set words in songs, operas, cantatas, and oratorios for four hundred years and have prided themselves on making the music fit the words. What is the sense of those words but an extended analogy?

The composer's mind obviously moves from sound to sense and back again, not caring what critics afraid of words may say. On occasion this shuttling has been noted down. In Beethoven's *Egmont,* for example, the margins of the score are dotted with comments such as: "Here Liberty is vindicated." A passage in Goethe's drama had inspired those sounds.

Now, if a drama inspires a work for instruments alone, the piece will be a series of moments distinctly characterized and put together according to some plan, just as in oratorio or opera. That simple-minded observation brings us to the confused subject of Program Music.

The current dogma is that program music is a bastard storytelling genre invented early in the nineteenth century, largely by Berlioz and Liszt. But if you pick up the thick tome on the subject by the old-time German scholar Frederick Niecks, you find that he begins his survey with the Renaissance contrapuntists, including Palestrina, and that he ends with his own contemporaries, Strauss, Mahler, and Brahms.

So the attribution to Berlioz and Liszt is a myth. Program music itself is a myth. What it is accused of doing cannot be done: musical sounds cannot tell a story. At the same time, music cannot be composed without a program, or, if you prefer, a plan. The primary plan or program is what we call its form—sonata, fugue, rondo, aria da capo; or the longer ones—suite, concerto, symphony. All these are conventions—extra-musical—since there is nothing in the nature of sound that compels a suite to have three movements, fast, slow, fast, and a symphony four, the second being slow and the third a scherzo, which means a joke. Similarly, the scheme of sonata

form or aria da capo *is* a scheme, not the product of a law of nature.

Underlying these forms is a human preference, a visceral yearning, for symmetry and balance, for unity with variety. This holds for all the arts, permitting parallels. Goethe called architecture frozen music, because in a building we see at once the proportions and contrasts within the symmetry. In music—or shall we say in "melted architecture"?—we perceive these features as they unroll. In Western music, as in the other arts that "unroll," the complex forms tend to follow that of oratory: exposition, development, recapitulation, and conclusion.

So much for program no. 1. No. 2 enters in when the music accompanies words, in song, cantata, oratorio, or opera. The critical mind then notes how well the composer has fulfilled the joint demands of the two programs. But notice that the composer does not try to match every idea in his text. Much of it is unimportant, repetitious, often silly—a fact that argues strongly against the menace of supertitles at the opera.

The truth to remember here is that the overwhelming proportion of Western music has been composed to words, words that refer to actions and ideas. The reason is that music has been for use: in church and in the theater; for dancing, hunting, and marching into battle; for glamorizing civic celebrations, and for rhythmic help to workmen on land and sea; all this in addition to domestic entertainment, mostly sung poetry, with its usual themes of love, death, deceit, revenge, springtime, and drinking.

It was only in the 1890s that the notion of "pure art" was touted, music being hailed as the purest—no subject matter, no basis in material substance. It should therefore remain absolute, so as to lift the listener into the contemplation of pure form. The doctrine was snobbish—and fallacious. When one is watching Pavarotti sing, one can hardly believe that music has no substantial basis in matter. And at Philharmonic Hall, when 110 men and women are vigorously blowing and

scraping in concert, they set in motion thousands of cubic feet of air, to such effect that when they stop, the audience cannot help breaking out in a clamor of its own. This material assault of music on the sensorium is in fact the only excuse for the barbaric custom of clapping and shouting bravos.

But the spell of the words "pure" and "absolute" is strong and leads to absurd illusions. I remember a concert of chamber music, performed by a group of talented youngsters whose leader, in his prefatory comments, described one of the Bach inventions as absolute music, because (he said) the score showed only notes—no other indications. I was tempted, when mingling later with the players, to tell him that if they had played the notes as written, the piece would have been intolerable. Fortunately, they had added tempo, bowings, and dynamics, inserted a crescendo, and wound up with the usual rallentando.

Some critics want to make music pure and absolute by another route: they claim it as the twin of mathematics—"numbers in motion" (as they put it), a formal, abstract game accessible only to learned minds. This is snobbish and fallacious too. Though Western music obeys certain rules arising from its chosen system of scales, these rules are far from having the rigidity of mathematics. Every age has violated some of those that were sacrosanct earlier. As for the mathematics of vibrations—the physics of sound—our music throws it overboard in the inspired cheating called equal temperament, the pretense that C sharp is the same as D flat, which enables the composer to roam freely among the keys. If you add that concert pitch has been raised and lowered ad lib for two hundred years, you can see how little respect our music pays to numbers.

With all this in mind, we can lay to rest the superstition of purity and the crime of program music. The works so called are but one application of the linkage between sounds and visceral response already described. The only difference between opera and symphony on this point is that for the symphony

the idea, mood, or action is indicated separately beforehand. The difference is negligible, since new listeners to opera or oratorio also acquaint themselves with the action ahead of time.

How then did the bad connotation of program come about and why blame the nineteenth century? This is what happened. To the musicians and audiences of that time, Beethoven's symphonies were chaotic works, unintelligible. To make them palatable, the composer E. T. A. Hoffmann (the same as in *Tales of Hoffmann*) had the idea of making up narrative analogies. They would put the listener in a suitable frame of mind to perceive the works' deep significance. Others followed suit, or thought up titles, such as *Eroica Symphony* or *Moonlight Sonata,* and thus began the practice of giving concertgoers "program notes." Sometimes, different fictions were offered for the same work, and literal-minded people, noticing the discrepancy, decided that "programs" were a fraud.

No doubt some were foolish or far-fetched. But if a symphony can be as dramatic as a work with a text, why object when the composer says what drama he had in mind? He can, like Beethoven, tell us that his music was conceived for *Egmont,* or like Berlioz in his *Symphonie Fantastique,* he can dream up a story of his own. By now, audiences are so familiar with this device of orientation that composers rely simply on a title. Berlioz led the way after the *Fantastique* had become well known, by saying that the titles of the five movements were sufficient.

Titles suggest the play or the novel, the personage, the landscape, or occasion that inspired the artist. Thus: Strauss's *Don Quixote,* Mendelssohn's *Fingal's Cave Overture,* Liszt's *Tasso,* Ravel's *Mother Goose Suite,* Brahms's *Academic Festival Overture.* And so it goes: just recently I came across notices of *Between the Tides* and *Windswept Peaks.*

None of these indications implies that program no. 1, the musical form, has been forgotten or maltreated. Who could

listen with patience to an incoherent, lopsided piece? It follows that so-called program music is "pure music"—like every other genre: all consist solely of organized sounds. And as always, any influence from the program on the work occurs only at important moments and when it is musically manageable. Hence the point of the mockery is rather blunted in the anecdote about Debussy's *La Mer,* of which the title of one movement is *From Dawn to Noontime on the Sea.* At the first performance his ill-natured colleague Erik Satie went up to the composer and said: "I liked particularly the passage around half past eleven."

Regrettably, discussions of program music are often muddled by the intrusion of an entirely different subject. I mean musicians' attempts to imitate natural noises. The classic instance is Beethoven's Sixth Symphony, called "Pastorale" because it professes to give us the sounds of a country scene— a brook, a bird, a storm. I say attempts because such echoes are rarely exact; the brook ripples only by listener's courtesy.

If imitation seems childish, then so must we call the great composers who have gone in for it. Haydn has an array of farmyard animals in *The Creation;* Bach in the *St. Matthew Passion* imitates the earthquake and the tearing of the veil in the temple; Strauss gives us the bleating of sheep in *Don Quixote;* and opera composers from earliest days to Handel, Rossini, Wagner, and beyond have fallen into the temptation like ninepins.

One question remains: What about compositions such as Mozart's G Minor Symphony or a rousing Bach fugue, or the great piano sonatas and string quartets that also "signify" but lack title or indicated setting? Do they exist merely to show off the form? I suggest that *if worth hearing* such works have a "visceral program."

Ask yourself what makes the difference between a Bach fugue that stirs you memorably and one that is academically correct but dull. You will probably answer that on a given day Bach was inspired. What this means is that as he composed, his

inner pulses led him to do one thing rather than another in rhythm, melody, and counterpoint, thereby weaving a richly evocative pattern around the skeleton pattern known as fugue. Such gestures of the spirit inform every piece of music that moves us. They constitute what might be called program no. 3.

I come at last to the latest use of the word "program," as a verb, as in—let us say —"Program your ears." My purpose is to dispel another dogma, closely related to the others: the notion that music is a universal language. Music is not a language, for it is inarticulate and needs words even to be played right. And music is not one and universal: there are musics, in the plural.

Millions who are passionate about the popular genres will tell you that classical music "means nothing" to them. Then there are the ethnic musics of the world, with their different scales, instruments, and cultural associations. You hear, but are disconcerted: you do not understand. Indeed, East Indian musicians maintain that you don't even hear their rhythmic subtleties, let alone relish them. Worse still, because commonly overlooked, music lovers in the West divide into innumerable factions, fanatical sects that worship at different shrines. They "cannot understand" what others find in this or that composer, this or that period, this or that genre. Many despise opera; to some, piano music is the only music; to the devotee of chamber works the orchestra is bombastic. It is idle to say they understand but do not like, since what they reject as "making no sense" speaks entrancingly to others.

Composers are often the most hostile of these self-appointed dunces. Tchaikovsky thought Bach a bore; Benjamin Britten detested Beethoven; Hugo Wolf depreciated Brahms. Debussy loathed Gluck. What is eloquent to one is incoherent to another—just listen to Charles Wuorinen about the whole of French music.

Shall we explain this as "visceral incompatibility"? Yes and no. Yes, because these revulsions are as deep-rooted as music itself. No, because some may change. In my youth,

truly musical people regarded Italian opera as fit only for the hurdy-gurdy. Various masters were deemed "rhetorically competent, but empty of significance," Berlioz, Dvořák, Bruckner, and Mahler among them. One could read in a best-selling highbrow novel: "When I hear Mozart, I want to throw open the windows." The large fund of Baroque music was scarcely tapped. But a little later, when Frank Lloyd Wright had finished his Guggenheim Museum, he decreed that music should be diffused through the building, but should not include anything composed after 1800.

Clearly, fashion is a great dictator. And change of fashion says something fundamental about music: many hidden factors govern receptivity. For example, the contempt for Mozart came during the Marxist thirties, when all art had to be "a weapon in the class struggle." His works were frivolous frittering. Then came the cold war, and it curiously favored the vogue of the modern Russian masters. Again, it was the long-playing disk that established Berlioz, because it is by repeated hearing that he becomes congenial. In short, the current situation programs the ear.

Nor is this all. The experience of music is far from being one and the same for everybody. The English psychologist P. E. Vernon studied its variations and found by testing audiences that nobody—not even the most proficient—takes in music *straight*. It is filtered through all sorts of conscious and unconscious elements of personality, and these vary again with mood, health, and surrounding opinion.

All who are not deaf hear the piece, but not all follow it. To some, music is no more than what Santayana described as "a drowsy reverie interrupted by nervous thrills"—which is not to say that such people are not sincerely fond of music and respectable concertgoers.

There are also other ways of incomplete hearing. A student or professor of music may be analyzing the work instead of yielding to it; he is talking shop to himself and may miss seeing how some fault, academically regarded, is a telling

effect. In short, exactly like brains and eardrums, viscera differ. Some are sluggish, others febrile; some plod along *moderato,* and still others, unreliable, respond waywardly.

Dr. Vernon confirmed that understanding most often depends on habit. People brought up on piano music dislike choral works, and so on for all the genres and all the periods. And when he gave a concert of unidentified pieces, he found that not knowing the title and composer's name interferes with comprehension. One does not listen to everything alike; one programs oneself at the outset with different expectations for Vivaldi and for Varèse.

This explains much in the history of music. A new and original composer—say Bartók—has a hard time getting accepted, because the audience lacks any favoring preconceptions. It might be said that his music is not really heard until it is familiar. All of which is further evidence not only that music is not a universal language, but also that as it exists in this world it is always something more and something less than the sounds emitted in the concert hall. We do not absorb music like a microphone but as human beings. *1996*

Music for Europe: A Travers Chants

There comes a time in the life of every artist when the attitude of the public toward him is set. He is a hero or a wit or a saint or a devil once for all. He seems all of a piece and he must die, or at least become a senile Grand Old Man, before his reputation changes. Berlioz having become known early, his treatment by the Parisians hardly changed, though he himself was still developing in both character and technique. He was the "fiery Romantic," the man whose opera had failed, the excessively mental composer who was not tuneful. He

stayed, in short, at the stage of "notoriety" rather than fame, and this largely because he continued to be his own producer instead of winning the one sign of musical worth understood by his century, success at the Opera.

It was not for want of trying. As far as he could Berlioz campaigned on all fronts. While forwarding his festival plans, he was composing small works to balance the monumental with the *intime:* "I want you," he wrote to Legouvé, "to hear what I composed last week on your charming verses about the Death of Ophelia. . . . If you like the music, I shall instrument the piano accompaniment for a pretty little orchestra and will have it at one of my concerts." For his other good friend Théophile Gautier, and upon his verses, Berlioz likewise composed the six great songs, *Nuits d'Été,* which he published in June 1841. And within the same months he was still scheming to obtain the vaguely promised libretto from Scribe. For this purpose he even endured the agony of going fishing with him at the cost of missing an afternoon with Delacroix.

The mission Berlioz had assumed as composer was to develop dramatic music on Shakespearean lines, and as theorist to defend the German or symphonic conception of the genre against the Italian; in other words, Gluck, Mozart, Beethoven, and Weber as against Pacini, Vaccai, Donizetti, Bellini, and the lesser works of Rossini. This was no sentimental partisanship. Berlioz's conviction rested on three postulates about the nature of his art: 1. That modern music was a new and independent art. 2. That music possessed intrinsic significance, which he called "expressiveness." 3. That music could not be judged by pre-established scholastic rules, but only *a posteriori,* through experience, by ear—in a word, pragmatically.

The belief that the *genre instrumental expressif* was the youngest birth of the human spirit, just come to maturity, Berlioz derived from direct observation, for his pragmatic temper went with an ability to make exact discriminations. He was therefore a pluralist in his judgment of art forms, and

what he saw was not simply that the convention known as equal temperament dated back only a century and a half, before which harmony and tonal structure were unknown or radically different, but also that within the life span of a single man—Beethoven—music had sloughed off the bonds of its primitive attachment to dance and words: its forms and its utterances could now develop at will. Moreover, in the multiplication and perfection of instruments, music was finding new ways to be expressive *überhaupt*. The modern "revolution" could then be easily defined: any composer who followed Gluck in "dramatizing the orchestra" and who followed Beethoven in making form organic was a soldier in the war of independence. Trial and error, innovation and pragmatic testing were the signs of the disciple on mission. The guilt of the Italians, and to a large extent of the French operatic composers, lay in toying with the new gains and, by dilution with old routine, reducing them to insignificance: they were reactionaries, or to use Berlioz's words, "infidels in regard to expression."

Among the old ways were such things as the virtuoso's supremacy over the composer—the singer who changes his part, interrupts with encores, draws attention to himself as more important than his role; or again, the belief that music is for "pleasure" in the narrow sense of "pastime." At the same time, Berlioz wanted music to keep its connection with life, through its adaptation to the needs of drama, psychological delineation, mass expression, the rendering of nature, and expressiveness *tout court*. But in so doing it must be jealous of its rights and keep as free as possible from accessories and empty conventions—the accessories for the dramatic musician being words and stage effects; the conventions being the clichés, padding, repeats, or anything else done "because the public expects it." The self-sufficiency of music also excludes the fusion of the arts preached in the eighteenth century and practiced in the nineteenth by Meyerbeer and Wagner. On this cardinal point, Berlioz takes issue with Gluck, whose

famous preface to *Alceste* he otherwise approves: "When Gluck says that music in a lyric drama has no other end but to add to poetry what color adds to drawing, I think he is guilty of a fundamental error. The musician's work . . . already contains both drawing and color; and to carry on Gluck's simile, the words are the *subject* of the painting, hardly anything more."

Berlioz goes on to reassert the rights of music as sound: "Expression is by no means the sole aim of dramatic music; it would be foolish and pedantic to disdain the purely sensual pleasure of melody, harmony, rhythm, or instrumentation, independently of their power to depict the passions. . . . And even if one should want to deprive the hearer of these pleasures and not let him turn his attention away from the main object, there would still be numerous occasions when the composer must alone sustain the interest of the lyric drama. In dances, for example, in pantomimes and marches, in all the pieces where instrumental music is the only fare . . . what becomes of the poet's sway? There, surely, music must contain both drawing and color."

Berlioz then shows the consequence of these principles applied to particular works: they must possess *musical* form: "It was still true thirty years ago that most of the instrumental compilations which the Italians honored with the name of Overtures were grotesque absurdities. Gluck himself, under the influence of bad example, and being moreover . . . not so great a musician as he was a composer of scene music, allowed himself to put forth that incredible inanity, the *Orpheus* Overture. He did better for *Alceste* and still better for *Iphigeneia in Aulis.* His theory of expressive overtures gave the momentum which later produced symphonic masterpieces, . . . though here again Gluck fell into error, not this time by limiting the power of music, but by ascribing to music a power it will never possess. For he says that the overture must indicate the *subject* of the drama. Musical expressiveness cannot go that far. It may render joy, sadness, gravity,

playfulness; it will show a striking difference between the joy of a pastoral people and that of a warlike nation, between the grief of a queen and the sorrow of a village girl, between calm, serious meditation and the ardent reveries which precede the bursting forth of passions. Or again, by using the characteristic musical styles of different peoples, it will be able to distinguish the serenade of an Abruzzi brigand from that of a Tyrolese or Scottish hunter, the evening march of religious pilgrims from that of cattlemen coming home from the fair. . . . But if it wishes to go beyond this immense circle, music will have to have recourse to speech, whether sung, recited, or read. Thus the overture to *Alceste* will foretell scenes of desolation and tenderness but it will never impart either the object of this tenderness or the cause of this desolation."

The allusions in this passage to movements in his own cantatas and symphonies show the way in which Berlioz found in Gluck's work the true precepts while signalizing their distortion in Gluck's theorizing. On a last important point, Berlioz quietly condemns his revered master, who had made light of innovation: "Composers had already blackened a good deal of score paper by the time Gluck wrote, and any musical discovery whatever, though it were but indirectly connected with dramatic expression, was not to be despised."

These extracts are enough to show that Berlioz's doctrine was double-edged. Against the upholders of routine and convention he preached expressiveness and psychological or dramatic truth; and against the theorists who wanted to subordinate music to stage effects or poetry he preached the formal unity of musical structures and the sensuous pleasure they can give apart from expressiveness. This is a position which critics apparently find it hard to grasp, or rather to classify— hence easy to misrepresent. In the history of ideas, all Third Positions incur this fate, the two-party system being intellectually simpler as well as more appealing to the instincts of partisanship.

What is more, the comfort to be derived from a rigid verbalized system—it can engender rules and provide the means of sectarian inquisition—makes the flexible pragmatist suspect to all. Berlioz knew this but did not yield to the temptation of cobbling up some absolute theory to furnish his followers with a creed. Gluck was an intelligent man and yet had misconceived the character of his own work; this suggested that perhaps artistic theory is a task apart, which most creators may be ill-fitted to take on. The principles that count must be looked for in a man's works rather than in his pronouncements; so when Berlioz's great admirer, Johann Christian Lobe, asked him for an aesthetic creed, he replied, "My aesthetic is in my works, in what I have done and what I have not done."

Berlioz did not of course undervalue the critical warfare he was even then waging in new territory, but he recognized the danger of taking a description for a rule. Unlike Wagner, he did not utter manifestos and then compose. His significant choices came out of experience, in both senses of that word—the things he felt within and the works he heard and studied. And his studies took place equally in the library, the opera house, and the concert hall. The current repertory was a hodgepodge of styles and genres, and if we except the works of Beethoven and a few others we have only a very imperfect notion of what Berlioz's musical experiences were. We know little at first hand of the Italian and French operas that he reviewed, and we know only a fraction of the works of Weber, Gluck, and Spontini—the tradition of which is virtually lost—to say nothing of the eclipsed Meyerbeer, then a dazzling sun. As for the symphonies, concertos, airs, and fantasias that kept virtuosos alive in that half century, most of their names have died with those who heard them. It thus takes an effort of the imagination to recapture the state of mind which it was Berlioz's mission to work upon and reform. He addressed, on the one hand, a public of exclusive opera-goers who became deaf the moment they could not also see; on the

other, a fashionable and academic circle of amateurs, reared on the eighteenth-century classics and contemporary "little pieces," to whom Bach meant C.P.E. or J.C. but never J.S. All but a few felt that the uncouth Beethoven went too far. On this basis, if we eliminate what Berlioz preached and played, go on to reconstruct the features of what was then "music," and then jump ahead to the conceptions and the substance of modern works such as those of Debussy, Mahler, Strauss, Moussorgsky, or Schoenberg, we can gauge the impact of Berlioz's mission and judge the merit of his Third Position, which repudiated alike the purveyors of airs and operas and the feeble imitators of classical masterpieces.

In setting out for his German tour, Berlioz was under no illusion about its inherent difficulties. Although a few years earlier Liszt had written him an open letter, saying, "Germany is the country of Symphonies; it is therefore yours," Berlioz knew better than to take music for a universal language. His very devotion to certain masters implied that there was not one Music but many musics. And he knew from Liszt and others that in Germany almost as much as in France, the taste for the Italian kind prevailed. Its inroads had helped darken Beethoven's latter days, and the resistance to it had only stiffened the upholders of the native tradition into academicism. At Leipzig, for instance, even Mendelssohn seemed musically modern and venturesome. Hence Berlioz would have to overcome the host of dilettanti, virtuosi, soprani, true or false *castrati,* and eternal *scholastici.*

Like most creators he would also have to fight the stiffer battle arising out of the originality of his own idiom. For music is not only *not* an international language cutting across political and cultural boundaries, it is also a form of individual utterance of which every hearer has to learn the vocabulary and syntax. At the very least, each composer's work is a dialect of the main speech current at the time and place, but more often—and this was and remains true of Berlioz—the "new

music" communicates new modes of musical thought that only deceptively employ the same technical means as previous music: they are of course "the same" in the abstract and in retrospect, but their first concrete presentation immediately puts the hearer on the defensive; he invokes earlier standards of beauty or meaning and the ancient debate begins afresh.

Berlioz was very much alive to this permanent state of artistic affairs, which he often analyzed in print, but which to this day is imperfectly recognized. Ernest Newman suggests that on this account a history of music is perhaps impossible to write—no one masters sympathetically all the musics, and in practice "love of music" reduces itself to the worship of one composer. M. D. Calvocoressi was similarly dismayed to find that the critical Babel could not be explained away by greater or lesser degrees of competence in the critics. The *dis*sensus is irreducible. But to Berlioz, who was among the first to explore it, this realm of cultural truth had far-reaching implications, affecting his critical and compositional techniques, his social conception of art, and his ultimate philosophy of life.

Not once but again and again throughout his writings he discusses this primary dilemma, the cause of immeasurable anguish: How is it possible to reconcile artistic convictions with the plain fact of the dissensus? Berlioz is at a concert with a friend whose judgment he respects; a Beethoven adagio is being played. Berlioz is transported while his companion remains cold, and is even angered by the music. This paradox is not simply an external phenomenon, to be recorded with amused interest by a third party: it involves the whole reality of art, especially for the creator. The critic cannot believe in Absolute Beauty; the artist must believe in it. Unless he is a mere contriver, an artificer, a charlatan, he must work in the conviction that there is such a goal for him to reach.

Nor is this the end of uncertainty, for experience confuses us still further by seeming to offer a partial verification of the creator's pragmatic hope: "At the first hearing [of Beethoven's Second Symphony] Kreutzer fled the hall with his hands on

his ears. . . . Let us not forget that Mr. Kreutzer's opinion of Beethoven was that of 99 musicians out of 100 . . . , nor that without the repeated efforts of an imperceptible contrary-minded fraction of the public, the greatest composer of modern times might still be scarcely known to us." History, in short, gives evidence of the possibility of change. What at any time was modern and ugly *becomes* beautiful.

There is, too, a mysterious affinity between new art and the younger generation, so that it seems as if recognition of the absolutely beautiful was constantly being reached. But this recognition is neither steady nor complete. "Understanding" follows fashion, comes in waves, depends on the persistency of a conductor or a group. At any one time, the repertory of music resembles, not a body of literature, nor even a well-stocked library, but a one-volume anthology, a capricious *Oxford Book of English Verse.* We see this in the relentless repetition of the piece that "represents" a given composer to the exclusion of his other work. At any one time also, it requires a kind of fanaticism—like Berlioz's and Liszt's for Beethoven—to maintain public faith in an artist or a school, and this faith, no more than any other kind, never achieves universality. There are still anti-Beethovenians and anti-Mozartians. At best what we see is a number of overlapping sects that ignore or condone one another's existence (or else join forces against a common infidel) in the smug belief that each worships the true god.

Less apparent but no less real is the subdivision of musical faith by *genres.* It is rare to find any devotee for whom music means all or even several of the forms which it has historically assumed. Many concertgoers scorn opera; the zealots of chamber music will not enter a symphony hall; the piano brigade detest choral music; the passionate followers of song recitals are unmoved by violin soloists; the "classicals" in a body loathe jazz; the jazz fans look upon traditional pieces as a junk heap from which to pick up tunes. Among performers and pundits the provincialism is even worse. The violinist who for

twelve years has trained his fingers to play the Wieniawski concerto faster than any man alive is absolutely deaf to a slow "easy" tune in a Bach cantata; while the scholar or teacher who knows all that the Vatican manuscripts tell us about counterpoint is convinced that no real music has been composed since 1700. As for educated instrument makers, don't talk to them about anything but the harpsichord or the old organ. Historical knowledge misapplied has completed the atomizing of art, so that nearly every time the word "music" is used it really stands for an accidental fraction of its total meaning.

Berlioz's own historical sense brought him a different message. Although he made no pretense at being a scholar or musicologist, he grasped the essential point that among the Western arts music had developed late, often in isolation from intellectual enlightenment, and that consequently it had almost always been shackled by prejudice. In the Foreword to his *Treatise on Orchestration,* he reminds his readers that: "When Monteverdi tried to add the chord of the unprepared dominant seventh, criticism and denunciation of every kind were heaped upon him. . . . When melody came to prevail, the cry was that art was degraded and ruined, and the sanctity of rules abolished—it was clear that all was lost. Next in turn came modulation. . . . The first who tried to modulate into an unrelated key was inveighed against. He should have foreseen it. . . . The innovator could keep saying 'Do but listen; see how gently the modulation is brought about, how well motivated and ingeniously linked to what precedes and what follows, how delightful it sounds.' 'That is not the point,' he was told. 'This modulation is prohibited; it must not be done.' But since on the contrary it *is* the point, *the only point,* here and everywhere else, non-relative modulations were finally accepted."

Berlioz's training at the Conservatoire had largely consisted in observing prohibitions and he knew how these avoidances form our taste: the boy drilled against the split infinitive grows into a man who sincerely shudders at its presence. It

takes a Schumann or a Scarlatti to calmly say "Count the fifths and leave us in peace." Expounding Beethoven to his readers, Berlioz accordingly defended those violations of academic rules that seemed to him self-justifying. For instance in discussing the Sixth Symphony, he takes up the forbidden resolution of the 6–5 chord on the subdominant: "This harmonic effect is most severely reproved by scholastic doctrine . . . [though] it is most felicitous . . . and the sudden passing from *piano* to *forte* on this singular change of harmony . . . doubles its charm." He points out likewise that if Beethoven defied the "principle of unity" by bringing together the two unlike themes in the instrumental part of the last movement of the Ninth Symphony, it is too bad for the principle.

More than that, Berlioz discovered that change and improvement themselves create prejudices in reverse. Living in an age of rapid orchestral innovation, he had to remind the public that chamber music was a high form of art and to show how senseless and inartistic it was to demand at all times a large ensemble displaying the latest brass. "It is even possible," he adds ironically, "to compose exceedingly beautiful music for the keyboard, since Beethoven has written for the piano some sonatas that are perhaps superior to his admirable symphonies."

The task of the artist who is at once original and comprehensive is therefore double. First, in composing he must remain entirely pragmatic, that is, follow his musical instinct and test the results in context and by ear, regardless of the rule and also regardless of any systematic wish to break the rule. He must dare and see what happens, not in order to shock the bourgeois (that is only an incidental reward) but in order to find out how his mature judgment and that of others respond after the passage of time. This is why Berlioz kept all but one of his scores for years before publishing, why he destroyed several early ones, and why he heeded the remarks of d'Ortigue, Liszt, Heller, and other critics, as well as the advice of humble performers in the many orchestras which he led. There was

thus a thoroughly empirical control through fresh experience, through pre-existing knowledge, and through divers sensibilities, which gave innovation its sole warrant of worth. No one knew better than Berlioz how much the art of music depends on the inspiration and powers of others and no one acknowledged his debts more fully and frequently.

Still, it was not enough to ensure the integrity of the product, letting it take its chance in a culture ruled by competitive passions and incomplete dogmas. The art of music is especially vulnerable to both, because its existence is by nature transitory. Accordingly, the creator with a mission and without protectors must—and this is his second task—serve as midwife to the work of art by teaching the public what to hear and how to think. For his part, Berlioz felt that he should not do so upon the body of his own work. He chose Gluck, Weber, and Beethoven as the masters whose interpretation would best acclimate his contemporaries to modern dramatic music, including his own. We have already seen how, in discussing Gluck's theories, Berlioz alluded to elements discoverable in his own symphonies. His discussion of the last movement of Beethoven's Ninth says not a word of the *Romeo and Juliet* symphony, but none the less throws a great light upon its conception. He seized topical occasions to make clear what he considered important as well as strictly speaking undefinable. For instance, when polytonal effects became a fad in the sixties, he who had ventured upon their use in 1830 wrote (apropos of Offenbach): "All this may be done, no doubt, but only with art, and here the effect is put forth with a carelessness and an ignoring of danger that are unprecedented." It was a question, he felt, of preserving the "very substance of music," which could indeed be molded to the creator's will, but "the way must first be found" (*il faut la manière*).

Again, whenever performances of his chosen masters afforded the chance, he drew attention to facets of music that are usually overlooked. He had observed that "an audience which would be instantly critical of poor intonation can listen

without displeasure to a piece whose expression is entirely false"; and he knew that to increase the general awareness of "expression" was not gratuitous: it protects the masterpiece from absurd objections: "I have often heard people make fun of this first theme [in Beethoven's Seventh Symphony]. Perhaps the charge that it lacks nobility would not have been made had the composer written in large letters at the top of his allegro, 'Peasant Dance.' For although some listeners do not want to be told that any subject has presumably been treated by the musician, there are others ready to condemn an idea which appears strange unless they are given some reason for this strangeness beforehand."

Berlioz had good reason to know that dramatic music without commentary stood at the mercy of the uncultivated imagination. To the audiences of the 1840s—and possibly of the 1940s—the *inherent* expressiveness of music was a closed book. If a given theme or movement was vaguely titillating and allowed their individual daydreams to go on undisturbed, they found the music "beautiful." If not, the tune or piece was held to be ugly, affected, "unmusical." Like children, who often mistake sweetness for flavor, they wanted candy all the time, and composers stood ready to furnish such music, however dangerous to diabetics.

Even for connoisseurs of stronger stomach, Berlioz's dramatic range seemed excessive. What a modern writer said about the emotional accuracy of Berlioz's melodies must be said about his contrasts and conjunctions: they proceed from a moral realism that alienates many sincere listeners. The majority of those who are said to enjoy any art demand quite literally a diversion; they want not so much an ordering of life-stuff as a softening of the contours of experience; and it is no exaggeration to say that it takes them from six hundred to two thousand years to grow accustomed to the sterner methods of a Homer or a Dante. Even had he wished to, Berlioz could not have complied with the Tired Business Man's requirement. Beethoven's "Peasant Dance" in the first move-

ment of the Seventh struck him as of equal beauty with the Allegretto which follows it, "that high sublime in symphonic music." It was not the contrast as such, not the shock of surprise that moved him; it was the ideal correspondence with a full and varied reality. When he was reading Lamartine in Rome, he found him "delicate, celestial" but regretted that the poet was "so incomplete: he never leaves the skies." When Berlioz was discussing librettos with Scribe, he urged the dramatist to provide scenes which would not "keep steadily to a heroic or dithyrambic style; on the contrary."

For the artist as evangelist, music presents yet another difficulty: it is such a powerful tonic that most people's nerves do not easily recover their poise under its impact, and so cannot report truthfully what displeases them. Thus one man will object to the harsh modulations in a piece that does not modulate; another hates the accompaniment of a theme which is in fact unaccompanied. Sound, in short, acts like a drug that causes hallucinations; its devotees respond allergically, fantastically, to the slightest deviation from blandness. If one adds to these impediments the lack of stylistic sense in composers, performers, and concertgoers alike, one can measure the strength of the resistance which a Berlioz encounters in his path. His mission seems self-centered until one perceives how few elements of understanding he can count on; the broader his scope the more he must teach, explain, and rationalize by means of analogies.

Because of this, perhaps, Berlioz has been called a "greater artist than musician" by some who did not quite see the trap their distinction led to. For the either/or would imply that musical sound is not so much material for an art as substance for a trade ruled by routine. If one translates the comment as "more artist than practiced hack" or "more artist than confectioner" the fallacy gives itself away. Nine times out of ten, what is meant by "truly musical" is the cliché, the *inevitable* association of ideas, the tastefully bromidic. It is consequently no paradox to say that when Berlioz seems "unmusical," he is

likely to be not remote from, but close to, the original sources of all music. He is recapturing and using the inherent plasticity of his material and disregarding only the turn or shape which the hearer of settled musical habits expects. This is not to say that whatever Berlioz does in the way of free handling must be accepted without question; it is to say rather that any criticism of his work must make sure that disapproval or displeasure does not spring merely from expectation denied—something like the feeling one has when a traditional misquotation is replaced by the poet's original words.

An additional sign of Berlioz's direct contact with the intrinsic and historic sources of his art is the number of elements which he feels impelled to treat simultaneously or in quick succession. In his encyclopedia article he had enumerated and defined them: Melody, Harmony, Rhythm, Expression, Modulation, Instrumentation, the Point of Origin of Sound, Dynamics, and the Multiplicity of Sounds. A tenth element which needed no definition but to which he attached importance was the negative one of silence. If one compares a Berlioz score with that of any contemporary down to Moussorgsky and the Impressionists, one is struck by the integral role Berlioz assigns to silence. Not only does he frequently give the first sketch of a melody the barest accompaniment or none at all, but his harmony is never thick, any more than his orchestration or polyphony. There is air, as it were, around the structural members (as in medieval or modern architecture) and the prevailing transparency in every section is designed to heighten the moments of pressure, complexity, or artful disorder.

The net effect is a unique sort of aliveness, a breathing quality. Berlioz may have learned this lesson from Gluck—who condemned opera scores that "stank of music"—or from Nature, whose steadiness hides behind intermittence. In either case, the result is capable of disconcerting tastes formed on other models. The sense of forward motion is more easily conveyed by steady singleness of thought and continuity of sound as, say, in a Bach chorale or a Brahms symphony. But

the lighter texture can be no less solid at the same time as it affords a special pleasure of its own—what Emmanuel in speaking of the *Harold* symphony called "particles of pure sound . . . music weighed and doled out as a precious substance."

This precious substance Berlioz worked at with an untiring hand until it was so molded in all its aspects as to afford sensuous, structural, and expressive interest simultaneously. No detail was too minute to consider in the total effect *as heard*—hence difficult choices had to be made between rival virtues. This is what leads to the two divergent interpretations of his technique which Berlioz was to encounter in Germany as elsewhere. On the one hand he can seem heedless or crude because he goes against the refinements of common practice: squareness, the pairing in cut or shape of elements that are usually made to match, well-filled harmony or smooth modulation. On the other hand sensitive musicians can come to see with Schumann what a "fine engraver's hand," what "stylistic elegance," what concision, economy, and care to make everything "tell," Berlioz exhibits in his work.

To become aware of this, however, takes time and thought. The usual analysis only ascertains the harmonic and formal structure of a movement and takes the other elements as bonuses which it is pleasant to have. In Berlioz we cannot make this distinction between superstructure and base. To him neither orchestration nor dynamics nor any other detail was *a priori* of secondary importance, for nothing was absolute. All elements were constitutive and modified each other. Thus the quality of a melody could determine an alteration in the form (say a shortening of one of its parts) if the theme, otherwise appropriate, did not deserve extensive development. This curtailing might in turn call for a heightening of rhythmical force and a richer orchestration to restore equilibrium by equivalence instead of symmetry.

Berlioz's pragmatism goes deeper, therefore, than a desire to achieve the right auditory effect at the moment of perform-

ance. It poses the problem of relative values and so impels him to search for the highest harmony possible among the greatest number of elements. This is par excellence the technique of the dramatist, to whom rendering the object in the round matters more than any other quality. Yet it does not prevent temporary concentration on one purpose: the dominant feature of a movement may, for dramatic or other reasons, be rhythm rather than melody (e.g., Introduction to *Romeo and Juliet*), counterpoint rather than orchestration (third movement of Symphony No. 1), harmony rather than thematic development ("Herod's Dream"). Moreover, musicians are attracted like other men by "problems" that stimulate their technical imagination. Berlioz was constantly incited in this way, though he never felt that triumphs of technique were the goal of art, or exempted one from supplying other sources of interest. He would have strongly discountenanced Wagner's rationalization in answer to an inquiry about his lack of rhythm that, after all, one cannot have everything.

Berlioz's aesthetic principles are easy to sum up: music was an art related to life through the recently magnified expressiveness of sounds; all the elements of music were capable of receiving or contributing to Form; the highest music must be as complete and independent an art as possible, even though there are many mansions on Parnassus—many genres and musical idioms. Absolute beauty was therefore a chimera, however much one's "fanaticism" desired it—especially as creator. As critic, one must be a pluralist. For the dramatic composer, the primacy of music meant the shaping of forms suited to words or action but never subordinated to them, and more often wholly autonomous. The occasion of a drama might be civic, social, or simply imagined; it should in any event need but a few signs to recall the mood or the myth to the hearer's latent responsiveness. Where this was lacking, the public must be taught by word and performance.

Such was the art which Berlioz in 1843 had been cultivating for two decades. *1950*

To Praise Varèse

It is a reproach to our civilization that in commemorating a great artist we must rely on the feelings and thoughts of the moment and the halting words that they provoke. Why are there not some ritual words to mark the passing of the artist as there are in the various churches to mourn the man? For the intention of ritual in rededicating the listeners through the Word is to remind them of certain permanent truths, and surely the conditions of art and more especially the tribulations of the greatest, most innovative, artists have not changed in five hundred years.

This generality is proved again in the figure of Varèse. Everybody now celebrates him. The newspapers run editorials, the auditoriums resound with his music. Where was this collective interest and effusive goodwill when he was alive and still able to produce? His was the standard case and it must not be misunderstood. He was never unrecognized. He had warm friends and admirers and helpers from the start and all along the road. His genius was manifest and his efforts enlisted their due following. But what a creator needs is public facilitation—and for his particular work, not for something else: facilitation to perform, to exhibit, and as we say, to establish his idea; not medals or prizes or fame in themselves, but the kind of acceptance that enables the man's energies to concentrate on creation, instead of the necessity to waste these energies on mere contrivance and management.

And that facilitation he was denied. It is the old story and nothing will change it. It is so familiar that one is even led to suppose that an artist who does not undergo this odyssey cannot be great. That is not true. One of the deplorable aspects of

our blindness is that it confuses judgment in this way, making us value real things irrationally, by the volume of public talk or by the absence of talk outside the small group of the faithful. Now that these two groups converge at last in support of Varèse, what we must be on the watch for is the next man who is ignored and who should be recognized, not for his own sake but for that of his work.

Meanwhile, it is evident that Varèse is the man who solved in music the generic problem of the twentieth-century arts, the problem of creating a new idiom by creating new materials. The half millennium of high art since the Renaissance has exploited its characteristic means to the utmost, and there is nothing more to do along those lines in any art. What we need now is not new technical tricks or new variations on old themes and feelings, but a new substance and its appropriate new feelings. In contemporary music, Varèse provided the first viable answer to this historic demand.

Let me now present testimony in support of what I said at the outset, that it is possible for a great man to be recognized by the best judges and to be a great unknown until his death. By chance, a few days before Varèse died on November 6, I was reading here and there in the correspondence between Richard Strauss and Romain Rolland, and my eye fell on the following: Rolland in Paris writes to Strauss on February 21, 1909: "I talked a great deal this morning with one of the heads of the Orfeo of Barcelona and with a young French composer who has been living in Berlin for a couple of years and who admires you so much that he is afraid to call on you. His name is Edgard Varèse. He has great talent and seems to me particularly gifted as an orchestrator. I think you will find him interesting. He possesses what I believe you love as much as I do and what is so rare today—I mean *life.*"

Varèse, it is clear, belongs to that extraordinary generation that came to maturity between 1905 and 1910, that so-called Cubist generation which is only now coming to be viewed as the fathers of modern art. Curiously, an important

group of these men came together again in this country during the First World War. I was reminded of this in a note I received from Marcel Duchamp. "With a deep feeling of nostalgia," writes Duchamp, "I remember when Varèse and I arrived in New York and the groups of friends we made or met there again at the time: Walter and Louise Arensberg; Picabia; Albert Gleizes, the Cubist painter just recently exhibited at the Guggenheim Museum; Ozenfant; Henri Barzun; and Louise Varèse who has been our friend's devoted companion ever since." And he concludes, "A bientôt, cher Varèse."

My father, whom Duchamp put in his list, not long ago published these words about Varèse: "He is the architect of the new simultaneity in pure sound, the master of our only living music, of which we who are leaving the scene will not hear nearly enough before we go. Hail and farewell."

Igor Stravinsky wanted to write a special note, but illness prevented him. I therefore quote from his tribute of a while ago in the *New York Times*. "I became acquainted with Varèse myself," he said, "only at the end of his life, and then only slightly. But that was enough to know his genuineness and his unauctionable integrity. I am deeply saddened by his death."

Others, too, who could not attend this commemoration wrote letters in his honor. William Schuman, who took part in the first performance of *Ionisation*, writes: "Edgard Varèse is surely among the giant creative artists of our time. It seems at least a hundred years ago that I was snared by Nicolas Slonimsky into taking part in a performance of *Ionisation*. It was not merely that I had never played the instrument that was assigned to me—I had never even heard of 'the lion's roar.' As in everything else, Varèse was ahead of his time. Buckets as musical instruments are no longer a rarity. But Varèse was no trickster. His scoring called for the same nuance and delicacy afforded any conventional instrument. How astonishing, little by little, to glean the remarkable combinations, gradually to understand the relationships, and finally to know that the ban-

quet set before us was indeed grand, the appointments of the table properly germane to the exquisite cuisine and that even my humble role as tamer of the 'lion's roar' had its place."

Norman Lloyd also writes: "Varèse was an elemental force. He brought new concepts of sound to a world which, whether it knows it or not, needs to understand itself in tone. As original as he was courageous, Varèse was a pioneer of the space age in the arts. If there were a true sense of values in the world, Varèse would have been honored as one of our few originals in a time of conformity."

Elliott Carter, a lifelong friend, tells us the following: "Having been an enthusiastic admirer of Edgard Varèse for forty years and a friend for thirty, I am still impressed by the fascination which his music never ceases to awaken by its originality of conception and execution. It was a special concern with sound, with music as a thing in itself, and its compelling assertion which gives his work so much meaning to these confused and distressed contemporaries under the conflicting, unfocused pressures of American musical life. The commanding imagination that demanded these musical formations challenges by its provocative, revolutionary position so characteristic of the man himself, no doubt the only position possible for a composer today confronted by a musical life of complacently accepted routines, administered by the docile to the somnolent."

And to conclude, Leonard Bernstein, whose interest in Varèse's *Amériques* will, I hope, lead to a new performance, adds these remarks: "It grieves me to be unable to attend this memorial concert. Varèse meant much to me both as musician and as music lover. Many words have gone forth in praise of Varèse as a composer and innovator, but it is as a music lover that I must spontaneously think of him. Involved as he was in electronic devices and sounds of the future, he never for a moment lost his love for the great sounds of the past. I recall him in my dressing room after a concert of Beethoven as enthusiastic and filled with joy as a student just discovering

the magic of this music. And it was certainly this intense love for music, which he never used for his own ends but in whose service he used his own person, that enabled him to make all his experiments into deeply musical and human experiences. His influence and vitality and contribution to music are forever immeasurable."

From boyhood I have also been a student and enthusiast of Varèse's music. *Amériques* transported me in the mid-twenties. *Ionisation* convinced me that here was the music of today. I believed this so strongly in my own twenties that thirty-two years ago when I was asked to contribute a chapter to the required readings for Columbia freshmen taking Contemporary Civilization I devoted a page to Varèse and concluded it with the superb encomium which the late Paul Rosenfeld devoted to *Ionisation*. Those freshmen of long ago didn't know what they were getting in for, but I still believe they were getting the right thing.

These witnesses-in-chief have been heard, and what they prove is that the genius does not simply need or want recognition and praise; or rather, he has no need or want of them unless their absence causes the big world to roll on heedless until the task is done and the man is gone. *1965*

Delacroix

Whether or not he was the son of his ostensible father or of Talleyrand is one of those questions that must be left to those who nibble at the arts for gossip's sake. The interesting fact is that like Berlioz and Balzac and Hugo, Delacroix is a cultural product of Revolutionary and Napoleonic France. His father was at his death, in 1805, an Imperial official in southern France, and the remembered tumult and glory of the years

of Delacroix's childhood and youth inform the artist's work to the very end.

An orphan at sixteen, Delacroix left the lycée a year later, to enter the studio of Guérin. His first published drawings also date from that same year of Waterloo, 1815. Precocious, taciturn, and shy, Delacroix worked with concentration, though not without the solace of friendship: he lived with his sister, and found among his fellow students three friends who remained his intimates for life. Overwork brought on a serious illness in 1820. Then comes another friendship, with Géricault, soon cut short by the latter's death. In 1822 Delacroix prepares his first salon exhibition: *Dante and Virgil*. This work may seem equally remote from the French Revolution and from Delacroix's later dramatic distortions of form, but his temperament is already in evidence. Indeed, it might be said that all his life Delacroix depicted only one subject in many forms—the menace and mystery of the universe. In the *Dante and Virgil*, the glowing walls of the fortress of Dis in the background and the limbs of the damned clutching at the boat in which the poets cross the infernal waters render the characteristic Delacrucian mood.

Soon the expression of that mood was to undergo technical development, thanks to a new artistic contact, with the young English painter Bonington. Delacroix was preparing his second salon, due in 1824, with a subject taken from current events in the manner of Géricault, the Turkish massacre of Greeks at Chios. A sight of Bonington's work led Delacroix to remake his own scheme. There follow portraits of friends and historical, literary, and religious scenes, culminating in the *Marino Faliero*, exhibited with nine others at the Salon of 1827.

By then Delacroix had begun to keep his famous Journal, in which he records his technical observations, his friendships, his relations with women, and his dissertations on style and on the great masters. Delacroix firmly believed that his taste and his art were alike austere, classical, anti-Romantic. He dis-

liked the new literature of Hugo and Balzac and preferred Racine to Corneille. True, he let himself become friends with George Sand, but it was probably because of Chopin, whose music he relished, while abominating that of Berlioz.

The paradox here is visible, but not inexplicable. To those who did not analyze but only tasted, it might seem as if the new literature and new music of the 1830s made a point of looseness and extravagance. The truth is that the geniuses among the crowd—Hugo, Berlioz, and Balzac—were deliberate craftsmen, whose main principle was exactly Delacroix's: the expression of the highest passion in the most controlled form. Only, the form need not be set form: it was to be original form, and used only for the one unique purpose; whereat the critics complained that all was lost. Delacroix, whether he liked it or not, was (correctly) lumped in with his great contemporaries as a Romanticist. Did he not paint *Liberty on the Barricades* after 1830? The artist nevertheless suffered from what he considered a deep misunderstanding, though he vented his spleen only occasionally in the Journal. Publicly, he was stoical, enduring until nearly his sixtieth year the contumely of the newspapers and the "right-thinking" bourgeois. Indeed, it took the World's Fair of 1855 in Paris before that all-knowing city was really aware of the great creator it had harbored for a third of a century.

At the beginning of that span, in 1832, Delacroix, aged thirty-four, underwent the last of his formative experiences: invited by a cousin in the government he went to Morocco, then a new and "exotic" land. Those seven months under a burning sky were the revelation of a new world of color. Delacroix discovered that shadows are not necessarily black but can be purple—or reflect other deep colors. His mind (and some wonderful notebooks) were filled with new shapes, costumes, animals, and architecture. He returned, dazzled, to begin the works of his maturity, starting with the great decorative compositions of the Chamber of Deputies and City

Hall—commissions obtained, once again, through official connections.

About this time also began his first serious liaison, with Mme. de Forget. All his ladies, until the end, when he came under the ascendancy of his housekeeper, were women of taste, position, and discernment. This last they must have had, to appreciate the haughty and penetrating intellect that one finds in the letters and the Journal and again in the hypnotizing *Self-Portrait*. It is a remarkable coincidence that Delacroix and Berlioz should have been, contrary to the norm, masters of the word as well as of their respective arts, and that Victor Hugo the poet should have been an extraordinary draftsman. The synesthesia of the arts, which we hear so much of nowadays, begins earlier than we think.

Out of the Moroccan trip came, in 1834, that seminal work *Algerian Women at Home,* which pulled like a magnet at nearly every great nineteenth-century painter. Then in 1838 comes the first of the two *Medeas,* each a diagnostic work in its period. By 1839, Delacroix had three times offered himself for membership in the Institute and been rejected. Illness, casual love affairs, heavy work on the ceilings and walls of public buildings fill out the years until the consecration of 1855. Only at the ninth trial, in 1857, did the Institute catch up with public opinion and elect him a member.

In the wonderful variety of Delacroix's works, some stand out as not merely characteristic but unique in the history of art for the expression of ideas and feelings in a form no other artist could have conceived. Such are those already mentioned—the *Dante,* the two *Medeas,* the self-portrait, and the *Algerian Women.* To these must be added as summits of his art: *The Crusaders Entering Constantinople,* the *Execution of Marino Faliero,* the *Death of Sardanapalus,* the *Battle of Poitiers,* and—to name only one of the stupendous murals, the Apollo ceiling in the Louvre. By their titles all these suggest the historical and mythological subjects typical of the time; but

Delacroix does not illustrate incidents any more than Berlioz fits sounds to programs. Each renders in his medium his vision of existence and communicates the thrill of recognition to thousands who know neither history nor literature but have some awareness of the multiform enigma of life.

By the time of his election to the Institute, Delacroix was chronically ill, worn out by a kind of warfare that the twentieth century scarcely understands: he had won innumerable battles; painted, drawn, or engraved nearly a thousand important works; lived in physical comfort and close friendships worthy of his genius—and yet the crown of recognition as it was then understood was wanting: to be an academician, even if nonacademic. By 1858, he had just enough strength and willpower left to undertake the chapels of St. Sulpice, with which he closed his career as painter in 1861. Between that year and his death two years later, we have—a symbolic touch—a fine essay on the work of a neglected contemporary and a painting on an Arab subject. *1971*

Visual Evidence of a New Age

A new art means only new forms, and new forms arise from one or both of two causes: new needs and new possibilities. The two often overlap, and they are brought to the conscious mind by the sudden discovery of new attractive sensations, of unfamiliar realities, of striking paradoxical connections in daily experience.

If all this is true, then the aspirations of the twentieth century that led to modern architecture grew out of the needs and possibilities, the perceptions and sudden visions, which distinguish the century from its predecessor. What is new about our age? First, perhaps, the New Look of industry: in the nine-

teenth century the advent of the railroad and the factory meant the uglification of life. The factory was the enemy of art, and as such was fought by the best minds for eighty years. But by the turn of the century a glimmer of light shone through the smoke and filth. It was seen that electricity and the new materials—steel and concrete—would permit industry to symbolize just the opposite of darkness. The modern factory or power plant would be shining white, clean, orderly, and even quiet.

At the same time, the gas engine (prerequisite to aviation), the motion picture, and wireless telegraphy were changing men's age-old perceptions of space and time. Looking at the earth from above while traveling at one hundred miles an hour, and hearing disembodied words from a loudspeaker also in motion, liberated man from his condition as an earthbound being, unable to move faster than a few miles an hour unless he doubled his legs by climbing a horse.

The new mobility had of course begun earlier, with the railroad, but it was only in the early 1900s that artists and thinkers became fully aware, first, of the psychological result and then of the social. The ever-increasing ease and frequency of motion made out of single, knowable individuals a generalized anonymous mass. For a century, population had been multiplying, but it was not numbers alone that turned men into the abstraction we call the mass society: it was the stripping away of differences through the practical need to treat everyone alike—and *en masse*—for the purpose of transportation. The large railway terminals of the nineteenth century must be thought of as the harbingers of the modern in architecture, if only because of their size and function. But the twentieth century, seeing their reason for existence, conceived a new desire, which was to express the function in new and unique forms. And soon this function of handling large crowds of anonymous beings was no longer limited to the occasions of travel by rail. It extended to all the necessities of the city—office buildings, stores, apartment houses—the block and the superblock.

These are the characteristics of daily urban activity which the twentieth-century architect could not help pondering when he framed his new ideals of design. Thus wide-open space, long vistas, unbroken and reflecting surfaces became aesthetic elements—that is, sights pleasing in themselves as well as adapted to mass use and mass production.

His choices were reinforced by the other new fact: the presence of new materials. In 1900 steel was the great new acquisition, and the love of it first inflamed the engineers. It was a bridge-builder, Gustave Eiffel, who first imagined the delight of building a great open-work tower of steel, for the Paris World's Fair of 1889. It was left to an American, Louis Sullivan, to produce the first buildings hung upon such a steel frame. It was the Transportation Building at the Chicago World's Fair of 1893 that signalized the innovation. Sullivan's steel-frame skeleton supplied the modern parallel of a new Gothic architecture for a new medieval mass society. Modern and Gothic agree that walls do not support or constitute the edifice; they merely fill in the blanks between pillars whose interlocking *is* the new form.

Since buildings are for shelter, however, walls are usual, and the new art found a new material with which to make them aesthetically new and endlessly adaptable. That material was reinforced concrete, and its use by Auguste Perret early in the century is the second great innovation of the new age, affecting form and texture as well as answering aspiration. For in the twentieth-century Gothic, other needs than religious instruction, entertainment, and worship determined architectural design. The violent changes I mentioned in the perception of time and space, coupled with the spiritual effect of anonymity, induced in the sensitive artist a relentless tendency toward abstraction. I mean by this the urge to bring out the geometry of things, the love of fleshlessness, characteristic of all the twentieth-century arts. You may wonder how airplane speed or motion pictures or anonymous crowds lead the sensuous artist to such an abstract ideal as abstraction. The

connection is simple. Abstraction is the natural result when the observer moves: detail is lost, contours flatten out; softness turns rigid; what is left is the framework.

How does the modern architect abstract? For the most part quite naturally. He does not have to dig out his framework; he starts with it, and it is of course fleshless. Since he believes in showing underlying forms without disguise, his outer covering will be flat, with strong edges reproducing the original simplicity of his skeleton.

Nor is it only for convenience that the modern architect chooses to leave surfaces bare, or at most tolerates a semi-traditional low-relief sculpture over his doorway. Unbroken flatness has the double intention of increasing the apparent scale and preventing the eye of anonymous man from dwelling on the particular. Within bare walls of some size even a large crowd will be dwarfed. In this regard, modern monuments achieve not a Gothic but an Egyptian impressiveness. And in the absence of rich and varied decoration—in the absence of any decoration—the mind is filled only by the single idea of abstract space, conveyed simply by light or color.

A caution about movements and aspirations is perhaps in order, by way of valedictory to our acknowledged heroes and salute to those to come. The caution is: Let the artist aspire freely, on any basis of thought and feeling and in any direction. But let him beware of "ideas." The great expressive artist is not indeed a thoughtless man, but neither is he a self-conscious man who tightly grips a merely plausible or paradoxical notion. The great mind that can fulfill aspirations should cultivate a calm indifference to notions, and especially to slogans. He will, let us say, build arcades around an office building because he likes their appearance and feels their attraction for the passerby. But he will not do so because he has read a sociological work which says that the modern world lacks "community" and arcades will correct the deficiency.

The modern artist is peculiarly vulnerable to this error because there are so many books lying about and he has

learned to read—in fact to read *and* write. It is deplorable for art that modern artists have been put by the public under the necessity of defending or expounding their works. Few can do it and keep from succumbing sooner or later to an idea in the sense I mean of a rigid and unexamined proposition. For whatever may be the case in logic, in art truth does not reside in propositions. It resides in objects, and those objects must, like a living being, be the fruit of desire as much as forethought, of brooding care as much as clear intelligence. *1961*

Museum Piece 1967

I have adopted a form of title used by some of our artists— you know the style: Predicament No. 3, Imposition 1942—in order that what I have to say shall remain free from any suggestion of an overarching thesis. I do want to marshal some facts in a certain order, and I can't help having opinions about those facts, but the collection is for you to look at from any point of view, whether in bits or as a whole, and in any case not as a doctrine to espouse or oppose.

We start with the fundamental museum question: How to interest people, especially the young, in what the museum collects? The answer is, broadly: to convey, preferably in some organized form, knowledge with pleasure—aesthetic pleasure sometimes, and the simple pleasure of knowledge at other times. In either case, the work is infected with pedagogical intent. I say "infected" because I believe it a peculiar mark of our age, and particularly of our country, to charge nearly every enterprise with educational zeal. Having lost religion as a means of saving our neighbor, we have substituted art and knowledge as supreme goods which we want everyone to possess willy-nilly; so we take steps to thrust these goods upon

the helpless and captive, as well as on the natural seekers. We should always be conscious that thrusting art and knowledge on the unwary is an invasion of privacy—perhaps justified, but an invasion nevertheless—as great as that of thrusting religion, a practice we have outlawed. And we should also remember that the special sign of the pedagogical intent is the use of contrivance—the school, the museum, the lecture.

Well, the twentieth century is committed to education, and that effort is often the chief cause of our unhappiness and despair, for education is the worst game of chance ever invented. But like the missionary among the cannibals, we're too far engaged to back out: the pot is boiling. The best we can do is consider how to fit the teaching to the taught, and to consider what unavoidable contrivances are suited to our purposes.

It is such reflections as these that bring us to examine the power of words and sight and books, the worth of projections, diagrams, pictures, and objects, and the force of spoken harangues, now so easily taped and piped into the ear. In using these means, we immediately become aware of radical differences among groups, ages, numbers, temperaments. For in our educational drive, as soon as we give up self-selection in favor of universal appeal and indoctrination, we run into the solid barrier of human diversity and must multiply our contrivances. We quickly discover that you cannot talk to two hundred people the way you do to twenty or to two. We learn that some persons rely on verbal memory, others on visual or muscular. We discover that the requisite organ for cultivating art in the modern museum is the calf of the leg. Hence, besides the needful physical education, we must give thought to the working of the senses and the mind. Is it true that there is no solid or pleasurable learning without questions or dialogue? Is the transparent fallacy about one picture being worth a thousand words itself a factor in closing the mind? We must, in other words, investigate the penetrative power of the contrivances that we use, and this not only in order to

pierce the individual skull, but also in the effort to traverse the layers of society as a whole.

As illustration, take a recent exhibition of life in Dutch New York. The exhibition begins with words, by way of furnishing historical background. The first words tell us that the capture of Constantinople by the Turks in 1453 forced Christendom to turn westward for trade routes to the Indies, and thereby make voyages that led to the discovery of America. Now it so happens that this event, caused by Christopher Columbus, was conclusively disproved in a book published, not last week, not last year, but in 1913.

You understand that if blame is to be thought of at all, it must rest on the whole of our culture, which allows an important discovery or conclusion to remain undisseminated for over half a century. The museum director is entitled to find, either in his own schooling or in the common reference books, the sifted knowledge and general truths that he may need. I have taken a typical, not an exceptional, instance. Educated people carry in their heads thousands of items of knowledge that are items of carefully instilled misinformation. I conclude that our apparatus of scholarship is grossly deficient. We have books in abundance, but we have not begun to learn their proper use.

Let us turn to a device of an apparently greater penetrative power, the picture. The example that suggests itself irresistibly is the "Mona Lisa." Its cosmic dissemination was proved with great *éclat* when it came to this country a while ago, though I heard of some who were disappointed not to find Leonardo nearby to autograph a copy. Well, what of the "Mona Lisa"? On a calendar, she has the requisite come-hither look, but by modern standards she's overdressed, and repetition in many sizes and colors has made her dull. Her effect is that of a trademark, and the upshot that should bother us is the phenomenon I have observed a number of times in front of the original. The honest man who has never seen the actual work, but is all too familiar with the face, goes through a dis-

mal time of teetering: Do I admire it or not? If I do, is it because I am supposed to admire? If I do not, is it because I am reacting against conventional admiration? The most perceptive end up by asking themselves: Do I actually see it when I look at it, or am I peering through a fog of reproduction?

Granted that the "Mona Lisa" is an unusual case, it is none the less indicative of what unlimited means of reproduction tend to produce. The sunflowers of Van Gogh, the Fifth Symphony of Beethoven, to say nothing of gobbets of Shakespeare, are in the category of the "Mona Lisa," and our proud machinery is catching up to do the same to anything that enough experts declare to be transcendently good and great.

Let me put the same facts more generally in historical terms. The liberal mind of the nineteenth century entertained a generous belief that, thanks to cheap books and free schools, everyone would be well-educated; that, thanks to lithography and photo-engraving, everybody would soon become an amateur of art—all in parallel with the free newspaper press, which would make everyone a good citizen—a whole world of democrats and aesthetes at small expense. We now know better. A measure of our disappointment may be found in the one domain of simple literacy, when we number the so-called functional illiterates by the millions. But that sad debacle, though related to our concern, is for the moment a byproduct. What is central is the obvious effect of the sum of demands on the modern senses, mind, and memory. We speak of *media* as if their proliferation through technology meant simply more channels for a reasonably constant quantity of stuff. That is not so: the media themselves continually break up the product and give it out again manifold, in bits and pieces. It is a prime case of division that turns out to be multiplication.

The several media, moreover, distort in various ways, as when a novel becomes a film and then the film is televised—additional fragments, multiplied scraps, that find their terminus in our human sensoriums. Nothing in evolution or in

physical training has prepared us for this overload of stimuli; so we meet it through the natural protective devices of the body, unconsciousness or narcosis. Mentally and nervously we "faint" without knowing it a hundred times a day, or we sink for a stretch into a waking coma.

Never mind whether it is good or bad, remedial or not, it is the barrage of mingled tedium and clangor that pounds and pulpifies our senses before we even begin to take in an object or idea that we desire, or attend soberly to what is proposed to us in hopes of our desire. The commonest such object, of course, is something said or written, and thus by an identical excess, word and machine noise have come to produce the same intolerable irritation. Against the word, the senses close up and the mind hibernates. We are all sick of print, of reports, memos, and agendas; of junk mail, newspapers, newsletters, and magazines; of reprints in pamphlets miscalled the "literature" of innumerable agencies. This glut of paper and the cellulose mush of the prose induce a paralysis of the visualizing function—whence the popularity of courses in "rapid reading." What they teach is the new art of letting the eye brush harmlessly over the page. We long simply to feel and taste—why not get rid of the book? An inventor once called on me with a machine that would enable the user to turn a printed roll past a little window and thereby absorb *The Brothers Karamazov* in fifty-four minutes. When you know the anguish of perusing that work, you can think of the reading machine as just the painkiller we all need.

As for talk, I need not elaborate. Hemingway's request, "Will you please, please, please, please, please, please stop talking," has fallen on deaf ears, quite logically: deaf ears are the last resort of silence.

But if the Word, which was in the beginning, has now come to an end, what have we substituted for pleasure and wisdom? The obvious answer is: the vision, arts and music, more particularly visual and musical *patterns*—not pictures with moral or intellectual overtones, not music with dramatic

structure and climaxes. The symphonies of Beethoven are too connotative, too graphic to give us what we want, which is to be let alone, to be insulated and to mull. The painting, sculpture, and architecture we prefer also refrain from giving too clear a direction to our thoughts. Their virtue is to be noncoercive. If you think this generality overlooks the shocks administered by modern art, consider that such a shock is always momentary and inconsequential. It is amusing and not coercive. In our day the highest merit—in public life, society, and art—is to amuse: by framing the familiar can, Campbell's soup becomes the cream of the jest.

While we thus take our visual experience as raw as possible, we are disposed by our spatial mobility to enjoy most what we can come upon unexpectedly, from all sides and at any time. We relish film and tape because we like the freedom they give us in relation to themselves: they are dead things that we can interrupt and abandon, flouting beginning, middle, and end. By tuning in and out we feel a little less enslaved. We no longer care whether this liberty amounts to liberties taken with masterpieces built for a different mode of perception. What could we change, even if we did care? So we step into the bar or the taxicab and readily endure the closing chords of the piece as a sufficient whiff of high art. We believe we can recapture the whole whenever we like, though we should know that this is an illusion. For the fragmentation that we condone is not reversible. The senses and the memory are delicate organs, from which we can erase little or nothing. But no matter, the breakup of high art has an important role to play in our cultural revolution. It is by pulverizing the former kind of artistic experience that we are getting rid of the Renaissance outlook and all its work. It is by the exposure to simple shape and pattern and the practice of tuning in and out that we discard consecutiveness—or at least the consecutiveness of intellect. Together, these new habits change the character of Attention, making it lively in response to every fresh pulse or start, meditative in response to what is gently uni-

form, and dull or absent in response to anything discursive. In such ways the sensibility of man is renewed and refreshed.

But what is good for the soul doesn't necessarily bake bread, and in the decline of Attention and the phobia against words, we are left with the workaday problems that we class under the heading of Communication. The paradox here is one of the choicest in the history of man. From the original three ways of transmitting notions—the spoken word, the drawn image, and the bodily gesture, each requiring a living soul—we have passed in a short time to dozens, if not hundreds, of machine devices that extend, record, duplicate, and transform for later recovery the notional elements in our common life.

The obvious countermeasure, which is repetition, only aggravates the disease. Those who can no longer catch anything on a first hearing soon have to hear everything ten times before it penetrates, and they end up impervious while the repetition goes on. Nor are the secondary results satisfactory. Public education stalls and social fabric disintegrates to an accompaniment of the spiritual malaise that is bound to come with isolation in the midst of Babel. The rising pitch of every shrill claim on attention; the attempts at concentrating interest on a few ideas, a few names, a few works; the false coloring lavishly applied to suggest variety and to make the over-familiar look original—all these emergency measures only increase disaffection, breed panic, and incite the young to secede.

Only slight relief is felt when the pounding temporarily stops. Rather, the drilled sensorium aches with a sense of vacuum as disturbing as the failure of a scheduled explosion. So the pupil turns on the squawking radio to do his homework, dinner parties get restless at general conversation and break it up into cacophonous tête-à-têtes, and loud humming machines are marketed to protect urban sleep.

At this point of common anesthesia, the bold and inventive propose a radical remedy; and it is here that our concern with the modern sensibility turns particular and practical. For all these indescribable experiences of chaos and fury, all these

longings for sensation and silence are democratically distributed among those with whom we deal from day to day, and it follows that any hope we entertain of reaching that drunken mind in our neighbor, our pupil, our colleague—let alone controlling the staggers in ourselves—must depend on some action appropriate to the predicament.

The remedy I refer to is familiar. It is based on the principle of like cures like. According to it, our flaps and flits would decrease and communication would resume, if we only gave up the direct effort and, instead of resisting the inevitable bombardment of stimuli, exploited it for the super-saturation of our senses—and not one sense at a time, but all together. Give up trying to sort out a single line of meaning from the confusing concomitants. Give in, rather, to a calculated assault on all the doors of perception. Forgetting the linear and the flat, plunge into the actual thickness of the four dimensions. Light, shapes, colors, sounds, touches, and smells are to be our simultaneous instructors, converging on the expanded psyche, filling the gaps in our attention, reproducing without effort from us the totality of experience—that "booming, buzzing confusion" that William James imagined to be the baby's accurate awareness of the world. This proposed remedy has quickly become a program and also a pastime, and since a crusade benefits from having an enemy to put down, books and the art of linear print have become the *infâme* that we are to crush.

If I were a cyclical historian, I should rejoice in this turn of the wheel of culture. For the artifice of communication through all available channels of sense is not wholly new in Western civilization. The ancients used trees, stones, weapons, fires, and monuments to fix in the mind great events or oaths taken or truths learned. By strong association the right feelings were aroused that spurred the mind. And the need for such messages in concrete form long survived the abstraction in written word. Even more elaborate was the "multimedia educational center" known as the medieval cathedral, where

music, painting and sculpture; pillars, vaults, and pulsing bells; light effects, recitation, and relics, playacting and miracles besieged the believer. So when Victor Hugo in *Notre-Dame* contrasts the printed book with the cathedral and says that the one will kill the other, he may have prophesied an endless duel with alternating victims.

But I am not a cyclical historian: I am rather a broken-spiral historian, and I read the story differently. The turns of history are irregular and the apparent samenesses betoken only delays and analogies. For hundreds of reasons, the cathedral is only *analogous* to the proposed kaleidoscope based on technology. It is a strange linear *delay* that brings us, in 1967, to ponder the merits of simultaneous sensations for expressing and conveying the contents of the modern mind. *1967*

Why Art Must Be Challenged

Readers of Nietzsche will recognize in the title I have given to this series of talks—The Use and Abuse of Art—a paraphrase of the title of his great essay "The Use and Abuse of History." Nietzsche was a trained historian and he was not undermining his own craft. Neither is it my purpose to undermine Art. It would be strange indeed if after a lifetime of concern and activity in behalf of the arts I should nurse a sudden whim to turn against them. What I hope to exhibit here is something very different from attack and defense—and more difficult. If one looks at Nietzsche's title in the original German one perceives his intention more exactly, and mine as well. What the German title says in so many words is: "the advantages and disadvantages of history for life." Such also is my preoccupation about art. Nietzsche goes on to speak of the worth and "un-worth" of history in relation to life. He came to

the conclusion that the historical sense under certain conditions weakens the sense of life. History nevertheless retains its proper uses and should greatly flourish. Similarly, I shall hope at the end to assess the worth and the uses of art and invite you to judge them with me. Throughout we shall be asking ourselves whether there may not be unsuspected disadvantages in both our formal and our casual absorption of art—even in our habitual modes of talk about it—all this in order to reach a conclusion about its value and its drawbacks *for life* at the present time.

I grant you that "life" is a rather vague term—whose life? What kind of life? spiritual or material or both? And life at whose expense? Think of that remark of William Faulkner's, which many people would applaud without scruple: "If a writer has to rob his mother, he will not hesitate: the 'Ode to a Grecian Urn' is worth any number of old ladies." The morals of this bravado are far-reaching. Is it right to sacrifice for art the lives that modern feeling would refuse to sacrifice for the good of the state? Perhaps. Then is it decided that art is superior to society? Yes or No? I shall try to give detailed answers to questions such as these.

Usually, when one speaks of "worth" and "unworth," merit and demerit in the great realm of art, one uses the words *distributively,* applying them to this or that artist, this or that work, this or that school. It is the critic's role to do this distributing of labels, and in the end the finer the discrimination of one artistic element from another, down to one detail in one corner of a painting or one word in one line of a poem, the greater the critical achievement. Such investigations belong to *art criticism.* What I have to offer you is something else, which is often called *cultural criticism.* It considers and makes distinctions within much larger wholes—culture, society, the state, modern man considered as an historical type, Western civilization today taken as a unit, or entire portions of the past. So it will be here. As a student of cultural history, I shall be dealing with art primarily as a single force in modern life.

This is to regard art in an unaccustomed way. Our natural attachment to particular kinds of work or to a particular art or artist makes us casual and vague when we refer to Art at large. And yet we find it easy to refer in just that way to science or technology or government or religion. In this familiar use of terms we do not stop to specify what religion, what branch of government, what direction of science or technology. Nor do we hesitate to attribute value or harm to the whole burden and bearing of these activities when we discuss the social or moral predicaments of the present world. In my examination of art, then, I shall be discussing its prevailing drift, its residual impact. This looking at tendencies is legitimate. In our time if ever in history, all that goes with the production and reception of works of art—the attitudes, ideas, clichés, pieties, goals, and methods of diffusion—applies on a large scale; it has in fact converged into an organized whole: art is one great institution with a high consciousness of itself as a vested interest.

Still, my judgments will be a good deal less wholesale than those of critics who find nothing but solace or menace in science, bureaucracy, or religion in the lump. For even though art today is a public institution, it is an institution without a theory. No coherent thought exists as to its aim or *raison d'être*. The artists, the critics, the consumers, the middlemen are content to defend themselves, each in his sector, as a party or as a person. Looked at in the mass, their attitudes, performances, and verbalizings are unpredictable and miscellaneous. Some of their acts and feelings come from recognizable traditions, others from a tradition turned upside down. Still other positions derive from catchwords borrowed from the past for a passing need in the present. Thus a contemporary painter will echo Daumier's slogan that "one must be of one's own time." As used today, the words very likely state a resolve not to be an academic painter, or not to paint portraits or objects, or imitate the Impressionist, Post-Impressionist, or Cubist techniques. The slogan does not carry us much further. What is the essence of one's own time? Revolution, reaction, retreat,

escape, indifference? And what is the timely mode of expression for any of these today? There are a dozen flourishing schools; fashions move spasmodically across frontiers; all past styles and twenty primitivisms are on display: which of them is Us? Our own time becomes an object of research with several equally valid findings, and the catchword is useless as either rallying-cry or interpretation.

It is into this thicket of facts and ideas that we must penetrate, with the help of a little history and analytic thought.

Naturally, where we are must also be discovered by a survey of the contemporary scene. What is it that we call art in the world around us? First of all the classics of all times and countries, that is, the objects in museums. They range in time from ancient Egypt to the most recent year. Our libraries and our book publishers promote the literature that parallels this great span. Our concert halls, theaters, opera houses are there also to reproduce what the past created that we think great or important. The historical sense, working in hundreds of trained minds, has dug out of the past an amazing pile of works of art, which are "made available"—as we say—to anyone who shows an interest.

Moreover, this accumulation of masterpieces big and little has been as it were mobilized by technology. You do not have to go to it; it comes to you—by the action of the mass media in print and in radio waves, by means of the long-playing disk, the film, and the color reproduction. In addition, there is the push of the educational systems, which means not only schools, but museums, libraries, and art centers. No longer static, these establishments are relentlessly active in propaganda for art. Regularly every two months I receive from the Metropolitan Museum of Art in New York a thick illustrated invitation to partake of their "Art Seminars in the Home." In one form or another, similar opportunities abound in many of our cities. Just as the schoolchild may find that the study-hour is suddenly canceled in favor of a visit from the musical

performing-and-lecture group called Young Audiences, so the citizen may be seduced suddenly by some offer or presentation of art in the midst of life.

This is quite new in Western societies. I can testify that when I first came to this country, in 1920, no such apparatus existed. The term "art center" did not exist and would not have been understood. The very word "Art" in the current sense was infrequently heard. Rather, people tended to pursue their preferred art exclusively. They would speak of music or the fine arts, or poetry and *belles-lettres,* and foregather with their own kind. These groups were small and were considered special interests. No such surprise awaited them as going to the bank and finding there an exhibit of contemporary pictures, or going to fetch Johnny from school and finding the output of his class displayed in the entrance hall. And the notion that a soft-drink manufacturer could sponsor a traveling art show or the government benefit in its foreign policy by flinging an orchestra or a ballet across the Iron Curtain would have seemed an absurdity.

In Europe, it is true, there was a tradition of official art and government subsidy. But it was tied to a severely restricted offering; it was academic in taste and social in purpose. The vigorous life of new art went on outside the official precincts, but again its channels were special and restricted. In other words, what we see now is the product of a cultural revolution. The Great Depression saw its faint beginnings, acknowledged in the New Deal by the WPA. The Second World War showed by its deliberate preservation of art and artists that the heedless destruction of both in the First World War had served as a lesson.

After the second war, the *Drang nach Künsten* got truly under way. It was aided by the accumulated disillusionment of two postwar periods. The long agony had persuaded many minds that public affairs were contemptible and vile. The only civilized existence was that which moved among spiritual things, and in the realm of spirit art was supreme. Some of

these new devotees had been awakened to the reality of art by contact with other lands and peoples. Still others were drawn into cultivated habits by the technological devices I have mentioned. To take but one instance, the boredom of the army camp induced thousands to read paperback books and listen to broadcast music. Very potent also was the pressure of advertising, which not only cast its usual glamour over the idea of being "cultured," but what is more important, adapted and exploited the painting and literature of the preceding century in its own displays. The mid-twentieth century was made both visual and responsive to verbal innovation by the new advertising techniques initiated around 1920.

Add to this the steady optical effect of modern architecture, furniture design, and packaging; the extension and distortion of reality by the motion picture and still more by television, and the saturation of the airwaves with music regardless of time, place, or occasion, and you have the main forces that opened eye, ear, and mind in the population of Western countries. Though artists and their promoters still deplore the "lack of support for the arts," the spread during the past fifty years not only of receptivity to art as such, but also of tolerance for it, is in fact amazing; indeed, it is unexampled in the history of our civilization.

We have so far looked at the classical sector—recognized, gilt-edged, consecrated art—and at its amateur offshoots. Beside it stands the whole of new art, infinitely ramified. In painting and sculpture even a short list of the names attached to schools suggests how difficult it is to ascertain what anybody means by "twentieth-century art," let alone by adjectives such as "new," "modern," "avant-garde," or "contemporary." The twentieth century does begin with Cubism, followed by Futurism and Constructivism, Vorticism, Expressionism, Dada, and Surrealism. These and other isms take us through the period between wars, after which—the deluge: we have had since: Abstract Expressionism, Neo-Dada, Pop and Op

art, *Tachisme,* Action Painting, Kinetic Art, New Realism, Hard Edge, Junk Art, Disposable Art, Aleatory Art, Minimal Art, and finally: Anti-Art.

All along too, under the original impetus of Marcel Duchamp, we have been shown happenings or arrangements designed to startle us into recognizing how conventional or arbitrary our artistic notions actually are. A few years ago, for instance, a painter in New York exhibited works done in human excrement; another exhibited molded plastic genitalia around a coffin in which he himself lay naked. A third cut off pieces of his own flesh and photographed them. A fourth made stencils of classic works in order to reproduce them by spraying canned paint on the exposed surface.

The use of new materials—such as Mylar sheets—also figures in the repertory of new art, and one movement flourishes under the title of Art and Technology. For its first exhibition, at Los Angeles in 1971, some seventy-five projects were submitted. Of those that were completed, the most striking were perhaps Mr. Claes Oldenburg's *Giant Icebag,* a huge structure of orange-colored vinyl, hydraulically operated, and Mr. Rockne Krebs's *Light-piece,* a system of red, green, and blue lasers surrounded by mirrors in a dark room, so that, according to the catalogue, "the lights are reflected to infinity." Light in darkness has a strong appeal. Two years ago, a rising talent from South America was given a one-man show in New York by an association to promote Inter-American relations, and his main work consisted of twenty-one small television screens around the walls of a dark room, all oscillating brightly but showing no image.

In the other arts, the range of inventiveness may not be so widespread, but the same characteristics recur, especially the effort to intermingle the sensations of separate arts as well as to make a point of elements directly drawn from life. Just as the junk artist will exhibit a broken-down icebox in the flesh, so to speak, the maker of concrete music will tape sounds from the street or a noisy factory. In Mr. Ben Johnston's *Knocking-*

piece the two performers use wooden mallets to hit the piano case irregularly for eleven minutes. Meanwhile the electronic musician will use the computer to provide themes or forms by random operation. Composers for traditional instruments match this novelty by abandoning the usual signs for notes and rhythms and substituting loops and whorls by which the performer is stimulated to improvise along the suggested arabesques In the latest of these scores the composer also colors the curves with crayon and thus influences the player by synesthesia. In so-called concrete poetry the fusion of sound, sight, and color occurs in parallel fashion.

As to the contemporary theater, I need only recall to you its principal devices of violence, symbolic cruelty, and obscene language to confirm the truth about much new art that it is meant to bruise the beholder's feelings and senses, in hopes of making him into a new person of the right kind. Indeed, in the works put on by the Living Theater, the audience was admonished and insulted from the stage and violently caressed by actors roaming the aisles to stimulate an immediate reform of character along lines explicitly anti-bourgeois. On the screen, finally, and in the novel, the same aggressive pedagogy conveys messages by symbols that are often obscure and by pornography that is unmistakable. It comes as a pleasant variation when a young French novelist of great talent devotes an entire novel about Job to the description of a heap of manure.

You will readily think of other features peculiar to the art of our generation. Those I have mentioned are only to remind you of what stands out in the environment, side by side with the classics and with certain echoes from the age of Realism and Impressionism. This coexistence, this pluralism that marks our age in the history of art, is worth reflecting on. With rare exceptions, earlier times and places were stylistically intolerant and possessive. They produced, or tried to produce, *their own art;* they put in the attic the art of the previous period; they were generally hostile to the art of another country or culture, and certainly to what they considered primitive

or barbarian. With them, the correspondence between the prevailing taste and the social conditions obtained also between these conditions and the art produced. For example, an age of courtly idleness favored a decorative and erotic art and stimulated comedy for the stage. When disputes arose about art, the struggle was between old and new doctrines or between two new tendencies claiming the right of succession to the great masters. We are far from such a simple contest. Art exists on too many planes and strikes out on too many tangents to permit genuine confrontation and the triumph of a style suited to our habits.

Here, then, is a first reason for examining Art as it is practiced today. What set of conditions does it accompany and illuminate? What sort of mind does it fulfill or edify? If you are invited to see a collection of flotsam tossed ashore by the sea and affixed to deal boards tinted blue, what is the bearing of that invitation and its effect? Or again, in a great and imposing museum, why the little enclosure where the visitor has to pick his way among ladders leaning at various angles? Granted that the artist's intention is often negligible and the effect proportional, it is but normal curiosity to speculate about them.

You may say that in these examples there is no avowable intention; it is a mistake to look too deep. Nowadays anything put up for seeing or hearing is only meant to be taken in casually. If it holds your eye and focuses your wits for even a minute, it justifies itself and there's an end of it. I will return to this notion of the Interesting which has replaced the Beautiful, the Profound, and the Moving. What I am bringing up for scrutiny is that if modern man's most sophisticated relation to art is to be casual and humorous, is to resemble the attitude of the vacationer at the fairgrounds, then the conception of Art as an all-important institution, as a supreme activity of man, is quite destroyed. One cannot have it both ways—art as a sense-tickler and a joke is not the same art that geniuses and critics have asked us to cherish and support. Nor

is it the same art that revolutionists call for in aid of the Revolution.

In short, there is here a radical ambiguity about that simple word Art, a confusion of terms and of aims that constitutes a second reason for examining the art of our time. In any case, it is clear that if art has importance, it is because it can shape the minds and emotions. It can enlarge or trivialize the imagination. If it can do so much, it affects the social fabric as well as individual lives for good and evil. *1973*

VII

On Teaching and Learning

The Art of Making Teachers

Now that the collapse of the American public school is admitted on all hands, after thirty years of blindness on one side and defensive lying on the other, attention has turned to the question, What about the teachers—are they to blame or are they victims too? And the related question follows, Where should we turn for good teachers? For shortage is added to the other woes.

It is a fact of nature that there are more born poets than born teachers. But the world's work cannot depend on genius; it must make do with talent, that is to say, fair material properly trained. Up to now teacher training has been done by people unfitted for the job. By temperament they have no interest in Learning or capacity for it; by purpose they are bent not on instruction but on social work. They care little about history or science or good English, but they grow keen about any scheme of betterment; one recent proposal is: teach the importance of washing the hands.

The result of half a century of this world-reforming attitude may be seen in the language in which educationists think and talk. Its characteristics are: abstraction instead of direct naming; exaggeration of goals and results; seeing the student not as an individual but as an example of some psychological generality; taking any indirect means in place of the straight one; and mistaking words for facts, and intentions for hard work.

Such is the educationist mind everywhere. A few years ago

New York City, finding its school system in bad shape, set up a task force to look into the trouble and devise remedies. After a time, a large gathering of interested and qualified persons was invited to hear of any progress made. An impressive and fluent official took about an hour to describe the committee's procedure, summarize its report, and explain how the recommendations worked to reform the whole system. Then she asked for questions. One bold spirit ventured "Could you tell us what success you have had so far?" The answer: "We have had complete success. All the heads of department to whom we sent the report have replied that it met with their full approval."

Nothing happened, of course. The educationist spirit is that of bureaucracy—marks on paper take precedence over reality—and bureaucracy is inconvertible. Indeed, some observers have lately said that no system, anywhere in the country, can be changed. Physicists can transmute the chemical elements but not the schools.

In short, teacher training is based on a strong anti-intellectual bias, enhanced by lack of imagination. The trainers live in a cloud of nomenclature, formulas, "objectives," evaluations, and "strategies." By instinct, it seems, doing is held at arm's length; any call for change starts with a pompous windup: "When we talk about goals, we imply a context for action that transcends a dictionary definition. Institutional planning embraces mission, goals, and objectives, while business strategic planning defines roles, goals, and tactics. Goals . . . theoretically can be commonly defined and shared so that everyone is heading in the right direction."

To most teachers this mode of thought is or becomes second nature; the school-teaching profession believes in fantasy. No doubt strong minds escape the blight, but they must go on to do their good teaching despite the creed and its oppressive atmosphere.

What, then, are the native qualities to look for in the person who, though not one of those born to the task, would

make a good teacher? And what sort of training should such a person get? As to the first requirement: brains enough to feel bewildered and revolted by the educationist language—and courage enough to admit it. Next, a strong interest in some branch of learning, meaning any one of the genuine school subjects. Which those are can be found every day in the newspaper articles that bewail the failure of the schools. Nobody writes about the poor showing in "Shopping and Community Resources."

In addition, a teacher should have some interests beyond his or her specialty. In bearing, in manner of thinking and talking, a teacher should quite naturally appear to be a person with a mental life, a person who reads books and whose converse with colleagues is not purely *business* shop; that is, not invariably methods and troubles, but substance as well. There is no hope of attracting students to any art or science and keeping up their interest without this spontaneous mental radiation. When it is reported that the teaching of biology imparts nothing but a rooted dislike of science, it is easy to see what disconnection exists between the mind of the teacher and the nature of the subject.

A key phrase in the foregoing is *naturally have a mental life*. It implies that the teacher *likes* books and ideas. With these likes, the teacher will not become a pedant or a martinet and will avoid another failing now often seen: false modesty and self-consciousness. Addressing parents, a teacher from a very good school confides: "Teaching is part performance, part pratfall—at least, my teaching is so. I never know what's coming when I go into a class." Then resign and take a less scary job. But the words are insincere—conventional hokum to show that the speaker is not highbrow or know-it-all, that a teacher is only a person older than his students, not wiser or better informed—"we all learn together." (The cliché that a teacher learns from his students is true, but the thing learned is not at all the same and it is not a continuous "course.")

Now suppose a young woman, a young man, with a good

mind and normal common sense, who is eager to become a teacher. Training to fulfill this ambition calls for nothing complicated or abstruse. The all-important thing is mastery of a subject matter. Ideally, it should be the freely chosen major in college. This main subject needs to be supplemented by courses in other fields, to give awareness of their contents and outlook and their relation to the main subject. Providing this "environment" is the ancient goal of a liberal education, which may be likened to a map of the mental life with one region of it extremely familiar, because it is "home." For the teacher, a history of educational theories would complete the program. It should be made clear too that science and mathematics are liberal arts, not some mystery of recent growth and suddenly in demand "for the twenty-first century."

Speaking of science, should the teacher learn psychology, child psychology in particular? No. The science, which is by no means settled, is like other sciences; it yields only generalities; and teaching is par excellence the adaptation of one particular mind to another. There is no such thing as *the* child—at any age. Teaching is not the application of a system, it is an exercise in perpetual discretion. One pupil, too timid, needs to be cheered along; another calmed down for the sake of concentration. Correcting faults and errors must take different forms (and words) in individual cases and must usually be accompanied by praise for the good achieved. Variety of tasks is indicated for some and steady plugging for others. The class is not to be spoken to in the same way as the single child, and fostering emulation must not generate anxious competitiveness.

Now, no method on earth will teach ahead of time when, how, and to whom these purposely contrary acts are right or wrong. Intuition—for want of a better term—is the true guide. A good teacher can spot a gifted child without learning the twenty-two characteristics listed in *The Encyclopedia of Education*. The few pointers of a general sort that would help a prentice teacher can be found in William James's *Talks to Teachers*, a small book still in print after a century.

The way to learn the art of teaching is by imitation. To teach well one should have had at least one good teacher and been struck, consciously or not, by the means employed and the behavior displayed. It follows that practice teaching is an indispensable part of the training. But here lies the appalling predicament of the present hour: How can imitation and practice teaching produce anything but the kind of teachers we have had, misdirected and miseducated? Unless bypassed, the profession will perpetuate, in all good faith and with heart-melting slogans, the damnable errors that have killed instruction and made the classroom a center for expensive waste.

1991

Where the Educational Nonsense Comes From

The first thing we must know under this heading is where the educational nonsense does *not* come from. The usual random guesses conceal the facts. I call nonsense any plan or proposal or *critique* which disregards the known limits of schooling or teaching. Schooling means teaching in groups. Thus a plan that might be workable if applied by a gifted tutor to a single child living continuously in the same house becomes nonsense when proposed for classroom instruction in an institution designed for hundreds or a national system designed for millions.

Similarly, the limits of teaching are transgressed if the plan presupposes extraordinary talents or devotion in the teacher. Finally, nonsense is at the heart of such proposals as replace definable subject matters with vague activities copied from "life" or with courses organized around "problems" or "attitudes." The attempt to inculcate directly, as a subject of

instruction, any set of ethical, social, or political virtues is either indoctrination or foolery. In both cases it is something other than schooling. That fact is not in conflict with another fact, which is that schools indirectly impart principles of conduct. Schools reinforce some portion of the current ethos, if only because teachers and books and the normal behavior of those brought together exemplify the moral habits of the time and place.

Summing up these definitions and generalities, we may say that educational nonsense comes from proposing or promoting something else than the prime object of the school, which is the removal of ignorance. *1971*

Occupational Disease: Verbal Inflation

How did the public school get to such a pass? The answer is: Inflation—not monetary inflation, but intellectual, emotional, social, egotistical inflation. For the last fifty years, American Education has pursued a policy of overstatement about its role and substance; it has lived by continual exaggeration of what it is for and what it can do. The medium naturally is words, words misunderstood and misapplied. It is verbal inflation.

As in the worst sort of advertising, whatever Education offers is said, ahead of time, to be the latest and best, most perfect, supreme. What is taught and the benefits that follow are held to be universal in scope; the authors acknowledge no limit: they will not tell the truth nor face simple facts. They suspend common sense and fly to metaphors and abstractions to cover the genuine thing that can be done, that *could* be done if they were not addicted to educationist guff. Read the

top-heavy curriculum plans, the twelve objectives, the twenty-three guidelines, and bring to mind the fraudulent slogans with which the profession has gargled during the last two generations.

The error began with the replacement of the word "pedagogy" with the word "education." Pedagogy is not a beautiful word, but it sticks to the point of teaching. It denotes the art of leading a child to knowledge, whereas education properly refers to a completed development, or the whole tendency of the mind toward it. A person is taught by a teacher but educates himself or herself—partly by will, partly by assimilating experience. The educator's egotistical urge to blur this distinction is at the root of our present predicament. Thinking that we can *give* an education, we make wild claims and promises and forget to teach what is teachable.

Look critically, for example, at what is said in discussions of art for the schools. Here is a short list of the aims: to develop aesthetic potential—what is that but vague and pretentious talk? to transmit the cultural heritage—how can this possibly be done in one course? to supply an outlet for self-expression—this is impossible before technique is mastered; to give a chance of success to non-verbal minds—good, but success in which art and to what degree? to enlarge the understanding of Man—does this really come out of modeling clay or playing in the band? to master a system of symbols—this may do for reading music but not for painting or any form of design; to fill out the outline of history, which is incomplete without art—that implies art history, not art in practice; to acquaint the child with foreign cultures—that would mean comparing styles after much familiarity with one's own; to show that not everything is quantifiable—this can be done while teaching English composition, American history, or any foreign language; to enhance achievement in other subjects— why use art for this purpose instead of pep pills or free hamburgers? to counterbalance utilitarian subjects—who says that

playing drums or drawing cans of tomato soup can't be utilitarian?

These stated goals are bad enough, but trailing after them is a batch of slogans supposed to organize the lust for art: teach a sensory language; communicate creatively; visual (musical) literacy; social-studies enrichment; engender general creativeness; build ethnic identity; enhance problem-solving; humanize schooling; give creative vision; achieve affective education. This last, according to one enthusiast, is interpreted to mean that "it is more important to feel rightly than to think rightly." What a false dilemma! Must one be either a fool or a knave? And if one feels rightly, does it not imply some thought which is also right? Why so many irresponsible words?

It is all Inflation—the plausible or possible inflated into the miraculous. And this collection of vacuous phrases is not taken from as many plans expressing different hopes: one document alone contains eighteen, all to be gone after and realized by one school program. Others list six or eight of these wonder cures. None connect any slogan or objective with any particular activity recognizable as teaching art. What this fatal gap means is that the most concrete, tangible, sensuous business in the world—art—becomes an abstraction, a great white cloud showering on us by magic six or ten or eighteen golden benefits.

Now compare with the hazy vistas of the inflationists something known to have happened. Under one art program sponsored from outside, a master dancer and drummer from Ghana came to a sixth-grade class "to focus on the arts of Africa for two weeks" (decide for yourselves what "focus" means). During that time the class "created African art of their own." Thanks to another scheme, the federal program called Artists-in-Schools, a professional weaver was sent to a school where six students were excused from music class for eight weeks to study her craft. According to one report, the course

"concentrated on technique rather than creativity, apprecia-
tion, or the history of the art."

Here at last we have two bits of reality, in contrast with
all the inflated descriptions. But don't mistake the point of the
contrast. I am not saying the weaver and the drummer did the
right thing—or the wrong thing, either. I am saying that
these are the modest little events blanketed under the usual
verbiage of "catalyst for general creativity" and "exciting
introduction of a new dimension in the school."

Is it not now clear that even when something actual, pos-
itive, is done about art in a class, the inflationary temper
immediately works distortion and confusion upon the facts?
Take first the prostituted word "creative." Think of the Cre-
ation, by God or by Chance—making something where noth-
ing was before, something new, unexampled, fresh, and fit to
arouse wonder. To me, the wonder of artistic creation is so
great that "creative" is a sacred word, forbidden except to
describe extraordinary achievements. I find it offensive to
African art that in two weeks a sixth-grade class *created*
"African art *of their own.*"

Similarly, in the judgment passed on the weaver one can
see how completely school people have lost the sense of reality.
How could that craftswoman have taught in eight weeks the
history of the art? How can any such course do anything but
show some small part of one kind of weaving? And until vari-
ous kinds are shown and compared, how can "appreciation"
occur? The disappointed tone of the comment is a measure of
educational illusionism—those eight weeks did not transmit
the cultural heritage, enrich the social studies, fill out the pic-
ture of history, teach a new sensory language, humanize
schooling, or acquaint the students with other cultures. All it
did was excite them like an unexpected party—and keep them
away from the art of music. *1978*

The Centrality of Reading

What is the present situation of literacy? It is a state that does little credit to our efforts. The universal light which, according to the hopes of one hundred years ago when most of the great Education Acts were passed, was supposed to bathe the world in knowledge and reason is not as dazzling as our generous ancestors expected. Its great source was to be literacy, and literacy is not in the ascendant. There are in this country several million functional illiterates.

These calamities are everybody's concern, but they can only be repaired by teachers and other professionals adept at using the right remedies. The professionals, moreover, need the backing of parents, school boards, and interested bystanders. There must be a public opinion on the question, Where, in the matter of reading, does the public interest lie? Certainly it is not the parents whom I saw marching toward Chicago City Hall to protest against the lax promoting of their ill-prepared children, who are for abandoning the teaching of reading in favor of electronic telepathy. These people know what they want for their children, and they have a sound sense of what the country must require of its future citizens. Only a sophisticated mind, that is, part-educated and full of unexamined ideas, could seriously advocate the carrying on of schoolwork without schoolbooks.

Where does that sophistication come from? Why did it seem plausible and attractive, after three thousand years of teaching reading by sounding each letter, to do just the opposite and encourage guesswork about the "shapes" of words? And now that this asinine substitution has massively failed as it deserved, why does it seem advanced and (once again)

sophisticated to suggest that reading is after all expendable, since we have at command so many knobs and buttons with which to circulate counterfeits of visual and vocal reality?

The reason for the second of these frauds is made up of two parts. One is the desire to hide the original blunder, as the clumsy servant whisks out of sight the fragments of the broken cup. The other is simple blindness to the truth that reading and its necessary twin, writing, constitute not merely an ability but a power. I mean by the distinction that reading is not just a device by which we are reached and reach others for practical ends. It is also and far more importantly a mode of incarnating and shaping thought.

Now, all legitimate power is the result of a double discipline, first a discipline of the self, and next a discipline of the acquired power within accepted constraints. Concretely, in order to exert the power of reading, after disciplining eye, ear, and memory, one must at each word accept the constraint of the black marks on paper. Guessing and inferring by context, and forcing these dubious egotisms upon the written text are a refusal to accept the symbolic constraints of the written word, after failing to discipline oneself to learn their clear demands.

Here we touch the political and social causes of the whole sad odyssey that has brought America to the condition of being a land of semi-literates. Make no mistake about it: the causes are not ignorance, poverty, or barbarous instincts; they are "advanced thinking," love of liberty, and the impulse to discover and innovate. It is from the action of the literate, the cultivated, the philosophical, the artistic that the common faith in the power of reading as central to Western civilization has been destroyed. The target of the separate attacks and collective animus has been the very notion of power, discipline, constraint.

For it is true that none of these resemble the rival goals which sophisticated thought preferred—the free play of fancy, creativeness, and immediate enjoyment; self-expression, novelty, and untrammeled choice. The intellectual elite had learned the value of these meritorious pleasures in the writings

of the best philosophers, artists, and political thinkers, and with impatient contempt of school dullness and rote learning resolved to emancipate the child and "give" him these joys.

The folly consisted, not in wanting the lofty results, but in thinking they were an alternative set that could be reached directly. I have elsewhere defined this fallacy as "preposterism"— seeking to obtain straight off what can only be the fruit of some effort, putting an end before the beginning. It should have been obvious that self-expression is real only after the means to it have been acquired. Likewise, for the other pleasant exertions, there are conditions *sine qua non*. And these justly praised parts and privileges of a free spirit are in fact used in meeting these conditions, in learning itself: the child *is* self-expressive when he painstakingly forms the letters *a, b, c,*— though he is not quite ready to "create" a "poem." Nor can creativeness be the *object* of his learning, since it is by definition unlearnable.

All this high-minded preposterism found its perfect expression in the look-and-say doctrine for the teaching of reading. The truth that practiced readers recognize whole words at a glance and do not need to sound each letter with their lips was pre-post-erously made the starting point of instruction—a method which on the face of it is the quintessence of anti-method. Thanks to it the child was left free, imaginative, creative; the printed text exerted upon him no constraint whatever: he could not read. At the same time, the child was not free to start reading till some teacher decided that he was "ready"; was not free to read any book, least of all literature, but only Dick-and-Jane; was not free to connect his whole speaking vocabulary with what was given him to read, but only 400, 500, 600 words, depending on his progress in guesswork; was not free to learn spelling at any decent rate, since a blank space has no "shape" and one cannot guess how to fill it without knowing the (forbidden) sounds of the letters. In the end, the desired "development of the self" did not seem to reach very far.

Whether this well-engineered movement can be reversed is what no one can predict. But before leaving the reader in suspense like the heroine hanging from the cliff, it is, I think, useful for private and public action to mention the three or four cultural forces that encouraged and still sustain the hostility to reading, to the alphabet, to the word.

The first is the emotion of scientism, which for seventy-five years has preferred numbers to words, doing to thinking, and experiment to tradition. This perversion of true science led to calling "experiment" almost any foolish fancy and to believing in "studies" of "behavior" without a scintilla of regard to probability, logic, observation, or common sense. That it took half a century to begin admitting the error of look-and-say (through another "study," not through daily evidence of failure) shows the extent to which science has turned into superstition.

Second, the last phase of the liberalism which by 1910 had proclaimed everybody's emancipation, including the child's, took the form of total egalitarianism. Everybody was, by democratic fiat, right and just in all his actions; he was doing the best he could; he was human; we knew this by his errors, his errors were right. *Q.E.D.* It therefore became wrong to correct a child, to press him, push him, show him how to do better. Dialectal speech and grammatical blunders were natural and, as such, sacred; the linguists proved it by basing a profession on the dogma. Literature was a trivial surface phenomenon, the pastime of a doomed elite: Why read books, why read, why teach the alphabet? Here, at least, the logic was perfect.

Third, the extension of free, public, compulsory education to all and in increasing amount (the high school dates from 1900) soon exhausted the natural supply of teachers. They had to be manufactured in large numbers, out of refractory material which could be more easily prepared in the virtues of the heart and the techniques of play than in any intellectual discipline. Themselves uneducated and often illiterate, they infalli-

bly transmitted their inadequacies, turning schoolwork into make-believe and boring their pupils into violence and scurrility.

Fourth and last, the conquest of the public imagination by the arts, by "art as a way of life," has reinforced the natural resistance of the mind to ordinary logic, order, and precision without replacing these with any strong dose of artistic logic, order, and precision. The arts have simply given universal warrant for the offbeat, the unintelligible, the defiant without purpose. The schools have soaked up this heady brew. Anything new, obscure, implausible, self-willed is worth trying out, is an educational experiment. As such, it is validated by both science and art. Soon, the pupil comes to think that anything unformed, obscure, slovenly *he* may do is validated by art's contempt for tradition, correctness, and sense.

These contrasts do *not* mean that tradition is right and innovation wrong; that artists ought not to try making all things new; that scientists may not experiment ad lib.; that the imagination should not have free play; that equality is not the noblest of political ideas; that children should not be treated with courtesy and affection. The point of the contrast is that what we have from our expensive schooling is not what we thought we were getting. What is the lesson to be drawn? It is that no principles, however true, are any good when they are misunderstood or stupidly applied. Nothing is right by virtue of its origins, but only by virtue of its results. Innovation that brings improvement is what we all desire; innovation that impoverishes the mind and the chances of life is damnable. Above all institutions, the school is designed for one thing only—fruits. But nowadays we despise the very word "cultivation." I admit that unweeded soil grows wondrous things, which nobody can predict. And these things we have in abundance. But it would be a rash man who would call it a harvest.

1971

The Tyranny of Testing

For months, magazines and newspapers have carried on a running debate on the theory and practice of testing. The greater part of the discussion has consisted of attacks on so-called objective tests.

The vogue of this type of test began after the First World War, during which it had been used by the Army in the hope of rating intelligence and sorting out capacities. Schools and colleges in the 1920s began to give similar tests to their applicants, who, once admitted, were subjected to true-false quizzes instead of the regular essay examinations. Of their own accord, students took whole batteries of commercially produced tests to help themselves decide on a career. By the Second World War, testing by check-mark was established practice everywhere in American life—in the school system, in business, in the professions, in the administration of law, and in the work of hospitals and institutions. The production and administration of tests was an industry employing many hardworking and dedicated people.

Halfway through this period, in the forties, it was manifestly useless to raise even a question about the value and effect of these tests. When in *Teacher in America* I devoted a short chapter to doing so, describing how mechanical tests raised mediocrity above talent, my remarks were ignored or dismissed. I was an obscurantist who lacked the scientific spirit.

Now the tide has turned. It is the testers who are fighting a rear-guard action against the argument which says that their questions are in practice bad and in theory dangerous. Given the widespread use of these tests, their evils affect every literate person. More abstractly but no less truly, the fate of the

nation is affected by what tests do, first, to the powers of those who are learning, and, second, to the selection the tests make among the potential leaders of thought and discoverers of new knowledge.

Multiple-choice questions test nothing but passive-recognition knowledge, not active usable knowledge. Knowing something means the power to summon up facts and their significance in the right relations. Mechanical testing does not foster this power. It is one thing to pick out Valley Forge, not Dobbs Ferry or Little Rock, as the place where George Washington made his winter quarters; it is another, first, to think of Valley Forge and then to say why he chose it rather than Philadelphia, where it was warmer.

Multiple-choice tests, whether of fact or skill, break up the unity of knowledge and isolate the pieces; nothing follows on anything else, and a student's mind must keep jumping. True testing elicits the pattern originally learned; an essay examination reinforces pattern-making. Ability shows itself not in the number of accurate "hits" but in the extent, coherence, and verbal accuracy of each whole answer. Science and math consist of similar clusters of thought, and, in all subjects, to compose organized statements requires full-blown thinking. Objective tests ask only for sorting.

The acts of learning and teaching are more subtle, delicate, elusive than any method so far found. The desire to teach great numbers does raise difficulties correspondingly great. But it is no solution to do something next door to what is wanted simply because that something is easier to do. If there was not enough milk for growing children would we distribute tap water? Though this is not precisely the analogue of what we have done in the matter of examining the young learner's knowledge, it is precisely true of the arguments used in support of mechanical testing: it is easier and cheaper than the method of confronting mind with mind through the written word.

The further argument that essay examinations cannot be

graded uniformly, even by the same reader, only shows again the character of mind itself: it is not an object to be weighed or sampled by volume like a peck of potatoes or a cord of wood. Variations in performance and estimate will always subsist. Hence an objective test of mind is a contradiction in terms, though a fair test, a searching examination, a just estimate are not. Among the tests that are unfair, certainly, are those which penalize the finer mind and those which, through the forceful presence of wrong answers, may divert that mind from the accurate knowledge it possessed a moment before. Anyone who has suddenly doubted the spelling of a word which he was about to write correctly will recognize how easily doubt can work distraction upon thought.

Again, a pupil does not really know what he has learned till he has organized and explained it to someone else. The mere recognition of what is right in someone else's wording is only the beginning of the awareness of truth. As for the writing of essays—and the art of correcting them—excellence can of course not be achieved without practice, which the fatal ease of mechanical testing tends to discourage.

If the tendency of such tests is to denature or misrepresent knowledge, to discourage the right habits of the true student, and to discriminate against the original in favor of the routine mind, of what use are such tests to a nation that has from its beginnings set a high value on instruction and the search for truth? There is no ready answer that is not invidious to the makers of tests. But they too are in good faith, which is why it is urgent and important to study their claims and decide for oneself on which side objectivity does in fact lie. *1962*

History for Beginners

History is first of all a story. It tells what happened at a certain time and place to certain persons and peoples. Or to put it more generally, history as a school subject is the account of human actions in the past. Because it is a story, some part of history can be taught to small children, and it is recommended here that such stories become part of the curriculum toward the end of kindergarten and be continued in the first grade.

The idea of "once upon a time" and "many years ago" gives a good first grasp upon history if it is attached to some interesting incidents and episodes and linked with good pictures or slides. For example: Benjamin Franklin drawing down the lightning through his kite; the Pony Express before trains and planes; Columbus's trouble with his sailors and his vindication by the discovery of land—the list of possibilities is virtually endless. The aim is to show that many curious events took place before the child was born and that there are ways of learning about them. What should be left in the young mind is: the doings and the names of men and women who actually lived on this earth "like you and me" and the vision of their dress, hairstyles, equipment, and modes of speech.

With these fundamentals should go the notion that each of us has a history of our own, each of us is part of the stream of history. Some portion of our share in events is known to our family and friends; some of it stays inside us, in memory, where our reasons for doing things and our purpose in doing them will probably remain hidden. Yet "one of us in this class" may in the future be "important historically." How then will later comers know his or her history? How do we know

what Franklin, Columbus, and the rest thought and did? They told us, directly or indirectly. While they lived or soon after, journalists, historians, and biographers put together what was said and done, by the actors and by the witnesses, and this is how we come to have histories and "lives" (biographies) of the great. From all these—the "contemporary record"—the stories so far learned in this class have been chosen.

It should be added that a well-read and imaginative teacher is often able to do more than I have suggested here. For example, men and women now living who are products of public schools remember hearing and reading at the age of eight or nine about the American Indians. Two or three weeks were devoted to the subject, which opened the young minds to a number of important things: If, as is believable, the Indians came from Asia, what is Asia? It is a continent, far away on the other side of the Pacific Ocean. The Indians over here were not all alike; they belonged to many tribes with different customs. Some were allied with the English colonists (what are "colonists"?); others were hostile and allied with the French (where is France?). Indian ways of getting their living varied from region to region; Indians differed in the works of art they produced and the beliefs they held about divinity. Taken all together, there was a *pre-Columbian* culture—remember Columbus? and the date of his arrival?—where? All this is part of American history, which you are sure to study later.

Beyond this point, the teaching of history in school should proceed cautiously, for as a fully developed subject, history involves adult motives and complex institutions that young children can take but little interest in—for example, the fight over a National Bank, state sovereignty, the franchise, or press censorship. It is therefore recommended that the study of history in continuous fashion should not begin until the seventh grade. Between the first and the seventh grades, the importance of history and interest in it should be sustained simply by reading and discussing more and more complex stories of the past. Teachers of English who assign

stories to read, and teachers of science as they come to great principles, should be asked to make historical points about authors and discoverers and should say something about their lives and works, reinforcing the idea that the consequences of history are with us still, present all the time; we not only make history but are bathed in it.

The adult concerns that make up the staple of written history will have begun to arouse the interest of boys and girls by the age of thirteen or fourteen. At home or at school, in print or on television, they have heard of elections, wars, strikes, treaties, diplomacy, and other features of public life. It is the time to draw on these casual noises from the big world and unite them into an increasingly coherent recital of their meaning, which is to say their origins and purposes. The study of these matters should properly begin with American history. Why American history? Because it requires the least amount of explanation about the details of culture and society. Most of these are familiar, close at hand, understood without effort— as the corresponding details of ancient Egypt or modern China are not.

But at this point, the scheme of instruction must change altogether from what it has been for the lower grades. It must no longer rely for interest on anecdotes, vignettes of the past, and quaint features of olden times—bits and pieces. The essence of genuine history is *continuity* and its main characteristic is *combination* (often *confusion*) of acts, hopes, plans, moves, efforts, failures, triumphs, tragedies—all these arising from the behavior of persons living at a certain time and place.

It follows that "a history course" must cover as many aspects of a period as possible, a period being a sizable span of time—a century at the very least. Near the present day or distant from it, the means of arousing and sustaining interest are always there, because points of comparison are never lacking. For example, if the course begins with the Civil War, the twentieth-century struggle for civil rights is there to provide a link with the issues of the past. If the starting point is 1776

and the War of Independence, modern anti-colonialism and wars for nationhood supply parallels. If it is the landing of the Pilgrims, it is clear that the story of freedom of thought and social betterment is far from over and done with.

But parallels must be wisely spaced and not overdrawn. The aim is to show similarity within difference; otherwise the point of history—the pastness of the past—is lost. The valuable lesson to keep in mind is that emotional and intellectual sympathy with other ways than ours can be achieved and enjoyed.

These aims and efforts in a seventh-grade course should result in the student's permanent possession of a sense of time—the Pilgrims did not arrive in Grandma's time, but much earlier, several grandmas back. After many similar perceptions the centuries begin to acquire their proper look; the student has been endowed with a sense of history. Here is the opportunity to show the value and importance of dates. They are not just a cruel strain on the memory for the sake of passing exams; they are pegs on which to hang clusters of events that share a common time and a related significance. If presented and explained as markings—buoys or lighthouses on the ocean of history—dates will be remembered and used with very little effort.

The seventh-grade course should leave in the mind a sense of rationality about the past. What is called the "logic of events" must begin to be felt. Logic and rationality do not mean reasonableness. Human acts often spring from mad, wild, impulses; but the later observer can rationally see how ambition, revenge, greed, ignorance, hope, habit, idealism, practicality, and unpracticality interact to produce the results that we know occurred. That is what is meant by the logic of events. It is part of the historical sense, a way of understanding that has a most useful result: it makes any part of history a recognizably human affair, something that shows what human beings really did and thought. The student who reads history will unconsciously develop what is the highest value of his-

tory: judgment in worldly affairs. This is a permanent good, not because "history repeats"—we can never exactly match past and present situations—but because the "tendency of things" shows an amazing uniformity within any given civilization. As the great historian Burckhardt said of historical knowledge, it is not "to make us more clever the next time, but wiser for all time."

The object of the course should be learning the full story *as* history, that is to say as facts and meanings the pupil can recite and write about in well-organized consecutive portions with a sense of their continuity. The seventh- or eighth-grade course should form a strong "priming coat" over which later courses can paint in greater detail the unfolding of the American story and its main characters. The same principle will hold true of any offerings in ancient history, European history, or English history.

This simple well-defined purpose cannot be achieved by using the familiar gimmicks and "methods." Beyond the elementary grades, where charades are harmless, there should be no playacting, literal or metaphorical. Impersonating William Penn and the Indians once again may be fun, but it is a waste of valuable time, it distracts from true study, and it gives disproportionate emphasis to episodes as against large events and movements.

It is no less playacting to go through the motions of "research." The word should not even occur, for at that level the thing is non-existent. A report on reading is a fine exercise and it should be called just that, which is its proper name. Even average students see through make-believe; they know they are only fooling around when "Egyptian religion" is first "researched," then "acted out" by the whole class.

Teachers brought up on "methods" may be convinced that good teaching consists in a succession of such "imaginative" devices, to make history "come alive" and keep the class "excited" about learning. But observation and interviews with the young suggest, on the contrary, that these exercises induce

boredom in those who want to learn and are taken as relief from work by those who do not. Excitement, anyway, is an occasional feeling and not the proper mood for learning.

In social studies, the field trip has its proper place, but its counterpart in a history course, which is the visit to some local site or museum, has not much value. The monument or battleground or Indian relic is apt to lack important connection with anything learned and thus remain just another episode. The "come alive" idea is, incidentally, a foolish cliché. A good teacher will so present, relate, and discuss with the class the facts to be learned that he or she will steadily stir up the imaginations of the listening class. History is not dead and does not need resuscitation: it lives in our habits of thought and our institutions, our prejudices and our purposes, and what the history course does is to tell how these things and thoughts came to be as they are.

But what, aside from discussing—turning over and forming opinions—shall the young students do? Read, first and last. History is for reading, and developing a taste for reading history ensures lifelong pleasure. Let some striking portion of Prescott's *Conquest of Mexico* be assigned to a few students, to be read and turned into a *précis*, the best among them to be read aloud in class. Other small groups can read and write something on the same subject, or a similar one. Teach the students to be good critics of what they read—which means, to know how to praise as well as criticize it, but not to moralize.

To find origins and trace the story down to ourselves, as suggested, one may go back a short distance—say, two hundred years—or a much longer one, like two thousand. In either case, one must be sure that the line of descent is clear and genuine. This prime requirement brings up the question frequently debated—what to do about world history? To learn about the United States only, or even about Western civilization, is not enough. We live in "one world" and children today should be taught about Asiatic cultures and African. The

countries of that large tract of earth—so runs the argument—
are going to affect our lives in future, have already done so.
They can boast old and admirable civilizations too, and if we
are to get along with their modern descendants we must learn
to appreciate their heritage. To neglect doing so is to show
ourselves narrow and provincial, ignorant of the greater and
more populous part of the world.

This reasoning sounds plausible and enlightened, but it
deals in abstractions and it loses its force once these are
reduced to concrete particulars. To begin with, the study of
any people's history requires a familiarity with innumerable
facts, customs, and institutions that do not get into the text-
books. The pupil knows about his own people from simply
living where he does. He or she understands what houses look
like, what being married means, and why people go to church
or to an election booth. The very words for these and a thou-
sand other things, as well as the motives and feelings linked
with the actions or conditions they denote, do not need to be
taught at all: they are the well-known facts of daily life. But as
soon as one starts reading about another civilization, the corre-
sponding facts all differ. They are obscure or mistaken until
one has painfully learned a set of other customs, institutions,
purposes, and emotions—a strange world that cannot be
quickly grasped. The terms themselves, even when they look
like ours, are charged with different connotations—for exam-
ple, "family feeling" here and in China, where ancestor wor-
ship has been omnipotent.

There are other obstacles, too. For example, the terms "Asi-
atic" and "African" do not mean simply two or more nations.
Each covers wide territories and diversified peoples and cul-
tures, forming an indefinitely large number of "subjects."
Each—or some—of these may be a proper study for social sci-
ence, but we can hardly claim to know their *history*. To sup-
pose they *have* only *one* history is the first mistake, as when we
lump together "Oriental" things. What is meant by "Orien-
tal"? Is it Chinese, and if so, Northern or Southern or Man-

darin? Is it Japanese or Korean? Is it Javanese or Cambodian? Is it Indian (Hindu) or Pakistani (Moslem)? Is it Tibetan or Sri-Lankian—? One could go on asking and each new name would point to a notably different culture. In short, what we face is several lifetimes of work to master diverse histories, each remote from that of New England or Texas, between which we ourselves see enough differences to require special effort in the teaching of a unified American history.

What may we conclude? Are American schoolchildren to remain "provincial" in the sense of knowing only the history of the West? Two answers suggest themselves. First, "world history" is a term that can apply to information that varies in depth—deeper "at home" (wherever home may be) than elsewhere. It is still a kind of knowledge of the world to know *that* something exists or took place, and even something of what it amounted to, without presuming to say how it was and is regarded by those in whose country it occurred. Every educated mind shows this variation in depth and range: natural limitations make encyclopedic knowledge an impossibility.

But there is nevertheless great value in knowing the *that* and—to a small extent—the *what*. It so happens—to come back to the difficulties of world history—that a good course in modern European history necessarily brings in the existence, and makes clear the importance, of the rest of the world. It brings in the western hemisphere with Columbus and cannot thereafter cut loose from it—European and American history are intertwined. So are European history and the histories of Africa and Asia. For good and evil, colonialism knitted together the destinies of all the peoples of the earth. In that part of the European story, the student learns—superficially but existentially—all that he can absorb of non-Western history, short of mastering the languages and the stories of the peoples involved. If such a student has a good grounding in history, a sense of history and a taste for reading it, his first, superficial awareness of those other great civiliza-

tions will—if he wishes—enable him to deepen that knowledge, by himself, and thus extend his human sympathies and worldly judgment in the unique way that the study of history makes possible. *1984*

Of What Use the Classics Today?

Obviously the first service that a classic does is to connect the past with the present by stirring up feelings akin to those that once moved human beings—people who were in part very much like ourselves and in part very unlike. That is an interesting experience in itself—as interesting as traveling to Tibet or studying the home life of the kangaroo. It is in fact travel, travel in time as well as in space.

But before going on with the other uses of the classics, we should perhaps ask, "What *is* a classic?" Many definitions have been given, which involve such words as "universal" and "permanent." I distrust what they imply. The merest reflection shows that a classic in one country is hardly known in another—therefore not universal. Certainly the classics of the Far East do not exist as such in the Western world. And the Far East is not very far off—it begins in Russia, where, for instance, Pushkin's *Eugen Onegin* is a very great classic. How many people know it over here? Only specialists, like those who know the classics of India, China, and Japan. So much for universality. As for permanence, history is there to tell us that over the centuries the great writers change in value like the dollar or the pound. Who today thinks of Cicero as a tremendous literary figure? Yet he was the idol of the Renaissance. And where was John Donne before T. S. Eliot and his followers made him their master? Shakespeare himself was canonized only 150 years ago by the Romantic poets and critics.

So our first notion about a classic should be that it is a variable designation: it is applied, or can be applied, to works that possess a certain potential of classicality. And it follows that there is no set number of classics—not one hundred or one thousand—no definitive list, even though today in the West a very small group of works have held their own for about four hundred years. This is what has given the illusion of permanence. But there are thousands of works in many languages that are or could be treated as classics.

The question, then, shifts to what makes a work potentially a classic. Here one can point with more assurance to certain features. The first is "thickness," as Henry James called it, referring not to the width of the book on the shelf, but rather to the density of its discourse: much is going on in every line or paragraph; every sentence contains an idea; the whole work covers acres of thought and feeling; whereas the ordinary book, no matter how thick in physical measurement, pegs away at one or two little matters—anything from *How to Win Friends and Influence People* to any of the recent discussions of Japanese industry. Likewise, the poems and novels of our daily fare may be enjoyable or instructive, but they do not recast for us the whole world into a new shape. They throw a few glancing lights on what we already know or suspect.

A second mark of the classic might be called its adaptability. When first launched, it fits an existing situation, perhaps an existing demand. Homer's *Iliad* was doubtless in request by the descendants of the conquerors of Troy. It entertained and flattered them to hear the tale of past glory, not too far in the past. Or, jumping to a much later book and a different situation, the English Civil Wars prompted Hobbes to write *The Leviathan* as a guide to political action. The work suited neither side in the struggle, but that doesn't matter—it did fit the actual predicament, though partisans could not see it.

Today, that same work fits the recurring situation of nationwide disorder and compels us to think not only about the nature of the state, but about the nature of man. For

Hobbes begins with a short treatise on psychology. A classic's thickness makes it serve more than its original purpose. It is owing to this capacity that the classics come and go at different times. Shakespeare did not suit the Augustan age, because he was irregular, wild, ignorant of all that mattered to the Age of Reason. But to the Romanticists who came next, these very defects became great qualities, and Shakespeare was rapidly promoted a classic.

The successive situations that a classic must fit are not of the same kind: the first time it is usually the state of society at the moment; later, it is probably the state of mind of artists and thinkers in search of what Coleridge called "elements that are wanted." These elements, to be sure, have some relation to society, but it is never the general public that digs out, or as we say, revives, the neglected, half-forgotten classic.

This fact leads us to the third requisite that a classic must have—another obvious one: it must gather to itself enough votes to be openly, publicly *called* a classic. The number required is indefinite, of course, and the vote is never unanimous. There is always, about every classic, an unconvinced minority. For example, in each generation many scholars think Virgil's *Aeneid* a feeble plagiarism of Homer, just as in the eighteenth century many believed Homer a barbaric sketch that Virgil had wonderfully perfected. Today, there are plenty of people who think Shakespeare a mediocre playwright, beginning with the theater people who produce him, since they cut, change, add, and generally spice up his plays with novelties before they let us see them on the stage. But an opposition, no matter how large, is usually silent.

One last point about classics: after a work or an author has been voted in, it is the academic community that records the vote and prolongs the term of office. Generally, one masterpiece is chosen as *the classic* by the given author and it is made compulsory reading. Editions with notes and introductions are published and thrust into the hands of the young, who suffer or not, depending on the teacher. In either case, the label is

fixed in the minds of the next generation; no doubt is possible: Shakespeare, Milton, Keats; Homer, Virgil, Dante; Twain, Melville, Poe; Dickens, Fielding, Swift are classics for the English-speaking world—today. By a further wrinkle, there is often a discrepancy between academic and what is called critical opinion. In my youth, Dickens was still read in high school, but leading critics thought him an inferior novelist. He has made a comeback, thanks to a few critics, followed by most, but not all, of the others. The main body is made up of sheep, led by a shepherd and a barking dog.

By now you are doubtless impatient to get to the further uses of the classics, beyond the first one I mentioned, that of establishing a live link with the past. To understand the next use required our going into the nature of a classic, because this second use is: to teach how to read. I mean "read" in the honorific sense of read intelligently and thoroughly. Because a classic is thick and full, and because it arose out of a past situation, it is hard to read. The mental attitude and attention that are good enough for reading the newspaper and most books will not work. We read ordinary matter by running the eye over the print at a steady rate, rarely stopping to think or wonder. The material was chosen and written precisely for this rapid, effortless pace. This easy progress is habit-forming and that is why the overwhelming majority everywhere, including most of the college educated, read only contemporary books, and of these only the read-as-you-run. In college these people may have struggled with a handful of classics and escaped unaffected, but more probably the curriculum was adapted to their tastes, and the readings in English and American literature were of the current sort. Then, once a B.A.—good-bye to all that!

But why, after all, learn to read differently by tackling the classics? The answer is simple: in order to live in a wider world. Wider than what? Wider than the one that comes through the routine of our material lives and through the

paper and the factual magazines—*Psychology Today, House and Garden, Sports Illustrated*; wider also than friends' and neighbors' plans and gossip; wider especially than one's business or profession. For nothing is more narrowing than one's own shop, and it grows ever more so as one bends the mind and energies to succeed. This is particularly true today, when each profession has become a cluster of specialties continually subdividing. A lawyer is not a jurist, he is a tax lawyer, or a dab at trusts and estates. The work itself is a struggle with a mass of jargon, conventions, and numbers that have no meaning outside the specialty. The whole modern world moves among systems and abstractions superimposed on reality, a vast make-believe, though its results are real enough in one's life if one does not know and follow these ever-shifting rules of the game.

Since it is a game and a make-believe, anybody who wants access to human life and its possibilities—to thoughts and feelings as they occur natively or by deep reflection—must use another channel. One such channel can be cut by using the classics of literature and philosophy; a second can be made through the fine arts and music. I say "made" and "cut" not "found," because of that "thickness" to which I keep coming back. The great works do not yield their cargo on demand; but if one reads them with concentration (for one "reads" works of art too), the effort gives us possession of a vast store of vicarious experience; we come face to face with the whole range of perception that mankind has attained and that is denied by our unavoidably artificial existence. Through this experience we escape from the prison cell, professional or business or suburban. It is like gaining a second life. Dr. Johnson, who was not given to exaggeration, said that the difference between a lettered man and an unlettered was the difference between the living and the dead.

This enlargement of vision has a useful by-product. The same habits of persistent scrutiny, of sensitivity to what is not said but implied, of patient meditation after encountering

what is strange—all enhance the power of judging life situations and human character. A course of the classics does not guarantee that a person will be happier or more ethical, but it does foster a certain detachment that tends to make for serenity and possibly for greater decency. In a still more practical, immediate way the classics serve human needs: as an extraordinary means of communication. At the lowest level they supply names and phrases charged with multiple meanings—shortcuts in explanation and persuasion; and at the highest, they create a body of understanding based on what is an actively shared experience.

The first of these aids to communication comes from the fact that the classics have contributed to the general vocabulary, even though the ordinary citizen is not aware of it. Take a recent headline on the front page of the *New York Times:* "Aluminum Not the Achilles' Heel of the U.S.S. Stark." The reference was to the ship bombed in the Persian Gulf, and it was the first indication that the ship had a heel. Achilles' heel of course means weak spot, but the newsman preferred a colorful turn of phrase; he used it perhaps without knowing where it came from and how it got its meaning. Nor is this an isolated instance. In one issue of *Time* magazine I found: the Golden Mean, a judgment of Solomon, and crossing the Rubicon. People evidently think by means of these images, and there are fat reference books to tell the ignorant what they stand for. Taken together, they might be described as the fallout from the high energy of the classics.

It would seem desirable to know these things in their original setting, in context. Especially now that education is skimpy, these traditional allusions are being corrupted by misuse and therefore lost to clear meaning. One comes across such things as: "undo the Gordon knot" (presumably a splice invented by one Gordon); the "rock of Sillyphus," and "a Senatorian shout." As for King Canute, that very intelligent ruler is misrepresented as wanting to roll back the ocean, when in fact he was showing his courtiers that he could not stem the

waves as they apparently wanted. In short, if one likes to know what one is talking about, it is well to be acquainted with the stories that give point to the catchwords.

And when one goes from the newspaper to ordinary books on contemporary matters, one will be at a loss if unable to grasp what is implied by quotations from the great poets, philosophers, and novelists. Authors find it a convenient shorthand to write: the thing-in-itself, more honored in the breach, Socratic irony, King Charles's head, Gargantuan appetite, mute inglorious Miltons. But again, reader and writer must be at one. Not long ago, I read an interview in which the wealthy builder of a new mansion said that he and his wife had now realized their dream of having "a fine and private place." What he did not realize was that he was quoting Andrew Marvell's description of the grave.

These classic elements of reading and writing are part of something larger known as our cultural heritage—the accumulated lore about our forebears, their doings and sayings. Nobody grows up in a settled society without picking up bits and pieces of it and being in some way molded by them. Young Washington and the cherry tree; Lincoln's log cabin and his toil as a rail splitter; General Sherman with his "War is hell" are fragments of past life embedded in the American mind. Their use is not immediately apparent, yet they mean more than "Do not tell a lie"; "humble origins do not keep a good man down," and so on. They recall a scene and carry a deeper message than the platitude they express: Sherman's emphatic word comes not from a pacifist but from the man who led a march of devastation into the South. It is this half-expressed, half-implied part that does the work of cultural continuity and keeps a nation unified thanks to common feelings and common understanding.

A famous anecdote makes the point. The poet Coleridge was once lecturing in London about English literature and happened to mention that Dr. Johnson, coming home one night, found a woman of the streets who had fainted and lay in

the road. He picked her up and carried her on his back to his lodging, where he revived and fed her and housed her until she was well. Coleridge's fashionable audience snickered and clucked, the men amused, the women shocked. Coleridge stopped and said gravely: "I remind you of the parable of the Good Samaritan." Ten quick words settled the murmuring. The appeal to a common cultural example, in this case from the Scriptures, had dispelled foolishness and made the crowd think and feel as one. An hour's preaching about charitableness and the virtue of forgetting conventions when human life is at stake would have had no such decisive force; it would have been explanation and apology, whereas the allusion to the Bible instantly evoked the right emotions in harness with the right ideas.

The need for a body of common knowledge and common reference does not disappear when a society is pluralistic. On the contrary, it grows more necessary, so that people of different origins and occupation may quickly find familiar ground and, as we say, speak a common language. It not only saves time and embarrassment, but it also ensures a kind of mutual confidence and goodwill. One is not addressing an alien, as blank as a stone wall, but a responsive creature whose mind is filled with the same images, memories, and vocabulary as oneself. Otherwise, with the unstoppable march of specialization, the individual mind is doomed to solitude and the individual heart to drying up. The mechanical devices that supposedly bring us together—television and the press, the telephone and the computer network—do so on a level and in a manner that are anything but nourishing to the spirit. Even the highbrow programs on television present literature and history in garbled forms; the medium requires that costume, scenery, and moving vehicles upstage philosophy. What is worth noting is that the public seems to be vaguely aware of this great void: programs high and low are falling in popularity and the suppliers are in trouble.

From one who feels deprived in this way, recourse to the classics requires nothing new; it does not call for superhuman powers. To earlier generations, books were as natural a source of information and entertainment as broadcasts are to the young today. It was the urge to learn from books that made the common people clamor for education; they were willing to pay for public schools so that everybody could read and write. Rising in the world was a strong motive, but the satisfaction of curiosity about life was another. William Dean Howells tells us in his autobiography how people felt about books in his native town on the Ohio around 1840. The river steamer would come up to the pier every so often—nobody knew exactly when—and amid goods of all kinds would unload a barrel of books. Within a few minutes these books would have been sold. The buyers were farmers and small tradesmen who had never been to high school, let alone college. Howells's self-education, like Lincoln's, came from these books.

What constitutes today the cultural heritage which formerly was automatically taken as known by people who were educated and who educated others? The quandary is real, because of the large number of classics piled up during the last five hundred years, and because the study of the languages needed to read the ancients has virtually ceased. Being troubled by this uncertainty, three thoughtful and learned persons have recently drawn up an inventory of nearly five thousand facts, names, ideas, and technical terms required for cultural literacy. That is their term for the minimum portion of the heritage they think adequate to maintain a national culture.

Having made and published the list, they are now at work on a dictionary that will explain the five thousand terms. This double effort is praiseworthy; it should call attention to the spread of a damaging ignorance. But the remedy seems more mechanical than educative. To learn "the facts" about Aristotle and Luther and Alexander Hamilton and 4,997 others, all in the air, so to speak, would be a gigantic feat of memorization, whereas to learn these facts and much else while studying

history and reading the classics is by comparison very easy. The facts then stick in the mind like the names of the streets around your house: you never set out to learn them, they come as part of your direct acquaintance with the place. This difference seems to me all-important; and it points to another use of the classics: they educate you as you read—provided you read them in the right manner and at the right time. Consider this last condition: when and how should the classics enter our lives? I have said that the classics cannot be read like a magazine article. It takes some form of compulsion to get started, and often the eager starter bogs down in difficulties. To give help, therefore, and to apply the steady pressure, coaching is necessary. Hence the classics must be met and conquered at latest in college.

At latest: the really appropriate time would be the last two years of high school, when the onset of maturing stirs feelings and thoughts about the meaning of life and the nature of society. Our obtuse educational experts would be astonished to see how passionately a group of perfectly average fifteen-year-olds can be brought to discuss Machiavelli's *Prince* or the *Confessions of St. Augustine.* But the opportunity is missed, and college offers the last chance of initiating the habit of reading and enjoying solid books.

Having so far sketched the advantages to be derived from the classics—their enlargement of the spirit by vicarious experience, their use as a medium of rapid and comprehensive communication, their influence in building a Self and strengthening the judgment—I am bound before closing to add a word of caution. Like all good things, the classics can be misused.

Studying the classics can wind up in mere bookishness. Their contents will have been absorbed faithfully and accurately, but the mind that holds them seems unable to get outside its acquisition and use it. If this is not due to an incurable flaw of the mind, it is due to teaching that has trained percep-

tion and left out imagination. By imagination I do not mean undirected fancy or daydreaming. I mean imagining the real, making a successful effort to reconstruct from words on a page what past lives, circumstances, and feelings were like. This ability does not come to everybody by nature, but any germ of it can be developed by practice after teaching has shown the way. It is anything but unchecked speculation. To imagine— say—the life of a medieval serf, one's ideas must conform to a large number of facts found in the sources as well as catch somehow an impalpable atmosphere. Usually, one must first unlearn the many thought-clichés absorbed from miscellaneous reading, bad films, and cheap romances.

Imaginative understanding is what enables the mind to transfer its knowledge to new situations. The England of *Tom Jones,* the Russia of *War and Peace* are gone, but the tribulations of Tom and of Pierre can still serve as touchstones in the present, provided our imagination clearly sees how the growth of a young soul has been changed by a changed state of society and how it has remained the same.

Again, for this play of the imagination the works themselves must be read and read whole, not the summaries in reference books. Only at this price can the mind form true and distinct images. If, for example, one goes to essays or handbooks on "The Legacy of Greece," Homer, Plato, Thucydides, and the rest merge into an idyllic picture of a joyful pagan people, all connoisseurs of fine art and expert mathematicians. The developed imagination rejects such a picture at sight. It knows that such things cannot be, because it has acquired the power of seeing the world in three dimensions—fact, connotations, and general truth or probability. The mind does not get stuck in the first or second position.

To develop in the young this power to move freely among perceptions, teachers must exhibit it themselves. They must of course know how to prevent misconceptions and how to coax and cheer the weaker spirits over the hurdles. But if they happen to be specialists, they must not abandon the readings to

teach the scholarship that relates to them. Some of the results of scholarship may be brought in to shed occasional light on and around the work, but the work is there to shed its own light; it is not material for dissection or dissertation. And everything in it may be usefully related to the world and to the Self; it is the role of the imagination to forge the links.

No doubt there are dangers in this free open realm as in every other. It is easy to talk nonsense and make false connections. But the reward is not in doubt: it is pleasure, renewable at will. That pleasure is the ultimate use of the classics. All the great judges of human existence have said so, from Milton, who called reading "conversation with the master spirits," to Virginia Woolf, who imagined the Almighty saying to St. Peter about some newcomers to heaven: "Look, these need no reward. We have nothing to give them. . . . They have loved reading." I can only add one thing: it is always time to stop repeating the wise sayings and begin to believe them. *1987*

The University's Primary Task

The modern university has become a great engine of public service. Its faculty of Science is expected to work for our health, comfort, and defense. Its faculty of Arts is supposed to delight us with plays and exhibits and to provide us with critical opinions, if not to lead in community singing. And its faculty of Political Science is called on to advise government and laity on the pressing problems of the hour. It is unquestionably right that the twentieth-century university should play this practical role.

But this conspicuous discharge of social duties has the effect of obscuring from the public—and sometimes from itself—the university's primary task, the fundamental work

upon which all the other services depend. That primary task, that fundamental work, is Scholarship. In the laboratory this is called pure science; in the study and the classroom, it is research and teaching. For teaching no less than research demands original thought, and addressing students is equally a form of publication. Whatever the form or the medium, the university's power to serve the public presupposes the continuity of scholarship; and this in turn implies its encouragement. By its policy, a university may favor or hinder the birth of new truth. This is the whole meaning of the age-old struggle for academic freedom, not to mention the age-old myth of academic retreat from the noisy world. *1954*

The Scholar Is an Institution

What is scholarship? Scholarship is simply the unceasing effort to bring order into the confusion of Tradition. By searching out, by comparing and weighing, by organizing facts, the scholar tries to hold in check the perpetual tendency of mankind to get things wrong, to mix up names and facts and ideas, to blur the outlines of its own active beliefs. The history of the human mind is the history of deviation from accurate meaning and memory. The history of scholarship is one long fulfillment of the formula: "Look! It is not as you think."

The scholar teaches us our language and our literature, interprets our history, compels us to recognize that other peoples inhabit the earth, lays open to our view their ways and wills, corrects at every turn the first false impressions that we form of the heavens, the fields, and the workings of our human frame; tells us how we should walk, sleep, eat, dance, and

think; and tries against heavy odds to light up the dark chamber of our brains with the artistic and religious visions of the great spirits of humanity.

This, then, is the scholar: he or she is a transmitter, a publisher of what it is good for us to know. As such he has always existed, whether as priest, poet, or garrulous elder of the tribe. He is an institution as old as society itself. In high civilizations his task is so huge that it is split up into specialties, which we now call by classical names ending in -culture or -ology. If some of these nowadays receive a kind of public worship as science, and are invidiously compared with scholarship, the distinction is here meaningless. For I am speaking of the scholar or scientist as the regulator of the people's mind; I am not speaking of the applied scientist or applied scholar who temporarily serves as ambassador or makes bombs.

When we complain that the behavior of mankind has not kept pace with its inventions, we recognize that mechanical appliances, though patent, are ultimately less influential than the intangible results of thought, which take the form of common beliefs and common practices. Lord Keynes once pointed out that the economic ideas of any generation of businessmen were the cast-off notions of the great theorists of fifty years before. This process illustrates a generality. The handing down of ideas is what we mean by a tradition, what we mean by a culture, and it has the force of any natural presence. Just as we assume that the existence of a bridge implies solid engineering, so the public assumes that the presence of a common opinion implies solid scholarship. "Everybody knows," they will say, "that all German philosophers have been Fascists"; or "It stands to reason that an alliance with a European state is bad for America"; or "*Of course,* Shakespeare is the greatest poet and Beethoven the greatest musician the world has ever seen."

Where do these dogmas come from? From the newspaper, the schoolbook, the broadcast, the popular encyclopedia—all of which ultimately lead back to the scholar, who is supposed

to know what he is talking about, and who is supposed to talk in a responsible manner about what he knows. Think of the number of firm convictions which go to make up a national culture, think of the number of souls who act from day to day on the strength of these convictions, and you begin to gauge the immense amount of potential energy that the scholar circuitously directs. You begin to see the scholar as manning the controls of a huge hydraulic press, slow in action, but irresistible in its multiplication of the pressure of a single hand.

1947

Exeunt the Humanities

Ah, the humanities! Everybody pays lip service to their worth; everybody agrees there is no finer sight than a full-blooded humanist; but the students don't seem to get humanized by contact with humanistic subjects, don't elect them *en masse*, and the prevailing but covert opinion is that the humanities are only for those who mean to make a career in one or another of them.

If that is true—and I have good reasons to think it is—then it must be that the caring for the humanities during the long stretch of their public agony has been wrong. But whence this wrongness? To begin with, are we sure we know which *are* the humanities? Usually, the study of language and literature; the history of the arts; philosophy; and sometimes history, sometimes not, depending on the whim of social scientists—it really doesn't matter. This threefold division—science, social science, humanities—which is convenient for academic organization, contains the germ of the evil that has infected nearly every attempt to revigorate and derive benefit from the humanities. By becoming "subjects" grouped over

against other subjects termed nonhumanistic, the humanities inevitably become specialties like those other subjects. And thus their original purpose has been perverted or lost.

So true is this that the latest type of study in literature and the arts is purely technical. One studies poetry and fiction or art and music not to receive and enjoy a message, but to apply one or another complicated method, a method through which feeling and pleasure and meditation are pretty well excluded. As specialist practices, these "approaches" as they are rightly called (for they do not reach the heart of the matter) may or may not be suitable for students who mean to specialize in this or that once-upon-a-time humanistic subject. Their value is not the point. The point is that if the humanities are made into so many social or other sciences, no humanizing effect can be expected from the transaction.

This assertion is really a concealed tautology, but it contains the principle that teaching the humanities to the nonspecialist requires the humanistic attitude. The teacher must extract from the humanities whatever they have to say about man, and the syllabus and department and dean and professional association must allow him to do so. This conclusion in turn brings unexpected discoveries. Listen to William James talking on this subject to a gathering of early American women graduates: "What is especially taught in the colleges has long been known by the name of the 'humanities,' and these are often identified with Greek and Latin. But it is only as literatures, not as languages, that Greek and Latin have any general humanity-value; so that in a broad sense the humanities mean literature primarily, and in a still broader sense the study of masterpieces in almost any field of human endeavor. Literature keeps the primacy; for it not only *consists* of masterpieces, but is largely *about* masterpieces, being little more than an appreciative chronicle of human masterstrokes, so far as it takes the form of criticism and history."

James's definition must be taken literally: "human masterstrokes" include the great performances of physical scien-

tists: "You can give humanistic value to almost anything by teaching it historically. Geology, economics, mechanics are humanities when taught with reference to the successive achievements of the geniuses to which these sciences owe their being. Not taught thus, literature remains grammar, art a catalogue, history a list of dates, and natural science a sheet of formulas and weights and measures. The sifting of human creations!—nothing less than this is what we ought to mean by the humanities."

James's final exclamation does not entail our browbeating the science departments into turning humanistic, though some scientists already are, and more are willing to be. What James saw as a plain possibility has been partly fulfilled by courses in the history and the philosophy of science, where the creations of scientists are dealt with as parts of human biography and human cultural history.

But the lesson in James's words can be applied even more generally. It tells us that all knowledge may be put to two uses: it may serve an immediate and tangible purpose by guiding technical action; and it may serve more permanent, less visible ends by guiding thought and conduct at large. If we call the first the professional or vocational use, the second may be called the social or moral (or philosophical or civilizing)—the term does not matter. One is know-how, the other is cultivation.

Now, for some hundred years American colleges and universities have innocently confounded the two, hoping to give their students the benefit of both. The double benefit is a proper aim. Both endeavors are worthy and both are valuable practically, but they require distinct uses of subject matter and of the mind, and they cannot be fused into one.

How did the mistake happen? At the turn of the nineteenth century the colleges were under great pressure—from the natural sciences, from organized business, from the growing technologies and the newly self-conscious professions. In addition, the new graduate schools were riding the wave of

specialism. The undergraduate colleges somehow had to rejustify their existence. To play a distinctive role, they had only the liberal arts to cling to; so in order to placate both the social demand for professionals and the scholarly demand for specialists, the colleges broke up the old classical curriculum and invented the elective system. It was Dr. Eliot of Harvard who became its great exponent; he was a chemist.

As such, Dr. Eliot would naturally expect that a future chemist or geologist would take three, four, six, or more years of his chosen subject to become an accomplished scientist. But Eliot was quite content to see that same undergraduate take, outside his science, one semester of this and another of that for four years—perhaps four years of freshman work. The need to *build* a humanistic education in a controlled and rigorous way was forgotten, lost in the shuffle. The college curriculum broke into fragments and departments became small principalities competing for students and seeking prestige by specialism.

Not all thinkers about education made the same mistake. One of the perceptive was William James, another was John Jay Chapman, a third and the closest to the institutional trouble was the president of Princeton, Woodrow Wilson. In 1910 he spoke to the Association of American Universities on "The Importance of the Arts Course as Distinct from the Professional and Semi-professional Courses." He began by saying: "All specialism—and this includes professional training—is clearly individualistic in its object. . . . The object . . . is the private interest of the person who is seeking that training." This exclusivity he regarded as "the intellectual as well as the economic danger of our times"—an intellectual danger because the merely trained individual is a tool and not a mind; an economic danger because society needs minds and not merely tools. What Wilson feared was social and institutional ossification through set routines. He saw that "by the time a man was old enough to have a son at college, he had become so immersed in some one special interest that he no longer com-

prehended the country and age in which he was living." So it should be "the business of a college to re-generalize each generation as it came on."

That phrase is evocative and precise: to *re*-generalize, that is, to correct a recurrent fault. To that end Wilson wanted "a discipline whose object is to make the man who received it a citizen of the modern intellectual and social world, as contrasted . . . with a discipline whose object is to make him the adept disciple of a special interest." He called for a body of studies whose goal is "a general orientation, the creation in the mind of a vision of the field of knowledge . . . the development of a power of comprehension."

With the aid of James and Wilson, it is easy to see that the humanities, the liberal arts, stand at the opposite extreme from the professional specialties, including the scholarship *about* the humanities—easy to see but evidently hard to remember. Why? Because the professional urge inspires the skeptical question, Of what use these liberal arts to the vocation-bent? Will they not resist the instruction or be spoiled by it? Neither James nor Wilson is the enemy of specializing or of vocational and professional training. The antagonism comes from the other side, the side of the trades and professions, and it has to be met head-on. James did so in one sentence which has become famous, though it is not generally understood. He said: "A certain amount of meditation has brought me to this as the pithiest reply which I myself can give: The best claim that a college education can possibly make on your respect, the best thing it can aspire to accomplish for you is this: that it should *help you to know a good man when you see him.*" As he was addressing women, James added: "This is as true of women's as of men's colleges; but that it is neither a joke nor a one-sided abstraction I shall now endeavor to show." The development of his aphorism was this: "At the [vocational and professional] schools you get a relatively narrow practical skill, you are told, whereas the colleges give you the more liberal culture, the broader outlook, the his-

torical perspective, the philosophic atmosphere, or something which phrases of that sort try to express. You are made into an efficient instrument for doing a definite thing, you hear, at the schools; but, apart from that, you may remain a crude and smoky kind of petroleum, incapable of spreading light. Now, exactly how much does this signify?

"It is certain, to begin with, that the narrowest trade or professional training does something more for a man than to make a skilful practical tool of him—it makes him also a judge of other men's skill. . . . Sound work, clean work, finished work: feeble work, slack work, sham work—these words express an identical contrast in many different departments of activity. . . .

"Now, . . . since our education claims primarily not to be 'narrow,' [are] we also made good judges between what is first-rate and what is second-rate only?"

The answer, of course, is Yes:

"Studying in this way, we learn what types of activity have stood the test of time; we acquire standards of the excellent and durable. All our arts and sciences and institutions are but so many quests of perfection . . . and when we see how diverse the types of excellence may be, how various the tests, how flexible the adaptations, we gain a richer sense of what the terms 'better' and 'worse' may signify. . . . Our critical sensibilities grow both more acute and less fanatical. We sympathize with men's mistakes even in the act of penetrating them; we feel the pathos of lost causes and misguided epochs even while we applaud what overcame them. . . . The feeling for a good human job anywhere, the admiration of the really admirable, the disesteem of what is cheap and trashy and impermanent—this is what we call the critical sense, the sense for ideal values. It is the better part of what men know as wisdom."

These several answers to the challenge, Of what use is the humanistic discipline? must be inculcated in the students from the outset. They must be made to see—or take on trust

provisionally—that their studies are intensely practical. The humanities properly acquired will effect in them a transformation of mind and character which cannot be described, but which they will find useful all life long.

Just as important as making this prediction is to refrain from making false promises. Studying the humanities will not make one more ethical, more tolerant, more cheerful, more loyal, more warmhearted, more successful with the other sex or popular at large. It may well contribute to these happy results, but only indirectly, through a better-organized mind, capable of inquiring and distinguishing false from true and fact from opinion; a mind enhanced in its ability to write, read, and compute; a mind attentive to the world and open to good influences, if only because of a trained curiosity and quiet self-confidence.

All these things are likely results; they are not guaranteed. Life, like medicine, offers no certainties, but we go on living and going to the doctor's. So it must be said again: no exaggerated claims for the humanities, but a conviction in the teacher, in the department, in the faculty, in the administration, in the indispensable group of advisers, that this body of studies has a use—a practical use in daily life, even though no one can say, "I made a more effective presentation to the board because I've studied Aeschylus."

When making his point about professional training as individualistic and the generalizing culture as social, Wilson unwittingly raised a political question. All too often it is discussed in the vague terms of "democracy" and "elitism," the humanities supposedly favoring the latter and running counter to the former. Such arguments are foolishly inconsistent. A person is not a democrat thanks to his ignorance of literature and the arts, nor an elitist because he or she has cultivated them. The possession of knowledge makes for unjust power over others only if used for that purpose: a physician or lawyer or clergyman can exploit or humiliate others, or

he can be a humanitarian and a benefactor. In any case, it is absurd to conjure up behind anybody who exploits his educated status the existence of an "elite" scheming to oppress the rest of us. Humanists, as Wilson knew, are individualists too. As such, they are the last people to suspect of a conspiracy against the laity.

A more real danger than the imagined elite is our present combination of specialist and half-baked humanist education. The danger is that we shall become a nation of pedants. I use the word literally and democratically to refer to the millions of people who are moved by a certain kind of passion in their pastimes as well as in their vocations. In both parts of their lives this passion comes out in shop talk. I have in mind the birdwatchers and nature lovers; the young people who collect records and follow the lives of pop singers and movie stars; I mean the sort of knowledge possessed by "buffs" and "fans" of all species—the baseball addicts and opera-goers, the devotees of railroad trains and the collectors of objects, from first editions to *netsuke*.

They are pedants not just because they know and recite an enormous quantity of facts. It is not the extent of their information that appalls; it is the absence of any reflection upon it, any sense of relation between it and them and the world. Nothing is brought in from outside for contrast or comparison; no perspective is gained from the top of their factual pile; no generalities emerge to lighten the sameness of their endeavor. Their hoard of learning is barren money—it bears no *interest*, because in the strictest sense it is not put to use. One might argue that this knowledge of facts is put to use when the time comes to buy more rare books or silver plate or postage stamps. But that is not using knowledge to adorn life and distill wisdom, as all knowledge can be made to do when it is held and used humanistically.

I do not offer these remarks as an outsider who is scornful. I love baseball, opera, railroad trains, and crime stories, and I know something about them. But I am dismayed that others,

who know much more, seem unable to do anything with their knowledge except foregather with their kind to match items of information.

All advocates of a humanistic education tend, as I have tended, to stress its all-importance as a discipline of the mind. It is formative, they say, rather than informative, and they urge teachers to remember that they should not be primarily concerned with expounding subject matter, but rather with developing modes of thought and feeling. In some humanists it is even a kind of flourish, a gesture of pride, to add that they care not if ten years out of college a graduate has forgotten everything he learned there. To say this seems to mark off the high-plane humanities from the earthy grind of the vocations and professions. It is a ridiculous affectation. If a student really grasps what the humanities are and are for, he cannot help remembering in detail the successive elements that he built up into a cultivated mind. *1980*

VIII

*On America
Past and Present*

On Baseball

Whoever wants to know the heart and mind of America had better learn baseball, the rules and realities of the game—and do it by watching first some high school or small-town teams. The big league games are too fast for the beginner and the newspapers don't help. To read them with profit you have to know a language that comes easy only after philosophy has taught you to judge practice. Here is scholarship that takes effort on the part of the outsider, but it is so bred into the native that it never becomes a dreary round of technicalities. The wonderful purging of the passions that we all experienced in the fall of '51, the despair groaned out over the fate of the Dodgers from whom the league pennant was snatched at the last minute, give us some idea of what Greek tragedy was like. Baseball *is* Greek in being national, heroic, and broken up in the rivalries of city-states. How sad that Europe knows nothing like it! Its interstate politics follow no rules that a people can grasp. At least Americans understand baseball, the true realm of clear ideas.

That baseball fitly expresses the powers of the nation's mind and body is a merit separate from the glory of being the most active, agile, varied, articulate, and brainy of all group games. It is of and for our century. Tennis belongs to the individualistic past—a hero, or at most a pair of friends or lovers, against the world. The idea of baseball is a team, an outfit, a section, a gang, a union, a cell, a commando squad—in short, a twentieth-century setup of opposite numbers.

Baseball takes its mystic nine and scatters them wide. A kind of individualism thereby returns, but it is limited—eternal vigilance is the price of victory. Just because they're far apart, the outfield can't dream or play she-loves-me-not with daisies. The infield is like a steel net held in the hands of the catcher. He is the psychologist and historian for the staff—or else his signals will give the opposition hits. The value of his headpiece is shown by the ironmongery worn to protect it. The pitcher, on the other hand, is the wayward man of genius, whom others will direct. They will expect nothing from him but virtuosity. He is surrounded no doubt by mere talent, unless one excepts that transplanted acrobat, the shortstop. What a brilliant invention is his role despite its exposure to ludicrous lapses! One man to each base, and then the free lance, the troubleshooter, the movable feast for the eyes, whose motion animates the whole foreground.

The rules keep pace with this imaginative creation so rich in allusions to real life. How excellent, for instance, that a foul tip muffed by the catcher gives the batter another chance. It is the recognition of Chance that knows no argument. But on the other hand, how wise and just that the third strike must not be dropped. This points to the fact that near the end of any struggle life asks for more than is needful in order to clinch success. A victory has to be won, not snatched. We find also our American innocence in calling "World Series" the annual games between the winners in each big league. The world doesn't know or care and couldn't compete if it wanted to, but since it's us children having fun, why, the world is our stage. I said baseball was Greek. Is there not a poetic symbol in the new meaning—our meaning—of "Ruth hits Homer"?

Once the crack of the bat has sent the ball skimming left of second between the infielder's legs, six men converge or distend their defense to keep the runner from advancing along the prescribed path. The ball is not the center of interest as in those vulgar predatory games like football, basketball, and polo. Man running is the force to be contained. His getting to

first or second base starts a capitalization dreadful to think of: every hit pushes him on. Bases full and a homer make four runs, while the defenders, helpless without the magic power of the ball lying over the fence, cry out their anguish and dig up the sod with their spikes.

But fate is controlled by the rules. Opportunity swings from one side to the other because innings alternate quickly, keep up spirit in the players, interest in the beholders. So does the profusion of different acts to be performed—pitching, throwing, catching, batting, running, stealing, sliding, signaling. Blows are similarly varied. Flies, Texas Leaguers, grounders, baseline fouls—praise God the human neck is a universal joint! And there is no set pace. Under the hot sun, the minutes creep as a deliberate pitcher tries his feints and curves for three strikes called, or conversely walks a threatening batter. But the batter is not invariably a tailor's dummy. In a hundredth of a second there may be a hissing rocket down right field, a cloud of dust over first base—the bleachers all a-yell—a double play, and the other side up to bat.

Accuracy and speed, the practiced eye and hefty arm, the mind to take in and readjust to the unexpected, the possession of more than one talent and the willingness to work in harness without special orders—these are the American virtues that shine in baseball. There has never been a good player who was dumb. Beef and bulk and mere endurance count for little, judgment and daring for much. Baseball is among group games played with a ball what fencing is to games of combat. But being spread out, baseball has something sociable and friendly about it that I especially love. It is graphic and choreographic. The ball is not shuttling in a confined space, as in tennis. Nor does baseball go to the other extreme of solitary whanging and counting stopped on the brink of pointlessness, like golf. Baseball is a kind of collective chess with arms and legs in full play under sunlight.

How adaptable, too! Three kids in a backyard are enough to create the same quality of drama. All of us in our tennis days

have pounded balls with a racket against a wall, for practice. But that is nothing compared with batting in an empty lot, or catching at twilight, with a fella who'll let you use his mitt when your palms get too raw. Every part of baseball equipment is inherently attractive and of a most enchanting functionalism. A man cannot have too much leather about him; and a catcher's mitt is just the right amount for one hand. It's too bad the chest protector and shinpads are so hot and at a distance so like corrugated cardboard. Otherwise, the team is elegance itself in its striped knee breeches and loose shirts, colored stockings and peaked caps. Except for brief moments of sliding, you can see them all in one eyeful, unlike the muddy hecatombs of football. To watch a football game is to be in prolonged neurotic doubt as to what you're seeing. It's more like an emergency happening at a distance than a game. I don't wonder the spectators take to drink. But who has ever seen a baseball fan drinking within the meaning of the act? He wants all his senses sharp and clear, his eyesight above all. He gulps down soda pop, which is a harmless way of replenishing his energy by the ingestion of sugar diluted in water and colored pink.

Happy the man in the bleachers. He is enjoying the spectacle that the gods on Olympus contrived only with difficulty when they sent Helen to Troy and picked their teams. And the gods missed the fun of doing this by catching a bat near the narrow end and measuring hand over hand for first pick. In Troy, New York, the game scheduled for 2 P.M. will break no bones, yet it will be a real fight between Southpaw Dick and Red Larsen. For those whom civilized play doesn't fully satisfy, there will be provided a scapegoat in a blue suit—the umpire, yell-proof and evenhanded as justice, which he demonstrates with outstretched arms when calling "Safe!"

And the next day in the paper: learned comment, statistical summaries, and the verbal imagery of meta-euphoric experts. In the face of so much joy, one can only ask, Were you there when Dogface Joe parked the pellet beyond the pale?

* * *

An American had been saying this, or some of it, once, to a British friend, on whose responsive face he saw signs of distress that made him stop. The American respected his friend's judgment and mistrusted his own headlong flights.

"Baseball," said the Englishman, "is an excellent game, no doubt. I can hear that smack of 'the pellet' in my palm, and almost feel it too. But aren't you a little unfair in taking all the credit for the game and calling it American? Shouldn't you mention the fact that baseball comes straight out of cricket, which is a wholly English game?"

"I'd mention it," replied the American after a moment of deliberation, "if it weren't for one thing—the fatal flaw in cricket, which, to my mind, puts it right out of consideration."

"What is that?"

"Simply the fact that no one understands it, I mean knows what it is."

"You mean no one in the United States?"

"No, no. I mean no one at all, anywhere. Just between you and me, I don't think cricket has ever been played."

"What *are* you talking about?"

"It's my belief that at some time in the past an Englishman may have had the idea of a game to be played with bats and balls. He started to explain it—as many Englishmen have done to their American friends—but he couldn't go on. It was too complicated. What saved him and his idea was that he was talking to fellow Englishmen. They hate theory anyway, so they went ahead and got bats and balls—of sorts—and to oblige their friend, they stood around with them, running here and there very quietly from time to time, making believe they were playing the game. That's how the tradition started."

"What tradition? I'm lost!"

"The tradition that cricket is the national game and that every Englishman loves it. In a sense he does love it. 'Playing the game' means he wouldn't do a thing to dispel the general impression that there *is* such a thing—it's an exact parallel to what they call the British Constitution."

"You're pulling my leg. There *is* such a game."

"I assure you there isn't. You'll admit, surely, a thing that everybody knows, namely, that Englishmen don't know when they're beaten? Well, that follows logically from the fact that Englishmen don't know when they're playing. Name me another game than cricket which you don't know you're playing when you are?"

"You're juggling with words!"

"And you're blinding yourself to the evidence. Is it likely that people capable of inventing a game would make it consist of such objects as sticky wickets, creases, fast bowlers, overs, and centuries? One of their terms gives the show away: every so often they have a *Test Match*—it's to find out whether the game is possible or not."

"What do you suppose happens then?"

"After a few days on the field, the excitement dies down. The issue remains in doubt. Meantime—and this is conclusive— every British subject has a perfect right to say to any other: 'This isn't cricket.' How do you reconcile that with a set of rules for an actual game?"

"B-b-but, you can't be serious. I can make allowances for the fact that you've never seen a cricket match but you must have read about the game in *Punch*. If you can't follow the sense of it, there must be some reliable source—"

"Would the *Encyclopaedia Britannica* do?"

"Certainly."

"Well then. Get hold of the last British edition and look up cricket. What do you find? The history of the local clubs. Names of great figures. Older and modern style—style, mind you! Not a single word about the rules or who does what. No diagram, even—in an encyclopedia too. But no wonder—it's as I told you. The best you can hope for is that by watching our G.I.'s play baseball, some of your brighter fellows will find a way to make cricket come out. Compared to a real game it's in the chrysalis state." 1953

Race: Fact or Fiction?

Among the words that can be all things to all men, the word "race" has a fair claim to being the most common, the most ambiguous, and the most explosive. No one today would deny that it is one of the great catchwords about which ink and blood are spilled in reckless quantities. Yet no agreement seems to exist about what race means. Race seems to embody a fact as simple and obvious as the noonday sun, but if that is really so, why the endless wrangling about the idea and the facts of race? Why is it that every writer and nearly every man, literate or illiterate, differs from every other on the questions: What is a race? How can it be recognized? Who constitute the several races? Which are superior? Which nearest the ape and which nearest the image of the Creator?

These questions are not the playthings of academic minds. Today no argument is needed to prove that race and the feelings connected with race are one of the powers shaping the world. One European nation of seventy million inhabitants is governed by men whose main policies involve certain hard-and-fast race-beliefs. Another European nation not long since found it useful to whip up animosity against black-skinned men to help justify an imperialistic war. In the Balkans, in Turkey, in Persia, in Scandinavia, in Holland, sizable groups of the population work with or without government backing to boost their own "racial type" at the expense of all the others. "Oppressed nationalities" in Catalonia, Brittany, Ireland, Alsace-Lorraine, and Palestine throw race into the balance of their economic and political grievances as an important makeweight. Immigrants from the various countries of Europe have spread the virulent germs of modern race-feeling

into other parts of the world, notably the United States, where the older antagonism of whites against all peoples of color has had a long history of prejudice and violence. Race may indeed be a mere pretext or it may be the aegis of a sincere fanaticism. In either case it is a reality in the minds of millions who hold the lives and fortunes of their neighbors in their hands.

The idea of race makes easy the transition from cultural to political ill-feeling, and when we want to condemn some course of national action in our neighbors, race provides the universal joint that holds together the aliens' ignoble traditions, their present shameful course, and their innate perversity. This pattern of judgment is familiar to contemporaries of the First World War, in which a sincere belief in the wickedness of Kant, Hegel, and Nietzsche—"cultural poisons"—strengthened the hatred of the enemy.

Within national boundaries, race as a basis of judgment in matters of art and thought helps carry on the critics' war. It nourishes self-approval, stiffens factions, and decides among imponderables. Russian music, jazz, atonality, and other live issues are discussed by critics as conservative as Ernest Newman and Olin Downes in terms of "barbarian races," "racial strain," "Celtic melancholy," and "Afro-American harmonic elements." In mathematics and philosophy, which might be thought abstract and passionless subjects, "races" are discovered by ingenious scholars all over Europe and "threats" or "dangers" to the national culture are staved off by the usual discriminatory means. The sincerity of the partisans can hardly be doubted when the elite of the nation goes in bodily for this form of ideologic warfare.

Such manifestations of the race-spirit have led observers of the ever-spreading intolerance to believe that it originated exclusively in Nazi Germany. It is quite true that the Third Reich was the most blatant apostle of racism in the modern world, but the movement has deeper roots than that regime. The race propaganda and "scholarship" in Germany show that it used words and ideas by no means novel in Western culture,

and that its ammunition was largely borrowed from the European science, art, and history-writing of the nineteenth century, without distinction of nationality—or race.

Equally important, though generally overlooked, is the fact that articulate minorities in other countries than Germany have been as deeply engaged in thinking and talking about race. The only difference is that no other government has yet gone as far as the Nazi regime in adopting race as a popular slogan, despite its obvious value as a means of diverting attention from economic problems and as a satisfaction of the ever-latent zest to persecute. But read attentively the press and political literature of the modern period in England, France, Italy, and the United States; in Mexico, Turkey, Rumania, and Scandinavia: you will not read very far before you are told or left to infer that the whites are unquestionably superior to the colored races; that the Asiatic Peril is a race-peril; that the Japanese are deemed so exceedingly yellow-perilous that the Chinese become white brothers in comparison (and vice versa); that the great American problem is to keep the Anglo-Saxon race pure from the contamination of Negro (or Southern European, or Jewish) "blood." The quarrel about race and blood comes even closer home when we are told that among the whites the tall blond Nordics are a superior breed destined to rule the world and that brown-eyed, round-headed Latins, whether in Europe or in South America, are a degenerate, revolutionary lot. They have no sense of race-discrimination and are incapable of governing themselves, probably because they live under a hot (and blue) southern sky.

But alas! even among Anglo-Saxons there seem to be impassable barriers of race. Few are the consistent believers in the Nordic unity of Anglo-Saxons and Germans; for the Germans are Teutons, a people notoriously refractory to civilization, as is conclusively shown by the Roman historians and the burning of the Library of Louvain in 1914. Of course, the Aryans among us are willing to patch up a good many contra-

dictions if only we can be made to unite against the dreaded Semite with his international ideas, decadent passion for the arts, and intolerable financial ability. The Semite himself is race-conscious and, given his chance, just as scornful and prejudiced as the Aryan who would oppress him. Needless to add, every one of the foregoing statements can be found refuted, modified, or twisted into strange compounds of incoherent animus. And yet these are but the cruder ways of race-prejudice: they form the common, casual superstition. When we rise into higher spheres and glance at learned papers on the race of fossil remains, or the proportion of Celtic blood in Shakespeare, we can measure the subtle spread and unlimited power of racist thought.

Within the babble of fanatics and theorists one can distinguish voices shouting that the notion of race is a myth which all intelligent people should discard. Yet the quarrel about race is certainly not between the uneducated, on the one hand, and the cultured elite on the other. Intelligence and education do not prevent a man from holding fast to race-prejudice. A British Foreign Secretary with a biblical surname feels it necessary to dispel doubts about his race. "I am not a Jew," says Sir John Simon, recklessly adding, "I am just an ordinary Briton of Aryan stock." The well-known scientist Sir Arthur Keith spends a great deal of time and energy stressing the value of race-prejudice in modern life and urging the necessity of conflict among races as a means of improving the species. It is not the German professors alone who publish treatises proving that the authors and their friends are Nordics, heirs of the Greeks, and creators of all that is good, true, and beautiful. In France, where it is often thought that race-ideas can take no hold, the most impenitent form of race-superstition thrives, namely, that which is unaware of itself. Indeed, race controversies raged in France long before they became a constant preoccupation in the rest of Europe. In seventeenth- and eighteenth-century France, race was already a weapon in the struggle between absolutism, aristocracy, and the middle

class. The warfare spread to the arts and philosophy in the nineteenth century, by which time independent shoots in other cultures had also borne fruit, leaving the grand harvesting on a worldwide scale to our generation.

Viewed in the light of such facts, the race question appears a much bigger affair than a trumped-up excuse for local persecution. It becomes rather a mode of thought endemic in Western civilization. It defaces every type of mental activity—history, art, politics, science, and social reform. *1936*

Thoreau the Thorough Impressionist

What follows is in no sense a scholarly study of Thoreau's work. I have read very little about his life and virtually none of the critical literature. My remarks are but the reflections of a devoted reader who first came to Thoreau from spending parts of each summer in Concord, on Nine Acre Corner itself, and getting to know the region and its history. My reading has been enthusiastic, but also critical, and at times hostile, as will appear. There are indeed two parts of equal weight that come together in this mere reader's assessment. By the end of Part One it may seem to an absolute admirer as if the assessor deserved a ducking in Walden Pond. But by the end of Part Two, I may perhaps—it is my hope—qualify for a life membership in the Thoreau Society.

Part One is concerned with Thoreau's writings on man in society and his reputation as thinker. The main works on which this reputation stands are, of course, "Civil Disobedience" and *Walden*, supplemented by innumerable entries in the *Journals*. The influence of Thoreau's "ideas" has been far-reaching; it is in fact worldwide. We know that Tolstoy in the

crusade of his last years was (in his words) "mentally uplifted" by reading Thoreau. Gandhi admired and learned from the teaching of "Civil Disobedience." Directly or indirectly, it was this teaching that was applied during the First World War by the recognition of the conscientious objector, a social species unheard of before. It was legalized again in the Second World War; and the war in Vietnam revived the Thoreauvian spirit of disobedience, both toward bearing arms and toward academic administration.

Thoreau has done yet another thing: he has helped create this country's view of itself, as a recent article in *American Heritage* indicated. The title was "Ten Books That Shaped the American Character." The drop line said: "*Walden* is here, of course . . ."—the other nine books had to be explained. Again, not long ago, in a judicial opinion on a case of activism in Ohio, the judge cited "Civil Disobedience" as relevant though without standing as an authority in law. What are, in fact, the intellectual contents of this piece of work that it has wielded such power? My reading of it is that it consists of a series of strong impressions, lucidly expressed but uncoordinated— indeed totally inconsistent. Let me demonstrate.

In his opening words, Thoreau adopts the motto: "That government is best which governs least"—an old and tenable maxim. From it, our author immediately deduces, illogically: "That government is best which governs not at all." At some point, he prophesies, men will have such a government. Where is all this leading? A few lines later, we find out; the real intention of the essay is stated as if it were an example by the way: a few individuals have brought on the Mexican War, in defiance of the people's will, and it must be stopped.

Government, it seems, government at large and in the abstract, has imposed itself, for its own advantage, on the people. What we are hearing is an echo of the eighteenth-century idea that kings and priests are the cause of all evils. But suddenly Thoreau says one must be practical. He will not ask for no government, but for a better government, *at once*. This is

to be a government which is not ruled by the majority but by conscience. What has happened to the will of the people objecting to the acts of a few individuals? And whose conscience is going to sit at the helm? We are not told. The thinker's state of mind is—shall we say?—childlike. For, says Thoreau, "the only obligation I have a right to assume is to do at any time what I think right." Here is the ground of all disobedience, from the nursery to Gandhi and Tolstoy. When it succeeds on any scale, it is necessarily government by one man, one conscience; that is, arbitrary rule—as the lives of Tolstoy and Gandhi amply prove.

The contradictions so far are manifest, the evasions of reality also. But they have only begun. Here are some more: undue respect for law, we should know, turns men into machines, which are then moved and worked by some unscrupulous man in power. Therefore great men—heroes and martyrs—resist. All men recognize the right of revolution, and each man must judge for himself when to revolt. But in any case justice must be done, cost what it may. Hence "this people must cease to hold slaves and to make war on Mexico, though it cost them their existence as a people." I follow the principles in sequence, not skipping any. The next one is: The hero is as one to ninety-nine in a hundred; indeed, less than one: "How many *men* are there to a square thousand miles in this country? Hardly one." In that case, one wonders, will the thousands agree to cease existing as a nation, just to let the single hero stop the Mexican War? But reading on, it appears that there are many virtuous and conscientious people; it is they who support the government and thus they are "the most serious obstacles to reform." In short, the one and the many are by turns the good and the bad.

Revolution has been temporarily shelved and the tone suddenly changes to pleading: "Why does not the government anticipate and provide for reform . . . cherish its wise minority?" The reader, who has been asking himself how government manages to act as it were from outside society and to its

detriment, now discovers that there is this wise minority whose counsels should prevail, an aristocracy of intellect, no doubt. But where to find it? "The American may be known by his manifest lack of intellect." Here another thought strikes the theorist: "If injustice is a necessary part of the machine of government, let it go . . . ; perhaps it will wear smooth and certainly the machine will wear out." But if *you* have to commit an injustice, don't let it go, "I say, break the law."

By now, the person addressed must be in some confusion: he has been called a fool and a coward; he has been urged to be a martyr and resist at the cost of undoing his country; he is assured that more than ninety-nine will invariably be against him; he is known, as an American, for his lack of intellect; but he should form part of a wise minority and proceed to break the law, so as to arrive at a government that governs not at all.

Meantime, speaking in his role as reformer, Thoreau asserts that it is "not his business to petition the governor and legislature," for if they should not heed, what can he do? This eventuality proves to him that the Constitution is the evil; that is the truth, even if saying it "may seem stubborn and unconciliatory." How did our revolutionist turn into this apologetic citizen? Nobody knows. But he gets a grip on himself and repeats that "all change is for the better," no matter what "convulsions" it may bring. And the urge toward martyrdom persists: "under a government that imprisons anyone unjustly, the place of a just man is in prison."

We now see the point of the momentary meekness: it and the prospect of prison make a powerful appeal to the masochism of the world. Passive resistance requires some self-control, but no energy or skill; it can be worked by very small groups, and it looks blameless, as Thoreau points out in suggesting the non-payment of taxes: "it would not be a violent and bloody measure; it would be the definition of a peaceable revolution." In other words, it is the tyranny of the weak, actually so provocative that it often does breed violence. We know this when we call these "passive" moves "activism"—in

Gandhi's India, the student riots of 1968, and the now established forms of coercion by minorities, the sit-ins and other modes of obstruction.

Thoreau is not unaware of the dangers. He asks: "Even suppose blood should flow. Is there not a sort of bloodshed when the conscience is wounded?" That piece of verbal trickery is effective rabble-rousing: always climb to a high moral plane when inciting the mob to break the windows. And the mob also responds well to the next moral ploy, the attack on money, on the rich man: "Absolutely speaking," we are told, "the more money, the less virtue."

This is gospel in the literal sense, and it leads to a curious calculation: Thoreau would not like to think that "he ever relies on the protection of the state." Yet if he does not pay his taxes, the state will take what he owns. "This is hard," he exclaims. All you can do is "squat somewhere and raise but a small crop"—in other words, resort to *Waldenizing*. He weighs the choices and decides: until he wants to engage in trade or build a large estate, "I can afford to refuse allegiance to Massachusetts. . . . It costs me less in every sense to incur the penalty of disobedience . . . than it would to obey."

He then cites his own experience of jail for not paying the poll tax. Someone "interfered" and paid it for him. This anonymous defeat did not seem to bother the beneficiary, because, as he proceeds to explain, he did not consider himself part of any association whatever; he would have signed an affidavit that he had not joined society itself. He could not respect an institution that wanted to lock him up instead of "using his services in some way." In treating him as they did, his fellow townsmen were "underbred" and the state was "half-witted."

This rather free name-calling leads to the invoking of spirit to defy matter. The town and the state regard Thoreau as "mere flesh and blood," a "body with senses," and use their superior strength against him; but such a multitude (the state has suddenly become the people) has no force. Only those

"who obey a higher law" could be stronger than he. On the earthly plane, "I am not responsible for the successful working of the machinery of society. I am not the son of the engineer." Then follows an analogy with nature: an acorn and a chestnut fall side by side; they grow as best they can till one destroys the other. If a plant does not "live according to its nature, it dies—and so does a man." This foreshadowing of Darwinian natural selection is rather rash: it could serve as an argument in favor of the Mexican War; and it is quite useless here.

The notion was only fugitive. We veer sharply into the description of the night in jail and his companion there—an excellent piece of story-telling, heightened by imaginative comments in Thoreau's best vein. The upshot of the one-night stand behind bars was to convince Thoreau that the people among whom he lived were "a distinct race from me." Still, no sooner freed, he "joined a huckleberry party, who were impatient to put themselves under my conduct." So group action and leadership are not entirely forbidden to those who have seceded from society.

The contradiction keeps nagging him. The reason he has not refused the highway tax is that he wants to be a good neighbor (a neighbor to that "distinct race"); his wish is only to "declare war with the state." This, as he puts it, "is my present position." But what (he is still speaking) if "his action be biased by obstinacy"? Worry over this makes him backtrack. If he could convince himself that he had "a right to be satisfied with men as they are," he would endeavor—what? Why, "to be satisfied with things as they are"—the loveliest tautology in all political science. Thoreau knew himself better than he knew others, and he is not at ease: he doesn't want "to split hairs, to make fine distinctions, to set myself up as better than my neighbors." He wants to "discover a pretext for conformity." The Constitution, formerly evil, is now "with all its faults very good."

This revised version of the state brings up, by association, statesmen, notably Daniel Webster. These movers and shak-

ers, who on an earlier page manipulated everything from out-
side, are now seen to be fully inside society; but they forget
that the world is *not* "governed by policy and expediency."
That is well observed; a thinker would conclude that the
march of history results from everybody's acts. And Webster,
no longer one of the unscrupulous governors, is declared "orig-
inal and practical . . . though his quality is not wisdom but
prudence." Indeed, "no man with a genius for legislation has
appeared in America." But weren't we taught to despise legis-
lation and act only according to our own law? Or is it that we
must have laws in order to disobey them?

Apparently we have missed the point (and no wonder!) for
after a passing suggestion that laws should be inspired by the
"science" of the subject found in the New Testament, the
homily winds up with a bow to the authority of government—
"such as I am willing to submit to, for I cheerfully obey those
who know and can do better than I." That authority must of
course "have the . . . consent of the governed," but equally of
course it must show "a true respect for the individual." The
very end of the document is once again a plaintive request:
Can we not take "a further step toward recognizing the rights
of man"? A really free state would "recognize the individual as
a higher and independent power." After that would come "a
still more perfect and glorious state, which also I have imag-
ined but never seen."

It is hardly necessary to list the inconsistencies of "Civil Dis-
obedience." Its meanderings are enough to disqualify it as
political thought and put it outside any classification. We
have here: anarchism (the best government is that which does
not govern at all) and government by consent—the people's
will; we have aristocracy (the majority is wrong, we must fol-
low a wise minority); we have reform (let us recognize more
"rights of man") and also revolution (be a hero and resist even
if the nation perishes); we have peaceful action and bloodshed
too; we have extreme individualism (no law but what my

453

judgment and conscience approve); we have tributes to practicality and the life of trade and also the denunciation of money; and we have total alienation (I have not joined society and my fellow men are a distinct race). One might call this last stance political solipsism. In between come passages of speculation, of fantasy, and of rather ordinary complaint against present policies. Nowhere do we find one word about methods or devices of government and politics—"machinery" is despised throughout.

This hodgepodge without definite aim is certainly the reason for the great influence the piece has exerted. There is in it something for everybody and a void of clear goals that might divide followers. It is fair to add that everybody—all of us—must at some time have felt every one of the sentiments that Thoreau strung together. He found to cover them a title with immediate appeal—a title that proposes a subject he never really discusses.

Where does that leave our revered author? I think the proper name for his performance is Impressionism. Thoreau saw and felt with acuity and he had the power to express his visions and feelings. These, moreover, came in such rapid succession that their coherence, or the depths they might conceal, did not check his utterance. One has only to take a glance at *Walden* to verify this suggestion. I leave out here the marvels of *Walden* that have nothing to do with doctrine. They have enchanted many readers and always will, but it is the doctrine that has become an American myth—and the doctrine is founded on a myth. Thoreau's purpose, taken at his own valuation, was to show how one can live better apart from society and without its help. He was to be, in R. W. B. Lewis's phrase, "A New Adam." According to another critic, he was sloughing off man's whole past. In reality, he was using society and its innumerable benefits to take a camping trip.

He borrowed an ax: that ax was the product and emblem of twenty thousand years of man's efforts to emerge from a purely animal life. And so in their measure were the beans, the

nails, the planks that he cadged, and the helpers with whom he raised the roof over his hut. Not a new Adam, but a new Robinson Crusoe, both of them lucky to have at hand the indispensable fruits of civilization—the fruits of material, commercial, conformist, ugly civilization.

What moved Thoreau both in "Civil Disobedience" and in the Walden adventure is the desire for what Nietzsche called "the unconditioned life." It is clear that all men want to escape *some* conditions; the love of freedom is the positive statement of that feeling. And some men want to get rid of *all* conditions; one remembers the eighteenth-century Englishman who committed suicide, leaving a note that said: "Too much buttoning and unbuttoning." He could no longer bear the daily routine of clothes, which was a condition of civilized life. Thoreau partook of that absolutist temperament, though at times—but not for long—he fought against it. In those moments he made gestures of neighborliness, friendship, and sociability.

A curious fact that has struck me in reading *Walden* and the *Journals* is that the conditions most men want to be free of did not bother Thoreau at all. I do not mean only isolation or public disfavor, I mean physical pain or discomfort. On Walden Pond he put up with conditions that even a poor farmer would have fled from, given the chance. But Thoreau goes even further; he relishes bodily constraints: on one occasion he records "a long soaking rain . . . while I lay drenched on last year's bed of wild oats, . . . ruminating." On another he thinks, "Would it not be a luxury to stand up to one's chin in some retired swamp for a whole summer's day?" And elsewhere he asserts that "nakedness is not such a bad condition after all."

In this difference from Everyman lies, I think, the clue to Thoreau's quarrel with Concord and with society. Society, government, law, trade, money, manners were devised and are maintained to get out of the cave, away from the state of nature. The overwhelming majority of men would rather

endure the ills of bad government and social pressure than the risks of primitive existence—"solitary, poor, nasty, brutish, and short." Indeed, people want more than security and creature comforts; they want leisure and luxury, large houses and pleasant prospects, entertainment and occasional flights from responsibility, which together make up what we call civilization.

Of all this, Thoreau enjoyed only books and music and, not wanting the rest, he could not understand his neighbors. His remarks about them in the *Journals* are unjust imputations of motives that he did not feel and could only hate. Hence his love of tramps and jailbirds who, like him, have cast off society. Hence also his suspicion of manners and his rather conventional denunciation of the shams and hypocrisies of men in towns and in trade. When one is a hermit—or nearly—one fails to grasp the reason for the compromises demanded by life in groups.

Nor did Thoreau understand his own relation to society. He never saw that he could live as he did only by the bounty of a large, well-established state. The position of conscientious objector, of civil disobedient, is made possible by the great strength, the surplus wealth, the contented willingness of the citizenry. In a lifeboat that carries shipwrecked sailors, there can be no conscientious objector. There is no "different drummer" to listen to. Everyone must row and bail—and row in the direction imposed by the natural leader of the group, who may wield a cutlass to have his orders obeyed. Palaver about rights starts after all have safely come ashore.

This fundamental rule of human life does not mean that protest in organized society is wrong and should be suppressed. It is by protest and palaver that civilization has made more elastic and generous the rules governing individual conduct. But if protest is to give any direction to change, its articles of war must be more consistent and consecutive than Thoreau's or (I may add) Tolstoy's. Theirs only serve to arouse vague discontent and flatter false hopes.

Meanwhile, Thoreau was ungrateful. The forbearance accorded to him was not merely general but particular. The town constable and tax collector, Sam Staples, out of pure understanding and benevolence let Thoreau go without paying the poll tax for several years. The crisis and the night in jail came only when Staples was leaving office and had to put his account books in order. Thoreau must have known he was enjoying a privilege uniquely his, and therefore unjust; yet he prided himself on being just and paying his ordinary debts, which he did. Was his truculent behavior toward the state due to the frame of mind that Edmund Burke in a famous phrase ascribed to all of New England—"the dissidence of dissent and the Protestantism of the Protestant religion"? There may have been in Thoreau a trace of this temper; it has made him congenial to his countrymen, squatters by cultural inheritance and agin' the government by sporting instinct. But I believe Thoreau was moved by a far stronger force—his poetic genius.

I will explain what I mean in a moment, but if I am right, Thoreau should not be regarded as double in nature, but single, integrated, one man throughout. His failure as a writer on politics comes from the same power as made him a matchless depicter of visions. He thinks in one and only one way, by instant association, not by controlled abstraction, as logical thought requires. There have been poets who could re-create impressions and also reason; they were makers *and* thinkers. Some are only makers and they do not need to think.

It may be asked, if Thoreau was a poet, why did he write such bad poetry? He did not; he wrote bad verse, like other great prose writers—Nietzsche, Melville, Rabelais. When Emerson edited *The Dial,* he found room for some of Thoreau's early verse, but could not keep up the favor: "the gold," he said, "does not yet flow pure, but is drossy and crude." The probable cause of the crudity was the constraint of meter and rhyme.

I remember discussing Thoreau with W. H. Auden when he was compiling his five volumes of *Poets of the English Lan-*

guage. No piece by Thoreau met his test, though he accepted fifteen of Melville's and even two by John Jay Chapman. Why, then, do I call Thoreau a poet? The answer comes down to what I have called visions. A poet's vision is not anything fanciful or vague. It is an actual sight with a glow and a hard edge. The glow comes from the fusion of the material core of sensation with any number of associations—emotional, intellectual, spiritual; present or remote; fleeting or permanent. In a word, it is a vivid image, recorded in faultless words; I see in Thoreau the earliest and greatest of American Imagists.

Examples of this poetic power are to be found in everything Thoreau wrote. Here is one from his first published work, the Concord and Merrimack adventure: ". . . as when a vase of water is jarred / the trembling circles seek the shore / and all is smooth again." Here is another from *Walden:* ". . . the unrelenting steel-cold scream of a jay, / unmelted, / that never flows into song, / a sort of wintry trumpet / screaming cold." Here is a third from the *Journals:* ". . . a place for fauns and satyrs / where bats hung all day to the rocks / and at evening flitted over the water, / and fireflies husbanded their light / under the grass and leaves, / against the night." I recommend rereading Thoreau—anywhere in one's favorite work—and picking out these Imagist poems. There are even one or two that flash out as a surprise in "Civil Disobedience." Through this exercise one comes to see our author as a forerunner of Emily Dickinson, of Robert Frost, and as a poet whose flights are more sustained than those of any Japanese maker of haiku. He himself was aware of his gift and like most artists defined his art in keeping with his own style: "Good poetry seems so natural a thing. . . . The best lines suggest to me what that man saw or heard or felt."

But in going about culling flowers out of context, are we not doing violence to works conceived for another purpose? What are these visions of or about? The answer cannot be given in one word. The visions arise from Nature, of course, first and

foremost. Color, sound, motion start the poetic fire. But other things set off visions as well: the inner life or stirrings of the spirit, including self-criticism; the acts and characters of other men; the dilemmas of ethics and the riddles of philosophy. All these occur as events and produce associations, especially in a mind as highly cultivated as Thoreau. For it is a false estimate to see him, through the mists of *Walden,* as an eloquent yeoman with a stout heart and a love of justice. He was a highbrow of the first order, the voice of outdoor life—true, but bookish to the back teeth. Nor was his scope limited to books and moral arguments. He was a good businessman and an inventor of machinery. His mind was comprehensive and his power of notation not specialized on the curiosities of the natural world.

It was indeed because of his wide reading and long brooding that Thoreau believed himself to be a philosopher and political theorist; and he has induced many to see him as he saw himself. Biographers and introducers speak of his Transcendental metaphysics and his doctrine of Political Individualism. Now, one way to be unjust to an author is to praise him for qualities he does not possess. To be sure, the error about Thoreau is due to the assured, masterly tone of his conclusions, particularly in the *Journals.* But these are marvelous not for any system that dictated their writing or emerges from them gradually. In them too inconsistency is the rule, not the exception. No: the marvel is Thoreau's fidelity to the successive visions; the marvel *depends* on the inconsistency.

For Nature and Man are not capable of being resumed in a system; they can, on the contrary, be best known through the reports of faithful observers, which are truest when they do *not* cohere. To take but one example, here is Nature seen at different times through the temperament of our poet. From the first, he sees Nature as solace and seeks communion with "her"—the personification is not questioned. But at times he asks, "What is Nature unless there is an eventful human life passing within her? . . . Nature must be viewed humanly or

not at all." The "beneficence" of Nature appears to Thoreau in all the instances of means and ends adapted to each other in sustaining animal and human life. In that guise, he tells us, "no word is so fit as Alma Natura," nurturing Mother. But then, cruel nature is plain to see also. He starts off: "When I think of the tragedies which are constantly permitted . . ." "permitted" is a criticism of personified Nature. And a low point is reached when he asks, "Is not disease the rule of existence? Not a lily pad on the lake but has been riddled by insects." Each of these observations is true, from solace to disease; for as he says, observation must be subjective.

Surely, this diversity and contradiction is the true measure of experience. Life has for each man a general drift, but it will not fit into a formula, no matter how broadly phrased. And we already have too many broad phrases from popular preachers and voluble philosophers. It is better to rely on the exact and intense visions of the poets.

There is, of course, another exactness that does yield a system, and that is physical science. But it achieves its purpose only by such a degree of abstraction that it must express itself in mathematics and discard the world of the senses. For science, Walden Pond and the loon flying and laughing overhead turn into unrecognizable protons and electrons. The mysteries of *that* system are gripping too, but they are not the only mysteries or the nearest to our waking lives. Thoreau saw the danger of trusting only science: "I count some parts and say 'I know.' "

To cherish Thoreau the poet and point out the perfection of his visions is not to belittle or forget his prose. He was as great a master of prose as he was of poetry. In this he compares, once again, with a whole class of writers, from Rabelais and Swift to Nietzsche and Meredith. How to define the quality of prose? It is motion allied to transparency. Prose is at its best when it does not call attention to itself; that is why it must keep up rhythmic interest without ever falling into meter. When in prose we come across the "poems" of the writ-

ers I have cited, it is only by compression and connotation that they are poems, and the rhythm at those points dare not even suggest meter; that is why such passages must be short—a hint of scansion, too long a vision, and prose turns into singsong and loses transparency by drawing attention to the medium. Thoreau has a remark about the sound of crickets that is in point here: "Serenely wise, their song has the security of prose."

Writing prose is a much more difficult craft than writing poetry. One proof of that truth is that all peoples have produced poetry—and this at the very beginning of their literature—but not all have developed a tolerable prose. There is none in English or French until the early seventeenth century. Up to that time, sentences meander at great length by the addition of clauses in no special order. The result is talk, not prose. But once the canons of order and lucidity come into force, the paradoxical result is that every good writer employs a prose of his own; he can be known by what we call his prose style.

That being so, it is interesting to study these individual ways. Thoreau's are remarkable, precisely for transparency and force. I have not come across a sentence of Thoreau's that was not perfectly clear on first reading. The same hard edge that gives definition to his images draws the contour line of the prose ideas. Go a few steps down the road to Mr. Emerson's and you will find a very different product. Vagueness to the point of obscurity sits like a patch of fog here and there in every paragraph; the paragraphs themselves lack contour, though the rhythm in general is pleasing. But it is talk, often inspired talk, and not prose.

Most sentences in Thoreau follow the so-called natural or simple order of thought—subject, verb, predicate. Only occasionally does he use the periodic form, in which the idea is not completed till the end. Such sentences, with him, begin more often with "when" than with "if" or "although." These technical features fit the writer's purpose: he is nearly always talking

about himself, what he did and what he saw—hence the simple declarative mode. A journal, in particular, must not sound like what the French call *apprêté*—all dolled up. Too periodic a style would suggest concern with the effect rather than the record. And since Thoreau's aim is to match in words the fluidity of his own impressions, his sentences are mostly short; they follow each other as if in a hurry to keep up with Nature and memory. But the paragraphs are often long, for the same reason of continuity. If now and then a sentence is long, it is in fact a chain of descriptive portions, each moving from subject to predicate.

Such a style, in other hands, might well grow tedious. In Thoreau's it is made perpetually fresh and self-propelling thanks to certain unique traits. One is a kind of backlash at the end of a passage; we read along innocently and are suddenly whipped around a corner. For example, we follow ten lines about his mixed feelings toward a friend and bump into: "I leave my friends early; I go away to cherish my idea of friendship." Or again, we are engrossed in a description of young phoebes in their nest; they have open and serene eyes that he finds memorable; then: "Such an eye was not born when the bird was, but is coeval with the sky it reflects." It is not too much to say that the lifelike sound of the *Journals* is due to these sudden turns—they virtually *turn upon* the reader and say "Wake up and look!"

Another feature of Thoreauvian prose is the epigram. A few are famous—the ones about new clothes, the different drummer, the quiet desperation, travel in Concord, and the trout in the milk. In the *Oxford Book of Aphorisms*, John Gross has chosen no fewer than thirty from Thoreau. For a writer whose output is not large, this is a high number. It puts Thoreau in a class with Bacon and Butler, Chesterton and Shaw. And thirty do not exhaust the supply; there are many wonderful sallies that draw their power from suddenness within a delicately fashioned context. For example: "Who hears the fishes when they cry?" Or still in the river, "the shin-

ing pebbles, not yet anxious to better their condition." The learned professors, he thinks, "communicate no fact which rises to the temperature of blood-heat. It doesn't all amount to one rhyme." Elsewhere, he rightly notes that "all perception of truth is the detection of an analogy; we reason from our hands to our head." And when he shies away from too scientific an outlook, he tells himself: "What I need is not to look at all, a true sauntering of the eye."

Thoreau was conscious of his art of observation and even more of his art of expression. He wanted his sentences to be "concentrated and nutty; . . . the body, the senses must conspire with the mind." And *his* mind, he knew, worked "by juxtaposing disconnected thoughts, thus opening a whole new field to labor."

It is such maxims and the resulting work that lead me to call Thoreau an Impressionist—the senses ever acting as triggers to the mind, and the verbal creation growing out of the juxtaposition of disconnected thoughts. In using the term "Impressionist" I am aware that it may raise memories of the French painters, whose method was exactly Thoreau's but whose results seem unlike—they did not seek the definite vision by means of the hard edge. But this difference is that of the sense to which they appeal—the sense of sight. It responds instantly to the bright shimmer of pictorial Impressionism and recognizes in it the facts of nature and human character immediately. To attain the same ends with words, the artist cannot use the indefinite, cannot blur the outline. His only hope lies in the opposite mode of the sharp and clear—which is what Thoreau gives us, without on that account distorting his subject. From no other writer does one get such a sense of the immensity of the cosmos, the minuteness of its parts, and the simultaneity of its motions, which keep any object from remaining unchanged even for a moment: the indefinite reality is the true one, conveyed here by the most definite of prose masters.

* * *

Such high art, if we are not careful, can have an unfortunate side-effect. Finding the marks of perfection here and here and here, we may become impatient and fretful when we do not find it in the man's work everywhere. Thus when first judging Thoreau's writings as a whole, one is tempted to think that, versed as he was in the classics, he should have obeyed the warning of Pythagoras: "Abstain from beans," meaning: Have nothing to do with politics (the ancients used beans for voting as we use ballots). We are only too conscious of how "determined to know beans" Thoreau was—in "Civil Disobedience" and on the slope of Walden. Caught by that fact, one goes on to wish he had followed his own advice: "to keep the crystal well . . . clear—that it be not made turbid by . . . contact with the world, so that it will not reflect objects."

But those wishes of ours are misplaced, and it is Thoreau who is right: Politics, the state, slavery, and Mexican wars are objects too, and they deserve to be reflected. As I surmised earlier, everybody has probably felt the kaleidoscope of emotions recorded in "Civil Disobedience." Karl Marx, for one, certainly ran the same gamut of attitudes. As a guide to conduct, Thoreau's tract is worthless, and as a pattern for the conscientious feelings, it is deplorable; but as a record of social fantasies and desires in their wild discontinuity, it has value. In writing it, Thoreau was carrying out his proper mission. He was one and the same man throughout; we must take him whole; we must take all our poets whole; him with special warmth, because few have been so dedicated to seizing the impression, inner and outer, or so able to turn it into an Image as hard and lucent as a gem. *1986*

The Railroad

While ideas of democracy, plans of social justice, reform legislation, and the remaining strength of Suppression were changing the culture of Europe, another force was silently adding its influence in the same direction. At first, machinery affected only those who organized its use and the men and women who worked in factories. But by 1830 a different type of machine came into being that changed the life and the minds of all people and peoples. The memory of it is nearly gone, but it was the completest change in human experience since the nomadic tribes became rooted in one spot to grow grain and raise cattle; it was in effect a reversal of that settling down. Locomotion by the force of steam—the railroad—uprooted mankind and made of it individual nomads again. This and other cultural consequences were quickly felt from the little stretch of land where the first public railway journey was made.

That locus classicus was the thirty miles between Manchester and Liverpool, and the date was September 15, 1830. On that inaugural trip the backers of the engineer George Stephenson rode with government officials and their guests, including the Duke of Wellington and William Huskisson, well-known economist and president of the Board of Trade. Thirty-three cars carried them in eight trains drawn by as many locomotives. The whirlwind ride at twenty to twenty-five miles an hour took them across country and over a large bog, Chat Moss, that everybody said was impassable and would sink the cars and the enterprise. But Stephenson found a way to float his rails on it and the cortege did not even hesitate at the supposed obstacle.

But about halfway, at a stop to refill the engines with water, the first railroad accident occurred. Amid exclamations of wonder and delight, the crowd poured out of the leading train on one track, while another passed slowly on the other. Huskisson, standing at the open door of the Duke of Wellington's carriage and conversing, was confused by the cry of "Get in! Get in!" He tried to get around the door, was knocked down by the engine and fatally injured, though conveyed to medical help in twenty-five minutes.

The accident is charged with a special meaning: from then on, human beings have had to sharpen their reflexes under the threat of moving objects. It has been a continual re-education of the nervous system as ever-new warnings by sight and sound command the body to halt, or step in the safe direction. The eye must gauge speed, the ear guess the nearness of the unseen. And besides sheer survival, the daily business of life calls for taking in and responding to an ever-enlarging array of lights, beeps, buzzes, and insistent rings.

Multiform danger on the track had to be guarded against from the start. Employing a man on a horse to wave a flag ahead of the train had a comic implication and did not last long. But for a quarter century the risk of accident was ever-present and multiform. One of the early catastrophes occurred on the Paris-Versailles line a dozen years after the English inaugural journey. It was doubly shocking, doubly fatal, because the passengers had been locked in "for safety." When the axle of the leading of two locomotives broke and the momentum piled up the second and the cars behind, fire broke out and made a funeral pyre of the injured and the dead—upward of fifty. The locking-in, which persisted for many years on the Continent and about which Sydney Smith had pungent things to say while it lasted in England, testifies to the mental disturbance caused by mankind's hurtling through space in a box.

As a mechanical invention, the railroad consists not merely of a steam engine mounted on a cart and dragging

another. Equally important are the flanged wheel, which gives automatic direction by following the rail, and the roadbed, which holds the rails firm and equidistant under tremendous periodic stresses. Startled and unobservant, Tennyson early got the impression that train wheels run in grooves, which accounts for the line in his poem about the world running forever "in the ringing grooves of change." Not long before the inaugural trip, De Quincey had written one of his finest essays, that on "The English Mail Coach." It celebrated the improved roads and solid carriages, the superior horses and expert coachmen that together provided the swiftest postal service on record and thrilled the passengers—especially the four on top—by racing along at nine miles an hour.

The mail also required a network of inns with horses ready to relay the exhausted arrivals, but that organization was simple compared with what the railroad soon had to install. First, enclosing the tracks to keep off people and cattle; then, a mode of signaling to make possible "single-track working," that is, having trains go in each direction on one track. Fortunately, the electric telegraph was ready to hand, thanks to S. F. B. Morse and his code. The system needed men to send and to convey these wire messages—dispatchers—and also station masters, signalmen, track inspectors, brakemen, and conductors, in addition to the engine's fireman and driver. Putting up barriers and lanterns at grade crossings, installing signal-and-switch towers at short intervals, improving these and their successive adjuncts: the air brake, electric track circuiting, steel-car construction, automatic stopping of engines, central dispatching, and numerous other means took seventy-five years and many deaths, but made the railroad a nearly perfect human achievement.

Railroad workers soon constituted a vast army, with officers and a manual of rules. They performed their tasks under constant pressure and a severe discipline, while being also subject to the penalties of the law for infractions that led to accident or death. This too was a transformation of the character of

Work. Earlier, the factory had meant regimentation, but it was plain, simple, relatively static—nothing like the life-and-death decisions required of the railroader, for whom avoiding injury was intrinsically more difficult. The railroad developed an aristocracy of labor marked by physical strength, skill, and judgment of entirely new kinds. As for increasing passenger safety by means of new rules or devices, it was considered at first no duty of the government. In England, where progress was steadiest, the task was taken on by a group of brilliant engineers (often from the army) who studied each accident and published recommendations to the competing companies; they were not conclusions enforceable by law. Since then, plane travel has been dealt with in the same Liberal fashion.

For a good while, the men and women who traveled on the railway kept being amazed by it and also appalled. They wrote descriptions and prophecies and polemics. Wordsworth inveighed against the disfigurement of tranquil valleys; Vigny versified the magic change of mankind from shepherd to flying adventurer on untold missions; Lamartine saw in the ease of travel the growth of mutual understanding across frontiers and the prospect of international peace. Dickens, with his quick sense of disaster, turned the traveler's sensations into a nightmarish vision that he reproduced in fiction more than once. The common people fell into an inevitable cliché: "Believe it or not, I took the eight o'clock train to X, getting there at 12; did my business, took the 2 o'clock back, and was home by 6." We know this, because Flaubert ridiculed it with scores of other platitudes in his *Dictionary of Accepted Ideas*. To the philosophical mind, the new marvel caused only the sad reflection that moving from place to place added nothing to intellectual or spiritual worth. One was the same fool or knave at either end of the journey. And the "business" done more quickly only added to the dominion of materialism. The businessman naturally ignored this jaundiced estimate and built railroads as fast as capital could be raised to do it. The 1840s in England suffered the "railway mania"—dozens of

lines projected, too many built; hence failures, lawsuits, much countryside spoiled, towns angry at being passed by, the coal and iron trades booming, rival designers steadily improving engines, rails, ballast, cars, brakes, signals, and operations.

For a country such as the United States, the railroad was the means of rapidly developing the open spaces and their natural resources. Recent revisionist opinion to the contrary notwithstanding, the Middle and Far West would not have become populated and prosperous so quickly with the sole aid of canals and the pony express. Russia's hinterland remained backward for lack of railroad builders with greedy intentions. In Africa and the Far East, the Westerners' railroads gave the start to the New Imperialism by pushing trade inland from the treaty ports and the old outposts dating back to the fifteenth and sixteenth centuries. The railroad did not begin or complete the making of "one world" in habit and outlook, but it gave the infiltration by the West of other parts of the globe its strongest push.

Alone among the products of the industrial age the railroad generated a special kind of admiration, indeed of affection blended with poetry—the so-called romance of the railroad. It is associated with the sound of the train whistle at night and the fleeting squares of light as the express rushes north; and during the day, with the first sight of the engine down the track, its hissing white plumes as it slows to a stop, the exchange of mysterious words and *billets-doux* between driver and stationmaster, and the majestic departure of such a bulk of iron and human freight—without us. These and kindred impressions, recorded innumerable times, have inspired poems down to our day. The train is a presence in literature throughout the nineteenth century in a way that the plane has not been in the twentieth. Zola's *Human Beast,* Hardy's "The Journeying Boy," and Anna Karenina's choice of suicide on the track are but a few examples out of many.

Tolstoy, incidentally, thought the railroad an invention of the devil; descriptions of Russian trains in his day tend to con-

firm his surmise. Crowding in the stage coach meant four bodies with cramped limbs; but the railroad introduced another kind of oppressiveness by the size of the masses it gathered and delivered. The well-known painting by Frith, *The Railway Station*, gives an idea of the new promiscuity. And as Daumier showed in *his* painting, *The Third-Class Carriage* was the equivalent of steerage on ships or a late-twentieth-century jet plane. But between, say, 1890 and 1940, first-class railroad travel afforded not only speed in comfort but a unique cluster of pleasures, from excellent meals cooked on the train and served in style to roomy and private overnight quarters, and from punctuality throughout the trip to the perfect base for seeing the country in its three-dimensional aspect. Today, "the train" evokes only charmless convenience in Europe and overlong discomfort in the United States. Nor is the uprooting of one's being a sensation any longer felt; people are no longer vegetables attached to the soil but self-packing objects always between destinations. *2000*

The Great Switch

The bandying about of the term *Liberal* these days does little credit to its users. The same goes for *Rightist, Leftist, Socialist,* and *Conservative*—all at this late hour meaningless, and therefore continually misapplied. It looks as if candidates, partisans, and journalists on all sides had lost the means of accurate invective and the sense of political fact. What does *Liberal* imply and who is one?

Begin with a little history. It is to the nineteenth-century Liberals that we owe our political and civil rights. Sometimes the Conservatives helped when they wanted to outbid their opponents, but Conservatism normally stood for state inter-

vention. It enacted the first factory laws, and "Tory Democracy" meant paternalism and protection over a broad range of social and economic activities. But toward the end of the century it became clear that neither Liberal freedoms nor Conservative restraints sufficed to give political equality and economic opportunity for all.

Meanwhile, Socialists of all schools had for decades been advocating the betterment of society through total ownership and management by the state, and in the mid-1880s Bismarck stole the Socialist thunder—or at least a few bolts. His legislation initiated workmen's compensation, old-age pensions, and other welfare entitlements. The large Liberal Party in the Reichstag voted steadily against his program, but he finally won.

That set off The Great Switch. By the 1890s Liberal opinion everywhere abandoned the principle that the best government is that which governs least, and for practical politicians the ideal of liberty turned into that of liberality. A generation later, by the end of the First World War, all parties favored some form of the welfare state. The Conservatives (Republicans in this country), slowly turning "Liberal" in the old sense, were now heard demanding a return to the "rugged individualism" of free enterprise and claiming Adam Smith as their patron saint. The switch had taken place.

It is the switch that accounts for the present confusion in debate and that makes it absurd to call anybody by any of the old names. Both sides—all sides—have lost their distinctive labels. No others drawn from history will fit, either. Who would fancy "Bismarckian" or the once popular compromise "LibLab," meaning Liberal-Labourite? Because of this muddle the old Liberals have been forced to call themselves Libertarians. For all the rest it is the politics of namelessness.

The political reality, the present character of the state, is of course a thorough mixture of tendencies impossible to identify simply. But for anyone who wants to talk principle, there is no difficulty. The menu goes like this:

- free enterprise, free trade, freedom to vote and run for office, free speech and religion are Liberal achievements;
- tariffs, the income tax, the S.E.C., zoning, and generally the regulation of social, economic, and even moral behavior, rest on Conservative ideas;
- the post office, the police and fire departments, public schools, city buses, and national parks are Socialist, indeed Communist, institutions.

It follows that a sensible person today is at once a Liberal, a Conservative, and a Socialist.

As anybody can see, the paradoxical merger has done nothing to calm down the old political antagonisms; the fusion of three principles does not promise that all measures henceforth will be bipartisan, much less tripartisan. On the contrary, because of the terminological darkness, the battle is fiercer than ever. Ideologues of every stripe are baffled equally by the views of their enemies and by those of their friends. With all the shadings of overlapping traditions and composite plans for the future, the fight is over the elusive proportions of the mix and the areas it should cover.

In the mêlée, nobody has had time to think up new names for the motley policies actually being urged—or adroitly swathed in veils of verbiage which make many voters angry and many more indifferent. The growing appeal of single-issue politics is the result, a way out of the jumble.

One thing is clear: Democracy and technology together require a regulating state. Everything we work or play with contains threats of danger, hence: "476 Substances Banned From Workplace" and all the other innumerable rules and warnings to protect us against ignorance, on the one hand, and heedless greed, on the other. *1989*

Is Democratic Theory for Export?

A permanent feature of American opinion and action in foreign policy is the wish, the hope, that other nations might turn from the error of their ways and become democracies: "They are a great people, why can't they manage their affairs like us?" A corollary has been, let us help those governments that are democratic, make them our allies, and let us oppose the others—indeed, if necessary, take action to coerce them. But there remains a question on this subject that has long bothered the thoughtful. What is it exactly that we want others to copy? What is the theory of democracy that we mean to export? Not all democracies are alike. Whose constitution is the best? On what theory is it based?

Different persons would give different answers. Some would point to the Declaration of Independence and the Constitution; others to Rousseau, Burke, Thomas Paine. Then there is Tocqueville's *Democracy in America* in two volumes, and a wonderful little book by Walter Bagehot on the English Constitution, not to mention *The Federalist* papers and many eloquent pages from John Adams, Jefferson, and Lincoln. Taken loosely together, those writings would be regarded by many as making up the theory of democracy.

Of course they don't all agree; they don't form a system. *The Federalist* writers are afraid of democracy; Adams disputes Paine and goes only partway with Jefferson. Burke and Rousseau sound like direct contraries. Tocqueville calls for so many of the special conditions he found here that his conclusions are not transferable. And Bagehot does the same thing for Great Britain: you have to be Englishmen to make the English Constitution work.

All these ifs and ans make a poor prospect for unified theory, but there is worse. When we actually read these documents we find that each theorized about a few subjects among many which very properly go by different names. We have: democracy, republic, free government, representative government, constitutional monarchy. There are besides: natural rights, civil rights, equality before the law, equal opportunity. Then there are also: universal suffrage, majority rule, separation of powers, and the two-party system. Nor should we forget another half-dozen topics that are found associated in modern times with the so-called democratic process—primary elections, the referendum, proportional representation, and so on.

That array of ideas and devices cannot but be daunting to the propagandist for democracy. Which of them are essential? How should they combine? The very need to explain what the terms mean bars the way to easy acceptance and enthusiasm. In addition, the key words do not mean the same thing to all the theorists. To cap these troubles, nowhere in the West has there been a central authority to define an orthodoxy, even a shifting one, such as there has been on the Communist side.

On that side, there is the advantage not only of unity but of broad abstraction: the class struggle, history as dialectical materialism, surplus value, society shaped by the forms of economic production, the contradictions in capitalism preparing its decline and fall, the aim and training of the revolutionist, and the dictatorship of the proletariat leading to the withering away of the state. These "big ideas" make up a scheme that has the ring of high intellectuality. The scheme is readily teachable as a series of catchwords which, as experience shows, can appeal to every level of intelligence. It offers not only a promise of material advantage, but also a drama—a struggle toward a glorious end, unfolding according to necessity.

Compared with a scripture and prophecy, which amount not to theory but to ideology, the concrete plans and the varied means of the writers on democracy present a spectacle of pettifogging and confusion. Common opinion reinforces this

lack of order and unity. The democratic peoples suppose that free governments did not exist before the population at large got the vote, which is not true, or that democracy is incompatible with a king and an aristocracy, though England is there to show that a monarchy with a House of Lords can be democratic. Was the United States a democracy when senators were not elected directly by the people? Were we a free government when we held millions in slavery or segregation? Finally, it takes no research to find out that the democracies of France, Italy, and Sweden, those of Brazil, Mexico, and the Philippines, and of Thailand, India, and the United States are far from giving people the same freedoms by the same means.

The truth is, the real subject for discussion is not "Is democratic theory for export?" but "Is there a theory of democracy?" We expect to find one not solely because a large part of the world boasts a rival theory, but also because in our admiration for science, we like to have a theory for every human activity. My conviction is that democracy has no *theory*. It has only a *theorem*, that is, a proposition which is generally accepted and which can be stated in a single sentence. Here is the theorem of democracy: For a free mankind, it is best that the people should be sovereign, and this popular sovereignty implies political and social equality.

When I say the theorem of democracy has been accepted, I am not overlooking the antidemocratic opposition. For in one sense there is none. Look over the world of the twentieth century and you find at every turn the claim that the government of this nation and that nation is a popular government— the People's Republic of China, the Democratic Republic of Yemen, and that of Kampuchea say so in their titles. Other nations profess the same creed and point to their constitutions. Parties and voting and assemblies are found up and down the five continents. The split comes over who "the people" are, what is meant by "party," and how the agents of government act for (or against) the people. Historically, the people has always

been recognized in some fashion. Athens was a democracy—with slaves; the Roman emperor spoke in the name of "the Senate and the Roman people"; the Germanic tribes and the American Indians had chiefs and also general councils; kings were the "fathers" of their people—and their servants too. And the old adage *Vox populi, vox Dei* has always meant that rulers cannot and should not withstand the people's will.

The theorem, then, is not disputed even when tyranny flourishes under it, for it has two parts and the tyrant can boast that the blessings of the second part, equality, are due to him. We are thus brought to the great question of the machinery of government—because it is how the wheels turn, and not a theory, that makes a government free or not free. The dictatorship of the proletariat may be the theory of Communism, but in fact neither the proletariat nor its single party rules. Voting and debating is make-believe set over a tight oligarchy led by one man. There is no machinery to carry out the promise that in time the proletariat will disappear and the state will wither away, and most often there is not even a device for ensuring the public succession from one top leader to the next.

The conclusion established so far would seem to be this: Democracy has no theory to cover the working of its many brands of machinery, whereas its antagonists use a single, well-publicized theory to cover in another sense, namely to conceal, the workings of one rather uniform machine, the police state.

A further conclusion is that the demand for a theory of democracy shows the regrettable tendency to think entirely in abstractions, never bringing general statements side by side with the facts of experience, or even noticing important differences between abstractions if they happen to be linked together by custom or usage. Democracy, for example, is thought of as synonymous with free government; "the sovereign people" is thought of as meaning all or most or some of the residents within the boundaries of a state. What kinds of freedom a government guarantees, how they are secured, and

which groups and individuals actually obtain them and which do not are complicated questions that theorists and journalists alike prefer to ignore. They know that such details are of no use in stirring up either protests at home or virtuous indignation about others abroad. The public at large takes government itself abstractly, as a kind of single-minded entity, an engine that works only in one direction and always expresses the same attitude toward human desires. The democratic, modern style of government is the good kind, and the rest, past and present, are the bad.

For this childlike view, there is only one remedy and that is a little history. I include under this term contemporary history, for after having excluded the possibility of a theory of democracy I am concerned to offer instead a survey, or rather a sketchy panorama, of its manifestations. I do this with a practical purpose in view: I think it is important to know how the so-called free world came into being, what ideas and conditions would be required for its extension, and most immediate and important, what changes are occurring in our own democracy that threaten its peculiar advantages and make its export impossible.

Let us return to our theorem. It calls for three difficult things: expressing the popular will, ensuring equality, and, by means of both, distributing a variety of freedoms. These purposes imply machinery. How, for example, is the popular will ascertained? The devices we are familiar with in the Anglo-American tradition have come from two sources. One is the long, slow, haphazard growth of the English Constitution from the Parliament of Simon de Montfort in 1265 through innumerable struggles for rights won (and listed) a few at a time—Magna Carta, the Bill of Rights, and so on. From this history, Montesquieu, Locke, and others variously derived the precepts and precedents that influenced the making of the United States Constitution.

The other source is antiquity—Greece and Rome—whose

practices and writings on government inspired thinkers to design plans or issue warnings appropriate to their own time. The most famous scheme is that of Rousseau. His is also the most instructive, for although he is crystal clear, his interpreters divide on the tendency of his great book, *The Social Contract*. Some say it promotes freedom, others say it leads to totalitarianism. This shows how double-edged propositions can be. But let us see what Rousseau himself says. He takes democracy literally: all the people, equal in rank, come together and decide policy and choose leaders. This is the old Athenian democracy, except that there are no slaves. Rousseau goes on to point out that only a small city-state can manage that sort of government. Knowing his ancient history, he adds that such pure democracy is too good for men as they are. He agrees with the great minds of ancient Greece—Aristotle, Plato, Xenophon, Thucydides: all were against democracy; they saw dozens of democratic cities perish from inefficiency, stupidity, and corruption.

Rousseau therefore falls back on representative government, which he calls, correctly, "elective aristocracy": the people elect those they think the best (*aristoi*) to run their affairs for them. He also requires a lawgiver to describe the structure of the government. For "lawgiver" substitute "constitution," a set of rules for day-to-day operations.

Why should anybody think that such a system must end in tyranny? One answer can be given through a quick reminder: Hitler did not seize power, he was voted in as head of a plurality party by a people living under a democratic government and with a constitution that combined the best features of all constitutions on record. If you add to the strength of Hitler's party that of the German Communists, you have a large democratic majority voting for totalitarian rule. To generalize from this example, if the people is sovereign, it can do anything it wants, including turn its constitution upside down. It can lose its freedom by choosing leaders who promise more equality, more prosperity, more national power through

dictatorship. The theorem of popular sovereignty is honored in the breach. The dictator says, "I represent the will of the people. I know what it wants."

On the other hand, a new nation can ask: "Popular sovereignty, the vote for everybody, then what?" That question was precisely the one put to Rousseau by envoys from two nations, Poland and Corsica. He wrote for each of them a small book that shows how he would go about being a lawgiver, a constitution-maker. These notable supplements to the abstract outline of *The Social Contract* are conveniently forgotten by Rousseau's critics. For in prescribing for Poland and for Corsica, Rousseau makes the all-important point that the history, character, habits, religion, economic base, and education of each people must be taken into account before setting up any machinery. No rules or means apply universally. What works in England will fail in Poland; what the French prefer, the Corsicans will reject.

Political equality can be decreed, but freedom cannot—it is a most elusive good. Rousseau warns the Poles that they should go slowly in freeing their serfs, for fear that in their economic ignorance the serfs will fall into worse misery than before. This was Burke's great point about the solidity of English freedom, which is freedom under a monarchy and what we would surely call a non-representative Parliament: based as it was on gradual change through history, freedom had taken root inside every Englishman. Burke criticized the French revolutionists because they did not revive the old assemblies and thereby give the French some training in the use of freedom. Instead, they wrote principles on a piece of paper and expected them to produce the right behavior overnight. On this central issue, Burke and Rousseau are at one, as A. M. Osborne long ago demonstrated to a non-listening world in her book *Rousseau and Burke*.

This element of Time, of the slow training of individuals by history, carries with it a predicament and a paradox. The predicament is: How can the peoples that want to spread free-

dom to the world propose their institutions as models if those institutions depend on habits long ingrained? It is easy enough to copy a piece of actual machinery, such as a computer or a nuclear weapon; it takes only a few bright, well-trained people with the model in front of them. But to copy a government is not something that a whole population can achieve by merely deciding to do it.

One may note in passing the double error of the former colonial powers: They did not teach the ways of freedom soon enough to their colonial subjects, and they let go of their colonies too quickly when the urge to independence swept the globe. The bloodshed was immediate and extensive, and it is not over. Some of the nations that emerged tried what they thought was democracy, only to succumb to military or one-party rule—always in the name of popular sovereignty, indeed of liberation. The word is not always a mere pretense, for it is liberation to be rid of a government that cannot govern.

As for the paradox, it is this: How can a people learn the ways of free government until it is free? And how can it stay free if it cannot run the type of machinery associated with self-government? On this score, the spectacle of Latin America is baffling. The several states gained their independence from Spain not long after the thirteen North American colonies gained theirs from England, during the period 1783–1823. Yet repeated efforts by able, selfless leaders have left South and Central America prey to repeated dictatorships with the usual accompaniment of wars, massacres, oppression, assassinations, and that great diagnostic fact, uncertainty about the succession of legitimate governors.

To contrast the history of the North American colonies with the history of those of the South is not to disparage Latin America, but to remind ourselves of the bases of free government. We make a great mistake in calling the American War of Independence "the American Revolution" and in bragging about the fact that it did not wind up in dictatorship like the English Revolution under Cromwell or the French under

Robespierre. In 1776 the Americans rebelled against very recent rules and impositions. What they wanted was not a new type of government, but the old type they had always enjoyed. They were used to many freedoms which they claimed as the immemorial rights of Englishmen. Once they had defeated the English armies and expelled the Loyalists, they went back to their former ways, which they modestly enlarged and codified in the Bill of Rights. Needless to say, when the people of South America threw off Spanish and Portuguese rule they had no such tradition or experience to help them.

The evidence is overwhelming that it is not enough to be left alone by a royal or imperial power in order to establish some degree of freedom and to keep it safe, to say nothing of achieving egalitarian democracy. One should remember the travails of Spain itself throughout the nineteenth century and down to a few years ago. One should think of France, eager for freedom in 1789 but hardly settled in it during its five republics, two empires, one partial dictatorship, and twelve constitutions. For hundreds of years in Central Europe, various peoples, unhappily intermingled by centuries of war and oppression, have been longing to form nations and nations to form free states. The lesson here is that *the people* must first define itself through a common language and common traditions before it can hope to be *the sovereign people*.

Nor are grass-roots aspirations alone enough to ensure either nationhood or liberal rule. We should recall the forgotten example of Russia. At the turn of the nineteenth century there had developed there a widespread, homegrown movement toward constitutional government. In 1905 several well-organized parties ranging from conservative and liberal to socialist and revolutionary had obtained from the tsar a representative two-chamber assembly based on nearly universal suffrage. Important civil rights and religious toleration were granted and able leaders arose from the middle class and professional groups, but the parties and leaders were unable to keep united behind their gains and the whole house of cards

soon collapsed. Politics were, so to speak, immature and the popular will was confused. A symbol of that confusion was the crowd's cheering for the Archduke Constantine to replace the tsar: "Constantine and Constitution" was the shout, and it turned out that many thought that Constitution was Constantine's wife.

That first experience was not forgotten. Ten years later, in March 1917, a second democratic revolution occurred, backed at first by everybody—not just do-or-die liberals and revolutionaries, but business and professional men, trade unionists and conservative landholders, urban workers and army officers. The force behind the call for reform was the desire to win the war, and the institutions set up to carry out the one and carry on the other were perfectly adequate. Again those in charge were unable to make the new institutions work, and in eight months they perished under the onslaught of a new autocracy led by Lenin and Trotsky. In less than ten years, then, two intelligent attempts to modernize government in Russia had failed—and Russia was a country where Western ideas had long since penetrated, a country whose educated class was at home in all the democratic capitals of Europe.

Our second large conclusion must therefore be that a democracy cannot be fashioned out of whatever people happen to be around in a given region; it cannot be promoted from outside by strangers; and it may still be impossible when attempted from inside by determined natives. Just as life on the earth depended on a particular coming together of unrelated factors, so a cluster of disparate elements and conditions is needed for a democracy to be born viable. Among these conditions one can name tradition, literacy, and a certain kind of training in give-and-take, as well as the sobering effect of national disaster—for example, France in 1870 and Germany in 1945.

The absence of theory and the rare occurrence at one time and place of the right pieces to assemble might seem enough to

rule out the export of democracy from nation to nation, but there is today a third and last obstacle: the present character of free governments in the West. This difficulty may be made clear by comparing our times with the heyday of enthusiasm for democratic freedom, 1918–20. The First World War had been fought against monarchies and empires, and this country joined in to "make the world safe for democracy." There is nothing foolish in that motto of Woodrow Wilson's. Victory seemed to give the Allied powers a chance to replace two conglomerate empires by a galaxy of new, true, and free nations. Russia itself seemed to have jumped the gun in March 1917.

What was not foreseen was the backlash of the war. Emotionally, it was a revulsion against four years of carnage. In practical effect, it was nothing less than a social revolution. The war itself was revolutionary, having moved the masses out of their routines—the men into the trenches, the women into the factories. What happened under Lenin in Russia, and for a time among its neighbors, advertised this social upheaval. The masses were now sovereign in their outlook and behavior. Henceforth, whatever was done must be done for their good and in their name. Their needs and wants, their habits and tastes, marked the high tide of democracy as Tocqueville had foreseen it in this country. The message was clear to all, because it had been reiterated for a century. Universal suffrage; the end of poverty; identical rights for everybody; social, economic, even sexual emancipation; popular culture, not elite aesthetics—these demands went with a distrust and hatred of all the old orders, old leaders, and old modes of life that had brought on the four years of homicidal horror and destruction. The new modes were to be anti-capitalist (obviously), anti-Victorian in morals, and anti-parliamentarian as well, for many thought representative government a corrupt and contemptible fraud. Democracy needed better machinery. In that mood it is no wonder that Fascism and the corporate state triumphed so rapidly. If England and France hung on to their constitutional freedoms amid this turmoil, it was due largely to historical

momentum, the same force that threw Russia back into its old groove.

After all this, it would be a mistake to think that what is now called the free world is just the continuation of the liberal regimes which existed before 1914. The social revolution has changed them all into welfare states, and this transformation, which is one expression of the socialist ideal, has so altered the machinery of free government that it no longer resembles the model one could previously define by a few plain devices, such as voting, the party system, and majority rule.

Although the changes in democratic nations have been similar, they have been uneven. In different countries the notions of freedom and equality have taken varying and sometimes contradictory meanings. Does a national health service increase freedom or reduce it? Does workers' compensation give equal treatment to workers and employers when it disregards contributory negligence in causing accidents? Are the rules for zoning and landmark preservation a protection of property rights or an infringement of them? More generally, can the enormous increase in the bureaucracy needed to enforce endless regulations and the high taxes levied for all the new services be called an extension of freedom or a limitation? Where it is clearly a limitation, the argument advanced is that it is imposed for the sake of equality, thus fulfilling the prediction of the earliest critics of democracy—that it begins by talking the language of liberty but ends by promoting an equality that destroys one freedom after another.

One can readily understand how the modern constraints to ensure rights came into being. The old inequalities were so flagrant, so irrational, and so undeserved, the exclusions and prejudices were so heartless and often so contrary to the laws even then on the books, that only concerted action by the government could bring the conditions of life for the masses into conformity with the democratic theorem—the popular will absolute implies equality also absolute.

But the steady drive toward social and economic parity for

all has brought about a great shift in the source of day-to-day authority over individuals. The guarantor of rights and freedoms is no longer political; the government we live under is administrative and judiciary. Hence the diminished interest in political life and political rights: the poor turnout at most elections, the increase in single-issue partisanship, the rare occurrence of clear majorities, and the widespread feeling that individual action is futile. To exercise his or her freedom, the free citizen must work through channels long and intricate and rarely political.

To see this situation in perspective, open your Tocqueville and see what he saw as the essence of the American democracy. For him, the federal government is of small importance compared with the government of each state—and so it was in 1835 for every American citizen. "The government" meant the legislature in the state capitol. What is more, in all the small things that affect individual life, from roads and police to schools and taxes, Tocqueville tells us that it is the township or county that is paramount. He gives New England as proof: the town meeting determines the will of the people and the selectmen carry it out. That is democracy at work. Everybody has a voice in decisions, everybody has a chance to serve in office, everybody understands the common needs, as well as the degree to which anybody's opinion or proposal is worth following. The democracy is that of Athens in its best days, the one Rousseau said was too perfect for human use.

Today, the government machine is more like the circuitry of a computer, too complex for anybody but students of the science. And this elaboration of devices for equality can only be endless. The lure of further rights is ever-present, because among men and women in society "equal" is a figurative term, not a mathematical one. For example, the justice of rewarding talent with higher pay has been gravely debated; the word "meritocracy" has been invented to suggest that merit violates democratic equality, because merit is not earned, it is as it were unmerited. Other attempts are being made, under the

name of comparable worth, to legislate the equality of very diverse occupations. Equality of opportunity has come to seem too indefinite and uncertain.

I am describing, not judging. The point here is not the contents or wisdom of these new rights conferred in batches on the minorities—ethnic and sexual, on the employed and the unemployed, the disabled, the pregnant, the nonsmokers, the criminal, the moribund, and the insane, to say nothing of the fanciers of old buildings, the champions of certain animals and plants, and that great silent majority, the consumers. What is in question is the effect of ever-extended rights on the conception or definition of free government. One such effect is a conflict of claims, a division of the body politic. Many complain that others have become not equal but superequal, that reverse discrimination has set in. The rights of women and those of the unborn are clearly opposites. Perhaps the smoker and the nonsmoker form the emblematic pair whose freedoms are incompatible.

The upshot is that the idea of the citizen, a person with the same few clear rights as everybody else, no longer holds. In his or her place is a person with a set of special characteristics matched by a set of privileges. These group privileges must be kept in balance by continual addition if overall equality is to survive. This progression has a visible side-effect: it tends to nullify majority rule, for in seeing to it that nobody loses through any decision, it makes majority and minority equal. Finally, progressive equality and bureaucratic delay encourage the thing known as "participatory democracy," which is in fact direct minority rule, a kind of reverse democracy for coercing authority by protests, demonstrations, sit-ins, and job actions in order to obtain the rapid satisfaction of new demands.

Regardless of one's like or dislike for the great complication that the original ideal of government by the people and for the people has undergone, one must admit once more that devising a theory for its actual working is impossible. And to say, "Here it is, come and observe, and then copy it," would be

a cruel joke. For one thing, the Western world still believes, rightly, that it is free. But though at one in the resolve to establish equality, its institutions remain wide apart in their allotment of freedoms. For example, an American citizen would find the extent of regulation in Switzerland or Sweden oppressive. He or she would call Switzerland's indirect elections at every level a backward, undemocratic system of representation. A Swiss (or an Australian) would retort, "You haven't advanced as far as the initiative and referendum for important national issues. You don't know what freedom is."

In France, that same American would be shocked at the practices by which the police regularly gather and use information about every citizen and would not be pacified by the reply that it is an old custom quite harmless to freedom. Elsewhere, the drag on democracy would seem to be the inability to act within a reasonable time, the result of government by coalition. In Holland, for example, because of the system of "pillarization"—the forming of groups according to religious, occupational, and ideological preference—there are over twenty parties competing at the polls and there is no majority. It is precluded by proportional representation, which many regard as essential to democracy. As for Germany and Italy, the same need for coalition works in the usual way to give extremists leverage against the wishes of the actual but disunified majority.

Which of these complexities would one recommend to a new nation eager for free government? If a detached observer turned to the American scene, he or she would note still other obstacles to the straightforward democratic process: gerrymandering, the filibuster, the distorting effect of opinion polls, the lobbying system, the maze of regulations governing registration for voting and nominating, the perversities of the primaries, and worst of all, the enormous expense of getting elected, which entails a scramble for money and the desperate shifts for abating its influence, including financial disclosure, codes of ethics, and the like. Nobody wants to play according

to the rules. Add the use of television to make quick bids for popularity through inane, fictional dialogue, and the employment of public-relations gurus to guide the choice of ideas to propose to the electorate, and you can gauge the decay of political campaigning. A symbol of the loss is the four-yearly spectacle called a debate between presidential candidates—no debate but an amateurish quiz program.

Being at the end of this rapid survey, I must repeat the caution I urged before: do not take description as disparagement. We do live under a free government, and it has enormous advantages over any that is not free or only part free. We could all name these advantages and show their rational and emotional value, but that would not help our present inquiry, which is to find out what foreign nations could use to model themselves on our polity, could adopt from our complicated practices. The answer, I think, is: Nothing. The parts of the machine are not detachable; the organism is in fact indescribable, and what keeps it going, the "habits of the heart," as Tocqueville called them, are unique and undefinable. In short, we cannot by any conceivable means "show them how to do it." *1986*

Administering and the Law

Administering as opposed to administration may be defined by this example. Some years ago a distinguished physician in Boston was doing research on several related afflictions characterized by anemia. He developed a new treatment, which included a strictly controlled diet. One day, entering a patient's room, he met the nurse coming out with the lunch tray, where he saw each of the prescribed dishes eaten only in part or not at all. He had a sudden revelation of his oversight. The carefully measured gluten, proteins, calo-

ries, and vitamins were going into his research paper, not into his patients. He had been making policy; he had not been administering it.

What is usually—and damagingly—meant by administration is shown in this incident that Dean Acheson relates in his book about his years as secretary of state. John Foster Dulles, who was shortly to succeed him, "dropped in for a thirty-minute chat, during which he told me that he would devote himself almost entirely to policy matters, and not spend as much time as I had done on personnel and administrative concerns." Mr. Dulles certainly thought of himself as about to engage in administration, but he would not condescend to administering.

When I was a university administrator and interviewed applicants for posts in my office, every one of the bright young persons expressed hope that after a few weeks of getting the hang of things he or she would be allowed to share in "making policy." They all visualized moments of higher consciousness in which we would sit in small groups and make policy, like a magic brew. They had picked up our society's rooted belief that it shows proper ambition to want a slice of policy as soon as possible—decision-making is the mark of glory. But in fact their daily handling of business as assistant provosts *was* the policy of the university, no matter what had been decided beforehand by the president, me, or the trustees.

It is curious that the modern world under the sway of science and technology, which pride themselves on exact performance, is so contemptuous of small detail in what affects everybody in private and social life. The proper working of an engine depends on the exact distance between two little bits of metal across which the spark is to jump. In art, critic and connoisseur go into ecstasies over the small detail, the single word or tone or touch of paint that transforms the commonplace into a stroke of genius. In science, our wizards are busy about smaller and smaller particles, and their fame is in inverse ratio. Law often hinges on small points, whose perception brings

success. Cooks know what difference one small ingredient makes. And in medicine, the dosage is a matter of minute accuracy. All true professionals, except the leaders of our social and political institutions, know that nothing is too small for their expert attention.

But in institutional life and in the public mind, it is considered trivial and below one's dignity to bother with details. It shocked some of my colleagues when as dean I gave my mind to revising some forms used by the graduate admissions office. Next I took up some one hundred models of letters used in reply to inquiries and reduced them to about twenty, making the choice easier and more uniform. I also reduced them to intelligible English. With help from reluctant academic colleagues, I prepared a faculty handbook, a student guide, and an administrative guide, which provided quick means of finding out how to get, without friction or floundering, what anyone was entitled to, from a sabbatical leave to a larger wastebasket. These scholarly works not only reassured faculty and students about the fairness and efficiency of the central administration, they contributed to both—by holding the supporting staff and the faculty to their duties and by stating the norm that would justify complaints.

While I was doing this supposedly dreary work, I was not making pronouncements in defense of the liberal arts or hammering out a new definition of the educated man. Some would say that I was not playing my proper role of educational leader. But I knew that I had eighteen thousand qualified colleagues across the country defending the liberal arts and giving eighteen thousand new definitions of education. So I could take time off to do a little practical work in education itself.

I do not mean that I confined myself to this sort of administering. There was much to do about curriculum, and I joined in several public campaigns about higher degrees. None of these things excluded the rest. But the principle of attending to both parts of the obligation is clear: if the perpetual task of curriculum reform is important, it is *ipso facto* important to

devise a procedure of spring and autumn registration that will not drive students to suicide. Ordering the nourishment and seeing to it that it is taken are responsibilities of equal weight, and the second is often the harder to fulfill.

How does the foregoing relate to the law? Like many others these days, I am concerned about the plight of our courts. I read articles about law reform, and I hope that behind the analyses and proposals submitted to Congress and the public, some attention is being given to what is too usually called the "mere mechanics" of the process under review—the way it actually works in detail and the way it ought to work.

All the great reforms of law and government have begun historically with procedures, with the rules for giving effect to moral and social judgments, and also with the mechanics of reaching the point where the rules can be invoked. The genius of Jeremy Bentham, which inspired the great English law reform of the last century, was sparked by his discovery that a client was made to pay for three attendances in the office of a master in chancery when only one attendance was granted. It was not the simple inequity of the overcharge that shocked Bentham, it was the perversion of truth built into the very structure of justice-as-administered. He found English procedure riddled with similar unnecessary falsehoods. One of the results of his work of reform was the repeal of obsolete legislation, including forms, which brought the contents of eighteen quarto volumes down to three octavos—a further aid to administering.

The idea of emptying the attic and throwing out the rubbish is not difficult to agree on. Everybody is for efficiency; nobody is against evenhanded justice, given out promptly and cheaply. In other words, policy is soon stated and hardly needs argument.

The trouble comes over the means, the arrangements for supplying enough judges, fixing their calendars to avoid an overload, reducing political influence and social prejudice,

securing a fair balance within the practices of sentencing and paroling, avoiding the paradox of plea bargaining, ensuring that the accused do not linger months in jail without trial, providing competent defenders for the poor and ignorant, keeping the prisons from being schools of vice or haunts of terrorism, and—not the least important—seeing that civil suits do not result in visiting on the litigants sufferings akin to those reserved for criminals.

These main heads should belong in any modern concept of justice. An approximation to this performance would be the glory of the law courts and the judiciary. Yet what are all these desiderata but a pyramid of actions based on a handful of general ideas and a mass of concrete arrangements, down to and including the printed form on which a complaint is entered on the police blotter?

It is at the level of the concrete particular that the law touches and affects the citizen. If one is not a seasoned criminal, it is here that fear, anger, indignation, and resentful hostility are generated. Who has not been caught in the toils of a system—not necessarily that of the law—that makes one feel like a sane man trapped in an asylum run by evildoers? It is this Kafkaesque sensation that breeds much of the subversive passion against "The System." But ironically, what sets off the desire to smash the whole institution is its failure to be a system.

1976

The Three Enemies of Intellect

That part of the world I call the House of Intellect embraces at least three groups of subjects: the persons who consciously and methodically employ the mind; the forms and habits governing the activities in which the mind is so

employed; and the conditions under which these people and activities exist. There is an important reason for not calling this domain more simply the House of Mind. Mind is properly equated with intelligence, and by Intellect I most emphatically do not mean intelligence. Intellect is at once more and less than Mind. The House of Mind may turn out to be as large as the universe; to treat of it would require dealing with the mental prowess of apes and bees and, for all I know, of fishes and flowers. Mind or intelligence is widely distributed and serves an infinity of purposes.

We ought, parenthetically, to remember this when the United States is assailed, from within or without, as a nation lacking in Mind and hostile to it. We have in fact intelligence in plenty and we use it perhaps more widely than other nations, for we apply it with praiseworthy innocence to parts of life elsewhere ruled by custom or routine—for instance, in the refined organization of all forms of work and play. We like ideas, new ideas especially, and we drive a brisk trade in them: the quickest way to get three Americans to travel a thousand miles is to propose an exchange of ideas. And there is reason to believe that this restless searching is becoming a habit the world over.

The modern educated democrat, then, is not anti-intellectual in the sense of shunning novelty or undervaluing intelligence. The truer and more serious charge is that he neglects or resists or shies away from one form of intelligence, which is Intellect. And this we see with peculiar vividness in the United States, where, precisely, customs and routines do not mask the defect: it is for lack of Intellect that we have such a hard time judging persons and ideas; it is absence of Intellect that makes us so frightened of criticism and so inept at conversation; it is disregard of Intellect that has brought our school system to its present paralysis. In any large collective enterprise, such as the production of rockets and satellites, it is dearth of Intellect—not of intelligence—that aggravates the normal causes of friction and slows down accomplishment.

What then is this rare lubricant and propellant that we lack? Intellect is the capitalized and communal form of live intelligence; it is intelligence stored up and made into habits of discipline, signs and symbols of meaning, chains of reasoning and spurs to emotion—a shorthand and a wireless by which the mind can skip connectives, recognize ability, and communicate truth. Intellect is at once a body of common knowledge and the channels through which the right particle of it can be brought to bear quickly, without the effort of redemonstration, on the matter in hand.

Intellect is community property and can be handed down. We all know what we mean by an intellectual tradition, localized here or there; but we do not speak of a "tradition of intelligence," for intelligence sprouts where it will and is spent day by day like income for incessant needs. Intelligence is the native ability of the creature to achieve its ends by varying the use of its powers—living, as we rightly say, by its wits. Accordingly, we can distinguish the intelligent from the stupid throughout the scale of sentient beings: an intelligent, but not intellectual, dog or child; an intellectual, but not intelligent, university professor. Intelligence is by definition the protean faculty. We find it in a political move or in a work of art, in the performance of a football team or in a piece of repartee, none of which are specifically intellectual. And though Intellect neither implies nor precludes intelligence, two of its uses are—to make up for the lack of intelligence and to amplify the force of it by giving it quick recognition and apt embodiment.

For intelligence wherever found is an individual and private possession; it dies with the owner unless he embodies it in more or less lasting form. Intellect is on the contrary a product of social effort and an acquirement. A man cannot help being intelligent, but he can easily help becoming intellectual. Intellect is an institution; it stands up as it were by itself, apart from the possessors of intelligence, even though they alone could rebuild it if it should be destroyed.

That is why I have used the image of a house. I would speak of the *realm* of mind—limitless and untamed—but I say the House of Intellect, because it is an establishment, requiring appurtenances and prescribing conventions. The distinction becomes unmistakable if one thinks of the alphabet—a product of successive acts of intelligence which, when completed, turned into one of the indispensable furnishings of the House of Intellect. To learn the alphabet calls for no great intelligence: millions learn it who could never have invented it; just as millions of intelligent people have lived and died without learning it—for example, Charlemagne.

The alphabet is a fundamental form to bear in mind while discussing the decay of Intellect, because intellectual work as here defined presupposes the concentration and continuity, the self-awareness and articulate precision, which can only be achieved through some firm record of fluent thought; that is, Intellect presupposes Literacy.

But it soon needs more. Being by definition self-aware, Intellect creates linguistic and other conventions, it multiplies places and means of communication, it seeks relief from other duties, such as fighting and tilling the soil—in short, it needs a house, with house rules and an income for its upkeep.

The need for rules is a point of difficulty for those who, wrongly equating Intellect with intelligence, balk at the mere mention of forms and constraints—fetters, as they think, on the "free mind," for whose sake they are quick to feel indignant while they associate everything dull and retrograde with the word "convention." Here again the alphabet is suggestive: it is a device of limitless and therefore "free" application. You can combine its elements in millions of ways to refer to an infinity of things in hundreds of tongues, including the mathematical. But its order and its shapes are rigid. You cannot look up the simplest word in any dictionary, you cannot work with books or in a laboratory, you cannot find your friend's telephone number, unless you know the letters in their arbitrary forms and conventional order.

From the image of a house and its economy, one can see what an inquiry into the institution of Intellect must include. The main topics are: the state of the language, the system of schooling, the means and objects of communication, the supplies of money for thought and learning, and the code of feeling and conduct that goes with them. When the general tendency of these arrangements makes for order, logic, clarity, and speed of communication, one may say that a tradition of Intellect exists.

Divided against itself, the House of Intellect today has lost the sense of being a company apart, associated perhaps fitfully with authority, yet comforted by a freemasonry of manners and speech; envied or scorned from above and below, yet justifying the envy and helped to forget the scorn by qualities and powers it had earned and felt free to enjoy. When literacy drew a dividing line across society, all the initiates found more in common with one another than with any other group. Besides the diverse professional bonds, there existed a more inclusive one based on the two fundamental habits of reading books and being articulate. Priests, poets, scholars could address one another without false pride or false shame. This opportunity for conversation, unspoiled by the need of posturing before other groups, established an intellectual class, or as Coleridge happily named it on the eve of its disappearance—a clerisy.

In nineteenth-century England this class came as near as it has ever done to wielding direct political power, for it subdued to the intellectual life the men who were cabinet ministers, high civil servants, and editors of large newspapers. Read the diaries and letters of the leading men of Victoria's time and you will find what a varied community of talents flourished, bringing together Tennyson and Tyndall, Huxley and Manning, Bagehot and Clough, Spencer and George Eliot, Gladstone and Jowett, Matthew Arnold and Lady Rothschild. The Victorian Age has rightly been called the Golden Age of

Intellect because of this remarkable fusion of interests and powers. Nowadays the amalgam is broken up; the bond between a labor leader and his Ph.D. consultant in economics is not between their intellects, but between the information on tap in the one and the vacuum it is to fill in the other.

For men have come to believe that they can link knowledge and action without a regular gradation of intellects to harbor and diffuse ideas, or a common concern about the welfare of Intellect as an institution. They trust to the exceeding fineness and particularity of the information stored in print and made foolproof by formulas. Yet at the very time when the sum of fact on all subjects begins to seem adequate to the demand, a silent panic overtakes both thinkers and doers: "the problem of communication"—Babel—become an everyday experience.

That same abundance of information has turned into a barrier between one man and the next. They are mutually incommunicado, because each believes that his subject and his language cannot and should not be understood by the other. This is the vice which we weakly deplore as specialization. It is thought of, once again, as external and compelling, though it comes in fact from within, a tacit denial of Intellect. It is a denial because it rests on the superstition that understanding is identical with professional skill. The universal formula is: "You cannot understand or appreciate my art (science) (trade) unless you yourself practice it."

This error is briskly propagated by the schools, in the name of scholarship and with genuflections before the menacing heap of knowledge, of which no man can appropriate more than a little. We forget that every age has carried with it great loads of information, most of it false or tautological, yet deemed indispensable at the time. Of true knowledge at any time, a good part is merely convenient, necessary indeed to the worker, but not to an understanding of his subject: one can judge a building without knowing where to buy the bricks; one can understand a violin sonata without knowing how to

score for the instrument. The work may in fact be better understood *without* a knowledge of the details of its manufacture, for attention to these tends to distract from meaning and effect.

Even if one sets apart those arts and sciences that require special preparation, there remains a large field to which Intellect has access in its own right. With a cautious confidence and sufficient intellectual training, it is possible to master the literature of a subject and gain a proper understanding of it: specifically, an understanding of the accepted truths, the disputed problems, the rival schools, and the methods now in favor. This will not enable one to add to what is known, but it will give possession of *all that the discipline has to offer the world.* The professional's fallacy, in short, is to make no distinction between knowing the subject and knowing the craft. To be ignorant of what is ancillary, of the scaffolding knowledge of an art or profession, is certainly the mark of the "outsider," but by cherishing the doctrine of inside and outside we have split the clerisy without noticeably improving the arts.

Still worse, this illusion about the extent of knowledge and this vainglory about professionalism have destroyed the intellectual audience. Though millions have literacy and hundreds of thousands have "education," plus the rudiments of a profession, it becomes harder and harder to find the few tens of thousands who are willing, let alone eager, to attend to intellectual matters.

Continuing our tour of the divided House, we come upon a third and final contradiction. It is this: While the scuttling of Intellect has been going on, the dissemination of its products has become a planetary frenzy. It was reserved for our age to see scholarship, science, and art expensively displayed through the loudest means of communication, while an angry chorus of thinkers and artists proclaims the new barbarism.

The facts that call forth these imprecations are familiar: the daily and weekly press enlarging its conception of journal-

ism and taking on the task of encyclopedic popularization; the new industries of musical and pictorial reproduction thrusting down the throats of the multitude not merely the masterpieces of the past, but also their retinue of historical information; the electronic mass media making it their hobby to scatter the small change of scholarship about innumerable subjects. It is a revolution, and without an end in sight. The ultimate effect is beyond our ken. The point is that dissemination creates demand, and the demand for Intellect—its substance or shadow—appears insatiable.

Under the same moral pressure of the time, every large private collection of books or other valuables of learning is expected sooner or later to become public property. In answer to that craving, our century saw what is perhaps the most astounding spectacle in history—certainly in military history: the armies of the world waging war, each burdened with a corps of art historians for the preservation and classification of *objets d'art*, these same treasures having nearly everywhere been buried at great cost in special shelters. Anyone looking down from Mars would say that our civilization had lost its mind to art and intellect.

But the earth-dwelling artist raises his voice to decry the whole effort as frivolous antiquarianism. He wants support for creation instead of diffusion and protection. He makes clear that regard for the works of the dead does no good to him, who is living, or rather starving, and that if our age wants a good name hereafter, it must give him the means to create. His plea has merit, but the difficulties of his position are not identical with the predicament of Intellect. Rather, his troubles aggravate the predicament by aligning him, in the name of "creation," against "mere intellectuality."

In this civil war between art and intellect, numbers and passion are on the side of art. A strong party wants government support for it, as a national concern, and not just as a medium of propaganda. The private foundations develop *tic douloureux* trying to do their manifold duty to creativeness,

while the help given by groups and individuals to anybody who shows the slightest capacity for self-expression is touching and tremendous. This is not to say that every artist thrives, but only that no other age has even dreamed of anything like this openhandedness. We are driven to it by our guilty knowledge of history: mindful of ruthless neglect in the past, we worry about the young and the unknown, the handicapped and the hopelessly striving. For them, as much as for the mature and valiant, we organize workshops, bookshelves, exhibits, festivals, fellowships, prizes, courses, camps, colonies, hospital wards, and mobile units, trusting that these will assist the fertile mind in its parturition. Amateurs are coddled into artistry, children stimulated by early acclaim, and in London a chimpanzee has had the first one-ape show. The word "creative" is so much in honor that it is the clinching term of approval from the schoolroom to the advertiser's office. And the quality it denotes is democratically assumed to lie latent in every bosom, only waiting for one of the opportunities we lavishly devise.

Yet all this, far from satisfying our contemporary artists, leaves most of them angered and gloomy amid the orgiastic dispersal of their works. As a result, artists are today the most persistent denouncers of Western civilization; and their lay following zealously presses the indictment. Beside theirs, the political animus against society seems tame. This is something new, in form as well as spirit. For the artistic outcry tends to be vague, abstract, and often absurd. It affects to despise materialism and the world of trade, but the ground of attack is that trade gives artists too little material reward. Being intellectually feeble, these complaints cannot lead to action; they merely poison the air and the lives of those that breathe it.

This autointoxication, which contributes to the modern intellectual's sense of martyrdom, is linked with another social change that has stolen upon us unregarded—the recent education of the artist to the ways of Intellect. In itself, art can exist

without learning and, in a sense, without reason. Painters, sculptors, musicians, actors, dancers, even poets and playwrights, resemble engineers and physical scientists in that they can follow modes of thought quite other than those of discursive intellect; some scarcely need literacy, as history proves; and they certainly have no obligation to traffic in established ideas. Some of the greatest have in fact been virtually inarticulate—to cite examples at random: Schubert, Daumier, George Stephenson, Ghiberti.

During the last century, the current has been reversed; artists of every kind have become men of words and ideas, bent on joining the Great Conversation. In youth, they no longer resist a liberal arts training; later, they accept academic posts, they set up as critics and social philosophers, they are caught—sometimes ridden—by political and other systems. This was notable in the Marxist decade and it still is so in the so-called religious revival of today. And now the artists have been joined by an increasing group of natural scientists, late-awakened by the noise of an explosion. In both groups, talent, education, and a fresh appetite for ideas produce an effervescence which has the coloring, though not always the substance, of Intellect.

Nor has the rapprochement been from one side only. The artist turning toward ideas has been met halfway by a public turning aside from words and greedy for speechless art. The new pastimes of the educated amateur are the arts of nonarticulate expression: music and painting. While fiction languishes and the theater is in the doldrums, ballet has risen to popularity, Sunday painting is fashionable, and chamber music thrives. Everywhere picture and sound crowd out text. The Word is in disfavor, not to say in disrepute—which is indeed one way of abolishing the problem of communication.

Nor should we be surprised: this shift in taste has been gathering momentum for three generations. From the Symbolist period on, Western art has been based on the repudiation of what is common—common speech, common life,

common knowledge—and its replacement by the singular and indefinable. Excellent reasons can be shown for the choice, and the right of artists to do as they see fit is not here in question. But neither is the effect in doubt, for art has never been so quick and potent in its influence: the revulsion from words, syntax, and coherence accounts for the widespread anarchy in the handling of the mother tongue, as well as the now normal preference for the abnormal in our conceptions of the real. Whereas the "experimental" in art used to take a generation to be recognized, now we encounter the latest modernisms overnight in the work of the commercial artist and the writer of advertising copy. The public approves and encourages, having learned to swallow and even to enjoy what shocks feeling and defies reason.

I dwell on the influence of art upon the intellectual life of today because it is all-pervasive. A member of the educated class nowadays need not have any direct or vivid contact with art to fall under the sway of the aesthetical creed and its emotions. He feels about life, business, society, the Western world, what the art-inspired critics of the last eighty years have felt, and he speaks the phrases appropriate to his borrowed disgust. He may be a minor foundation official living comfortably on the earnings of some dead tycoon, but he talks like Baudelaire. Indeed, the attitudes I describe are no longer confined to those engaged in intellectual or semi-intellectual occupations. They have touched the wider public whose exposure to ideas is through the press, where readers find reflected not only the worship of art but also its attendant contempt of the world, both alike taken for granted as the natural response of any intelligent and "sensitive" modern. A deep unconscious anti-intellectualism thus comes to be the natural adjunct of any degree of literacy and culture; and this at the very time when new social groups, fresh from the educational mills and thoroughly aestheticized, think of themselves as intellectuals and mean to live as artists.

But, it may be asked, is there not a great intellectual force, still more powerful than art and working against it, namely, the force of science? Science is exact, science is strict, science is influential—especially in the press where art must compete with it for attention. Why should Intellect be at the mercy of art?

The question is pertinent, and the answer not encouraging. For despite their differences, science and art have reinforced each other's effect. Through the increasing fantasy of its concepts and symbols, through its diverging technical tongues, science has also receded from the common world. Science too has helped to break up the unity of knowledge. In the name of untrammeled inquiry, scientists have planted citadels throughout the realm of mind, but have taken no thought of the means of intellectual exchange among them. The House of Intellect is lost somewhere in this no-man's-land. When scientists talk about their supposedly common enterprise, they take one of two contrary views and sometimes both together. One is that science is radically unlike any other intellectual pursuit—in method, language, and type of mind. Science is numerical, objective, certain; nothing else is—as we imply in the common use of "unscientific." The second or "enlightened" view is that the scientist's work is essentially akin to that of the poet. It relies on inspiration and a god-given power to handle symbols "creatively."

In spite of this second interpretation—a further tribute to aesthetic propaganda—and in spite of the influence of scientific jargon on common thought, the natural sciences and their practitioners continue to form a world apart. When their representatives meet with those of other branches of learning, the verbal deference does not signify much sympathy. The clans soon re-form and on each side the sense of apprehensive loneliness returns. What will "they" be doing next? The question is charged with the promise of money and power. Is the public on "our" side or theirs? I have myself heard scientists speak of a "conspiracy of the humanities" to blacken science in general

opinion, restrict research, and "reverse the trend of modern progress." What literary men say of the scientists, chaste ears ought to be spared.

When science won its place in academic and general opinion a century ago, the mutual hostility was perhaps justified, because the claims on each side were extravagant. But there has been ample opportunity since then to codify and make known the ways in which the knowledge of nature is like and unlike the knowledge of spirit. The visitor from Mars would surely suppose that these truths formed part of our elementary curriculum, a *pons asinorum* for all who make the least pretense to the life of the intellect. As things stand, the best that common knowledge can show is a pair of dull clichés about music being somehow related to mathematics, and poetry being "in its way" as exact as science; but the how and the way are left prudently in the dark.

The prestige of science remains of course pre-eminent, despite the superficial hold that science itself has on the minds of the intellectual class. And it is that prestige, acting as a perpetual goad to imitation, which makes science's share in the decay of Intellect equal to that of art. Each in its way undermines the sense of unity, defeats communication, and throws the individual back on his own resources in a world whose worth, and even whose reality, is challenged by these two imposing enterprises. We may conclude, then, that for a century more or less, Art and Science have been the chief enemies of Intellect among intellectuals. But there is a third and closely related enemy, which is Philanthropy.

I use philanthropy to mean the liberal doctrine of free and equal opportunity as applied to things of the mind. This application has two results. The first is the corruption of judgment; the second is the corruption of the products of intellect themselves. In their corrupted use, "opportunity" is no longer wholly free and often not at all opportune. Rather, opportunity turns into social pressure, and the desire for intellect becomes part of the urge to share the wealth—a double imper-

ative ceaselessly dinned into our ears: "Patronize your local library, enjoy a museum seminar in your home, see what the Zoo can do for you. You owe it to yourself to have an intellectual life—learn Russian in your spare time, read the 101 classics during the next 1,001 nights, or at least take up playing the recorder and paint on Sundays. Remember that education should never end: join a class after 5 P.M. Creativity is within you; learning releases it. Education is the best recreation; square dancing is recreation; square dancing is education. Have no fears: in our love is your understanding."

True to its origins, this philanthropy carries out the behests of pity; its watchword is "help." The slightest response to the proffer of opportunity creates a claim to special treatment. Help is abundant, overflowing, and thanks to it willingness in the learner is enough: why distinguish intention and performance? Philanthropically speaking—"in terms of eagerness"— the aspirant is often superior to the passed master. Nor can there be a finer object of philanthropy than struggling incompetence, since evangelical charity says: give to those that want. The opposite, the worldly rule, would give to those that have talents and would take away at least the opportunity from those that have not. But this, proceeding from intellectual judgment, would be cruel; it is indeed a flaw in the reign of love and welfare that Intellect seeks to concentrate its resources rather than spread them as consolations for helplessness.

The connections of this philanthropy with modern art and science are easy to trace. The evils that art discerns in the very nature of politics and business, philanthropy also condemns and tries to make up for. It bars competition, is suspicious of power, and ignores failure. For the usual prizes of philistine greed it substitutes the guerdons of higher lusts—a certificate of proficiency in French or a scrapbook of two-by-four gummed reproductions of the old masters. Now, none of this would be possible without the surpluses that technology has created. The freehanded ways of intellectual philanthropy reflect the abundance of paper, ink, books, schools, photo-

graphs, recordings, and free-lance lecturers, but also the more general sense of copiousness arising from the pride of science and the litany of numbers, numbers, numbers.

It hardly needs saying that though the whole world is now the playground of philanthropy, its headquarters everywhere are the schools. The talk of "education" where none is wanted or needed, or where something else is meant, is characteristic of our time. But even more illuminating is the identity between education and psychology or psychiatry, two demi-sciences ridden by philanthropic moralism. The doctrine of pity and help, originating in the church, the settlement house, and the clinic, has found in the modern psychologies a convenient means of carrying abroad the war against Intellect. Though the genius of Freud was unswervingly intellectual, it has given birth to a large progeny of adapters who, from generous as well as selfish motives, put philanthropy first. They mean to cure, or at least to "help" at any cost. They respect no intellectual limits or principles, and one by one the chief elements of our culture have fallen within the area of their devastation. Thus the school is not to teach but to cure; body and mind are not to use for self-forgetful ends but to dwell on with Narcissus's adoring anxiety; the arts, not to give joy and light but to be scanned for a "diagnosis" of some trouble, a solution of some "problem," or else exploited for the common good in occupational therapy; and all other social or political institutions are not to serve man's material needs but to be brought to the bar of cultural justification.

The final twist in this transformation is that the clinician-publicists who carry on the war breathe love in hostile phrases while finding in Intellect untold aggressions to condemn. Their love hates Intellect because they feel and disapprove its impersonal calm, and also because its triumphs look like conquests not so much by, as over, common humanity. Avant-garde psychology, avant-garde art, and the philanthropy that is coeval with them, alike cherish the warm confusions of animal existence.

These foes of Intellect nevertheless make stern demands. Art, like professionalism, claims of its devotees exclusive allegiance. Science reserves the right to apply its method where it chooses and hopes for world empire. Philanthropy leaves no one alone, and its educational and psychological allies, taking universal welcome for granted, turn vindictive when challenged. For Intellect to say that its duty is clear and limited, that it cares little for happiness, that it puts other virtues ahead of goodwill and does not seek world peace, convicts it out of its own mouth. So much sobriety is not in fashion, it looks like provincialism, a refusal of enlightenment—complacency.

The anti-intellectual emotions at work here being even more complex than usual, one can easily mistake them. Yet it does seem as if the prevalent desire to embrace the whole world in some benevolent imperium of love, science, or art expresses chiefly a rooted aversion toward the immediate and actual. Living habitually at the full stretch of their perfectionist fancy, modern men of ideas loathe the world they know. If proof were needed, one could cite the utopian passion which governs nations in the East and the corresponding Orientalism which works as a ferment in the West. War and travel in Asia have made Western intellectuals once more preach the wisdom of the East.

But it is one thing to study and another to adopt, and even the attempts at adaptation may be regarded critically without its implying provincialism. The motive which brings an image of the goddess Kwannon into the window of a Fifth Avenue department store is but the fashionable curiosity that is always shifting from one source of new slogans and sensations to another. To prefer the exotic to the homegrown is a usual form of "sophistication"; and when, as in the present fad for Zen-Buddhism, the fashion enjoins contempt for Intellect, the pleasure is double.

But Intellect is not abashed. It goes to work on anti-Western arguments and easily shows how false is the warm,

generous, philanthropic attitude which they affect. Taking up the charge of "blatant parochialisms" and "obsessive nationalism" leveled at "our age and civilization," Intellect asks: How is our detestable pride to be measured——by Arab tolerance, African neighborliness, Chinese humanitarianism, Japanese indifference to gain, Egyptian humility? Where is the model state and people? And where have empires more or less voluntarily given up their alien possessions, and governments their oppressive powers——in the East or in the West?

The love for all peoples far away has in it also a touch of self-pity, occasioned by the presumed "decline of the West." The phrase may mean many things, but in one of its meanings, Intellect points out, it is exactly matched by the decline of the East. Every piece of machinery found east of Suez, every word of English spoken, every pair of trousers, every bad movie, must be accounted a "triumph" of the West over the declining East. To say this is to show the absurdity of the phrases which pass for "intellectual" comments on Western civilization and for signs of large comprehension on the part of the users. The only importance of these pronouncements is that they are inspired by "otherworldliness" in a new sense, one which associates all the evils of life with our historic past and our characteristic modes of thought, in an effort to repudiate them both.

For it is true that Intellect as I am defining it belongs largely to the Western tradition——the tradition of explicitness and energy, of inquiry and debate, of public, secular tests and social accountability. What Intellect satisfies in us is the need for orderly and perspicuous expression, which may lead to common belief and concerted action. Eastern philosophies and religions undoubtedly contain ideas that are valuable to persons and peoples outside the East, but one cannot help noticing that the first signs of a Westerner's involvement with Oriental thought, whatever inward good may go with it, is a toxic condition of the vocabulary——every word meaning not only what it denotes but its opposite as well——complicated by

serious lesions in coherence and a rapid lowering of the logical pulse. With the loss of articulate precision, Intellect as the West has developed it—the social and publicly responsible Intellect—sickens and dies. Whether this is desirable is not the point. The point is that, until we choose to go under, we must look upon all philanthropic gestures, and especially upon amateur Orientalism, as a warning. The signs of these effusions are unmistakable—easy indignation, the throb of pity, portentous promises, and still more generally: vague words, loose thoughts. The state of the mother tongue is in fact the index of our control over destiny.

These three great forces of mind and will—Art, Science, and Philanthropy—have, it is clear, become enemies of Intellect not of set purpose, not by conspiracy, but as a result of their haphazard assimilation within the House of Intellect itself. The intellectual class, which ought always to remain independent, even of Intellect, has been captivated by art, overawed by science, and seduced by philanthropy. The damage done by each has been that of heedless expansion combined with a reliance on the passage of time to restore order and decency. But time mends only by blotting out. In the modern riot of art and science and loving-kindness, Intellect has seen decline the virtues that make it what it is: unity, concentration, communicativeness, and knowledge of itself. *1959*

An American Commencement

An American commencement, when you come to think of it, is an extraordinary event, even though it occurs every year and in many places. Consider: At commencement, credit is given to those who have earned it; public recognition goes

to hard work, not influence; prizes and honors are awarded according to merit. This will never happen again in the lives of the graduates.

Notice too that among those gathered to see these miracles, an atmosphere of pure benevolence prevails. You find that strangers have spelled everybody's name correctly on the diplomas and in the program; and to top the pleasure, there is often some form of free lunch. All these signs suggest that Utopia is at hand. But as in the Garden of Eden, there is a joker lurking, someone with a line of talk all prepared to spoil the bliss: that is the commencement speaker.

What he does is remind the dwellers in Utopia of the harsh world outside; and he does this usually in the most uncomfortable, inappropriate way. Here he is, addressing students who have been toiling so as to enter a profession, to pursue a career on home ground, and the speaker tells them that they must do something for peace in the Middle East; or that they cannot any longer ignore the blight of drug abuse, to say nothing of their responsibility for better policies in South America, South Africa—and the District of Columbia.

Very few students are prepared for such assignments, but they never protest, perhaps because they are flattered to hear from the speaker that the future is in their hands: the world depends upon them. At any rate, none of them or their parents object, because they are polite and willing to let the speaker get his words in the newspaper the next day, which will happen only if he raises issues of global importance.

For my part, when I speak at a commencement, I prefer to say a few words not about what the newly hatched might do for the world but what they might do for themselves, as individuals. Suppose they are graduating from a music school; the speech goes something like this:

As you are now, the world does *not* depend on you; it is not aware of your existence; it will acknowledge it slowly, perhaps in keeping with your professional efforts, perhaps not. These efforts are unquestionably your main business, now that

you have taken such pains to be knowledgeable and proficient. But these very pains, this professional preparation, and the striving to establish yourselves which comes next, are all activities that narrow the mind and stifle the spirit.

One might suppose that because your studies relate to the art of music, your scope has been both broad and deep. But your studies have made you technicians, specialists, and your further progress will make you specialize even more. In every niche you will be bound by set procedures and compelling needs. You will do what you must much more often than what you want. The higher you rise—as the world measures height of accomplishment—the greater will be the compulsions, the necessary conditions of your professional life. True, if you are a great success as a great artist, you will have some power and some free choices. But that fact itself will make the surrounding limitations all the more galling.

You should also consider the possibility that you will not manage to get even that limited area of freedom. For in our world, which is ever more crowded with talents, success depends ever more on a run of happy chances. Undoubtedly, after trial and error, you will find a suitable field for your abilities. Looking for it, making it truly your own by (as we say) proving yourself, will be engrossing and satisfying. But after your success, what? There comes a time in every career when this cheerful sense of accomplishment comes to an end. Life begins to repeat, or seems to. And even before you come to occupy the desired spot, there are bound to be moments of self-doubt, when hope and energies are at a low ebb. What do you do then? What are your resources for coping with the usual questions that arise at those moments: What am I worth, really, and, how can I replenish the founts of self-confidence?

There are no guaranteed answers to these questions. But when the will to self-searching has you by the throat, there is immense value in being able to find a Self: that is to say, a solid entity that you can trust, because you have made it yourself, and made it well. A well-made Self is not a haphazard col-

lection of habits and prejudices, of notions and fancies; it is an ordered set of reflections, conclusions, and convictions. Now, the task of continually bringing these elements together and putting some order among them requires an outside stimulus and a discipline. This stimulus may be of the regrettable kind, such as a grave illness or a great sorrow; or it may be a strong and sustained religious faith. But for most people, the stimulus and discipline are deliberately chosen. They take the form of getting outside one's routine and filling the mind with vicarious experiences. This is best done through reading.

Reading of course can easily be nothing more than a way to kill time; but if it is calculated and intense, it is a steady extension of one's life. If life is measured by consciousness, one whose mind is full lives longer than one whose mind is empty—just as one who is awake eighteen hours a day lives longer than one who sleeps away every twelve hours. You add to life by adding to the quantity of conscious moments through reading. This is true no matter what you read— history, poetry, novels, essays, letters, diaries, memoirs, criticism. One curious result of the habit is that after a while, even the reading that kills time brings with it some addition of value, because the mind is equipped to extract some good thing or other from the low-grade substance.

You will ask, How does reading-with-intent help to build a Self? If all it does is eke out your experience with that of others, why isn't your own sufficient? Why doesn't it organize itself into inner strength? What is lacking is the contrast, the otherness, the novelty and strangeness; the shock of difference and the recognition of sameness; in other words, the work of the imagination. For to read intelligently and profitably, your imagination must work every minute, reconstructing the lives, events, and emotions depicted in print.

If this is true, you can see why filling the mind with a vision of what happened to other people, or of what is happening right now elsewhere, is an antidote to the narrowing effect

of a profession. It reminds you at critical moments that the present concern, the irritating predicament, the stupid mess created by an individual act or an institutional rule, is not the sum total of the universe. It gives you, as we say, perspective, a sense of proportion. These words in fact refer to that second Self, that solid Self, full of experience, which stands like a backstop behind the everyday Self, which is engaged in dealing with the vicissitudes of life.

That second Self is of course a permanent acquisition. You don't lose it like an umbrella and miss it the next time it rains. You carry your strong identity with you through the whole course of life.

I have so far stressed the use of a cultivated Self in cushioning the defects and annoyances of existence, because at your stage of life utility is doubtless uppermost in your mind—and rightly so. But the cultivated Self is also a source of joy. With it, the idea of leisure gains all its meaning; it is not empty time, but time in which the mind takes pleasurable exercise, as the body does in jogging or swimming. No need to look for "leisure-time activities," so-called. One can be perfectly idle and also contented, self-entertained. When Walt Whitman said, "I loaf and invite my soul," his soul was not a vacuum or a jumble, else he would have loafed the shortest possible time and looked for company and a pack of cards. To put it the other way round, to a cultivated mind the boredom of solitude is unknown. Such a mind can be bored only by other people; and those other people are very few, because ordinary bores, like trashy books, often contain matter of interest.

You may wonder why I suggest filling and organizing the mind by reading. Why not the contemplation of the other arts? And since you have all dedicated yourselves to the art of music, why is this happy choice not sufficient to cultivate a Self as resistant and as pleasure-giving as the good life requires? I partly answered that question earlier, by pointing out how professional studies and work coerce body and mind

into narrowness—the fulfilling of immediate demands, the pursuit of self-interest, as contrasted with the pursuit of interest in one's Self.

But there is another part to the answer. It is just possible that all of you like music—or that only some of you do. I am not joking when I suggest that doing music and liking it are two different things. The parallel in ordinary life is familiar enough: a couple who are passionately in love but do not really like each other. One can be a passionate performer, a composer of genius, a dedicated teacher, and yet totally neglect music as a source of cultivation. And this relation applies of course to all the other arts, including literature.

Cultivation, or what I have called for short *liking*, calls for a certain detachment—standing off and looking, comparing, reflecting, concluding. Whereas a performer (let us say) puts his whole soul into rendering the works of a few chosen masters, or at best of a given style or period, the true music-*liker* enjoys many masters, styles, and periods. As for the composers, they very properly equate music with their own or kindred creations. As listeners and beholders we are grateful for these fanaticisms; they are wonderfully productive *for us*, but they do not benefit these single-minded beings themselves in the way of cultivation.

Finally, it must be added that music and the plastic arts serve cultivation best when the experience of them becomes explicit, that is, when it is discussed or read about. The reason for this is simple—feelings and memories are stored up and relived most fully with the aid of words. Recall a superb performance of the Ninth Symphony or your first sight of Chartres Cathedral, and you will find that these recollected emotions are strung upon a thread of perceptions, incidents, details, all couched in words. This is by no means to treat music or architecture in a literary way, but only in the normal way of the human mind. When you tell a friend of a near-accident in mountain climbing, you are not dealing with your life and the Rockies in a literary way: you are giving shape to

confused emotions. Complete experience involves words, even though the words do not themselves reproduce the experience. Only one thing gives it—the imagination.

This truth brings us back full circle to our beginning. Whoever wants to build a Self for the sake of inner strength and the pleasures of vicarious experience had best make the play of imagination a part of his program. As Voltaire said, "Cultivate your garden."

But one last, quick question: Isn't this goal of self-sufficiency a piece of selfishness? What about the horrors of the Middle East and of drug addiction? We are not separate islands in the sea, as John Donne reminded us; therefore these public concerns are ours too, in some way and to some degree. A main way is as citizens and voters, and in that capacity chances are good that a mind rich in vicarious experience will yield sounder judgment than one cultivated only by the newspaper. Part of that good judgment will be to recognize ability in those one votes for; another part will be to know that ignorant opinions about what to do in complex situations are worse than useless—they are dangerous. "Cultivate your garden" also means: Attend to what you are fit to do and delegate the rest.

1987

IX

*On France
and the French*

Paris in 1830

If with your ideas of present-day Paris you were to approach it in 1830—by air or on horseback—you would look in vain for its famous landmarks: no Eiffel Tower, no Sacré-Coeur atop Montmartre, no obelisk on the Place de la Concorde—in fact, no Place there at all, but a muddy expanse crossed by ditches. The Champs-Elysées would exist in the form of a broad dirt road, but if you looked up toward the Etoile, you would see only the stumps of the Arc de Triomphe. Though started in 1809, it was not finished till 1836. In the heart of the town, you would find the river turbid and full of loaded barges sailing past ferries, laundry boats, and public baths moored to the mud-banks—no stone embankments and no paved roads alongside, no pleasure boats, and fourteen bridges instead of the present twenty-seven. As you walked north, you would indeed see the Louvre and find some pictures, but even more artists lodging there, amid a general dumping place for government property. Turning west toward the Tuileries gardens, you would see in the middle a grand palace, the king's residence, burned down in a riot forty years later. From the neighboring rue de Rivoli you could take the rue Royale toward the boulevards without any sight of the Madeleine, only some foundations surrounded by vacant lots. After the building was finished, many thought it should be a railroad station, the first in Paris, for the first line, Paris to Saint-Germain, had just been opened. The edifice was not consecrated until 1842.

In 1830 the boulevards did begin at that spot and pursue their present course, but by going east you would not come across the gaudy Opéra that you know, or its avenue. You would indeed see the Place Vendôme and its tall bronze column celebrating French victories. But the ornament at the top would be a huge fleur-de-lis. Napoleon had been taken down by the restored Bourbons in 1815 and only after Louis-Philippe's accession, in August 1830, did the emperor regain his perch. Continuing toward the southeast would bring you to sites you would recognize—the Comédie-Française and the Palais-Royal adjoining. That enclosure you would find more crowded and less sedate than it is now: it was a shopping mall, supplemented by gambling dens and houses of assignation, conveniently close to the parading courtesans and their clients in the crowd. Glancing at the side streets, you would find little to admire; your prevailing impression would be of a small, crowded, unplanned town. Apart from the boulevards, streets were narrow; many were dead-ends; few were paved, the rest were muddy lanes without sidewalks. The gutter was in the middle and its purpose was to receive the daily slops emptied from the windows of the houses, many of which had overhanging upper stories.

The people who walked these dark tunnels full of peril to clothing, dignity, and health wore a variety of colorful costumes. The authorities call the years 1825–1836 the "second original dress period of the century." One clear advance was that children were no longer garbed like small adults, but I shall not attempt to describe the grown-up fashions—the men's tall hats, the pointed collars sticking into the chin, the trousers pulled up tight by a strap underfoot, or the women's tight-corseted waists that could be circled with two hands. You have seen pictures and have noted the high hairdos for both sexes, as well as the men's clean-shaven cheeks. Only students wore beards. All this beauty and finery must have been in a wretched state by the end of the day. Stendhal, who had been to Milan as a youth and who often returned there, keeps

cursing the black, sticky Paris mud and the foul smells, and he points out why the Italian town is sweet and clean: the sewers are not in the street but underneath.

Paris obviously occupied a much smaller area than the place you know. Not until the walls were moved outward in 1845 did the surrounding villages or hamlets become part of the city. Montmartre, that evocative place where Berlioz went to live and compose his second symphony in 1834, and where Chopin and Vigny would visit him, was only a rural hillside with goats and farmhouses

And yet Paris in 1830 was a city in full progress. When Napoleon fell, in 1815 after a quarter century of revolutionary and nationalistic war, the city was shabby. Money, labor, and enthusiasm had gone into other things than adding to comfort or beauty. The house-fronts had not been scrubbed, the street paving realigned, or the projected bridges and monuments finished. Only in the '20s did the opening up of new residential districts (such as that near the Etoile, where young Victor Hugo went to live with his bride) begin to change the face of Paris. Demolition and new building were soon going on all over town. By 1830 gas began to replace the malodorous oil lamps: in a few years, of the twelve thousand lampposts one in ten was lit by gas. Going about the city, which had become a hazardous adventure, now benefited from a new device, the omnibus—the first system of public transportation. John McAdam's great invention for surfacing roads was even beginning to be used here and there, while the utopian hope of sidewalks and side gutters was beginning to haunt the fevered imagination of idealists. It was high time for all these improvements: in the thirty years since 1800 the population of the capital had grown from 530,000 to 786,000, an increase of nearly fifty percent.

Such, in brief, is the physical setting of the great movement of ideas, of innovation in social life, of creation in the arts, that you already associate with Paris in 1830—the date commonly

assigned to the victory of Romanticism in France. It was the year when Victor Hugo's verse drama *Hernani* was fought over during the premiere itself and not hissed off the stage. But of course French Romanticism did not begin with that play; at least ten years of argument and of abundant production filled the preceding decade. What was Romanticism? Everybody knows what it is, or thinks he knows, which may be why nobody is really sure. I shall not attempt any compact, portable definition that might be insupportable to others. I content myself with saying that Romanticism embodied the same spirit of renovation that I have said was at work in the streets of Paris, the desire to replace the old, crumbling structures with new and more spacious ones.

To begin with, the yearning for liberty was once again active. Fifteen years under Bonaparte and fifteen under the Bourbons had built up great pressure, and on 28 July 1830, a fresh set of censorship laws set off the explosion. Three days of fighting got rid of Charles X. His cousin, Louis-Philippe, assumed the title not of King of France, but of "King of the French." The different formula marks a step, small but significant, toward modern democratic government. The situation may be summed up as that of a new social consciousness attempting to break out of an old framework—just like physical Paris in 1830.

The immediate source of this social consciousness was the Revolution of 1789, but the restless spirit had been energized by the tremendous mixing of peoples and ideas during the Napoleonic wars. The sheer feeling of movement, the habit of change, the pleasures of risk and adventure—all these gave the new generations a sense of Possibility. True, these same things inspired in some people a desire for peace and quiet, a breathing spell. You can read the story of 1830 onwards as the struggle between these two human traits. What is interesting is that both can be seen as constructive—to build an entirely new world or to rebuild a sober world on tested principles. This choice explains why you find Romanticists on either side

of the political struggle. For our purpose, it is the innovations, actual or just desired, that are important facts. What I have called the new social consciousness is easy for us to understand, because its tendencies are still with us: in Paris in the 1830s you could have heard feminists; you could have met George Sand in trousers and smoking a cigar and read her arguments in the *Revue des deux mondes.* Nor was she alone: the Countess Marie d'Agoult was writing novels under the name of Daniel Stern that contained a very rational critique of the status of women. Her salon came to be known as the House of Democracy. Other groups besides women wanted to be free. Paris in 1830 was the center of the first socialisms, the plans for a just society. Small groups of dedicated men and women were to give models of what all of society should be like—men, women, and children equal; no rich, no poor; everybody a worker and everybody's emotions at peace as a result of such harmony. There were also a few like Blanqui, whose motto was "Neither God nor Master," and who preached direct action—the war of the poor against the rich. Communal bliss would follow.

Among the less doctrinaire, the prevailing mood was the familiar mixture of despair and hope that afflicts the young in any era. What varies is the object of the hope; the despair is always about society—because it is not just and because it does not recognize talent. As Balzac's novels or Vigny's play about Chatterton indicate, the aggressive impulse of youth is against things as they are. An extreme manifestation of it in 1835 was the trial for murder of François Lacenaire, now famous for his *Memoirs and Revelations,* written while awaiting execution. In court and in the book, he brilliantly argued the quite modern thesis that society is the real criminal and the felon a noble victim. As for the hope of the geniuses of 1830, it fused together several objects—the triumph of art over bourgeois greed; the leadership of the country in the hands of intellectuals; and love. This last item may seem out of key; but that is only because the word is ambiguous. You can

hear in the calculated ranting of *Lélio*—the sequel to Berlioz's first symphony—what art, society, and love have to do with each other in the 1830s. It is this: Art is an expression of love, and art and love together are perpetually threatened by social institutions. Art and love signify the individual at war with society. The greater the love, the fiercer the war—on both sides.

Love, in this view, is not sex; and it isn't a cheerful, elegant affair, either; least of all is it "a meaningful relationship." It is the total dedication of a great soul to another. Note that I did not say: "of two great souls to each other"; for a great love can be one-sided and have the same effect on the individual and society: love is passion lifted to the plane of tragedy; it is Romeo and Juliet, Tristan, Othello. Obviously that degree of individual self-assertion cannot be provided for in any social order. It runs its reckless course in the teeth of convention, decorum, parental wishes, marriage vows, duty to the state, and whatever other obstacles it finds. If tragic love is absolute individualism, then love is revolutionary—and so is the art that embodies it.

What the Romanticist revolutionaries accomplished in the arts, you are familiar with: they threw over the rules of versification and playwriting, of music theory and academic painting; they widened the vocabulary and the subject matter; they revalued the Middle Ages; they found remote parts of the world attractive instead of barbaric; they invented techniques not quite yet exhausted; and in doing so they left a vast collection of masterpieces that fill our museums, libraries, and concert halls. Through these works, or side by side with them, they also gave vent to their opinions on current events. When Victor Hugo published a new volume of poems, in November 1831, his preface dealt almost entirely with political questions and reaffirmed his love of liberty and of the people. Earlier, from 1827 on, writers and artists had spoken out in support of the Greek revolt against Turkish rule. Byron went to Greece and died there organizing the rebel forces, having first sung

their hopes of freedom and rallied Europe to the cause; in Paris Hugo, Delacroix, and Berlioz composed works signalizing the Greek cause. "Hellenism" became a fashion which influenced architecture and interior decoration.

These were not the only discoveries of the Parisians in those days: there was Shakespeare, newly translated and now no longer seen as a barbarian; there was Goethe, whose *Faust* seemed the prototype of the adventurous soul seeking a great love and welcoming all of experience; and there was Beethoven, likewise a heaven-stormer, whose lightest emotion was sublime and whose methods opened up a new world.

Beneath great ideas and movements there goes on a counterpoint of fashions and conventions which is no less real and formative: besides the new tendencies, we should understand the lives of those who endure, resist, or promote them.

Our first glance should be at this "society" that the artist or thinker is always cursing and attacking. Whom does it consist of and why doesn't it recognize geniuses as soon as they declare themselves? For we should not suppose that the people we now admire and write dissertations about—Victor Hugo, Delacroix, Berlioz, Lamartine, Musset, George Sand, Franz Liszt, Lamennais, Nerval, Vigny, Sainte-Beuve, Gautier, Mérimée, Balzac, Stendhal, Dumas, Michelet, Saint-Simon, Auguste Comte, and the rest—were the darlings of the contemporary public. Quite the contrary: most of them died before being accepted. In life they were of prime importance to one another, and each of them to a relatively small group of different followers. They were not unknown; they were talked about by a public that was part friendly, part hostile, but they were not the great men of the day. The unquestioned bard was the songwriter Béranger. This situation is an historical constant; nothing can or will change it, for the simple reason that people are busy about their own pleasures and duties, apart from which they take in only what is easy and fashionable.

If this was true of the Parisian public of 1830, it must be

true forever, because the public then was a small, fairly homogeneous aristocracy. Please take note of what I mean by that word: aristocracy as I use the term does not mean nobility; it means the part of the nation that considers itself the best and has the means to act as if it were. Its members gravitate together from all quarters—the wellborn, some few of whom have titles of nobility; the rich—old wealth, not new; the upper bourgeoisie, no longer in trade; the high officials of government and top brass of the army; the men of talent in journalism, the law, and the arts; and also a miscellaneous lot of men and women with charm and good looks, who have wit and live by their wits. Such is the aristocracy.

When we speak today of elitism and "the establishment," we do not know what we are talking about. The slice of society I have described—*that* is an elite; and it always consists of *two* establishments at least, one of people in power at the moment, and another made up of those in opposition. They are establishments through what they can direct or control. Both continually recruit themselves. They take in second cousins from the provinces, or plausible foreigners who speak the language, or poor boys from anywhere who have talent and the right sort of nerve. An elite is not snobbish in the ordinary sense; it is only demanding about a certain combination of qualities. Brilliance helps, but it is not enough if lacking in deportment. Genius or high intelligence may be a drawback if not coupled with amiability and conversation. These last two will suffice, even in the absence of brains.

Where is all this on display? In the salons. In the Paris of 1830 there were nearly as many salons as there were wives of men in high posts who possessed the skill to form and keep a stable of individualists looking to be entertained. Everybody who was anybody was a regular visitor at eight or ten or a dozen salons. Each presiding lady received on a certain day at a certain hour. The hours of the week were so taken up that one literary bachelor who wanted a salon of his own chose Sunday midnight. A "regular" anywhere could bring a friend, and

thus a subsection of the elite would grow and replenish itself. All these groups together constituted the Tout-Paris—the committee of the whole, as you might say. It was cohesive despite strong political and religious antagonisms, for at the edges the coteries mixed and overlapped. So any news worth knowing, any bright saying, any new love affair would soon be known by everyone.

If you read Balzac or Stendhal, you discover that to succeed in Paris—in anything whatever—you must have the support of a salon, you must be pushed by its presiding lady. The push meant pull. Through friendship, influence, family connection, or a love relationship, that woman would get you appointed, promoted, listened to, awarded a prize or decoration, given a commission to perform or create; she could save you from embarrassment or from prosecution. The maneuver was not corrupt; it was the way things were done. But the result was that men and women who by temperament were not suited to salon intrigue had to fall back on pure merit— only to find that pure merit is invisible. Since each salon was in competition with all the others for the same plums of centralized patronage, you can imagine the amount of tactful pleading and persistence required to achieve the slightest goal. And these people had no telephones, telegrams, typewriters, or duplicating machines; it was all handwork and footwork.

How did they manage? Though the salon was indoors, naturally, they lived very much outside. Take Stendhal when he was a young man on the make, trying to capture the three needful things: a great love, literary fame, and a position. He started well before the generation of 1830, but his case remained typical. Young Henri Beyle (that was his real name) came from a well-to-do family in Grenoble, but he had a stingy father. In Paris he had to live in a modest hotel room or share lodgings with a cousin. They would get up in midmorning and go to a café for breakfast. Paris was full of cafés and restaurants, ranging from cheap to ruinous, but all good of their kind, for the 1830 renaissance included gastronomy.

After breakfast, Stendhal began his round of visits; first to his influential older cousin, Count Daru, high in the bureaucracy and ready to help his odd but talented relation from the provinces. The beautiful Countess, exactly Stendhal's age, was fond of him, and he on his part wanted her to be his great love.

With this in mind he studied her character, looks, words, and marks of affection toward himself. He had daily opportunities of a favorable kind, for current manners allowed Stendhal to sit by her dressing table while she did her hair and even to see her in bed. He could call at the house at any time, even mealtimes, and he would be asked to stay. If requested, he must take the ladies—the Countess, a young daughter, and the grandmother—on some expedition: to the Tuileries or Luxembourg gardens, to the speeches at the French Academy, or to see the animals at the botanical gardens. Since 1815 the giraffe sent by the Bey of Egypt had made this excursion popular. Parisians liked to stroll—not only the best people, but all classes of society. They mingled freely and comfortably. When the saunter was not in a park (three new ones were opened soon after 1830), it was on the Boulevards, where in the mid-afternoon or after the theater one would expect to run into one's friends. These elegant people saw each other daily, if not at home or on the street, then at a restaurant or a café. Each coterie gathered at only one or two such places, giving them a character of their own, like a club. After lunch, one might drop in at one's *cabinet de lecture,* the paying library where one would read the newspaper if none had been available at the restaurant; otherwise one would ask for the latest book in order to be able to talk about it at the next salon.

After reading, more strolling, another visit to friends, or perhaps a lesson in English or Italian or fencing or elocution. (Stendhal took lessons in declamation from a famous actor, in hopes of eliminating his provincial accent, and also believing it would help him to write tragedies.) Another pastime was to ride on the Champs-Elysées, in a carriage with ladies or on horseback, so as to see and be seen in bright new clothes. Din-

ner came next, from five o'clock on, after which the theater or the opera. There were fourteen regular theaters in Paris in 1830 and a varying number of fly-by-night shows. Like the streets, the theaters accommodated all classes, and audiences might be rowdy. Seats were cheap, especially at the vaudevilles. These were not the variety turns of that name in this country; they were one- or two-act plays aimed at pleasing the populace. Along the Boulevard du Temple, these plays were gory and terrifying; it became known as the "boulevard of crime."

Of the more pretentious plays and operas in the newly reorganized and prosperous state theaters, most were put together by authors absolutely forgotten. Yet they and their works were the talk of the town; they filled the time as television does now: vaudevilles were soap operas, and that clever man, Scribe, rose to fame from apprenticeship in this genre. One alternative to the theater was the private or public ball. The public ones were either at the Opéra (once a year) or at some shabbier establishment, or in one of the two or three huge gardens where one could stroll with a woman in comparative secrecy, buy drinks, and even disappear à deux into the bushes. At private balls, the visitors' list was enlarged, children were present, and tea and barley water were served. The dances in 1830 were new and daring: they involved clasping one's partner close—for example in the waltz; or they were wild like the galop, or strenuous like the polka, which came from Poland and on that account was favored by the liberals.

Entertainment at home included card games (usually whist), lotto (now called bingo), piano pieces and songs by the hostess or her marriageable daughter, or reading aloud the parts of some tragedy, or, most taxing of all, listening to an author read his latest work. The family was a sizable group, not just two parents and a pair of children. A real brood, plus grandparents, relatives, and lifelong servants made up the crowd living together in some sort of harmony. They might occupy a whole house (known as an *hôtel particulier*) or a floor

or two of a six-story building with other tenants. The layout of apartments was poor—one small room opening into another and no separate dining room. Plumbing was non-existent, water was brought up daily from outside by carriers whose visit left the stairways awash. In the 1830s the taste for history generated a craze for antiques, so the furniture was rarely comfortable or solid, except for wardrobes, which were the current form of closets. Since everybody, children included, milled about quite freely, one question has remained unsolved by the most searching scholarship: where and when, under these conditions, did extramarital lovemaking take place?

I have said that the several social classes mingled in public freely. The same mixing obtained also within a city house. On the ground floor might be a shop whose owner, a member of the lower bourgeoisie, lived with one or two servants and perhaps an apprentice, these being the working class. The first floor above would be occupied by people of wealth; the next one by a well-to-do retired couple or a general on pension. Above were more modest folk—petty bourgeois clerks or even members of the artisan class, the typical *ouvrier,* but not a factory wage slave. And so to the garret, where a milliner's assistant and a starving poet might find ways to mitigate their common misery.

Class distinctions were not forgotten: clothing, speech, manners made them evident, and they were jealously guarded; a petty bourgeois parent would not want his daughter to marry an artisan; yet they shared the street and the staircase and the theater fairly amicably. The revolutionary declaration of the rights of man had begun to confer on the lowest ranks a dignity that all recognized. Besides, since Napoleon, everybody knew that titles of nobility meant much less than before: too many jump-ups were now dukes or counts or barons, and high-sounding names were often assumed without right, to secure entrée and a little deference from the housemaid at the door. As for writers, they would put a *de* in their name as they would in a sentence. In short, when Tocqueville and his friend

Beaumont came to this continent in 1831 to study American democracy, it was not to discover the common people: in his own country Tocqueville had seen what his fellow-theorist Royer-Collard called "the full tide of democracy."

The difference was that in France the institutions were not yet adapted to the new spirit. Marriage customs are a good index of social assumptions and can show what I mean. In 1830, in the middle and upper classes, the old ways of giving in marriage had yielded only on one point: parents did not force a girl to marry someone she disliked, though strong suasion might still be employed. Balzac and other young hotheads all said that even pressure was shameful; only true love justified marrying, love leveled ranks. And they denounced the dowry system, for it turned the sacrament into a business deal in which one of the two principals had no voice. The family solicitor drew up a contract between the father and the groom and the girl was delivered with her fortune like a package from a shop. The height of bliss—*for the family*—was to have the contract countersigned by the king or some high official. Then came the church ceremony. After it the couple left, but not on a honeymoon, just to their new home. The next morning they attended a church service, alone. For one year afterwards, it was not deemed proper for the young wife to go out without her husband, her mother, or her mother-in-law.

But that year once over, the gates to freedom opened wide. She may have been eighteen by that time and her husband thirty-five. His life was in many ways set; he might have a mistress or be used to having a series. Or again, he might be fond of his wife, even in love with her, and she might not reciprocate, especially if (as Balzac said in plain words) she had been violated. Somehow the pair would come to terms as to the conduct of their lives. With discretion, each might engage in affairs or liaisons: the difference is that a liaison is quasi permanent. Meanwhile, the wife would conscientiously run the house, bear and rear the children, each spouse behaving with respect (and possibly affection) toward the other. Many of

the famous salons of the 1830s were run by such women, titled or not, with a husband sharing the honors—or staying quietly in the background while the acknowledged lover, often a distinguished figure in the world, acted as the drawing card and set the tone, political, artistic, or philosophical.

Described in words, these ways and varieties of marriage sound more painful and less decent than they actually were. The behavior of lovers was rarely promiscuous, both because well-bred men and women grew up with enough conscience and self-respect, and because this small-city society cast a censorious eye on what it considered bad behavior. There were, for example, very few seducers. A young girl's chastity was sacred and safe. And though a young married woman could be approached with impunity, this extramarital courtship must be gradual and respectful; the would-be lover's intentions must be honorable, that is, he must offer a lifelong attachment; her decision would also be well pondered. Moreover, some of these attachments were proposed and accepted on the understanding that they would be passionate friendships and no more. Others included physical relations, and the resulting offspring, called natural children, were accepted by society, often brought up side by side with the unnatural children born in wedlock. The breakup of a liaison or an affair was an event no less agonizing than is with us the breakup of a marriage.

As for the husband or wife left outside these liaisons, he or she was expected to act with dignity, without jealousy or resentment; after all, they too were free, and only when one of them loved the legal spouse in vain did strain occur. Divorce had been abolished by the Bourbons when they returned in 1814; it was not reinstated by the bourgeois king, and recourse to mere separation was rare. What met with general opprobrium was to flaunt a grand passion and in pursuit of it abandon spouse, children, home, or the long-accepted lover. In 1833 and 1834 two such events occurred which rocked Paris society: George Sand left for Venice with the poet Alfred

de Musset, and the Countess d'Agoult followed the pianist Franz Liszt to Switzerland. The Sand-Musset escapade was the more expectable of the two, for she was a woman of affairs who confided about them in speech and print. But Marie d'Agoult was a remarkably serious and cultivated woman, who, after Liszt left her ten years later, accomplished the feat of reinstating herself in society. She had meanwhile borne three children, of whom one was the redoubtable Cosima, later the wife of Wagner's old age and curator of his fame.

What made the rehabilitation of Marie d'Agoult possible was her exemplary behavior, her continued fidelity to Liszt, and her thoughtful writings. This calm and sober conduct fitted the temper of the times. For the nickname of "bourgeois monarchy" which is given to Louis-Philippe's regime refers both to the class that supported him and to his character and influence. As you know from seeing Daumier's caricatures of the king's pear-shaped face, Louis-Philippe was ridiculed, week by week, in the satirical journals. They mocked his humdrum attitudes and bonhomous appearance. He was a good family man; he took his Sunday walk with his wife and children like any shopkeeper; he favored a middle course in everything; he carried a cotton umbrella, holding it (I suppose) by the middle; he wanted peace at any price, judging that France had bled enough under Napoleon. Compared with the emperor, he was the anti-hero par excellence.

All these traits, useful but dull, were widely shared and they ushered in a new morality. When we call it Victorian, we make a mistake in dates. In both England and France, the outlook began to change about 1820, when the future Queen Victoria was a newborn babe. Byron noted the shift adversely as so much hypocrisy. And it is another mistake to think that the term *bourgeois* means what the stereotype suggests, especially in the phrase "the rising bourgeoisie." The bourgeois, that is, the burghers or burgesses—townsmen—were "rising," becoming important, as far back as the eleventh century and their class was not a perpetual soufflé still rising seven hundred years

later, in the 1800s. They were already "governing" under Louis XIV and had long been a power, as wealth always is.

This fact reminds us that not all bourgeois are wealthy. The bourgeoisie includes everybody above the manual worker, from the smallest shopkeeper to the high official who has not touched trade for three generations. If we want to think straight about the 1830s we must leave the unqualified word *bourgeois* to the angry artist (himself of bourgeois stock)—it is his means of insult and derision—and we must speak more precisely of whichever group is in question: bankers, industrialists, civil servants, and others of the ruling class, those I have called the self-appointed aristocracy; or again, of some other group. The bourgeois caricatured by Daumier and played up to in public by King Louis-Philippe belongs to the middle-middle or lower-middle class, who have always hated elegance, art, and sexual freedom.

By the mid-1830s their effort to moralize life had got as far as to alter manners: stuffiness was on the rise. For example, in 1834 new editions of Rabelais and François Villon were attacked in the press as immoral and the publishers threatened with prosecution. These events provoked Gautier to write the wonderful preface to *Mademoiselle de Maupin*, which is the classic statement of the new cult of art: Art is the highest expression of man's spirit; the genius in art is a seer and a law unto himself; art is the glory of the senses and the enemy of utility; and since utility is the god of the bourgeois, art is the enemy of the bourgeois, this mediocrity who rules the world and wants to make it a vale of puritan dullness. This manifesto has remained the creed of the independent artist. By implication, it created the artist's Bohemia over against the realm of respectability and philistinism. The bourgeois, said one of Gautier's colleagues, is "a watery nothing"; and another entitled his fiction *Immoral Tales*. The echoes of this outcry have not died out yet.

* * *

To sharpen the meaning of the Paris of Gautier and Liszt and George Sand and help out your association of the familiar with the unfamiliar, I have mentioned some sequels of events and ideas. But these outcomes must not be read back into the year or even the decade of 1830. When we are there we witness, for the most part, beginnings. To reinforce this statement, I want before closing to sketch in a few more details of ordinary life, picking up the day's routines where we left them with Stendhal.

I said that the ambitious young men who had not yet made their mark in literature or politics had to have a position. They sought it either in journalism or in the civil service. Newspapers were as numerous as the leaves of the forest; for printing was cheap and some person or party always wanted to push a cause. Anybody who could write would find a place for an article or book- or music-review, or what was called an "echo"—a short paragraph retailing an anecdote or launching a witty lie. These tidbits were paid by the line and did not support a man, though they led to a better-paid hackwork. Besides, the new form, the *feuilleton* or "column," whether a novel in serial parts or a weekly critical essay, could make one's reputation. A prosperous sheet with a circulation of five thousand would reach everybody who mattered. As Sainte-Beuve said, its regular readers formed a kind of family, for the four-page paper thrived on opinions shared, rather than news. But free and easy journalism also had its risks: to be challenged to a duel. Two of the intellectual tragedies of the time were the deaths of Armand Carrel, a young historian and publicist, and of Charles Dovalle, a gifted poet of twenty, both killed as the result of incautious words in print. Dueling was generally disapproved but considered unavoidable. Honor sullied by a remark or gesture had to be cleansed in blood. And there were of course bullies whose skill with sword or pistol encouraged them to make a career of insulting and triumphing.

Positions in the civil service were less exposed, more lasting, and better paid than journalism, and the good ones were

virtually sinecures. It sounds comical to us when we read in Stendhal's diary that on a certain day he proved his capacity as "a hard worker" by going to the office for two hours and carefully looking over the work of his clerks. It is obvious that he and his fellows could not have done the rounds of visits, the strolling, dining early and courting late, if they had had to put in a nine-to-five day. Likewise, when Stendhal became a consul in Civita-Vecchia near Rome, his leaves of absence between 1831, when Louis-Philippe appointed him, and his death in Paris twelve years later amounted to about five years. On one occasion he came to Paris for three months and stayed three years. This system enabled Henri Beyle to become Stendhal, and we may be grateful for it. It was the necessary bridge between the former support of writers and artists by individual patrons and the modern dependence on the general public, which supposedly buys books and pictures.

From the schedule of work and play that I have given, it should not be inferred that these 1830 characters were loungers. True, they enjoyed a leisure we envy, but they were also enormous producers—and not the men alone. The numerous women writers turned out good current literature like a factory. Stendhal wrote *La Chartreuse de Parme* in two months. The size of Balzac's output is literally inexplicable. And we must not forget that, with some exceptions, most people died in what we would call middle age. The Countess Daru died at thirty-two following her eighth childbirth. Balzac died at fifty, Stendhal and Heine at fifty-nine, Nerval and Musset at forty-seven, and so on. And they should be regarded as tough survivors, for the life expectancy was thirty-nine years; in every family death was a constant visitor.

Early dying was due in part to the inadequacy of medicine, but even more to bad hygiene, public and private. The childhood diseases carried off the very young; the miserable state of Paris that I described took care of the adults. When they bathed, it was in the river polluted by sewage. They had sense enough to drink only wine, but the preparation of food,

the diet itself, and the disregard of fresh air and clean hands
seconded the ravages of tuberculosis, scrofula, dropsy, hepati-
tis, and the rest. The likelihood of dying young gave life and
the passage of time a measure different from ours. George
Sand says in one of her letters that she is now too old to marry:
she was twenty-eight. In a memoir, someone speaks of "a little
old lady": she was forty-seven. Men settled down to marriage
in "middle age"—usually thirty-five. It was best to be fatalis-
tic. Since 1817, Europe had suffered from the Asiatic cholera
originating in India. The epidemic years took a fearful toll—
anywhere from one in a hundred to one in twenty—not count-
ing the deaths from panic, which included the murder of
strangers on the street when they looked ill. Eighteen thirty-
two was the great cholera year in Paris. The onset of the dis-
ease was as dramatic as any Romanticist playwright could
wish. It struck at a society ball, where the guests as usual were
wearing masks. Without warning, people gasped as they felt
fearful cramps and fell down unconscious or dead. This *coup
de théâtre* was due to the fact that cholera painlessly dehydrates
the body and prevents the flow of salt into the bloodstream—
until the collapse occurs. The plague is highly contagious. The
prime minister, Casimir Périer, visited the hospitals and
shortly succumbed. By great good fortune, the miraculous
violinist Paganini survived the performances that he gave for
the benefit of the families left destitute by the loss of a bread-
winner.

The figure of Paganini suggests one other feature of Paris
in 1830, and with it I want to end this quick tour: Paris was a
cosmopolitan city and a city of cosmopolites. I mean that it
was both a place to which foreigners came, as in the eigh-
teenth century, and a place from which the French traveled to
foreign lands. The Napoleonic wars had got the French out of
their cozy country; they had made friends abroad, married
abroad, discovered abroad treasures of art or scenery. They
braved the brigands in Italy; they learned foreign languages
and a taste for foreign ways. From 1820, Anglomania domi-

nated Paris; the young bloods, called lions, put on the airs of the dandy, and there were lionesses too, women who behaved aggressively without being feminists. The men rode the English saddle, or the cabriolet with a tiny groom in attendance called a tiger. They took up the habit of smoking in public, which revolted the ladies. They organized English-style horse-racing with Lord Henry Seymour's help and founded a Jockey Club. They followed Lord Brougham to Cannes, which he made into a winter resort, the only other seaside bathing place being Dieppe, on the Channel, where the attendance was so meager that as late as 1821 Dumas could walk naked on the beach, the emblem of the new individualism.

More important than aping the English was the presence of notable foreigners. I have mentioned the poet Heine; he should be paired with Mickievicz, the greatest poet of Poland, who lived in Paris from 1832 to 1848, wrote a couple of masterpieces there and taught literature at the Collège de France. After Paganini and Liszt, one thinks immediately of Chopin, Thalberg, Mendelssohn, and many other musicians settled in Paris or frequent visitors. Cherubini ran the Conservatoire, where the Czech Reicha taught. Rossini, Meyerbeer, and Spontini ruled the opera stage, where the Garcia sisters (Malibran and Viardot) and Mme. Pasta were divas in residence, Taglioni and Fanny Elssler being their equals in ballet. Schlesinger, from Berlin, published music as well as the influential *Revue et Gazette musicale,* where Berlioz wrote and where he helped Wagner publish articles during his stay in Paris in 1839. Adolphe Sax, inventor of the saxophone, and Ignaz Pleyel, the piano-maker, were but two of the three or four hundred manufacturers of pianos and other musical instruments who employed skilled foreigners. Paris was a Mecca for musicians from Italy and Central Europe, drawn there by the hope of concert careers or more humble employments as players, copyists, engravers, theater choristers, or—saddest of all—street musicians.

With this decrescendo I believe I have reached the end of

my assignment. I hope I have not gone beyond it in speaking of music at all, for the speakers next on the program will give you a wonderfully complete survey of the musical and theatrical scene. Knowing the high merits of those who will unroll that panorama, I would be presumptuous indeed not to stop here, with a word of thanks for your attentiveness and of good wishes for the remainder of your trip through Paris in the 1830s.

1987

Food for the NRF

I pick up the half-galleys that the publisher has sent me and start to read. The book is the American edition of Roger Martin du Gard's *Notes on André Gide*. They begin, you remember, with the first meeting between the two men at the offices of the *Nouvelle Revue Française* before the First World War. The translation seems competent, the atmosphere of forty years ago is well rendered. But what's this? "On the counter a plateful of dry buns . . ." Alas! This must refer to *gâteaux secs* in the original, and those are cookies, not stale bakery stuff. Does it matter? Under the eye of eternity, I suppose not. But right here and now it does. For we are not a magnanimous race, we twentieth centurions. We fasten on trifles, live on hints, and form conclusions from signs, which we interpret way beyond the probable. So in a thousand minds, the *NRF* will be ticketed as a carefree bohemian place, where the buns of the last monthly meeting recur until eroded by time; whereas sustained by Gide's money, the magazine was actually a rather posh establishment, punctilious in style and proud of its teas.

I read on and strike other trifles of the same sort. On a comparative basis, I should still have to call the book well

translated; but drawn off by the act of comparison, my mind leaves the book and dwells on the theory and practice of modern translation. I think of the place that modern French literature occupies in our English-speaking world, and out of thirty years' reading I conjure up the accumulation of hidden error, of factual and emotional misconception, which our awareness and admiration of that literature enshrine.

No doubt the educated American is hardened to the "Frenchy" style of the nineteenth-century classics that one reads in youth—*The Three Musketeers* or *Les Misérables,* in which all colloquialisms of the type *Que voulez-vous?* are given a word-for-word rendering. But doesn't this, combined with the hundreds of unintelligible sentences, lay the foundation for the curious beliefs of adults about France and the French? In some, it is the conviction that life over there is less drab than with us, by virtue of the many provocative turns of thought. In others, it is a faith in the subtlety of every phrase, charged as it obviously is with *hidden* meaning. The philistine, of course, wonders how these foreigners manage to understand one another, and for once he is the better judge, given the evidence presented. Open the latest, "modernized" reissue of *Les Misérables* and you will find, in every other paragraph, sentences such as this one about Napoleon: "He had in his brains the cube of human faculties." Undoubtedly, the routine discredit in which the novels of Victor Hugo now stand owes much to the bald transliteration of a rhetoric which could be out of fashion without seeming insane. As rendered in this same version, Hugo's preface—which is a clear and simple social manifesto—can show only three phrases with a rational meaning. The rest is translator's English.

Scanning the books of our own day, one might think that publishers had acquired a greater sense of responsibility and had recourse for translation to genuine writers, in place of the old-time hack whose livelihood depended on mass output, just as his linguistic knowledge depended on the dictionary he happened to own. This apparent improvement is on the sur-

face only. Enough jokes have been made about the obvious traps for everybody to avoid them. But the same wrong principles prevail as regards the moral and artistic obligations of publisher and translator. It is still taken for granted that literary facility, coupled with what is called a working knowledge of a foreign tongue, is enough to make a translator. Yet this combination of talents, rare as it may be, does not begin to suffice—witness Havelock Ellis, whose version of *Germinal* is made unreadable by gibberish like: "They don't gain enough to live"—meaning *earn* enough to live *on.*

One must go further and say that being an experienced translator is no guarantee of competence in a particular effort, any more than being a concert violinist is a guarantee of a good performance every night. C. K. Scott-Moncrieff was perhaps the greatest translator of our century. He gave us a Proust and a Stendhal which, though incomplete, are monuments of an art—triumphs of a type of thought—that I hope to define more fully in a moment. Yet on at least two important occasions he fell from his own high standard and attached his name to the usual illegitimate product in which English and French incestuously mingle. In *Sweet Cheat Gone,* and notably in the dialogue, one is reminded of the Hugo-Dumas school of translators: " 'Listen, first to me,' I replied, 'I don't know what it is, but however astonishing it may be, it cannot be so astonishing as what I have found in my letter. It is a marriage. It is Robert de St. Loup who is marrying Gilberte Swann.' " And even in the narrative parts of the book: "Well, this Albertine so necessary, of love for whom my soul was now almost entirely composed, if Swann had not spoken to me of Balbec, I should never have known her." This sentence is not Proust twisting the tail of syntax, but a common construction that the translator had not only the right but the duty to make readable.

Scott-Moncrieff's other dereliction affects Stendhal. On the title page of the only available edition of *On Love,* our translator is credited with having "directed" the work. This is a solemn responsibility, for the signature is a high guarantee.

But the directing cannot have been close or active, for the text abounds in errors and infelicities. Besides gross blunders like "deduct" for "deduce," one meets ambiguities at every turn. According to the preface, for instance, the book "is not a novel and contains none of the distractions of a novel." What Stendhal actually says is that this book will not afford entertainment like a novel. Typical of a still worse incompetence is the rendering of one of the aphorisms at the end: "The majority of men in this world only abandon themselves to their love for a woman after intimacy with her." What the original states is that most *men of the world* only *begin to love,* etc.

When one knows that fifteen years before this luckless attempt upon Stendhal's work a first-rate version by Philip and Cecil N. Sidney Woolf was published here and in England, one begins to imagine an imp of the perverse at work to balk communication between literatures. The truth is that translation is not and has never been recognized as an art—except in the way of lip service. Judges of the art are naturally few, and among its practitioners little or nothing is consciously known of its techniques. Perhaps the decline in classical studies accounts for this deficiency, which should then be called a forgetting of a once established discipline. I remember from my youth a series of trots which were advertised as containing two parallel translations, "the one literal, the other *correct.*" Today the distinction would probably puzzle many readers and not a few translators.

In any event, the present oblivion on the part of writers and critics goes with a rooted faith in publishers that translation is a mechanical job, hardly worth paying for, and merely incidental to the finished book. Note how one firm after another will reissue—sometimes at great expense, with illustrations and introductions by good craftsmen—the same execrable translations dating from the Flood. Thus there is not, I believe, a single readable version of Gautier's *Mademoiselle de Maupin.* When the work was being brought out again in 1943, I offered, as the introducer, to go over the old anony-

mous text that Tradition and Thrift alike recommended to the publisher. This offer (gratuitous in both senses) was declined with some surprise as surely not worth the time and trouble. My own surprise was that a perfectionist in book production, who did not mean to cheat anybody, should be quite content to palm off a mass of verbiage in the vein of: "His doublet and hose are concealed by aiguleuts, his gloves smell better than Benjamin. . . . There has sprung up between the planks of the St. Simonian stage a theory of little mushrooms. . . ."

Little mushrooms indeed. Their poison is absorbed into the literary system, which it afflicts with insensitivity to meaning whenever anything foreign—and especially anything French—is concerned. The resulting misconceptions in turn produce conscious, large-scale misinterpretations. For instances of this we need not go much beyond titles. To be sure, the false lead in a title usually causes but a passing confusion; one example is Gide's *My Theater* for a collection of plays—as if "Shakespeare's Theater" meant "Shakespeare's Plays"; another is Stendhal's *Souvenir of Egotism* for "Reminiscences of an Egoist." But in at least one famous instance the established form of a title is a literary disaster: we all speak of Flaubert's *Sentimental Education.* We do not, it is true, attach quite the same meaning to "sentimental" here as we do in Sterne's *Sentimental Journey;* yet unless we are warned we may miss the fundamental point of the entire work. The supposition of many an intelligent reader who knows no French is that the education of Flaubert's hero was "sentimental" in the sense of nurturing illusions, fostering "Romantic emotions," and that the novel records the consequences. Because he was badly brought up, Frédéric Moreau lacked the wits to see how "unrealistic" his ideas were—hence his unhappiness, his wanderings, and his feeble nostalgia for the youthful days of his first visit to a house of prostitution.

This interpretation is just tenable enough to prevent the search for a truer one, and few even of the seekers would begin by consulting a French dictionary. If they did they would find

that *sentimental(e)* means simply "of the feelings." Flaubert's title applies not solely to his hero but to all his characters: he is saying: "Look! This is how modern life educates the feelings"—the irony resting on the dreadful word "educates." As to this interpretation of the title there can be no doubt: we have Flaubert's word for it. While at work on the novel, he writes to a friend: *"Je veux faire l'histoire morale des hommes de ma génération—sentimentale serait plus vrai"* (to Mademoiselle de Chantepie, October 6, 1864).

The title once changed, we see that Frédéric is a failure, not because of his emotions of whatever kind, but because of his lack of them. He is not even that sloppy thing *we* call sentimental: he is dry as a bone—and thus only half-brother to Emma Bovary. She at least tried to live out her dreams. She took risks, showed courage, and partly reshaped her surroundings. Her faults of judgment, her "unrealistic" choices are more to be respected than Frédéric's caution and lack of will. Flaubert could and did say that Emma was himself; he never would have owned any kinship, except momentary, with Frédéric. All of which is part of the answer to "What's in a title?"

For the translator or would-be translator, Flaubert's misrendered adjective deserves to symbolize Nemesis. Sooner or later he who meddles with foreign texts will succumb to his fate, which is traducing. This may seem a strange necessity, for the criteria of a good translation are few and simple: that it shall be clear to its readers and in keeping with their idiom; that it shall sound like the original author; and that it shall not mislead in substance or implication. But the steps to these results are beyond computing, they are dissimilar in kind, if not contradictory, and they are nowhere codified. *1953*

French and Its Vagaries

No two languages are closer and further apart than English and French. They are close in their mixed history and mutual borrowings, and they look close in their vocabularies—thousands of words are spelled exactly or nearly alike. But they are far apart in grammar and idiom and in the meaning of these very thousands of look-alikes. They are farthest apart in turn of thought and, most important, in the way the "same" sounds are uttered.

French is a vowel language: that is the great principle to remember. It has determined several of the "arbitrary rules" and it solves other puzzles. Whoever wants to learn to speak, or simply to read poems in French, must believe this primacy of the vowels and do something about it. In his famous *Elements of Rhetoric*, Bishop Whately approves the common English advice to speakers: "Take care of the consonants and the vowels will take care of themselves." In French, the exact opposite is true. The language numbers officially nineteen vowels, but as Valéry remarked, "The French vowels are numerous and distinctly shaded *(très nuancées)*." There are more than nineteen "shades," most of them essential to meaning, especially the nasals.

For the sake of the verse harmony that so often escapes the foreign ear, I must labor the point. One reason French tradesmen are often impatient with foreigners' speech is not chauvinism, it is frustration: What am I hearing?—*Danton, d'Antin, Autant, Autun?* There is no way to guess. Is the tourist saying *trop loin, trop lent,* or *trop long?* The taxidriver's tantrum is despair. Even a completely bilingual ear (as it were) is baffled by this confusion, which Ronald Knox paro-

died in quoting Musset: *"Qu'est ce que c'est que le tong, Maintenong?"*

French, moreover, never allows a plain vowel to turn indistinct (the linguist's *schwa*), as in the last syllable of "author," the first of "career," the middle one of "emphasis," and a host of others. This vagueness in English is normal, for as Whately said, the consonants suffice. In a typical long word such as "enlightenment" there is only one clear vowel out of four. In French, the failure to differentiate *é* and *è* or any other related pair denatures the word. Take the rough play on words in the title of the comedy *Oh! Calcutta!* (*oh! quel cul t'as*); it disappears altogether when the *u* in Calcutta is given its English pronunciation. The English speaker may not be as ignorant as Landor; he is merely unable to say the fluted *u*, the four nasals, and the first syllable *e* of *Monsieur*. "No Englishman," says Uncle Ponderevo in H. G. Wells's *Tono Bungay*, "pronounces French properly." When he tries to, "it's all a bluff." And as if to prove it, he quotes "Le steel say lum."

Although the French vowels are farthest from their English analogues, the consonants also differ markedly. As everybody knows, the *r* is difficult, whether one attempts the Parisian near the throat or the southern, trilled on the tongue, both admissible. The *l*-sound is the continental *l*, less fruity and forceful than the English; and the rest, in French alone among European languages, must be toned down and brought out without explosiveness.

There is an old American catchphrase according to which "Paddle your own canoe" is supposedly rendered in French through the (meaningless) sentence: *Pas de lieu Rhône que nous*. On the same erroneous principle, a bilingual writer has published a small volume called *Mots d'heures gousses rames*. Uttered properly, these French words in no way reproduce the intended "Mother Goose Rhymes," and this holds true of the contorted equivalents inside the book. The consonants in each destroy the resemblance with the other.

French has a distaste for consonants just as English is

impatient of vowels. In the early Middle Ages the French used to pronounce *d*'s and *t*'s and *p*'s at the end of words; they have dropped them since, while keeping many of them in the spelling. At the beginning of words, the French of every age have found double consonants hateful and got rid of one or the other at the earliest opportunity: spasmus became *pâmer*; scala, *échelle*; spatha, *épée*. In the middle position, the consonants of the Latin originals were also purged: *nativum* turned into *naïf*; *hospitalem*, *hôtel*; *regem*, *roi*; *potionem*, *poison*. To these feats must be added the softening of words borrowed from English or German: bowling-green = *boulingrin*; packet-boat = *paquebot*; bollwerk = *boulevard*; landsknecht = *lansquenet*. The French are lazy-lipped.

At the same time, the French consonants, though muted as compared with the English, must remain perfectly clear and distinct. It will not do to blur *t*'s and *d*'s or *p*'s and *b*'s as foreigners can do in English and still be understood.

These dampers on vocal energy act as both cause and effect in the well-known lack of what is the main feature of English poetry—a definite stress on some part of each word. In French, a very light stress—no more than a slightly rising tone— lands on the last syllable of the word and on the last word of any unit of meaning—a phrase or sentence. In this lack of accentuation, French, again, is unique among European languages. It resembles (I am told) Algonquin, which after the American War of Independence was proposed in New York as the national replacement of the hated English. But stresslessness was a fatal obstacle to adoption by speakers used to accenting their words. In French, even the weak tonic accent, as it is called, may be neutralized for various reasons and shifted to different syllables. Hence a great variety in poetic rhythm in the very place where the inattentive find monotony.

Knowing these facts will not by itself open the foreign ear to French poetry, but it should at least modify prejudice by holding in check the mistaken impression that the rhythm of verse after verse is drearily the same. Take Hugo's line: *"Je suis*

veuf, je suis seul, et sur moi la nuit tombe." The accents fall on
veuf and *seul* and not again until *tombe;* but it would be pos-
sible in reading aloud to raise the voice a little on *moi,* besides
which there are two ways of sounding the final word: *tomb'*
and *tomb(eu);* that is, the so-called mute *e* can be neglected or
given a slight value. The choice would probably depend on
whether the next line opened with a vowel or a consonant, or
again, on whether the sense stopped at *tombe* or went on.

What is this mute *e?* It ends many French words, and its
role in spelling is to make sure that the preceding consonant is
sounded; without the *e,* one would automatically suppress the
b of *tombe* and pronounce the word like *ton,* just as in *plomb*
(the metal "lead") one says *plon.* It is this same *e* that ends
many English words in Chaucer, where it must be pronounced
if his lines are to scan. Soon after his death English pronuncia-
tion changed, the *e* was dropped, and for three centuries his
work was neglected as unmetrical doggerel.

In French, mute *e* has a second role, which is to indicate
the feminine in adjectives: *clair, claire.* Finally, in verb forms
ending in *-ent* (third person plural), these three letters count
and are pronounced as a mute *e.* In reality, this *e* is not mute
but obscure, toneless. It should also be called unstable, since it
can be sounded or not and, as Jeanne Varney Pleasants has
shown by delicate measurements, it is sounded by the same or
different speakers in widely varying degrees of length and
forcefulness. It might thus seem as if French did have after all
a vowel like the English schwa (*uh*). But the two are not com-
parable, because the mute *e* has definite places and uses,
whereas the English *uh* can be put for almost any unstressed
vowel anywhere as a means of speeding up utterance. The
important conclusion is this: with its strong accent, English
comes down hard on one key syllable which is virtually
enough to give the meaning of the word; stressless French
requires equal value throughout and meaning fails without it.

The combined effect of these peculiarities is nicely illus-
trated by an anecdote in Heine's reminiscences. After the poet

came to Paris as a political refugee in the 1830s, he was sought out by German friends (and spies) who traced him to his successive lodgings. But he was never caught up with, says Heine, because they went about asking the concierges and shopkeepers for one HEINrich HEINe, whereas all these good people knew only of their neighbor *Enryenn*.

While pronunciation and accentuation separate the two languages, grammar and vocabulary make them seem close. They are both "analytic" languages, that is, they have dropped most inflections and show grammatical relations by position— subject, verb, predicate. But as hinted earlier, the kinship in vocabulary is a constant cause of deception—hundreds of words visually the same, from identical Latin roots, and possibly carrying the same meaning, but again and again having a sharply divergent use or connotation. Take this common word "deception" I have just used: its counterpart in French implies no deceit, it means disappointment. French grammar is hard enough for the foreign learner; it takes a lifetime of alert reading for the English speaker to make sure he grasps the right connotations of familiar words. Even veteran translators of prose stumble and publish what is not merely false connotations but factual error.

Thus *malice* does not mean malice but mischievousness; *fastidieux* not fastidious but tiresome; an *égoïste* is not an egotist but a selfish person; *une phrase* is not a phrase but a sentence; *atroce* rarely means atrocious: it is usually "cruel"; *demander* is never "demand," but merely "ask"; *prétendu* is not "pretended" but "alleged"; *curé* and *vicaire* must be rendered in reverse order: vicar and curate. As for an *ancien ami*, he is not an old friend but formerly a friend.

The recurrent small words and transitional phrases are misleading too: *en effet* is not "in effect" but "sure enough"; *mon Dieu!* never means "my God!" and *bien*, which is part of so many expressions, should seldom be rendered "well"—it has a dozen or more other meanings. Several books have been

compiled to guide reader or translator amid these perils and the term "false friend" aptly coined to designate the insidious similars. Many idioms seem perversely designed to mislead. The foreigner's reading of French poetry is thus continually threatened. One misconception, one false nuance, one implied feeling overlooked will ruin a line. In a respected version of a Baudelaire poem we come upon "the sainted earth"; it should be simply the Holy Land. The very title *Fleurs du Mal* is twisted slightly out of true by being rendered as Flowers of Evil. For one thing, *fleurs* connotes rather fruits, products; and for another, *du mal* refers not so much to sin as to *the* Evil (principle), Satan himself.

This self-misrepresentation of the French vocabulary is compounded by another characteristic: French is not double like English, but single: it does not possess a second, Latinate word parallel to the Anglo-Saxon derivative—"tool" and "instrument," "strength" and "fortitude," "land" and "territory," "quick" and "rapid," "motherhood" and "maternity." Such pairs are not exact duplicates; usually, the sense of the Latin derivative is more abstract or lofty. Thus the spaceship was named *Voyager* and not *Tripper* (or even *Traveler*), and when Wordsworth wrote of Newton, he spoke of him as "voyaging through strange seas of thought." French has only the one word *voyageur*, and the effect of this lack on the unreflecting English is that French poetry seems to be always "aloft," full of fancy words and resounding abstractions—*"C'était pendant l'horreur d'une profonde nuit"*—why can't Racine say "dread" and "deep"? Because he has Virgil behind him and not *Beowulf.* And the critical mistake is to feel *profonde* as meaning profound when it does mean deep.

On top of the constraints imposed by semantics, another set comes from the makeup of French itself. Its being a vowel language precludes what is technically called hiatus. A hiatus or "yawning" occurs when two vowels have to be uttered in succession: we say "*an* accident" because "*a* accident" forms a

hiatus—"hiccup" or "stutter" would describe it better than "yawning." In French, hiatus can be avoided only by elision or by liaison. Eliding one vowel—saying *l'*arbre instead of *le arbre*—gets rid of the hiatus, and so does liaison, which activates a consonant or throws one in: the *t* in *y a-t-il* or the *s* in *mes-(z)-amis* instead of the normal *mè*, as in *mes livres*. All mute *e*'s can be elided and all nasals make liaisons: *un-n-animal, en-n-avant*. But this leaves many common expressions incurable by these means and thus excluded from Neo-Classic verse: *tu as, tu es, il y a, si on veut, joli oiseau, peu à peu, j'ai été*, and so on. *Oui* would be banned altogether if it were not considered, plausibly enough, as beginning with a consonant.

Hiatuses vary in badness: *il y a* and *tu es* are not nearly so awkward to say as *et après* or *a acheté*, which nobody would plead for. Yet all are forbidden alike, a severe handicap for the versifier, since it kills in the egg any number of ideas that come spontaneously to mind as natural or striking. And changes in habits of speech add to the predicament. At some point in the nineteenth century, words ending in *-er* (pronounced like *é*) no longer sounded the *r* in liaison with a vowel. Racine could write, with a perceptible *r*: "*Rendre docile au frein un coursier indompté.*" Two hundred years later, a poet would not risk the *-ier-(é)-in* hiatus brought about by changed habits of speech.

This example reminds us that the nasals *in, un, an, on*, are vowels indeed. They will clash with their own kind, as much as with the plain ones, whenever the final *n* cannot make liaison with what follows. *Un chagrin inquiet* is a deplorable sequence—though Racine wrote it. *En Amérique* can sound the *n* before *a* and is licit, but *en Hongrie* is ruled out, because the *h*, technically aspirate, bars elision and liaison both. What a language! If the nasal vowel precedes a plain one, it is a matter of tact whether the collocation will escape censure; a pause in the sense will ease the pain; but if the sense is continuous, the hiatus will be noticeable, as in another of Racine's verses: "*Le dessein en est pris. Je pars, cher Théramène.*"

A word more about liaisons: some are dangerous, as in Laclos's famous novel. First, a poet must know how to handle aspirated *h*. There *is* no aspirated *h* in French, but some words that begin with *h* are deemed to have this invariably silent letter aspirate. Others are not. In *les hommes* one says *lay-zom;* but in *les haricots* the *h* is as it were activated: one must say *lay-arrico,* and this second pair contains a hiatus. Besides the *h*-question, there are certain words such as *onze* that cannot tolerate liaison and still others that cannot make up their minds. They accept the tie in some places and not in others, depending on the entire succession of sounds. Thus poets have argued that the phrase *loin encore* was proper in verse, even though *loin-n-encore* would sound affected in conversation.

In fact, modern speech has tended to give up making liaisons other than with *s* and *t*, and even some of these drop out in familiar talk. To put in all possible liaisons suggests great formality—or controlled anger. In applying for a high position or in denouncing an opponent, liaisons rise to the lips as a weapon in the tense encounter. Of course, a few traditional ones have the force of idiom: *pied-à-terre,* with the *d* sounded as *t* and *sang et eau,* with the *g* rendered as *k,* are compulsory. But in *le pied à l'étrier* or in *rang honorable* and similar sequences the *d* and *g* remain silent and hiatus occurs.

The Neo-Classical poet's last point to settle in writing his verse has to do with diphthongs. The count of syllables in words that end, for example, in *-ion* is not fixed. In *Cyrano de Bergerac* one finds: *"Pension paternelle, en un jour tu vécus."* If spoken on the street, this verse would have only eleven syllables, the first word being uttered in two syllables: *pen-sion.* But Rostand quite legitimately made it three: *pen-si-on,* and it is anybody's guess whether an actor in the role will deliver the line short or long. Endless argument has gone on as to which words containing diphthongs can stand the distortion without sounding ridiculous, and long lists have been made of those eligible for lengthening. Obviously, *ciel* and *cieux* can only be one syllable, the *e* and *eu* being short and the whole

word spoken at one stroke. But what of *précieux,* where the length of the word somehow makes *ci-eux* plausible? *Pieux* can stand the same treatment, but *vieux* cannot—why not? Because the word is so commonly used. French "vowelness" exacts a high price! In the event, poets have followed their instinct more often than they have consulted the lists, for the lengthening often contributes to the harmony of the line. Only, the poet depends on the reader to scan the verse correctly in his mind's ear; it needs its full count of syllables—for example, in Hugo: *"C'était l'heure tranquille où les* li-ons *vont boire."*

<div align="right">1990</div>

Flaubert's Dictionary of Accepted Ideas

French readers of Flaubert's last novel, *Bouvard and Pécuchet,* have long been entertained by browsing through its supplement, the *Dictionnaire des Idées Reçues,* to which is sometimes added the *Catalogue des Idées Chic.* The Dictionary is known by reputation in England and America, better known perhaps than *Bouvard* itself, but the little work cannot be said to have entered our literature as have Flaubert's letters and novels.

It is not surprising that the character of the Dictionary is frequently misunderstood, for it cannot be guessed at from mere description or random quotation. Indeed, the use and effect of the contents he has left us were probably not entirely clear to Flaubert himself. The Dictionary and the dialogue of *Bouvard* show many parallels, and Flaubert may have intended that after his two disappointed heroes have given up active endeavors and started "copying" again they should in fact collect and copy the materials of the Dictionary, together with the quotations of the so-called Album or anthology of absurd-

ities. Both works exhibit specimens of the same conventional stupidity. But the alphabetful of definitions that we have is compiled from a mass of notes, duplicates, and variants that were never sorted, much less proportioned and polished, by the author. We therefore do him an injustice in calling these flying sheets a "work." More than one of them would very likely have been discarded as his intention grew clearer in the task of revision.

What is clear is Flaubert's attitude toward the objects of his satire. We know his state of mind from *Bouvard,* from the letters, from innumerable anecdotes. Traveling by train during the time he was composing the novel, he was accosted by a stranger: "Don't you come from So-and-so and aren't you a traveler in oil?" "No," said Flaubert, "in vinegar." From infancy, we are told, he refused to suffer fools gladly; he would note down the inanities uttered by an old lady who used to visit his mother, and by his twentieth year he already had in mind making a dictionary of such remarks. And of course, like nearly every French artist since the Romantic period, he loathed the bourgeois, whom he once for all defined as "a being whose mode of feeling is low." From the early 1850s, Flaubert kept writing and talking to his friends about this handbook, this Dictionary, as his beloved work, his great contribution to moral realism. The project was for him charged with a personal emotion, not simply an intellectual one: "To dissect," he wrote to George Sand, "is a form of revenge."

Before its adaptation to the requirements of *Bouvard,* the separate Dictionary was to mystify as well as goad the ox: "Such a book, with a good preface in which the motive would be stated to be the desire to bring the nation back to Tradition, Order and Sound Conventions—all this so phrased that the reader would not know whether or not his leg was being pulled—such a book would certainly be unusual, even likely to succeed, because it would be entirely up to the minute" (to Bouilhet, 4 September 1850). The same animus against the philistine public, which hardly lets up for an instant through-

out Flaubert's letters, was to find overt expression in the Dictionary, and with impunity: "No law could attack me, though I should attack everything. It would be the justification of Whatever is, is right. I should sacrifice the great men to all the nitwits, the martyrs to all the executioners, and do it in a style carried to the wildest pitch—fireworks. . . . After reading the book, one would be afraid to talk, for fear of using one of the phrases in it" (to Louise Colet, 17 December 1852).

All this may be called Theme 1 of the Dictionary: the castigation of the thought-cliché. This purpose was not new with Flaubert, though it arose in him from native impulse. The captions of Daumier's drawings, the sayings of M. Joseph Prudhomme in Henri Monnier's fictional *Memoirs* of that character (1857), as well as a number of other less enduring works, testify to the nineteenth century's growing awareness of mass production in word and thought.

The cliché, as its name indicates, is the metal plate that clicks and reproduces the same image mechanically without end. This is what distinguishes it from an idiom or a proverb. *The Dictionary of Clichés* published some years ago by Mr. Eric Partridge straddles several species of set phrase and hence bears no likeness to Flaubert's: it makes no point. The true nature of the thing Flaubert was out to capture and alphabetize was first discussed by an American in our century and endowed by him with a new name which has passed into the language: Gelett Burgess's "Are You a Bromide?" appeared as a magazine article in 1906. In book form it lists forty-eight genuine clichés (including the archetypal: "It isn't the money, it's the principle of the thing") and it makes the fundamental point that "it is not merely because this remark is trite that it is bromidic; it is because with the Bromide the remark is *inevitable*."

In reading Flaubert's Dictionary, this principle has to be borne in mind, for some of the utterances pilloried are manifestly true; they have to be said at certain times, being in themselves neither fatuous nor tautological. What damns

them is the fact that they are the only thing ever said on the subject by the middling sensual man. The form, imagery, and intention of the remarks are immediately recognized as approved, accepted, inescapable. In Flaubert's entourage these expressions recurred, more frequent and regular than the tides, and drove him frantic. For we should remember that he passed much of his life at Croisset, on the right bank of the Seine below Rouen, and was forced to listen there to much conversation that was not simply bourgeois and philistine, but made still more narrow by provincialism. Traces of this aggravation are abundant in the Dictionary, and one may surmise that in the finished work these local allusions would have been either eliminated or signalized as home variants of cosmic bromidism.

At any rate, to Flaubert these repetitions proved more than signs of dullness, they were philosophic clues from which he inferred the transformation of the human being under machine capitalism. This he took as a personal affront. Representing Mind, he fought the encroachment of matter and mechanism into the empty places that should have been minds. He kept seeking ways of rendering what he saw, and in addition to *Bouvard* and the Dictionary, he got as far as writing and circulating—no one would produce it—a sort of Expressionist play called *The Castle of Hearts,* of which the effect was to be "comic and sinister." The chief scene would show, through the glass walls of identical houses along a Paris street, identical bourgeois families eating identical meals and exchanging identical words to identical gestures. This of course is akin to the scheme of Zola's *Pot-Bouille* (*Restless House*) and many another attempt at literary Unanimism since: the device was in the air with the hum of machinery.

But while giving the previous century its share in the formation of the bourgeois and bromide, one must not overlook a second influence at work in shaping Flaubert's material. The Dictionary frequently derides the specially French as against the European or world outlook; the stay-at-home timidity and

love of the familiar which, although a universal trait, is reinforced in France by a tradition of complacency that dates back to Louis XIV. This is what Flaubert had in mind when he spoke of his work bringing back the nation to Tradition, Order and Sound Conventions. The reception of *Salammbô* by the Paris critics, and particularly by Sainte-Beuve, illustrated for him the same self-centeredness.

To this one must add that the French language, despite its marvelous power of combining force and subtlety, is traditionally a language of clichés. Ready-made expressions abound and are to be preferred; indeed it is not licit to break them up, it is "extravagant." The seventeenth-century aesthetician Père Bouhours has an anecdote on this point which has become famous—almost a cliché: a piece of writing having been shown to an "illustrious personage," this arbiter of taste smiled and said: "These words must be greatly astonished to find themselves together, for assuredly they had never met before."

It is but a few steps from this to Flaubert's "always preceded [or followed] by" and his other set devices. They all indicate a fixity, which on reflection is seen to go beyond forms of speech or lack of ideas or aimless parroting. Social in origin, it is lust for order through convention.

To the extent that some of the remarks "date," the Dictionary is an admirable document. A good many sayings are inspired by the Franco-Prussian War, which, as we know from Gobineau's searching essay on the debacle, let loose an unprecedented amount of nonsense. In such circumstances the cliché becomes a shield against hard truth, humiliation, and despair. And that is the moment seized by the satirist to avenge himself, like a reborn Cassandra, by dissecting the present: "All our trouble," writes Flaubert to George Sand in the wretched year 1871, "comes from our gigantic ignorance. . . . When shall we get over empty speculation and accepted ideas? What should be studied is believed without discussion. Instead of examining, people pontificate."

In so saying, Flaubert states Theme 2 of the Dictionary—the attack on misinformation, prejudice, and incoherence as regards matters of fact. Flaubert has an infallible ear for the contradiction that everybody absent-mindedly repeats: "ABSINTHE—Violent poison: one glass and you're dead. Newspapermen drink it as they write their copy." He plumbs with equal sureness the depths of well-bred ignorance—or rather his eye takes in at a glance the shoals of common knowledge: people know only two things about Archimedes, not three. Here too, in culture, art, history, science, and social thought, some things are to be "thundered against," others are "very swank." The bourgeois mind in this department of life is a compound of error, pedantry, misplaced scorn, fatuous levity, and ignorance of its ignorance.

As before in language, so again in opinion, the French tradition works toward a conventional narrowing. French textbooks repeat the same views, offer the same extracts, and lest the student should rashly venture on a perception of his own, guide him with footnotes to the correct criticism of the text: the child reads and repeats apropos of a verse or a turn of phrase: *"métaphore hardie," "pléonasme vicieux,"* and the like. In working at *Bouvard* Flaubert consulted—or had helpers abstract for him—over a thousand works of reference or instruction, from which he culled the enormities that enliven the pages of the novel and that were also to fill out its documentary sequel. The Dictionary appears as a vestibule between two storerooms.

It also (one cannot too frequently repeat) is but a mass of notes out of a folder. Would that all our scattered papers held half so insidious an appeal to later minds!

ACADEMY, FRENCH. Run it down but try to belong to it if you can.

ALABASTER. Its use is to describe the most beautiful parts of a woman's body.

BACHELORS. All self-centered, all rakes. Should be taxed. Headed for a lonely old age.

BEETHOVEN. Do not pronounce B*eat*hoven. Be sure to gush when one of his works is being played.

BREASTWORKS. Never use to refer to a woman.

CHATEAUBRIAND. Best known for the cut of meat that bears his name.

CONCERT. Respectable way to kill time.

EXERCISE. Prevents all diseases. Recommend it at all times.

EXTIRPATE. Verb applied only to heresy and corns.

FACE. The mirror of the soul. Hence some people's souls must be rather ugly.

FEUDALISM. No need to have one single precise notion about it: thunder against.

GODFATHER. Always the actual father of the godchild.

GORDIAN KNOT. Has to do with antiquity. (The way the ancients tied their neckties.)

HARP. Gives out celestial harmonies. In engravings, is only played next to ruins or on the edge of a torrent. Shows off the arm and hand.

HASHEESH. Do not confuse with hash, which produces no voluptuous sensations whatever.

HOMER. Never existed. Famous for his laughter.

MACHIAVELLI. Though you have not read him, consider him a scoundrel.

MATERIALISM. Use the word with horror, stressing each syllable.

MEMORY. Complain of your own; indeed, boast of not having any. But roar like a bull if anyone says you lack judgment.

OLDEST INHABITANTS. In times of flood, thunderstorm, etc., the oldest inhabitants cannot remember ever having seen a worse one.

OPTIMIST. Synonym for imbecile.

PHAETON. Inventor of the carriage named after him.

POET. Pompous synonym for fool, dreamer.

PRINCIPLES. Always "eternal." Nobody can tell their nature or number; no matter, they are sacred all the same.

PRINTING. Marvelous invention. Has done more harm than good.

SKIFF. Any small boat with a woman in it. "Come into my little skiff. . . ."

SOUTHERN COOKING. Always full of garlic. Thunder against.

STOICISM. Not feasible. *1954*

X

On Crime, Truc and Make-Believe

The Aesthetics of the Criminous

Raymond Chandler was a great literary critic, as anyone who reads his magnificent letters will readily admit. It is therefore to the letters that we must turn in order to find out his considered views on the part of literature properly called crime fiction. In addition to the letters, we are fortunate enough to have a paper of some thirty-five hundred words, written in 1949 and entitled by his editor "Casual Notes on the Mystery Novel." These are so far from casual that we may call them the most searching and consecutive thoughts on the subject that any practitioner of the genre has left us. In that memorandum we may question some of the judgments of particular authors and stories, but the principles, once stated, seem virtually self-evident.

What are these principles? One is that good crime fiction must have most, if not all, of the qualities of literature. There must be a good story, full of dash and suspense; details and characters must seem real; the author must be honest throughout; and the reasonably bright reader, who is to be kept guessing all the way, must be given a clear and satisfying explanation at the end. You may say there is nothing very startling in these ideas, except perhaps the claim of literary merit. But in fact, if we scan the entire output in the genre since Edgar Allan Poe, we see that only those works which answer to Chandler's specifications survive as readable and thereby establish the claim.

Nor is this all. Chandler makes three other important

points: the perfect mystery story can never be written, because the genre itself demands an impossible feat—that of first misrepresenting certain facts in order to present them again truly, yet without letting the reader feel cheated. Therefore one or another element of good fiction must be sacrificed, usually some explicitness of character or event. It follows—this is the second point—that crime fiction partakes of fantasy. Lastly, the plausibility of any such story is (in Chandler's words) "largely a matter of style . . . a matter of effect, not of fact."

1984

Rex Stout

If he had done nothing more than to create Archie Goodwin, Rex Stout would deserve the gratitude of whatever assessors watch over the prosperity of American literature. For surely Archie is one of the folk heroes in which the modern American temper can see itself transfigured.

Archie is the lineal descendant of Huck Finn, with the additions that worldliness has brought to the figure of the young savior. Archie is cynical but an idealist. He is of easy approach, simple speech, and simple manners, but he makes the sharpest, subtlest discriminations in his judgments of status, speech, looks, and clothes. He drinks milk, but can describe and savor *haute cuisine* like any freshly made aristocrat. He is body-proud and ready to knock any man down who disobeys *Robert's Rules of Order*—indeed he is not averse to clutching women by the elbow or the neck when they claim an equal right with men to disturb the committee work that goes on so tirelessly in Nero Wolfe's big room; yet Archie dislikes violence and carries firearms only as a badge of office. He also dislikes the policemen that his work compels him to consort

with, but he is of course on the side of law-enforcement. He is promiscuous with his eyes and his thoughts, and a woman must be past hope, or else wanting in civility or human feeling, before Archie ceases to interweave his erotic fantasies with his shorthand notes on the case; yet he clings to Lily Rowan with the fervent monogamy of a healthy man living in sin.

In short, Archie is so completely the standard American's embellished vision of himself that at times he helps one to understand the failures of American foreign policy and the paradoxical success that so many individual Americans achieve abroad while their government misrepresents itself. For Archie has vitality, candor under boyish guile, inventiveness, a remarkable memory, and an all-conquering efficiency. Above all, he commands a turn of humor that goes to the heart of character and situation: not since Mark Twain and Mr. Dooley has the native spirit of comedy found an interpreter of equal force. Our other professional humorists of the last half century have been solid and serviceable, but their creations are not in a class with Archie. His whole mind is a humorous organ, and not just his words.

Archie is spiritually larger than life. That is why his employer and companion had to be made corpulent to match. Archie is an arche-type; Nero Wolfe is a portrait—a portrait of the Educated Man. Unlike other detectives of fiction, Nero is not a know-it-all, much less a pedant. He hates work, perhaps the clearest symptom of a really fine education, for idleness is the only means discovered so far for civilizing the mind through the reading of books. I mean *read*, not use or consult for one's livelihood. Wolfe has to adopt these inferior courses from time to time, but it is always under duress. Just once Wolfe reads as an avenger, and it is as the vindicator of faith in the Word. That occasion is the one dramatic scene in the otherwise pallid history of literary criticism. As the curtain goes up, he is disclosed at the chimney corner glumly reading in a huge work. Each time he comes to the end of a page, he tears it out and throws it on the fire. The book is *Webster's*

International Dictionary, the third edition. And to Archie, who enters and protests, Wolfe, with a Johnsonian power for drawing distinctions, expounds the argument against book burning.

Wolfe's manner and manners also deserve attention. He is courteous where Archie is merely civil, but Nero pays himself back handsomely by telling people to their face what he thinks of their mental and moral confusion. And, of course, his penetration of motive owes as much to his knowledge of literature as to his natural shrewdness. To a reader of Balzac and Dostoyevsky, how rudimentary must seem the turns of cunning of a self-made millionaire or a made-up TV personality.

In this sublime duet of Don Quixote and a glamorized Sancho Panza who go tilting together against evil, there is no mystery, nothing but matter for admiration, edification, and (if desired) self-identification. The true mystery is in their inspired creator, Rex Stout. Not two characters alone, but a palpable atmosphere exists in that brownstone house on West Thirty-fifth Street. And what sinewy, pellucid, propelling prose tells those tales—allegories of the human pilgrimage, rather—in which there is little or no blood, but rather the play of mind; no stagy antics, but much passionate drama, as ingenious and varied in its lifelike situations as certain other kinds of plot one could name are repetitious and standardized.

To the reader who has followed the evolution of this imaginary world and its chief actors, it is entertaining to ponder why Nero is almost never ill, despite the prodigal use of condiments and cream sauces on the richest foods, accompanied by vintage wines and the swilling of beer. I can only ascribe this poise in the face of otherwise liver-corroding forces to the thorough—almost religious—lack of exercise.

This question raises that of the recipes. Where does Nero (or his chef) find those dishes with evocative names and dimly hinted ingredients? My only hypothesis is that the four hours a day that Wolfe is said to spend incommunicado in the plant rooms are not spent in horticulture at all. I am no gardener,

but I doubt whether an intelligent man could spend that much time—one thousand four hundred and sixty hours a year—simply spraying and surveying some forty head of cattleyas. I believe instead that he engages in secret trials of night-born notions of food (note the significantly named *saucisse minuit*).

The only other possibility is that he retires up there to read the novels of Rex Stout and picks up in them his strokes of genius.

<div align="right">

1965

</div>

A Catalogue of Crime

For the seasoned reader, tales of crime fulfill the definition that Dr. Johnson gave in another context: "the art of murdering without pain." Contrary to what is often said, the pleasure is not the symbolic satisfaction of aggressive desires. The pleasure of reading crime fiction is intellectual and exploratory—the world seen under a special light. If a more visceral emotion goes with curiosity satisfied, it is the love of making order out of confusion. The philosopher R. G. Collingwood, in *The Idea of History*, put it simply: "The hero of a detective novel is thinking exactly like an historian when, from indications of the most varied kinds, he constructs an imaginary picture of how the crime was committed and by whom."

The need for "varied indications" enables the skillful storyteller to combine with facts and situations that we recognize a great many things we did not know before, yet which belong to ordinary life—habits, motives, practical arrangements, local customs, and the peculiarities of trades and professions. It is a kind of archaeological dig into the present.

This display differs from what we find in great novels.

They pay no such attention to this species of detail, except for an occasional one, used perhaps as a symbol, such as Proust's famous crumb of cake in the teacup. In real life, the place where the stuff of crime fiction is treated with exceeding care is—logically enough—the criminal trial. Hence the fact that readers of crime fiction generally develop a taste for analytical accounts of true crime.

This rational linking of fact, motive, and explanation is what distinguishes sensible crime fiction from the thriller, which is the acme of the helter-skelter. Thrillers can be fun when the writer makes things happen so rapidly and surprisingly that the reader never even thinks of motive or probability. Otherwise, actions and agents appear childish and insane by turns, and the effect is tedium and disgust.

A further comparison, this time with what people call "serious" or "straight" novels, also brings out differences that define. Stories of crime, whatever their kind—police procedural, private eye, elegant amateur, espionage, or psychological suspense—are not, properly speaking, novels at all. They are tales. When we are told that some great nineteenth-century novelists—Balzac, Dickens, Dostoyevsky—wrote crime stories that are also true novels, the remark is a hasty judgment. Works such as *Bleak House* or *Crime and Punishment* include a murder or a mystery of identity, but little time is spent on obtaining the solution. The riddle is mentioned now and then, but the key to it is offered gratuitously at the end. The main concern is character and social fact, pursued with undivided attention.

To distinguish novel from tale raises the question implied in the word *realism*. The truth is, realism does not denote a relation to life so much as a literary effect. To the literary imagination anything can happen and all of it is equally true. An English country house is as real as a Los Angeles slum and a butler as actual as a gangster. Realism, then, is what the author induces you to believe, and this definition has importance for the discriminating reader of crime fiction. Such a

reader will believe as readily in the country house as in the slum, provided the author has the literary art to make his people and things consistent and lively. He must himself believe in what he presents and gauge accurately both probability and the extent of our store of credence. Thus we can accept a private eye who thinks about political corruption and the vices of the rich, and who is keen about jazz; but when he drinks and fornicates incessantly we cease to believe in his capacity for consecutive thought.

Nor do we credit his opinion, drunk or sober, of the late Beethoven quartets: they do not suit, and while he detects crime, we detect the author. Similarly, the foolish little man with a perpetual cold is not adequate to his detective role, nor is any unintentional burlesque of human character, such as that of the "Gothic" maiden who goes out at midnight alone on the least provocation. The same goes for sinister atmosphere: it must be laid on with a brush, not a trowel. The upshot of these maxims is that the crime tale depends rather more than the novel on literary art. Raw substance and a fresh outlook will carry a novel; they leave the crime tale a botch.

Since the thirties, the main branches of crime fiction and their subgenres have undergone an evolution that has modified substance and decoration, both. Length, types of investigator, grasp of technicalities, and explicit views of society have changed, together with narrative methods. The standard length has come down from some 300 pages to 185, this reduction being effected by the omission of the once obligatory red herrings and of the inquest, which repeated what the reader already knew.

Whether this new compactness made the short story less attractive to authors by requiring comparatively too much time to write and yielding too little money, the fact remains that it is now in a slump. The best writers attempt it occasionally but do not shine, and the average talents turn out dreary imitations or contorted evasions of the real thing. Most

often, the plot turns on a single point—a slip of the tongue by the suspect, or a small discrepancy in time or space. One senses that having thought of this trick, the author cobbled together a situation for its use and set up would-be characters absent-mindedly. It is a far cry from the well-wrought complexity and rich surface of Conan Doyle or H. C. Bailey.

But in all his modern avatars the investigator has one new and indispensable characteristic: expertise. Today, the early masters would get rejection slips for all their works. Conan Doyle would hear harsh words for the errors—the offenses— he lets Holmes commit in such affairs as "Silver Blaze," where the rules of the turf are violated right and left. These days, readers full of indignation write to authors who misstate topographical truths, ignore court procedures, do not know diplomatic etiquette, or scamp police routine, to say nothing of mistakes in pathology, ballistics, or the lore of wines. Accuracy to the point of pedantry is part of twentieth-century enjoyment.

Unfortunately, this meticulous care stops short at the use of language. In two popular categories, the endless reuse of Holmes and Watson and the frequent re-creation of past periods, authors are deaf to plausibility in speech. Holmes is as likely to refer to "the bottom line" as an ambassador of Henry VIII to accuse Spain of "insensitivity toward her minority people." The imitations of Holmes are tedious anyway; it is easy to trot out his accoutrements and mannerisms without exhibiting anything of his mind and outlook on life. Plagiarism—for that is what it amounts to—is a cheap way to supply setting and character, which amounts to a kind of fraud upon the reader.

As for the historical reconstructions, they run into a danger common to other subspecies of the classic genre: overstuffing. Too many of the new hands have been attracted to crime fiction because, aside from salability, it gives an opportunity to show off special knowledge. They are not really interested in the form and, ignoring its requirements, they present as

story what is in fact a series of lecturettes—on museum curatorship, the tricks of brokerage, or the vicissitudes of social work. Worse still, cultivated authors air their general knowledge at every turn. Before the suspect's interrogation at home (and interviewing too is grossly overdone), every stick of furniture, all pictures, rugs, books, and the color of paint on the walls are inventoried, with judgments as to taste and quality. The superior investigator turns out to be an interior decorator.

Surroundings can of course supply legitimate clues, and notice taken of architecture and scenery and dress can serve to define character and produce "realism," but the tale of crime must have pace, and must alternate tense and rapid progress with passages quiet enough for a little thinking. Then comes the modern convention which, instead of a long recap, calls for a final twist followed by a smash ending—a parallel to the concluding crescendo of a Rossini overture.

Is all this a sign that moth and corruption have overtaken an interesting literary form and are destroying it? Well, decline and demise have been predicted before. Each time the prophets have been wrong; the crime tale has rebounded, the same but different. Certainly no drop in output is discernible now, nor have the best talents exhausted their vein. The danger that may really threaten is that soon there will be more writers than readers, that is, persons content to be seated at home, TV off, book in hand. *1971/1989*

Why Read Crime Fiction?

The short answer is: Because it's fun to read good tales. Because reading good tales is fun. I repeat myself to stress the word *tales,* which is all-important, for if you go to crime fiction expecting to read *novels* you are going to be disap-

pointed. What is the difference? To begin with, tales are as old as mankind. The novel is a modern invention, about 250 years old. Its purpose is to delve into human character and describe its environment—that is to say, society. We commonly say of some novel that it is a "study" of such and such a character, or a "picture" of contemporary society. A novel is deadly serious.

A tale, by contrast, does not study anything and it is therefore cheerful. It presents ready-made characters who are familiar types, such as the postman, the doctor, the college girl, the grandparent, the sailor, the shopkeeper—all people whose generic character we know. As for the society they live in, the tale counts on your knowing how it behaves. The teller of tales uses these types and these norms to unfold an adventure. *This time,* he says, things didn't go as you would expect. The outlandish events hold you in suspense, but they are so presented that you believe they have happened.

This is not to say that whereas a novel tells you something about life, a tale does not. On the contrary, a good tale also throws light on human affairs, but in a glancing way. Think of that famous tale *Robinson Crusoe.* Not only could it happen, it did happen. Defoe wrote it when Alexander Selkirk came home and said he had been marooned for four years on a desert island. But Defoe made the fact engrossing by inventing a host of details that show the feelings of being alone for endless years and the multiple needs that must be met for survival. Crusoe himself is only a plausible peg, not a character like Hamlet or Tom Jones.

Even so, in many good tales, the author makes the types vary from the usual, in some amusing or striking way, to match the unusual tangles that he sets down amid the dull routines of daily life. But he does not plumb the depths of any individual soul or reveal the hidden forces of society. For example, Voltaire's *Candide* is a tale that takes you all over the world depicting the misfortunes that await an innocent but not stupid young man. The people are appalling and the events entertaining—high comedy.

Now take another young man, Pierre in Tolstoy's *War and Peace*. He too makes his way through the realities of the world, but in no comic spirit. And everyone around him is the object of a separate study. We get to know more about them than we know about our family and friends and we understand every predicament in full. By the end we feel we have lived through a lifetime of worry, dismay, hope, shameful ignorance, love, sorrow, the anxiety of battle, and the terror of death.

It may illustrate the difference between novel and tale if I tell you about the time when a friend who was a great reader of novels asked me to recommend a work of crime fiction; he had never read any. I suggested a title, but I failed to warn him about novel *versus* tale. He came back full of indignation. He said: "I read that thing and can't imagine what you see in it. There's a murder at the end of the first chapter, and we're told that the household is upset, the wife is in tears, just for a couple of pages. Then the author goes on to things like who was where at what time. It's incredible. Murder is a dreadful thing. It wrecks whole lives. The misery can last for months, and it affects different people differently. But here not a word about any of this. The murder seems forgotten except for finding out how and why it occurred. The only concern about people is with their behavior beforehand and after suspicion rests on each one of them in turn."

I calmed my friend down and explained about the two distinct genres, adding that what he wanted was a crime *novel*. I suggested Dostoyevsky's *Crime and Punishment*, in which a poor student kills an old woman for her money, is so appalled by his act that he forgets to rob her, agonizes for a hundred pages, then confesses and gladly goes to prison. My friend smiled and said: "That makes your tales unnecessary." I asked whether he had ever read fairy tales, ghost stories, the Arabian Nights. He shook his head. Apparently he had not had a proper childhood. Finally I said: "Do you know Dickens's *Christmas Carol?*"—which is obviously a tale. He nod-

ded and admitted that it dealt with human feelings in a memorable way. The three ghosts and the happy ending do not prevent one from reading it with pleasure, including suspense.

More than one great novelist has written tales. Dickens wrote almost as many as he did novels. Mark Twain likewise—in fact, *Huckleberry Finn* is really his only novel. One word more to clinch the point. Those of you who read Graham Greene will remember that he called some of his works novels and others "entertainments." For this second group he might have used the word "tales."

Entertainment, then, is the prime intention of the tale and it is a pity that in our time people are so addicted to entertainment that they must restore their dignity and self-respect by pretending that some things they like are not for pleasure, but uplifting, informative, *educational.* And so novels are read with a serious face, and crime tales with an apologetic air and a confession to friends that part of the time they are lowbrows.

That last word is contrary to fact. From its beginning in Edgar Allan Poe's four model tales, the detective story has been written by highbrows for highbrows. Many such tales are works of art and some deserve the name "classics." To arrive at this estimate, one must know what to look for.

It may surprise you when I say that crime fiction—or any tale—is to be judged on the strength of its literary qualities. We are so accustomed to reserving the word "literature" for great poetry and great novels that we have forgotten certain facts. One is that a novel can be great and yet deficient in specifically literary merit—badly written, badly proportioned, lacking in the elements of literary pleasure that I shall mention in a moment. Some masterpieces are not even finished—for example, *Brothers Karamazov.* The substance, the vision alone, not the literary art, justify their high place.

The deficiencies are not merely ignored but also unsuspected, because readers are content to discover new twists of character in the grip of social predicament and see how it all

comes out. Only after much rereading does literary skill get noticed. But how often do readers reread? In crime fiction, the genre compels, from the outset, close attention to the narrative art—or to its absence. It makes these essential demands:

First, invention. What are we offered in the way of incident, people, and milieu that was not done before? Next, plotting. Is the plot well conceived and neatly executed? Do any portions drag? Or are some scamped, so that we feel confused and cheated? Is the telling—the prose itself—smooth, free of clichés, and deft at leading you on? Has it a verbal charm that reveals the individuality of the author? Is the dialogue lively and does it move the action forward? Has the author humor, or wit, or both? Are the clues original, adequate, and well hidden?

Some of the main incidents being as unlikely as those of a fairy tale, they must be made believable, unquestioned as we read, and the ordinary actions surrounding them must not be tedious—hence the need for humor and wit. Similarly, the figures that act out the story must not be cardboard but types with pleasing variations. I repeat that it does not take a connoisseur—or a rereading—to be aware of these features, because without them the tale falls apart, the suspense fades away, and we stop reading. These requirements must be fulfilled or there is no fun.

The detractors of crime fiction often accuse it of being just a puzzle. And it is true that examples abound of stories cobbled together that serve up nothing but a situation and an outcome. But writing to formula afflicts all literary genres, including the novel.

This menace calls for discrimination. I spoke a minute ago of Poe's four tales as detective stories. That is the root form, the tale in which a crime (not necessarily a murder) generates an engrossing inquiry. The point is not *whodunit?* but how did it come about? The criminal *who* is the decoy for the hunt—but it is the hunt under difficulties that furnishes the fun. This being so, I do not like to see the artistic tale of crime

called a mystery, or thriller, or suspense story. All good stories, novels included, and even ordinary jokes, have suspense; and wherever there is suspense there is mystery: how will the hero in the novel overcome his enemies, survive shipwreck, manage to marry the girl?

That is why the kind of literary work to which I invite your attention must be kept separate from the mass of fiction with which it is confused. This once done, the best examples of the preferred group must be chosen from the run-of-the-mill productions. This is not the time to survey the history of the genre since Poe. I can only suggest the point at which to begin your exploration: it is the so-called Golden Age of the genre: 1920–1970. Within it, the works to start with are those of the five great Englishwomen: Dorothy Sayers, Margery Allingham, Georgette Heyer, Agatha Christie, and Ngaio Marsh. Marsh was a New Zealander, but lived and wrote in England, and helped create the English model.

With mastery of the form and the needed literary qualities, these writers offer variety among themselves as well as within the range of their individual imaginations and talents. One word confirms their merit: they can be reread. Let a few months go by to dim the recollection of the lesser details, and even if you remember whodunit, you derive manifold pleasure from the artistry.

In the same period a sizable company of writers English and American wrote notable works. But if you go to the crime section of the library and pick up a book at random, you will have more disappointments than lucky strikes. Fortunately, there is a guide, a reference work that lists over five thousand titles, each with a terse description and a clear assessment. It is called *A Catalogue of Crime,* the fruit of a lifelong collaboration between my late friend Wendell Taylor, of Princeton, and myself. The book is now out of print, so look for it in the library too.

There is, alas, another obstacle on the way to the Golden Age. Not all libraries have kept the golden works. But some

have acquired and still own the one hundred tales that Taylor and I chose and induced Garland Publishers to reissue in two uniform sets, one bound in bright orange, the other in bright green, to make them stand out amid their less distinguished shelf mates. The whole series covers the years 1900–1975; it is a kind of island in the sea of the commonplace. These books also are out of print; referring you to them conceals no dream of future royalties.

You will certainly ask, what about the crime fiction of the last twenty-five years? If not Golden, is it not shining silver and worth treasuring too? My view may be disputed by anyone who has long been a devotee of the genres and who finds the contemporary output as satisfying as that of the past; tastes cannot be decreed. I can only state by way of conclusion what I find and fail to find in the tales now highly prized or merely popular.

My impression is that the best talents have been trying to turn the crime tale into the novel. My example here is P. D. James, who had to her credit half a dozen excellent detective stories and then began to write long books stuffed with moral and social issues together with a surfeit of scenery and interior decoration. In this clutter, the unfolding of Crime and Consequences gets lost—and my interest falls to zero.

Other modern deviations include making the tale into a guidebook, either to some region of the earth or to the workings of some industry or occupation. So much is told about the way the great museum is organized and how its internal rivalries interfere with its day-to-day operations that we cease to care whether the man who slashed the Rembrandt and also the beautiful assistant curator is ever identified.

Those of you who read the modern school can supply instances of comparable irrelevancy and disproportion when an extraneous interest usurps the foreground. The same must be said of stories that promote a social or political cause. These hybrid works may be well done and deserve praise, but they are not tales of crime and detection.

Finally, the genuine article is now so endlessly imitated by men and women of modest ability that we may say it has been overtaken by mass production. It has nothing new to offer. The few exceptions are usually survivors of the better time, for example Michael Gilbert. But others of the same vintage, such as Robert Parker, have fallen into tedious repetition.

All this has come with the expansion of the public for the genre. When it was treated with contempt, it reached and maintained excellence, but the authors had to be content with very small returns for their work. Now Patricia Cornwell is offered an advance of $8 million for three stories. Like P. D. James, she started well; her laborious efforts now exploit the love of violence and the gruesome. If, as I think, the art form has reached exhaustion and nothing more can be done with it, that only makes it the more desirable to recall its best days and reread the classics. Other great genres have perished too: the epic, the classical drama in verse, and—let me whisper it softly—the novel itself. *1999*

The Place and Point of "True Crime"

True crime is the match of crime *fiction*, the detective story, commonly called mystery. It has been said that a seasoned reader of crime fiction graduates to true crime. But such a graduate does not leave the campus and its reading list; he only adds a new source of pleasure to the one he has been cultivating.

It should not be supposed that those who read about either sort of crime do so because of a taste for mayhem and gore. To think so is to miss the point. In good crime fiction, the victim is disposed of quickly with a minimum of physical

detail. In true crime the detail may indeed form part of the recital, because the body has been found in shocking condition—in a trunk or a cellar. But the evidence is soon left behind in the quest for motive and circumstance. In both genres, the deep interest does not even lie in whodunit; it lies in how this is ascertained by a close examination of time and means and other probabilities.

I say "the interest," meaning the suspense that must grace any sort of writing from riddles to theology. The *pleasure* is something else again. In both the crime offerings, true and fictional, the pleasure is literary.

This may surprise the addicts themselves, who often think their taste well beneath that of people who read highbrow novels. The truth is that great novels are often inartistic compared to the great works that retell great crimes. The qualities, besides lucid prose, that distinguish true crime are narrative skill, the right order of topics (equivalent to plot), the writer's grasp of character and knowledge of life, his wit, and judicial detachment coupled with sympathy.

To bring these talents to bear on the details of an actual crime calls for great powers, greater perhaps than are needed when the writer invents his facts; for the crimes worth writing about are those that present a murky tangle in which essential points may remain forever doubtful. Thus the famous Wallace case of the 1930s in Liverpool bewildered all true-crime fanciers for years, until the genius of Jonathan Goodman solved it by a combination of wide research and brilliant analysis. Before then, an aficionado such as the theater critic James Agate would call up a friend and say, "Come over and we'll talk about the Wallace case."

The exposition of notable crimes, with or without solutions, has a long history; it begins with the earliest pleadings at the bar. Cicero in 72 B.C. gave a splendid example in his defense of Aulus Cluentius, and before him the Athenians heard Socrates pull apart the charges of his accusers. In eighteenth-century London there was the Newgate Calendar

and street-vendors' broadsides—cheap and crude tales of recent crimes; in the nineteenth century it was that fine critic De Quincey who after a notorious murder wrote a long analysis for the literary public: "On Murder Considered as One of the Fine Arts." But it mainly sang the praises of the killers.

The modern genre, more law-abiding, usually begins with excerpts from the transcript of the trial, where each side gives a version of what happened. How these slanted stories are dealt with by the later critic shows the degree of his art and judgment. Henry James took delight in the accounts by William Roughead of cases that others have written up with dissenting conclusions. In our time, Edward Radin showed that Lizzie Borden was probably innocent of her parents' murder, which contradicts the accepted view put forth by Edmund Pearson, Mrs. Lowndes, and Victoria Lincoln.

There is no end to the speculative opportunities that an interest in true crime bestows on the devotee. Did Crippen kill his wife by accident, mistaking the right dosage of the sedative hyoscine? Was Stanley Morrison innocent after all, like Oscar Slater, who owed his release from prison to the tireless efforts of Conan Doyle? And then there is the perennial question, Who was Jack the Ripper?

A wag suggested Matthew Arnold, the advocate of "sweetness and light." Unfortunately, Arnold had been dead six months when the killings began. Looking up this little fact shows the truly accomplished—what *shall* we call the connoisseur of true crime, that capacious scholar-like mind, attentive to scientific truth and wedded to legal logic? May I venture to suggest a name? As usual, the ancient Greeks had a word that is (I think) the root of a proper answer. They used a single word for "the actual murderer"; it was *authentes*. Why not adopt *philauthentist* as our proud designation, on a par with *philatelist* and indeed with *philosopher?*

2000

Meditations on the Literature of Spying

As I begin these notes, the American public is making into best-sellers two works of light literature: *Candy* and *The Spy Who Came in from the Cold*. The one is supposed to be a parody of the modern novel of sex; the other is held up as a really real realistic tale of modern spying; and there is evidence from conversation and printed comments that readers who usually scorn the best-seller are giving these books their attention. I suspect that something important but unspoken links these two efforts and also attracts the consumer of so-called serious novels.

I do not know what that something is, but I do know that *Candy* and *The Spy* are dull and, under their respective cloaks of gaiety and of sobriety, affected. The point of *The Spy* is that he wants to quit but is impelled to go on by professional routine. This is enough, I imagine, to make him congenial to all of us. He does not believe in what he is doing; he is anything but a hero; he is a good deal of a masochist. And being a spy in the field, indeed a potential martyr to an unfelt cause, he entitles himself to certain low pleasures—despising his associates; having, skill apart, a poor opinion of himself; sinking morally and physically into degradation almost beyond control; falling in love listlessly, like a convalescent; and, after being betrayed in action by headquarters for double-cross purposes, making a sacrificial end. Death, we are to think, is the only "coming in from the cold" there is.

I am sure that this melodrama played in iron curtains corresponds to something older and deeper than our anxieties of the cold war. The soul of the spy is somehow the model of our

own; his actions and his trappings fulfill our unsatisfied desires. How else explain the stir caused by the death of Ian Fleming? Ten books about James Bond, published in a little more than ten years, do not justify the front-page laments, and even less the studies by academic critics who have argued over Fleming's morals and political philosophy. No, there is something here like earlier ages' recognition of themselves in the pioneer, the warrior, the saint, or the poet. We are the spy— an agent, mind you, not a man—hiding behind the muffling zeros of 007 which mean: the right to kill *in the line of duty*.

The advertisers, who always know the color of our emotions, rely on our being good Bondsmen. Leafing through *The New Yorker,* I am told by a travel magazine: "Come to Beirut and see spies. Real spies . . . with shifty eyes and tiny cameras." In *Playboy,* cheek by jowl with a discussion of the "cultural explosion," I am invited to examine a dinner jacket and to "ask Agent 008, the one for whom survival often depends on the smallest detail." These hints play on the surface and suggest the depths. As technologists we love that tiny detail, that tiny camera. As infidels without purpose, we attach a morbid importance to survival. Yet our aplomb is restored by the possession of cosmetic virtue: with those faultless garments on, we would be content to let our eyes shift for themselves.

The spy story does this for us, then: it permits us not to choose; we can live high and lie low. Since Graham Greene no longer writes "entertainments," read Eric Ambler's *Light of Day* and see how the ironic title is brought down to mean simple survival for an outcast in a dirty raincoat with a mind to match. We are on his side, for as with the cold spy in his Skid Row phase, we relish the freedom that exists at the bottom of cities. And we know that in exchange for a few dirty tricks there is also power and luxury, cash and free sex. True, even James Bond marries while *On Her Majesty's Secret Service,* but the wife mercifully dies within a few hours. They had been lovers, so all is well.

The advantage of being a spy—a soldier—is that there is always a larger reason—the reason of state—for making any little scruple or nastiness shrink into insignificance. But I want to leave the question of morality to a later place. At this point I am still curious about the satisfactions that the tale of espionage affords Western man in the afternoon of this century. It is the satisfactions that produce the illusion of reality: man despising and betrayed, listless in his loves, dying pointlessly every second, scared, scared, scared—this is, if one may so speak, the life existential. But in the portraits and myths of that life what calms our fears is that dangers and difficulties yield to technique. The spy is imperturbable not by temperament or by philosophy, but from expertise. He is the competent man. Whether the need of the moment is to play bridge like Culbertson, speak a Finnish dialect like a native, ski to safety over precipices, or disable a funicular, he comforts us with his powers no less than with the specialism of the subject. He makes mistakes, of course, to keep us in countenance, but they are errors of inattention, such as killing the wrong man. We respond to this agreeable image of our scientific world, where knowledge commands power, where facts are uniformly interesting, and where fatalities appear more and more as oversights, professional *faux pas*. These results constitute the romance of the age; why should they not be translated into stories—spy stories especially, since what we know as science comes from ferreting and spying, and since we care so much for truth that we are willing to drug and torture for it?

One stumbles here on a pre-established harmony: the novel as a genre has been prurient and investigative from the start. Growing out of the picaresque adventure, which is high life seen from below stairs, the novel does not merely show, it shows up—and what a mountain of discreditable information it has unloaded into our eager minds! What pedantry! What snobbery! At first, simple encounters and reversals kept the reader going; lately it has been character and relationships; but it is all one: from Gil Blas to Henry James's "observer"

somebody is always prying. From Scott to Dreiser we take a course in how some other half lives, how fraudulent men and their society really are. The novel is dedicated to subversion; the novelist is a spy in enemy country. No reason, then, to be surprised that his ultimate parable should be the tale with a declared, certified spy in it, one who like the original *picaro* sees society from below, and resentfully.

Mr. Matthew Head, who has written a dozen good detective stories and whose name conceals a well-known art critic, gives in *The Devil in the Bush* what might be called the moral strategy of the novel-bred mind. His archaeologist hero confides that "the first thing I always wonder about new people is what they manage to do for a living and how they arrange their sex life, because it seems to me that those two activities plus sleep and a movie or two account for most people's twenty-four hours a day." This is the brass-tacks appeal, and it goes well with our primitivism, our reliance on formulas, our fatigue at the thought of understanding "new people": there are so many of them, thanks to immoderate prenatal care.

And the wish to invade the privacy of sex gives a clue to the kinship I suspected between the two best-sellers with which I began these notes: spying and pornography are related through the curiosity of the child about the mystery of sex. Perhaps the relentless curiosity of science has the same root; certainly our fiction does not neglect the fundamental needs, only the fundamental decencies. It neglects, that is, the difference between recognizing the demands of the body under the elaborations, softenings, and concealments of civilized society and thinking that one is very sharp to have discovered them and made the rest negligible. The genuine primitive has another ring to it. The *Iliad* is about "Helen and all her wealth"—money and sex if you will, but like other national epics it is also about war and the gods, human character, and the sorrowful brevity of life. The novel is about malice domestic, and this is what ends by stunting our souls.

The cold-spy, cold-war story presumably expresses and discharges the tension of violence under which we have lived since 1914. But that expression is rarely touched with regret or remorse. Only occasionally, as in William Haggard's story *The High Wire,* is the theme in contradiction with the mode of life depicted. The main character here is a peaceable, middle-aged engineer who is catapulted into espionage and finds in it only horror, helplessness, and torture. He manages to live and marry the heroine, an agent who is—or just has been, for purely professional reasons, of course—the mistress of an opposing agent: again, the true romance of our times.

An uncommonly deft practitioner, Hubert Monteilhet, gives us another singular version of this romance in *Return from the Ashes,* which tells how a woman survivor from a concentration camp attempts to regain an old lover who may have betrayed her to the Gestapo. She has to turn spy, privately, to achieve her ends, and in so doing she destroys others as well as the hopeful part of herself. At one point she defines the embroidering of sentiment over brutality as "the work of a tragic Marivaux, one to suit this century." But why blame the century? Why are we told over and over again, as by Raymond Chandler in his masterpiece *The Lady in the Lake:* "Doctors are just people, born to sorrow, fighting the long grim fight like the rest of us"? Or in reverse, by one of Chandler's imitators: "She was really a rather naïve and inexperienced little girl. She apparently still believed in things like love and hate and gratitude and vengeance, not realizing that they had no place in this work, where your enemy one minute is your ally the next—and maybe your enemy again a few minutes later." The speaker of this maxim, the tough spy Matt Helm, in *The Ambushers,* by Donald Hamilton, acknowledges that ours is "not a chivalrous age, nor is mine an honorable profession." The excuse, it appears, is necessity. Chandler's indestructible hero, Philip Marlowe, who crystallized a good many of these poses, declares: "However hard I try to be nice I always end up with my nose in the dirt and my thumb feeling for somebody's eye."

Obviously the reason why these things occur and are bewailed is the way men choose to take life, and modern men take life in the way of sophistication, that is, universal suspicion, hostility, fear of being taken in. People who read only "noteworthy" novels do not know how far the second- and third-hand fiction has copied and exploited the disillusioned stance of the masters. At times one could imagine that it was Somerset Maugham who had decanted into all the lesser works the sour wine from the great vintage casks: "His intelligence was obvious . . . he never quite gave himself away. He seemed to be on his guard. . . . Those eyes were watching, weighing, judging, and forming an opinion. He was not a man to take things at their face value." This is Maugham's Dr. Saunders, the hero-observer of the well-named *Narrow Corner*. To know in advance that everything and everybody is a fraud gives the derivative types what they call a wry satisfaction. Their borrowed system creates the ironies that twist their smiles into wryness. They look wry and drink rye and make a virtue of taking the blows of fate wryly. It is monotonous. I am fed up with the life of wryly.

One reason for my annoyance is the contamination that the sophisticated and the spies have brought into the story of detection. Mr. Le Carré himself began with two attempts at the genre, in which his talent for situations is evident and any interest in the rationality of detection altogether missing. Under a surface likeness, the purposes of spying and criminal detection are opposite: the spy aims at destroying a polity by sowing confusion and civil strife; the detective aims at saving a polity by suppressing crime. Thanks to our literary men we have been made so much at home with crime, we have found the spy's shadow world serving us so well as a sort of subconscious of society, that we readily agree with the head of the French Secret Police who said no man "could fully understand our age unless he had spent some time in prison." Logic thus

compels the writer to turn detective fiction into the domestic branch of espionage.

In consequence the murders that do not arise from the drug traffic arise from the enchanted realm of "security." And so an excellent story such as Val Gielgud's *Through a Glass Darkly* seeks the solution to a London murder simply by turning inside out the lives of the wife, the friends, and the business associates of the victim. In place of the classical observation and inference, there is snooping, which obliterates action. Simenon's Maigret, whom many innocent readers take for a detective, is but a Peeping Tom. He is praised for his patience in looking out of windows across a road, but his "psychology" is a mere offprint of Dr. Saunders's: "He took an interest in his fellows that was not quite scientific and not quite human. . . . It gave him just the same amusement to unravel the intricacies of the individual as a mathematician might find in the solution of a problem." In short: the mathematical interest that a Paris *concierge* takes in his lodgers and finds rewarded by the Sûreté.

The great illusion is to believe that all these impulses and enjoyments betoken maturity, worldliness, being "realistic." The truth is that Maugham's observer and the ubiquitous spy are bright boys of nine years. Nine is the age of seeking omniscience on a low level. The spy's ingenuity, his shifting partisanship without a cause, like his double bluffs, his vagrant attachments, and his love of torturing and of being tortured, are the mores of the preadolescent gang. For adult readers to divert themselves with tales of childish fantasy is nothing new and not in itself reprehensible. What is new is for readers to accept the fantasy as wiser than civil government, and what is reprehensible is for the modern world to have made official the dreams and actions of little boys.

1965

XI

A Miscellany

Definitions

PRAGMATISM. James says that we shall know a truth by relating its consequences to its avowed purpose. Something is true, not because it has been repeated often, not because someone in authority has said it, not because it copies the world outside in every detail, not because it has been deduced from an infallible generality; but because it leads as accurately as possible to the kind of result that we have in mind. Pragmatism, in other words, takes a stand in opposition to the genetic fallacy, which bade us look at the antecedents of a thing, an institution, or an idea in order to discover its worth. *1941*

REALISM. In a precise critical sense all artists are realists. What they depict in words or paint is to them an object of consciousness. A dream, a ghost, an illusion is as real as a beer barrel or a toothache. "Realism," "realistic," as used in talking about literature, therefore have a crabbed sense, and that sense became so rapidly corrupted that it is unfit for use by anybody who likes to be precise. *2000*

LOGIC. Logic as an antidote to loose inference was helped in the Middle Ages by the use of the international language, not Latin, but *Medieval* Latin, a medium of exact expression, simplified in syntax and enriched in vocabulary. The modern tongues owe to it the subject-verb-predicate form of sentence and most of the abstract terms used in science, philosophy, government, business, and daily intercourse. *2000*

VISION. An age is always too crowded for seeing in it the few things that are by definition unique. One sees chiefly the cloud of dust around them, or one does not know where to look for them, or one sees them in a denaturing light which later, suddenly and mysteriously, will go out. The Gettysburgs and Waterloos are but a vast confusion; it is largely accident when to any apt witness the field of carnage appears as the park commissioner will preserve it for posterity. *1961*

PERSONALITIES. Saint-Evremond was the "representative man" par excellence. In any age such a man is influential because his ideas chime in with those of other influential people. He is thereby of historical importance, but gradually he sinks into the third or fourth rank and is read only from curiosity. If the past could really be described as it felt when it was the present, it would show a large gathering of personages like Saint-Evremond, their contemporary admirers sure that here were the classics of the age and unable to believe that a later time would not even recognize the names. *2000*

SPECIALISM. Our age of specialism is intolerant of breadth, even when it is accompanied by competence all around. Fame follows concentration. It is safer to repeat oneself shamelessly than to try to carry one's first readers across an intellectual boundary. *1993*

PARTICULARS. To say it once again, the abstract and the general (as Blake pointed out) are the death of art. It is because art embodies particulars that it deserves to be called a creation; that is why systems and absolutes falsify it under guise of giving us an explanation; and that is why also a lifelong student of art like John Jay Chapman said very soberly that "we cannot hope to know what it is." *1947*

Jottings

The reviewer who wrote: "This book fills a much-needed gap" may have misstated his meaning, but his phrasing is worth remembering for eventual use now and again.

Great art is at once autobiographical and detached, decorative and dramatic, programmatic and self-contained.

Vulgarity comes in two grades that critics often fail to distinguish. There is vulgarity in its Sunday best, in celluloid collar and cuffs, and this kind the public feels at home with. And there is the natural, expressive, wholesome vulgarity, such as we find reproduced in Shakespeare, Beethoven, Balzac and other makers of robust and spacious works.

It is more surprising that a professor of English should be a poet than that an admiral should be a philosopher. The admiral has time to contemplate the sea and does not have to square his mind with the dumbest of the crew.

In art, all too often, it is only the dead men who tell tales.

Removing ignorance in school is as painful as removing tonsils and calls for a rarer skill. Besides, the teacher should not use an anesthetic or be one.

The painting dates, but not the landscape. Those New England hills should have looked Victorian around 1850, but they didn't. This doubles the value of art.

Philanthropic foundations abound in the United States. Even before tax credits there was a cult of *richesse oblige*.

The fall of ancient civilization has been attributed to many things—change of climate, Christianity, race mixture, immorality, mosquitoes, the decay of agriculture, and poisoning by lead pipes. Nowhere is given the simplest and most plausible reason: the enforced cessation of waste. All is well as long as there is more than enough soil, food, slaves, markets, goods, space.

To educate the educated is notoriously difficult.

On my next application for a driving license, under Physical Characteristics: "Pragmatism of both eyes."

Punsters should not be blamed. Medical research has found in some people a gland, the puncreas, which when inflamed causes one to puncreate.

In presence of the highest art, you have to believe it to see it.

Clerihews

Margaret of Navarre,
Strummed on the guitar
While her bawdy friend Rabelais
Warbled *cantabile*.

William Butler Yeats,
In one of his states,
Swore: "The French say I'm no *gentilhomme*:
I'm sailing to Byzantium!"

El Greco
Took a long dekko
And put his sitter in place;
Then he said: "Now pull a long face."

The young Napoleon
Hadn't a simoleon
When he married Josephine.
Soon he hadn't a bean.

Robert Frost
Turned and tossed.
His nightmare was, What to do
If the road branched into more than two?

Arthur Conan Doyle
Burned the midnight oil
To create a sinister party
Named Moriarty.

Jonathan Swift
Was visibly miffed:
His horse had implied it was new in him
To be kind to a Houyhnhnm.

René Descartes
Murmured: "For my part,
If I cogitate, it must be clear
That I am here."

G. W. F. Hegel
Invented the bagel.
He liked its peculiar density.
(His prose has the same propensity.)

Henry James
Named no names,
But The Bostonians knew
Who was Who.

Feodor Dostoyevsky
While skating on the Nevsky
Cried: "Think of me as of
Another brother Karamazov."

Wise old Lao-Tse
Knew he knew The Way.
Had it been wiser to walk with the Buddha,
He woudda.

Ars Poetica (The Muse Is Speaking)

The poet Coleridge, S. T
Defined and backed the CLERISY.
With quite another end in view,
One Bentley hatched the CLERIHEW.
Which is of all the kinds of verse
The most informative and terse:
One line invokes a well-known name,
Three more disclose, for praise or blame,
In words that make one want to quote,
A single vivid anecdote.
 This Bentley, then, (E. C. for short)
Believed that it would be good sport
To ransack history and descant
On persons dead or still extant.
Debate has freely ranged as to
The need that such reports be true.
Without resorting to a poll,
We may conclude that on the whole
(Though truthful words are bound to be
A rare and welcome novelty)
It's now maintained by very few
That *ben trovato* will not do.
 So let us concentrate on form.
In clerihews it is the norm

For rhythmic anarchy to reign.
The poet, though, will not disdain,
Even as he acts the *vers-libriste*
And treats the famous like a beast,
To let the sound regale the ear
And make rhetorically clear
The pregnant vision or the myth
He hopes to leave his reader with.
This purpose uppermost in mind,
He is to ruthlessness inclined:
Line Two is factual and curt,
The Third is planned to disconcert—
A "sprung" or "contrapuntal" stab;
The varying last may clinch or jab,
While strange but rigorous rhymes in pairs
Impress the memory unawares.
These rules the maker gave the game—
Also his curious middle name:
That Bentley man, without a doubt,
Knew quite well what he was about.

And now it should no longer worry you
To hear the question, "What's a clerihew?"

Bibliography

I. *On a Pragmatic View of Life*

TOWARD A FATEFUL SERENITY. *Living Philosophies: The Reflections of Some Eminent Men and Women of Our Time*, edited by Clifton Fadiman, pp. 31–39. New York: Doubleday, 1990.

II. *On the Two Ways of Knowing: History and Science*

THE SEARCH FOR TRUTHS. *Forbes ASAP*, October 2, 2000, pp. 117–120.

HISTORY AS COUNTER-METHOD AND ANTI-ABSTRACTION. *Clio and the Doctors*, pp. 89–99. Chicago: University of Chicago Press, 1974.

THE IMAGINATION OF THE REAL. *Art, Politics, and Will: Essays in Honor of Lionel Trilling*, edited by Quentin Anderson, Stephen Donadio, and Steven Marcus, pp. 3–7. New York: Basic Books, 1977.

CULTURAL HISTORY: A SYNTHESIS. *The Varieties of History*, edited by Fritz Stern, pp. 387–402. Cleveland and New York: World Publishing, Meridian Books, 1956.

ALFRED NORTH WHITEHEAD. "On the Art of Saying 'Quite Mad.' " *Harper's* 196 (March 1948): not paginated.

WILLIAM JAMES: THE MIND AS ARTIST. *A Century of Psychology as Science*, edited by Sigmund Koch and David E. Leary, pp. 904–910. New York: McGraw Hill, 1985.

THOMAS BEDDOES, M.D. "Thomas Beddoes or, Medicine and Social Conscience." *Journal of the American Medical Association* 220 (1972): 20–23.

SCIENCE AND SCIENTISM. *Science: The Glorious Entertainment*, pp. 1–30. New York: Harper and Row, 1964.

MYTHS FOR MATERIALISTS. *Modern Culture and the Arts*, edited by James B. Hall and Barry Ulanov, pp. 514–525. New York: McGraw-Hill, 1967.

III. *On What Critics Argue About*

CRITICISM: AN ART OR A CRAFT? *Proceedings of the American Philosophical Society* 134 (1990): 455–460.

THE SCHOLAR-CRITIC. *Contemporary Literary Scholarship: A Critical Review*, edited by Lewis Leary, pp. 3–8. New York: Appleton-Century-Crofts, 1958.

JAMES AGATE AND HIS NINE EGOS. Introduction to *The Later Ego, Consisting of Ego 8 and Ego 9*, by James Agate. New York: Crown, 1951.

THE GRAND PRETENSE. Review of *The Seven Ages of the Theatre*, by Richard Southern. *The Mid-Century* (January 1962): 8–11.

ON SENTIMENTALITY. *From Dawn to Decadence: 500 Years of Western Cultural Life*, pp. 410–411. New York: HarperCollins, 2000.

SAMUEL BUTLER. "Voices of Dissent." *Darwin, Marx, Wagner: Critique of a Heritage*, pp. 117–124. Boston: Little, Brown, 1941.

ON ROMANTICISM. *From Dawn to Decadence: 500 Years of Western Cultural Life*, pp. 465–469. New York: HarperCollins, 2000.

DOROTHY SAYERS. *From Dawn to Decadence: 500 Years of Western Cultural Life*, pp. 741–744. New York: HarperCollins, 2000.

JOHN JAY CHAPMAN. Introduction to *The Selected Writings of John Jay Chapman*, edited with an Introduction by Jacques Barzun, pp. v–xiv. New York: Farrar, Straus and Cudahy, 1957.

REMEMBERING LIONEL TRILLING. *Encounter* 47 (September 1976): 82–88.

IV. *On Language and Style*

RHETORIC—WHAT IT IS; WHY NEEDED. *Simple & Direct: A Rhetoric for Writers*, pp. 1–8. New York: Harper and Row, 1975.

THE RETORT CIRCUMSTANTIAL. *The American Scholar* 20 (Summer 1951): 289–293.

THE NECESSITY OF A COMMON TONGUE. *A Word or Two Before You Go: Brief Essays on Language*, pp. 164–177. Middletown, Conn.: Wesleyan University Press, 1986.

THE WORD "MAN." *From Dawn to Decadence: 500 Years of Western Cultural Life*, pp. 82–85. New York: HarperCollins, 2000.

ON BIOGRAPHY. *Classic, Romantic and Modern*, pp. 81–86. Boston: Atlantic–Little, Brown, 1961.

VENUS AT LARGE: SEXUALITY AND THE LIMITS OF LITERATURE. *Encounter* 26 (March 1966): 24–30.

ONOMA—ONOMATO—ONOMATWADDLE. *Kenyon Review* 12 (Fall 1990): 110–114.

v. *On Some Classics*

SWIFT, OR MAN'S CAPACITY FOR REASON. *The Energies of Art: Studies of Authors Classic and Modern*, pp. 81–100. New York: Harper and Brothers, 1956.

WHY DIDEROT? *Varieties of Literary Experience: Eighteen Essays in World Literature*, edited by Stanley Burnshaw, pp. 31–44. New York: New York University Press, 1962.

WILLIAM HAZLITT. *From Dawn to Decadence: 500 Years of Western Cultural Life*, pp. 510–512. New York: HarperCollins, 2000.

HOW THE ROMANTICS INVENTED SHAKESPEARE. New York. Columbia University Library, Barzun papers.

BERNARD SHAW. "The Colossus Laid Out": Review of *Bernard Shaw: A Bibliography*, by Dan H. Laurence. *The American Scholar* 54 (Autumn 1984): 546–549. Liner notes, Bernard Shaw: *Don Juan in Hell*. Columbia Masterworks recording OSL-166, 1952.

GOETHE'S *FAUST: A TRAGEDY, PART ONE*. Translated by Alice Raphael. Introduction and notes by Jacques Barzun, pp. v–xxv. New York: Holt, Rinehart and Winston, 1955.

WHEN THE ORIENT WAS NEW: BYRON, KINGLAKE, AND FLAUBERT. New York. Columbia University Library, Barzun papers.

THE PERMANENCE OF OSCAR WILDE. Introduction to *De Profundis*, by Oscar Wilde, pp. v–xix. New York: Random House, 1964.

BAGEHOT AS HISTORIAN. Introduction to vol. 3, *The Historical Essays*, in *The Collected Works of Walter Bagehot*, edited by Norman St John-Stevas, pp. 23–40. London: The Economist, 1968.

LINCOLN THE LITERARY ARTIST. "Lincoln the Writer." *Jacques Barzun on Writing, Editing, and Publishing*, pp. 57–73. Chicago: University of Chicago Press, 1971.

THE REIGN OF WILLIAM AND HENRY. *A Stroll with William James*, pp. 181–226. New York: Harper and Row, 1983.

vi. *On Music and Design*

WHY OPERA? *Opera News* 31 (January 28, 1967): 7–10.

IS MUSIC UNSPEAKABLE? *The American Scholar* 65 (Spring 1996): 193–202.

MUSIC FOR EUROPE: A Travers Chants. *Berlioz and the Romantic Century*, vol. 1, pp. 404–430. Boston: Little, Brown, 1950.

TO PRAISE VARÈSE. *Columbia University Forum* 9 (Spring 1966): 16–18.

DELACROIX. *Atlantic Brief Lives: A Biographical Companion to the Arts*, edited by Louis Kronenberger, pp. 214–216. Boston: Little, Brown, 1971.

Bibliography

VISUAL EVIDENCE OF A NEW AGE. *New York Herald Tribune* Sunday Forum, May 21, 1961, sec. 2, p. 3.

MUSEUM PIECE 1967. In *Museum Communication with the Viewing Public: A Seminar*, pp. 73–80. New York: Museum of the City of New York, 1969.

WHY ART MUST BE CHALLENGED. *The Use and Abuse of Art*, pp. 3–23. Princeton: Princeton University Press, 1974.

VII. *On Teaching and Learning*

THE ART OF MAKING TEACHERS. *Begin Here: The Forgotten Conditions of Teaching and Learning*, pp. 96–100. Chicago: University of Chicago Press, 1991.

WHERE THE EDUCATIONAL NONSENSE COMES FROM. *Papers on Educational Reform*, vol. 2, pp. 1–2. La Salle, Ill.: Open Court, 1971.

OCCUPATIONAL DISEASE: VERBAL INFLATION. *Begin Here: The Forgotten Conditions of Teaching and Learning*, pp. 101–113. Chicago: University of Chicago Press, 1991.

THE CENTRALITY OF READING. Sheridan Baker, et al., *The Written Word*, pp. 17–25. Rowley, Mass.: Newbury House, 1971.

FOREWORD TO *THE TYRANNY OF TESTING*, by Banesh Hoffmann, pp. 7–11. New York: Crowell-Collier, 1962.

HISTORY FOR BEGINNERS. "History: What It Is." *The Paideia Program: An Educational Syllabus*, by Mortimer J. Adler, et al., pp. 109–117. New York: Macmillan, 1984.

OF WHAT USE THE CLASSICS TODAY? *Perspective* 1 (Winter 1988): 1–12.

THE UNIVERSITY'S PRIMARY TASK. *New Letters of Berlioz: 1830–1868*, pp. v–vi. New York: Columbia University Press, 1954.

THE SCHOLAR IS AN INSTITUTION. New York. Columbia University Library, Barzun papers.

EXEUNT THE HUMANITIES. *The Culture We Deserve*, pp. 109–119. Middletown, Conn.: Wesleyan University Press, 1989.

VIII. *On America Past and Present*

ON BASEBALL. *God's Country and Mine*, pp. 159–165. Boston: Little, Brown, 1954.

RACE: FACT OR FICTION? *Race: A Study in Superstition*, pp. 1–16. New York: Harper and Row, 1937.

THOREAU THE THOROUGH IMPRESSIONIST. *The American Scholar* 56 (Spring 1987): 250–258.

THE RAILROAD. *From Dawn to Decadence: 500 Years of Western Cultural Life*, pp. 539–543. New York: HarperCollins, 2000.

THE GREAT SWITCH. *Columbia Magazine* (June–July 1989): 32.

IS DEMOCRATIC THEORY FOR EXPORT? *Ethics and International Affairs: A Reader,* edited by Joel H. Rosenthal, pp. 39–57. Washington: Georgetown University Press, 1995.

ADMINISTERING AND THE LAW. *American Bar Association Journal* 62 (May 1976): 625–627.

THE THREE ENEMIES OF INTELLECT. *The House of Intellect,* pp. vii–viii, 1–30. New York: Harper and Brothers, 1959.

AN AMERICAN COMMENCEMENT. *Columbia Magazine* (June 1988): 49–51.

IX. *On France and the French*

PARIS IN 1830. Introduction to *Music in Paris in the Eighteen-Thirties,* edited by Peter Bloom, pp. 1–22. Stuyvesant, N.Y.: Pendragon Press, 1987.

FOOD FOR THE *NRF:* OR, MY GOD, WHAT WILL YOU HAVE? *Partisan Review* 20 (Nov.–Dec. 1953): 660–674.

FRENCH AND ITS VAGARIES. *An Essay on French Verse for Readers of English Poetry,* pp. 8–16. New York: New Directions, 1990–1991.

FLAUBERT'S *DICTIONARY OF ACCEPTED IDEAS.* Translated with an introduction and notes by Jacques Barzun, pp. 1–12, 13–77. New York: New Directions, 1954.

X. *On Crime, True and Make-Believe*

THE AESTHETICS OF THE CRIMINOUS. *The American Scholar* 53 (Spring 1984): 239–241.

REX STOUT. *A Birthday Tribute to Rex Stout by Jacques Barzun and The Viking Press,* pp. 5–9. New York: Viking, 1965.

A CATALOGUE OF CRIME, by Jacques Barzun and Wendell Hertig Taylor, pp. xiii–xxii. 3rd revised edition. New York: Harper and Row, 1989.

WHY READ CRIME FICTION? New York. Columbia University Library, Barzun papers.

THE PLACE AND POINT OF "TRUE CRIME." Forthcoming, in a book by Albert Borowitz. New York. Columbia University Library, Barzun papers.

MEDITATIONS ON THE LITERATURE OF SPYING. *The American Scholar* 34 (Spring 1965): 167–178.

XI. *A Miscellany*

PRAGMATISM. *Darwin, Marx, Wagner: Critique of a Heritage,* p. 387. Boston: Little, Brown, 1941.

REALISM. *From Dawn to Decadence: 500 Years of Western Cultural Life,* p. 557. New York: HarperCollins, 2000.

LOGIC. *From Dawn to Decadence: 500 Years of Western Cultural Life,* p. 230. New York: HarperCollins, 2000.

VISION. *Classic, Romantic and Modern,* p. 151. Boston: Atlantic–Little, Brown, 1961.

PERSONALITIES. *From Dawn to Decadence: 500 Years of Western Cultural Life,* p. 348. New York: HarperCollins, 2000.

SPECIALISM. "An Historian Who Writes History." *The American Scholar* 61 (Winter 1993): 103.

PARTICULARS. "Perennial Pastime: Annexing Art." *Harper's* 195 (December 1947): not paginated.

JOTTINGS. New York. Columbia University Library, Barzun papers.

CLERIHEWS. "Clerihews for the Clerisy." *The American Scholar* (passim).

ARS POETICA (THE MUSE IS SPEAKING). Introduction to *The Clerihews of Paul Horgan,* pp. vii–viii. Middletown, Conn.: Wesleyan University Press, 1985.

The editor thanks the following firms and periodicals under whose imprint parts of this book originally appeared, or from whose copyrights he has quoted: Appleton-Century-Crofts, Inc.; Atlantic–Little, Brown, Inc.; Basic Books, Inc.; *Columbia Magazine;* Columbia University Press; Crowell-Collier Press; Crown Publishers, Inc.; Doubleday, Inc.; *Encounter;* Farrar, Straus and Cudahy, Inc.; *Forbes ASAP;* Georgetown University Press; *Harper's Magazine;* Holt, Rinehart and Winston, Inc.; *Journal of the American Bar Association; Journal of the American Medical Association;* Macmillan, Inc.; McGraw Hill, Inc.; Museum of the City of New York; New Directions Publishing Corp.; New York University Press; Newbury House Publishers; Open Court Publishing Co.; *Opera News; Partisan Review;* Pendragon Press; *Perspective;* Princeton University Press; *Proceedings of the American Philosophical Society;* Random House, Inc.; *The American Scholar; The Economist; The Kenyon Review;* University of Chicago Press; The Viking Press; Wesleyan University Press.

Index of Names

About the Author

Born in France in 1907, JACQUES BARZUN came to the United States in 1920. After graduating from Columbia College, he joined the faculty of the university, becoming Seth Low Professor of History and, for a decade, dean of faculties and provost. A finalist in the National Book Awards, he received the Gold Medal for Criticism from the American Academy of Arts and Letters, of which he was twice president. He lives in San Antonio, Texas.

About the Editor

MICHAEL MURRAY, whose previous books include *Albert Schweitzer, Musician* and *French Masters of the Organ*, is writing a biography of Jacques Barzun.

 Perennial Quill

Books by Jacques Barzun:

FROM DAWN TO DECADENCE
1500 to the Present: 500 Years of Western Cultural Life
ISBN 0-06-092883-2 (paperback) • ISBN 0-694-52548-0 (audio)

A National Book Award finalist and *New York Times* bestseller, this is Barzun's account of what Western man has wrought from the Renaissance and Reformation down to the present in the double light of its own time and our modern concerns.

"Will go down in history as one of the great one-man shows of Western letters, a triumph of maverick erudition." —*Newsweek*

A JACQUES BARZUN READER: *Selections from His Works*
ISBN 0-06-093542-1 (Perennial Classics paperback)

"A sampler of Barzun's writings . . . demonstrating again the depth and breadth of his learning, the originality of his thinking, and his commitment to speak to the general reader in engaging, intelligent prose. . . . Each essay yields unexpected insights, and the volume as a whole makes clear why Barzun is probably our best-known public intellectual. Challenging, satisfying, elegant." —*Kirkus Reviews*

SIMPLE & DIRECT: *A Rhetoric for Writers*
ISBN 0-06-093723-8 (paperback)

Jacques Barzun distills from a lifetime of writing and teaching his thoughts about the basic choices every writer makes in his craft.

"The student of the craft of writing needs the company of others who know the way. Barzun in his instruction and by the example of his own prose is an excellent choice of travelling companion." —*Washington Post*

THE HOUSE OF INTELLECT
ISBN 0-06-010230-6 (Perennial Classics paperback)

Jacques Barzun takes on the whole intellectual (or pseudo-intellectual) world, attacking it for its betrayal of intellect in such areas as public administration, communications, conversation, home life, education, business, and scholarship.

"A stimulating thinker. . . . In 18th century terms he is an enlightened philosopher; in the superlative of our age, a 'genius'." —*The Guardian* (London)

Don't miss the next book by your favorite author.
Sign up for AuthorTracker by visiting *www.AuthorTracker.com*.

Available wherever books are sold, or call 1-800-331-3761 to order.

(((Listen to)))

From Dawn to Decadence

The Twentieth Century

by Jacques Barzun

performed by
Edward Herrmann

Taken from Barzun's landmark study of the
past five centuries, *From Dawn to Decadence*,
this enthralling analysis of the 20th century
rates the present not as a culmination
of Western civilization, but as a decline.

ISBN 0-694-52548-0 • $29.95 ($44.95 Can.)
9 Hours • 6 Cassettes • UNABRIDGED SELECTION

HarperAudio *An Imprint of* HarperCollins*Publishers*
www.harperaudio.com